AFRICA

AFRICA

AFRICA

VOLUME 3

COLONIAL AFRICA, 1885–1939

Edited by

Toyin Falola

Carolina Academic Press
Durham, North Carolina

Library of Congress Cataloging-in-Publication Data

Africa / edited by Toyin Falola.
 p. cm.
 Includes bibliographical references and index.
 ISBN 0-89089-768-9 (v. 1)—ISBN 0-89089-769-7 (v. 2)—
 ISBN 0-89089-770-0 (v. 3)
 1. Africa—History—To 1884. I. Falola, Toyin.

DT20 .A61785 2000
960—dc21

 00-035789

Carolina Academic Press
700 Kent Street
Durham, North Carolina 27701
Telephone (919) 489-7486
Fax (919) 493-5668
E-mail: cap@cap-press.com
www.cap-press.com

Printed in the United States of America

For Professors Adu Boahen, Bethwell Ogot and Ali Mazrui

Contents

Preface and Acknowledgments

This text is intended to introduce Africa to college students and the general public. It presents in a simplified manner different aspects of African history. The book does not generalize about the continent; it reconstructs the history of many societies at different historical periods. This book meets the requirements of history and culture courses in most schools, and addresses those issues of interest to the general public. The choice of topics is dictated both by relevance and by the need to satisfy classroom requirements.

This volume is an interpretive and thematic history of the colonial period in Africa, from the beginning of the partition of the continent in the 1880s to the outbreak of World War II. This was an era of colonial conquest, consolidation, and the establishment of political systems. The book is divided into three parts. Part one discusses the imposition of colonial rule, covering the reasons for the conquest, the Berlin Conference, the stages in the Scramble, and the response of Africans to the conquest. In the first decade of colonial rule, Europeans established early forms of their political systems and took measures to consolidate their rule. By World War 1, colonial power had been firmly established in many parts of Africa. To demonstrate the success of European rule, Africans had to contribute to the success of Europe in World War 1.

The second part of the book deals with the major changes introduced during the colonial era. Various chapters cover different topics such as the colonial political systems (theory and practice, indirect rule, assimilation, association, paternalism); the political impact of European rule (e.g., the impact on indigenous politics the evolution of new boundaries, and ethnicity); the economic impact of European rule on land distribution, taxation, labor, cash crops, currency, and communication; ecological history; Western education; Christianity (issues of conversion, independence, and religious change), Islam; culture and society (issues of race, class, music, arts, law, dress, food, sports, leisure, and emerging social networks); gender; population, cities, and urbanization; intellectual history; and African nationalism. In the last part, a chapter is devoted to each region, to provide a chronological narrative of the major events of the period.

The choice of the contributors is primarily based on their competence as teachers in explaining history to college students and beginners, and their skills in synthesizing large bodies of data and ideas. The pedagogical features of the book include chapter abstracts that orient readers to the objectives and ideas of each chapter, review questions to help students test their knowledge of the main ideas

of the chapter, and suggestions on additional reading materials to facilitate advanced research.

I am grateful to all the contributors, students, and readers who have helped in various ways to make the book readable for a diverse audience. Dr. Ann O'Hear offered a number of editorial suggestions. Sam Saverance produced the maps, and many of the illustrations are from my private collections.

Toyin Falola
The Frances Higginbothom Nalle Centennial Professor in History
The University of Texas at Austin

List of Illustrations and Maps

Notes on the Authors

EDMUND ABAKA completed his Ph.D. in History in 1998 at York University, Canada. He is currently an Assistant Professor of History at the University of Miami, Florida. He is the author of a number of articles: "Kola Nut" (*Cambridge History of Food and Nutrition,* 2000); "Eating Kola: The Pharmacological and Therapeutic Significance of Kola Nuts" (*Ghana Studies,* 1998); with J. B. Gashugi, "Forced Migration from Rwanda: Myths and Realities" (*Refuge,* 1994); and with Samuel Woldu, "The International Context of the Rwandan Crisis" (*Refuge,* 1994). He has completed a manuscript entitled "Kola is God's Gift": The Asante and Gold Coast Kola Industry c.1815–1950," as well as a number of entries for the *Encyclopedia of African History.*

SAHEED A. ADEJUMOBI completed his Ph.D. in African History at the University of Texas at Austin, where he also taught in the Center for African and African American Studies. In 2001, he relocated to Wayne State University as an Assistant Professor. He specializes in African intellectual history, researching and writing on indigenous and transnational cultural forms, popular culture, and identity politics. He has other degrees from the University of Lagos, Nigeria and the University of Oregon, Eugene.

JULIUS ADEKUNLE holds a Ph.D. degree from Dalhousie University, Halifax, Canada. He has taught at Dalhousie University and St. Mary's University, Halifax, Canada, and at Tennessee State University, Nashville. He is currently an Assistant Professor of African History and the Caribbean and the Director of the Graduate Program at Monmouth University, West Long Branch, New Jersey. His work on the precolonial history of Nigerian Borgu is being revised for publication. He has published articles in *Anthropos, Ife: Annals of Cultural Studies,* and *African Economic History.* He has won many academic awards, including the Judith M. Stanley Fellowship for Improvement in Teaching at Monmouth Univeristy.

FUNSO AFOLAYAN holds a Ph.D. in African History from Obafemi Awolowo University, Ile Ife, Nigeria. In addition to his research publications in Africa, Europe, and the United States, he is co-author (with John Pemberton) of *Yoruba Sacred Kingship: A Power Like That of the Gods,* (1996). Among the many books which he has contributed are *Yoruba Historiography; Warfare and Diplomacy in Precolonial Nigeria; Dilemmas of Democracy in Nigeria; The Historical Encyclopedia of World Slavery; Culture and Society in Yorubaland; War and Peace in Yorubaland;* and *African Democracy in the Era of Globalization.* He has held a number of research and teaching positions at Obafemi Awolowo University, Ile Ife, Nigeria; in the Department of Religions, Amherst College; and in the Department of History and African and Afro-American Studies Program, Washington University in St. Louis. He

currently teaches African and World History at the University of New Hampshire, Durham, where he is an Associate Professor of African History and the African Diaspora.

KWABENA OPARE AKURANG-PARRY, a poet and historian, graduated from York University, Toronto, Canada, in 1998 with a Ph.D. degree in African History. He has held teaching posts at York University and Tulane University, New Orleans. He is currently an Assistant Professor of African and World History at the Department of History and Philosophy, Shippensburg University, Shippensburg, Pennsylvania. He specializes in colonial and contemporary Africa, with a research focus on the social and economic history of Ghana. His work has appeared in *Okike: An African Journal of New Writing* (1997); *Ufahamu* (1998); *Ghana Studies* (1998); *Slavery and Abolition* (1998); and *Refuge* (1999). His forthcoming publications include essays in *History in Africa, Transactions of the Historical Society of Ghana*, and *African Economic History*. He is currently working on two books: *Chieftaincy and World War 1 in Colonial Ghana*; and *Colonial Rule and Abolition of Slavery in the Gold Coast*.

ANDREW E. BARNES is an Associate Professor of History and the Director of Graduate Studies in the History Department at Arizona State University, Tempe, Arizona. He has published numerous articles on both African and European history. Among his recent publications on African history are "Aryanizing Projects: African Collaborators and Colonial Transcripts," in *Comparative Studies of South Asia, Africa and the Middle East* (1998); and "Some smoke behind the Fire': The Fraser Report and Its Aftermath in Colonial Northern Nigeria," in the *Canadian Journal of African Studies* XXI, 2 (1998). He is presently completing a study of the introduction of Western civilization to colonial Northern Nigeria.

FELIX EKECHI (Ph.D, 1969, University of Wisconsin-Madison) is Professor of History and Coordinator of the African Studies Program at Kent State University. He is the author of several books, including *Missionary Enterprise and Rivalry in Igboland, Tradition and Transformation in Eastern Nigeria*, and he is co-editor of *African Market Women and Economic Power*. His numerous articles have appeared in journals in Africa, Europe, and America. His forthcoming book is *The Life and Times of Rev. M. D. Opara of Nigeria*. Professor Ekechi is a specialist in missionary and gender studies.

TOYIN FALOLA, Ph.D., editor of the series, is the Frances Higginbothom Nalle Centennial Professor in History at the University of Texas at Austin. He is the author of numerous articles and books, most recently *Tradition and Change in Africa; Yoruba Gurus: Indigenous Production of Knowledge in Africa; The History of Nigeria*, and *The Culture and Customs of Nigeria*. A teacher at numerous institutions in various countries since the 1970s, he is the recipient of the 2000 Jean Holloway Award for Teaching Excellence at the University of Texas at Austin.

ERIC GILBERT, Ph.D., teaches African and Middle Eastern History at Arkansas State University. His research focuses on the maritime trade of the Indian Ocean. He has conducted research in Kenya, Zanzibar, and Yemen. He is the author of several articles on the western Indian Ocean dhow trade.

KIRK ARDEN HOPPE is an Assistant Professor of History at the University of Illinois at Chicago. His areas of expertise include the history of colonial East Africa, environmental history, and the history of colonial science.

CHRISTIAN JENNINGS is a doctoral student at the University of Texas at Austin, specializing in East African and environmental history. He has contributed several articles to the forthcoming *Encyclopedia of African History*, and he is currently co-editing a set of papers on *African Studies*.

FEMI KOLAPO earned his doctorate in History from York University, Toronto, Canada. Before this, he had taught History at Ahmadu Bello University, Nigeria, for several years. He is currently a postdoctoral research fellow with the York/UNESCO Nigerian Hinterland Project at York University, Canada. His recent publications include "Trading Ports of the Niger-Benue Confluence Area, c.1830–1873" in R. C. Law, and S. Strickrodt, eds., *Ports of the Slave Trade: Bights of Benin and Biafra*; and "Post-abolition Niger River Commerce and the 19th Century Igala Political Crisis," *African Economic History* (1999). Among his forthcoming publications are "CMS Missionaries of African Origin and Extra-religious Encounters at the Niger-Benue Confluence, 1858–1880," *African Studies Review* (2000); "The 1858–59 Gbebe Journal Of CMS Missionary James Thomas," *History in Africa* 27 (2000) and "The Jihad Logistics and Etsu Masaba's Southward Military Campaigns c.1830–1853," in P. E. Lovejoy, ed., *African Slaves and Dar es-Salaam*.

PATRICK U. MBAJEKWE teaches African History at Dillard University, New Orleans. He is also completing his dissertation, "Land, Social Change and Urban Development in Eastern Nigeria, 1900–1995," at the Department of History, Emory University, Atlanta. He holds an M.A. in History from the University of Lagos, and a B.A. from the University of Nigeria, Nsukka. He has taught various aspects of African History at the University of Lagos in Nigeria and at Emory University.

BAYO OYEBADE obtained his Ph.D. in History from Temple University, Philadelphia. He is currently an Assistant Professor of History at Tennessee State University. He has co-edited *Africa After the Cold War: The Changing Perspectives on Security* (1998), and is currently completing a book length manuscript on United States strategic interest in West Africa during World War II. He has authored book chapters on African history and published scholarly articles in such journals as *African Economic History* and the *Journal of Black Studies*. He has also received scholarly awards including Fulbright and Ford Foundation Research Grants.

JONATHAN REYNOLDS (PhD, Boston University, 1995) is a specialist in the history of Islam and politics in West Africa. He has previously received fellowships from Fulbright and the West African Research Association in support of fieldwork in Nigeria, Niger, and Ghana. He is the author of *The Time of Politics (Zamanin Siyasa): Islam and the Politics of Legitimacy in Northern Nigeria, 1950–1966* (1999). He was named Teacher of the Year at Livingstone College in 1998. He is currently an Assistant Professor of History at Northern Kentucky University.

STEVE SALM received his B.A. in History and African Studies from the University of Wisconsin-Madison, and his M.A. from the University of Texas at Austin. He is currently finishing his Ph.D. dissertation at Austin. He has performed fieldwork in a variety of West African countries, most recently in Ghana and Sierra Leone. The focus of his research is urban subcultures in twentieth-century Africa. He has received a number of awards and fellowships for his work, including the Jan Carleton Perry Prize for his M.A. thesis, an NSEP fellowship for fieldwork, and a University of Texas at Austin The-

matic Fellowship on Urban Issues. He has given many guest lectures and presented research papers at various academic meetings. He has published chapters and articles on a wide range of topics such as gender, youth, music, literature, alcohol and popular culture. His writings have appeared in *Africa Today*, *African Economic History*, the *Encyclopedia of African History*, and other publications. His forthcoming work will address the development of urban subcultures in Accra, Ghana after World War II and the changing dynamics of globalization, cultural consumption, and identity transformation.

SEAN STILWELL, Ph.D., York, 1999, is currently Assistant Professor of African History at the University of Vermont. He is working on a monograph for Heinemann's Social History of Africa series on the social and political history of royal slavery in the Sokoto Caliphate between 1807 and 1903. He has published articles in *African Economic History* and *Slavery and Abolition*, and has an article forthcoming in *Africa*.

JOEL TISHKEN is a Ph.D. student at the University of Texas specializing in African and World history. He teaches World History at St. Edward's College. His dissertation entitled "Prophecy and Religious Authority in African Initiated Churches," is a comparative analysis of the Nazareth Baptist Church, l'Eglise Kimbanguiste, the Cherubim and Seraphim, and the Harrist Church. He contributed reviews and articles to *African Economic History*, the *Encyclopedia of Historians and Historical Writing*, and *History Teacher*.

Introduction

Toyin Falola

Colonial rule served as one of the most decisive agencies of African modernization. Whether in its immediate or long-term impact, colonial rule reshaped many African institutions and ideas. The African experience during this time continues to influence the way Africans view themselves, look at others, and discuss their future.

The process of conquest began in the last decades of the nineteenth century, and ended in the early decades of the twentieth century.[1] By the time of World War I, with colonial power already consolidated in many areas, Africans were asked to serve in the Allied armies and contribute their resources to win the war.[2] European motives for expansion into Africa were many: the desire to obtain raw materials; create larger markets for their finished products; spread Christianity and other elements of Western civilization; boost nationalism at home by using the colonial expansion as a political achievement; enhance international prestige by acquiring overseas territories; and increase the knowledge of geography and science. Many analysts have concluded that economic objectives were by far the most important of all. Even when claims were made regarding the scientific need to acquire knowledge about Africa or the philanthropic desire to spread the gospel, the end result in each instance was the promotion of commerce. By acquiring the Congo, which is eighty times its size, Belgium gained respect in Europe and among investors, Britain's possession in Africa was forty times its size, a huge market for its traders, and a source of pride for its politicians and empire builders. In short, the purpose of the conquest was not to assist Africa to modernize, even if some of the consequences may be described as having led to this.Although several European countries participated in the conquest of Africa—Britain, France, Germany, Belgium, Italy, and Portugal—the biggest winners were Britain and France. They took two-thirds of Africa before 1914 and more than 70% after 1919. After the Berlin Conference of 1884–85, the race for conquest was swift. Africans put up stiff resistance, but by the first decade of the twentieth century, the face of the continent was permanently altered as European territorial control achieved success. Only two African countries, Liberia and Ethiopia, escaped formal colonization. Germany eventually lost its 8% territorial acquisition, as part of the peace treaty following the World War 1. Its colonies were taken over by the Allied powers and given to the League of Nations in a mandate system that allowed Britain to take Tanganyika and the Western part of Cameroon;

1. For details, see chapters 2 and 3 below.
2. For details, see chapter 4 below.

xvii

Belgium received Rwanda and Burundi; while France took the rest of Cameroon and Togo. South Africa was rewarded with the leftover, South West Africa, now Namibia.

The Logic and Nature of Imperialism

European imperialism in Africa had strong elements of racism, cultural imposition and economic exploitation. With respect to race and culture, the imperialist ideology assumed Africans were inferior. European officers would go among them not just as conquerors, but largely as superior overlords. Even the project of Christian expansion was not without the agenda of cultural imperialism. In an ethnocentric framework, white missionaries regarded themselves as superior agents in the redemption of African souls. Indeed, some missionaries even believed that force was necessary and justified to convert Africans, although the greater majority worked through persuasion and inducements. Even the inducements, notably the provision of schools, clinics and welfare services, were offered with the assumption that "pagans" and "primitive" people were deficient in these aspects. In cases where the missionaries experienced hostility or found progress too slow, they did not hesitate to call on their governments to establish colonial control or greater political presence. In other words, the "enlightenment" and conversion of Africans were not matters to be taken for granted or even regarded as optional.

Missionaries appeared to be more charitable than many colonial officials who saw Africans as grossly inferior to whites. The writer Rudyard Kipling described Africans as "half-devil and half-child" and corresponding to Kipling's characterizations, the continent was seen as a "white man's burden" by a number of officers. This arrogance disguised and diminished what the so-called primitive people offered in their labor and resources. Condemnation was standard fare for programs of so-called civilization, and even of institutionalized brutality, that many Africans experienced.

Imperialism served as an agency of domination. Not only was the continent subordinated, its resources were exploited. Colonies became sources of manpower, which could be direct, as in the demand for service in war. About one million Africans served in the Allied armies during World War 1, and about two million in World War II. Still, on the issue of domination, colonies were economic estates to be "developed" and exploited in the service of capitalism. In ways that could appear indirect, millions of Africans served the colonial systems in their various roles as producers and consumers of goods and services that generated enormous profits for European industries.

Imperialism constructed and profited from "otherness," that is, by regarding Africans as subjects who were different and primitive. Although racial attitudes of European colonizers varied and underwent change, the premise was similar. They all expressed contempt for traditional African values and customs, feeling that a new generation of Africans required elements of European culture. Only their strategies and theories differed. The Portuguese sought, through the conjugal relationship of Portuguese men with African women, to produce a new, superior race of "pure Africans" that would, nonetheless, lack equal social standing with the

full-blooded Portuguese. For the French, assimilation was possible, but the conditions were stringent. The "new African" must acculturate by abandoning his indigenous customs. For the British, while there would never be any social equality between Europeans and Africans, the latter could at least be socially mobile.

The most extensive racial policy was undertaken in South Africa, where apartheid—a system of segregation and domination based on race—was practiced until the 1990s. Elsewhere, racial attitudes and segregation were also practiced, although on a different scale and style. In the British colonies, Europeans lived far away from Africans, and both were served by separate schools, hospitals and even churches. Where European settlers lived in large numbers, as in South Africa, Kenya and Zimbabwe, segregation could be legitimized in city codes and ordinances. In places like Nigeria or Ghana, where an official policy of discrimination was not pursued, successful educated elites could hope to live in white neighborhoods, but without social equality. While Africans could even aim to acquire power in British territories, that power had to be exercised over other Africans and never, of course, over British citizens. The French pursued a policy of assimilation, opening the door for a limited number of Africans to enter their room of civilization. The premise was that people without culture or history, as Africans were regarded, could be converted into French citizens through a process of cultural immersion. The French believed that Africans could be tamed and schooled to become French citizens, but they were hardly generous enough to extend assimilation to the majority of Africans, including those who aspired to it.

The Portuguese did not disguise their racism or ethnocentrism. Their social policy was not opposed to inter-racial marriages or co-habitation, but they only tolerated relations between Portuguese men and African women. Many marriages were free and illegal, and the men ignored their children. According to Portuguese officials and entrepreneurs, Africans should be compelled to work and be disciplined like unruly children. If Africans could go to school, speak Portuguese, have jobs and avoid local customs, they could acquire some respect in Portuguese circles and become assimilated. The vast majority were to remain *indigenas*, that is, they would remain "natives" who could be exploited and drafted into forced labor.

European imperialism constructed administrative arrangements (or political systems) that supported their racial ideology and economic objectives. Where Africans were regarded as totally inferior and incapable of anything but limited change, a policy of apartheid was pursued, as in South Africa. Where it was believed they could go to school and improve, and that their local institutions were adaptable to a new era, a policy of indirect rule was put in place. Such was the case in most British colonies. Where assimilation was considered a possibility, the French tried direct rule. In cases where exploitation was the prime objective, company rule was found suitable, as the Belgians did in the Congo. Under company rule, Africans and their resources were handed over to a few private companies to manage and exploit in the most brutal manner imaginable.[3]

Colonial administrative systems were cost-effective and efficient from the European standpoint. Where a system of indirect rule was implemented, it reduced cost since the number of European officers was small. As much as possible, educated Africans were to be granted only enough power to curb their tendencies to-

3. For details, see chapter 5 below.

ward radicalism. Only a tiny percentage of Africans were to receive privileges, in order to produce a large and permanent pool of taxable "subjects" who would be forced to work, join the army, and produce cash crops.

Colonial systems were authoritarian and opposed to democratic tendencies. Neither the boundaries of modern Africa nor the administrative systems that were imposed on them, were discussed with Africans themselves. Division of power between the organs of government—the executive, judiciary and legislative—was not necessary as one person could exercise all the power. The police and the army were created to check aggressive Africans and to implement colonial laws, even when these were harmful to the colonial subjects.

Because imperialism managed to generate more enemies than friends, it produced nationalism. Educated Africans felt empowered to criticize colonial governments, demand reforms and fight for independence. The writers and thinkers who emerged in Africa articulated anti-colonial themes and advocated black unity, as well as liberating ideologies such as Negritudé. Nationalism during this period was expressed by the following: resistance to colonial imposition; resistance to many aspects of colonial policies such as the introduction of taxation; vigorous demands for reforms and development; and articulation of the need to involve the educated elite in governance.[4] If Europeans wanted a prolonged colonial period, Africans ensured that this would not happen. The colonial period was shorter than many anticipated.

Political Change in Africa

Pre-colonial nations lost their sovereignty, since they were all subordinated to European powers that carved out new countries with new boundaries.[5] The kings and chiefs of old became pawns in the hands of colonial governments. Many were co-opted in the service of the colonial administration, to collect taxes from their people, to organize the recruitment of forced labor, and to announce colonial policies. A few had their powers enhanced, as was the case with some kings who administered indirect rule in British colonies. But, in general, most chiefs lost their power, and their institutions ultimately became more symbolic than powerful.

While the map of Africa appears tidier than before, with a smaller number of countries replacing hundreds of kingdoms and states, the new boundaries produced severe problems leading to conflicts and wars. Some indigenous groups were split into two or more countries; some found themselves in the same country with former rivals; a number of countries were land-locked and now have to beg their neighbors for access to the sea; and a few are so small that they cannot be economically viable as modern countries. These boundaries are mainly artificial, determined by the process of conquest rather than African needs.

Ethnicity and its attendant problems began to take strong roots. In a policy of divide and rule, one group could be set against the other simply to consolidate colonial power. These governments tried to abort any attempts by the ethnic groups to unite since this would foster greater nationalism.

4. For details, see chapter 16 below.
5. For details, see chapter 6 below.

Economic Change in Africa

Colonial governments initiated policies and changes that promoted the cultivation of cash crops for export, extensive mining of available and profitable minerals, and an import trade to distribute products manufactured in Europe. Indigenous economies and lifestyles were altered to meet colonial economic objectives of acquiring the raw materials and markets for finished products.[6] In south and east Africa, land was expropriated, resulting in the transfer of the most fertile and productive land from African to European ownership. When large-scale land expropriation did not take place, other policies were pursued to ensure that the African farmers produced goods needed in Europe. By far the most effective strategy was taxation, which forced producers to look for cash to pay the government. Taxation was resisted by Africans, due to its newness, its unfairness, and because it forced people to sell their products.

Few efforts were made to develop the continent. To ensure that sources of manufactured goods remained in Europe, industrial development was avoided in many countries. Foreign merchants came from Europe and Asia, thereby reducing participation by African entrepreneurs in the most lucrative sectors of the economy. Substantial wealth was transferred abroad, in various forms and guises such as cash crops, salaries of officials, and foreign reserves. The colonies were expected to generate funds for their sustenance and development through direct tax, indirect tax on imports and exports, and forced or underpaid labor. Economic changes impacted the environment greatly, in addition to new ecological policies pursued by the colonial government.[7]

The basis of a modern economy was established, as new currencies were introduced to displace indigenous ones. New roads and railways were constructed so that they could enhance colonial governments, communication facilities were developed, and new economic services such as banking were provided. However, the economic basis was narrow. A limited attention to the creation of industries, reliance on a few products for export, failure to promote inter-regional trade among African countries, and dependence on Western markets all eventually led to the underdevelopment of the continent.

Education and Other Social Changes

In the areas of education, health and social services, the missionaries pioneered important projects that the colonial governments built upon.[8] Early efforts were made during the nineteenth century to create mission houses that served as churches, schools and dispensaries. In areas where Christianity spread, African converts came to expect new schools in exchange for accepting a new religion. During the colonial period, the missionaries established partnerships with governments whenever possible.

6. For details, see chapter 7 below.
7. For details, see chapter 8 below.
8. For details, see chapter 9 below.

Western education was not without its motives and agendas. Africans were needed for semi-skilled jobs in the civil service, firms and churches. They had to be trained, if only as workers to run the system. For the missionaries, education was a tool to promote religious values and spread European culture. These became the core of education while knowledge of indigenous religions and customs was prohibited. Education also aided the creation of a new elite that was expected to be disconnected from an African way of life. In spite of its limitations, Western education was one of the most important legacies of colonial rule. Africans not only took the opportunity of going to schools they increasingly asked for more schools, and access to higher education. New skills and formal education opened avenues to various career paths.

The other goal of colonial education was to promote assimilation. Those members of the educated elite who were eager to assimilate often held the local cultures in disregard. With access to power, the new elite became critical of the indigenous kings and chiefs whom they sought to displace. Education and social changes led to the creation of new cultures that undermined some existing ones or creatively re-adapted them to meet the demands of a new generation.

The spread of Western medicine has been beneficial for facilitating the prevention and cure of a number of diseases such as malaria. New cities emerged, older cities in administrative and economic centers expanded, and the continent witnessed a population increase.[9] Because of this, various aspects of traditional life in the cities either had to be modified or abandoned.

Islam and Christianity spread rapidly. Although both undermined indigenous religions, they did offer alternative worldviews and philosophies relating to salvation, the rights and privileges of individuals in society, and worship.[10] There were also significant changes in other cultural aspects, either as new ideas were introduced or as Africans exhibited creativity through adaptation and invention of ideas and institutions necessary for their survival and leisure.[11]

Where colonialism and Christianity combined, new cultures began to emerge. Practices that the missionaries and colonial governments regarded as primitive were abolished. Nuclear and monogamous marriages were encouraged as a way of attacking polygynous relations. Converts began to imbibe notions of individualism. To be sure, indigenous institutions did survive, but often only by adapting to changing circumstances.

Organization of the Book

The chapters that follow elaborate on all the themes identified above. The first section traces the process of the establishment and consolidation of European rule from around 1885 to 1919. Between 1919 and 1939, the colonial regimes were fully established, so much so that many colonial officers thought that they were in Africa for good.

9. For details, see chapter 14 below.
10. For details, see chapters 10 and 11 below.
11. For details, see chapter 12.

The second section looks at a variety of themes relating to the African experience of colonialism. The last section focuses on historical developments in the different regions of Africa. In this section, specific details are provided to further illustrate some of the themes in the second section.

The colonial period is one of the most important eras in African history. Certain local institutions did indeed survive. African attire, food, music and art survived the colonial period—a testimony to their relevance and vibrancy. But many other institutions did not. Many changes were introduced that have affected the continent in profound and enduring ways. The African economy was further integrated into a world system, in such a way that Africa is always affected by changes in the global market. In such aspects as the use of European languages, the colonial boundaries between countries that continue to exist, the emergence of new social classes and the educated elite, the political models being implemented, and the modernization of the economy, the impact of the colonial period is all too clear to see.

PART A

HISTORICAL TRENDS

Chapter 1

The Imposition of Colonial Rule

Sean Stilwell

This chapter explores the European imposition of colonial rule on Africa. It first examines the reasons European nations were interested in formal expansion and the chronology of conquest. The nature of African responses and initiatives to formal European expansion are then highlighted. Africans resisted for a variety of reasons, but in all cases technological inferiority and internal historical divisions undermined the scale of these movements. Next, the nature and methods of colonial rule are explored. The imposition of colonial rule in sub-Saharan Africa occurred in two main stages. The first occurred between 1885 and 1903, when the European powers transformed their informal territorial interests into formally demarcated zones. The second occurred between 1903 and 1920, when the European nations established formal administrative and economic structures of colonial rule with varying degrees of success. The evolution and nature of this economic, political and social order are then examined in depth.

* * *

Introduction

Although the European states and chartered companies had a long history of trade and diplomatic relations with Africa, for centuries their power was extremely limited. For the most part, Europeans were forced to remain on or near the African coast, where they dealt with African intermediaries for the goods and products they desired. This relationship came to an abrupt and violent end in the nineteenth century, when Africa was partitioned, then conquered, and finally, subjected to formal European administration and rule. This chapter explores the initial stages of colonial rule, from military conquest to the strategies employed by Europeans to transform their conquests into colonies. In the following sections, we will look at the imposition of colonial rule as a process, beginning with the European scramble for Africa, formal European conquest and the nature of African resistance, and the imposition of political and economic structures of colonialism.

The imposition of colonial rule in sub-Saharan Africa occurred in two main stages. The first occurred between 1885 and 1903, when, by force of conquest,

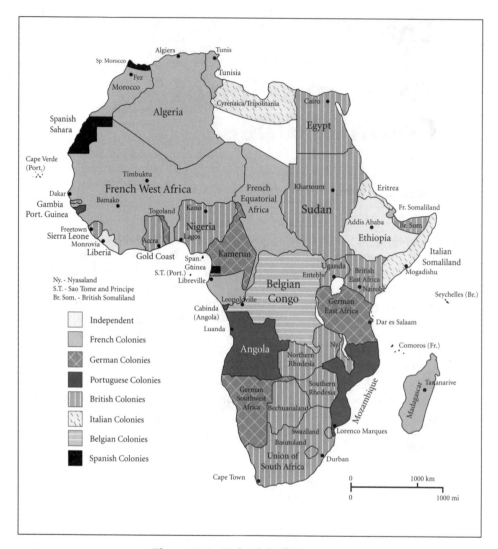

Figure 1-1. Colonial Africa, 1914

the European powers transformed their informal territorial interests into formally demarcated zones. The second occurred between 1903 and 1920, when the European nations established formal administrative and economic structures of colonial rule with varying degrees of success. Throughout this period, the methods used to subjugate Africans gradually became more homogenous. Central elements in the transition from "military" to "administrative" rule included the imposition of colonial and indigenous political and administrative structures, forced labor, customary law and colonial courts, cash-crop production, and taxation.

Background to Expansion:
The Scramble and Partition of Africa

How was independent Africa conquered? For most of the nineteenth century, Europeans were content to remain on or near the coast. However, beginning in the middle of the nineteenth century, European interest in the African interior was heightened. No longer content to let Africans dictate the terms of trade and exchange, European nations and merchants hoped to take more direct control of the interior in order to dominate trade in "legitimate" commodities, such as groundnuts and palm oil. Britain, the leading industrial power for most of the period, was faced with increasing competition from both France and Germany.

To secure African markets for their manufactured products, the French and Germans decided to establish protected zones in Africa. By replacing an ideology of free trade with an ideology of protectionism, the European nations began a "scramble" in 1880 for what they thought were the richest and most productive parts of Africa.[1] This dramatic increase in the pace of European expansion was "justified" by a new ideology of "scientific racism." According to this ideology, it was possible to "scientifically" rank the various human races in order from the most primitive to the most advanced. This ideology helped to justify European expansion by suggesting that the conquest of Africa was ordained by nature and science because Africans were, according to this ideology, inferior to Europeans.

The Scramble for Africa was initiated on the ground by French expansion up the Senegal River into the interior of West Africa in 1879. This "determined bid for territory"[2] by the French forced other powers to stake out their own spheres of influence or risk being shutout of African trade.

The Governor of Senegal, Louis Faidherbe, initially masterminded French expansion in the 1850s. Faidherbe, like many French military men, believed French imperial power could only be secured by destroying all opposition to French rule in Africa. Although his expansionist program was cut short by the French defeat in the Franco-Prussian War of 1870–71, his legacy and designs were drawn upon by the architects of French imperial policy in the 1880s: Jean Jauréguiberry and Charles de Freycinyet. Both men were convinced that the scramble was already underway and that the African interior would yield untold wealth and opportunities for trade. Jauréguiberry placed the Sudan under military control in 1879, and Major Gustave Borganis-Desbordes was appointed commander and given full control over military operations. Backed by Paris, the military in West Africa became a force for continued and further expansion. In 1882, the French marched on the Upper Niger, renewed their protectorate over Porto Novo, and opened a second "front" in the Congo by ratifying treaties signed with the African rulers of

1. In general, see George Sanderson, "The European Partition of Africa: Coincidence or Conjecture?" in F. Penrose (ed.), *European Imperialism and the Partition of Africa* (London: Cass, 1975); A.G. Hopkins, *An Economic History of West Africa* (New York: Columbia University Press, 1973); and P.J. Cain and A.G. Hopkins, "The Political Economy of British Expansion Overseas, 1750–1914," *Economic History Review* XXXIII, N.S. (1980).

2. C.W. Newbury and A.S. Kanya Forstner, "French Policy and the Origins of the Scramble for West Africa," *Journal of African History* 10, 2 (1969): 253–276; and C.M. Andrew and A.S. Kanya-Forstner, "Centre and Periphery in the Second French Colonial Empire, 1815–1920," *Journal of Imperial and Commonwealth History* 16, 3 (1988): 9–34.

the region by Ferdinand de Brazza. In similar fashion, the French negotiated treaties throughout the Niger Delta Region, including Bonny and Calabar, both of which were centers for British trade.

Soon other European powers began competing to establish their claims in Africa. For example, Britain claimed control of the Lower Niger River region under the aegis of Sir George Goldie's United African Company, while Germany proclaimed protectorates over Togoland, Cameroon [Kamerun] and South West Africa [Namibia] in 1884. In each case, the state was becoming a more important "agent of expansion."[3] With the scramble for African territories well underway, the major European powers gathered at the Berlin West Africa Conference between 1884 and 1885. Although colonial boundaries were not formally drawn at the Berlin Conference, spheres of influence and the principle of "effective occupation" were established to reduce international conflict and competition. Each imperial power was allowed to extend its influence into the interior.[4] While some expansion was driven by "men on the spot," or the colonial officials themselves, most formal expansion and colonialism was not driven by individuals. State backing was required to actually occupy and administer Africa.

Influence was initially extended by signing treaties with African rulers and by negotiating between the various European powers. Most European powers had drawn up treaties of "cooperation" with indigenous African rulers and, on the basis of these treaties, European nations continued to declare protectorates over those parts of Africa they wanted to protect from their rivals. In 1885, almost immediately after the Conference, Otto von Bismarck, Chancellor of Germany, declared a German protectorate over Tanganyika in East Africa. Gradually, each European power, anxious over possibly losing its African "sphere of influence," began to establish a formal presence in Africa. Thus, Africa was partitioned largely to keep other powers out, and to preserve national rights over what many believed were large markets in the continent's interior. France claimed control of the Ivory Coast as it continued its march into the West African interior via the Senegal and Niger Rivers. The British, through the newly formed Royal Niger Company led by Sir George Goldie, claimed the lower Niger river, and a protectorate was declared over the Oil Rivers and Niger Delta area to keep out German influence. By 1890, the British were willing to sanction formal expansion into East Africa, as they responded to increased German activity in the region and missionary pressure. On the basis of an agreement reached at the Berlin West Africa Conference, King Leopold II of Belgium created his own personal colony in Central Africa in 1885, which was called the "Congo Free State."

European states generally came to terms with each other via "bilateral partition treaties" that drew boundaries between their respective spheres of influence. For example, the Anglo-German treaty of November 1, 1886—which divided much of East Africa into British and German spheres of influence—was supplemented by the Heligoland Treaty of 1890. By "partitioning" the East African interior, this treaty gave Britain rights over Uganda, while Heligoland was offered

3. See Newbury and Kanya Forstner, "French Policy and the Origins of the Scramble for West Africa."

4. See S. Föster, W.J. Mommsen, and R. Robinson (eds.), *Bismarck, Europe and Africa: The Berlin Africa Conference 1884–1885 and the Onset of Partition* (New York: Oxford University Press, 1988).

to Germany. Similar arrangements between European powers were made throughout Africa. By 1890–91 internal colonial boundaries had been largely established via the Anglo-German Treaties of 1890 and 1893 (whereby the Upper Nile went to Britain), the Anglo-Italian Treaty of 1891, the Franco-Portuguese Treaty of 1886, the German-Portuguese Treaty of 1886, the Anglo-Portuguese Treaty of 1891 (which recognized Portuguese influence in Angola and Mozambique), the Anglo-Congo Treaty of 1894 (which set the boundaries of the Congo Free State), the Say-Barruwa agreement of 1890, and the Niger Convention of 1898 (which partitioned West Africa).[5] In each case, the goal of European policymakers was to secure markets and trade with Africa's interior states. However, the Europeans had not formally occupied the vast majority of the continent. Although African rulers certainly wanted access to the lucrative European trade, they by and large did not agree to extension of formal European control into the interior. As a result, European nations often imposed direct control by force — a process that was long, bloody, and remained incomplete until the beginning of World War I. Thus, the imposition of colonial rule was by no means an easy or uncontested process. Each European power launched military campaigns on the ground in Africa, and by 1900, Liberia and Ethiopia were the only two states in sub-Saharan Africa that managed to retain independence.

Conquest: African Initiatives and Responses, 1885–1903

The imposition of colonial rule was not a simple process; it was the product of a long history of African and European interaction. Only in the last half of the nineteenth century were Europeans able and willing to conquer African states and peoples by force. As John D. Hargreaves has suggested, at no point in the entire process was a single set of monolithic policies and goals pursued by the European powers.[6] Once European states made the decision to expand into the African interior, the African states were faced with two main choices: resist European expansion or collaborate with European powers. Although "resistance" and "collaboration" or "accommodation" have often been treated as a stark dichotomy, in practice, most African leaders chose to adopt a variety of strategies to cope with the European intrusion.[7] Many states tried strategies of both resistance and accommodation with the European powers, thereby helping to shape the nature and timing of European colonial expansion.

5. See A. Adu Boahen, *African Perspectives on Colonialism* (Baltimore: Johns Hopkins University Press, 1989), 34; and G.N. Uzoigwe, "European Partition and Conquest of Africa: An Overview" in *General History of Africa VII* (Paris: UNESCO, 1985), 33–34.

6. John Hargreaves, "West African States and the European Conquest" in L.H. Gann and P. Duignan (eds.), *The History and Politics of Colonialism in Africa*, Vol. I (Cambridge: Cambridge University Press, 1969), 199–200.

7. See Allen Isaacman and Barbara Isaacman, "Resistance and Collaboration in Southern and Central Africa, c. 1850–1920," *International Journal of African Historical Studies* 10, 1 (1977): 31–62.

European success against African armies was achieved largely by superior military technology, as suggested in the famous nineteenth century refrain: "Whatever happens we have got the Maxim gun and they do not."[8] Imposition of colonial rule occurred first and foremost at the point of a gun. Perhaps most importantly, this imposition was made possible because African states were unable to present a "united front" against the European powers. African states did not form large transnational alliances to oppose European powers because they had no historical precedents or reasons to do so. With different interests and aims, African states often allowed European colonial armies to conquer each state separately. Indeed, many African states initially became "sub-imperial" states. They bought weapons or enhanced their power through alliances with European powers, which they used against other African states thus weakening the scale of resistance to European penetration.[9] Often, the most successful resistors mobilized supporters via religion and religious ideology.

In many cases, African rulers were more concerned with maintaining their own interests as the privileged elite rather than fighting for broadly defined "national" interests. Philip Igbafe has shown that attempts by the ruling elite of Benin to raise a countryside rebellion were preempted when the British simply threatened to undermine their power by freeing all their slaves.[10] The scale of African resistance was further limited because the African rulers could not always rely on the support of their subjects, who often had very real grievances against their rulers.[11] There were, of course, exceptions. In South Africa, the ruler of Lesotho, Moshweshwe, attempted to forge an anti-European alliance with other African rulers. In the vast majority of cases, however, African states and societies remained divided by the circumstances of their precolonial history.

Until roughly 1890, Africans had the freedom to choose different strategies for relating to the European powers. But when these nations became determined to conquer Africa, any choice had been eliminated, leaving resistance as the only feasible option. The intensity of resistance, however, varied from place to place. For example, in West Africa the French pursued a policy of expansion from Senegal toward Lake Chad while relying on African troops, called the *tirailleurs senegalais*, who were led by European officers. To establish their rule over the interior, the French had to defeat a number of powerful African states in the region, one of the most important of which had been established by Samori Toure in the mid nineteenth century. A large army that had access to modern firearms backed this powerful state. In 1887, the army likely numbered between 30,000 and 40,000 men who were well trained and loyal to Samori.[12]

After the French began their West African expansion, Samori attempted to come to terms with them a number of times before finally committing himself to all out confrontation. Samori signed the Peace of Kenyeba Kura in 1886–87 to

8. M. Perham, *The Colonial Reckoning* (London: Collins, 1961), 32.

9. For example, see Allen Isaacman and Barbara Isaacman, *The Tradition of Resistance in Mozambique: The Zambesi Valley* (London: Heinemann, 1976).

10. Quoted by Bill Freund, *The Making of Contemporary Africa: The Development of African Society Since 1800* (Boulder: Lynne Reinner, 1998), 93.

11. See Isaacman and Isaacman, "Resistance and Collaboration in Southern and Central Africa."

12. See Yves Person, "Guinea-Samori" in Michael Crowder (ed.), *West African Resistance* (London: Hutchinson, 1971), 111–143.

end conflict with the French so he could concentrate on defeating internal African enemies, such as the state of Sikasso. He also tried to play the British off against the French, seeing the possibility of using European imperial rivalries to his own advantage. Despite this and other treaties, it became clear to Samori that by 1890 the French were unwilling to honor their agreements or compromise with him. Colonel Archinard, in command of French forces, believed that African Islamic states were too great a threat to French interests to be left intact. As a result, beginning in 1891, Samori committed himself to fierce and unrelenting warfare against the French until he was eventually captured in 1898. In this period, the French moved across West Africa and conquered the Umarian Caliphate, led by Amadu Seku. Forces from the North reached Lake Chad by 1900 and defeated the army of Rabeh. In the forest zone of West Africa, Dahomey was conquered between 1892 and 1894, and the so-called "stateless" peoples of Guinea and the Ivory Coast put up a prolonged and fierce resistance to French expansion. Nonetheless, by 1903, the French had completed their imperial conquest of West Africa.

Meanwhile, the British launched campaigns against a variety of *African states*. Although, unlike the French, the British were initially more willing to sign treaties with African rulers. In 1895–96, the British invaded Asante (modern Ghana) and declared a protectorate over the region without firing a single shot. The King (*Asantehene*) of Asante, Prempeh, tried to come to terms with the British before the invasion, and had even sent a delegation to London in hopes that a peaceful agreement could be reached. When this failed, Prempeh instructed his generals to allow the British to enter Kumasi unopposed. However, in 1900 a rebellion occurred in Asante against British rule, which involved the deposition of a number of chiefs and the imposition of a trade tax. The rebellion lasted from April to November, when it was finally defeated by the British. In Nigeria, the British expanded via the Royal Niger Company, which extended its hegemony over the states of Yorubaland in southern Nigeria between 1890 and 1902. After the defeat of Ijebu in 1893, most of the other Yoruba states submitted "peacefully" to British rule, while the Kingdom of Benin fell to a British invasion in 1897. Under Frederick Lugard, the Royal Niger Company then continued to move northward and conquered the entire Sokoto Caliphate by 1903. This expansion relied on the West African Frontier Force, the military arm of the Royal Niger Company that was comprised of Africans from various places in West Africa. In the Sudan, the British defeated the Mahdist State that had emerged as a very real threat to British interests in Egypt. The final blow was struck at Omdurman in 1898, when 20,000 Sudanese soldiers were killed.

In East Africa, the British, Germans and Italians extended their control both by force and by treaty between 1884 and 1894. The East African coast was partitioned between the British and Germans in 1890. Afterwards, the British faced numerous rebellions against their expansion in the 1890s. In Tanganyika, the Germans also faced armed resistance against imposition of colonial rule. Both powers were able, however, to arrange alliances with some Africans while simultaneously conquering others. As with Nigeria, the initial expansion phase was conducted by chartered companies. The British chartered the Imperial British East Africa Company and the Germans chartered the Deutsche Ost-Afrika Gesellschaft. The Swahili-Arabs put up the fiercest resistance to European military expansion, although the Sultan of Zanzibar was unable to do so openly. For-

mer Swahili slave and ivory traders of the East African interior rebelled against German rule in a series of local uprisings, the largest of which was led by Abushiri between 1888–89. As with West Africa, Africans resisted European encroachment when it made sense for them to do so.

In Buganda, the Muslims resisted British expansion while the Christians in the Kingdom hoped to use the British to enhance their own power in local politics. As a result, when the Christians prevailed, Buganda became Britain's major ally. They supported British expansion into the interior, while local Muslim and Arab factions left Buganda for another Kingdom, Bunyoro, which was only conquered after a long campaign between 1894 and 1899 during which the British used Bugandan troops. In East Africa, the Portuguese also faced prolonged and fierce resistance from Africans in Mozambique. The Gaza Empire raided coastal Portuguese settlements in 1894, but they were defeated in two battles by a Portuguese army. Elsewhere, the Portuguese relied heavily on African armies that were directed by Portuguese officers.

In South Africa, the British were faced with opposition from both the Afrikaner Republics and African states. After the discovery of diamonds at Kimberly (1870) and gold in Witwatersrand (1886), British policy focused on finding a way to secure access to both African labor and gold. Initially, they secured their interests through Cecil Rhodes' British South Africa Company. Rhodes extended British influence into the South African interior by annexing the regions that became Northern and Southern Rhodesia, and, thereby, preventing the Afrikaner Republics from gaining similar access. Rhodes' subordinates and British settlers deliberately provoked a conflict with King Lobengula, the Ndebele King, who thought that he had come to terms with the British by granting them mining concessions in 1890. In 1893, the British settlers finally defeated his army.

The contrasting experiences of Lobengula and another African leader, Lewanika of Barotseland, best illustrate the dilemmas of African resistance and accommodation. Lobengula of the Ndebele faced a determinedly expansionist British South Africa Company. Lobengula had few internal reasons to collaborate with the British—he had few enemies, and his state was predominant in the region. Lobengula did, however, try to delay action against the British, mainly by playing the Afrikaners and British against each other. Realizing that his regiments would likely be too weak to defeat the British, Lobengula granted a mining concession, known as the Rudd Concession, to the Company because he thought the agreement would protect him from further white pressure. For this same reason, Lobengula did not attack the Pioneer Column as it advanced into Mashonaland. But in 1893, when the British were determined to invade, Lobengula had no choice but to resist. In contrast, King Lewanika of Barotseland tried to use British expansion to solidify the strength of his own kingdom, rather than delay or resist British expansion. Lobengula even made an offer to ally with Lewanika, but this offer was rejected in favor of negotiating with the British for some sort of protection, and to secure economic and social privileges. The British eventually did offer Lewanika "protection" in 1890, but they refused to allow Lewanika the opportunity to strengthen his kingdom. In 1899, Lewanika's authority was replaced by that of the British Queen, marking the end of his ability to act independently.

Afrikaner nationalism, however, still remained a problem for the British in South Africa. The Afrikaner Republics were hostile to British imperial designs, and wanted to retain their independence from both Britain and the Cape Colony.

The Afrikaners wanted to control all South Africa without being subject to the British Empire. Especially, they hoped to preserve their language, religion, and economic position by ensuring that Africans would be granted very few political rights in South Africa. Clearly, the British and Afrikaner competing aims of controlling South African gold placed the parties on a collision course. The British, led by Sir Alfred Milner, eventually provoked Paul Kruger, President of the Afrikaner Republic of the Transvaal, into declaring war in 1899. The so-called "Boer War" lasted until 1902, resulting in the imposition of British colonial rule in South Africa until the Union Election of 1910, which renegotiated the imperial Afrikaner-British relationship by ceding more power to the local Afrikaner elite.[13]

After the conquest, the European nations still had to develop a means to control the regions they had claimed. First and foremost, the European nations struggled to contain popular resistance to their rule. The common people launched popular protests and rebellions to combat and challenge the imposition of colonial rule. For example, the Germans had to contain both the Herero War in South West Africa between 1905 and 1906 and the Maji Maji Rebellion in Tanganyika from 1906 to 1907, while the British had to defeat a sustained rebellion among the Shona and Ndebele in Rhodesia between 1896 and 1897. The British were also faced with a "Hut-Tax" Rebellion in Sierra Leone and a revolutionary Islamic Rebellion at Satiru in the Sokoto Caliphate. The "Hut-Tax" Rebellion was motivated by the British attempt to impose taxation on local African households. A group of Temne chiefs refused to pay the tax, and rebelled against colonial rule under the leadership of Bai Bureh. The Temne were later joined by the Mende, who proceeded to raid, loot, and attack British stations, officials, and African sympathizers. Otherwise, Africans migrated away from European colonial authorities, or deliberately slowed down the work they were forced to do by the colonial state as another form of resistance.

By the end of the nineteenth century, nearly all of Africa had been conquered by the European powers. As we have seen, African rulers and states pursued a variety of policies to retain their independence, ranging from outright resistance to complete accommodation. However, as European national governments became more committed to extending formal control over Africa, African rulers had fewer choices available to them. Ultimately, nearly every African state or society put up a sustained resistance against European expansion, but in the end they were hampered by inferior weapons, as well as internal and external divisions that were used, manipulated, and reinforced by the European powers.

From Military Rule to Civilian Administration: The End of the Chartered Companies

The colonial powers sought to rule their possessions as cheaply and efficiently as possible. In this initial period, force was most often used to crush local rebellions, impose taxation, and to "recruit" Africans for work on colonial projects.

13. In general, see T.R.H. Davenport, *South Africa: A Modern History* (Toronto: University of Toronto Press, 1987).

European administrative systems were established both tentatively and gradually. In this period, colonial policies differed markedly. Concessionary companies were used most extensively in parts of French, German, and Portuguese Africa. In these regions, private companies were granted large land "concessions." In return, they paid the cost of developing and administering the regions under their control. As we have seen, the British also used private companies in Nigeria (Royal Africa Company), East Africa (The Imperial British East Africa Company), and South Africa (The British South Africa Company); but the British government usually took control from these companies much earlier than either the French or Germans. For example, the Charter of the Royal Africa Company was revoked in 1898, and the British assumed formal control over northern Nigeria in 1900. In Uganda and Kenya, the British government took control from the Imperial British East Africa Company in 1894 and 1895 respectively. However, the administrative functions of the British South Africa Company were not eliminated until 1924. The concessionary companies operated in French Equatorial Africa until the 1920s, and the Portuguese allowed company rule to continue in Mozambique until 1942.

In the vast majority of these cases, the regimes of the concessionary companies were brutal and motivated by short term, private gain. Very little emphasis was placed on developing an infrastructure or an effective administration. Rather, Africans were systematically brutalized and coerced into providing the labor necessary to produce or collect cash crops for export. In French Equatorial Africa and German Cameroon, private companies were given substantial parcels of land in return for administering the region. In this period, African populations fell dramatically as more and more Africans were subjected to forced labor as porters, for constructing railways, and for collecting rubber and ivory. In these regions, colonial rule resulted in a serious ecological and demographic crisis. Overall, the impact of forced labor regimes was devastating. Furthermore, the European colonial powers used "bio-medicine," or western medical theory and technology, as a tool of colonial expansion and consolidation. Colonial rule in Africa was not simply a function of military conquest, but was brought about by re-ordering African societies and by controlling African labor.

King Leopold's Congo Free State was perhaps the best example of this system at work. As noted previously, by 1885 Leopold had managed to acquire the Zaire Basin as his personal property to develop and administer. In the "Congo Free State," Leopold granted vast rubber concessions to companies who used forced labor backed by African troops, known as the *Force Publique*, to collect rubber throughout the region. Africans were required to collect certain quantities of rubber for the representatives of the company for little or no compensation. Those who refused were beaten, shot, or mutilated by having their hands cut off. E.D. Morel, who led the Congo Reform Association, wrote of the "Red" (bloodstained) rubber produced in the Congo.[14] One visitor noted:

> His method of procedure was to arrive in canoes at a village, the inhabitants of which invariably bolted on their arrival; the soldiers were then landed, and commenced looting, taking all the chickens, grain, etc out of

14. E.D. Morel, *Red Rubber: The Story of the Rubber Slave Trade Flourishing on the Congo in the Year of Grace 1907* (London: T.F. Unwin, 1907).

the houses; after this they attacked the natives until able to seize their women; these women were kept as hostages until the chief of the district brought in the required [amount] of rubber.[15]

In the Belgian Congo, the fight against disease was tied to broader concerns about ways to acquire and maintain African labor. The solution to the sleeping sickness epidemic that spread throughout the region in the early twentieth century was to isolate Africans into special camps. The unhealthy work environment was not changed or reformed, but "infected" Africans were simply separated from "healthy" Africans. Thus, public health legislation served to increase state intervention into the daily lives of Africans and was vital to the imposition of colonial rule in Africa. Medical passports, medical exams, and sanitation regulations were tools used by the colonial state to supposedly "fight" epidemic diseases but in reality, they were colonial attempts to regulate and control Africans. Indeed, many Africans were hurt more than they were helped by these policies. More importantly, the epidemic was itself *caused* by the predatory labor regime imposed on Africans by concessionary companies and, later, the Belgian authorities. In general, African populations suffered demographic setbacks until 1920, which were the result of forced labor, migration, and the environmental degradation created by the imposition of colonial rule in Africa.[16]

In the long run, early colonial rule was unable to generate substantial and long-term profits, given that its methods provoked intense resistance from local African populations and it was costly to administer. Numerous concessionary companies went bankrupt only to be replaced eventually by direct European control. In the case of the Congo, popular opposition to Leopold's regime in Europe forced the Belgian government to assume full responsibility for the region in 1908. Only Portugal, which was simply unable to finance the development of an extensive colonial infrastructure, continued to operate and administer its African colonies through private companies, especially in Mozambique.

Although in French and British Africa colonial rule resulted in the gradual abolition of slavery, the colonial powers also had to resort to the use of forced labor to mobilize enough manpower to construct railroads and other colonial infrastructure projects.[17] Initially, the colonial states had no means other than force to recruit African labor. In Senegal, when the Marabouts (Islamic holy men led by Amadu Bamba) and the French colonial administration cooperated, the French were able to use the Marabouts to institute a form of forced labor in the production of cash crops, especially groundnuts.

However, it also became clear to many officials that to be more effective, colonial rule had to motivate Africans with something other than force. Ironically,

15. Quoted by Roger Anstey, *King Leopold's Legacy: The Congo under Belgian Rule, 1908–1960* (London: Oxford University Press, 1966), 6.

16. See Maryinez Lyons, "From 'Death Camps' to Cordon Sanitaire: The Development of Sleeping Sickness Policy in the Uele District of the Belgian Congo, 1903–1914," *Journal of African History* 26, 1 (1985): 69–91; Maryinez Lyons, *The Colonial Disease: A Social History of Sleeping Sickness in Northern Zaire, 1900–1940* (Cambridge: Cambridge University Press, 1992); and Megan Vaughan, *Curing Their Ills: Colonial Power and African Illness* (Stanford: Stanford University Press, 1991).

17. For example, see Martin Klein, *Slavery and Colonial Rule in French West Africa* (Cambridge: Cambridge University Press, 1998).

as colonial administrations became larger and more complex, direct force was used less. Peasant producers in West Africa were encouraged by a variety of coercive and non-coercive means to farm cash crops such as cocoa and groundnuts for export. In British and French West Africa, more elaborate colonial administrations and policies gradually evolved based on local, small scale production rather than large plantations or concessionary companies. But in Portuguese Africa, as well as the Belgian Congo, colonial rule relied until much later on brute force, coercion and naked violence. By 1920, more elaborate colonial bureaucracies and administrative systems were evolving as a means to impose colonial rule on Africa.

From Military Rule to Civilian Administration: Indirect and Direct Rule in British and French Africa

No single approach to colonialism prevailed in Africa. As Europeans found out what worked and what did not, they enshrined their successful policies into official doctrines, practices and ideologies. Because the early period of colonial rule was often contradictory, inept and brutal, the Europeans gradually formalized colonial policies and techniques. The European states drew three lessons from their early colonial experiences. First, the outrage against the most brutal forms of exploitation led to some attempts to reduce the scale of the coercion used against Africans, and many advocated eliminating the administrative regimes of the concessionary companies. Second, when it became clear that Africa would not provide the same kind of economic prosperity as had been envisioned in the nineteenth century, the colonial states looked for a way to make their colonies "finance themselves." Third, when it became known that educated Africans were creating problems by demanding their political rights, the colonial powers increasingly preferred to deal with the so-called "traditional" Africans.

Until shortly after World War I, the colonial states in Africa remained precarious. Methods of colonial rule and administration could only be developed gradually. The central goals of these administrations were twofold: to enforce and maintain order, and to discover a means to get the colonies to pay for their own governance. However, in both the French and British cases, very few European officials were actually in Africa. At the time of conquest in 1903, Lugard had 231 officers to "administer" 7,000,000 Africans in Northern Nigeria. The ratio of Europeans to Africans remained low, even at mid-century. By 1940, there were 1,315 European officials and 20,000,000 Africans in Northern Nigeria. In French West Africa, on the same date, there were 3,660 European Officials and 15,000,000 Africans. Both the French and the British were forced to use Africans as intermediaries to impose colonial rule, but they devised different methods of operation. The British looked to local African "elites," a system that was later codified and popularized as "Indirect Rule." The French, on the other hand, developed "Direct Rule" rather than using pre-existing political hierarchies and systems.

The British administered their colonies separately. Each had its own administration and set of officials for controlling local policy and day-to-day affairs.

Given their numbers and positions, European officials had tremendous latitude in interpreting orders and making decisions. Whatever the place or the "grand theory," the character, aims and goals of the European officials in charge profoundly shaped the nature of British colonial rule. The Colonial Secretary in far-away London tended to confine himself to outlining basic policy "thrusts," leaving it up to local officials to work out the details. Initially, most colonial officials were "military men." When their importance to decision making became clear, the colonial service became more bureaucratized. Officials then had to pass formal exams (e.g. entrance, African languages) and meet specific requirements for promotion. By the 1920s, most officials were recruited from Cambridge and Oxford Universities, where they had been trained in law, history, and the classics.

Lord Frederick Lugard first established indirect rule in Northern Nigeria. According to Lugard, colonial rule in the British colonies was to be enacted through indigenous African institutions and systems. Instead of sweeping away African political structures, the British retained them. Local languages were used in administration and European immigration was limited. Indirect rule developed gradually, first as a series of Political Memoranda sent to British Political Officers in Northern Nigeria, and later popularized in Lugard's famous book, *The Dual Mandate,* published in 1922. According to Lugard, the dual goals of colonial rule were to earn money for Britain and to "improve" the African way of life. The idea behind using African political structures was to "enhance" African governance by regularizing taxation and the administration of justice. In practice, indirect rule based itself on three pillars: the Native Authority, the Native Treasury, and the Native Courts.

British Residents lived in offices in larger urban centers, and advised the local political elites, who, in Northern Nigeria, were headed by the emir and his officials. This official class became known as the "Native Authority." While in practice, the emir had to consent to British policy, colonial rule was actually implemented through the pre-existing political system. As Lugard noted in 1903: "Every Sultan and Emir will rule over the people as of old time but will obey the laws of the Governor and will act in accordance with the advice of the Resident."[18] The emirs appointed their own subordinates, administered justice, and collected taxes. Rather than relying on Western-educated, Christianized Africans, the British turned to so-called "traditional" African rulers with whom they could collaborate without facing risk of Western style claims to basic rights. By collaborating with the pre-existing social and political elite, they hoped to "legitimize" colonial rule rather than relying on open displays of force which, nonetheless, were employed if the situation so warranted. The entire system was financed by taxing the production of peasants, farmers and artisans. The emir's officials traveled to the countryside, collected taxes, and brought them back to the capital of the emirate. These proceeds were then placed in the "Native Treasury." Because half went to the British government and half remained in Africa for use by the Native Authorities, the British were able to pay for public works projects and the salaries of native officials. In other words, colonial rule effectively forced Africans to finance their own occupation and exploitation.

18. Quoted by John Iliffe, *Africans: The History of a Continent* (Cambridge: Cambridge University Press, 1995), 200–201.

Lugard also created native courts that dispensed so-called justice to Africans according to "customary law," or what had been defined as "native" customs and laws. These courts were run by the "African political elite," the chiefs or the minions of chiefs, whose authority among African communities was thereby increased and bolstered. Often, so-called "customary" authority was in practice merely a European invention that bore little relationship to precolonial legal systems. Colonial powers basically assumed that African "customs" were unchanging and never subject to debate. This was clearly a mistaken impression; there was no single, undisputed notion of what was "customary" in Africa. But, for law, and therefore indirect rule, to function, a single customary law for each region had to be invented. The British needed to have "Native Authorities" claim they were exercising power according to a pre-existing tradition. As a result, the privileged elites who ran or had access to such Native Authorities could be assured that their version of customary law would be approved by the British more easily than that of the peasant farmers.[19]

Because chiefly power was entrenched, one of the results of colonial rule was that decisions traditionally made at a household level were now made in the courts run by the chiefly elites. Through this system, the British extended colonial power and the colonial economy by appropriating and defining African "customs" and "customary" law.[20] These laws could then better serve European interests.

In the British settler colony of Southern Rhodesia, colonial officials consulted "legal" experts. These individuals were always powerful members of the elite who created customary laws to increase the control older men had over the labor of children and women.[21] By gaining support of the elders, the British colonial regime could ensure that women would remain in rural areas, producing income and food for their husbands. In short, the freedom that new economic opportunities brought to rural women needed to be controlled by both the colonial state and the "traditional" authorities they worked through. If women refused to marry their appointed partners, left for missions, cities or mines, male authority would be undermined, and the system of indirect rule would also be threatened. As one British official stated: "For some time I have noticed that the women assume a very arrogant, independent and indifferent attitude toward their husbands and take exception to any genuine remonstration which he may make and this is very often pounced upon as an excuse for deserting him."[22]

In actual fact, women ran away because of physical abuse and neglect, or to further their own economic opportunities when their husbands married other women. But the logic of indirect rule and the economics of colonialism meant that this had to be stopped by changing and encoding one "approved" version of cus-

19. See Elizabeth Schmidt, *Peasants, Traders and Wives: Shona Women in the History of Zimbabwe, 1870–1939* (Portsmouth: Heinemann, 1992), and Mahmood Mamdani, *Citizen and Subject: Contemporary Africa and the Legacy of Late Colonialism* (Princeton: Princeton University Press, 1996).

20. See Martin Chanock, *Law, Custom and Social Order* (Cambridge: Cambridge University Press, 1985).

21. Elizabeth Schmidt, "Patriarchy, Capitalism and the Colonial State in Zimbabwe," *Signs* 16, 4 (1991): 732–756; and "Negotiated Spaces and Contested Terrain: Men, Women and the Law in Colonial Zimbabwe," *Journal of Southern African Studies* 16, 4 (1991): 622–648.

22. Schmidt, "Patriarchy, Capitalism and the Colonial State in Zimbabwe," 744–745.

tomary law. To keep women under the thumb of rural elders, women's claims in court cases of abuse or neglect were no longer heard. Thus, a new "tradition" was created that served the interests of the colonial state and the male elders. After World War I, colonial regimes across Africa attempted to codify customary law and formalize the structures of indirect rule as a way to impose colonial rule on Africa.[23]

These "codifications" provoked conflict. Internal disputes arose over chiefly status, and debate over custom and tradition was common. Although the British tried to institute a "stable" system of indirect rule based on "custom" and "tradition," their efforts to impose a "fixed" set of rules provoked conflict, debate and struggle over the meanings of custom, political authority and tradition.[24] The British tried to make access to land, labor and wealth contingent on social identity (e.g., traditional status, chiefly position, age, religion) but Africans, at the same time, tried to negotiate and create new social identities to take advantage of these commercial and/or political opportunities. For example, a number of Kumasi chiefs tried to assert customary rights over land. In 1935, in the name of "custom" and "tradition," the British restored to Kumasi the capital of the old Asante Empire and control of a number of neighboring administrative units which were previously inaccessible.

While the "theory" of "indirect" rule developed haphazardly, and only became a theory in the 1920s, the "doctrine" of indirect rule spread to other British colonies from northern Nigeria, including Asante in Ghana; Buganda in British East Africa; and Rhodesia in Central Africa. Because Lugard believed incorrectly that the "underlying principles" of indirect rule could be established almost everywhere, Native Authorities were created in places where none had existed before. But northern Nigeria was unique, and a very real and profound problem arose when "indirect rule" spread to other areas. European definitions did not correspond to African realities. In regions where there were no chiefs, new chiefs were created. In West Africa, the British created "Warrant Chiefs" in Igboland. By giving these so-called chiefs "warrants," they became members of the Native Court System. They could then make laws on the authority granted by their membership. The system began as early as 1891, but was consolidated by 1912, and later justified by Lugard's "Dual Mandate." Although they claimed that they ruled "indirectly," in practice the Warrant Chief system bore no relationship to precolonial Igbo political structures.[25] In similar fashion, the "monarchy" was reintroduced to Benin in 1916, in the 1920s the Asantehene was "restored" to the golden stool, and the British also attempted to recreate a "Yoruba" monarchy in and around Oyo. This was done despite the fact that since the 1850s Ibadan, not Oyo, had been the most important Yoruba state.[26] Thus, the imposition of colonial rule in many British colonies relied on the creation of a precolonial history and tradition that very often did not correspond to the actual history of Africa.

23. On the invention of tradition, see Terence Ranger, "The Invention of Tradition in Colonial Africa," in E. Hobsbawm and T. Ranger (eds.), *The Invention of Tradition* (Cambridge: Cambridge University Press, 1983).

24. See Sara Berry, "Hegemony on a Shoestring: Indirect Rule and Access to Agricultural Land," *Africa* 62, 3 (1992): 327–355.

25. See A.E. Afigbo, *The Warrant Chiefs: Indirect Rule in Southeastern Nigeria* (London: Longman, 1972).

26. See Toyin Falola, *The Political Economy of a Pre-Colonial African State: Ibadan, 1830–1900* (Ile-Ife: University of Ife Press, 1984).

The ideology of indirect rule influenced other colonial powers, including the Germans and the Belgians, who tried to rule through so-called "traditional" chiefs in parts of Central Africa, including Rwanda.

In general, colonial officials envisioned African peoples as "tribal," and they then tried to turn the so-called "tribe" into an "administrative" unit. However, "tribes" were largely creations of European officials and anthropologists. According to these officials, Africans were members of particular "tribes" that shared well-defined genetic and biological characteristics. Thus, certain "tribes" were favored over others based on the ways in which Europeans defined these supposedly inherent qualities. But in precolonial Africa, ethnic identity was fluid; and because it was often tied to a particular occupation, ethnic identities could change in the course of one's lifetime. Nonetheless, European administrators envisioned African ethnicity as fundamentally static and inflexible, and they used certain ethnic groups and their leaders to enforce colonial policies such as taxation or labor recruitment. Ethnic identities were thereby transformed and used by the colonial state in the way it exercised power.[27]

For example, in the precolonial period there were two main ethnic groups in Rwanda; the Tutsi who herded and controlled cattle, and the Hutu who farmed. Both Tutsi and Hutu held political positions, although a Tutsi royal dynasty controlled the kingship. The Hutu and Tutsi were bound together in a series of personal "patron-client" relationships. Generally, a rich Tutsi gave a few cows to a Hutu client. In return, the Hutu client gave a share of his future calves to the Tutsi patron. In turn, the Hutu gained access to both wealth and a chance at upward social mobility. If the Hutu did well, he could eventually become a cattle-keeper, marry into a Tutsi lineage and, in effect, become a Tutsi. If a Tutsi lost all of his cattle, he could eventually become an agriculturist, marry into a Hutu lineage, and effectively become a Hutu. Thus, in the precolonial period, there was no absolute division between Hutu and Tutsi; rather, ethnicity was based largely on occupation, and people moved between ethnic categories in certain situations.

The Germans and the Belgians, however, believed that differences in the ways the Hutu and Tutsi physically looked meant they could be ranked in order of "development" and "civilization." They believed that the Tutsi were the "natural" leaders and kings, while the Hutu were less "civilized" farmers. Both the Germans and the Belgians needed to work through indigenous institutions, and, therefore, they increased the power of kingship and of the Tutsi at the expense of the Hutu. Between 1926 and 1931 the Belgians introduced a series of "reforms" that purged all Hutu chiefs from administration. By giving the Tutsi power to demand forced labor from the Hutu, they over-systematized colonial rule and empowered the monarch. The Tutsi in control, however, took advantage of their authority to enrich themselves. Because the imposition of colonial rule made access to material resources contingent on ethnicity, the fluidity of the precolonial system was simply ignored or misunderstood. The Tutsi were codified and legitimized as "leaders" while the "Hutu" were made into inferiors. Colonial anthropologists claimed this entire system was legitimate and traditional, and it became the accepted version of Rwanda's history. Although the system was both incorrect and artificial, it

27. See Berry, "Hegemony on a Shoestring: Indirect Rule and Access to Agricultural Land," 334–336.

was made into "tradition" by colonial rule, indirect rule, and the ideology of European imperialism.[28]

French territories, on the other hand, were divided into two main federations: the West African Federation and French Equatorial Africa. Initially, the French sought to "assimilate" their so-called subjects by making them become "French." But, by the twentieth century, the French argued that "association" was a better model to follow. They declared that with the exception of four towns (known as communes) in Senegal, all Africans would be labeled "subjects" rather than "citizens." Thus, Africans born in the four "communes" had the legal rights of French citizenship beginning in 1871 and were represented in the Chamber of Deputies in France. Otherwise, Africans were not subject to French civil or criminal law, and were not exempt from forced labor. In short, the French came to believe that Africans were not capable of developing into "Frenchmen." They created a system that made the French into permanent superiors and the Africans into permanent inferiors. Out of this ideology emerged the colonial administrative system known as "Direct Rule."

French colonial administrations were highly centralized. Their officials aimed to ensure that the chain of command ran through them as far as was possible, and local African political systems were not utilized as fully as was the case with indirect rule. In French West Africa, Frenchmen headed the administrative divisions known as the *cercles*, and below them Africans administered the *cantons* and villages. Cantons were artificial French creations that failed to correspond to any African administrative divisions or political boundaries. All of French West Africa was administered from Dakar by the Governor General. Second in command were Lieutenant Governors in each colony who, in turn, ruled through the *commadants* of the *cercles;* who, in turn, ruled through the *canton* Chiefs and village heads.

Direct rule thus forced Africans into a foreign framework. African local administrators did not hold so-called "traditional" titles, nor were precolonial states left intact. Instead, both became part of a foreign, official, French-speaking bureaucracy. The Governor General of French West Africa noted in 1917: "the chiefs have no power of their own, for there are not two authorities in the cercle, there is only one! Only the commandant de cercle commands, only he is responsible."[29] After 1880 in French West Africa, any French administrator was allowed to impose the *indigenat*, a punishment of up to 15 days in jail for a series of minor infractions, such as failing to be courteous to French officials.

More often than not, both the French and Portuguese created African rulers where there had been none before. Overall, in both French and British cases, African intermediaries were used; but advocates of indirect rule generally placed more stress on ruling through what were defined as "traditional" and "legitimate" African institutions. The French approach was significantly more "top-down." They used local Africans to collect taxes and manage labor, while essentially ignoring local political precedents. There were variations of course. In some

28. See David Newbury, "Understanding Genocide," *African Studies Review* 41, 1 (1998): 73–97; and Gerard Prunier, *The Rwanda Crisis: History of a Genocide* (New York: Columbia University Press, 1995), 1–45.

29. J.V. Vollenhoven, "Circulaire au sujet des chiefs indigènes" in *Une âme de chef* (Paris: Deieval, 1920), quoted by R.F. Betts, "Methods and Institutions of European Domination" in *General History of Africa VII* (Paris: UNESCO, 1985), 321.

cases the French, like the British, preserved the authority of powerful ruling elites and their families. In other cases, the British ignored or deposed "legitimate" chiefs. Although British and French colonial systems can be roughly characterized as either indirect or direct, in both cases there were exceptions, and often a combination of policies was followed.

Between 1903 and 1920 the methods of colonial rule were being worked out and rationalized. The early part of the period was the most violent, disruptive and coercive with later regimes becoming more homogenous and less directly coercive. The years between 1920 and 1945 were the "High Noon" of the colonial period, when administrations had developed most fully and the colonial economy was in full swing. Over these years, African labor was secured by means other than direct coercion, generally through taxation and peasant production. An ideology of "rulership" was also produced, and Africa was mentally mapped by the Europeans as a collection of "tribes." In all cases, colonial rule became more bureaucratic. Military rule gave way to civilian colonial governments and direct force was replaced by "administrative persuasion."[30] Nonetheless, the European monopoly of violence was always *the* key factor in maintaining colonial rule.

Colonial rule initiated profound social, economic, cultural and political transformations; but it did not control everything. Often policies like indirect rule provoked unintended or unforeseen consequences, and some Africans disputed and changed the "customary" to secure their own economic interests. In Ghana, the spread of cocoa farming raised land values, and people asserted their claims by arguing that they were entitled to their land by custom. As a result, the British had to adjudicate a nearly constant series of land conflicts. Thus, far from imposing "one tradition," the British imposed a system in which Africans competed to define tradition.[31]

The Settler Colonies in East, Central and South Africa

By formally settling parts of East and Central Africa, the Europeans created a much different colonial pattern than in non-settler colonies. In these regions, fewer Africans were engaged in the production of cash crops for export. Thus, for the Portuguese, Germans and British, the solution to the revenue "problem" was to encourage and promote white settlement. By establishing farms and plantations, and by using African labor, the whites hoped to produce substantial revenues for the colonial state.

Portuguese settlers, for example, established farms in the interior of Angola and Mozambique where they had a tremendous power to levy taxes and impose judicial sentences on their African laborers and tenants. Even though the British limited the power of settlers more than the Portuguese, in Portuguese settler colonies Africans had fewer economic and political opportunities. This was be-

30. R.F. Betts, "Methods and Institutions of European Domination," 327.
31. Berry, "Hegemony on a Shoestring: Indirect Rule and Access to Agricultural Land," 333–338.

cause colonial rule was imposed by white elites who had a direct stake in Africa, as opposed to British officials who kept their homes and families in England. In 1923, administrative power in Rhodesia was transferred from the British South Africa Company to 33,000 white settlers. In these regions, a few white settlers owned the best and most profitable land, while the majority of the African population labored on their farms and plantations for minimal wages.

From Military Rule to Civilian Administration: Economic Structures and the Imposition of Colonial Rule

Because the European colonial project cost money, the colonial powers advocated and tried to impose "economic development" on Africa. The colonial powers wanted to ensure that they could sell their manufactured goods to Africans in return for their primary products. As a result, Africans had to be both forced and encouraged to participate in a monetized, market-based economy. Each colonial regime needed secure access to African labor in order to get Africans to produce what the colonial state wanted them to produce. The imposition of colonial rule was not simply a political and ideological process, it was also intimately tied to the imposition of new colonial economic relationships and structures. As we have seen in the sections above, in order for the political and ideological structures of colonialism to function, they needed a firm source of revenue. Likewise, the entire colonial project required Africa to be incorporated into the world economy as a producer of primary products. We will now turn to the imposition of the economic structures of colonial rule in Africa.

Railroads served as a central element in the imposition of colonial economic and political structures on Africa. Because prior to the colonial period, African economies had been constrained by inadequate transport networks, colonial regimes attempted to improve transportation by building railroads. The ways in which railroads were constructed and operated serves as an excellent window into the ways in which economic "development" projects worked in Africa. These colonial railroads did not link African economies and production together. Rather, they served only the purpose of linking African producers to "international" trade and the marketplace. In some places the existence of railroads meant that larger amounts of African produced crops could be sent to the coast, but they did very little else. Railroads tended to run from coastal ports into the interior, and they were owned and controlled by European companies. All of the equipment used in building and operating the railroads was manufactured in Europe. They typically brought very little sustained economic growth to Africa, beyond reinforcing the production of cash or primary crops for an external market. Furthermore, thousands of African men were forced to construct these railway lines, often for very low wages. These workers traveled long distances, performed backbreaking labor, and were subjected to unfamiliar disease environments.

Overall, what kinds of economies developed as a result of the imposition of colonial rule? In some mineral rich colonies, mining became important; in others,

local African peasants farmed crops they sold for cash; in yet others, Europeans tried to institute colonial plantations and farming projects. There were two main variations in the economic structures imposed by colonial rule: peasant, small-holder production, and migrant/wage labor production on European owned or managed mines and plantations. In West Africa, peasant production predominated. In most of East, Central and South Africa, fewer Africans were able to engage in the production of primary products for export, and instead became migrant or wage laborers.

Because agriculture served as the main occupation of most Africans, European administrators desperately looked for ways to increase agricultural production. They arrived at two main solutions: get African farmers to sell their products as exports, or take land from African farmers and set up plantations that would use African labor but would be managed by Europeans. The central goal in each case was to establish an effective means of appropriating the surplus of rural farmers to finance the expense of colonial rule and to ensure that primary products were being produced for the export market. Thus, colonial regimes tried to regulate rural economic activity. European firms purchased the primary goods produced by Africans, and set the terms of exchange (the prices) that Africans received for their goods. The idea was to force Africans into a capitalist-oriented market system.

In West Africa, by taxing rural producers, the colonial state could force Africans to farm "cash crops" which they would then have to sell on the market for cash. These, in turn, could be taken from the producers as tax, which sometimes would be a tax on land or produce, and, at other times, would be taken as a "hut tax." In places that had been involved in market-based exchange, such as West Africa, many Africans responded on their own to produce cash crops. Farmers in Senegal and northern Nigeria produced groundnuts for export; and on the Gold Coast, cocoa became the primary cash crop. As Freund and Philips have noted, African economic systems were not immediately swept away by colonial rule: "Precapitalist social forms...survived to a remarkable extent...[o]ne reason was the resistance to transformation, to the expropriation of material, social and cultural values, by a resilient population of cultivators."[32] They, in short, persisted despite European attempts to change them. In northern Nigeria, farmers deliberately chose to produce groundnuts rather than cotton, the crop the British wanted them to produce, because groundnuts were less risky to farm and prices were higher.

Other Africans responded to these new opportunities by moving into the peanut production belt. Workers would "hire" land from local leaders, plant peanuts and food crops, and then sell the peanut crop at the end of the season.[33] They then bought an assortment of imported goods for resale after they returned home. In some places, especially West Africa, African peasant small-holders could, therefore, make their own economic choices and determine for themselves

32. Freund, *The Making of Contemporary Africa*, 98–99, and Anne Philips, *The Enigma of Colonialism: An Interpretation of British Policy in West Africa* (Bloomington: University of Indiana University Press, 1989).

33. See Martin Klein, *Slavery and Colonial Rule*, 69–70; Ken Swindell, "Serawoolies, Tillibunksa and Strange Farmers: Development of Migrant Groundnut Farming along the Gambia River 1848–1895," *Journal of African History* XXI (1980); and George Brooks, "Peanuts and Colonialism: Consequences of the Commercialization of Peanuts in West Africa, 1830–1870," *Journal of African History* XVI (1975).

what crops they produced. The Gold Coast cocoa crop developed through this kind of African initiative. Cocoa was first introduced in 1878, and by 1911, exports had reached the level of 40,000 tons. African farmers started out with small cocoa farms, then formed local cooperatives that allowed groups of farmers to pool financial resources and buy larger tracts of land.[34] However, because prices were controlled by European marketing firms, peasants often had to sell their produce at very low prices. Although some farmers prospered, many spiraled into a cycle of debt and poverty. The general impact of the imposition of colonial rule was, therefore, that the state received tax while Africans became enmeshed in producing "primary products."[35] As a result, African farmers were able to plant fewer food crops, which led to increased risk of famine.

In places without long histories of agricultural production for the market, the colonial state had to use coercion to force people to produce certain crops. Cotton, and small-holder agriculture did not develop until the 1920s and 1930s in Cameroon, the Ivory Coast and Chad. In East Africa and in Rhodesia, on the other hand, settler agriculture dominated the colonial economy and a much different pattern of economic development emerged. The white settlers who lived in these colonies managed large farms, while Africans worked for wages. These large tracts of land were taken over by Europeans, who managed the farms and gained most of the profit from running them. In Kenya, for example, the "white highlands" policy reserved 16,000 square miles of excellent agricultural land for Europeans. Likewise, economic development was much different than the cash-cropping model described above in regions where Europeans took direct control of mining operations and land. In these cases, Africans could not adapt their pre-existing forms of production to the new order (as did cash-cropping peasants). They were forced to compete directly with European firms or agree to the terms of employment offered by European farms and mines.

Key to the development of these early colonial economies was the need to control labor. In some cases this was not a problem. Small producers in West Africa mobilized household labor to produce groundnuts or crops for food. In the settler colonies and in places with extensive mining or plantation systems, many Africans became migrant laborers. The colonial state imposed taxes on African households to force them into the cash economy and break down the ability of rural farmers to be self-sufficient. Because cash was needed to pay taxes, many Africans migrated to places where they could find employment in wage labor. The family of the worker stayed behind growing food for their own needs, while the men made enough money as mine workers or agricultural laborers to pay the colonial taxes. This often began as a temporary move that was undertaken by young men during certain seasons. Later, some migrants brought their families with them leading to a permanent change in residence. Although migrant laborers worked throughout Africa, including West Africa, where migrants would be hired by rich African farmers to produce cocoa; the largest and most comprehensive system was in South and parts of East and Central Africa. Here, African men migrated to mines and large plantations to work for wages. Portuguese Mozam-

34. On cocoa outside Ghana, see Sara Berry, *Cocoa, Custom and Socio-Economic Change in Rural Western Nigeria* (Oxford: Clarendon Press, 1975).

35. See for example, Ralph Austen, *African Economic History: Internal Development and External Dependency* (London: James Currey, 1988), 137–147.

bique, for example, gave the Witwatersrand Native Labour Agency a monopoly over the recruitment of labor in the region. Soon thereafter, southern Mozambique became a vast migrant labor reserve for the South African gold mines.

Overall, colonial states imposed a variety of economic relationships and structures on Africans. In all cases, and especially in West Africa, some Africans found ways to profit from the new economy. However, many Africans were forced by the cash economy and taxation into becoming migrant laborers in European-owned mines or plantations. In all cases, the imposition of colonial rule was made possible and effective only when colonial regimes were able to acquire and control the labor of African workers, farmers, and traders.

Conclusion

This chapter has explored the imposition of colonial rule from the scramble for Africa to the creation of dependent, resource-based African economies in the 1920s. The European nations involved in the scramble hoped to keep other European powers out of Africa and thus protect their national economic interests. By 1903 nearly every African state had been conquered after fierce, and sometimes prolonged, resistance movements. Between 1903 and 1920 the methods used to subjugate Africans became more alike and homogenous. Central elements in the transition from "military" to "administrative" rule included the imposition of colonial and indigenous political and administrative structures, forced labor, customary law and colonial courts, cash-crop production, and taxation.

Review Questions

1. What were the factors that led to the scramble for Africa?
2. Why and how did the scramble for Africa become a formal "partition" of Africa?
3. What were the different kinds of African responses to European military expansion?
4. Why and how did European powers conquer Africa?
5. What were the major stages in the imposition of colonial rule?
6. How and where did concessionary companies operate? Why did they fail?
7. Through what political methods was colonial rule established?
8. What were the differences between British and French colonial rule?
9. What was customary law? How was the use of customary law related to the imposition of colonial rule?
10. What kinds of economic structures were imposed on Africa by the colonial powers?
11. How and why did these structures vary over time and place?
12. How were the political and economic structures of colonialism interrelated?

Additional Reading

Austen, Ralph. *African Economic History: Internal Development and External Dependency*. London: James Currey, 1988

Berry, Sara. *No Condition is Permanent: The Social Dynamics of Agrarian Change in Sub-Saharan Africa*. Madison: University of Wisconsin Press, 1993.

Boahen, A. Adu. *African Perspectives on Colonialism*. Baltimore: Johns Hopkins University Press, 1989.

Coquery-Vidrovitch, Catherine. *Africa: Endurance and Change South of the Sahara*. Berkeley: University of California Press, 1988.

Cooper, Frederick and Ann Laura Stoler, eds. *Tensions of Empire: Colonial Cultures in a Bourgeois World*. Berkeley: University of California Press, 1997.

Headrick, Daniel. *The Tools of Empire*. Oxford: Oxford University Press, 1981.

Hochschild, Adam. *King Leopold's Ghost: A Story of Greed, Terror and Heroism in Colonial Africa*. Boston: Houghton Mifflin, 1998.

Mamdani, Mahmood. *Citizen and Subject: Contemporary Africa and the Legacy of Late Colonialism*. Princeton: Princeton University Press, 1996.

Chapter 2

The Consolidation of European Rule, 1885–1914

Felix K. Ekechi

The European scramble to colonize Africa culminated in the Berlin West African Conference of 1884–85. This conference, which was called by the German leader, Bismarck, set up the parameters for the partition of Africa. The Berlin Conference was summoned to discuss the issue of free navigation along the Niger and Congo rivers, as well as to settle new claims to the African coasts. In the end, the European Powers signed the Berlin Act (Treaty), which set the rules for the European occupation of African territories. It stated, among other things, that a European's claim to any part of Africa would only be recognized if it was "effectively occupied." In essence, the Berlin Conference set the stage for the European military invasion and conquest of the African continent. Thus, in the critical years, 1885–1914, Africa experienced the trauma of invasion, conquest, and European colonial domination. With the exception of Ethiopia (in the northeast) and Liberia (in the west), the entire continent came under European colonial rule. The major powers were Britain, France, Germany, Belgium, Italy and Portugal. For all practical purposes, the story of Africa from the Berlin Conference to c.1914, revolves around these five major themes: the establishment of European colonies, the consolidation of political authority, the development of the colonial estate through forced labor, the cultural and economic transformation of Africa, and African resistance. Basil Davidson, a popular British writer on Africa, has aptly described the colonial period as "a prolonged interlude of destructive subjection and foreign occupation [of Africa], whose main achievement was not to carry Africa into a new world [of progress] but merely to complete the dismantlement of the old [order]."[1] The dismantling of the old order included, of course, the loss of political independence and sovereignty, the radical transformation of the traditional economy, as well as the society. The colonial period marks, therefore, a revolutionary era in which African institutions and cultural practices were fundamentally altered and undermined.

* * *

1. Quoted in Lewis H. Gann and Peter Duignan, *Africa and the World* (San Francisco: Chandler Publishing Company, 1972), 484.

European Penetration and African Resistance

To begin, it should be noted that the "effective occupation" clause in the Berlin Treaty (1885) gave Europe a blank check to use military force to occupy African territories. Thus the years 1885–1914 were years of European conquests and amalgamations of pre-colonial states and societies into new states. However, the European imperialists continued to pursue earlier treaty making processes, whereby African territories became European protectorates. In other words, there was a "loaded pause" before the eventual European military occupation of Africa. Because these protectorate treaties posed serious challenges to African independence, most African rulers naturally rejected them. In West Africa, for instance, Asantehene Prempe II, the King of Asante, was firmly resolved not to submit to British protection. Instead, he maintained the integrity of Asante "as of old." When pressured in 1891 to sign a protection treaty, which implied British control of Asante, Prempe firmly and confidently rejected the idea, stating to the British envoy:

> The suggestion that Asante in its present state should come and enjoy the protection of Her Majesty the Queen and Empress of India, is a matter of very serious consideration, and…I am happy to say we have arrived at this conclusion, that my Kingdom of Asante will never commit itself to any such policy. Asante must remain [independent] as of old[2]…

Similarly, in modern Tanzania, King Machemba rejected German entreaties to bring his kingdom under German control. His self-confidence is clearly reflected in his defiant reply to the German envoy Hermann von Wissemann in 1890, "I have listened to your words but can find no reason why I should obey you—I would rather die first….If it should be friendship that you desire, then I am ready for it, today and always; but to be your subject, that I cannot be….If it should be war you desire, then I am …ready, but never to be your subject…."[3] Also in Namibia, the Nama leader Hendrick Witbooi, warned his Herero antagonist Chief Maherero against forging an alliance with the Germans. To Chief Maherero, he wrote:

> You think you will retain your independent Chieftainship after I have been destroyed…but my dear Kaptein you will eternally regret your action in having handed over to the White man the right to govern your country….But this thing you have done, to surrender yourself to the Government of the White man, will be a burden that you will carry on your shoulders. You call yourself Supreme Chief, but when you are under another's control you are merely a subordinate Chief.[4]

Clearly, African rulers adopted a negative stance towards European attempts to occupy their states and kingdoms. Their strategies to forestall European occu-

2. Quoted in A. Adu Boahen, *African Perspectives on Colonialism* (Baltimore: The Johns Hopkins University Press, 1987), 24.
3. Ibid., 23.
4. Quoted in Kevin Shillington, *History of Africa*, revised edition (New York: St. Martin's Press, 1995), 328.

pation included recourse to diplomacy, alliance and, above all, military con-
frontation. Where alliances were struck between the African leaders and the im-
perialist powers, as in the above quotation, it should be emphasized that the
Africans did so in an attempt to enhance their commercial and/or diplomatic ad-
vantages. Thus, for instance, the king of Daboya in northern Ghana (West
Africa), who signed a treaty of friendship with the British in 1892, did so with the
hope of attracting British trade. "Tell my friend, the Governor of Accra," Daboya
told the British representative, "I like my country to be quiet and secure; I want to
keep off all my enemies and none to be able to stand before me.... Let plenty
guns, flint, powder and cloth, and every kind of cost goods be sent here for sale."[5]
In essence, the king did not sign away his independence.

In Nigeria, King Jaja of Opobo resorted to diplomacy as a means of resistance
to European intrusive imperialism. A former slave of Igbo origin, Jaja was elected
as the king of the Anna Pepple House in Bonny, in the Niger Delta, in 1863. This
election followed the death of his master, Alali, in 1861. But struggle for power
between the Anna Pepple House and the Manilla Pepple House, under the leader-
ship of Oko Jumbo, led to the outbreak of civil war in Bonny in 1869. The civil
war resulted in King Jaja's migration and the founding of an inland kingdom of
Opobo, which lay in the palm oil producing hinterland. Jaja, an avowed national-
ist, was determined to control the trade in his political domain. He was also de-
termined to prevent European incursions into the interior, which would invariably
disrupt the economic organization on the Niger Delta. Essentially, his ambition
was to maintain full control of the palm oil trade. More specifically, Jaja wanted
to ensure that Opobo oil markets remained outside the sphere of foreign traders.
To this end, he signed a trade treaty with the British Government in 1873. Part of
the treaty reads as follows:

> After April 5, 1873, the King of Opobo shall allow no trade establish-
> ment or hulk in or off Opobo Town, or any trading vessels to come
> higher up the river than the whiteman's beach opposite Hippopotamus
> Creek. If any trading ship or steamer proceeds further up the river than
> the creek above mentioned, after having been fully warned to the con-
> trary, the said trading ship or steamer may be seized by King Jaja, and de-
> tained until a fine of 100 puncheons [of palm oil] be paid by the owners
> to King Jaja. [6]

By this treaty, the British formally acknowledged Jaja as the king of Opobo, and
also as the dominant middleman in the Niger Delta trade. However, the ensuing
Scramble of the 1880s upset this understanding, as British merchants and officials
were no longer in the mood to respect Jaja's preeminence in the Niger Delta hin-
terland. Instead, by penetrating the hinterland they sought to open free trade in
Opobo and elsewhere, making confrontation with Jaja inevitable.

King Jaja's response to the British about-face was unequivocal. He was not
only determined to control the hinterland trade, but he also sought to export
palm oil directly to Europe. In the process, he sought to bypass the African Mer-

5. Boahen, *African Perspectives*, 37.
6. S.J.S. Cookey, *King Jaja of the Niger Delta: His Life and Times 1821–1891* (New
York: NOK Publishers, 1974), 77.

chants Association, a British commercial organization that monopolized the palm oil export trade in the Niger Delta. To this end, Jaja appointed a Scottish merchant, Alexander Miller, as his agent. Through him the palm oil would be sold directly in Europe. But this was not to be. For just as Jaja was determined to maintain control of palm oil trade, as well as to preserve the political integrity of his kingdom of Opobo, so also were the British determined to trade directly in the interior. Indeed, as a matter of policy, the British supported their nationals in matters of trade. Said the British consul Wylde: "Wherever there is money to be made, our merchants will be certain to intrude themselves, and...public opinion in this country practically compels us to protect them."[7] Consequently, as British merchants aggressively intruded into King Jaja's political domain, conflict ensued. Ultimately, King Jaja was ruined. In 1887, the British consul Harry Johnston cunningly enticed Jaja to a British gunboat for discussions but then exiled him to the West Indies, where Jaja died, in 1891. But even at death, Jaja continued to be remembered. A monument erected in his honor at Opobo reads, in part:

> A King in title and in deed
> Always just and ever generous
> Respected and revered in life
> Lamented and mourned by all when dead.[8]

Obviously Jaja's diplomatic resistance failed. Yet other African rulers adopted other strategies, largely military confrontation, to resist European encroachments. In West Africa, rulers like Samori Toure of the Mandinka, in modern Guinea, fought the French for about sixteen years (1882–1898) before he was finally defeated and exiled. Samori was an Islamic reformer, a nationalist to the core, and an outstanding African military leader and strategist. He used both guerilla warfare and scorch-earth policy to harass the French. Besides, he had his own well-trained, professional cavalry (sofas), an ammunitions industry, as well as an abundant supply of gold with which he was able to buy arms and ammunition. Sadly, in 1898, Samori was captured by the French and exiled to Gabon, where he died. To contemporary West Africans, Samori was the quintessential African nationalist and one of the most illustrious military leaders of the age. Many even saw him as "the Napoleon of West Africa." Nationalist newspaper editorials held him in high regard, no matter what opinion the outside world held of him. The Nigerian Lagos Weekly Record stated: "no matter how much effort may be put forth to detract from the renown which belongs to him, the intelligent African will always regard Chief Samadu [Samori] as one of the ablest of Negro generals and rulers [in modern history]."[9] And there were, of course, other resistors. For example, King Behanzin of Dahomey, who prided himself as the "shark of sharks," courageously fought the French for four years (1890–94). Dahomey was, without question, the strongest state in West Africa in the nineteenth century. But it constituted an obstacle to the French economic interests in the hinterland. For the French, Dahomey was the gateway to the rich palm oil hinterland. Egged on by the na-

7. K. Onwuka Dike, *Trade and Politics in the Niger Delta 1830–1885* (Oxford: The Clarendon Press, 1956), xx.

8. Cookey, *King Jaja*, 168.

9. *Lagos Weekly Record*, 31 Dec. 1898, cited in Georgia McGarry (ed.), *Reaction and Protest in West African Press* (Cambridge: African Studies Center, 1978), 146.

tionalist press, the French committed huge military and financial resources to the Dahomean military campaign. By the end of the war, France had spent about 27 million francs and committed over 4,000 men to the military expedition. Indeed, between 1890 and 1894 war raged, and Dahomey was ultimately defeated. King Behanzin was captured and exiled to Martinique, West Indies. He died in exile at Blinda, in 1906, but his remains were brought back to Dahomey in 1928. With the fall of Dahomey, the French then colonized the palm oil rich Dahomean hinterland as well.[10]

While the focus so far has been on centralized states, decentralized societies, where there were no paramount rulers, equally resisted European penetration. Indeed, both the British and the French found segmentary or decentralized societies particularly difficult to subdue The Baule of the Ivory Coast and the Tiv and the Igbo of Nigeria were among the African peoples that most stiffly resisted colonial occupation. The Baule, for example, fought the French from 1891 to 1911 and beyond, while the Tiv fought the British from about 1900–1930s.The Igbo resistance to British imperial pretensions, as in the case of the Baule and the Tiv, was particularly widespread and prolonged. Because of the nature of their society, which is characteristically egalitarian in its social ethos and republican in political structure, the British found it extremely difficult to subjugate them. In fact, the British had literally to fight its way from Igbo village to village and from town to town before it could finally declare its imperial authority over the people. Even then, British authority remained precarious well into the Nigerian Independence in 1960.

The Igbo were hostile to British imperial encroachments from the start, as was clearly revealed in their refusal even to parley with British officials. The elders challenged British imperial pretensions and even invited the British to "come and fight": "If you want war, come, we are ready."[11] The British, of course, came and war raged from about 1898 to after 1910. The Anglo-Igbo confrontation can be separated into the western phase (1898–1905) and the eastern phase (1901–1910).

The war on the "western front" (i.e. west of the River Niger), directly involved a secret society known as the Ekumeku Society. This nocturnal society attacked the Roman Catholic missions, which had been established in the area since the early 1880s, and also waged a guerilla war against the British colonial forces. Of the numerous military encounters, the battle of Ubulu-Ukwu in 1905, seems to have been the fiercest. Because of Ubulu Ukwu's strategic location, the British considered its capture particularly crucial. Of this war, Don Ohadike writes:

> The Ekumeku warriors assembled at Ubulu-Ukwu [and] began to make war preparations.... There were hot exchanges on all fronts as the [British] soldiers fought to gain entrance into the town. Ekumeku riflemen occupied the natural and artificial trenches they had dug on the eastern approaches of Ubulu-Ukwu, from where they kept up a brisk fire and

10. Boniface I. Obichere, *West African States and European Expansion: The Dahomey-Niger Hinterland, 1885–1898* (New Haven: Yale University Press, 1971).

11. CMS Archives (London): G3/A3/0, "Report of a Journey into the Hinterland of Iboland" by Bishop James Johnson, 24 February–8 April 1903. See also Felix K. Ekechi, *Tradition and Transformation in Eastern Nigeria: A Sociopolitical History of Owerri and its Hinterland, 1902–1947* (Kent, OH: Kent State University Press, 1989), 29–30.

were able to move rapidly through the bush from one point to another....
The colonial forces were strained to their limit not only because of the
skill of the military operations of the Ekumeku, but also because of logis-
tics. [In large measure,] the colonial troops were disturbed by the fact that
they fought an enemy they could not see, [given that the Ekumeku war-
riors fought a brilliant guerilla war]. [12]

Despite Ekumeku successes, British colonial forces ultimately triumphed, result-
ing in the suppression of the Ekumeku movement and the consolidation of British
power and authority in Western Igboland. As punishment, "All the towns that
took part in the uprising were made to pay heavy fines and to surrender their
guns. Many were compelled to rebuild the mission and government houses that
had been destroyed during the war."[13]

On the eastern front, that is, eastern Nigeria, the British also fought a most
determined people, who, like their western Igbo counterparts, sought to maintain
their independence and to preserve their traditional way of life. The British sought
to take control of the rich eastern Nigerian hinterland, the richest region of palm
oil production in Nigeria. Before they could gain access to this rich hinterland,
however, they had first to deal with the Aro of Arochukwu. Through their manip-
ulation of the most powerful Igbo oracle known as *Chukwu*, the Aro had estab-
lished considerable commercial and religious influence in the region. However, the
British objective was to eliminate the Arochukwu Oracle, known to the Euro-
peans as the "Long-Juju" of Arochukwu, so they could operate freely in the re-
gion. Even the Christian missionaries, as elsewhere, supported the military inva-
sion, ostensibly in the name of "Christian civilization." In the words of the
Roman Catholic Superior, "This war is necessary. It is necessary to abolish slav-
ery, human sacrifices, twin murder...and to destroy the Long Juju of Aro
Chuku....Were it not the duty of European powers to prevent even by force such
murders?" [14] Accordingly, the famous Arochukwu expedition was launched on
December 1, 1901 and ended on March 24, 1902.

Armed with rifles and a variety of guns, the Igbo and their neighbors stoutly
resisted British attempts to take over their country. As the British officers ruefully
acknowledged, "the enemy, who occupied strategic positions in the bush and in
trenches, attacked from all sides." But in spite of the stiff resistance, the British ul-
timately triumphed. The Arochukwu Oracle was destroyed and many of its
priests were either executed or sent to prison. Indeed, the British conquest of the
Aro was cause for jubilation among the Christian missions because the expedition
resulted in throwing open the hitherto closed doors of the Igbo hinterland to mis-
sionary enterprise. The expedition, also "opened up" eastern Nigeria to British
imperialism. What followed was colonial resistance.

In East and Central Africa, the story was similar: conquest and resistance pre-
dominated. In Southern Rhodesia (now Zimbabwe), it was the British South

12. 12 Don C. Ohadike, *The Ekumeku Movement: Western Igbo Resistance to the
British Conquest of Nigeria, 1883–1914* (Athens, OH: Ohio University Press, 1991),
121–22.

13. Ibid., 124.

14. See F.K. Ekechi, *Missionary Enterprise & Rivalry in Igboland, 1857–1914* (London:
Frank Cass, 1972), 122.

African Company, under the control of the imperialist megalomaniac Cecil Rhodes, that waged war against King Lobengula, ruler of the Ndebele kingdom. Rhodes' forces, known as the "Pioneer Column", invaded the kingdom in 1890. From that time on, white settlers gained dominance, politically and economically. The colonial exploitation and extortion, which followed, gave rise to the famous Ndebele and Shona Rebellion (Chimarunga War) of 1896–97. Virtually everywhere, Africans were subjugated, largely because of the European possession of superior firearms, such as the Maxim gun. Even the Africans acknowledged the superiority of European technology. "He who possesses the Maxim wins the war," conceded the King of Dahomey. A Senegalese elder concurred: The French "got their power from their cannon, [which] enabled them to dominate the people here." [15]

But the Ethiopian defeat of Italy provides a classic example of a successful African resistance to European imperialism. Like other Europeans during the Scramble, the Italians sought to stake out territories in Ethiopia by making treaties with Ethiopian rulers. They claimed, in 1891, that Emperor Menelik II had ceded a part of Ethiopian territory to them by the Treaty of Wuchale, signed on May 2, 1889. But this was contested. Reminded by his wife, Empress Taytu, of the supreme price that his predecessors had paid in defense of Ethiopian land, Emperor Menelik firmly intimated to the Italians that "[This] country is mine and no other nation can have it." He accordingly annulled the Treaty and with some trepidation braced himself for war. "Not only do I dread this war, but the thought of shedding Christian blood also saddens me."[16] The Ethiopian-Italian war, which broke out in 1895, resulted in the defeat of the Italian forces at the historic battle of Adowa in 1896, signifying a momentous event for the African resistance. "The victory was a tremendous life for the Ethiopians. Fear of the white man's invincibility was [forever] laid to rest."[17] But virtually everywhere else, as already indicated, the Europeans were triumphant.

Colonial Rule and Socio-Political Change

In establishing of colonial rule with its far-reaching changes, Africa was radically and fundamentally transformed. In some places such as Algeria, Kenya, Southern Rhodesia (Zimbabwe), European settlers occupied the best lands and hoarded the indigenous inhabitants into unproductive reserves. In Algeria, the settlers (*colons*), who called themselves *pieds noirs*, dominated both the politics and the economy. In Kenya, too, the white settlers claimed title to the "White Man's Country," appropriating the best land, the Kenya Highlands, as theirs. By the 1950s, the "stolen land" question led to the famous Mau Mau Rebellion. The introduction of new administrative systems almost certainly obliterated indigenous African systems of government.

15. Joe Lunn, *Memoirs of the Maelstrom: A Senegalese Oral History of the First World War* (Portsmouth, NH: Heinemann, 1999), 23.

16. Quoted in Chris Prouty, *Empress Taytu and Menelik II: Ethiopia 1883–1910* (London: Ravens Educational and Development Services, 1986), 90.

17. Ibid.

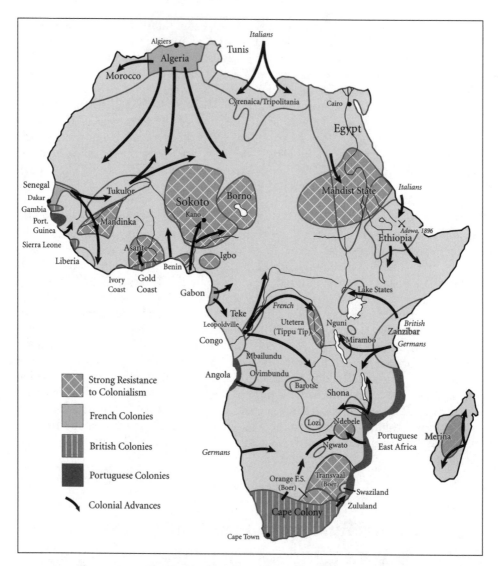

Figure 2-1. The Subjudication of the Continent, 1885–1914

Demographically, "[p]eoples and groups were [arbitrarily] partitioned by competing European countries. New countries were formed, with new boundaries to replace the pre-colonial states."[18] Almost everywhere, European conquest heralded the fusion of pre-colonial states and societies into new colonial states, such as Nigeria, Kenya, Ghana, Zimbabwe, to name but a few. Because of the arbitrary redrawing of pre-colonial boundaries, ethnic groups such as the Ewe of modern Ghana were disrupted, resulting in the location of the same ethnic group in different colonial states. Today, the Ewe are found in Ghana and Togo in West Africa. The same is true of the Somali in northeast Africa, whose inhabitants are today

18. Toyin Falola, "Africa in Perspective," in Stephen Ellis (ed.), *Africa Now: People, Policies & Institutions* (London: James Currey, 1996), 10.

located in Somalia, Kenya, and Ethiopia. Indeed, European colonial presence marked a revolutionary period in African historical experience. The forced unity, brought about by the artificial creation of colonial states, has been the bane of modern African politics. In short, the persistent "nationality" problems in contemporary African societies stem from colonial state structures. Oliver and Atmore put it succinctly:

> The very basis of nationality, to which all states laid claim [at independence], was nothing but a colonial superstructure hastily erected over very diverse populations still speaking many different languages, in which only a small minority of the best-educated people had any strong sense of an allegiance wider than the ethnic group.[19]

Economically, pre-colonial Africa was fundamentally restructured to suit European interests, whose major focus was on the exploitation of human and natural resources. Indeed, forced labor and human degradation became the essential components for developing the colonial estate.

Practically all colonial administrations operated under the colonial hierarchy dominated by colonial Governors (*Commandant de Cercle* in the French colonies), Residents (as in British colonies), and District Commissioners (DCs). Because the number of Europeans was so small, the colonial regimes actually found it much cheaper to employ Africans rather than Europeans. In fact, the African presence allowed the administrative systems to function. Africans, for example, served as soldiers, police officers, court messengers and clerks, as well as chiefs, interpreters and so on. African armies were not only involved in the colonial conquests, but they also generally "provided the coercive force that made European rule in Africa possible."[20] In most cases, they were used for the maintenance of "law and order." In addition, the rank and file of the European regiments, such as the British King's African Rifles (KAR) in East Africa, the Royal West African Frontier Force (RWAFF) in West Africa, the French *Tirailleurs Senegalais* (Senegalese Army), or the Belgian *Force Publique* in the Congo, were essentially Africans. In the era of almost interminable military operations, euphemistically called "pacification," African soldiers were routinely sent to "pacify" recalcitrant towns and villages.

Indeed, all colonial administrative systems gave orders through some African intermediaries, including the colonial chiefs. These chiefs recruited labor and collected taxes. They also heard cases in the native courts, set up by the colonial administrations. Chiefs, therefore, played important roles in the working of the new colonial society. But because most of them were corrupt and exploitative, as well as tyrannical, they were almost uniformly resented and hated. The colonial regimes' aim was to "control the African populations, either directly through their appointed officials or indirectly through the existing African authorities."[21] This system of administration, known as indirect rule, was popularized by the British but adopted by almost all the colonial administrations. Hence, the ubiqui-

19. Roland Oliver and Anthony Atmore, *Africa Since 1800, New Edition* (Cambridge: Cambridge University Press, 1995), 267.

20. Timothy Parsons, *The African Rank and File: Social Implications of Colonial Military Service in the Kings African Rifles, 1902–1964* (Portsmouth, NH: Heinemann, 1999).

21. Philip Curtin et al., *African History* (Boston: Little, Brown and Co., 1978), 473.

tous colonial chiefs through whom government orders filtered down to the local people.

Forced Labor

The establishment of colonial rule heralded the era of forced labor. Practically everywhere, Africans were forced to work. Failure to comply with labor requirements generally resulted in severe punishments, such as being flogged publicly, or being incarcerated in prison for any length of time. Many Africans died in colonial prisons. As a matter of fact, being sent to prison in the early colonial times was almost tantamount to being condemned to death. In desperation, Africans at times killed the colonial oppressors, as was the case of one Crewe Read and Dr. Stewart, both officers in Nigeria. Indeed, other than taxation, no colonial exaction proved as vexing as forced labor. From the onset of European colonial administration, up to the Second World War, Africans were faced with endless demands for labor. Colonial labor laws made it possible for officials to force Africans to work, even without pay. For instance, the Rivers and Roads Proclamation (Ordinance) empowered District Commissioners (DCs) to compel ablebodied men and women to work. These Africans were compelled to build roads and railways, clear rivers for ship and boat transportation, construct government houses, military and police barracks, and so on. To insure an ample labor force, the European officials held African elders to ransom. A missionary's eyewitness account of German practices states, "An assistant district officer summoned a large meeting of elders. Eight hundred attended. After business an order was issued that none would go unless a young man came in [the] place [of each elder] ready to start for the coast plantations."[22] Under the compulsory labor regulations, those who resisted recruitment or who deserted were severely punished. Roadwork, a hard and backbreaking labor, was particularly hated, essentially because it denied Africans their basic freedoms. Besides, it left an enduring mark on "the laboring poor Africans," who grew old prematurely because of extremely hard work. Indeed, to most Africans, forced labor was pure "hell" on earth.

Africans were also forced to produce and deliver commodities such as palm oil, cotton, groundnuts (peanuts), tea, rubber, and so on to the European commercial stations. In the white settler areas like Algeria, Kenya, Northern and Southern Rhodesia (Zambia and Zimbabwe respectively), as well as South Africa, Angola and Mozambique, the Compulsory Service laws or regulations empowered the colonial authorities to compel Africans to work in the European settler plantations and mines. In fact, imperial decisions to allow forced labor continued well into the World War II and beyond, with African chiefs entrusted with the recruitment of labor. In many instances, these chiefs had to meet assigned quotas, or face severe punishments, including removal from office. Men, women, and children in the Belgian Congo were forced to collect rubber from the wild rubber trees of the forest. And even though they were not paid for this, those who failed to comply had their hands cut off to teach them and others "a sharp lesson"!

22. *Church Missionary Review* (1918): 457.

Many were also massacred, as contemporary and historical accounts reveal. In *The Crime of the Congo*, for example, the British writer and creator of Sherlock Holmes stories, Sir Arthur Conan Doyle (1859–1930), provides this ugly portrait of the Belgians:

> There are many of us in England who consider the crime which has been wrought in the Congo lands by King Leopold of Belgium and his followers to be the greatest which has ever been known in human annals.... There have been massacres of populations [elsewhere].... But never before has there been such a mixture of wholesale expropriation and wholesale massacre all done under an odious guise of philanthropy and with the lowest commercial motives as a reason. It is this sordid cause and the unctuous hypocrisy which makes this crime unparalleled in its horror.[23]

To add to the ordeal, Africans were compelled to carry loads for government officials, the military, as well as for the Christian missionaries. Africans even had to carry District Commissioners (DC) and missionaries in hammocks during their travels! It was commonplace for Africans to carry heavy loads to far away places, and thereby expose themselves to the dangers of life and limb. To the colonial administration, however, the carrier or porterage system seemed inevitable. As a British governor in Nigeria argued, "Where there are no other means of transportation, the natives must be utilized for the purpose of transport." He went on: "It must never be overlooked that the Government cannot go on without it, the people cannot even be fed without it. It is the basis of the whole life of the country." [24] African experiences with the carrier system may be appreciated from the poignant words of a Nigerian elder, who himself was a victim of forced labor:

> The loads were heavy. And we traveled for many, many miles without food or rest. On many occasions we, the carriers, decided to stop and rest or to find something to eat. Often, however, this brought instant harassment from the soldiers or the DC, or the overseer. My son, remember we traveled through unfamiliar places and many of us were deeply concerned about our safety. So, apart from the bad treatment from the officers, fear of losing our lives weighed heavily on our minds. This is why we often dropped the loads, escaped into the bush and returned home. But if you were caught, that was the end of your life. [25]

In the European settler areas, Africans had to work for the government as well as for the settlers. In the Portuguese colonies of Angola and Mozambique, Africans were subjected to forced labor as a matter of policy. In the words of a Portuguese official, "The rendering of work in Africa cannot continue to depend upon the whim of the Negro, who is, by temperament and natural circumstances, inclined to spend only the minimum effort necessary to meet his basic needs." Therefore, whenever a private European farmer or labor recruiter, or even a com-

23. Quoted in Bruce Fetter (ed.), *Colonial Rule in Africa: Readings from Primary Sources* (Madison, WI: The University of Madison Press, 1979), 87. See also Adam Hochschild, *King Leopold's Ghost* (London: Macmillian, 1999).

24. Ekechi, *Tradition and Transformation*, 40.

25. Ibid., 39–40.

pany needed African labor, all they had to do was simply contact the colonial ad-ministrators, and the request was promptly met. Similarly, in Kenya:

> ...a settler who wanted labour for his farm would write to the DC saying he required thirty young men, women or girls for work on his farm. The DC [thereupon] sent a letter to a chief or headman to supply such and such a number, and the chief in turn had his...retainers to carry out the business. They would simply go to the people's houses—very often where there were beautiful women and daughters—and point out which were to come to work. Sometimes they had to work a distance from home, and the number of girls who got pregnant in this way was very great.[26]

A Protestant missionary in Kenya further commented on the ordeal of forced labor:

> I was in a village a few weeks back, when a poor man just dragged him-self in and threw himself down exhausted. I could see he was ill, and gave him some medicine. He had stopped there to rest, and was just off ten days' work...some miles away from home, and ill possibly part of the time without enough to eat, as when they are on the work of that kind.... The poor man did not recover; in five days he was dead.... When I asked the other man with him: "Why did not the sick man tell the overseer of the road he was sick?" the reply was: "If we say we are sick, they say we are telling lies [or are lazy], and beat us back to work; it is better to go as long as we can." [27]

Accounts of the horrors of forced labor abound. In Mozambique and Angola, the Portuguese were particularly exploitative. They not only forced Africans to cultivate cotton, rice, sugar, and other cash crops, but they also claimed lands be-longing to the Africans. Land alienation meant limited amount of lands available to the indigenous to grow staple food crops. Hence the frequent famines in the colonies. Equally disturbing is the brutality that accompanied forced labor. A Mozambican elder recounted his experience to an American scholar as follows:

> I was in my village at Nawana quite ill. The *sipais* [labor recruiters] en-tered my hut and beat me because I had not completed planting my cot-ton field. One raped my wife. Then I was bound and taken with other vil-lagers to Nangoro [sisal plantation] where I was given a strip of land to work each day. Because I was still sick I could not finish, so the overseers beat me. At Nakoro we only received food once a day and only if we completed our task.... On occasion they gave us corn with a bit of dried fish but it was never enough to go round. Many workers died.[28]

To this day, memories of forced labor continue to linger in people's minds, most of which are now expressed in popular songs.

26. Quoted in Audrey Wipper, "Kikuyu Women and the Harry Thuku Disturbances: Some Uniformities in Female Militancy," *Africa* Vol. 59, No. 3 (1989): 323.

27. E. Mayor, "Report on Forced Labour in Kenya," *Church Missionary Review*, Vol. 72 (1921): 89.

28. Allen Isaacman and Barbara Isaacman, *Mozambique: From Colonialism to Revolu-tion, 1900–1982* (Boulder, CO: Westview Press, 1983), 42.

Taxation, Forced Labor, and Revolts

Taxation and forced labor were inextricably linked because taxation was an important instrument for the recruitment of labor. Listen to this policy statement by the governor of Kenya: "We consider that taxation is the only possible method of compelling the native to leave his reserve for the purpose of seeking work... and it is on this that the supply of labour and price of labor depends."[29] Accordingly, whenever the Africans showed any reluctance to turn up for work on the settler farms, taxes were not only imposed, they were often increased to force Africans to work. The constant raising of taxes, as well as the imposition of pass laws, which meant Africans had to carry identity cards (*kipande*), led to the nationalist protests spearheaded by Harry Thuku, in the 1920s. Predictably, his protests led to his arrest and incarceration in a Nairobi prison in 1922. Attempts by Kikuyu women to rescue him proved futile. Sadly, British forces fired at the unarmed women, fatally shooting some. Among them was Mary Nyanjiru, who has now become a symbol of nationalist resistance to British colonial rule in Kenya.

Taxation served many functions, in addition to raising revenue. It was used as an instrument of political control. As a British official in Nigeria conceded, "to pay tax is to admit the overlordship of the person to whom it is paid." In that regard, he considered taxation to be "a most useful means of asserting and augmenting [our] authority" over colonized peoples. "Where it is absent," he insisted, "the people have that much more excuse for attempting to flout the Government."[30] In essence, taxation was an expeditious means of consolidating European power in Africa. While it was hated virtually everywhere by Africans, colonial governors had no qualms about imposing it. Frederick Lugard (later Lord), the former Governor General of Nigeria (1914–22), justified the imposition of direct taxes on the people of the Southern Provinces on grounds of revenue derivation. In 1914, he explained it to the Colonial Office in London:

> Recent events in Europe have completely altered the outlook [of the economy] and it may be that the institution of direct taxation will be necessary...to enforce revenue. [Furthermore] I anticipate a very serious shortage of imports and exports for some time to come which will decrease the revenue both from customs and railway freights. In the circumstances it may be imperative to augment the revenue by direct taxes.

Initially, the Colonial Office demurred, largely because of fear of possible revolts in time of war. Therefore, Lugard was instructed to shelve his "ridiculous suggestion," at least "for the present time." [31]

Years later, direct taxes were introduced in Southeastern Nigeria. The imposition was explained in terms of laying the foundation for "the political education of the people," but this exploitative mechanism invariably led to "worries of the heart." Indeed, said a Dahomean elder ruefully, "I can't sleep for thinking of the taxes; if I am put in prison [for non-payment] what will happen to my children?

29. B.A. Ogot & W.R. Ochieng', *Decolonization & Independence in Kenya, 1940–93* (Athens, OH: Ohio University Press, 1995), 7.

30. Ekechi, *Tradition and Transformation*, 165.

31. Ibid.

[The French] force us to make roads and don't pay us; they don't give us any time to make up; what can I do?" [32] Hatred of colonial taxation was so widespread that it was often greeted with revolts. Perhaps the most celebrated tax revolt of the twentieth century was the women's revolt in eastern Nigeria, known popularly as the Women's War. This revolt, which occurred in 1929, was triggered by the rumor that the British administration was about to tax women just as the men. So at Aba, in eastern Nigeria, women revolted *en masse* against Chief Okugo, who was entrusted with the compilation of the tax rolls. They attacked British facilities, including government houses, native courts, prisons, factories and so on. As the revolt spread, the British administration responded by sending soldiers to quell the disturbances. In the ensuing conflict, British soldiers killed over 50 women and wounded several others. By 1930, the revolt was all over, but a new era of reforms dawned. Eventually, the women's war forced the British to reexamine the indirect rule system, leading to its collapse in Eastern Nigeria and beyond.

The Introduction of European Currency

Taxes were paid in European currencies. This introduction of foreign currencies served as a practical method of consolidating European power and control, and implied the elimination of African currencies. Prior to the 1900s, Africans traded with a variety of currencies, notably cowrie shells, nzimbu shells, nji, manillas, iron rods, copper, and so on. With the advent of colonialism, all these currencies were replaced with European currencies. In effect, only the new European coins and paper money became the accepted legal tender.

For purposes of illustration of the way the currency revolution transformed African economy and African economic life, let me provide a brief history of the currency revolution in Eastern Nigeria. Although the currency revolution had begun in Western Nigeria as far back as the late nineteenth century, it was not until the Arochukwu expedition (1901–02) that both silver coins and currency notes were first introduced in Eastern Nigeria. The commander of the expedition explained how silver coins were first introduced:

> [During the war] every column carried cash with it; and all towns who were not hostile and who were called upon to supply food to the troops, were paid for the same in cash. By this means quite a considerable amount of money was distributed throughout the country.... On the termination of the operations the permanent garrisons...had about four months pay to them, which they received in cash; consequently after the next few weeks there will be quite a large amount of cash in circulation in the new territories.[33]

The new coins, as well as the currency notes that came later were unpopular. African market women, in particular, would not touch them. Instead of advanc-

32. Fetter, *Colonial Rule in Africa*, 111.
33. F.K. Ekechi, "Aspects of Palm Oil Trade at Oguta (Eastern Nigeria), 1900–1950," *African Economic History* No. 10 (1981): 47.

ing trade, the new currency actually hindered it, in the beginning. In fact, both British merchants and colonial administrators lamented the rejection of the new currency notes: "Currency Notes will not be received by the average native attending the market," reported the District Officer of Owerri District. Agents of the United African Company (UAC) also lamented the decline of trade resulting from the unpopularity of the currency notes.

It was not until the early 1920s that both the silver coins and the currency notes were finally accepted, but only because of the use of force. "By the Currency Ordinance of 1918 Africans who resisted the new notes were liable for prosecution."[34] At any event, economic historians seem to agree eventually that the currency revolution marked a progressive step towards modern commercial expansion because it facilitated trade and led to a remarkable increase in "the number and variety of possible transactions," including modern banking transactions. [35]

Spirit Mediums, Resistance to Colonial Rule, and Pacification

African resistance to European imperialism was widespread and prolonged. Indeed, "primary resistance" movements dotted the African landscape from the onset of colonial rule, unleashing a new wave of European violence, euphemistically termed "pacification." Colonial forces were generally mobilized to maintain law and order. In almost every case, the soldiers became armies of occupation, resulting in predictable bloodshed and loss of life. In fact, military occupation became standard practice, and was considered by the Belgians as "one of the best ways of preventing any idea of revolt, [or] of making the natives carry out their legal duties, and of keeping up habits of work among them." The British adopted a similar tactic. "Where a town refuses to submit to Government control or supervision," declared the governor, "it is our policy...to occupy it...until the chiefs and people have been made thoroughly to understand that Government laws must be obeyed." [36] Joseph Chamberlain, the British Colonial Secretary, while admitting that military force entailed the loss of "native life" and the destruction of property, nevertheless endorsed its use as a means of attaining colonial objectives. As he bluntly stated, "you cannot have omelettes without breaking eggs."[37] Thus control through coercion became a characteristic feature of European rule in Africa.

Africans, of course, adopted several methods of resistance against forced labor and other forms of colonial oppression. Often spirit mediums played an im-

34. Ibid., 49, 50.

35. A.G. Hopkins, *An Economic History of West Africa* (New York: Columbia University Press, 1973), 150; R.O. Ekundare, *An Economic History of Nigeria, 1860–1960* (London: Methuen & Co., 1973), 197. For more on the new currencies in Eastern Nigeria see Ekechi, "Aspects of Palm Oil Trade," 48–49.

36. Basil Davidson, *Modern Africa: A Social and Political History, Third Edition* (London: Longman, 1994), 23; Ekechi, *Tradition and Transformation*, 40.

37. Quoted in T.N. Tamuno, *The Evolution of the Nigerian State: The Southern Phase, 1898–1914* (New York: Humanities Press, 1972), 48.

portant role in the African resistance movements. In many places, resistance was mediated through oracular powers or through the use of medicines believed to work magic. In their desperate efforts to drive out the hated imperialists from the land, Africans occasionally resorted to supernatural forces or divine intervention. In the case of Southern Rhodesia (Zimbabwe), for instance, spirit mediums played a crucial role during the Chamuranga War of 1896–97. Also, in Tanzania, spirit mediums featured prominently in the revolt against the Germans. Here, the Maji Maji Rebellion (1905–1907) was directed against German oppressive forced labor policy. In preparation for war, a priestess concocted a medicinal potion, which the warriors drank. This medicine, believed to render the warriors immune to bullets, was supposed to turn the German bullets into water. But sadly, German guns pulverized the local population. By 1907, therefore, the Germans had succeeded in brutally and ruthlessly suppressing the rebellion. Yet, the war was not a total failure, for the Germans were forced to introduce reforms.[38]

Similarly in German Southwest Africa (Namibia), the Herero were up in arms. As in the Tanzanian case, the Herero-German war (1904–07) arose from labor recruitment problems. In this case, Prophet Stuurman, claiming to have been sent by God to drive out all whites from Africa, spread the millenarian message that the time had come for the Herero to fight a war of liberation. He said that, God had taken power from white men throughout the world, and that blacks would "inherit the land" after the war. The Germans, who remained, would become servants, a reversal of roles. But the revolt failed to dislodge the Germans. On the contrary, the war resulted in unspeakable horror and brutality. "Herero society, as it had existed prior to 1904, had been completely destroyed" and many were either killed or lynched. The majority of those who survived were women and children who were incarcerated in prison camps and made to work as forced laborers for the German military and settlers. Worse still, "German authorities set up concentration camps in which they placed their prisoners.... The inmates of these camps were distributed, as forced labourers, among various settlers, businesses and military units." In addition, Herero women were raped with reckless abandon.[39] A missionary provided this eyewitness account:

> When...[I] arrived in Swakopmund [one of the prison camps] in 1905 there were very few Herero present. Shortly thereafter, vast transports of prisoners of war arrived. They were placed behind double rows of barbed wire fencing, which surrounded all the buildings of the harbour department quarters...and housed in pathetic...structures...in such a manner that in one structure 30 to 50 people were forced to stay without distinction as to age and sex. From every morning until late at night, on weekends as well as on Sundays, they had to work under the clubs of raw overseers...until they broke down. Added to this the food was extremely scarce: rice without any necessary additions was not enough to support

38. For these rebellions see T.O. Ranger, *Revolt in Southern Rhodesia 1896–7* (New York: Heinemann, 1967); John Iliffe, *Tanganyika Under German Rule, 1905–1912* (Cambridge: The University Press, 1969), Chapter 2.

39. Jan-Bart Gewald, "The Road of the Man Called Love and the Sack of Sero: The Herero-German War and the Export of Herero Labour to the South African Rand," *Journal of African History* Vol. 40, No. 1 (1999): 21, 27.

their bodies, weakened by life in the field.... Like cattle, hundreds were driven to death and like cattle they were buried.[40]

In West Africa, as well, Africans had recourse to religious symbols as weapons of colonial resistance. In Nigeria, the Igbos consulted the Ogbunorie Oracle, believed to have the power to "drive out the white man" from the country. Of this oracle, the DC of Owerri Division reported ominously: "There is reported to be a big *juju* called Obonorie which, as far as I can gather, is at Nsu.... This *juju* is becoming a serious danger to this district, as people from all parts are visiting it and professing that it enables them to disregard the white man, and their chiefs, and the courts.... [Furthermore] there have been open manifestations of it, even in the most friendly towns."[41] Consultants were said to have sworn an oath with the water from the lake that surrounded the shrine of the oracle. This oath, which symbolized unity and resolve, apparently emboldened the people to fight and "kill anyone associated with the government." When government troops were dispatched to "pacify" the recalcitrant towns, the officers found to their dismay that the "enemy was waiting in large numbers." From "everywhere," reported the military commander of the operation, "we were fired upon." Indeed, war raged from 1909 until 1911. In the end, the British were triumphant, largely because it was a war of attrition. As an elder said of the war, "the destruction was too much." To completely eradicate the "baneful influence" of the Ogbunorie Oracle, its shrine was "bombarded for weeks" and finally set on fire. Captain Ambrose, who commanded the colonial troops, was jubilant: "We accomplished the work of destruction by cutting down all the trees around the water, and adding the skull altar to the bonfire."[42]

Punitive measures, to be sure, entailed the infliction of both physical and psychological terror on the Africans. As was common practice, colonial forces "burnt down whole villages, wantonly destroyed farms and other property, seized goats and cattle, took hostages, and demanded heavy ransom."[43] Terrorism and plunder thus characterized European imperialism. In the words of a Belgian official, "when an immediate chastisement became necessary, when it had to be proved on the spot who is master: I believe that burning [of homesteads] should be used [systematically] in such cases." Other colonial regimes, of course, adopted similar measures, as illustrated in the case of the Portuguese in Mozambique.

In 1910 a Portuguese force of more than 4,600 men, supported by heavy artillery, simultaneously attacked the positions of Angoche and its Makua allies. The unprecedented commitment of manpower and the deployment of the most sophisticated weapons in the colonial arsenal clearly indicated Lisbon's commitment to impose its rule.... By the end of the year the Makua had surrendered. Spurred on by this success, Portuguese troops attacked Quitanghona, and within a year they established their hegemony over this region as well. The defeat of the Makua, Angoche,

40. Quoted in ibid., 27–28.
41. Ekechi, *Tradition and Transformation*, 29.
42. Ibid., 29–32.
43. Isaac M. Okonjo, *British Administration in Nigeria, 1900–1950: A Nigerian View* (New York: NOK Publishers, 1974), 57.

and Quitanghona ensured Portuguese control over the northern coastal region.... [44]

Clearly, the consolidation of colonial authority in Africa was a thoroughly bloody affair. Colonial armies and administrators were feared because of their brutality, harshness and their overbearing attitude towards Africans. The British District Commissioner H. M. Douglas, who served in Eastern Nigeria in the early colonial period, clearly illustrates all that was rotten with European imperialism. Douglas had a pathological addiction for violence, as manifested in his constant beating of young men as well as the elders. His imperious behavior drew this poignant rebuke from a Protestant bishop:

> Adopt a kinder and more generous attitude towards a subject people.... From what I heard from the people as I passed through your district... your system of administration appears to be nigh unbearable. The people complained bitterly of your harsh treatment of them, while those who accompanied me (through your district) do not cease to speak in the strongest terms of your overbearing manner towards them. [45]

Similarly in Senegal, French officials treated African life with levity, as reflected in this account by a Senegalese *griot*: "One Sunday, at a house next to ours—which was a commercial house—a 'Tubab' [Frenchman] was on the balcony with his wife. A Senegalese was walking by wearing a tarboosh on one side of his head....And the Tubab said to his wife, 'I can shoot the hat [off his head] with my hunting rifle.'" He fired, but missed the hat and fatally shot the man on his forehead! [46]

Christian Missions

No account of European colonialism in Africa is complete without at least a brief mention of the role of the Christian missionaries who paved the way for European imperialism. By all accounts, missionary activity made it easier for Europe to consolidate its hold in Africa. Years before the European Scramble and conquests, American and European missionaries had established mission stations in various parts of Africa. In the first half of the nineteenth century, for example, it was the missionaries who, by and large, called upon their home countries to take control of the regions of missionary propaganda. David Livingstone, of the London Missionary Society, for instance, implored the British government to colonize the Zambezi region so that Christian civilization might flourish. Arguably the most articulate proponent of European colonization of Africa, for the so-called advancement of trade and Christian civilization, was Bishop Ajayi Crowther, a freed Yoruba slave, who was educated in Sierra Leone and ordained a bishop in 1864. He pioneered the British Church Missionary Society's enterprise in the

44. Jean Suret-Canal, French *Colonialism in Tropical Africa, 1900–1945* (New York: Pica Press, 1971), 27; Isaacman, *Mozambique*, 22.
45. Ekechi, *Tradition and Transformation*, 19–20.
46. Lunn, *Memoirs*, 17.

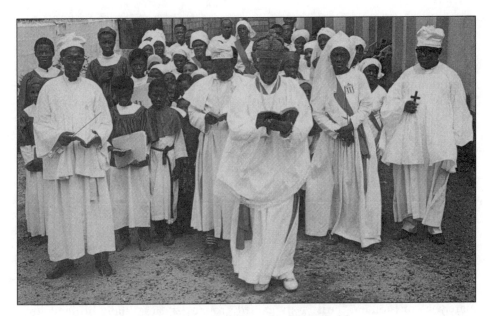

Figure 2-2. Christian open fellowship

Niger Delta, in Nigeria. As early as the 1860s, Bishop Crowther had called upon the British to "pacify" the Niger Delta city-states and their neighbors, so that missionary and European commercial enterprise might flourish. Unless "the hostile" Delta-city states were "humbled," Crowther insinuated, mission stations in the interior would collapse for lack of regular supervision. He explained, "As long as the [River] Nun is left unoccupied [by force of arms] the passage through the Delta left unsafe and closed up to legitimate commerce, slave ships will never cease entering and screning [sic] themselves behind the mangrove network like creeks between the Nun and Brass." Accordingly, Crowther strongly urged the British to occupy the Niger Delta and its hinterland, otherwise the French would do so. To H.S. Freeman, Governor of Lagos, Nigeria, Crowther wrote:

> I know you are very much interested in the opening of increased commerce to European markets, as well as in the civilization and evangelization of the teeming population on the banks of that noble river [Niger] and its tributary the Tshadda [Benue]....The natives know no other European nation in that river but the English....I have heard with some solicitude by a letter from England, that the French had an eye to the Niger, which I am inclined to believe; and if decided steps are not taken by the English Government to occupy the Niger I am afraid the French will step in on a sudden and occupy it in the same or like ways as they have done Porto Novo [in Dahomey].[47]

In Crowther's mind, the pacification of the Niger Delta would not only foster the spread of Christianity into the hinterland, but it would also advance legitimate trade. With respect to the latter, he strongly appealed to British merchants to

47. Church Missionary Society Archives, London: CA3/04(a), Crowther to Venn, 6 Sept. 1860; Crowther to H.S. Freeman, 2 March 1863.

come to the Niger because "there is plenty of cargo " to be had. He even promised to help: "I will gaurantee to send 200 tons of [palm]oil home monthly. *There is work for ten steamers*" here. [Italics in the original] To the Liverpool cotton barons, Crowther also promised to help, noting that the Lower Niger "[is] a place in West Africa capable of supplying a very large quantity of raw cotton for Manchester."[48] By the 1880s and 1890s, to be sure, the Niger Delta and its hinterland had become regions of effective missionary work as well as arenas of British commercial activity. By 1900, the region had been colonized by the British, thanks, in part, to the missionary pioneers, whose missionary intrusion prepared the ground for the ultimate British conquest of Nigeria.

Elsewhere, as in central Africa, missionaries also played critical roles in European colonization. For example, it was the Roman Catholic missionary Francois Coilard, of the Paris Missionary Society, who facilitated the British South African Company occupation of the Lozi kingdom under King Lewanika. By 1888, the BSAC had signed a treaty with King Lewanika. Father Coillard was the interpreter for the king during the treaty negotiations with the BSAC. By deliberately and cunningly mistranslating the terms of the treaty to the Lozi king, he contributed to the company's occupation of Northern Rhodesia (Zambia). Ultimately, as missionary Christianity gained ground, and especially in the colonial period, African institutions, customs, and value systems crumbled. Most of the damage was done through missionary education.

Admittedly Western education resulted in the rise of the educated African elite, and provided new avenues for social and economic mobility. Yet missionary schools became the veritable centers of indoctrination and denationalization. Through missionary education, African schoolboys and girls were systematically wooed away from their cultural heritage. They were taught that Africa was uncivilized and primitive; and that whatever is African was bad and pagan. Catechisms reinforced this image, being replete with caricatures of African religion and life: "native ways are silly, repulsive and unrefined." Customs are superstitions. To be judged as being "civilized," Africans had to use the European language, dress, and habits. The colonial mentality was in this way thoroughly instilled in African minds. In schools, conceded a Portuguese priest, "we teach the native [our civilization and] the grandeur of the nation which protects him." To this, a Mozambican girl protested that colonialists, "wanted to form in us a passive mentality, to make us resigned to their domination. We couldn't [then] react openly, but we were aware of their lie; we knew that what they said was false; that we were Mozambicans and we could never be Portuguese."[49]

Missionaries, of course, firmly believed in the superiority of their own civilization, holding that it was in the Africans' best interests to change completely every aspect of their lives, including their social, economic, and political organizations, religious beliefs, clothes, food, cosmology, and so on. Accordingly, as school children and converts embraced missionary teaching, propaganda, and indoctrination, respect for traditional institutions, customs and practices almost vanished. Indeed, missionaries prided themselves as revolutionaries. Their spokesman, H. Kraemer, of the International Missionary Council, for instance,

48. Ibid., Crowther to H.G. Foote, 3 May 1861; Crowther to Venn, 9 July, 1862.
49. Africa Research Group, *Race to Power: The Struggle for Southern Africa* (New York: Anchor Press/Doubleday, 1974), 52, 51.

defended the radical stance of missionaries. "The missionary is a revolutionary and he has to be so, for to preach and plant Christianity means to make a frontal attack on the beliefs, the customs, the apprehensions of life...on the social structures and bases of primitive society." Indeed, Kraemer went on, "missionary enterprise need not be ashamed of this, because [to] transplant and transfer [the people's] life-foundations into a totally different spiritual soil, [missionaries] must be revolutionary."[50] Not surprisingly, missionaries tended to condemn African culture and society with reckless abandon. Of these missionaries the American critic James Coleman writes:

> The early missionaries were inclined to feel that the African was in the grip of a cruel and irrational system from which he ought to be liberated.... [Thus] they included among the preconditions for entry into the Christian fold the abandonment of such customs as initiation ceremonies...dancing (a vital part of the aesthetic and recreational life of the African), marriage payment...polygamy...African names, and traditional funeral ceremonies. Renunciation of the old order of things was a prerequisite to acceptance of the new.[51]

By undermining or destroying African religious and social rituals and beliefs, the missionaries unwittingly destroyed all that gave coherence and meaning to the religious and social fabric of society. As already noted, church and school became the chief "agencies of conformity and coercion." They were, indeed, the effective centers of acculturation, as Africans assimilated European culture and values through them. What seems even more sinister, and certainly disturbing, is this: missionary teachings tended to predispose Africans to accept and even to admire the colonial system. In this, and in many other ways, missionary activity created "loyal citizens" and enabled Europe to consolidate its hold in Africa. As one missionary critic put it pointedly, "The interpretation of the Bible in mission lands tended to emphasize the themes that upheld subjugation and subservience, and passages which threatened European control and comfort were carefully screened out. Great Biblical themes of freedom and justice, which liberation theologians in former colonial lands are hammering upon today, were almost ignored."[52]

Missionaries themselves took some pride in that they, in one form or another, made the consolidation of European rule possible. In the words of the superintendent of the London Missionary Society: "Missionary stations are the most efficient agents which can be employed to promote the internal strength of our colonies, and the cheapest and best military posts a government can employ."[53] Is it any wonder, therefore, that colonial administrations valued the work of the missions? As a matter of fact, colonial governments supported the missions, despite occasional disagreements between church and state. After all, both shared a

50. Angola under the Portuguese, 153; Hendrik Kraemer, *The Christian Message in a Non-Christian World* (London: TheEdinburgh House Press, 1938), 342.

51. James S. Coleman, *Nigeria: Background to Nationalism* (Berkeley: University of California Press, 1958), 97.

52. Kofi Asare Opoku, "The West Through African Eyes," *The International Journal of Africana Studies (The Journal of the National Council of Black Studies, Inc)* Vol. 4. Nos. 1 & 2 (December 1996): 91.

53. Ibid., 85; Suret-Canale, *French Colonialism*, 366.

common universe—the transformation of the African into a submissive Black European. But African intellectuals and nationalists were not amused. First, they saw the missionaries' "logic of domination" as arrogant and abhorrent. Second, they argued, and rightly so, that missionary work corrupted African traditions, and was essentially injurious to Africa. Finally, they contended that, because the missionaries' "program" was part and parcel of the assertion of European sovereignty in Africa, the "colonial stereotype" or claim of European humanitarianism must, therefore, be rejected. "Suppose we had come to Europe in the twelfth century and claimed we were sent," an inquisitive African student once asked a missionary, "what would you have thought of us?"[54] Let me close this discourse with the trenchant words of V.Y. Mudimbe, the distinguished African scholar and philosopher:

> The more carefully one studies the history of mission in Africa, the more difficult it becomes not to identify it with cultural propaganda, patriotic motivations, and commercial interests; since the missions' programme is indeed more complex than the simple transmission of Christian faith.... Missionaries were part of the political process of creating and extending the right of European sovereignty over newly "discovered" lands.[55]

Chartered Companies

Like the missions, European companies played a vital role in the colonization and consolidation of European rule in Africa. First and foremost, it should be recognized that European expatriates, largely private or chartered companies, dominated the economy. In places like Nigeria, Zimbabwe, Zambia, Congo, and South Africa, to name only but a few, private companies dominated the scene. Some, in fact, not only conquered but they also ruled the areas until their charters were revoked. Examples include the Royal Niger Company in Nigeria and the British South African Company in Southern Rhodesia (Zimbabwe). As Kevin Shillington notes, "European governments used concessionary companies to colonize their new-found empires. By this system private, European companies were granted vast stretches of African territories to exploit and colonise at their own expense in the name of the European country concerned. It was an attempt by Europe to colonise 'on the cheap.'"[56]

Finally, let me briefly look at the patterns of European domination of the economy, with particular reference to the Elder Dempster Company in West Africa. In West Africa, British and French companies dominated the export and import trade. Companies like the British United African Company (UAC), the Elder Dempster Company (ED), or the French Societe Commerciale de l'Ouet Africain (SCOA) and Compagnie Française de l'Afrique Occidentale (CFAO) were the prominent companies that actually dominated the commercial life of West Africa. For convenience, I shall examine, in summary form, the imperial

54. Opoku, "The West through African Eyes," 85.
55. Quoted in ibid.
56. Shillington, *History of Africa*, 333.

character of the Elder Dempster Company, which was founded by the British businessman Alfred Jones. His commercial empire stretched throughout the British and French West African colonies. In fact, the ED established and dominated the most profitable shipping line in West Africa. The shipping business included the export of palm oil, cocoa, cotton, coal, etc. from West Africa to Europe. In fact, it was the company's control of the palm oil trade that enabled it to garner huge profits.[57]

Additionally, the company controlled considerable banking operations in British West Africa. It virtually controlled the British Bank of West Africa (BBWA), through which much of the financial transactions of the region were effected. As it turned out, the company's activities put African entrepreneurs at a great disadvantage. Not only did the banks deny Africans loans and credits, but the Elder Dempster also made it impossible for the Africans to ship their goods directly to Europe. As the American critic of European imperialism Leslie Buell noted in 1928, "some native traders have attempted to ship directly to England and the United States, but they have found it almost impossible to obtain shipping and credit." In practical terms, "Africans' power to compete with European firms in any aspect of trade and production was almost obliterated by policies of the banks."[58] The denial of access to capital proved to be most injurious to African business initiatives. First, the lack of capital tended to retard the development of indigenous businesses. Second, the absence of capital/credits significantly contributed, as Sherwood has shown, to the collapse or destruction of many African businesses, including the tin-plating industry, which required substantial capital outlay.[59] Equally serious, the Elder Dempster Company often fixed the price of produce. In the process, it deprived African producers and merchants a fair balance of trade.

Moreover, although the ED employed Africans in its various enterprises, it would not let them rise above the menial or lowest ranks, nor did it allow them to unionize. In fact, those who belonged to unions were summarily dismissed. By all accounts, the company's treatment of African employees was manifestly unfair.

Clerks, who had to have the Senior Cambridge Certificate, had to work a probationary period of three to twelve months without pay, as apprentices. Their starting salary was between 10 and 20 shillings (50 pence to £1); the maximum pay was £6 per month, *after about 10 years experience*. Clerks were not given annual leave, paid or unpaid. A European clerk [on the other hand] was paid ca. £400 p.a."[60]

Significantly, it was over European economic dominance and discriminatory shipping and banking policies that spurred, for instance, the National Congress of British West Africa's 1920 response. It proposed, among other things, the founding of African banks, which would provide loans to African entrepreneurs. Moreover, the Congress adopted an action plan to provide "shipping facilities" to

57. Marika Sherwood, "Elder Dempster and West Africa, 1891–c. 1940: The Genesis of Underdevelopment?" *The International Journal of African Historical Studies* Vol. 30, No. 2 (1997): 260–264.

58. Ibid., 261, 274.

59. Ibid., 259.

60. Ibid., 265–6.

Africans. Such facilities, it was hoped, would enable African business enterprises to flourish. Furthermore, they would help Africans compete effectively with their European counterparts.[61] In short, European domination of the economy provoked African nationalist movements, such as the activities of the National Congress of British West Africa and those of Marcus Garvey, the Pan-Africanist from the West Indies. Garvey's "Africa for the Africans" movement and his programs for the economic emancipation of Africa from European economic strangulation resonated widely in colonial Africa. Indeed, the abundant literature on foreign companies in Africa clearly suggests that the Elder Demptser Company, as well as others, not only exploited Africans, but also contributed to the underdevelopment of Africa.[62]

Conclusion

Throughout this chapter, we have sought to highlight some of the major issues relating to the European consolidation of power in Africa. Special emphasis has been given to forced labor and African responses. On the whole, it has been argued that European colonialism was a curse to Africa. It is further argued that explanations for many of Africa's persistent troubles—political, social, and economic—can be found in the legacies of European colonialism. Certainly, much of the general underdevelopment of Africa may be traced to European imperialism.

Review Questions

1. What was the Berlin Conference?
2. Why did the Europeans establish colonies in Africa?
3. What factors enabled Europeans to conquer Africans?
4. Carefully explain the nature of European rule in Africa and the patterns of African resistance.
5. "The European colonization of Africa was an unmitigated disaster." Discuss.

Additional Reading

Shillington, Kevin. *History of Africa*, revised edition. New York: St. Martin's Press, 1995.
Iliffe, John. "The Maji Maji Rebellion," Chapter 2 in *Tanganyika under German Rule, 1905–1912*. Cambridge: Cambridge University Press, 1969.

61. Ibid. For more on African reactions see Akintola J.G. Wyse, *Bankola-Bright and Politics in Colonial Sierra Leone, 1919–1958* (Cambridge: Cambridge University Press, 1990).
62. See, for example, Walter Rodney, *How Europe Underdeveloped Africa* (London: Bogle-L'Ouverture Publications, 1972); Robin Palmer and Neil Parsons (eds.), *The Roots of Rural Poverty in Central and Southern Africa* (Berkeley: University of California Press, 1977).

Ohadike, Don. *The Ekumeku Movement: Western Igbo Resistance to the British Conquest of Nigeria, 1883–1914*. Athens, OH: Ohio University Press, 1991.

Ekechi, F.K. "The Pacification of Igboland, 1900–1910," Chapter 6 in *Missionary Enterprise and Rivalry in Igboland, 1857–1914*. London: Frank Cass & Co., 1972.

Obichere, Boniface I. *West African States and European Expansion: The Dahomey-Niger Hinterland, 1885–1898*. New Haven, CT: Yale University Press, 1971.

Chapter 3

Africa and World War I

Kwabena Akurang-Parry

No medal will be theirs, no role honor will record their names, no monument will mark the graves of those who have perished and tell posterity in what course they lost their lives.[1]

This chapter examines Africa and World War I. It looks at how information about the potential for war reached Africans and the initial African attitudes toward the war. It analyzes wartime colonial policy, mobilization and recruitment of Africans for the war effort, and the nature of African responses. It also discusses the overall African contributions to the Allied war effort. Additionally, it looks at the nature of the various theaters of war in Africa and elsewhere, stressing the contributions of African troops and noncombatants. Lastly, the chapter examines problems of demobilization and the effects of the war on African society and economy.

* * *

Introduction

Since the 1970s, African participation in World War I has become an increasingly important aspect of African historiography. Historians largely agree that Africa's contributions to the war and, in turn, the impact of the war on Africa, were immense and diversified. On the one hand, the war accelerated the pace and consolidation of colonial rule.[2] On the other hand, the tempo of African nationalist activities increased. Overall, the war led to significant social, political, and economic changes within African societies and redefined the relationship between Africans and the European colonizers.

Specific figures for overall African participation are lacking. However, historians mostly agree that large numbers of Africans took part in the war, either as

1. Quoted in David Killingray and James Matthews, "Beast of Burden: British West African Carriers in the First World War," *Canadian Journal of African Studies* 13 (1979), 23.
2. Richard Rathbone, "World War I and Africa: Introduction," *Journal of African History* 19 (1978), 4.

combatants or as laborers. Some figures can suffice here to indicate the scale of African participation in the war. The French recruited about 211,000 troops from their West African and Equatorial colonies, about 270,000 from their North African colonies, and 40,000 from Madagascar. Also about 135,000 Africans, mostly from the Maghreb, worked in French factories. Casualty figures have been put at 200,000.

For their part, the British recruited about 85,000 men from the Gold Coast (now Ghana) and Nigeria to serve the imperial war cause, and more than 2,000 were killed. In East Africa the British made use of over one million Africans during the East African campaign, and over 100,000 died in the course of the war. About 25,000 Africans formed the membership of the South African Native Labor Contingent (SANLC) that was sent to France to assist British troops.[3]

Preexisting colonial armies, namely the British West African Frontier Force (WAFF), the French Tirailleurs, the German Schutztruppen, and the Belgian Force Publique,[4] were augmented to cater to newly recruited African soldiers and laborers. Africans served at four theaters of war in Africa: Togoland, 1914; South-West Africa, 1914–1915; the Cameroon, 1914–1917; and East Africa, 1914–1918.[5] The Allied war aims to secure German colonies in Africa,[6] had a definitive bearing on the theaters of war in Africa since the war was fought in German colonies. Also, Africans served as combatants and performed non-combatant tasks in France at the Western Front.[7]

Outbreak of the War

Although the outbreak of the First World War in 1914 took Africans by surprise, many knew about the possibility of war in Europe. In the Gold Coast or Ghana, for instance, news about the impending war appeared in two newspapers: *The Gold Coast Leader* and *The Gold Coast Nation*. European settler colonies in Southern Africa and North Africa with their connections to Europe also spread word about the inevitability of war. Overall, rumor and gossip became agency for spreading news about the war. Once the European colonizers committed to the war, the colonized Africans automatically became involved in the war without any choice of neutrality. Throughout the war, the colonial powers, especially Britain and France, mobilized Africans and exploited natural resources to harness their war efforts.

3. See, for example, Basil Davidson, *Modern Africa* (New York, 1983), 5; A. Andrew and S. Kanya-Forstner, "France, African and the First World War," *Journal of African History* 19 (1978), 14–16; and B.P. Willan, "The South African Native Labor Contingent, 1916–1918," *Journal of African History* 19 (1978), 61.

4. Davidson, *Modern Africa*, 5.

5. For a detailed account of these theaters of war, see, for example, Byron Farwell, *The Great war in Africa 1914–1918* (New York, 1986).

6. See, for example, Rathbone, "World War I and Africa," 4.

7. See, for example, Joe Harris Lunn, "Kande Kamara Speaks: An Oral History of the West African Experience in France 1914–1918," in Melvin Page (ed.), *Africa and the First World War* (London, 1987), 28–53.

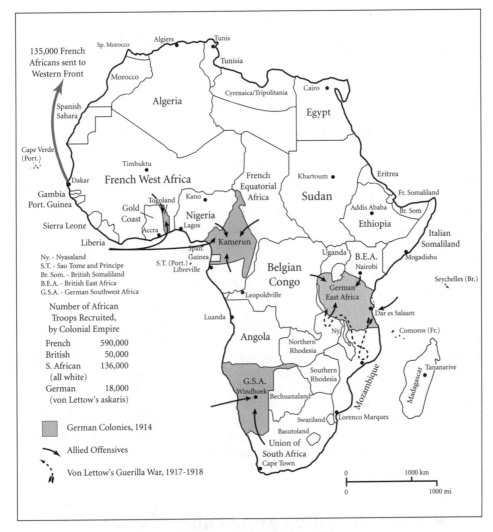

Figure 3-1. World War I in Africa

Before the outbreak of the war French colonial armies had become inextricably linked with the French metropolitan military institutions and engagements. Because the French had used African troops to rectify a demographic imbalance that had affected the recruitment of French nationals, they already had plans in place for using their colonized African troops when World War I broke out.[8]

By 1914, the British also had colonial armies, such as the WAFF. The British had used their colonial armies to conquer African states and societies, maintain law and order, and protect colonial frontiers and boundaries. The British, unlike the French, maintained that Africans should not fight in wars that involved whites. Indeed, the British only allowed Africans to be sent to France as non-combatants

8. See, for example, Andrew and Kanya-Forstner, "France, Africa, and the First World War," 1–9.

to assist British soldiers.[9] Towards the end of the war, when need for troops arose, the British considered using African troops in the Middle East and Europe. This was abandoned, however, when the war ended. Equally, the Germans and the Portuguese used African troops, but fewer saw service outside Africa.[10]

Propaganda Towards Recruitment

To gain the support of Africans for their war efforts, the French and British colonial governments embarked on massive anti-German propaganda schemes. Anti-German propaganda sought to convince Africans that British and French brands of colonialism were superior to the German brand. An objective of the anti-German propaganda was to encourage Africans to assist in the war effort so that France and Britain might win the war and prevent Germany from taking over the African colonies. In Nigeria, chiefs, Western-educated elites, teachers, school children, indigenous priests, and traders were all involved in the dissemination of the anti-German propaganda.[11]

The anti-German propaganda worked to the advantage of Britain and France in three ways. First, it led to relative acquiescence to colonial rule. Second, it promoted the recruitment of soldiers and laborers for the war effort. Third, the anti-German propaganda stimulated Africa's material and financial contributions to the war efforts. Special funds were set up in the colonies to assist in the war effort. For example, the people of Ghana and Nigeria contributed money to buy war planes for Britain. The extent to which anti-German propaganda in the wartime benefited the Allied powers remains to be fully assessed. But there is no doubt that the colonized Africans perceived the looming shadow of German colonialism as more menacing than that of the British and French.

Patterns of Military and Labor Recruitment

The massive scale of military and labor recruitment that supported the war efforts was unknown in previous decades. Military and labor recruits refer respectively to combatants and non-combatants and work of the latter included carrier services, cleaning and washing, supply of food items and water, cooking, clearing bush and road-building, dock-work and boating, medical assistantship and bear-

9. See, for example, Willan, "South African Native Labor Contingent," 63–64; and David Killingray, "The Idea of a British Imperial African Army," *Journal of African History* 20 (1979), 421–428.

10. Melvin E. Page, "Introduction: Black Men in White Men's War," in Page, (ed.), *Africa and the First World War*, 1.

11. See, for example, Donald C. Savage and J. Forbes Munro, "Carrier Corps Recruitment in the British East Africa Protectorate 1914–1918," *Journal of African History* 7 (1966), 313–342; and David Killingray and James Matthews, "Beasts of Burden: British West African Carriers in the First World War," *Canadian Journal of African Studies* 13 (1979), 16.

ing stretchers.[12] To a large extent, the colonial armies had to rely on carriers to transport military accessories and food.

Recruitment of Africans for non-combatant roles was as difficult as recruitment of soldiers. David Killingray and James Matthews have identified the following British methods of recruitment: "political and economic threatening of chiefs and headmen, intimidation and extortion of individuals and kidnappings en masse."[13] The carriers, like the soldiers, were divided into groups with appointed leaders who taught basic drill and communication signals.

The Africans further resented serving as carriers because they were sniped at by the enemy, forced to walk long tortuous distances with heavy loads,[14] and they worked under regimental conditions. Often carriers suffered more than soldiers. During the East African campaign, the group with the highest death rate was the carrier corps. Of the 14,184 carriers who served in the Cameroon campaign, more than 515 died from disease. Overall, one half of the 14,184 carriers suffered from "ulcerated feet and legs, digestive and respiratory problems, and malaria."[15] Indeed, carriers lacked basic necessities, including blankets, footwear, and medical care.

To attract and mobilize Africans, the colonial states effected enticing policies. In Ghana for example, conditions and wages for recruits were published in newspapers. To make recruitment more attractive, funerals for the recruits' relatives were borne by the indigenous state. In addition, puberty and widow rites were hurriedly performed to secure more marriageable females for the recruits.[16] Bylaws were passed stipulating additional fines for infidelity to protect the spouses of recruits. The French promised those who enlisted that they would be spared the infamous *indigenat* and that French citizenship would be conferred on them.[17]

Throughout the war, colonial authorities enlisted African rulers as the main agents for labor and military recruitment, a policy made easier because of a precolonial tradition whereby African rulers assumed the responsibility of mobilizing their subjects for war. Another reason was the paucity of colonial officials, a situation that was worsened in the course of the war, as white officers left to join the war.

The responses of the African rulers may be divided into three. First, some African rulers, for example, King Ofori-Atta of Akyem Abuakwa in the Eastern Province of Ghana and Chief Wadingo of Obela in the Owerri Province of South-

12. See, for example, Donald C. Savage and J. Forbes Munro, "Carrier Corps Recruitment in the British East Africa Protectorate 1914–1918," *Journal of African History* 7 (1966), 313–342; and David Killingray and James Matthews, "Beasts of Burden: British West African Carriers in the First World War," *Canadian Journal of African Studies* 13 (1979), 16.

13. Killingray and Matthews, "Beasts of Burden," 13–17.

14. Ibid., explains that military regulations had it that carriers should not carry more than 50 to 60 pounds weight, based on the man's build, and that they should not travel more than 15 miles per day with such weight. But the wartime exigencies made this regulation unenforceable.

15. Ibid., 16–19.

16. These rites had to be performed for females before they could be married. The Akan and Krobo, for example, performed such rites of passage.

17. Andrew and Kanya-Forstner, "France, Africa, and the First World War," 16–17; and Anne Summers and R.W. Johnson, "World War I Conscription and Social Change in Guinea," *Journal of African History* 19 (1978), 26–29. *Indigenat* was a system of summary justice applied to the Africans by the French colonial authorities and their agents.

ern Nigeria, took their recruiting tasks seriously. As a result, they incurred the disaffection of their subjects.[18] Second, some African rulers who adopted a passive attitude toward the recruitment exercise, in some cases, supplied unfit recruits. For example, in southwestern Nigeria, some chiefs supplied recruits who were 50 to 60 years, and a group of recruits from Northern Nigeria were described as a batch of cripples. Pushed by coercion from the colonial state and resistance from their subjects, such rulers satisfied none and alienated all. Lastly, there were those African rulers who actively opposed recruitment and even instigated their subjects to rebel against the colonial authorities. For example, in 1916, the "war chiefs" of Okeho in the Oyo Province authorized a policy of no recruitment. But the chief, assisted by the British resident, nullified the efforts of the "war chiefs". This culminated in a series of rebellions against the colonial state and its agents.[19]

Additionally, societies that were emerging from the abolition of domestic slavery tended to have a large number of recruits of servile origin. French recruitment in Guinea exemplified this pattern. Exactly how many of such slaves and freed slaves enlisted may never be known. But what is certain is that, lacking economic choices in addition to the stigma of their servile status, freed slaves sought to use their war participation as a vehicle for social mobility. Also, the Nandi of Kenya used the war as a chance to recapture their customary social, political and warrior roles that had been negated by the so-called pacificatory phase of the colonial conquest.[20]

Another group who participated in the recruitment drives was the African intelligentsia. These were the opinion leaders and pressure groups in the colonized society. In most parts of Africa, the intelligentsia was instrumental in the overall African war contribution. While many enlisted, especially in South Africa and French West Africa, the majority only assisted in the recruitment campaigns and drives.

Despite the paradox underlying their roles in assisting the oppressors of their societies, the African intelligentsia remained relatively loyal to the Allied cause throughout the war. Some of them, for example, in Ghana, Nigeria, Senegal, and South Africa, felt a sense of visceral attachment to the Empire and, therefore, supported the British and French declaration of war against Germany. Second, the African intelligentsia came to accept the anti-German propaganda, believing that if Germany won the war, it would take over the British and French colonies and impose a harsher brand of colonial rule. In fact, on the eve of the war, Africans in coastal Ghana, living adjacent to the German colony of Togoland, believed that German colonial rule was more brutal than British one. Lastly, the African intelligentsia presumed that Allied success in the war would bring about better conditions in the colonies. They hoped that their support for the war would propel their sagging role in the colonial society to a more participatory one, serving as an engine for future social mobility. This was truer for those in the European-settler

18. Killingray, "World War I in the Gold Cost," 45–46; and Killingray and Matthews, "Beasts of Burden," 21–22.

19. Akinjide Osuntokun, "Disaffection and Revolts in Nigeria During the First World War, 1914–1918," *Canadian Journal of African Studies* 5 (1971), 184–186. The "war chiefs" were traditionally responsible for raising armies.

20. Lewis J. Greenstein, "The Nandi Experience in the First World War," in Page, (ed.), *Africa and the First World War*, 82–84.

and racially-stratified societies of Southern and North Africa than the non-European settler West African region.

Problems of Recruitment

Overall, the colonial authorities did not meet their recruitment targets. Several factors explain this failure. Colonial rule had diminished the power and authority of African rulers that could have enabled them to mobilize their subjects in large numbers. In southern Ghana and Southern Nigeria, for instance, the chiefs failed to meet recruitment targets because of the opposition from their subjects.[21]

Furthermore, recruitment incentives provided by the various colonial states did not always match dividends from other sectors of the colonial political economy. In the cocoa growing areas of Ghana, military recruitment coincided with the period of economic boom in cocoa farming. Consequently, Africans found wage employment in cocoa production to be more financially beneficial than service in the colonial army.[22] Similarly, in Southern Africa, wage employment in the mines and on white-settler agricultural estates proved to be more attractive than military service.[23]

In Southern Africa, African interest in recruitment was hampered by many factors. White owners of the agricultural estates and mines, believing that massive enlistment of Africans would lead to labor shortages, did whatever they could to stifle the recruitment. Moreover, racial stratification and sentiments influenced recruitment. The white settlers of Southern Rhodesia were very cautious about recruiting and arming Africans. The historical precedent of the Anglo-Ndebele wars of the 1890s reinforced strong beliefs among white settlers that armed Africans could rise up against them. Furthermore, white settlers did not want Africans to fight alongside them because that could undermine the pretense of white superiority and diminish the politically constructed racial divide that kept the two races apart. For their part, blacks in Southern Africa did not want to fight for their white oppressors. Indeed, black South Africans more often enlisted for the reason of possible economic gains than as an expression of patriotism or filial piety toward the state.[24]

Fear of the unknown also served as a roadblock to recruitment. The idea of traveling by sea, serving in distant alien lands, the possibility of getting killed, as well as experiencing different cultures, prevented a great number of Africans from

21. See, for example, Osuntokun, "Disaffection and Revolts in Nigeria," 185; Killingray, "World War I in the Gold Coast," 50–53; David Killingray, "Military and Labor Policies in the Gold Coast During the First World War," in Page (ed.), *Africa and the First World War*, 158–164.

22. See, for example, Killingray, "Military and Labor Policies in the Gold Coast," 160–161.

23. See, for example, Peter McLaughlin, "The Legacy of Conquest: African Military Manpower in Southern Rhodesia During the First World War," in Page (ed.), *Africa and the First World War*, 131.

24. Willan, "South African Native Labor Contingent," 68–69; and McLaughlin, "The Legacy of Conquest," 120–121.

enlisting. Others also assessed their familial relationships, considering what might happen to the loved ones they would leave behind. Furthermore, despite colonial efforts to conceal the realities of war from Africans and would-be recruits, information about the war filtered into the crevices of African societies. For example, when news of the sinking of the *S.S. Mendi* in February 1917, that killed 600 members of the SANLC, reached South Africa, it deterred black South Africans from enlisting. Also, stories of wounded soldiers who demobilized discouraged recruitment. Equally, stories about the harsh treatment of soldiers and carriers thwarted recruitment efforts.[25]

African Responses to Recruitment

Africans responded to recruitment efforts in several ways. These included individual, collective, violent, and non-violent actions. These were not mutually exclusive, as some of them overlapped. But in all cases, the objective was to avoid recruitment into the colonial forces. Personal or individual acts involved self-mutilation, feigning sickness, and running away. The extent to which these were used and their impact on recruitment remains to be fully studied. However, there is no doubt that as ordinary Africans began to feel the impact of wartime deprivations and hardships, and the inability of African rulers to protect them, many took matters into their own hands. Collective efforts to avoid recruitment entailed mass migration of whole communities to regions that were either geographically or politically inaccessible to the recruiting parties or agents. For example, harsh recruiting methods forced Africans in French West Africa to immigrate into Liberia and British-governed territories. About 15,000 to 18,000 people moved from the Ivory Coast to the Western Province of Ghana.[26]

Violent response took the form of rebellions and armed resistance against the colonial authorities and their African agents. Not all of the resistance, however, was due to recruitment policies. Some causes are traceable to pre-war African grievances against colonial rule. Nonetheless most of the revolts coincided with the peak periods of recruitment between 1915 and 1917. In the Seyidie Province of Kenya, the Giriama revolted and two companies of the King's African Rifles (KAR) were mobilized to quell the rebellion. After the rebellion failed, the Giriama refused to enlist or contribute money.[27] Similarly, in 1916, the Bongo revolt occurred in northern Ghana was directed against the chiefs, who were the agents of military recruitment.

Africans also responded due to religious beliefs. By foretelling the imminent departure of the Europeans, the leaders of millennial movements promoted a sense of independence that corroded respect for colonial administrations and their African agents. Among the Luo of Kenya, the cult of Mumboism syncretized with

25. See, for example, Willan, "South African Native Labor Contingent," 66–71; McLaughlin, "African Military Manpower," 125–126; Killingray, "Military and Labor Policies," 160–161.

26. Killingray, "World War I in the Gold Coast," 52–53; and Killingray, "Military and Labor Policies," 164.

27. Savage and Munro, "Carrier Corps," 318–319.

prophesies of the Seventh Day Adventist. Alarmed by these millennial leanings, the colonial administration tried the leaders and some of their adherents under the Witchcraft Ordinance and deported them to serve as forced laborers.[28] Millennial rumors and agitations also occurred in northern Ghana. Some anticolonial sentiments were not on cultist beliefs as such, but on practical realizations of the paucity of white administrators, a seeming indication that colonial rule was coming to an end.

Theaters of War in Africa and Europe

Four major campaigns were conducted in Africa: Togoland, 1914; South-West Africa, 1914–1915; Cameroon, 1914–1917; and East Africa, 1914–1918. These campaigns served as an extension of the European rivalry in which France and Britain sided against Germany. The Germans called upon the terms of the Berlin Conference of 1885 that bound the European colonies in Africa to neutrality in the event of war, but the Allied powers ignored this aspect of the treaty.[29] Thus, all the various theaters of war in Africa were in German colonies, underscoring one of the major war aims of France and Britain: to conquer German-held colonies in Africa.

The first of these wars was the Togoland campaign of 1914. In fact, one reason why the Allied powers rejected the German plea for neutrality in the African colonies was because the German wireless station at Kamina in Togoland, was considered to be a valuable communication tool.[30] As a result, the French invaded Togoland from Dahomey (Benin) and captured Anecho. This was the first Allied occupation of German territory during World War I. For their part, the British forces in neighboring Ghana took about three weeks to defeat the Germans. Indeed, the first shot of World War I associated with Britain took place in Togoland, not in Europe.[31] The Germans put up little resistance, but they did blow up the Kamina wireless station.

The Togoland campaign was significant in two ways. First, it revealed the latent rivalry between France and Britain over German territories. The French concluded that if they allowed the British-led forces to conquer the German territories, the British would unilaterally occupy these territories without considering French interest. Second, the ease with which the French and British forces overran Togoland convinced them, rather erroneously, that the rest of the German colonies could be taken without struggle.

The war in German South West Africa (Namibia) was largely undertaken by the Boers, the descendants of the early European settlers, namely Dutch, French and German in South Africa. The Boers hoped that once they defeated the Germans they could annex Southwest Africa. Paradoxically, the war led to sectional rebellions in South Africa between the loyalists who supported the British cause,

28. Ibid., 317–318.
29. See Farwell, *The Great War*.
30. Ibid., 23–24.
31. Ibid., 21–30. Germany secured Togoland in 1844, but it was not until 1899 that the boundaries of the colony were defined.

mainly those with British ancestry, and the Boer rebels. Eventually, the loyalist forces led by Louis Botha prevailed.[32]

Under Botha, the South African army included people of different nationalities and social backgrounds, but the bulk of the soldiers were white South Africans. Unlike the wars in Togoland and the Cameroon, the war in South West Africa involved aerial battles with the Germans demonstrating superior air power at the beginning of the war. The war also involved poisoning of bodies of water and the use of land mines. The Germans put up a strong resistance, but in the end, the South African occupation of the strategic capital of Windhoek effectively concluded the war.[33]

During the Cameroon campaign the strategic port capital of Doula became the main focal point of Britain and France. Rivalry flourished between France and Britain, but eventually, the French agreed to place their troops under the command of the British, Brigadier General Charles Dobell. Unlike the Togoland campaign, the German colonial government in the Cameroon put up a spirited resistance. They engaged the Allied forces in scorched-earth maneuvers by moving intermittently and destroying all resources, such as food and water, that could benefit the pursuing allied forces.[34] In the end, having captured the strategic port of Doula, the Allied forces prevailed by cutting off German supplies.

The East African campaign involved major sea, land and air battles. It was the most costly and protracted, punctuated with the heroic saga of General Paul von Lettow-Vorbeck, the German Commander. The campaign also involved thousands of African troops and carriers. The major naval battle involved the destruction of the German ship, the *Konigsberg,* while the battle of Tanga was one of the most important land engagements. In the end, the British-led forces were victorious, but it was the military strategy and exploits of Lettow-Vorbeck that attracted the attention of military strategists and observers.[35]

Apart from these major theaters of war, Africans participated in the war outside Africa. The French and British sent Africans to France to support their war effort. The French colonial armies served as combatants at the Western Front, while Africans from South Africa performed non-combat tasks, such as dock work, for the British troops in France. Overall, historians agree that African labor contingents and combatants performed their tasks with zeal and enthusiasm.

While in France, the SANLC were kept in camps to isolate them from the French citizenry, culture, and politics. This was done to prevent assimilation of French social, political and cultural norms that might politicize them to challenge white rule after demobilization. The African contingent in France suffered from frostbite and tuberculosis, the latter killing about 331 members of the SANLC. Additionally, Africans suffered the effects of a rigidly enforced segregation policy, they resented night shift work, and they expressed discontent over food.[36]

32. Ibid., 72–85.

33. Ibid., 86–96.

34. Ibid., 34–71; and Frederick Quinn, "The Impact of the First World War and its Aftermath on the Beti of Cameroon," in Page (ed.), *Africa and the First World War,* 174–176.

35. For an interesting account of the East African campaign and the exploits of Lettow-Vorbeck, see, for example, Farwell, *The Great War,* 86–319.

36. Willan, "South African Native Labor Contingent," 70–80.

Demobilization

Demobilization differed from colony to colony, but overall it was character-
ized by measures that lacked the careful planning of the recruitment schemes. At
the onset of demobilization, the colonial powers feared the impact ex-servicemen
would have on their communities. In Nigeria and Sierra Leone, the British tried to
prevent the demobilized soldiers from staying in the urban areas, fearing they
would foment a watershed of political agitation.[37] Africans who were sent back
were first taken to the colonial capitals and quarantined, and then dispersed to
their places of recruitment where they were demobilized and given their final pay.
Not only did the quarantined ex-servicemen lack adequate food and medical care,
but the demobilized Africans suffered because the *ad hoc* facilities and institutions
set up to receive them were woefully inadequate. In Nigeria, for example, the bar-
racks provided for the ex-servicemen lacked roofs and proper walls, leaving the
ex-servicemen to the vagaries of weather.[38]

Failure to honor payment of annuities and other promises fueled anger and
disappointment among ex-servicemen who vented their frustrations on the chiefs
who had recruited them and the colonial state. In South Africa, compensation
claims for members of the SANLC were not properly handled, nor were they
given medals awarded to them by King George V.[39] Payments and recruitment
records were not properly kept, leading to complicated annuity payments, for ex-
ample, to ex-servicemen involved in the Cameroon and East African campaigns.[40]

The Impact of the War on African Societies

The war's impact was both socio-economic and political. The different sys-
tems of prewar colonial administration and the ways Africans responded to the
war effort affected the impact of the war on African societies and economies. The
war definitely redefined the relationship between African communities and the
colonial rulers.

With regard to the socio-economic impact, the war enabled the colonial pow-
ers to intervene more vigorously in African economies than they had done previ-
ously. This intervention originally enabled the colonial authorities to harness the
colonial economies to assist in the war efforts. Such intervention in the economy
was meant to prevent Germany from benefiting from international trade. For in-
stance, cocoa exports from British colonies were not to be sent to German ports.

Furthermore, shipping shortages affected trade. As the war progressed, it be-
came imperative to give greater preference to shipping war materials than com-
modities from the colonies. This affected trade, creating a glut in agricultural pro-
duce and lowering prices. In 1917, faced with acute shipping space, the British
government decreased the import of Gold Coast cocoa to 50 percent. To control

37. Killingray and James Matthews, "Beasts of Burden," 19–21.
38. Ibid., 19–20.
39. Willan, "South African Native Labor Contingent," 83.
40. Killingray and Matthews, "Beasts of Burden," 20–21.

the cocoa industry, licenses were issued to traders mainly associated with British-based companies that dealt in the import-export trade. This policy eliminated African traders and importers.

While lower prices for exported agricultural commodities prevailed, higher prices for imported European goods became the order of the day. These high prices stemmed from inflation, but there was a decrease in shipping space, which led to fewer imports of European-made goods into the colonies. This combination of having only a few select companies controlling the import-export trade and a lack of shipping space, also created higher prices on export commodities.[41]

Because production was stimulated either to support the war effort or to make up for the scarcity of foreign goods due to wartime shipping problems, the war augmented African economies. At the same time new colonial ventures were undertaken. For example, in the Gold Coast, massive geological surveys explored the possibility of exploiting minerals to support the war effort. As a result, manganese and bauxite were added to the list of exploitable resources in the colony. In fact, as David Killingray notes, manganese, "a vital material for hardened steel was first shipped out [to Britain] in September 1916."[42]

In the pre-war period, many parts of Africa had experienced labor shortages. This worsened with the massive wartime labor mobilization. In Ghana, the Northern Region provided labor for the mines and also served as the major area for recruiting laborers and soldiers for the war effort. To sustain this effort, the colonial government was forced to suspend labor recruitment in the region for the mining industry.[43]

In Nigeria, labor shortage affected development of the public infrastructure. For example, the Emir of Bauchi had supplied 3,000 laborers for the Bauchi Light Railway, but the exigencies of the war reduced the number to less than 1,000.[44] Moreover, the labor shortage created by the exodus of white artisans and blue collar workers who had gone to fight, served as an avenue of social mobility for Africans in British West Africa and the racially stratified society of South Africa.[45]

Despite the fact that the colonial economies were all subsumed under wartime needs and goals, some African initiatives occurred during the war. For example, in Ghana, Africans whose capital accumulation had been constrained by wartime exigencies invested their capital in vehicular transport or what became known as the "lorry revolution." Some also invested their capital in landholdings. Additionally, lacking colonial input because of the wartime needs of the colonial state, Africans took the initiative to build roads and schools.[46]

Another important effect of the war was the devastating outbreak of the influenza pandemic in 1918–1919, estimated to have killed about 20 million people worldwide or twice the number of casualties from the war. In Africa about 1.5 to 2 million Africans perished. Suffering from the exigencies of the war, the colonial states were not prepared for the outbreak of the pandemic. The disease spread by

41. Killingray, "World War I and the Gold Coast," 54.

42. Ibid., 56.

43. Ibid., 52.

44. Killingray and Matthews, "Beasts of Burden," 22.

45. Rathbone, "World War I and Africa," 6; and Killingray, "Military and Labor Policies," 164.

46. Rathbone, "World War I and Africa," 8–9.

ship from Europe to the African coastal belt and then to the inland regions. The war also caused the spread of smallpox, sleeping sickness, venereal disease, and dysentery. Apart from the high mortality and morbidity rates, the influenza pandemic affected production, especially the agricultural sector and the backbone of colonial economies. Although the epidemic initially broke out in the coastal regions, it was the interior backwater and agricultural regions that were hardest hit. In northern Ghana, it disrupted recruitment of labor and the cattle trade with neighboring French territories.[47] Overall, the pandemic caused tremendous misery and disruption of everyday life, compounding the hardships brought about by the war.

While the war most certainly brought together Africans from different cultural backgrounds and experiences, the subject has not been rigorously studied. It is fair to say that the war led to a cross-cultural sharing of ideas. Africans learned new things by associating with the peoples they encountered at the various theaters of the war. This set in motion a process of diffusion of innovations in musical traditions, dance, architectural patterns, dress, and cuisine.

Politically, World War I has been identified as a seedbed for nationalist activity. Demobilized soldiers, invigorated by their new experiences, began to challenge the colonial authorities. This occurred in Guinea, Nigeria, and South Africa.[48] In Ghana, the war partly accounted for the shift in nationalist activity. The reformist Aborigines' Rights Protection Society (ARPS) of the late nineteenth century gave way to the formation of the National Congress of British West Africa (NCBWA) in 1920. The formation of the NCBWA was influenced by wartime measures and ideas, including the principles of self-determination, race consciousness, and pan-Africanism. These developments were reported in the Gold Coast press and patronized by the Western educated elites.[49] Indeed, unlike the ARPS that was based on the Gold Coast, the NCBWA was regionalized, covering the whole of British West Africa. Although, the membership of the NCBWA, was as elitist as the ARPS, the ideology and activities of the former were revolutionary and sought to bring about radical changes in the colonial system.

The activities of demobilized African soldiers had far reaching consequences on their communities. Ex-servicemen not only had new ideas that broadened their social and political horizons, they also collected annuities that enabled them to sidestep societal norms. Writing about Guinea, J.H. Lunn notes that with their relative wealth, veterans "circumvented convention and acquired wives without indenturing themselves to elder kinsmen and that slaves purchased their freedom or arbitrarily severed their bondage. In some cases, African communities took extreme measures against the radical stance and influence of demobilized soldiers. The account of Kande Kamara, a Guinean ex-serviceman who fought on the Allied side in France, exemplifies this. Fearing the changes that the ex-servicemen were likely to bring about in the status quo, local authorities managed to ostracize them from their rural communities."[50]

47. See, for example, K. David Patterson, "The Influenza Pandemic of 1918–19 in the Gold Coast, *Journal of African History* 24 (1983), 485–502; and Killingray and Matthews, "Beasts of Burden," 22.

48. See, for example, Willan, "South African Native Labor Contingent," 82–85; and Summers and Johnson, "Social Change in Guinea."

49. See, for example, Killingray, "World War I in the Gold Coast," 57–58.

50. Lunn, "Kande Kamara Speaks," 45–49.

The war impacted the institution of chieftaincy by either increasing or weakening the power and authority of the chiefs. In Guinea, for example, some chiefs regained the power and authority they had lost since the imposition of colonial rule. Using the harsh French recruitment methods, the chiefs coerced their subjects into subjugation either by forcing them to enlist or else inflicting severe punishment on those who resisted. French authorities buttressed the position of those chiefs who demonstrated loyalty and contributed the most to military and labor recruitment.[51] When financial gains and other forms of remuneration were provided to the chiefs for serving as agents of recruitment, the clientage and patronage that resulted served to further inflate the chiefs' power and authority over their subjects.

In some parts of Africa, the war weakened preexisting political structures. In the Northern Region of Ghana, the indigenous political authorities lost the allegiance of their subjects because of forced military and labor recruitment.[52] According to Killingray and Matthews, at "Obela in the Owerri Province of Southern Nigeria, Chief Wadingo was 'driven from his town and threatened with death should he return... because he had endeavored to persuade certain of his people to act as carriers.'" Also, relatives of those who died in the course of the war, blamed the chiefs for homicide and slave-dealing.[53]

The war led to the consolidation of colonial rule. The decisive wartime colonial policy of mobilization of manpower and exploitation of natural resources, coupled with the support of a considerable number of the elites of African societies, made colonial rule a *fait accompli*. The war itself became a part of colonial rule, and like the so-called pacificatory campaigns that preceded it, wartime exigencies and disturbances were forcefully and brutally quashed.[54] This paved the way for the colonial powers to assert rigorous political control, enabling them to maximize the economic exploitation to assist in their war endeavors.

African involvement in the war equipped them to understand and question the hegemonic underpinnings of colonial rule. B.P. Willan, writing about the experiences of the SANLC, offers an insightful account:

> Marks Mokwena, was particularly impressed by the fact that "the people of that territory (Sierra Leone) were pure black negroes of very high educational attainments equal to that of the best Europeans," an observation that he communicated to a large political meeting in South Africa after his return by way of contrast to the existing state of things in his own country.[55]

Indeed, that the war provided windows for a great number of Africans to pry into the hegemonic construction of white superiority is indisputable. Fighting against and alongside whites revealed the fallibility and foibles of whites to the Africans and equipped them to question the assumed superiority of whites. This weakening of socially constructed notions of white superiority accounted for arguments that Africans should not fight alongside Europeans. Overall, the war became a

51. Summers and Johnson, "World War I Conscription," 28–29.
52. David Killingray, "Repercussions of World War I in the Gold Coast," *Journal of African History* 19 (1978), 59.
53. Killingray and Matthews, "Beasts of Burden," 21–22.
54. Rathbone, "World War I and Africa," 3–5.
55. Willan, "The South African Native Labor Contingent," 78.

vital epistemological agency for the advancement of African social consciousness and a sense of political empowerment.

The Allied victory brought to an end German activities in Africa. The German territories of Togoland and Cameroon were divided between Britain and France as the League of Nations Trustee territories. German South West Africa became a trusteeship territory, placed under South Africa. In East Africa, Britain took over Tanganyika, while the Belgians annexed Ruanda/Urundi.[56] Also socially and economically, German activities in Africa suffered. For example, suspecting the Swiss Basel Mission and the Basle Mission Trading Company of pro-German sentiments, the Gold Coast colonial administration expelled the missionaries and seized the holdings of the trading company.[57] Thus, with the demise of German colonial activities in Africa, the war marked the turning point for Britain and France to become the most powerful colonial powers in Africa.

Conclusion

The outbreak of World War I occurred in the aftermath of the consolidation of European colonial rule in Africa. Africans had no option for neutrality; they were irrevocably drawn into the war by the European colonial powers. All the European colonial powers used coercive measures to mobilize Africans for their war efforts. African rulers and leaders were made, for the most part, unwilling agents of recruitment. As a result, they bore the brunt of the colonial authorities and the angst of their subjects. The colonial states did not always obtain the targeted number of recruits. Recruitment was seeded with problems, not the least of which were competition from other sectors of the colonial political economy, the harsh methods of recruitment, the poor treatment of soldiers and carriers, the fear of the unknown, and unwillingness to fight in a "white man's" war. African responses to recruitment took many forms, including warfare, migration, hiding, feigning sickness, and desertions.

The war impacted Africa in several ways. It led to more vigorous colonial policies and intervention in African economies than had existed before. Also, the war posed challenges to indigenous rulers, who were torn between protecting the interests of their subjects and meeting the dictates of the colonial state. Furthermore, despite its sometimes evanescent nature, the radicalization of African nationalism prepared a fertile ground for the effective challenge to the colonial system in the inter-war period. And while, it is a subject that needs further research, there can be no doubt that the war led to a cross-cultural sharing of ideas and a diffusion of innovations in the material culture within Africa. Undoubtedly, the global celebratory remembrances of the two World Wars tend to overlook the contributions of Africans. But it needs to be stated, indeed unequivocally, that the contributions of Africans to the war efforts were immense and long-lasting.

56. Davidson, *Modern Africa*, 7–8.

57. Margaret Gannon, "The Basle Mission Trading Company and British Colonial Policy in the Gold Coast," *Journal of African History* 24 (1983), 503–506; and Davidson, *Modern Africa*, 6. For Nigeria, see Osuntokun, "Disaffection and Revolts in Nigeria," 178–180.

Review Questions

1. Discuss some of the problems of military and labor recruitment in Africa during the First World War.
2. What role did the Western-educated elites play in the military and labor recruitment drives during the First World War?
3. How did Africans respond to military recruitment and labor mobilization in the course of the First World War?
4. Why were the demobilized soldiers able to effect a measure of social change in the post-war period?
5. What were some of the obstacles in the way of military recruitment during the First World War?
6. Why did the colonial authorities rely on African chiefs as agents of military and labor recruitment during both wars and what problems did the chiefs face in their labor recruitment drives?

Additional Reading

Bush, Barbara. "Africa After the First World War: Race and Imperialism Redefined," Chapter One in *Imperialism, Race and Resistance: Africa and Britain 1919–1945* (London, 1999), 20–46.

Crowder, Michael and Jide Osuntokun (eds.). "The First World War and West Africa," in J.F.A. Ajayi and Michael Crowder (eds.), *History of West Africa* Vol. Two (London, 1974), 546–577.

Lunn, Joe. *Memoirs of the Maelstrom: A Senegalese Oral History of the First World War* (Portsmouth, 1999).

Osuntokun, Akinjide. *Nigeria in the First World War* (New Jersey, 1979).

Page, Melvin E. *The Chiwaya War: Malawians and the First World War* (Boulder, 2000).

PART B

CHANGE AND CONTINUITY IN AFRICA

Chapter 4

Colonial Political Systems

Adebayo Oyebade

The thrust of this chapter is colonial administrative systems and the ideologies that underscore colonial policies. The analysis focuses on the framework and dynamics of colonial administration. It examines direct and indirect rule systems, and discusses the dominant theories of colonial administration namely "assimilation," "collaboration," "separate development," and "paternalism."

* * *

European territorial acquisition in Africa accelerated in the post-Berlin Conference period. By 1900 the imperial powers had concluded military conquest of most of the continent. Consequent to this, the opening years of the new century saw the colonial powers confronted by a major task: how to effectively administer the vast territories they had acquired. This task was not to be a simple one; the European powers first had to consolidate their new acquisition before a meaningful administrative system could be put in place. Up until the outbreak of the World War I in 1914, the European powers were still smashing existing pockets of opposition mounted by determined Africans.

During the initial era of African occupation European powers struggled to consolidate their territorial holdings by imposing temporary administrative measures. For instance, Britain, France, Belgium and Germany administered some of their territories through company rule by granting large and powerful joint-stock companies, commercial monopolies in their areas of jurisdiction. But the charters granting the companies commercial monopolies also empowered them to exercise political authority. It permitted them to set up a government with a military force to keep the peace and order, and a judicial system to administer law and justice. For example, the Royal Niger Company (RNC), armed with a royal charter granted it in 1886, established a government over the Niger delta and the middle belt areas of Nigeria. The government was made up of a high court, a constabulary, and a branch responsible for the administration of customs. Endowed with political authority, the company collected taxes and duties on imports and exports on the Niger. It signed several treaties of protection with local chiefs, thereby exercising considerable influence over local politics. In other parts of Africa, the imperial powers also used company rule in the late nineteenth century. The German East Africa Company (GEAC) administered the German colony of Tanganyika. The Imperial British East Africa Company (IBEAC) initially controlled Kenya and Uganda. The British South Africa Company (BSAC), under Cecil Rhodes, held tutelage over the Rhodesias (which became Zambia and Zimbabwe). A great part of the Congo Free State, the private empire of King Leopold

of Belgium, was parceled out to concession companies who established adminis-
trative and political authority over them. The Portuguese also placed their terri-
tory of Mozambique under company concession.[1]

In some conquered territories where company rule was not the instrument of
governance, the imperial powers simply imposed their military administration.
Officers responsible for the subjugation of these territories were invested with
some administrative powers over their conquered areas. They contracted "protec-
tion" treaties with African chiefs and relied on their so-called discretion to deal
with people.

Although company rule and outright military administration persisted in
some parts of Africa, by the early 1900s European powers had come to terms
with the fact that they must assume direct governance of their widening colonial
empires. Company rule had not always proven successful. Some companies such
as IBEAC faced financial troubles and were unable to administer effectively. Some
could not handle the constant African resistance. Eventually, most of the compa-
nies lost their charters and governing authority. The charter of GEAC was abro-
gated in 1889, and that of IBEAC in 1893. The RNC had its charter revoked in
1899 when Britain assumed the governance of its territories. Other companies
lost their administrative powers in the twentieth century. In the Congo, company
rule ended in 1908 when the Belgian government took charge of the state admin-
istration. In South Africa, the charter of the BSAC and its governing powers were
finally ended in 1923. It was only in Mozambique that company concession con-
tinued until 1942.

After World War I, by which time the colonial era had begun in earnest, Eu-
ropean powers were able to settle down to administering their territories more
formally. The colonial powers quickly reorganized their conquered territories into
colonies and proceeded to devise administrative systems to govern them. These
systems were informed by European ideas about how best to define the dynamics
of colony/metropolis relationships, including the mechanism of imperial control
over colonized peoples. The rest of this chapter is devoted to examining the colo-
nial administrative systems and the ideologies that underscored colonial policies.

The Framework of
Colonial Administration

As the colonial state began to evolve, company rule and military regiments
yielded to a more civil administrative system with highly specialized bureaucracies.
Under the new dispensation, colonial management was centrally administered with
a variety of governmental agencies. However, for day-to-day activities, local rulers
were often permitted to retain their traditional positions and powers. In such cases
the local institutions became instruments for managing grass root activities by the
colonial authorities. These authorities could thereby operate a system of direct rule
at the central government level and indirect rule at the local level.

1. See Chapter 2 of this volume for detailed discussion of company rule. (Felix Ekechi,
"The Consolidation of European Rule").

Direct Rule

All the European powers instituted some form of direct control over their colonial empires. With the significant exception of the French in West Africa, a fairly uniform centralized administrative structure is discernible. This general administrative framework remained relatively stable at least until the post-World War II reforms brought about major changes.

The highest authority in the colonial government was vested in the central administration headed by the Governor-General (or simply Governor). The Governor-General who resided at the colony's capital was responsible to the metropolitan government in the European capital. For example, in the case of Britain, the Governor-General was directly accountable to the Secretary of State for the Colonies. In major policy matters such as constitutional changes, the Governor-General received orders from the imperial government. Otherwise, the central administration wielded considerable discretionary powers within its jurisdiction. Its administrative machinery included executive and legislative bodies. The Governor-General presided over the executive council and had the responsibility for reviewing policies and recommendations from the service departments. The legislative council was responsible for passing laws, but was subject to the approval of the Governor-General. In reality, the Governor was the principal source of legislative authority. Both the executive and the legislative bodies were often primarily made up of Europeans. When a small number of Africans sat in the legislative council, they were usually nominated and held no power to reject bills.

For administrative purposes, most colonies were divided into regions sometimes called provinces each with its own headquarters and governmental seat. The head of the regional administration was the Provincial Commissioner, called "resident" under the British system. Although the Provincial Commissioner was responsible to the Governor at the colonial capital, his administration exercised a measure of autonomy in that it ran its own service departments. However, the provincial administrative budgets were subject to the Governor's approval. A further subdivision of the colony was the district, headed by a District Officer or Commissioner and, sometimes, assisted by an Assistant District Officer. The District Officer was the colonial official who was directly in contact with the local people. He was responsible for the grass-roots implementation of colonial policies, especially the maintenance of law and order, and revenue collection through taxation.

For a colonial administration to run smoothly, a number of service agencies were required, such as education, health, treasury, posts and telegraphs, and public works. During the early period of colonial rule, only Europeans administered the civil service. Due to the system's inherent racism, Africans were hardly allowed to rise beyond the clerical level. Indeed, prior to World War II, Africans generally served only in a variety of non-managerial positions such as interpreters, messengers, clerks, tax collectors, postal workers, soldiers, and policemen.

An armed constabulary served the administration by enforcing law and order. As taxation was important to the colonial economy, the constabulary particularly served to assist the collection of widely resented taxes. Most administrations also kept colonial armies such as the British West African Frontier Force, the French *Tirailleurs,* the Belgian *Force Publique*, and the German *Schutztruppen*. In both the constabulary and the colonial regiment, Africans served as recruits and Europeans as commanders.

The political system in French West Africa was more ambitious than that of the other colonial powers in that it was more centralized. The French adopted an administrative framework that placed all their colonies under a single federal government. The organization of French West Africa into a federation called *Afrique Occidentale Francaise* (A.O.F.) was a step beyond the centralized political systems of the other colonial powers. The colonies were all under the political headship of the Governor-General who administered the federation from the capital, Dakar, in the colony of Senegal. Each colony within the federation had its own Lieutenant Governor, who although was responsible to Dakar, but still had considerable autonomy in the colonial administration. Each colony was divided into administrative districts that were called *cercles*, and were headed by the *commandants*.

Unlike the French in West Africa, the other colonial powers set up individual central governments for their colonies. A federated administrative structure for all their colonies was simply not feasible because their colonies did not share common boundaries, as did the French. Nonetheless, the imperial powers' reasons for creating centralized political systems were often similar. Foremost was financial expediency, such as in Nigeria where the Northern and the Southern Protectorates were amalgamated in 1914. The primary reason for creating a unified Nigerian government was to reduce cost. This could be done most effectively by using the resources of the rich south to augment development in the relatively poor north. A unified government could also reduce duplications and harmonize colonial developmental projects such as the railway.[2] The French West African federation was also based on this same principle of financial expediency.

Indirect Rule

The indirect rule is the administrative system where colonial powers ruled Africans through their traditional leaders and institutions. To varying degrees, all the European powers utilized indirect rule when it best served their administrative purposes. Even, France, despite its more recognizable centralized system, often used indirect rule.[3]

But the British used the indirect system most widely. One of the earliest places where the British practiced this system was the Gold Coast. In the late nineteenth century, colonial administrators had to govern the Gold Coast interior with the help of traditional authority. Even in the so-called "civilized" coastal towns such as Elmina, Cape Coast, and Accra, the British found it indispensable to use traditional authority to administer a wide range of services.[4] As systematic colonial policy of the British Empire, however, indirect rule was most pronounced in Nigeria. Its application in various parts of the colony best demonstrates its character, success, and failure.

2. See Toyin Falola, *The History of Nigeria* (Westport: Greenwood Press, 1999), 68–69.

3. See a brief discussion of the French indirect rule in J.B. Webster, A.A. Boahen, and M. Tidy, *The Revolutionary Years: West Africa Since 1800* (Essex: Longman, 1980), 210–211.

4. A good account of this early practice of indirect rule in the Gold Coast colony could be found in Roger S. Gocking, *Facing Two Ways: Ghana's Coastal Communities Under Colonial Rule* (Lanham: University Press of America, 1999). However, the classical Lugardian concept of indirect rule was not officially applied to the Gold Coast until the late 1920s.

The British Indirect Rule System

The implication of indirect rule is that most colonized people continued to be governed in their daily lives by traditional rulers whose authority was recognized by colonial administrators. The traditional elite would then serve as intermediaries between colonial authorities and the African community. Imperial orders, regulations, and laws were handed down to the colonized subjects through these elites, who, willingly or not, became collaborator in the colonial system. Through this so-called "Native Authority," colonial administrators exercised indirect control over the colonized people. Their chief responsibility was to collect taxes, adjudicate local disputes, and generally ensure their subject's obedience to colonial authority.

By its setup, indirect rule permitted British colonial overlords to have minimal contact with the subject people. Operating behind the scene, the colonial authorities gave orders and passed laws which the colonized people received second-hand from their own chiefs. As Lord Frederick Lugard, the notable British colonial administrator and first governor of Nigeria explained,

> The Resident's advice on general policy must be followed but the native ruler issues his own instructions to his subordinate chiefs and district heads — not as the orders of the Resident but as his own.[5]

This setup reduced the chances of opposition to colonial rule by the people.

Why did the British adopt an indirect rule system in Nigeria? The overriding factor was the non-availability of an adequate number of European colonial officials to govern the vast territory that was Nigeria. Not many Europeans were willing to come to Africa to serve as administrators, and even if there were enough, how could such a large bureaucracy of paid European administrators be financed? The British colonial authority calculated that the cost of running such an all-British administration would not only offset colonial profit but also pose an undue burden to taxpayers at home. It must be remembered that the chief goal of colonialism was economic exploitation. The colonies were expected to be economically self-sustaining and Europe's expenditure on them, if any, was supposed to be minimal. Financial expediency called for the British to use existing traditional political institutions, a system that had the added advantage of actualizing imperial domination and control.

The colonial administrator most identified with indirect rule was Lord Lugard. Appointed governor of the Protectorates of Northern and Southern Nigeria in 1912, he then amalgamated both territories in 1914, whereupon he was appointed the Governor-General of the single colony of Nigeria. Lugard first applied indirect rule in Northern Nigeria where his success could be attributed largely to the Hausaland administrative structure already in existence. In Northern Nigeria, the conclusion of the 1804 Fulani *Jihad* had established a somewhat centralized political system in the Sokoto caliphate. In the post-*jihad* era, the hitherto fragmented and competing Hausa states were united under the central authority of

5. Frederick Lugard, *The Dual Mandate in British Tropical Africa* (Edinburgh: W. Blackwood & Sons, 1922), 20.

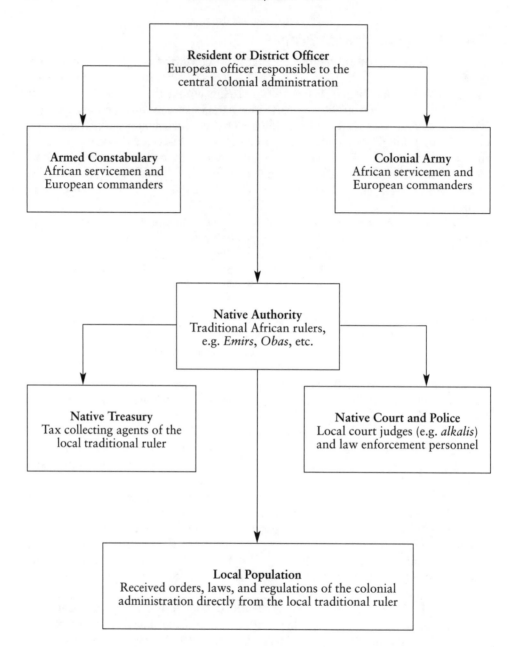

Figure 4-1. Structure of the British Indirect System

the caliph at Sokoto, the headquarters of the Islamic state. The caliphate was made up of a number of emirates each headed by an emir whose appointment was subject to the caliph's confirmation. In this way the emir held allegiance to the caliph, receiving instruction and advice, and to some extent, orders from Sokoto. As part of the administration of the caliphate, there was a judicial system based on the Islamic law, the *shari'a*, administered by learned judges, the *alkali*. The caliphate also had a system of public revenue derived from taxation.

This centralized political authority established by the Sokoto Caliphate proved effective for running of the indirect rule system. Lugard simply recognized the authority of the emirs, and created a "Native Authority" under their political leadership. The emirates were transformed into new administrative divisions, and the emirs came under the direct supervision of district officers. The existing system of taxation in the caliphate was turned into a "Native Treasury." The emirs were invested with the power to collect tax, a bulk of which went to the colonial administration, and some of which provided the revenue for the "Native Authority" administration. The *alkali* courts were also constituted into a "Native Court" under the authority of the emir.

Lugard, however, modified the system to suit the purposes of the British colonial system. Sokoto's authority over the caliphate was largely assumed by the central colonial administration. Stripped of his power to supervise the emirates, the caliph was reduced to a mere religious leader. Allegiance of the emirs to the caliph was then transferred to the colonial authority. Indeed, the emirs no longer held their offices at the pleasure of the caliph, but at the discretion of the colonial governors who appointed them. Lugard, for example, appointed the pliant and cooperating, Muhammadu Abbas, as the emir of Kano in 1903 and H.R. Palmer appointed Durbi Muhammadu Dikko for Katsina in 1907.[6] To further their control, the British often removed, and sometimes exiled or imprisoned non-cooperating emirs from office. In Daura, the ruling emir was deposed and a replacement found in a pre-caliphate ruling family.

On the other hand, cooperative emirs received rewards in many ways. For instance, they drew high incomes as attested to by the Emir of Kano, whose salary in the 1940s was £8,000, and an allowance of £2,500.[7] They also received the backing of the colonial authority against rival claimants to power. In this way, the emirs could enhance their authority and assume important powers such as the control of the "Native Police" and the prisons. Some increased their power beyond what tradition allowed. However, in reality, their freedom to rule independently was significantly curtailed since they owed their income and position to the colonial authority.

The resident or the district officer did not relate to the native authority administration merely in an advisory capacity as the system portrayed. His 'advise' to the emirs, especially on matters of importance to the colony, constituted an instruction which the emirs often had no option of refusing. Although the emirs controlled the local treasury and the administration of justice through the courts and police, practically all their actions were still subject to the district officer's approval. For example, the district officer constituted an appeal court beyond the "Native Court." He approved lesser chiefs appointed by the emirs and also reviewed the budget of the "Native Authority" administration. The colonial official was, in reality, a behind-the-scenes manipulator of "Native Authority," which had to operate within the parameters of the regulations established by the colonial authority.

6. J.F. Ade Ajayi and Michael Crowder (eds.), *History of West Africa, Vol. II* (Essex: Longman Group, 1987), 499.

7. Memo for the President from William J. Donovan, Feb. 27, 1942, President's Secretary File (PSF), Diplomatic Correspondence, West Africa, Box 53, Franklin D. Roosevelt Library, Hyde Park (FDRL).

But interference in indigenous institutions did not go all the way. To ensure stability and peace, the British colonial officials reasonably enough refrained from changing certain traditional institutions. The most obvious was Islam, the established religion of the Hausa-Fulani after the *jihad*. Believers were allowed to pursue their faith, and colonial officials actually discouraged British missionary activities in Northern Nigeria. The "Native Court" continued to function under the *shari'a* system, although certain aspects distasteful to the colonial administration were discouraged.

Indirect rule worked well for the British in Northern Nigeria where the preexisting hierarchical political authority of the Sokoto Caliphate enhanced it. Through the emirs, who were usually very autocratic, the colonial authority was able to govern the people effectively. British directives reached the subjects through their emirs whose authority ensured compliance.

A key aspect of indirect rule in Nigeria was the pervasiveness of the powerful indigenous chiefs. As much as possible, the British retained the traditional chiefs, especially when they proved to be willing tools of the colonial system. When these rulers were removed because of non-subservience to imperial lordship, new appointees from royal families were often found with some claim to traditional authority. When Lugard amalgamated the Northern and Southern Protectorates in 1914, he introduced indirect rule to the south, hoping to find and use powerful chiefs equal to the emirs. This proved difficult. Among the Igbo of the southeast, powerful traditional authority did not exist, and it was weak among the Yoruba of the southwest. In areas where traditional authority did not exist at all, colonial administrators created it by inventing chiefs drawn from the ranks of people who had demonstrated previous loyal services to the colonial authority. These people had served in some menial capacity — such as interpreters, clerks, and servants to the colonialists — but they had no legitimate claim to chiefly authority.

The unsuitability of indirect rule to areas without centralized political authority was amply demonstrated in Eastern Nigeria. Unlike the Hausa-Fulani of the north with recognizable traditional authority, the Igbo lacked the authority of paramount chiefs. Living in independent village communities, the Igbo political system was largely a fragmented one. The highest political authority was the village government where the elders could only make political decisions with popular consent. Without traditional chiefs, who could legitimately exercise political authority, indirect rule in Igboland was unworkable. Lugard's solution to this problem was to create his own chiefs who were invested with authority to rule like monarchs. These invented chiefs became known as "warrant chiefs." Though they lacked traditional relevance, their warrant to rule was expected to enhance the authority now bestowed on them.

Lugard's action constituted a flagrant disregard for the Igbo political culture. The "warrant chiefs," some of whom had had no significant social standing in the society, were supposed to rule over people who had never submitted to any autocratic traditional authority. The "chiefs" naturally could not play the role of the emirs of the north. Not only were they deeply resented, but their corrupt practices and arbitrary use of power, especially through the "native courts" and the "native police," invited opposition. Anti-tax riots, like the famous 1929 Aba Women's Riot, was triggered by the prospect of imposing regular taxation on women by the colonial government. This riot was as much against the colonial masters as it

was against their agents, the warrant chiefs.[8] Indirect rule in Igboland, without recognizable legitimate chiefly authority, proved to be a monumental disaster.

Among the Yoruba in Western Nigeria, while indirect rule was not exactly a total failure as in Igboland, it did not match the northern success. In extending indirect rule to the west, Lugard failed to understand that the Yoruba traditional rulers, the *obas*, were not as authoritarian as the northern emirs. While a centralized political system existed among the Yoruba, the *oba's* position was akin to that of the emir. Not only was the Yoruba centralized political system severely weakened by the early twentieth century, but also the *oba* had never exercised the authoritarianism of the emir. His power was limited by a complex system of checks and balances, which ensured that authority was divided among chiefs who, though subordinate to the king, were by no means under his control. For instance, in the case of Oyo, one of the most prominent Yoruba towns, a council of chiefs, the *Oyomesi,* could pronounce a death sentence on the king, the *Alafin,* if he became too despotic.

Under indirect rule, the British tried to increase the *obas'* authority beyond traditional practice. In Oyo, in particular, the *Alafin* assumed new and wider powers contrary to the traditional dictates of his office and the reality of changed times. In enhancing the *Alafin's* authority, Lugard hoped to make him equivalent to the caliph of the Sokoto Caliphate, to whom the other Yoruba kings would be answerable. Lugard's mistake was his apparent lack in understanding early twentieth century Yoruba history.

Oyo, a once powerful kingdom had lost its power and dominance in Yorubaland, and in its place had emerged other kingdoms, the most prominent of which was the militaristic state of Ibadan. To return to the heydays of Oyo's supremacy in Yorubaland, where the *obas* would hold a paramount position by the design of indirect rule, was a proposition many people were not willing to accept. Opposition was rife, particularly as the *Obas* attempted to fulfil their role as the colonial government's tax collecting agents. In many places, Iseyin and Abeokuta, for example, there were protests against forced taxation. The tax riot of 1916 at Iseyin, a dependent town of Oyo, was a reaction against the attempt of the *Alafin* to impose direct taxation on the people of the town. The Egba tax riot of 1918 at Abeokuta was even more violent, requiring about a thousand troops to put down, and claiming about five hundred lives.[9] In summary, indirect rule met with little success in Yorubaland.

The Ideology of Colonial Policies

A broad range of administrative policies guided the European powers in governing their colonies. These policies could be identified as "assimilation," "collaboration," "separate development," and "paternalism." Although they differed in goals, the policies shared the same racist premises of European superiority.

The late-nineteenth century, which was the consolidation period of European rule in Africa, was also the beginning of the rise of pseudo-scientific racism in Eu-

8. A brief account of the riot is provided in Elizabeth Isichei, *A History of Nigeria* (London: Longman, 1983), 399–401.

9. Isichei, *A History of Nigeria,* 389.

rope. Various theories advanced the notion of European superiority. It was assumed that world cultures were at different developmental stages, ranging from savagery to civilization. While other cultures were still far behind, European culture, it was claimed, had already attained the highest level of civilization. Colonial administrative theory was naturally influenced by the prevalent racist thought in Europe. By subscribing to an idea of the superiority of European culture over that of Africans, colonial administrators felt justified by the notion that they had a God-given mandate to bring "civilization" to Africa.

While one or the other of the theories identified above guided the colonial powers in their administrative policies, these policies were often modified. Some colonial powers initially utilized one policy only to abandon it later for a different one. Since policy implementation was the direct responsibility of colonial officials in the field, their discretion often dictated the extent to which policy guidelines were adhered. Nevertheless, as will be shown, it is possible to identify given colonial powers with particular policies.

Assimilation Policy

Assimilation policy aimed to Europeanize Africa, so that it could be tailored along the lines of Euro-Christian culture and civilization. This policy sought to see African societies adopt European social, economic, and political institutions. It assumed that to the extent African societies could be transformed along European lines, they would eventually become an integral part of the metropolitan country.

Assimilation policy, typically identified with the French, rested on the notion that French culture was so advanced that it ought to be imposed on what they perceived as a less civilized people. This policy proceeded from the assumption that Africans were culturally inferior and that they could be advanced only if they were assimilated into the French culture. This evolutionary process meant that Africans would abandon their culture to become assimilated Frenchmen. Their political, economic, and social institutions would yield to French ones.

As assimilated people, Africans in the colonies were theoretically French citizens, endowed with the same rights as their counterparts in France proper. The colonial empire was regarded as part of metropolitan France, save that it was separated by distance from the "mother" country. As *France Outre-Mer* (overseas France), the French transferred to the colonies their administrative and legal systems. The *Quatre Communes* (four towns) of the colony of Senegal—namely Dakar, St. Louis, Goree, and Rufisque—held a status akin to the *departements* in France. Assimilated Africans held important positions in the municipal councils that resembled those in France. They also elected local representatives to the *Conseil-General*. As black Frenchmen, they could even elect their representatives to the Chamber of Deputies, the French parliament in Paris.

In practice, however, the assimilation policy did not work as theorized. It could never be widely applied throughout the French colonial empire. Qualification for French citizenship was stiff, often including the ability to speak and write French, adherence to the Christian faith, and previous French employment. Only a handful of Africans, particularly in areas designated as *departements*, met such qualifications and actually became French citizens. As late as 1945, assimilated Africans in the whole of French West Africa numbered less than 100,000. Only in the *quatre communes* of Senegal did assimilation policy produce sizable Black Frenchmen. In

the rest of the French colonies, while a small number of Africans were assimilated, for instance, in Algeria, the vast majority remained unassimilated.

The assimilation policy had an important effect on the French colonies, especially in Senegal, where it had its greatest impact. It divided the colonial people into two socio-economic classes. On one hand were the *evoloues*, the assimilated Africans with the benefits and rights of French citizenship. Small in number, they became influential and important as a result of their access to higher education, sometimes even in France itself. They were also able to acquire some level of political participation in the colonial administration. Many of them were proud to be Frenchmen who adored the French culture and civilization. Many were so enwrapped in the mentality of being French citizens that they did not, for a long time, entertain the possibility of African nations existing independently outside the French federation.

On the other hand were the *indigenes*, who constituted the bulk of the colonial population. These were the unassimilated "native" people who lacked all the democratic rights and privileges of their counterparts who were French citizens. As *indigenes*, they were subject to direct taxation, and to what the French called *prestation*, a system of forced labor. They were also subject to the *indigenat*, the summary administrative justice under which colonial officials could imprison someone for up to fifteen days without due process.[10]

The failure of assimilation as a policy was soon apparent to the French colonial authority. With the possible exception of Senegal, in no other part of the French Empire were they able to impose their supposedly superior culture on a large number of people. Eventually, assimilation had to be abandoned altogether and the French toyed with an alternative policy known as "association." This policy which was expected to bring mutual benefits to the French and Africans alike was never really implemented. The depression of the 1920s and 30s derailed it.

But France was not the only European power to adopt an assimilation policy. Portugal adopted a similar system where its colonies of Angola, Mozambique, and Portuguese Guinea were, theoretically, constituent parts of Portugal. In these colonies, regarded as "overseas Portugal," attempts were made to assimilate Africans into the Portuguese culture. Again, as in the case of France, just a tiny section of the colonial population could be assimilated and thereby granted Portuguese citizenship and some civil rights. However, unlike the assimilated Frenchmen in West Africa, the *assimilados* in Portuguese Africa lacked any real political rights, the only exception was during the republican period in Portugal (1910 to 1926) when some in Angola were able to elect representatives to the parliament in Lisbon. The *assimilados*, in any case, were better off than the majority of the population that remained unassimilated subjects. The latter were subject to all forms of racist rules. Eventually the Portuguese like the French dropped assimilation.

Collaboration Policy

The collaboration policy shared the conversionist ideology of assimilation in that African societies should be transformed according to European modes of de-

10. For more on the *indigenat*, see Michael Crowder, *West Africa under Colonial Rule* (Evanston: Northwestern University Press, 1968).

velopment. This policy, however, was less radical in the degree of African conversion to European civilization. It stopped short of making the colonies a part of the metropolitan country as expected by the policy of assimilation.

The early British colonial policy in its West African coastal territories of Bathurst, Freetown, Accra, and Lagos, exemplified the collaboration policy. In the late nineteenth century, the British sought to impose their political and judicial institutions on the colonies. The colonial towns were to be governed just as English towns were, under municipal governments with elected town councils. Africans were also to be converted into the British way of life, and as such would be able to assume a partnership position with the British in administration, commerce, religion, and other areas of colonial life. Although the British did not regard the Europeanized Africans as equals, they were still permitted to occupy positions of responsibility. This handful of educated Africans could be found in important partnership positions in the colonial administration. They served at every level, in the executive, judicial, and the legislative branches, as well as in the civil service. Particularly, the system of municipal administration had prominent African representation. This was true of the municipalities of Freetown, Accra, the Cape Coast, Sekondi, Lagos, and Calabar in the 1850s. In 1888, the Municipal Ordinance enacted in the Gold Coast even gave Africans the majority of the elected seats.[11] Also, the Freetown Municipal Council established in 1893 provided for an African mayor and an African majority.

The educated class in coastal British West Africa saw Western education and the acceptance of Western culture as a sure path to advancement in the changing world of European hegemony. With the encouragement of the British authority, they struggled to acquire Western values, sometimes at the expense of their own African culture. British collaborationists assumed that adopting a European lifestyle would serve the Africans well in their role as associates in the operation of Western-style institutions established in the colonies. However, the British had no particular interest in turning Africans into Black Englishmen with rights equal to British citizens. Nor was it their aim to constitute the colonies into a kind of "outer" Britain, an extension to the metropolitan country. The educated Africans, the so-called "detribalized" or "civilized" elements of the coastal towns, were consequently made British subjects, not citizens, like their assimilated counterparts in French West Africa.

Separate Development Policy

The separate development policy is based on the premise of a cultural difference between Europeans and Africans. This policy is best identified with the British who, in the manifestation of racial arrogance, believed that their culture was far too advanced for Africans to understand and acquire. Since African culture was incapable of being Europeanized, it was thought that the best option was to preserve African traditional institutions in so far as they did not run counter to imperial interest. Under this policy, Africans were not to try to emulate the British way of life but should be encouraged to retain their own identity under the super-

11. For the history of municipal government in the colony of Gold Coast, see David Kimble, *A Political History of Ghana: The Rise of Gold Coast Nationalism, 1850–1928* (Oxford: Clarendon Press, 1963), 360–361, 418–426.

vision or tutelage of the supposedly racially superior British. Such subjugation was considered to be in the best interest of Africans.

The separate development policy was a later phase of the British Empire. From the late nineteenth century, the British colonial attitude toward its empire changed significantly from one of encouraging Africans to acquire a Western attitude to one of discouraging it. Britain no longer believed in the wisdom of creating a class of Westernized Africans like the Creoles of Sierra Leone. The root cause of this policy change was the rise of racism in Europe that castigated Africans as being eternally inferior to Europeans. As Britain expanded its territorial acquisition in Africa, it was increasingly difficult to extend western models of administration, already in use in urban coastal areas, into the newly conquered interior territories. As much as possible, the establishment of British institutions was curtailed. Where British political institutions already existed, like the municipal governments of Freetown, Accra, and Lagos, African participation was gradually reduced. In Sierra Leone, for example, Governor Frederick Cardew's policy in the late 1890s systematically eliminated educated Creoles from government positions, replacing them with Europeans. So many Westernized Africans were eliminated from prominent positions in British West Africa that, by the first decade of the twentieth century, only an insignificant number remained in the municipal governments and legislative councils. Even then, the very few Africans remaining in the colonial service were in positions where they did not hold real power over policy matters.

The introduction of indirect rule with its use of a traditional elite rapidly contributed to the decline of the African intelligentsia as associates of Europeans in the colonial project. The ideological foundation on which the indirect rule system rested was the separate development policy. To a large extent the system preserved traditional institutions and discouraged the western model of modernization. Where it succeeded most, in northern Nigeria, it minimized western influence. Colonial officials refrained as much as possible from effecting change that would alter the traditional status quo. By discouraging the growth of western culture, they sought to promote indigenous culture. The system subordinated the African educated elite to the traditional one. Side-tracked in the colonial scheme, the educated elite found itself pitched against the native authority which, in their view, was the agent of the British.

The separate development policy could not, however, totally obliterate the growth of British civilization in the colonies. The work of the Christian missions was necessarily accompanied by the spread of a European attitude. The mission churches and schools frowned at many African traditional practices that they considered inimical to Christian behavior. The products of mission education were often Eurocentric in outlook. Their view of modernization and development was basically through the lenses of European civilization. The spread of the faith thus became an inevitable instrument for social change and propagation of Euro-Christian culture and civilization.

Administrators often realized that they could not do without the services of Africans who had some level of western education. For instance, they needed interpreters and clerical staff for the civil service, which they had to draw from among literate Africans. Ultimately, they had no option but to continue to make Western education available to Africans even though quite often they tended to limit this to a minimal level of instruction.

Paternalism

The premise of a paternalistic theory was also that the African's alleged racial inferiority precluded them from grasping European culture. Since it was impossible for Africans to be westernized, they must adhere to their own so-called inferior culture. This paternalistic doctrine viewed Europeans as having a duty to rule Africans who were allegedly innately inferior. Paternalists held a belief that Europeans, as custodians of a "superior" civilization, had a benevolent responsibility toward Africans, a responsibility akin to that of a father to his children. The Belgian colonial policy, for example, regarded Africans as eternal children requiring the fatherly direction of Europeans.

In its less radical form, paternalism assumed that there would be a time, though it might be long, when Africans would be capable of self-determination and Europeans would relinquish their stranglehold on imperial empires. This strand of paternalism projected an eventual goal of independence for the colonies. However, a more extreme variant of paternalism, which can be described as "racial subordination," held that the supposedly racially "inferior" Africans should be permanently subordinated to the Europeans. It did not envisage eventual independence for the colonies but, rather, hoped for permanent European dominance. In this extreme racist view, Africans were seen as eternal children incapable of self-rule. According to this doctrine, only under European rule could Africans enjoy the benefits of a superior civilization, because, on their own, they were incapable of developing it.

It must be stated that this extreme view of paternalism was not very popular among most colonial officials. Its greatest proponents were the white settlers who formed a small but powerful minority in settler colonies. Virulently racist, often more than colonial officials, the white minority groups often aspired to a partnership position with the colonial authority in the colonial administration. In some colonies, such as Kenya, the colonial authority resisted the settlers' demands for political dominance, although it granted considerable concessions to them. In most places, however, they were able to achieve representation in the colonial government. But the settlers achieved much more than this in Rhodesia and South Africa where they were able to hold political power to the detriment of the majority African population. The apartheid system that was later imposed on South Africa by the *Afrikanner* government symbolized the extreme form of racial subordination.

Conclusion

When the colonial powers conquered African territories, their primary motivation was economic exploitation. Once the territories were occupied and the people subjugated (misleadingly termed "pacification"), it was quite obvious that the goal of exploitation could not be achieved without an atmosphere of peace and orderliness. The Imperial powers quickly realized the need to set up colonial administrations to aid in the systematic extraction of Africa's resources.

In formulating colonial policies and setting up administrative structures, the European powers were confronted by a range of possibilities. Were they to rule

the conquered people directly or indirectly through existing traditional institutions? Would the colonial empire be constituted as an integral part of the metropolitan country, or would it remain a separate entity? Would Africans be absorbed into the culture of the colonizing power, or would they be encouraged to adhere to their culture?

At times, answers to these questions were provided by the set of circumstances the colonialist found in their conquered territories. For instance, in places where they found strong traditional authority, indirect rule became a very important tool of local government. Where they misjudged the prevailing situation, as in Eastern Nigeria where they introduced indirect rule, colonial policy was a failure. Often times, European pre-conceived ideas about non-Western peoples dictated the kinds of policies deemed fit to exist between the colony and the metropolis. Such policies were often influenced by European cultural arrogance that cast Africans as inferior to Europeans. Whether it was the more subtle conversionist theory of assimilation that sought to turn Africans into Europeans or the extreme form of paternalism that envisaged perpetual subordination of Africans to Europeans, colonial policies were tainted by the late nineteenth century pseudo-scientific racism.

Even though African realities and European ideas about non-Western peoples provided the framework for colonial policies, in practice such policies were hardly fast and unchangeable. There were often adjustments, modifications, ground shifting, and even outright abandonment of policies. France and Portugal, for example, retracted from their policy of assimilation.

Review Questions

1. Describe the general structure of the colonial administration. In what way was the organization of the French Empire in West Africa different from that of its British counterpart?
2. Explain the British indirect rule system. Why was it a success in Hausaland and a failure in Igboland?
3. Describe the French Policy of Assimilation. Assess the policy in French West Africa.
4. Account for the initial British policy of collaboration in the coastal towns of West Africa. Why did the British abandon this policy for "separate development" in the late nineteenth century?"
5. Discuss the paternalistic colonial ideology applied to settler colonies.

Additional Reading

Asiwaju, A.I. *Western Yorubaland Under European Rule 1889–1945: A Comparative Analysis of French and British Colonialism*. London: Longman, 1976.
Gann, L.H. and Peter Duignan. *Colonialism in Africa, 1870–1960*, 5 vols. Cambridge: Cambridge University Press, 1969–1972.
Nicolson, I.F. *The Administration of Nigeria 1900–1960: Men Methods and Myths*. Oxford: Clarendon Press, 1969.

Phillips, Anne. *The Enigma of Colonialism: British Policy in West Africa*. London: James Currey, 1989.

Ponte, Bruno da. *The Last to Leave: Portuguese Colonialism in Africa*. London: International Defence and Aid Fund, 1974.

Young, Crawford. *The African Colonial State in Comparative Perspective*. New Haven: Yale University Press, 1994.

Chapter 5

The Political Impact of European Rule

Femi J. Kolapo

In the violence associated with colonial occupation, many precolonial African rulers, military leaders and a significant population of young warriors lost their lives. This opened Africa to easier social and economic restructuring by the colonizers. Indigenous African governments were dismantled, modified or replaced, and new political boundaries corresponding to the colonizers' spheres of interest replaced indigenous ones.

Quasi-modern bureaucratic administrative infrastructures were introduced but the basic organ of colonial administration remained the precolonial local chieftaincy with more or less drastically transformed status and roles. Also, new forces unleashed by colonialism transformed sociopolitical identities. New ethnic identities were forged and the scopes of old ones transformed, but in other respects, ongoing local processes of sociopolitical integration were truncated.

This chapter begins with a picture of the tragic impact of the European military occupation of Africa and the subsequent elimination of much of Africa's indigenous leadership. Following this is a discussion of the loss of sovereignty by African states as a result of colonial occupation, the ensuing boundary demarcation and the new or modified social and political structures that emerged between 1885 and 1939.

* * *

Colonial Occupation and Africa's Indigenous Political Personnel

Patrick Manning noted that colonial conquest brought Africans and their rulers deep political humiliation. Many African rulers were killed in battle resisting conquest or died later from battle wounds. Others were demoted, dismissed altogether or exiled.[1] Widespread death among the African rulership was a blow to traditional political structures and arrangements. The elimination of African rulers by execution, exile, and dismissal created political vacancies *en masse*. Indigenous political structures and leadership selection mechanism were subjected

1. P. Manning, *Francophone Sub-Saharan Africa 1880–1985* (Cambridge: Cambridge University Press, 1988), 57.

to tremendous stress and in some cases to outright crisis. Moreover, huge numbers of young adult soldiers and recruits were killed in various military encounters during the period of colonial aggression. Colonial occupation and pacification wiped out a large number of Africa's political, cultural and, in some cases, religious leadership. This generation of military-political personnel undoubtedly constituted a sizeable proportion of those imbued with the local political and cultural ethos.[2]

These African leaders were the first line of defense of the indigenous cultures against the imperialist colonial onslaught. With the elimination of this important group of military-political personnel across the continent, the African psyche as well as the precolonial African institutions and practices, were greatly weakened.[3] Nonetheless, the outbreak of insurrections, riots and other forms of protests by the surviving members of the precolonial African leadership demonstrated the resilience of African political structures. In spite of such efforts, the elimination by military force of this primary layer of protection over African societies and the

2. Below is a sample list of African casualty caused by European wars of colonization gleaned from sources used for this chapter.

		
1892	Dahomey encounter with French	almost all the Amazon killed and 3,000 wounded
1894	Benhazin the last Dahomian king was captured	removed
1886	Lat Dior, Damel of Cayor killed by the French	killed
1892	One of Samori Toure's battle with the French	about 1,000 men killed
1898	Samori Toure's capture	exiled
1900	Rabih Ibn Abdallah of Borno	killed
1901	Fad'lala, Rabih's son and successor	killed
1891	Yeke ruler Msiri of Katanga	killed
1897	Queen Ranavalona III of the Imerina kingdom	exiled
1900	Asantehene Nana Prempe, the Queen [mother] Edweso, Nana Asantewaa and military-political personnel	exiled
1894	Nana Olomu of Itsekiri	exiled
1887	Jaja of Opobo	exiled
1899	Kabarega of Bunyoro	exiled
1899	Mwanga of Buganda	exiled
1885	Muhammad Ahmad al-Mahdi of Sudan	killed
1899	Khalifa Abdullah killed wounded	20,000 wounded, 15,000 killed
1908	Abd al-Kadir Muhammad Imam, Wad Habuba A Mahdist leader in the Sudan	executed
1931	Sayid Muhammad of Somalia Umar al Muktar	died in war, executed
1930–32	Italian war against Lybia	30,000 died in concentration camps
1932	Yusufu Abu Rahil, Umar al Muktar's success	killed
	Seku Ahmadu of Tukulor empire	exiled, 3,000 killed in the last battle alone
1879	Zulu King Cetshwayo	exiled
1905	Kijikintile Ngwale Tangayika	killed
1894	Mkwawa, Hehe leader. He had been hounded all over East Central Africa	committed suicide
1890	Abushiri of Kilwa	executed

3. W. Rodney, "The year 1895 in southern Mozambique: African resistance to the imposition of European colonial rule," *Journal of the Historical Society of Nigeria* 4 (197): 509–36.

Figure 5-1. Part of the Palace of a Yoruba king — modern architecture was part of the new changes

subsequent crisis of confidence among Africa's leaders opened the door to colonial administrative and economic restructuring policies. In fact, stable colonial administrative structures did not emerge until this crop of African leaders had been subdued or removed.

This period of general peace that is usually associated with the imposition of colonial rule should be viewed in this context. The conquest process knocked military power and political authority out of the hands of the precolonial political elite, scattered or destroyed their military forces, and conquered their states.[4] The success of this process generally precluded any independent ability of the surviving African leaders to demonstrate their historical will to wage war against neighbours, engage in interstate political negotiations, carry out national economic policies, or exercise effective and widespread judicial authority. An evident political outcome was that a great number of military-political centers within and between African states that had been hostile rivals and that had coveted their neighbours' territories, were swallowed up. They were subsumed under a few, new and powerful colonial states dominated by a European elite and aided by African auxiliaries. In other words, a larger and more powerful political perimeter had been imposed from the top, within whose confines previously independent struggles, negotiations and renegotiations were made nearly irrelevant. This *pax coloniale* was, however, brought about only at the end of the military violence of conquest and "pacification." Moreover, the likes of such military violence had never been encountered by most African societies.

4. A.E. Afigbo, "Social Repercussion of Colonial Rule: The New Social Structures," in A. Adu Boahen (ed.), *UNESCO General History of Africa. VII. Africa under Colonial Domination 1880–1935* (Paris: UNESCO, 1985), 492.

For some of the military-political elite, the appearance of the European colonizers afforded an opportunity to employ outside military or economic resources in internal politics. J.D. Hargreaves, in a different context, noted that "among the short-term advantages obtainable from treaties or from collaboration with Europeans were not merely access to fire-arms and consumer goods, but opportunities to enlist powerful allies in external or internal disputes."[5] This development in Buganda, Kaarta in Bambara, and on the Gold Coast among the Fante, predated 1885. Moreover, the military-political elite of some neighboring states were able to manoeuver themselves and their states into more advantageous positions vis-à-vis their rivals. Buganda, Bunyoro, the Imerina kingdom of Madagascar, Porto Novo, Katanga, and Tukolor empire of Ahmadu Seku were examples of the latter reaction to imperialist incursion.[6] In previous centuries up to the late nineteenth century, African utilization of external influence usually pertained to religious or military principles or resources that were able to enrich the society at large or certain sectors of it. Islam, for example, was employed in the internal state formation processes in different parts of Africa.

The Loss of Sovereignty

The immediate and palpable effect of European colonization of Africa was the loss of political independence. Liberia, and Ethiopia until 1935, were the only exceptions. The combination of superior military, transport and telecommunication technologies ensured the defeat of African states. Ultimate defeat was, of course, also facilitated by rivalries and antagonisms generated by ongoing internal processes of territorial expansion. Unstable sociopolitical bases of some of the conquest states like those of Msiri or Ahmadu's Tukulor and the hostilities such states had generated among themselves precluded unity of action against foreign invasion.

Where African indigenous structures of governance were not totally destroyed as in Uganda, Northern Nigeria, Morocco and Yorubaland, their surviving administrative structures were each brought under foreign control.[7] Direct military violence was excluded in the occupation of some African states. Some states tried to negotiate favorable submission terms, hoping to play different colonial powers against each other as Lobenguela the Ndebele King or Lawenika the Lozi paramount chief both did. Indeed, some states formed diplomatic alliances with the colonizers, like Swaziland, Bechuanaland and Nyasaland, thereby achieving some measure of success when they were able to negotiate a protectorate rather than a "full-fledged" colonial status.[8] In other cases, the colonialists achieved overlordship through a combination of threat of force and diplomacy, as was the case in the Senegambia, with Sine and Salum, or as in most of the Yoruba

5. J.D. Hargreaves, "West African States and the European Conquest" in L.H. Gann and P. Duignan (eds.), *Colonialism in Africa, Vol. 1: The History and Politics of Colonialism* (Cambridge: Cambridge University Press, 1969), 205–206.

6. A. Boahen, African Perspectives on Colonialism (Baltimore: John Hopkins University Press, 1987), 41–44; for the Bambara example, see A.S. Kanya-Forstner, "Mali-Tukulor" in M. Crowther, *West African Resistance* (London: Hutchinson & Co. Publishers, 1971), 64.

7. A.E. Afigbo, "Repercussion of Colonial Rule," 492.

8. Boahen, *African Perspectives*, 40.

states. However, the administrative rearrangements and fiscal or economic policies that were initiated by the colonizers resulted most often in revolts that had to be crushed by force.[9] In fact, the majority of African states (much of French Equatorial Africa being notable exception) had to be militarily subdued to be brought under colonial governance.[10]

This process was hardly restricted to West Africa as North Africa ably demonstrates.[11] The colonial conquest of the Maghrebian states, excepting Morocco (1899), predated 1885. Algeria was colonized in 1830, Tunisia in 1818, Egypt in 1882, and Tripolitania in 1911. In Algeria, the French were forced for several decades after 1830 to fight the Berbers of the interior who would not accept foreign domination. Meanwhile, the army of the Dey, the Algerian ruler, and his administrative structure and personnel had been taken apart by the French. The nominal sovereignty over Algeria held by the Ottoman Caliph thus had effectively passed onto the new occupying power. In 1899, the French invaded In Salah, defeated the forces of the local chief, an appointee of the Moroccan Sultan, and by 1901 had all of Tuat conquered and effectively excised from Morocco.

Morocco itself was occupied by French troops in 1912 and a protectorate was imposed over the country. As was the case in Algeria, the Berbers of bilad *assiba* in the interior mounted a resistance that was not easily subdued. The French, in this case, as with Algeria, directed their wars against the Berbers from a position of military and political supremacy from within the country. In 1911, Italy invaded and occupied Tripoli and a few other coastal cities of Tripolitania. With the assistance of European international diplomacy, Turkey was pressured to grant "independence" to Tripoli, thus losing its sovereignty over the province. Italy seized on this situation to renew its attacks on Libya, and while resistance continued through the First World War, the European colonizers were already established as the new overlords.

The colonial conquest experiences of Tunisia and Egypt were exactly along these lines, although a protectorate was not officially declared over Egypt until 1914. However, a number of ethnic peoples, the *Bedouin* and the Berbers of the Atlas and the interior of the Maghreb, as well as some *zawiyas* (religious brotherhoods), organized independent government structures that long resisted the invaders. Nevertheless, these local administrative structures and activities occurred in the context of resistance or rebellion to an imperial military/political order that had been imposed on them from outside. In this respect, their activities were a reaction to their loss of independence.

In Northeast Africa, the Sudan, from 1881, came under an independent Mahdist government that had driven out its Egyptian colonizers.[12] Purportedly helping Egypt to reconquer the Sudan, British soldiers, with some Egyptian army

9. Chapters 3–10 of *UNECSO General History of Africa. VII* give detailed region by region examination of African resistance to colonization.

10. For details of such activities in West Africa, see M. Crowther, *West African Resistance.*

11. The discussion of the colonial invasion and resistance efforts in North Africa is based on A. Laroui, "African Initiatives and Resistance in North Africa and the Sudan" in *UNESCO General History of Africa. VII*, 87–113.

12. The discussion of the colonial invasion and resistance efforts in Northeast Africa is based on H.A. Ibrahim, "African Initiatives and Resistance in North-East Africa" in *UNESCO General History of Africa. VII*, 61–86.

units, invaded the Sudan in 1896. Between 1898–1899, they had effectively de-
stroyed the Mahdist government. While Britain declared that it was jointly ruling
the Sudan in a condominium arrangement with Egypt, the British governor-general
exercised virtual political power over the territory. Then, following an assassina-
tion in 1924, Egyptian army units were ordered out of the Sudan, and British and
Sudanese administrative officials replaced their Egyptian counterparts. The façade
of condominium was removed and the British assumed open sovereignty over the
Sudan, establishing direct colonial administration over the territory. The Nuba,
Nuer and Azande peoples of the Sudan, who all struggled to maintain their sover-
eignty, were each conquered. Between 1885 and 1897, Somaliland came under
colonial domination by the French, British, and the Italians. Protectorate treaties
were obtained in the coastal provinces mostly without recourse to military vio-
lence. However, some local Somali clans refused to surrender their independence
easily, thus calling forth military expeditions against them. Indeed, between 1900
and 1920, a mahdist movement that was able to unite the Somali people fought to
maintain their independence until its leader Sayyid Muhammad was killed.

In East Africa, the Nandi of Kenya between 1890 and 1905, Kilwa state, Bun-
yoro, embarked on spirited military resistance. Others like the Kikuyu, the Masai
and Luo groups, and the Baganda entered into series of diplomatic negotiations
with the British invaders. All these were various ways by which the peoples felt
they could protect or prolong their sovereign status from the British and German
imperialists. The same pattern obtained in Central Africa. Some centralized states,
and especially those that had prior contacts with European or Arab traders put up
violent resistance to colonization and many that submitted peacefully or em-
barked on negotiations soon rose in attempts to regain their independence.

In Southern Africa, as in West Africa, colonization truncated ongoing mili-
tary/political developments. The political expansion of the Zulu, Ndebele and their
Ngoni offshoot in Central Africa, as well as their successful sociopolitical device of
incorporating conquered peoples into their revolutionary kingdoms, were cut
short. On the other hand, the Swazi, Sotho, Lozi and other non-Nguni groups, as
was the case with many other African societies threatened by powerful neighbours,
seized on diplomacy to manipulate the powerful forces of imperialism to their de-
fence by accepting, and sometimes openly soliciting for, protectorate status under
Britain. Indeed, these moves could be seen as potent diplomatic instruments with
which they partially preserved their distinct status as separate peoples under their
own governments. The Twana, who were also in fear of take-over by the Boers of
Transvaal and the settlers of Cape colony, strenuously petitioned for direct British
protectorateship. In the end, by the late 1890s all of the peoples of Southern Africa
had either lost their sovereignties or had replaced previous overlords with British,
German, British South African Company, or Boer domination.

With respect to the impact of colonial rule on Africa, J.A. Ajayi observed that
"once a people lose their sovereignty... they lose their right of self-steering, their
freedom of choice as to what to change in their own culture or what to copy or
reject from the other."[13] African states were deprived of the fundamental ability to

13. J. Ade Ajayi, "The Continuity of African Institutions Under Colonialism" in T.O.
Ranger (ed.), *Emerging Themes of African History: Proceeding of the International Congress
of African Historians held at University College, Dar es Salaam, October 1965* (Nairobi:
East African Publishing House, 1968), 196–197.

determine or control the patterns of their sociopolitical developments once they lost their sovereignty. Basic diplomatic relationships and understandings that had emerged among the states were distorted in some cases. Where indigenous reorganization of interstate and intra-society political and diplomatic hierarchies were taking place, whether within the context of military/political struggles or economic demographic processes, the take-over of supreme political authority by the colonizing Europeans constituted a major disruption or modification. This was made worse by the fact that the modifications were not predicated on internal factors that derived from the current of local history, but were mostly extrinsic and in some cases happenstance. As Afigbo noted, the right of African states to participate directly in the affairs of the world community or even of their immediate regional neighbourhood was thereby disallowed.[14]

Inter-state and Intra-state Political Boundaries

An important follow-up to the loss of sovereignty by African states was the arbitrary, artificial and unilateral redrawing of the geopolitical boundaries of a considerable portion of Africa. The colonies formed entirely new political jurisdictional spaces into which African peoples were regrouped and within which they were administered. Most traditional borders between states, and to some extent those among peoples were disregarded, over-ruled or drastically adjusted. This is why a considerable percentage of the interstate borders are geometrical in shape. Uzoigwe noted that "some 30% of the total length of the borders were drawn as straight lines, and these and others often cut right across ethnic and linguistic boundaries."[15]

West Africa is the best example among African regions where colonial boundaries made two or three separate entities what used to be single states. These included the celebrated states and kingdoms of the Tukulor, the Sokoto Caliphate, Borno, the Mandingo state of Samori Toure and Borgu. Once divided, each was reconstituted into a new geopolitical unit in different colonies. Within the colonies, administrative divisions were sometimes as divisive of previous large state systems as were the boundaries between colonies. The French, especially, in pursuit of administrative uniformity, felt the need to dismember large state structures, curtail the political influence of powerful rulers, and more closely administer the smaller units under their chosen agents.[16]

The question of arbitrariness in the colonial boundaries has always come up in discussions about the partition of Africa. It has often been noted how fluid the precolonial African borders were. Attention has often been drawn to the "great number of small, tribal sovereignties which had been such a barrier to almost every kind of progress" and to the allegedly great job European partition did by

14. E.A. Afigbo, "Repercussions of Colonial Rule," 493.

15. G.N. Uzoigwe, "European Partition and Conquest of Africa: An Overview" in *UN-ECSO General History of Africa. VII*, 43–44; see also H.S. Wilson, *African Decolonization* (London: E. Arnold, 1994), 101.

16. M. Crowder, "West African Chiefs" in M. Crowder, *Colonial West Africa. Collected Essays* (London: Frank Cass, 1978), 214–215.

solidifying what, in effect, were indefinite frontiers, enclaves and boundaries.[17] Other commentators, referring to criticisms about the arbitrariness of colonial boundaries that were imposed on Africa, noted that all boundaries are artificial. This is to say, they are essentially an abstraction of political power within a definite territorial space, and that African boundaries were not unique in this respect.[18]

However meritorious these observations are, they should not divert attention from an important implication and consequence of the partition and occupation of Africa. This is that the indigenous dynamic for the demarcation of boundaries among African states and peoples was, by force of arms, over-ridden. Hence, while European boundaries might have been as arbitrary as colonial African ones, they were not imposed by non-European powers. They were reflections, at the time of their constitution, of the military-political and diplomatic capabilities of the European states. They defined the territory that each of the countries could effectively call its own for the purposes of political, economic and legal jurisdiction. Moreover, they represented previous centuries of autonomous European historical development. Africa's colonization, on the other hand, denied Africa the right to the unfolding of its internal historical dynamics. Africans were no longer able to constitute and reconstitute themselves in a manner appropriate to their characters and potentials. European colonization, through military force, put an end to this.

Henceforth, colonial boundaries that occupying powers negotiated among themselves became the bases for the international borders of modern African states, a very few irredentist cases been the exception.[19] The colonizing powers reconstituted Africa into geopolitical spaces that would facilitate their administrations, the introduction of their political and other ideals, and economic exploitation. All these factors essentially catered to the needs and aspirations of the colonizing nations. Ever since then, political initiatives, developments, and administrative arrangements in Africa have been largely patterned after Western systems and measured against European standards.

Equally important for considering the political impact of the colonial partition of Africa is the physical spaces and culture areas in which African peoples lived their day to day lives trading, grazing their livestock, worshipping and celebrating their religious and other cultural festivals which were also partitioned. In a checklist of partitioned culture areas resulting from the imposition of colonial rule, Asiwaju listed a hundred and three across all regions of Africa. In many cases, a boundary partition divided as many as four different culture groups and even more, while some of the groups were apportioned between three different

17. R. Oliver and A. Atmore, *Africa Since 1800* (Cambridge: Cambridge University Press, 1994), 125.

18. A. Allott, "Boundaries and the Law in Africa," in C.G. Widstrand (ed.), *African Boundary Problems* (Uppsala: The Scandinavian Institute of African Studies, 1969), 12; A.I. Asiwaju, "Global Perspective and Border Management Policy Options," in A.I. Asiwaju (ed.), *Partitioned Africans. Ethnic Relations Across Africa's International Boundaries 1884–1984* (London: C. Hurst & Company, 1985), 233–34; K.E. Svedsen, "The Economics of the boundaries in West, Central and East Africa" in Widstrand, *Boundary Problems*, 34–36.

19. A.I. Asiwaju, "The Global Perspective and Border Management Policy Options" in Asiwaju, *Partitioned Africa*, 234.

administrative areas.[20] With each colonial government bent on integrating its con-
quered subjects around one central political and administrative structure, people
previously belonging to the same state and who had focused their political lives
towards their single indigenous political centers, found themselves torn apart.
Their political foci were now forcibly redirected towards different political cen-
ters. Consequently, "different symbols of formal status, above all, citizenship, are
imposed on the same people."[21] The right of the people and their leadership to in-
teract officially and freely with other African neighbours was not only foreclosed,
it was, in many respects disallowed.[22] What used to be normal economic and so-
cial interaction among the same people became, with borderlines separating them,
illegal smuggling activities. The new invisible boundary lines dictated that the
same people experienced different regimes and different rates of taxation.[23]

In addition, inside each colony, the political significance of borders that were
previously inter-state became either invalid or were demoted in significance. The
Zulu state was balkanized into thirteen chiefdoms, Dahomey and Asante suffered
a similar fate during the early years of colonization. Seku Ahmadu's Macina em-
pire was dismembered, while the boundaries of the emirates of Sokoto Caliphate
that fell within the British colony of Nigeria were largely persevered. Territories
that were previously subject to the latter were several times rearranged and others
previously outside of its control were forcibly merged into its emirate system.
Thus, many who were previously separate polities were put together, not just
under one colonial government, but into one administrative sub-unit. All this re-
quired moderate to drastic adjustments of precolonial borders arrangements and
frontiers. While experiences differed from colony to colony, the exigency of colo-
nial administrative requirements ensured that all colonial governments actively
engage in this political engineering of African sociopolitical structures.

Political Structures and Political Power

By 1939, the civil administrative systems of the various colonial governments
had matured and come to possess the characteristics for which they became so
well known. As shown in Chapter 4, the establishment of colonial administration,
whether it was direct or indirect, and whether it was based on assimilationist or
associationist principles, confronted African peoples with fundamental changes to

20. Asiwaju, "Partitioned Culture Areas: A checklist" in Asiwaju, *Partitioned Africa*,
252–259.

21. A.I. Asiwaju, "The Conceptual Framework" in Asiwaju, *Partitioned Africa*, 3. See
also in B.M. Barkindo's "The Mandara Astride the Nigeria-Cameroon Boundary"; A. Ade-
fuye's "The Kakawa of Uganda and the Sudan: The Ethnic Factor in National and Interna-
tional Politics"; and S.H. Phiri's "National Integration, Rural Development and Frontier
Communities: The Case of the Chewa and the Ngoni Astride Zambian Boundaries with
Malawi and Mozambique"; all in Asiwaju, *Partitioned Africa*. The respective chapters dis-
cuss divided culture/political groups along the Nigeria/Cameroon, Uganda/Sudan and Zam-
bia/Malawi and Mozambique borders.

22. Afigbo, "Repercussions of Colonial Rule," 493.

23. J.D. Collins, "The Clandestine Movement of Groundnuts Across the Niger-Nigeria
Boundary" *Canadian Journal of African Studies* 10 (1976): 259–78; Wilson, *African Decol-
onization*, 101–05; Phiri, "National Integration," 114–15.

their political structures and to the operation of political power among them. At one extreme was the experience of the Africans of the four communes of Senegal who elected representatives to the French National Assembly in Paris from the mid-19th century.[24] While ordinary Africans in Senegal might not have considered themselves French, the elite certainly did. It was an early experience in Western democratic processes, and of direct participation by Western educated African elite in a political institution that transcended the local African perimeter of Senegal. The paradox was that the focus of this political participation was on France, to which the Senegalese French citizens saw themselves as belonging. This reorientation of focus to the metropole was also evident in Portuguese Angola among the *evolues*.[25]

In the British territories also, by the 1920s, colonial administrations had begun to have councils of appointed or elected members to assist the governors in either advisory or legislative capacities. The members of these councils were drawn from among settlers, resident foreign commercial and local African elite groups. In the future devolution of political power to Africans, a power shift was to occur from those indigenous political elite that had been forced to accommodate or assist colonial governance to these new (or modern) elite. As R.F. Betts noted, the early councilliar experiments referred to above emerged as proto-parliamentary bodies and as one of the methods by which this power shift was accomplished.[26] More importantly, for many of the colonies, the councils constituted the beginning of national administrative or legislative structures that had permanently come to supplant the precolonial multiplicity of local kingly and chiefly governments.

The African "chief," as the *cadi*, the emir, the *chef de cecle*, *chef de canton* or *regulo*, was the most crucial element in the application of colonial political authority on the African subjects. As Chapter 4 shows, whether appointed by colonial administration or incorporated as an officer in pre-existing structures of political authority over the local population, all colonial governments made use of the chief. Because the institution was close to the population, the most obvious and immediate political effects of the imposition of the colonial order were quickly reflected by this institution. The direct effect of foreign military and political occupation was most likely to be felt by the people in the change or else by transformations caused by subordination to Europeans in the role, purpose, operation, privileges and power of their local rulers. Nonetheless, the use of chiefs by the various colonial governments differed as did the effects upon the various territories where different attitudes to chiefs and policies about them prevailed.

In general, the French were wary of powerful kings, Caliphs, emirs or, as M. Crowther and O. Ikime termed them, "strong chiefs."[27] Given the more violent manner in which the French imposed their colonial domination in West Africa

24. G.W. Johnson, "African Political Activity in French West Africa" in J.F. Ade Ajayi and M. Crowder (eds.), *History of West Africa*. Vol. II (Hongkong: Longman Group), 613–14; Manning, *Francophone Sub-Saharan Africa*, 70,79; M. Crowder, "West Africa 1919–1939: The Colonial Situation" in M. Crowder, *Colonial West Africa*, 233.

25. Manning, *Francophone Sub-Saharan Africa*, 59.

26. R.F. Betts, "Methods and Institutions of European Domination" in *UNECSO General History of Africa*. VII, 317.

27. M. Crowther and O. Ikime, "Introduction" in M. Crowther and O. Ikime, *West African Chiefs: Their Changing Status Under Colonial Rule and Independence* (New York: Africana Publishing Corporation, 1970), xiii.

and their general tendency to dismember large empires and states, especially those that had put up strong resistance to their incursions, they often had more chiefs removed (or replaced with straw chiefs) than their British counterparts.[28] Compared to Italian Somaliland, Lyaute's Morocco, or even Spanish Western Sahara, Africans in French West Africa and the Congo were more likely to see their chiefs replaced by people without any legitimate claim to chiefly or royal positions. And sometimes chiefs were retained, even as new ones were created. For the purposes of local administration and the functions of tax collection and labor recruitment, whether it was in French West Africa, French Equatorial Africa, British and German territories, or the Congo and Angola, chiefs were created as it was felt necessary, even among people who had no such political traditions.[29]

As most of these chiefs became tools to collect taxes for the colonial administrations and to organize or impress local labor for colonial or settler projects, the institution became unpopular and its legitimacy was undermined. Indeed, as Jean Suret-Canale observed, "the chiefs took advantage of [their position] to exact money and labor for themselves."[30] The institution, in those cases, became directly identified by the oppressed subjects and disaffected educated elite with the oppression of foreign colonial rule. This became especially clear in the case of French West Africa, as well as in the Congo and even more so in Portuguese Guinea, Angola and Cape Verde. Because of the dependent relationship of the chief with the colonial government, and because colonial appointees were often devoid of local legitimacy, the "chiefs" were forced to protect their positions by satisfying colonial administrations with efficient performance of duties. On the other hand, the emergent educated elite, who generally felt excluded from governance despite their qualifications, came to see both the chiefs and the colonial administrators as allies in a policy that excluded them from participating in government and from enjoying political privileges. An emergent class antagonism and group animosity between these two sections of the African elite was birthed eventually leading to the general demise of chieftaincy institution in the French territories. This was reflected in the slogan of Chad's first political party after the Second World War: "No more cotton, no more chiefs, no more taxes."[31]

In this case, the imposition of colonial domination and the establishment of its administrative system seemed to have devalued the usefulness or relevancy of chieftaincy institutions both in the eyes of the local people and the emergent educated elite. Some of the famous *chef de cantons* like Houphouet Boigny or Justin Aho Glele obviously had chiefly or royal backgrounds. However, the cantons of their jurisdictions did not necessarily correspond with traditional jurisdictions, nor were they restricted to precolonial perimeters of chiefly rule. Essentially, their

28. Afigbo, "Repercussions of Colonial Rule," 494; see other reasons in Crowder, "West African Chiefs," 214–5.

29. M. Crowder, "The White Chiefs of Tropical Africa" in Crowder, *Colonial West Africa*, 131; R.A. Austen and R. Headrick, "Equatorial Africa Under Colonial Rule" in Birmingham and Martin, *History of Central Africa, Vol. 2*, 41–42; B. Jewsiewicki, A Rural Society and the Belgian Colonial Economy" in Birmingham and Martin, *History of Central Africa, Vol. 2*, 122.

30. Suret-Canale, "The End of Chieftaincy in Guinea" in M.A. Klein and G.W. Johnson (eds.), *Perspectives on the African Past* (Boston: Little, Brown and Company, 1972), 373.

31. Austen and Headrick, "Equatorial Africa", 61, quoting Robert Buijtenhuijs, *Le Frolinat et les revoltes populaires du Tchad, 1965–1976*, (The Hague, 1978), 69.

positions as *chefs de canton* merged, or rather dissolved, into the more modern political structures of emergent representative governance.

The British system of native rule, in non-settler colonies had different immediate and long-term political repercussions on the institution, functions, and role of the chief and his estimation in the eyes of both ordinary people and the modern elite. The British did not hesitate to remove or create chiefs like the French did when they felt it necessary to advance their administration. However, the British were generally "much more concerned than the French to retain as their executive agents chiefs who had traditional claims to office and also...they were more concerned to administer their territories through precolonial territorial units even at the expense of a bewildering variety of administrative units in shape, structure and size."[32] The now famous indirect rule system of the British sought to incorporate the traditional political functions and structures into the colonial administrative structure, as a system of self-rule. The chiefs' precolonial responsibilities and privileges were to be preserved. Moreover, the system of indirect rule allowed chief and other native authority officials to retain up to 70% of tax intake as remuneration. The chiefs were also allowed to keep police and prison forces. In many cases, these extended the direct jurisdiction of the chief beyond what the precolonial ruler actually exercised.[33] The British Resident was thus to act in an advisory capacity to the chief, while the chief was left "to appear in the eyes of the local populations as the legitimate rulers." The major difference was that they were now agents of the colonial administration, with some initiative of their own no doubt, but limited by reference to what was acceptable to "civilized standards."[34]

Because of the apparent local legitimacy of the chief in most British colonies and the fact that he ruled over the same people he would have ruled over in precolonial times, the local populations were not alienated from the institution. In fact, the chiefs were easily conceived to be more than mere colonial agents. This position of considerable power and the fact that the educated elite felt left out created latent animosity between the two groups, as was the case in the French territory. However, because the chief's local power base was still intact, and perhaps strengthened during the colonial period, the educated elite in British West Africa could not eliminate the chiefs outright from political reckoning in the future party-politics towards independence and after. The chiefs were either wooed by the modern politicians or else incorporated into the structures of the nationalist political parties and in some cases into the administrative councils.[35] French-ruled Morocco, with an administrative experience similar to the British Northern Nigeria, not only maintained the Sultan as the all time most powerful indigenous ruler, but inadvertently constituted him as the leader of the country's nationalist movement. This process had developed in the 1920s and 1930s, but its political impact on Africa lasted until the post-independence period. In the settler colonies of Southern Africa, the political experience of the African populations were the extremes of what occurred in non-settler colonies elsewhere on the continent. With

32. Crowder, "West African Chiefs," 215

33. Crowder, "Indirect Rule—French and British Style" in Crowder, *Colonial West Africa*, 199; Crowder, "West African Chiefs," 218.

34. Betts, "Methods and Institutions," 318–19; Crowder, "West African Chiefs," 220–21.

35. Crowder, "West African Chiefs," 229.

a central purpose of colonial administration being the maintenance of colonial law and order, the functions of African political institutions were transformed and in some cases distorted.[36]

The colonial administrative style that enhanced the power of the chief had a lasting political effect. The social and political mechanisms that some precolonial African kings and chiefs had to negotiate to make political power and authority responsible were either completely removed or weakened. Thus, the particular mechanisms by which effective civil societies were developing among African polities were destroyed, as the chief was no longer answerable to local precolonial check structures or ideologies. Moreover, his loss of sovereignty was actually less evident than his increase of power over his subjects. The result was the paradoxical situation in which colonial chiefs, though lacking in sovereign authority, nonetheless possessed autocratic and sometimes arbitrary powers.[37] Another important political impact of colonial administration was the development of a paid bureaucracy that extended down to the local levels. Many precolonial African societies, in North Africa, some in West, north East, and East Africa, have no doubt developed bureaucratic structures of administration. Nevertheless, the systematization of government bureaucracy came with colonial administration. More important, however, was the evolution of salary structures, either paid directly by the colonial government, or from the "native treasury" which, for the first time, separated states' earnings from the king's.[38]

Beyond the mere introduction of new political structures and modern methods of political actions, it is important to note that the unavoidable inclusion of African elites in colonial administration was brought about essentially through a process of agitation and protests. Moreover, these protests were conducted by new methods totally different than were common in precolonial African states; they were led by new elites that came to conceive themselves as leaders of the "emergent" Africa. They thus regarded their entire colonies as constituencies. They did not fight to reclaim lost sovereignty but rather aimed to establish new sovereignties that were modern, more broad-based, and in many cases multi-national in character. The first aspect of this change, the structural change, did not take place everywhere at the same time. Southern Africa substituted European settlers for Africans either in the creation of the structures or in their operations. However, the harshness of settlerist colonial administrations, and their exclusion of the emergent Western educated African elite, was itself a stimulant to modern political awareness among the people. It encouraged the emergence among Africans of the region of pan-Africanist and radical political organizations.

While the roots of the African nationalist movement is beyond the scope of this chapter, it is important to note that the foreign political domination, made worse by racist attitudes and policies, engendered the seeds of its own destruction.[39] This is more palpable in Southern and Central Africa and Algeria, where very substantial European settler populations occurred. In those places, settlers occupied African land, conscripted African labor into state projects and settler farms, as well as denied African elite a tangible say in government. Colonial rule

36. Boahen, *African Perspectives*, 98.
37. Crowder, "West African Chiefs," 220–21.
38. Betts, "Methods and Institutions," 325–26.
39. Boahen, *African Perspectives*, 98.

and its racist, exploitative, and unjust character, combined with other factors like the social and economic deprivations suffered by the peoples, the rise of a aggrieved educated elite, Christianity, and black American and Soviet political influences, began to produce a sense of nationalism. Together, they initiated the spirit of Pan Africanism. By 1939, the foundation of popular, radical, and militant nationalism had been laid in most part of Africa.

Colonial Rule and Ethnicity

Sociopolitical and economic processes unleashed by colonial rule affected developments and transformations in ethnicity and social identity among African peoples. Urbanization, Western education, uneven regional development within colonies and their impact on independence politics, all affected the character of ethnicity in postcolonial Africa. However, even during the early period of colonial rule, processes that affected development in community self-identity and intercommunal relations were already set afoot. The remapping and carving up of African communities into different bounded administrative units was an important process in this regard. The introduction of structures of local and provincial governance that either cut across or engrossed previous social and political groups was another. Labor migrancy and segregated labor control policies, especially in the settler colonies of Southern and Central Africa, were also important economic elements of colonial rule that affected ethnicity. In some instances, these factors modified the previous character of ethnic identities, or actually led to the emergence of new ones.

An example of the effect of inter- and intra-colonial boundary divisions (between Uganda and Congo, and internal administrative re-divisions within Uganda) on the dynamics of ethnicity is seen among the Alur people of Uganda and Congo.[40] The Alur were organized into chiefdoms comprised of segmetary patrilineage, with lineages linked across chiefdoms by clans. Though clearly having a core self-identity as Luwo, nonetheless, they had a very permeable periphery where a high degree of incorporation of non-Luwo people into the society was constantly taking place. Thus, large parts of other ethnic groups like the Okebo, Lendu, Madi, and other much smaller groups of non-Luwo peoples up to the period of colonization, have always featured as the composite Alur.

The expansive motor of Alur society was the ritual specialization of their chiefs as rainmakers and, thus, as the promoters of general wellbeing in a draught prone region. They owned cattle and were also considered to possess conflict resolution capabilities. As political specialists with ritual knowledge and abilities, Alur chiefs were often invited by independent non-Luwo groups to settle among them to secure ritual, political and economic advantages. In this way, Alur chiefs' sons with their accompanying entourages went to live out among their neighbours. The Alur chieflet and his retinue, would in effect, start a new Alur chiefdom. In this new chiefdom, non-Alur members were gradually incorporated into

40. A. Southall, "Ethnic Incorporation among the Alur" in R. Cohen and J. Middleton (eds.), *From Tribe to Nation In Africa. Studies in Incorporation Processes* (Scranton: PA: Chandler Publishing Company, 1970), 71–92.

Alur polities and over time either lost their languages or incorporated a large dose of Alur vocabularies into their languages. While some imposed their own languages on their Alur overlords, they nonetheless, took up material aspects of the latter's culture. The character of colonial administration and the logic of colonial demographic policies truncated many such processes of ethnic enlargements, incorporation and new community building. Not only did the colonial boundary between Congo and Uganda divide subjects and overlords, but also many non-Alur groups were actually resettled so they had no contact with the Alur chiefdoms to which they were subjects. The rupturing of social and political bonds that followed these processes effectively put an end to this internal process of incorporation and integration.

Another example of how colonialism affected ethnicity occurred among the non-centralized Tonga of Zambia and northern Zimbabwe.[41] Before colonization, they had headmen and chiefs as the highest political authorities and their maximum extent as territorial units consisted of no more than a few related neighborhood communities. These societies had ritual offices but political posts were most rudimentary and the sense of identity was primarily limited to the immediate neighborhood within which ritual, kinship and marriage ties created a basis for a common community. Outside of this area, whether or not the language was the same, it was considered foreign territory with an alien population.

The requirement for an effective and efficient colonial administration imposed a transformation on these types of societies. Two factors were particularly important in this process. One was the delineation of viable and uniform local administrative units that were linked to successive layers of superior hierarchies, all coming under a central colonial government. The second was the need for a responsible hierarchy of officials who could be tasked with the collection of tax, tolls, and labor dues, or with other duties. These factors ensured that local neighborhood communities that were considered administratively non-viable were consolidated into chieftaincies. Chieftaincies were further consolidated into bigger district units. These new hierarchies were staffed with European officials and, at lower levels, with African "chiefs" who were not necessarily members of the communities. In these new political arrangements, the colonial government related with members of particular administrative units as socially and politically homogenous bodies. Subjection to a uniform set of administrative and socioeconomic policies from a single political center, and possible competition with other comparative units that were composed of other ethnicities quickly fostered a sense of ethnic identity within each unit. The political boundary under which they were brought to relate with other peoples and with the colonial government was considerably widened relative to the precolonial period. In the process, the perimeter of their ethnic identity was similarly affected. Hence, the boundary beyond which members were considered aliens drew further back. The development of such ethnic self-consciousness among people of the same language with a previously severely restricted sense of pan-ethnic self-identification was not limited to the non-centralized societies.

41. E. Colson, "The Assimilation of Aliens among Zambian Tonga" in Cohen and Middleton (eds.), *From Tribe to Nation*, 35–54.

In relation to peoples of southern Africa, J. Guy and M. Thabane rightly observe that colonial economic and labor policies "reinforced the divisions between them as a pre-requisite for effective rule."[42] About 87% of South African land was confiscated from Africans and the local populations were compartmentalized into "native reserves" where traditional chiefs and traditional land tenure continued to operate. After the Second World War, these reserves were turned into the notorious "self-governing" Bantustans of apartheid. Indeed, a fictional social and "ethnic" category of "colored" was created to encompass those who were products of early miscegenation between Europeans and Africans. In the course of the twentieth century, not only were the "colored" treated as a different "race," but they also came to perceive themselves as such.[43] Colonial and settlerist governments of South Africa, in particular, using the so-called "divide-and-rule tactic," stressed ethnic differences and encouraged ethnic antipathy between different African groups. This was aimed at undermining a unified local political action against the government.[44]

Ethnic divisions were also reinforced among and between migrant laborers from outside of South Africa, as well as those from South Africa. People from Lesotho, Mozambique and Zimbabwe, were employed to work in the mines because their presence could lower South African wages. These workers, who also labored in farms and in factories were usually settled in separate hostels. Because the color bar largely denied Africans access to more remunerative skilled and semi-skilled jobs, competition among different groups ensued in bidding to secure leadership positions. Moreover, foreign migrant laborers were resented by those from within South Africa who perceived the migrants as instruments of the government to deny social, political and economic rights to indigenes. The incorporative and integrative process among the Zulu during the Mfecane, when many non-Zulu were integrated into the society through the military recruitment system was reversed. This reversal was achieved not only by disarming and demilitarizing the society, but even more by the colonial authority's deliberately playing upon ethnic differences in their demographic, administrative and labor policies.[45]

Emphasizing the influence of the Western educated elite and missionaries in the creation of ethnic identities, Leroy Vail comments that "empirical evidence shows clearly that ethnic consciousness is very much a new phenomenon, an ideological construct, usually of the twentieth century…an offspring of changes associated with so-called 'modernization.'" While an examination of the roles of Christian missionaries and Western educated African elite is beyond the parameters of this chapter, Vail's examples of ideological constructions of ethnicity in pre-World War II Malawi can assist in the analysis that follows.[46]

By the end of the World War I, migration of men to South African mines was producing clear results of rural disintegration. To counter this trend, the colonial

42. J. Guy and M. Thabane, "Basotho Miners, Oral History and Workers' Strategies" in P. Kaarsholm (ed.), *Cultural Struggle and Development in Southern Africa* (Harare: Baobab Books, 1991), 243.

43. R.C. Adam, "The Coloureds of South Africa" in B.M. Du Toit (ed.), *Ethnicity in Modern Africa* (Boulder, CO: Westview Press, 1978), 253–270.

44. L. Vail, "Introduction" in L. Vail (ed.), *The Creation of Tribalism in Southern Africa* (London: James Currey, 1989), 3.

45. See Guy and Thabane "Basotho Miners," 239–258.

46. L. Vail and L. White, "Tribalism in the Political History of Malawi" in L. Vail (ed.), *The Creation of Tribalism in Southern Africa*, 151–192.

government decided to promote traditional chiefly authorities so that traditional sanctions could be brought to bear on society and avert the downward trend. Administrative areas were created, new chiefs were appointed and some defunct chieftaincies resuscitated. Some tangible powers were given to the chiefs to effect the goals of the colonial government. The educated elite and missionaries, serving as culture brokers, were able to seize on this colonial political policy to implement the ethnic and "cultural" ideals they had conceived. Missionaries and educated elite helped to create or refurbish ethnic ideologies. They did this by reducing local languages into writing, having one adopted as the standard language over others, and by specifying "customs," "traditions," "histories," and "heroes" and then, by actualizing these cultural ideals by working with the new chiefs, with school pupils, church adherents, and with colonial administrators. Thus the Tumbuka refugees from Ngoni expansion in northern Nyasaland who, since the time of the Ngoni invasion were not established in chiefdoms, now were able to have a defunct pre-Ngoni chiefdom resuscitated. With the assistance of a core of educated elite, armed with written "histories," "cultures," and "customs," and the greatness of the Tumbuka past, a new self-identity was created. The Ngoni were cast as the "them." This process was repeated for other groups in this area.

Colonial rule served as a versatile instrument that, in some cases, reversed the ongoing formation of heterogeneous multinational identities while, in other cases, it led to the emergence of new groups with new identities within its new borders. In other cases, people who had not been self-conscious of their identity or who had been merged into larger identities, rode on the wings of colonial rule to shake off their precolonial lack of identity. In other cases, our examples demonstrate, colonial rule introduced enduring hostilities and local group insularity among ethnicities and culture groups that have continued to create serious problems for independent Africa.

Conclusion

Ultimately, we have to bear in mind Adu Boahen's view on whether or not the brief period of colonialism had fundamental or superficial impact on Africa. He observed that "in some respects the impact of colonialism was deep and certainly destined to affect the future course of events, but in others, it was not." However, citing, among others, the importance of colonial boundary demarcation in the post-independence geo-political map of Africa and "the change of focus of political authority and power from the old ruling aristocracy of kings and priests to the educated elite," he noted that many "aspects of the political impact of colonialism are going to be...lasting."[47]

Clearly, the elimination of the original leadership of African states and the destruction of the military or militia forces of the kings because of colonial occupation of Africa had fundamental effects. At a grand level, these processes ensured that the gradual process of modernization and Westernization of African political structures, processes and philosophy would take deep root. The immediate politi-

47. Boahen, *African Perspectives*, 110.

cal consequence was, however, to strip Africa of much of its important layer of military-political and religious opposition to effective colonial governance of the ordinary African. They were the first and necessary steps in the suppression of, as Governor General W. Ponty of French West Africa put it, "the great native polities which are nearly always a barrier between us and our subjects."[48] They cleared ground for the creation, or co-optation of a new, more pliable cadre of leaders who was perceived to have been subdued, and through whom governance would proceed with less opposition.

Herein, however, lies the resilience of African institutions in the face of colonial invasion. Afigbo noted, "with ease many indigenous African institutions and ideas survived the impact of, or even blended with, alien European values."[49] Local administrative systems of emirates and kingdoms were adopted for local colonial administration. Thus the colonial authorities still had to rely on chieftaincy institutions or even create new ones in the image of known ones, however truncated they were. In such protectorates as Swaziland, Lesotho, or in Northern Nigeria, their usefulness or indispensability won some form of sovereignty for these societies, at least in principle.[50] Rural political life for most Africans, thus, maintained the form, if not the fundamental essence, it had always been. In some respects, the powers of the chiefs were drastically curtailed, and in others, they actually attained a measure of autocratic power that the precolonial arrangements had never allowed them.

For many African peoples, this period also marked the beginning of the emergence of Western-type bureaucratic and judicial systems. It also marked the beginning of a political ideology that separates the state from the person of the ruler, as well as the sphere of religion from the secular political. The territorial consolidations that colonial rule imposed on Africa is also important.[51] Since such sociopolitical consolidations were not in themselves new to precolonial Africa, the importance of the latest actions can be located in the fact that the states and boundaries that emerged from them have remained largely fixed and immutable. Moreover, in some areas, they facilitated social organization of very large populations into single units that had the potential of effectively mobilizing productive efforts to meet the needs of the modern world.

Review Questions

1. *Project*: Students should use the table in footnote 2 as an example for this project. For each region of Africa, a group of students should tabulate a casualty list that includes the date of military incursion; name of political and other leaders killed, deposed, or exiled; number of soldiers/people killed; villages burnt, etc. during its colonial occupation. Group discussions should then be held to examine what immediate and long-term effects would be produced assuming that in a war in which a country of their choice was involved the president, vice president, half the cabinet members, a third to half

48. Quoted by J. Suret-Canale, "The End of Chieftaincy in Guinea," 373.
49. Afigbo, "Repercussions of Colonial Rule," 488.
50. Suret-Canale made this point in "The End of Chieftaincy," 373.
51. Afigbo, "Repercussions of Colonial Rule," 493; Boahen, "Colonialism in Africa: Its Impact and Significance" in *UNESCO General History of Africa. VII*, 785.

of the supreme court judges, half the entire land, sea, and air forces and most of its top religious authorities had been wiped out.

2. Why did the colonial occupation of most of Africa entail bloody military confrontations?

3. Would you consider African territories that achieved protectorate status, and those indigenous governments that were incorporated into colonial administrative structures as been able to maintain their sovereignties?

4. How would you assess the view that rather than destroy Africa's basic political power structure, colonial rule only modified some of its aspects?

5. How would you react to the view that the delineation, the role and character of the colonial boundaries of Africa are not fundamentally different from those of Europe?

6. In what different ways did colonial rule affect ethnicity in Africa between 1885 and 1939?

Additional Reading

M. Crowder, *Colonial West Africa. Collected Essays* (London: Frank Cass, 1978).

A. Adu Boahen, *African Perspectives on Colonialism* (Baltimore: John Hopkins University Press, 1987).

P. Manning, *Francophone Sub-Saharan Africa 1880–1985* (Cambridge: Cambridge University Press, 1988).

A. I Asiwaju (ed.). *Partitioned Africans. Ethnic Relations Across Africa's International Boundaries 1884–1984* (London: C. Hurst & Company, 1985).

Cohen and J. Middleton (eds.). *From Tribe to Nation In Africa. Studies in Incorporation Processes* (Scranton Pennsylvania: Chandler Publishing Company, 1970).

Chapter 6

The Economic Impact of Colonialism

Erik Gilbert

Between 1885 and 1939, Africa's economic engagement with the non-African world changed dramatically. Where previously most economic interaction between Africans and other people came in the form of trade, this period saw the beginning of direct European involvement and direction of African economies. Farmers who once grew crops for their own purposes came under pressure from colonial governments to grow new types of crops. A more fundamental change was the rise of wage labor. Before 1885, very few Africans were engaged in wage labor. By 1939, wage labor had become widespread as Africans either sought new opportunities or were compelled to perform new types of work.

* * *

Africans were economically engaged with the world for centuries before 1885. They had sold agricultural products, manufactured goods, the produce of the forest and chase, and slave labor to Europeans, Arabs, and Indians for centuries, receiving in return products ranging from cloth to iron and salt to onions. This external trade was itself an extension of a considerable internal trading network that linked one African society to another, moving salt, cloth, dried fish, kola nuts, and metal goods, to mention but a few trade goods. Serving this trading economy were seaports like the cities of the East African littoral, river ports like the city of Jenne on the Niger, cities like Timbuktu that served the trans-Saharan trade, and Atlantic seaports like Whydah and Cape Coast. Camels plied the sands of the Sahara, canoes traveled the Niger and Congo Rivers, and countless porters trudged the caravan tracks of East Africa, all for commercial purposes. So Africa was no stranger to the global economy nor was the internal economy of the continent commercially unsophisticated.

But despite the prevalence of trade, most Africans in 1885, like their counterparts in preceding centuries, made their living primarily from agriculture. In a few places, where a fortuitous combination of climate and proximity to either sea or river transport allowed, agriculture might mean cash cropping-growing crops with the primary intention of selling them instead of consuming them. On the East African coast, cloves and coconuts were produced on plantations for export and the income from their sale provided food and the other necessities of life. Similarly, in Senegal, groundnuts (peanuts to Americans) were grown for export; and on much of the West African coast the oil palm was grown on a considerable scale. But for most Africans, agriculture meant producing primarily for one's own

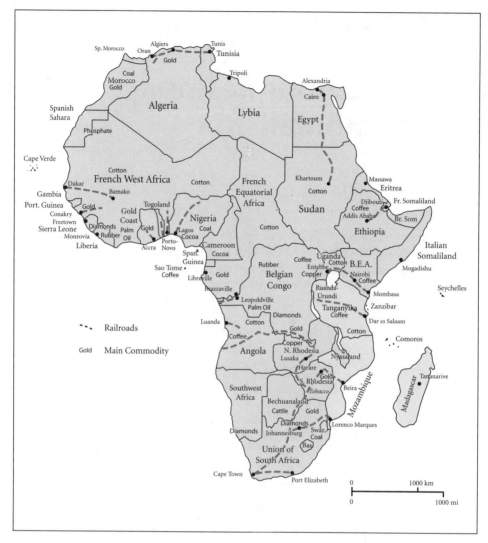

Figure 6-1. The Colonial Econony

household with a bit left over to exchange for those items that simply could not be produced locally. This type of farming is called subsistence farming, and it is what most farmers in most places throughout history have done. Such farmers lived almost entirely without money. When they exchanged their small surplus for trade goods it was through direct barter rather than the use of money. Just as these farmers were unlikely to have sold the produce of their farms for money, they were equally unlikely to have sold their labor. When needed, extra labor was recruited from family, then friends and neighbors, and in cases where extra labor was needed for long periods of time, by purchasing slaves. But wage labor was virtually unheard of.

Perhaps most crucial, few of these farmers paid taxes. They may have given some portion of their harvest to a state as tribute, but that only required that they plant a little bit more of the same crops that they already grew. They rarely en-

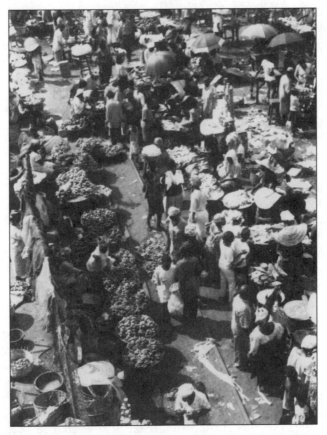

Figure 6-2. A market scene

gaged in growing something special just to turn it over to the state. Furthermore, the state never saw fit to direct how farmers went about producing such crops as they grew. With some notable exceptions (and these mostly where cheap water transport put farmers in the orbit of some major export trade), subsistence farmers saw to their own needs with little interference from the state or from the global economy.

In 1939, on the eve of the World War II, Africans were still primarily farmers, but the conditions under which they farmed had changed dramatically. By 1939, most had either been enticed or coerced into growing a cash crop that would then be sold for money. The money they received was produced, distributed, and controlled by the colonial state. The purchaser of the cash crop might be an independent merchant, African or otherwise, but most likely a farmer would sell his crop to a government-controlled marketing board. The marketing board would judge the quality of the goods for sale and set a price for them.

The state's intervention in the farmer's work did not end with setting the price of his harvest. It might also include encouraging or coercing him to grow a particular crop or to manage it in a specific way. If he had cattle, the state might now require that he dip them in pesticide. If he lived in a hilly area, the state might require him to plant trees to prevent erosion, and he might also be told that the trees he had been cutting for years were now on a forest reserve and thus the

property of the state. If the farmer lived in a colony that had a large number of European settlers, instead of being told which cash crops to grow, he might be told which ones he was forbidden to grow, so that he could not undercut the settler farmers.

If the farmer needed extra labor to clear land or harvest the crops, he might still call on friends and family, but he would no longer have the option of buying slaves. Instead, he might hire laborers with money, and his sons and daughters might well engage in wage labor themselves working in a mine or in the service of the colonial state. They would engage in this wage labor in order to meet their need to pay taxes (now payable only with money), to pay school fees, or to buy previously unavailable consumer goods which were now available but only in exchange for money.

The commercial networks that crisscrossed the continent in 1885 had not disappeared, but they had been overtaken by new networks that relied on railroads, river steamers, and trucks. These networks no longer linked one African society to another as many of the nineteenth-century trade routes did, but rather linked interior portions of newly defined political units to the seaports that connected the African colonies to their European metropoles.

And what of the Arabs and Indians who had once traded on a more or less equal footing with Europeans? They too found themselves economically overwhelmed by Europeans, with their commerce subject to regulation and control by the colonial state. In many cases they managed to find an intermediate niche in the colonial economy, above that of the African producer and below that of the colonist. By 1939, in much of East and southern Africa, Indians dominated the commercial and professional classes while in West Africa much of the retail industry was controlled by Syrians and Lebanese.

Within the span of a single human lifetime, a huge change swept through the African economy. People all over the continent found themselves, for better or worse, deeply engaged with both the global economy and a system of state intervention in economic matters that few had encountered before. The hows and the whys of this transformation are the topic of the following pages. We look first at the economic motives and agendas of the various colonial states. No two had exactly identical purposes and intentions but a few broad patterns emerge. Next, we examine the infrastructure development that was the main form of investment colonial states made in their new possessions before World War II. Next, we look at the changes this new infrastructure forced on African agriculture and on the recruitment and use of wage labor in Africa. Finally, we look at the growing number of people who worked outside the agricultural sector, whether in mines, on railroads, as shopkeepers, or in the cities as laborers, prostitutes, and bureaucrats.

The Colonial State and Its Economic Motivations

To what extent did European nations seize their African colonies for economic reasons? What economic benefits did they hope to realize from having colonies? How did these aspirations affect their policies toward their colonies?

The extent to which European powers grabbed their African territories for economic reasons is a hotly debated topic. European advocates of imperialism often used the potential for economic gain as part of their argument for the expansion of their nations' empires. Their opponents often made equally persuasive arguments to the contrary, that is, that colonies would be an economic burden rather than a benefit. Many of the colonial efforts of European nations were pioneered by private companies. German East Africa (later Tanganyika and now Tanzania) was initially a possession of the German East Africa Company. Private British companies initiated the colonization of the Kenya coast and northern Nigeria and the two Rhodesias. With the exception of the Rhodesian example, all of the companies quickly proved inadequate to the task of carving out an empire and making a profit from it, and were rapidly replaced by direct administration by their respective governments. Still, the fact that these private companies made the effort to go where their governments were initially unwilling to go suggests that some European investors thought there was money to be made in African empires.

Some colonies were seized for transparently economic reasons. The British grabbed the South African Rand for its gold mines. Their imperial interest in Nigeria and Ghana grew out of a long tradition of trade with both places. Leopold, the king of Belgium, acquired the Congo primarily for its ivory and wild rubber. But many colonies were acquired without any immediate economic objective. The British took over Zanzibar for reasons that were more strategic than economic. The French seized thousands of square miles of the Sahara for reasons of national prestige rather than economics. Whatever the reason for taking colonies, once they were taken, the first rule that colonial administrators had to obey was that the colonies should not cost the metropolitan government anything. National ambition might drive the French to seize Chad, but it did not impel the French public to want to pay for the maintenance of a colonial administration there.

Metropolitan governments were often willing to foot the bill for major projects, such as the construction of transportation infrastructure, but then only if a clear case could be made that there would be a payoff in the long term. As a result, colonial states invested little in health and education before World War II, in part because the immediate return on the investment was hard to see. Instead, what investment they made was in creating conditions that would allow them to wring just enough money out of their colonies to pay the expenses of administration.

Types of Colonial Encounter

In his survey of Africa's economic history, Ralph Austen divides colonial regimes into two broad categories; "Etatist-Peasant regimes" and "regimes of competitive exploitation." These, he says, are not dictated by geography or by the nationality of the colonial power; indeed, both approaches could coexist in a single colony. Instead the differences resulted from the type of European who was setting economic policy.[1]

In the Etatist-Peasant regimes, it was bureaucrats who used their power to try to shape the economic activities of peasant producers in order to make them serve

1. Ralph Austen, *African Economic History* (London: James Currey, 1987), 122–123.

the interests of the state. "Etatism" might be translated as "statism," and it refers to the habit of governments of trying to direct or manage economies. In a colonial context, this might mean encouraging farmers to grow crops that were needed by metropolitan industries. In the case of French West Africa, it resulted in a determined effort to shape local cotton production to meet the needs of the French textile industry. In other cases, local production might be shaped around the revenue needs of the state. In Zanzibar, British officials encouraged the production of cloves, most of which were exported to the Dutch colony of Indonesia, simply because taxing clove production looked like the best way to cover administrative costs.

In contrast, in the "regimes of competitive exploitation," the interests of European investors and settlers took precedence over those of bureaucrats and most definitely over those of Africans. In these areas, economic policy served the mines, the plantations, and settler farmers. Africans were expected to cede their claim to mineral rights and agricultural lands, to provide labor for the Europeans who were exploiting the resources that formerly belonged to Africans, and to refrain from competing with Europeans in the production of cash crops. In these areas administrative costs were borne—at least in the direct sense—by Europeans, not by Africans. In the regimes of competitive exploitation, there was less state intervention—at least within the confines of the mine or plantation economy—and competition set the direction of the economy. But it should be noted that these economies were often insulated from market forces by the state's intervention designed to prevent competition from African farmers and to provide a labor pool for the settler economy. In general, the most exploitative colonial economic policies were found in these types of economies rather than in areas where policies favored cash cropping by African farmers.

Whichever approach to colonial administration was in force in a given colony, the biggest initial obstacle to implementing the colonial state's plans was lack of an adequate transportation infrastructure. It mattered not a whit that the region of southern Congo called Katanga was full of copper ore, or that the Kenya highlands were well suited to coffee growing if neither commodity could be brought to market. Even before most colonial governments managed to articulate an economic policy, they set out to improve the local transport networks.

Transportation Infrastructure

The difficulties of internal transportation on the African continent set limits on economic development before the colonial period, and Austen suggests that this challenge is one of the reasons Africans failed to meet Europeans as economic equals. Most of the major river systems presented some sort of obstacle that prevented them from linking the interior to the sea. In the case of the Congo, the last 200 miles of the river flow down an escarpment whose many rapids render the river impassable. As a result, the upper reaches of the river, which are easily navigable and stretch deep into the interior, are cut off from the sea. This limited the Congo basin's access to Atlantic trade which was a blessing at times but also denied people the opportunity to trade. The story was the same on other rivers. The Niger Delta and the rapids at Bussa (in present-day Nigeria) were obstacles to direct trade between the Sahel and the sea.

Figure 6-3. Moving goods with labor-powered cart became common in urban areas, an improvement over carrying loads on the heads

The presence of the tsetse fly closed some regions to animal transport. While camels provided a very efficient means of crossing the desert, they and other pack animals were vulnerable to a disease called trypanosomiasis which was transmitted by tsetse flies, and so they were excluded from the fly belts of East and Central Africa. As a result, the main form of transportation in these regions was human porterage, which typically limited trade to high-value, low-bulk items — ivory but not potatoes, in other words.

The Logic of Infrastructure Improvement

Transportation was essential for two reasons. First, by extending the reach of the state into the interior, it increased the area under the state's immediate control. Many of the colonies were only paper colonies in large part at the start. Colonial administration, and hence colonial economic meddling, was limited to the few coastal enclaves that the state controlled. The desire to increase the area administered by the state and to increase revenues was served by the extension of the transportation infrastructure into the interior.

There was a second objective, which was less often explicitly recognized by the state and its officials. By creating new trade routes and introducing new technology, colonial states were able to increase their control over the economies of their new possessions. By forcing a shift away from preexisting transportation networks toward new ones, the colonial state undermined the older, more established merchants and economic elites. This simultaneously strengthened their own hand while weakening that of their most dangerous competitors. When the Niger River was opened to steamboats, not only was the hinterland better linked to the sea, but also the canoe houses and trading states that had controlled Niger trade and hindered the extension of British control on the Niger were undermined.

When the colonial government of Zanzibar decided to replace locally owned sailing ships used in inter-island commerce with steamers, they were seeking to weaken the position of Indian middlemen in the local economy.

Finally, a certain amount of infrastructure development occurred because colonial administrators had a sort of blind faith in certain types of technology. Railroads and steamships, which were both technologically complex and capital intensive, were the darlings of the colonial mind. These technologies produced only in the West and themselves symbols of Europe's power in the age of steam had an almost talismanic quality to the imperialists. In East Africa, colonial states operated their own steamship lines, often at a loss, partly because a few steamers were easier to control than hundreds of small sailing craft, but also because these steamers represented the technological side of modernity that the colonizers hoped to establish in their colonies. So great was the correlation between certain technologies and the "progress" of colonialism that the Brussels Treaty of 1890, which called for its signatories to make real colonies out of their paper possessions in the name of suppressing the slave trade, directed colonial administrations to construct railroads, build telegraph lines, and establish river steamer services. The intention was to eliminate the use of human porters, some of whom were slaves, in an ideological rather than an economic use for technology. At sea, the treaty directed colonial powers to take control of indigenous shipping, by registering, documenting, and controlling the movements of indigenous craft.[2] So there was more at work here than a desire to move goods from the interior to the coast; transportation technology was also a symbolic and ideological part of the colonial project.

The Railroads

The speed at which this new infrastructure was constructed and the economic and social effects that followed from it were dramatic. Railroads were under construction in southern Africa as early as 1862 when a forty-five-mile line was built in the Cape Province. But the real railroad boom came between 1890 and 1914. During this period rail lines sprang up in German, French, and British colonies, and even in the undercapitalized Portuguese colonies. They were built for a variety of purposes. The Uganda Railway, begun in 1895 and eventually stretching from Mombasa on the Kenya coast to Lake Victoria, was built primarily with Brussels Conference objectives in mind. The Belgian Congo's first railroad was constructed in 1898 to link the port of Matadi, down river from the rapids on the lower Congo, to Leopoldville, above the rapids. Rail lines linked the copperbelt of Central Africa to the sea by way of southern Africa, with profound implications for twentieth-century politics. Railroads brought the Gold Coast's cocoa to the sea and northern Nigeria's cotton to the ports on the coast. Railroads in German East Africa were built with primarily political objectives, but also served to move crops to the coast. Most of these projects were paid for with public funds provided by metropolitan governments. A few, mostly in

2. The highlights of the treaty that emerged from the Brussels conference are quoted in the British Admiralty's, *Instructions for the Guidance of Her Majesty's Ships of War Employed in the Suppression of the Slave Trade, Volume One* (London: His Majesty's Stationers Office, 1892), 104–105.

southern Africa, were built with private funds. The labor for these projects ranged from forced African labor to wage labor. Imported Indian laborers built the Uganda Railway.

By World War I most regions of the continent, save for French Equatorial Africa, were served by a rudimentary rail system that linked points in the interior to a port or two on the coast. But getting the produce from the interior into ships and hence into global markets was still a challenge.

Maritime Infrastructure

On the East African coast, there are some fine natural harbors, most notably on the island of Zanzibar. But the ports that existed at the beginning of the colonial period, Zanzibar included, were the products of a political economy quite unlike that of the emerging colonial states. Precolonial East Africa's shipping had largely treated the coastal ports as feeders for Zanzibar. When Zanzibar lost its sovereignty over the coastal areas, the new colonial regimes on the coast had no desire to ship products though Zanzibar, and so they set out to upgrade their coastal ports. Soon the Germans upgraded Dar es Salaam to a full-service port and the British did the same for Mombasa in Kenya.

West Africa has few decent natural harbors, and the rest of the continent is not much better off. As the railroads were constructed, the need for better harbors became more and more apparent. Much of the West African coast consists of beaches or mangrove swamps. Beaches, or "open roads," are pleasant places for swimming but offer little shelter to ships that want to take on or unload cargo. Creek and river mouths offer protection to ships but are frequently shallow and choked with mangroves, which complicates the handling of ships.

Dakar, in Senegal, has a good natural harbor, but the rest of the West African coast was served by poor natural harbors—creek ports like Lagos, or open roads, where cargo and passengers had to be transferred between ship and shore in surf boats. Even in the creek ports and natural harbors, cargo had to be handled by lighters. Lighters are small barge-like boats that can be brought alongside a ship to load or unload cargo. They can then be beached or brought to a jetty to be unloaded. Lighterage allows ships to stay in deep water during loading and unloading, and so the expense of dredging harbors is spared. But cargo handling is the most expensive part of shipping costs, so the less the cargoes have to be handled the lower the shipping costs and the lower the final price of the commodities being shipped. In many cases, cargo-handling costs added significantly to the final cost of African agricultural produce. As a result, there was a rush to improve port facilities in West Africa in the early part of the twentieth century.

The most prominent of these projects was at Takoradi in the Gold Coast (or Ghana). The Gold Coast's major surf port, Sekondi, and the goldfields of the interior were linked by rail as early as 1903. Later links connected the increasingly important cocoa producing regions to Sekondi. But until 1928, all the produce that moved to Sekondi by modern railroads had to be loaded on to ships by surf boats. Ghana's relative prosperity gave Governor Frederick Gordon Guiggisberg, an engineer, the opportunity to construct a substantial deep-water artificial harbor at Takoradi, entirely with local revenues. Takoradi's construction required that large artificial breakwaters be constructed, but the end result was one of the

most freight-efficient harbors in West Africa. Takoradi was undoubtedly part of the reason that cocoa was so successful an export crop for Ghana.

Changes in the Agricultural Economy

Improved ports, and the railroads that served them, played an important role in linking the colonial economies to the industrial economies of Europe. The steamships that called at these improved ports carried off two types of goods: minerals and agricultural goods. In the late nineteenth and early twentieth centuries, European industries had reached a new level of sophistication. New transportation technologies and means of communication, notably the telegraph, made it possible for European industry to rely on regular deliveries of raw materials from the tropics, Asia, and Africa. Until the late nineteenth century, cotton was the only warm-climate raw material that was truly essential to Europe's factories, but by the early twentieth century, other fibers—jute, sisal, and coir—were in great demand. Oil crops like groundnuts, sesame seed, shea nuts, coconuts, and palm oil came into general use in Europe. Palm oil had been exported to Europe earlier but it was used primarily as an industrial lubricant; by the early twentieth century it was used for the more mundane (and cheaper) purpose of soap making and as a food. (Palm oil is what makes the filling of an Oreo Cookie so tasty.) Rubber consumption increased as first bicycles and then automobiles became more common. Stimulants like coffee, cocoa, and tea though not industrial raw material were still purchased in increasing amounts by Europeans as incomes rose among Europe's working classes.

Even if one accepts that Europe did not colonize Africa to secure supplies of these raw materials, then the timing was certainly, and suspiciously, convenient. For some Africans, Europe's demand for these goods, coupled with the new transportation infrastructure provided an opportunity. In some places, notably Ghana, which became a major cocoa producer largely on the initiative of local farmers, cash cropping created a prosperous African middle class. In other places this demand for raw materials had appalling consequences. In some cases it led merely to ill-advised government-directed development schemes. In the Congo Free State, the result was a system of quotas for the gathering of wild rubber, a system that was enforced with mutilations, beatings, and terror. In a few locations, where the climate allowed Europeans to thrive rather than merely survive, settler farmers became the main producers of these crops. In the Kenya highlands, Rhodesia, and South Africa, settler farmers displaced indigenous farmers, took their land, and carved out plantations that produced, with variable success, tobacco, coffee, sugar, and sisal.

Smallholder Cash Cropping

There were many state-directed efforts to encourage Africans to become cash croppers, but only a few were successful. Interestingly, the most successful transitions to cash cropping came when African farmers themselves chose the crops they wanted to grow and how to grow them. Here we examine three case studies:

cocoa in the Gold Coast, groundnuts and cotton in northern Nigeria, and cotton in Uganda.

In the Gold Coast, cocoa farming grew out of the pre-colonial experience with growing kola as a cash crop. (Kola nuts are chewed for their caffeine and once served to give Coca-Cola part of its bite.) Asante farmers in the Gold Coast had long been growing kola for export to the Sahel, where kola was popular but could not grow for lack of rainfall. Kola, like cocoa, was a tree crop and did well in the same guinea-zone forests that cocoa favored. Many of the tools used for kola farming were useful in cocoa production. The commercial and financial institutions that served the kola industry also helped to smooth the transition to cocoa farming.

While it is not clear exactly how cocoa (an American crop) was first introduced to the Gold Coast, one of the leading candidates as the first person to introduce it is Tetten Quashie, a blacksmith. Although the British colonial government's botanical garden at Aburi was selling cocoa seedlings by 1893, apparently the sales were too small to account for the rapid expansion of cocoa farming, so indigenous farmers must have been responsible for producing most of the necessary seedlings.[3] Cocoa farming spread first through the Akwapim ridge north of the capital city of Accra. As cocoa production increased and land became increasingly scarce on the Akwapim ridge, farmers began to migrate to new lands to the north and west. Eventually the cocoa industry reached the Asante region around Kumasi. The spread of the cocoa industry was complicated by the capital-intensive nature of the business. It took money to clear the land, money to buy the seedlings, and more money to survive the seven or so years it took for the trees to come into production. Gold Coast farmers met these challenges themselves. Some used money they earned in the rubber industry to break into the cocoa business, and others became tenant farmers in an effort to acquire the capital to start out on their own.

Interestingly, the opening of the Accra to Kumasi railroad in 1911 followed rather than preceded the spread of cocoa production there. In that same year, the Gold Coast became the world's leading cocoa producer. Over the course of twenty years, local farmers had selected a crop of their own choice, spread its cultivation through their own means, found the capital to invest in cultivation, and transported their crops to the sea. The result of this largely self-directed economic development was a level of prosperity in the Gold Coast that few neighboring colonies could match. The role of the colonial state in this transformation had been more supportive than directive. The state reacted to economic initiatives by African farmers rather than deciding on their behalf what they should plant.

In northern Nigeria the opposite was true, and the results of the state's efforts to encourage cotton farming are illuminating. Here too we encounter our first marketing board, a critical part of the Etatist-Peasant regime. Marketing boards are parastatal institutions that were first used in Europe to prop up prices for agricultural produce and generally support agriculture. Translated to the colonies, they used their monopoly buying powers less to support producer prices rather to depress them, believing this to be in the interest of the state.

3. Jan Hogendorn, "Economic initiative and African cash farming," in *Colonialism in Africa: 1870–1960, Vol. 4, The Economics of Colonialism*, edited by Peter Duigan and L.H. Gann (Cambridge: Cambridge University Press, 1975), 320–321.

In northern Nigeria it was the British Cotton Growers Association (BCGA) that spearheaded the effort to establish cotton farming. The BCGA distributed free cottonseed, established cotton gins, and set a fixed price at which the Association would buy cotton from African farmers. Their arrival in northern Nigeria coincided with the completion of a rail link to the city of Kano, the economic center and administrative capital of northern Nigeria. When the railroad opened in 1912, the BCGA expected farmers to start coming to sell their cotton for export. Instead they came with groundnuts, which sold for a much higher price than cotton at the BCGA's artificially low price. Over the next few years, groundnuts steadily replaced cotton in the fields around Kano, and what cotton was grown was mostly sold on the local market to meet the new demand for local textiles created by the income from groundnuts.

A similar effort by the French to stimulate cotton production in the West African Sudan was similarly blocked. Farmers in French West Africa grew cotton, but they rarely sold it to the Association Cotonnière Coloniale, the French answer to the BCGA. Instead they sold their cotton in regional markets that predated the arrival of the French, to the endless consternation of the French. In two colonial regimes in West Africa, farmers found themselves encouraged to grow a particular crop of the state's choosing. In one case they chose to grow something else and in the other they grew exactly the crop the state desired but sold it through channels that the state could not control.

Now and then, state-directed efforts to stimulate production of a particular crop worked. The same BCGA that failed so miserably in northern Nigeria was a success in Uganda. Four forces seem to have been responsible for the spread of cotton farming in Uganda. First, the opening of a rail link from Mombasa to Kisumu on Lake Victoria made it possible for goods from Uganda, just across the lake from Kisumu, to get to Mombasa for 48 shillings a ton as opposed to £200 to £300 sterling per ton when porters had carried goods to the coast. Second, the British colonial government in Uganda instituted a hut tax in 1900, thus requiring almost every Ugandan household to enter the cash economy. Third, the BCGA, the Uganda Company, and the colonial government distributed large amounts of free seed between 1903 and 1905. The BCGA and the Uganda Company also set up twenty gins before World War I. Fourth, Indian merchants, some of whom had originally come to work on the railroad to Kisumu and others who had come with the express purpose of entering the retail trade, began to penetrate even the more remote areas of Uganda. They made available consumer goods that spurred local farmers to increase their production. These factors worked together to make the new cotton industry profitable both for Ugandan farmers and for the colonial state, which derived much of its revenue from cotton.[4]

Labor in the Early Colonial Period

In those places where Africans had the bad luck to live in climates that interested European settlers or to live near mineral deposits, the colonial experience

4. Hogendorn, "Economic Initiative," 314–315.

was less kind. For African farmers in the Etatist-Peasant regimes, the colonial economy was full of pitfalls and humiliations, but it also provided some opportunities. Some entrepreneurial farmers found economic advantages in the new world of cash cropping. But for farmers in the Kenya highlands and Rhodesia, the colonial era meant dispossession and a new life, not as agricultural entrepreneurs, but rather as "squatters" who worked for wages on land that had once been their own. Africans who lived in the economic orbit of the goldfields of the South African Rand or the Central African copperbelt found themselves transformed into a proletariat (a working class that sells only its labor). In both places, Africans found themselves competing directly with Europeans. In the Kenya highlands it was a competition for access to land and the right to grow certain crops. In the mining areas it meant competition with white labor for wages and skilled work. In both cases, the deck was stacked against Africans by colonial governments that saw their primary role as representing the interests of European agricultural or mining interests.

Settler Farms in the Kenya Highlands

The highland regions of central Kenya have a truly delightful climate. The climate is temperate, mosquitoes are few, and crops like coffee and sisal thrive. The result was that European settlers were able to settle there in comparatively large numbers. Beginning in the 1890s, settlers, mostly British, began to move into the highlands. After the Uganda Railway opened, the number of settlers arriving increased. The city of Nairobi, nonexistent before the railway, sprang up in the central highlands, eventually becoming the capital of Kenya and the focus of settler life. As the settler farms grew in number, more and more land was alienated (a polite term for "seized") from the Kamba and Kikuyu. At the same time the settlers needed labor. Coffee and sisal require tremendous amounts of labor, especially during the harvest. Since the harvest of the cash crops coincided with the harvest of local food crops, most potential laborers were already busy with their own farms during the coffee and sisal harvests. Furthermore, the societies of the highlands were accustomed to recruit labor through kinship networks or through age grades (social groups of young men who were approximately the same age). They had no tradition of slave labor or wage labor. As a result, they were not willing to work on settler farms.

The settlers came saddled with a variety of stereotypes about Africans that exacerbated the situation. The 1903 *Report on Slavery and Free Labour in the British East Africa Protectorate* had this to say about Africans: "the African is essentially a child. Like a child he dislikes sustained effort over a long period of time, is careless of the future, and requires constant supervision."[5] Settlers believed that Africans were immune to the lure of high wages, and that their labor was worth little. As a result, they offered paltry wages. Naturally, the Kikuyu and Kamba did not beat down the doors to be allowed to take up difficult, low-wage work. They chose, instead, to farm as best they could on the land that they still had.

5. Quoted in Robert L. Tignor, *The Colonial Transformation of Kenya* (Princeton, NJ: Princeton University Press, 1976), 96.

Enter the colonial state. In true "regime of competitive exploitation" fashion, the state's representatives set out to procure labor for the settler farmers. First the government established a poll tax and insisted that it be paid in cash rather than kind. Where to get cash to pay the tax? Get a job on a settler's farm! Next the state enacted laws, notably the Masters and Servants Ordinance of 1906, that allowed employers to use legal sanctions against employees who "misbehaved." For example "not starting work contracted, absence without permission, intoxication, failure to perform the work required, the use of the employer's property without permission, and use of abusive language against the employer or his wife..." could all land an African in jail for a month or cost him a month's wages.[6] The state also pressured local chiefs, many of whom owed their office more to their collaboration with the state than to any traditional authority, to procure labor. The chiefs often did this by force. To the colonial state's credit, it made some feeble efforts to ensure that laborers were provided with shelter, blankets, and food or the opportunity to grow their own food. But the state's ultimate loyalty was to the settlers and it was the latter, not African laborers, who usually got the benefit of the doubt in a dispute.

The result was a system of "free" but coerced labor. Chiefs rounded up the laborers, the state encouraged this process by leaning on the chiefs and by requiring the payment of taxes in cash, and the settlers disciplined their employees with the assistance of draconian labor laws put at their disposal by a compliant state. Other regions of the continent also acquired settler farmers and plantation agriculture, and in each the system used to recruit and discipline labor was different. But in all, the state supported the efforts of settlers to get the labor they needed and to keep laborers at work once they had been recruited.

Working on the Mines

Labor regimes in the mining industry were even more varied than those in agriculture. Katanga in the Belgian Congo and the diamond mines of South Africa represent the two extremes.[7] In the former, African laborers worked almost without competition from European labor and managed to obtain a reasonable prosperity. In contrast, South African miners were forced to remain temporary workers, to live in secured compounds, to leave their families at home, and perform only unskilled labor; the skilled jobs were reserved for whites.

In Katanga, where copper mining was the main industry, mining companies had great difficulty attracting sufficient labor. Katanga had a low population density, at least in part because of the presence of the tsetse fly. The Union Minière, the owner of the major copper mines, sought at first to employ African labor on short-term contracts. Employers tended to prefer short-term contracts because they allowed miners who had been dismissed to be sent home; thus, they did not remain in the mining areas where they might pose a threat to the social order.

Short-term contracts also meant that the families of the miners remained at home, where they continued to farm. Thus the miner's family was self-supporting and the wages paid to African miners were seen as supplements to their farm in-

6. Tignor, *Transformation*, 102.
7. Austen, *African Economic History*, 165–166.

come and not their sole means of support. The cost of feeding, educating, and providing medical care for the miners' families was not the mining companies' concern, so long as the miners could be kept on short-term contracts and their families kept at a safe distance.

In labor starved Katanga short-term contracts proved difficult to enforce. Labor was in such short supply that much of it was recruited from neighboring Northern Rhodesia. In 1911, the Bourse de Travail du Katanga (Katanga Labor Exchange) was organized by a consortium composed of the government of Congo, the Union Minière, and the railroads, in an effort to see that labor was procured as efficiently as possible and shared among the industries that needed it. This was an excellent example of state intervention on behalf of industry.

But even this could not create a sufficient workforce, especially when World War I created a huge demand for carriers, the porters who transported the supplies needed by the various armies moving through East and Central Africa. The result was a shift in policy. The Union Minière decided in the 1920s to shift to a "settled" labor pattern, issuing long-term contracts and allowing—even encouraging—the miners' families to join them and to live in company housing. Basic medical care and education were furnished to their families. In short, the copper miners became what Marxists call labor aristocrats. In Katanga, a small number of African miners were able to live at a fairly high standard of living.

Further south, another group of miners enjoyed a standard of living roughly comparable to that of workers in the West. Here, on the mines of the South African Rand, the labor aristocracy was white. For a variety of reasons, ranging from a larger pool of African labor on which to draw, to the political power exercised by white workers in white-dominated South Africa, the short-term labor contract survived. The result was all-male enclaves of black miners living in closed compounds.

They lived in barracks; their families lived at some remove. For technical reasons having to do with the nature of the mines in South Africa, there was little pressure to replace unskilled labor with labor-saving machines operated by skilled labor. So there was little incentive to keep workers as long-term employees. A crippling strike by white workers in 1922 was resolved by reserving all the skilled work for whites. The result was a system that set average salaries for African miners in 1936 at 68 Rand per annum while the average white miner earned 786 Rand per annum. The system also branded African workers as permanently temporary while their white counterparts lived with their families as permanent residents of the Rand.

Review Questions

1. What were the economic goals of European imperialism in Africa? How did these goals shape colonial economic policy?
2. What were the effects of colonial economic policy on Africans?
3. Did the colonial economic effects vary from place to place? And if so, what caused this variability?
4. Did colonial economic policy usually have the results that colonial administrators hoped for? If not, why not?

5. What role did Africans play in shaping the colonial transformation of their economies?

Additional Reading

Austen, Ralph. *African Economic History*. London: James Currey, 1987.

Cooper, Frederick. *From Slaves to Squatters*. New Haven, CT: Yale University Press, 1980.

Duignan, Peter, and L.H. Gann (eds.). *Colonialism in Africa: 1870–1960, Vol.4, The Economics of Colonialism*. Cambridge: Cambridge University Press, 1975.

Roberts, Richard. *Two Worlds of Cotton*. Stanford, CA: Stanford University Press, 1996.

Chapter 7

African Environments in the Colonial Era

Christian Jennings

This chapter examines the environmental impact of colonialism in Africa. It considers both the perceptions and the reasoning used by European administrators in making policies concerning the African environment. It also looks at the perceptions of Africans themselves in their continuing efforts to shape landscapes to their own needs and aspirations. We will first introduce key concepts used by ecologists and environmental historians, and then review the background of environmental history in Africa before the colonial conquest.

Drawing on examples from West and East Africa, we will see how Africans have modified their landscapes over the course of several thousand years. By the time of European colonial conquest, the African continent no longer consisted of "natural" or "primeval" environments. In the second section of this chapter, we will examine the widespread environmental disasters of the late nineteenth century in eastern Africa, noting the ways in which it disrupted social and ecological patterns in Ethiopia, Sudan, and the Rift Valley of Kenya and Tanzania. We will also note the ways in which European colonialism was linked with this time of ecological distress. In the third section, we will review the mixed legacy of colonial conservation policy, focusing on three areas of concern: wildlife conservation and its relation to European hunting; the creation of forest reserves as a continent-wide phenomenon; and the soil erosion "scare" in East and South Africa. In conclusion, we will see how environmental problems and policies had long-lasting consequences for Africa. Hopefully, this chapter will offer a useful introduction to the broad scope of environmental history, and provide an understanding of the many ways in which colonialism rested upon the dynamic history of African landscapes and ecological relationships.

* * *

Environmental History in Africa

Environmental history combines the techniques of two academic disciplines, history and ecology (or biology in a broader sense), using the data of "hard" science to interpret the past as it relates to human interactions with the diverse landscapes they inhabit. Environmental historians try to "read" landscapes. That is,

they try to collect as much information as possible about humans and their envi-
ronments at given points in time, and then they detect the historical dynamics af-
fecting these ecological relationships. During much of the twentieth century, the
debate on African environmental history alternated between two extremes. On
one side were scholars who conceived of a primitive pre-colonial Africa. Here
man lived in a constant state of war against nature until he was introduced to
modern agriculture and industry through the imposition of western science and
technology. Others argued that pre-colonial Africans lived in harmony with their
surroundings, and that colonialism robbed them of their natural wealth and
abundant resources. But most scholars now agree that both of these views were
simplistic, because they neglected the fact that humans have always lived in con-
stantly changing relationships with their environments. In other words, to "read"
landscapes properly requires both an understanding of ecological relationships
and an ability to interpret them within a dynamic historical context.

Ecology is the study of relationships between organisms and their surround-
ings. While ecologists previously thought of "good" environments as having some
sort of internal balance or stability, these days it is widely accepted that all envi-
ronments are constantly changing. They are not necessarily moving in one partic-
ular direction or towards any culminating "climax" state. A crucial component of
current ecological thinking is biodiversity. Biodiversity involves both the total
numbers of species in an area and their complex interactions. Like the environ-
ment itself, biodiversity is constantly changing. This is an elusive idea, impossible
to measure with any sort of definitive standard, but ecologists generally agree that
greater biodiversity is an important indicator of a healthy environment.

Human beings are an integral part of this biodiversity. We now know that hu-
mans have dramatically modified their environments for thousands of years, in
ways that both positively and negatively affect biodiversity. Human activity
makes a significant impact upon soil composition and vegetation patterns, as well
as the distribution and diversity of animal populations. Humans modify their en-
vironments through subsistence practices such as hunting, gathering, fishing,
herding, and farming; through increases in population size and density; and
through technological development, such as the use of iron tools. Many of the
landscapes once considered "natural" are actually the result of human modifica-
tion. The great African savannas, for instance, would simply be overgrown wood-
lands without the continual grazing of cattle and the occasional brush fires set by
human inhabitants to maintain the rolling grasslands.

Environmental history in Africa involves changes within different time
frames, from very long-term climate variation, to very short-term human deci-
sions, such as those made by individual farmers or herders. Over very long time
spans, Africa, like other continents, has been subject to slow fluctuations in the
earth's climate, which have produced dramatic changes in African landscapes. For
example, more than four thousand years ago, the Sahara was a rolling grassland
that supported substantial populations of humans, cattle, and wildlife. The vast
Sahara desert we see today is largely a product of climate change, which unfolded
over millennia, slowly, but significantly altering the human history of the area. In
contrast to such long-term changes, there are important short-term climate varia-
tions that can be detected and adapted to by humans. Most of the African conti-
nent, for example, is characterized by a "bimodal" pattern of wet and dry seasons
rather than the four seasons of the earth's temperate zones. This bimodal pattern

means that much of Africa is particularly susceptible to drought, forcing humans, as well as plants and animals, to adapt.

African communities have adapted to these dry conditions in creative and diverse ways. Agriculturists rotate their crops in careful patterns to conserve water and soil, while pastoralists maintain a high level of mobility to make wider use of watering points and grasslands for their cattle. Such human adaptations are usually the result of individual decisions in response to immediate concerns. Over the long term, a series of decisions often develops into a noticeable historical trend, a process that scholars call "incremental adaptation." Incremental adaptation, or the accumulation of individual decisions in the context of long-term or widespread environmental patterns, of which humans may be only partially aware, is the primary way in which humans modify their landscapes, and affect the biodiversity surrounding them. In fact, evidence of incremental adaptation can be seen as a fundamental component of environmental history, providing many of the small pieces of information that historians put together to tell a larger story.[1]

In thinking about the background to the environmental impact of colonialism in Africa, it is essential to remember that Africa was not an isolated continent before European annexation. Rather, Africa had been interacting with the broader world for an extraordinarily long time. This interaction involved not only the exchange of trade items and intellectual ideas, but also an ecological exchange of plant and animal species dating back at least thirty million years. Africans incorporated many species from elsewhere and made them their own. Domesticated cattle were adapted to local African environments perhaps seven thousand years ago, and not long after that, wheat and barley were worked into African agriculture. Perhaps two thousand years ago, Africans borrowed bananas from Southeast Asia, and made them a staple of many African diets. More recently, important crops such as manioc (cassava) and maize (corn) were brought to Africa from across the Atlantic Ocean. African peoples used all of these ecological exchanges to dramatically modify their landscapes and the biodiversity of their environments.[2]

Africans also interacted with their environment through the different ways in which they organized their social and economic lives. Precolonial Africa consisted of a vast network of communities in diverse environmental settings, linked together by markets, urban centers, and far-flung trading routes. In addition, different communities were often linked by ties of "reciprocal obligation" through kinship or marriage alliances. All of these economic, political and social connections provided ways by which Africans could cope with environmental adversity and shape the landscapes they inhabited. During times of severe ecological stress, such as famines or outbreaks of disease, these complex networks of human interaction were often disrupted and restructured, so that environmental history is closely intertwined with the history of African political and social institutions. Historians have even suggested that the development of many of Africa's powerful empire states, such as Mali, Aksum, and Great Zimbabwe, might have been deeply af-

1. William Doolittle, "Agricultural Change as an Incremental Process," *Annals of the Association of American Geographers* 74 (1984), 124–37.

2. James McCann, *Green Land, Brown Land, Black Land: An Environmental History of Africa, 1800–1990* (Portsmouth, NH: Heinemann, 1999), 12–15.

fected by the influence of long-term climate changes. At the same time, these king-doms played a large part in modifying, sometimes dramatically, the environment of precolonial Africa.[3]

The development of the Asante empire in central Ghana illustrates many of the ideas introduced above. Akan kingdoms preceded Asante in the frontier area between the Upper Guinea forest along the coast and the interior savanna. Akan settlement and state-building was fueled by two processes which dramatically altered the ecology of the area; the refinement of a forest fallow system of agriculture and the heavy involvement of Akan in the emerging Atlantic mercantile system from the sixteenth century onwards. The Akan forest fallow system involved the removal of the high forest canopy to let sunlight down onto fields, combined with careful management of the succession of forest regrowth to improve farming conditions. At the same time, the Atlantic exchange was transporting humans, food crops, and diseases between Africa, Europe, and the "New World." One by-product of this exchange was that Akan farmers began to experiment with cassava and maize imported to West Africa aboard Portuguese ships from the Americas. These new crops proved well suited to forest agriculture, and soon provided the foundation for an expanding population. The Asante empire, which rose in the eighteenth century, built upon these earlier legacies, so that by the reign of Osei Bonsu in the early nineteenth century, the landscape of central Ghana was hardly "natural" at all, but rather was the result of careful human manipulation over the course of several hundred years.[4]

Environmental history in Africa isn't merely related to large-scale kingdoms and empires; stateless, decentralized societies have played an important role in shaping Africa's diverse landscapes. The broad savannas of East Africa, for example, may strike the imagination as wildlands roamed by herds of elephant and wildebeest, but they were largely a product of human manipulation. Pastoralists, people who live by keeping cattle, have been in East Africa for at least four thousand years. This continual grazing of cattle, combined with occasional brush fires, has helped maintain the grasslands that support wildlife. The Maasai, who came to prominence during the 19th century, practiced a highly sophisticated form of transhumant pastoralism, in which small groups of stock-owning families moved in seasonal and yearly cycles across a wide stretch of land. Maasai range management techniques included the rotation of grazing patterns, the use of dry-season reserves, and the use of special grazing areas near homesteads for calves. Keen observers of their environments, they recognized distinctions between several types of grasses and their nutritional value for livestock. They also used trees and other plants for fencing, medicine, building materials, and a variety of other purposes. The Maasai also established wide-ranging trade linkages, acquiring agricultural produce, iron implements, clothes, and ornaments in exchange for goods produced from their cattle. But the Maasai suffered a crushing disaster virtually on the eve of colonial intrusion into their territory: a "triple disaster" of bovine pleuropneumonia, rinderpest, and smallpox. This series of epidemics tore apart

3. David Anderson and Richard Grove, "Introduction: The Scramble for Eden," in David Anderson and Richard Grove (eds.), *Conservation in Africa: People, Policies and Practice* (Cambridge University Press, 1987), 6–10; McCann, *Green Land*, 23–51.

4. McCann, *Green Land*, 110–27; see also Ivor Wilks, *Forests of Gold: Essays on the Akan and the Kingdom of Asante* (Athens, OH: Ohio University Press, 1993).

human communities and the landscapes they inhabited, not only in Maasailand, but also across East Africa.[5]

Environmental Disaster
and Colonialism in Eastern Africa

European representatives gathered at the Berlin Conference in 1885 to stake their respective colonial claims on the African continent, they worked under the assumption that European militaries would be able to defeat any African resistance they might encounter. For the most part, this assumption was correct, since European military technology held a decided advantage over the weapons available to most African societies. But there was another and perhaps equally important factor which gave Europe a tremendous advantage, especially in the areas stretching from Ethiopia to Tanzania. Coinciding with the colonial expansion into Africa during the late nineteenth century, a catastrophic wave of disease and famine swept across the eastern side of the continent, dramatically altering African political and social systems, and crippling the military capabilities of many African societies. These disasters set the context in which many of the early colonial conquests were undertaken, and deeply influenced their outcomes. In this section, we will examine the ways in which colonial encounters with three African societies — the Ethiopian empire, the Mahdist state in the Sudan, and Maasai pastoralists of the Rift Valley — were affected by environmental catastrophe.

Between 1888 and 1892, a triple disaster of rinderpest, drought, and infestation by locusts and caterpillars swept across Ethiopia, demolishing the country's agricultural system and leading to the time remembered as the "Great Famine." Rinderpest, a disease that killed cattle throughout Africa with the onset of European colonialism, first arrived in Ethiopia through the Red Sea port of Massawa in Eritrea, borne by a shipment of cattle from India. The disease spread lighting-quick into the countryside, destroying herds with astonishing ferocity. Emperor Menilek personally lost a quarter of a million cows to the disease. The rinderpest epidemic swept steadily from north to south, through the districts of Tigray and Showa to Arsi and on towards Somalia, where once-wealthy herdsmen found themselves reduced to poverty without warning. Because the rinderpest left Ethiopian farmers without oxen for ploughing, an unusual dry spell in 1888 and 1889 resulted in widespread crop failure. To make matters worse, what little grain could be harvested was then destroyed by an infestation of locusts and caterpillars. Famine spread throughout Ethiopia, setting off a wave of migration, as impoverished rural dwellers took to the roads in search of food. Perhaps abetted by this demographic upheaval, epidemics of typhus, smallpox, cholera, dysentery, and influenza followed in the wake of famine. In the end, perhaps a third of all Ethiopians died during these disastrous years.[6]

5. Peter D. Little and David W. Brokensha, "Local Institutions, Tenure and Resource Management in East Africa," in Anderson and Grove (eds.), *Conservation in Africa*, 193–209.

6. Richard Pankhurst and Douglas H. Johnson, "The Great Drought and Famine of 1888–92 in Northeast Africa," in Douglas H. Johnson and David M. Anderson (eds.), *The*

The Great Famine occurred at a dangerous moment for Ethiopia. The past few decades had been spent in fending off invasions from the British, Egyptians, Italians, and Mahdists, and the pace of conflict showed no signs of slowing down. The Italians, in fact, used the depopulation caused by the famine as a pretext for further settlement in their newly established colony of Eritrea, and advanced unopposed into northern Ethiopia. But in a remarkable show of self-reliance, Emperor Menilek rallied his country and preserved its independence. Menilek urged his people to use hoes and spades to compensate for the lack of plough oxen, leading by example as he worked the fields himself in public view. Menilek then took legal action to prevent hoarding and speculation in grain, forcing supplies of food back onto the market. Finally, the emperor established granaries for his troops, and formalized a system of taxation on agriculture for troop provisions. By 1895, Menilek was able to take the offensive, eventually defeating the Italians and bringing several southern peripheral areas under the sway of the Ethiopian empire. In this case, environmental disaster actually helped consolidate African state power and military strength, but Ethiopia proved to be the sole exception to the general pattern of weakened African independence.[7]

One example of an African political system brought to its collapse by environmental disaster was the Mahdist state, which held areas of the Sudan formerly claimed by Egypt. The Mahdists had a *jihad* government, constantly seeking to expand their influence through military conquest. When the dry season of 1888–89 hit the Sudan, its effects were intensified by the Mahdist practice of allowing troops to plunder the countryside for their provisions. When roving Mahdist armies prevented any kind of agricultural recovery, refugees flooded into the towns, adding to the unstable demographic pattern caused by the state policy of forced urbanization to the Mahdist capital at Omdurman. Grain reserves were already dangerously low by 1889 when the locust swarms hit Sudan, accompanied by scattered outbreaks of rinderpest. Finally, with Mahdist military campaigns reduced to little more than foraging expeditions, some armies were forced to stop and farm for themselves. British officials in Egypt, who were hostile to the existence of the Mahdist state, used the famine as an opportunity to vie for allegiance by supplying food aid to "friendly tribes" in the Sudan. And Egypt itself launched an invasion in 1891, leading to the eventual demise of the Mahdist *jihad*. In contrast to the Ethiopian events discussed earlier, in this case, environmental disaster severely crippled an African state, leaving it with an insurmountable disadvantage in the colonial encounter.[8]

Moving to an example of environmental catastrophe in a stateless (or decentralized) African society, the "triple disaster" in East Africa proved to be a similarly crippling experience for Maasai pastoralists of the Rift Valley. During the late nineteenth century, the Maasai were hit by three epidemics in quick succession: first, bovine pleuropneumonia; then, rinderpest; and finally, smallpox. This time of distress is remembered by Maasai communities as *emutai*, which means "to finish off completely." It was unusual by East African standards in that it was caused not by drought, which is recurrent and therefore can be coped with, but by disease. Bovine

Ecology of Survival: Case Studies from Northeast African History (London: Lester Crook, 1988), 49–54.

 7. Pankhurst and Johnson, "The Great Drought," 51–57.

 8. Pankhurst and Johnson, "The Great Drought," 57–66.

pleuropneumonia (or BPP) first appeared in Maasailand in 1883 and spread across a wide area. The disease, which had appeared elsewhere in Africa during the nineteenth century, was deadly but not disastrous by itself. The Maasai responded to BPP by carefully controlling cattle movements to avoid further infection, and even by practicing a form of inoculation through tissue graft. But in 1891, rinderpest followed on the heels of BPP, sweeping down from Ethiopia and Somalia and decimating Maasai herds with astonishing quickness. Tensions erupted between Maasai sections, as raiding parties sought to restock impoverished herds, and the conflict only intensified when smallpox swept across Maasailand in 1892.[9]

Civil wars followed the "triple disaster," illustrating the ways in which environmental distress can radically alter political and social realities in human communities. *Emutai* brought about a sudden realignment of social networks in the East African interior, with many Maasai pastoralists, who had established their control of the savanna only a few decades earlier, now forced to seek refuge among agriculturalists and hunter-gatherers. At the same time, the civil war that broke out among the remaining Maasai, became entangled with the process of colonial expansion in East Africa. This proved to be the turning point in the war, when the northern Maasai alliance allied itself with the British colonialists, thereby defeating its southern enemies, who were under severe pressure from German punitive expeditions.

The "triple disaster," and the crises that followed, produced dramatic changes in East African landscapes. When European explorers pressed inland, they found large parts of Maasailand depopulated. The German geographer, Fritz Jeager, visiting once-inhabited Serengeti in 1907, described it as "grass, grass, grass, grass, and grass. One looks around and sees only grass and sky."[10]

Like the Italians in Eritrea, British and German colonialists misread these disaster-stricken East African landscapes as representing the normal, "natural" state of things, a perception that would inform colonial policies for decades to come, with mixed results for both conservation and the well-being of African communities. In the case of Maasailand, colonialists saw the "uninhabited" northern part of the Rift Valley as prime land for European settlement, and the Maasai were coercively moved in 1904 and 1911 onto an arid, tightly-controlled reserve in southern Kenya. This confinement radically disrupted the ecological relationships of Maasailand. When the Maasai no longer had access to crucial dry-season grazing reserves, social and economic links between different communities were cut off completely and, perhaps most importantly, the prior flexibility with which the Maasai could cope with environmental stress was severely limited.[11]

The Mixed Legacy of Colonial Conservation

During the colonial era, Africans throughout the continent continued to modify their environments as they had before. But they now acted within the overar-

9. Richard Waller, "Emutai: Crisis and Response in Maasailand 1883–1902," in Johnson and Anderson (eds.), *Ecology of Survival*, 73–86.

10. Jonathan S. Adams and Thomas O. McShane, *The Myth of Wild Africa: Conservation Without Illusions* (Berkeley: University of California Press, 1996), 37.

11. Anderson and Johnson, "Introduction," 17.

ching political context of colonial administration, which began to dictate the shape and dynamics of African landscapes in new and often radical ways. European imperialists came to Africa with their own ideas of what Africa should look like, and when reality didn't meet their expectations, colonial policy was often enacted to reshape Africa into the romantic images held by Europeans. At the same time, colonialism had a driving motive, economic profit, and environmental policy had to be crafted to best suit maximum production. The new power structure created by colonial occupation allowed the Europeans to take over the role of modifying African landscapes, but they did this without benefit of the African's detailed environmental knowledge and experience, gained during the past several centuries. The results of such policies, often based on superficial knowledge, continue to affect Africa's environments to the present.

To put the story in its broadest terms, colonial officials during the years 1885 to 1939 attempted to reshape Africa in order to simultaneously preserve its "natural" aesthetic qualities and to integrate the continent productively into the colonial market system. Colonial administrators saw their task as one of managing natural resources. To this end, they emphasized export production and "scientific" data, while largely ignoring local production and indigenous knowledge. Throughout the continent, and especially in West Africa, cash crop production was the primary concern, and landscapes were modified to best support this enterprise. At the same time, in many parts of the continent, especially in eastern and southern Africa, colonial administrators and settlers strove to preserve what they saw as a "primordial wilderness" against the threat of human encroachment, even in areas where Africans had maintained thriving communities for millennia. In the following pages we will trace the evolution and impact of colonial conservation policy in three related areas: hunting and wildlife conservation; forest reserves; and soil erosion.

Colonial Hunting and the Wildlife Conservation Movement

When one reads the contemporary literature associated with the rise of European control in Africa, it is hard to avoid the impression that the colonial era was essentially one gigantic hunting safari. This impression is not entirely without basis in truth, for "the Hunt" was a fundamental component of the colonial project. Game hunting was a common, crucial activity, of explorers, prospectors, missionaries, settlers, and administrators alike. Hunting went hand in hand with imperial expansion, to the extent that one almost always necessitated the other, and vice versa. British literature and social institutions elevated hunting to a cultural phenomenon, taking it to represent all of the glamorized attributes of the men who carried the colonial flag abroad: manliness, adventure, patriotism, class status, and a touch of romantic nostalgia. Even as it took a serious toll on Africa's wildlife and human communities, hunting became a primary means by which Europeans reshaped African landscapes to fit their own notions. Eventually, hunting played a significant role in the development of the wildlife conservation movement in Africa, with mixed results for African environments and African communities.

The centrality of hunting to colonialism in Africa can hardly be overstated. During the first years of imperial reconnaissance in the early nineteenth century, hunting was usually a necessity for explorers, missionaries, and settlers trying to

survive in an unfamiliar and challenging environment. As Europeans began to establish themselves and push further into the interior during the mid-nineteenth century, a group of rugged professional hunters emerged, taking prominent positions in African trading networks while entangling themselves in local politics. For example, white hunters, who first appeared in Ndebele-land in Central Africa after 1850, began arriving in large numbers by 1870. The Ndebele kings solicited the hunters for diplomatic favors, firearms, and ammunition, in exchange for granting them access to the area's rich game. White hunters, who wasted no time in decimating elephant populations, were forced within twenty years to shift from hunting on horseback to tracking the few remaining elephants on foot through the dense brush to which they had retreated. Perhaps the most famous professional hunter to make his fortune in Ndebele-land was Frederick Selous. Novelist Rider Haggard modeled his literary hero Allan Quartermain on the real-life Selous, anticipating a cultural trend toward the glamorization of white hunters that would peak a few decades later.[12]

Hunting continued to play a prominent role in the consolidation of European rule during the late nineteenth and early twentieth centuries. Pioneering imperialists, such as Frederick Lugard and Frederick Jackson in East Africa, used their hunting profits to finance British colonial expansion into the interior. During the many "pacification" campaigns to quell African resistance, troops were regularly provisioned with whatever wildlife they could shoot. When the railways of East, Central and Southern Africa were being built, colonial engineers included the cost of hunting game to feed their laborers as part of their financing calculations. Once the railways were completed, tourists then used the trains as mobile hunting platforms, gunning down animals as they rolled by. To make matters worse for the animals, Africans had acquired guns, and found themselves in economic circumstances that often necessitated hunting for food. During the late nineteenth century wildlife became noticeably scarce. And by the turn of the twentieth century, the devastating impact of hunting was so obvious to anyone who cared to look, that colonial administrators began to take seriously the idea of establishing game reserves.[13]

Despite the obvious detrimental effects on African wildlife, hunting evolved right along with consolidation of the colonies. As the wars of "pacification" settled into administrative routine in the early twentieth century, a new cultural phenomenon emerged — the recreational hunting safari. Hunting safaris soon became a status symbol for upper-class men able to hunt at their leisure. Their lifestyle was glamorized by countless juvenile adventure stories as well as popular novels such as Isak Dinesen's *Out of Africa* (1937) and Ernest Hemingway's *The Green Hills of Africa* (1936). None other than Frederick Selous personally guided Theodore Roosevelt through East Africa in 1909, on perhaps the most celebrated safari ever. In the course of this single journey, Roosevelt's entourage shipped home to the Smithsonian five thousand mammals, four thousand birds, two thousand reptiles, and five hundred fish. Roosevelt and his son Kermit shot more than five hundred animals on their own, including nine endangered white rhinoceroses. When the "Golden Age" of hunting between the two World Wars drew promi-

12. John M. Mackenzie, "Chivalry, Social Darwinism and Ritualised Killing: The Hunting Ethos in Central Africa Up to 1914," in Anderson and Grove (eds.), *Conservation in Africa*, 41–44.

13. Mackenzie, "Chivalry," 45–49.

nent men from around the world to enjoy their own safaris, these devastating effects were compounded.[14]

This new kind of hunting sportsman, and the mythic image he evoked, was no less linked to colonial domination than the earlier imperialist who hunted out of necessity, an association that would deeply affect the rise of the conservation movement in Africa. White hunters such as Roosevelt and Selous were portrayed as free individualists, adventurous and masculine, the very embodiment of European triumph over the "Dark Continent" and its indigenous peoples. Since the early days of British imperialism in India, hunting in the colonies had been explicitly linked to military training, and young boys were taught to see themselves growing into heroic soldiers for the empire. Lord Baden-Powell, founder of the Boy Scouts, was hardly an exception when he touted virtues of the South African hunt as preparation for hunting "wild beasts of the human kind." In some ways, whites held hunted game animals—beasts of "nature" killed through ritualized sport—in higher esteem than African casualties of colonialism who were killed because of their "savage" resistance to Europe's civilizing mission. The establishment of game reserves in colonial Africa during the early twentieth century was inextricably linked to the desire that these wildlife sanctuaries would also provide sanctuary for whites from the harsh political realities of colonialism.[15]

As the colonial movement for wildlife conservation developed in the 20th century, it maintained the twin elements of professed concern for "natural" environments, on the one hand, and a deep-seated refusal to acknowledge African rights or involvement in their own lands on the other. Colonial conservationists began to bolster their attitudes with pseudo-scientific arguments. Many hunters, for example, made a great show of pretending to be naturalists on their safaris, dutifully collecting and classifying the various species they were hunting. But despite these claims to a higher calling, the primary goal of early conservationists was clearly to protect and restrict the practice of hunting as the domain of white sportsmen. The separation of Africans from hunting was supported by colonial law, which criminalized African hunters as "poachers," even when hunting seemed to be a necessary measure. When famine struck African communities, as it did in Kenya at the turn of the century, and Southern Rhodesia in 1922, Africans were not allowed to hunt for food as they had during times of famine before colonial rule, with tragic results. The conservation movement in Africa would not fully outgrow its racist background until the late 20th century, and even today, many of the attitudes that shaped colonial conservationism still inform policy decisions on environmental issues.[16]

The Creation and Contestation of Forest Reserves

As we have already seen, forest landscapes in Africa have been modified and manipulated by human actions for several millennia. Africans used forest resources for food, building material, fuel, medicine, and countless other purposes,

14. Adams and McShane, *Myth of Wild Africa*, 28–29.
15. Mackenzie, "Chivalry," 51–53.
16. Mackenzie, "Chivalry," 55–58.

and they shaped the biodiversity of forest environments to best suit their needs and aspirations. With the advent of colonial rule, however, centuries of learning and effort would be ignored, as European officials saw only natural or "primeval" forests threatened by African "mismanagement." Forestry departments established within colonial governments generally shared a common set of assumptions and goals, whether they were in French Guinea or British East Africa. Colonial forest administrators placed primary emphasis on commercial forestry for the export market. They favored the planting of exotic, marketable trees such as conifers and eucalyptus, at the expense of indigenous species; they showed little interest in the ways Africans used forest resources; and they often regarded Africans as ignorant spoilers of forest landscapes. Perhaps the most important and widespread forest policy during the colonial era was to set aside "forest reserves" as off-limits to Africans, even when that meant physically removing people from lands they had been using for centuries.[17]

In this section, two forest-management case studies will be examined, from opposite sides of the continent. By the time of formal European colonization at the end of the nineteenth century, the broad stretch of the Guinean forest in west-central Africa had been completely reshaped by human hands, over the course of several centuries, to develop an extensive forest fallow system of agriculture. But after the consolidation of *Pax Britannica*, another modification took place, as entrepreneurial farmers spread along the forest to set up cocoa plantations. Cocoa farming during the early colonial era linked small, independent farmers to an international market and cash economy, and soon brought railways, cars, and trucks into the forest. By the early twentieth century, farmers in the Gold Coast (Ghana) had become the world's leading cocoa producers. It did not take long for colonial observers to begin worrying about this forest agriculture boom and its effects on the environment. Administrators in the Gold Coast mistakenly assumed that Africans were clearing "virgin" forest, as yet untouched by human influence, to make way for their cocoa plantations. In fact, the exact opposite took place in many parts of the forest. In French Guinea, the conscious selection of woody shrubs, through concentrated cattle grazing, actually helped to build up a patchwork of human-induced secondary forest growth in areas that had once been grasslands. Colonial administrators were not interested in such subtleties, however. In 1908, the British government of the Gold Coast established a Forestry Department which, in 1927, began to place forest reserves under direct government control. By 1939, 1.5 million hectares, equaling about twenty percent of the Gold Coast forest, had been taken away from African farmers and set aside as forest reserves.[18]

Another case study, from Kenya in East Africa, illustrates the ambiguous history of conservation efforts during the colonial era, as well as the many ways in which battles for control of forest resources in Africa could become highly politicized. The Lembus forest, situated in a transitional zone between the river systems of the Rift Valley and western Kenya, has for centuries been a site of mixed agricultural and pastoral use, as well as an important gathering and negotiating point for peoples from different social and ethnic groups. Prior to colonial administration, the Lembus forest had been partially cleared and cultivated by farmers. As

17. Little and Brokensha, "Local Institutions," 202–203.
18. McCann, *Green Land*, 60–63, 128–33.

such, it had provided seasonal grazing reserves for Maasai and Nandi pastoralists from the drier lowland savanna regions, and it had also been housed a small population of hunter-gatherers who played an essential role in inter-regional trade. The forest was an area of interaction, used by many ethnic groups but controlled by none, and usage varied seasonally or even over stretches of years. British officials charged with governing this area, however, did not find this ambiguity helpful; they preferred to have clearly marked territories, each inhabited by a distinct "tribe." This tension, between colonial ideas of how Africa should look on the one hand, and ground-level African reality in the Lembus forest on the other, produced an arena for argument and conflict that lasted more than three decades.[19]

Shortly after the turn of the century, Charles Eliot, the High Commissioner of British East Africa, gave an enormous land concession, including the Lembus forest, to a small Canadian-South African business group led by Ewart Grogan. Eliot intended for Grogan to set up a timber industry in the forest, but he had neglected to get the approval of his own Forest Department, which would battle Grogan for influence in Lembus well into the 1930s. A clause had been put in the land agreement to protect the rights of any Africans living in the forest, but Grogan considered the area to be nearly uninhabited since it was "only" used seasonally by most of its visitors. But when it became clear that quite a few Africans considered the forest to be theirs, the administration in 1923 issued a statement supporting the inhabitants' rights, on the condition that they could prove they had used the forest "according to native law and custom" in pre-colonial days. Five hundred families took up this challenge, most of them from the Tugen ethnic group, giving the colonialists exactly what they wanted: a clearly defined territorial unit, inhabited by a single "tribe." In the meantime, however, the forest had in fact become an important sanctuary for many ethnic groups, as it was one of the few remaining African areas left amid the alienated settler areas of the "White Highlands." The government resorted to occasional police raids to root out this unauthorized mingling, but found it difficult to control movements of cattle and people beneath the forest cover.[20]

The situation finally came to a head after 1930, when an international depression in timber trade finally gave the Forest Department an edge over business concerns for control of the Lembus forest. But another opponent had gathered strength in the meantime. The Tugen, who had been working to consolidate their official recognition as the "tribe" of the forest, now had the District Administration officials firmly on their side. The Forest Department intended to close off much of the Lembus from African grazing and cultivation, even if it meant denying the Tugen their legal rights to the forest. As was typical of the early conservation movement in Africa, Kenyan forestry officials considered African inhabitants a nuisance at best and a threat to environmental stability at worst. The Forest Department had conventional wisdom on its side, arguing that the Lembus had to be saved from African mismanagement before it would fall victim to the degradation then feared to be sweeping across Africa's soils (see below). But in this case, the Tugen, who had established legal precedent and who had the local administration on their side, were able to hold on to their control of the forest. Even this small vic-

19. David Anderson, "Managing the Forest: The Conservation History of Lembus, Kenya, 1904–63," in Anderson and Grove (eds.), *Conservation in Africa*, 251, 261.
20. Anderson, "Managing the Forest," 252–60.

tory, however, carried a mixed legacy: the Lembus forest had become "tribalized," a strictly defined ethnic enclave where no such exclusivity had existed before.[21]

The Soil Erosion "Scare" of the 1930s

During the 1930s, the British administration in East Africa, spurred by a set of alarming circumstances in Africa and abroad, began to worry that the region's soils were rapidly deteriorating. First, there had been a worldwide economic depression, which colonial governments tried to offset partially by increasing agricultural production and acreage. Second, the "Dust Bowl" in the U.S. plains of the early 1930s sent panic far and wide, and, in the process, heralded the first "global" environmental problem of the twentieth century. Colonial administrators read with urgency the voluminous literature coming out of the Dust Bowl, and worried that the same erosion crisis might be looming in their own territories. Third, there was a growing awareness in East Africa that the "African Reserves," which had been demarcated during the previous decade with the intent of limiting each "tribe" to its own tightly controlled area, were dangerously overcrowded and their lands overworked. Finally, a dismal drought that lasted from 1926 to 1935 threw each of these issues into an even more glaring light, prompting many officials to advocate drastic measures towards halting a perceived soil-erosion catastrophe. Characteristically, colonial administrators and settlers attributed most of the danger to what they saw as African mismanagement of agriculture and grazing resources. And when it became fashionable for colonial agricultural officers in East Africa to "see" soil erosion at work everywhere, the perceived problem served as a pretext for massive intervention into African agricultural practices.[22]

At the hearings of the Kenya Land Commission in 1933, white settlers accused African "squatters," landless families who had taken up residence on alienated settler estates, of spreading bad agricultural practices from the Reserves to the White Highlands. Most European settlers were hardly agricultural experts themselves, and when the depression hit their farms, they simply lashed out at the nearest available scapegoat, the African farmer. But the fact remained that the Reserves really were suffering from erosion as a result of overcrowding. The Reserves had been created by officials who first saw East Africa in the aftermath of the "triple disaster" and they believed that Africans were sparsely scattered on the land. When African communities began to recover from the epidemics and famine, they found themselves confined to small areas that could not possibly support normal levels of population, farming, or cattle grazing. But most administrators saw only African mismanagement in these precarious landscapes. When Kenya established its Soil Conservation Service in 1938, the idea was not to find ways for Africans to regain the agricultural initiative they had held prior to the colonial conquest, but rather to prescribe "scientific" improvements for Africans to follow. In the ensuing years, African farmers would be forced to build agricultural terraces and use heavy machinery, often making their problems even worse,

21. Anderson, "Managing the Forest," 260–65.

22. David Anderson, "Depression, Dust Bowl, Demography, and Drought: The Colonial State and Soil Conservation in East Africa During the 1930s," *African Affairs* 83 (1984), 321–43.

while their pastoralist neighbors would face mandatory destocking programs and bans against fires, leading to the rapid encroachment of thick bush and tsetse flies into grazing areas.[23]

In southern Africa, the soil erosion "scare" and the resulting colonial policy took on wide-ranging social and economic dimensions. During the late nineteenth century, African farmers in Lesotho (then called Basutoland) had been highly successful entrepreneurs, providing substantial grain supplies for workers in the nearby diamond mines. But they soon faced competition from white South African farmers in the neighboring Orange Free State. Not coincidentally, when soil erosion became an international concern in the 1930s, these white settlers were quick to accuse Africans of causing erosion through bad agricultural practices. The government stepped in forcefully, coercing African farmers into building terraces, furrows, and "meadow strips" (all labor-intensive practices thought to prevent erosion). But far from restoring agricultural soundness in the region, colonial policy gradually transformed Lesotho's communities from self-reliant agricultural producers into an impoverished labor reserve for the mine economy. Here, as elsewhere, colonial environmental policy developed within the broader context of economic motives and political expediency. This mixed legacy of ecological concern and colonialist attitudes would continue to set the tone of the environmental movement throughout Africa well into the latter part of the twentieth century.[24]

Conclusion

By the end of the 1930s, colonial officials in Africa had adopted a widely-shared set of assumptions about African environments, developed from the combined influence of early experiences in Africa, as well as ecological problems and attitudes from abroad. First, administrators agreed that Africa's landscapes were rapidly deteriorating, in terms of soil quality, forest cover, and wildlife populations, and that Africans themselves were incapable of managing their own resources. Second, they believed that the proper response to these conditions was conservation through scientific management and technological progress, using coercive measures when necessary. After World War II, this "ideology of conservation" would underpin a range of sweeping colonial policies, mostly aimed at the "modernization" or "development" of Africa. As before, colonialists reserved for themselves the right to decide what African landscapes should look like. But this intrusive meddling in African agriculture and social life also provoked many Africans to think of their situation through the lens of a new political consciousness. Even as tensions between ecology, politics, and race reached new levels of magnitude during the twentieth century, they were also setting the stage for new relationships between humans and their environments.[25]

23. Anderson, "Depression, Dust Bowl," 323–34; Little and Brokensha, "Local Institutions," 197.

24. McCann, *Green Land*, 142–45.

25. Anderson, "Depression, Dust Bowl," 321, 339; McCann, *Green Land*, 75.

Review Questions

1. How did the environmental disaster of the 1890s in eastern Africa (Maasai-land, Ethiopia, and Mahdist Sudan) affect the onset of colonial conquest in those areas?
2. What does it mean to say that colonial attitudes and policies left a "mixed legacy" for the conservation movement in Africa?

Additional Reading

Adams, Jonathan S. and Thomas O. McShane, *The Myth of Wild Africa: Conservation Without Illusions*. Berkeley: University of California Press, 1996.

Anderson, David and Richard Grove (eds.). *Conservation in Africa: People, Policies and Practice*. Cambridge University Press, 1987.

Johnson, Douglas H. and David M. Anderson (eds.). *The Ecology of Survival: Case Studies from Northeast African History*. London: Lester Crook, 1988.

Maddox, Gregory, James Giblin and Isaria N. Kimambo (eds.). *Custodians of the Land: Ecology & Culture in the History of Tanzania*. London: James Currey, 1996.

McCann, James C., *Green Land, Brown Land, Black Land: An Environmental History of Africa, 1800–1990*. Portsmouth, NH: Heinemann, 1999.

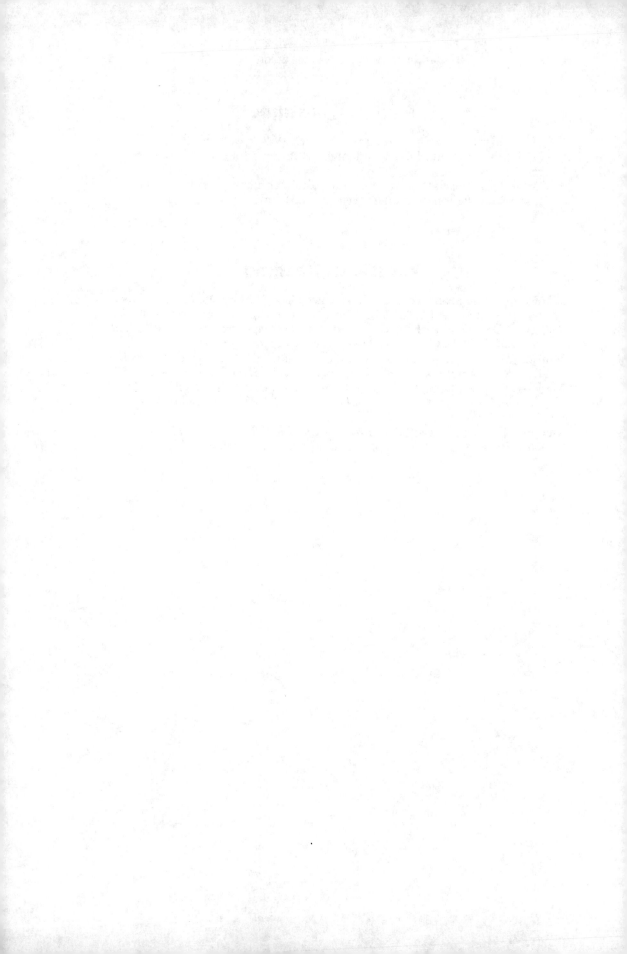

Chapter 8

Western Education in Colonial Africa

Andrew E. Barnes

Traditional as well as Christian and Muslim systems of education existed on the African continent before the advent of European colonial regimes. Initially, colonial regimes attempted to make use of Christian educational systems to supply their need for trained African clerks and artisans on one hand, and their need for loyal African political collaborators on the other. Christian educators balked at the idea of compromising religious instruction with either vocational training or political indoctrination. After World War I, colonial governments ceased to look toward religious schools, and turned their energies instead toward creating their own school systems. The worldwide depression of the 1930 wiped away the funds to pay for their proposed educational systems, however. After World War II, the earlier educational goals of colonial governments were replaced by the concern to blunt the challenge posed by nationalist independence movements.

* * *

This chapter provides an overview of Western education in Africa during the colonial era. It describes and characterizes the various strategies followed by European governments in the development of mass education in their African colonies. As shall be shown, governments, after an initial period of leaving Western education in the hands of Christian missions, took the initiative and developed plans for making education better serve the needs of the colonial state. Key to these plans were educational ambitions to produce loyal African subjects. The plans failed, ultimately, because of the de facto alliance formed between the Africans and Christian missions. The Africans wanted Western education, but not the kind offered in government schools. Mission schools offered a form of Western education for all who were interested. The determination of missions to maintain schools that conflicted with government expectations, combined with the African willingness to attend those schools, thwarted the government push to make Western education a vehicle of political subordination.

A consensus arose among colonial administrators and missionaries about the locus and procedures of learning. Until the last decade of the nineteenth century, state entry into mass education was actually a rare occurrence even in Europe. In previous centuries education, especially on the primary and secondary levels, had been a preserve of the churches. European governments borrowed the churches' idea that young people learned best when they were provided with standardized curricula and taught in a building designed for educational purposes. Missions, of

course, were already following this model in the schools they maintained in Africa.

Disagreement among Europeans came over content and goals. Administrators wanted schools to produce one type of African, missions wanted another. The curricula taught in European state schools focused on the acquisition of literary and intellectual skills, primarily the abilities to read and write, but also the cognitive skills involved in extracting political and social insight from the study of the lives and thoughts of the "great men" of the European past. It was an education for "ruling races." Designed to produce leaders who would be ready to rule others, it was obviously not the kind of education colonial governments were eager to give to subject peoples. It was, however, the kind of education that missions were providing in mission schools.

At the heart of the disagreement between colonial governments and missions was the governments' conviction that missions were educating Africans beyond their station. Missions insisted in response that they were only offering traditional Christian education. The reading and writing skills students acquired in state schools in Europe were the same skills students had always acquired in Church schools. Likewise the study of the thoughts and actions of great men was a secularization of Christian hagiography. As for the political assertiveness this type of education was understood to foster, missionaries had no problems with it when it was directed toward establishing Christian authority.

The point about government opposition to Western education for Africans needs to be qualified in one important way. European governments saw Western education as producing individuals who could think. As such, it was too dangerous to use as the basis for mass education in the colonies. But colonial governments maintained the hope that it might serve as the basis of an elite education. All the colonizing states sought to limit access to European style schooling to a selected elite, chosen for its potential for political collaboration. This strategy of limiting access never worked, mostly because there were always other ways to gain access to the intellectual skills governments wanted to reserve for the chosen few. And the chosen elites did not always collaborate in the hoped-for ways. Still, though the subject will merit only brief mention below, colonial governments continued to experiment with various approaches to elite education throughout the colonial era.

The chapter is divided into four sections. To provide a sense of educational practices before the colonizers arrived, the discussion begins with a brief overview of education on the continent before the advent of European colonialism. The next section outlines developments up to the end of the First World War. The third section describes the great push made by colonial governments between the two world wars and the reaction to it. The concluding section briefly considers educational strategies adopted by colonial governments after World War II, when it became clear that Africans would fight until they gained their independence.

Education Before the Colonial Era

All African societies had systems for instructing their young in the values and skills needed for those societies to survive. At the start of the colonial era, it is possible to see across the continent three types of competing but also occasionally

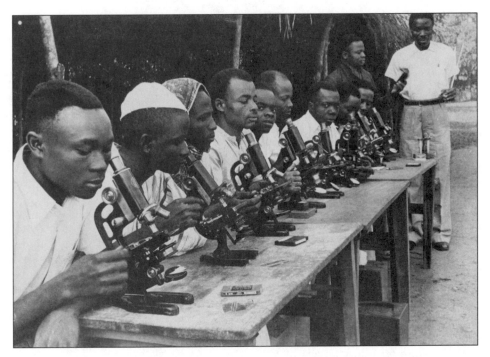

Figure 8-1. Teaching modern science

overlapping systems. The first type of educational system can be called traditional, a term designating those systems that passed on knowledge primarily through oral communication. In contrast to the traditional type of education system was the literate type. These were systems that passed on knowledge primarily through written communication, and therefore placed an emphasis on the acquisition of reading and writing skills. Because reading and writing skills were historically associated with the study of sacred texts, it is not surprising that at the end of nineteenth century literate educational systems in Africa were connected to either Islam or Christianity. Because Muslim and Christian societies educated their young in different fashions, the educational systems the two maintained will be discussed as separate types.

To lump all African societies that did not transmit their knowledge and values through written texts into the "traditional" category can be misleading, partly because there was no one type of traditional system, and partly because many societies that were not literate, nonetheless had sophisticated procedures for transmitting knowledge. Still, certain generalizations can be made. Traditional African societies passed on collective knowledge and values through the performance of rites and rituals. These activities might be dispersed across the childhood years, or they might be bunched together during periods of initiation. The initiation periods, in turn, might occur within the context of communal life, or participants might be isolated from the community for the duration of the initiation. Significantly, after initiation, participants were considered adults, which is to say that they were assumed to have the basic knowledge needed to function as full members of the community. As for skills, in traditional systems the ones needed for survival, such as food preparation, hunting or farming, were passed on by word

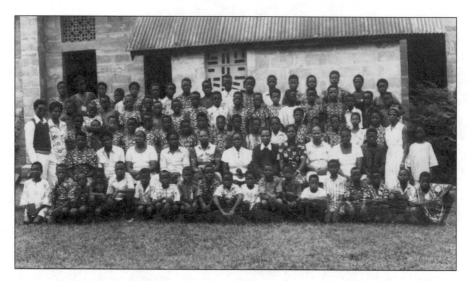

Figure 8-2. An elementary school, the teachers stand on both sides

of mouth from generation to generation, while more specialized skills, such as those having to do with healing or the production of artifacts, were passed on through apprenticeship.

Traditional educational systems did not challenge as much as complement literate systems of education. In other word, at the start of the colonial era, literate systems began to overlay traditional ones. Traditional systems of education are best appreciated as being limited in their scope. They convey specific ideas and skills. They communicate collective values but the values are not understood to have global applications. Literate educational systems, on the other hand, do make global claims. Literate systems also teach skills, such as reading and writing, that have both global and local applications. Conflict between the two types of educational systems is usually initiated by proponents of the literate type, mostly because they insist that the knowledge possessed by literate people must take precedent over of the knowledge possessed by illiterate people. While this process certainly was occurring in pre-colonial Africa, along the long frontiers where Islam and Christianity were expanding, most individuals found it easy enough to learn in the context of both oral and literate systems.

The holy book of Islam, the Koran, provided the basic text of Muslim education. On the simplest level it was taught in Africa through techniques of memorization in *kuttab* or Koranic schools that stretched in a crescent from the empires of the West African savanna lands, through the northern Mediterranean states and down through the cities along the East African coast. Teachers would gather children in a semi circle in front of them and write out a passage from the Koran with chalk on a piece of slate. The teacher would explain the meaning of the passage while the students memorized it. *Kuttab* schools fed into *medrasah*, schools of higher learning taught by masters who represented various Islamic brotherhoods. Only students who displayed some real command of the sacred writings would make it to this stage. At these higher schools they would acquire a systematic understanding of various interpretations of the Koran, an introduction to other forms of Islamic literature and training in logic and mathematics. During

the centuries that corresponded to the European medieval and early modern eras, brighter students in North and West Africa could finish their education at the great Islamic university at Timbuktu. By the nineteenth century, however, the university had disappeared. The defining experience of every Muslim's profession of faith is the *hadj*, or pilgrimage to Mecca. Young scholars from Africa, as scholars from across the Muslim world, were expected to complete their training by making the pilgrimage. Many young scholars from West Africa paid for the *hadj* by working their way across Africa to Mecca. After visiting the holy sites they might sit for a year or so at the feet of some master in Cairo, before working their way home again. After their travels many returned to their home country to become masters themselves, providing the advice and guidance supplied in traditional societies by sages.

At the start of the colonial era, Christianity's sway was more localized than that of Islam, and the challenge it presented to traditional systems of learning less developed. Coptic Christianity had been the faith of the people of Ethiopia since the time of the apostles and its tenets had been conveyed from generation to generation through age-old monasteries. Starting in the sixteenth century, Portuguese missionaries had introduced Roman Catholicism to African peoples living in proximity to Portuguese colonial outposts. The priests could not contain the rapacity of the Portuguese and other European slave raiders, however, and, from that initial start, Catholic missions to the continent remained in a virtual hiatus up until the middle of the nineteenth century. The revived Catholic mission, now staffed primarily with French-speaking priests, did not always turn to evangelizing through schools as a first option. Yet there were few Catholic mission stations that did not have some form of school, if only for the boys who served as servants for the priests.

The establishment of the colony of Sierra Leone for repatriated African slaves in the late eighteenth century signaled the emergence of slave trade abolition as a political objective of the Anglo-American Protestant evangelists. It can also be accepted as the starting point for widespread Protestant mission activity on the continent. In ever increasing numbers, Protestant missionaries from Britain, France, Germany and the United States began spreading inland from coastal ports. The essential acts of Protestant Christianity are reading and expounding upon the Bible. Accordingly, Protestant missions taught reading and writing, though not necessarily in any systematic fashion.

African Protestants set great store in the acquisition of Western intellectual skills, however, and during the nineteenth century, particularly along the West African coast, schools for training African evangelists were established. Of these the most significant was Fourah Bay College in Sierra Leone. Protestant missions in the southern half of the continent, many of which streamed northward from ports in the British colonies in South Africa, started later than did those in West Africa. But, ultimately, they had a similar impact. On the eve of the colonial age there also there existed a small set of schools dedicated to the training of African Christians.

Western Education to the End of World War I

The initial education strategy of most colonial governments involved seeking a partnership with religious educators. Because colonial governments had need

for African clerks, artisans, mechanics, and others to help set up administrative offices and to implement colonial policies, they turned to religious schools to help identify and train the men they needed.

Colonizers conceptualized their needs as necessitating four different types of schools:

1) *Primary schools.* While these were schools for mass education, they were never intended for a majority of school age children. Rather, they were aimed at providing Africans with discernible abilities or skills with a modicum of Western style education so they would be loyal to the colonial state. Involving anywhere from four to six years of standardized curricula, usually in the early stages, and especially in small village day schools, instruction was in the local vernacular. During the latter stages, especially in large urban boarding schools, instruction was in the language of the colonizer or, as was the case in many British colonies, a standardized vernacular specifically chosen by the colonizer. These schools functioned only to identify boys with intellectual or vocational promise.

2) *Secondary or pre-professional schools.* These schools aimed to prepare students for an occupation. Schools for the sons of chiefs may also be included in this category. Offering a four to six year course of study, students were recruited according to their displayed intellectual ability, as well as, their potential to serve as political collaborators. Aside from schools in British colonies where instruction was either in Hausa or Kiswahili, these were large boarding schools where instruction was in the language of the colonizers. It was in these schools that African officials and administrators were to be trained.

3) *Normal schools.* Dedicated to the production of primary school teachers, this form of secondary school offered a highly rudimentary instruction lasting two to four years. While there were many large urban normal schools, where the students boarded, and where instruction was in the language of the colonizer, more typically normal schools should be seen as small, rural affairs, where instruction was in the vernacular, even though the students still boarded.

4) *Vocational schools.* These schools sought to train artisans and technicians to maintain the physical plant of the colonial regime. Vocational training could extend for as long as six to eight years. Most such schools were located in cities and administrative centers, places were governments could afford to build and staff workshops. Many students recruited for vocational schools were fairly mature at the time of matriculation. While we can surmise that most of students probably boarded at the schools, the age of the students combined with the length of their programs probably translated into a significant number of students living off campus. It is equally difficult to generalize about the language spoken at vocational schools. Few students had systematic training in European languages. Yet, to the extent to which they had a technical understanding of their craft, it must have been in a European language. Note that in French and Belgian colonies, clerical training was a category of vocational training. This was not the case in British colonies, where the flood

of graduates from mission schools provided a more than adequate pool of potential clerks.

Two comments need to be made about this list. First, is that two or three of the types of schools might be maintained together in the same buildings. This was especially the case in cities. Second, is that while girls were not excluded from these schools, opportunities were not provided for them. Female students made up perhaps ten percent of the overall school population. In villages they attended the same classes as the boys until there were sufficient numbers to establish a girl's school. The curriculum in these schools was heavily weighed toward training girls to be wives for Westernized spouses.

The colonizing powers did not approach Muslim and Christian educators with the same partnership options. Following upon their perceived success in building collaborative regimes with Muslim rulers in Asia, the British sought to build regional administrative cultures based upon Muslim foundations. In both their West and East African colonies they sought to co-opt the local language used by Muslims and make it the vehicle of colonial cultural development. In West Africa, the language was Hausa. In East Africa, it was Kiswahili. For both, the British government spent money to have alphabetic scripts devised and then translations made. The government then mandated that the language become the language of instruction in local primary schools.

Local Muslim schools were left relatively untouched by British colonial officials. The students who emerged from these schools, however, became prime targets for recruitment for the government's normal and vocational schools, where they were taught the alphabetic versions of Hausa or Kiswahili, and then placed in clerical, artisan or teaching positions. More important was the effort to recruit Muslim officials, the motivation behind the famed British colonial policy of indirect rule. Versions of English public schools were set up, and Muslim elites were pressured to enroll their sons. These young men were permitted to practice their faith at the schools, yet the main goal was to place the young men "on the same page" politically and socially as the British imperialists with whom they were to collaborate.

While the French never committed themselves to a program of co-opting Muslim education systems to the same extent as did the British, they did experiment with using medrasah level schools to identify and recruit Muslim collaborators. The Roman Catholic biases of the Belgian and Portuguese governments, the other colonizing powers, precluded their turning toward Muslim educational institutions with anything but animosity.

The partnerships proposed to Christian educators by colonial governments were more multifaceted. While it is true that in northern Nigeria the British government contemplated using Muslim schools as the basis of a mass education system, for the most part colonial governments sought to involve Muslim educators only in elite training. Christian educators were invited to participate in any and all colonial educational ventures.

These invitations were not offered without ambivalence, however. An animosity against Christian missions was discernible in every colonial government. Christians and nationalists were bitter competitors for public influence in late nineteenth and early twentieth century Europe, and colonial administrators were usually recruited primarily from the nationalists. While recognizing the educa-

tional assistance missions were rendering, colonial administrators still sought to constrain the influence of mission schools as much as possible.

In the effort to make mission schools serve their purposes, the basic strategy followed by colonial administrators was to offer the "carrot" of government subsidization. Colonial governments set up standards for evaluating schools, appointed school inspectors to assess mission schools, then offered missions government funds for measuring up to their standards. Schools that accepted the subsidization were listed as "assisted" in government documents.

Colonial administrations had neither a sufficient grasp of education as a process nor an adequate educational staff to make this strategy work. As noted above, mass education in Europe itself was still in its infancy. There was very little scholarly understanding of education as a cultural process, or of schools as social institutions. Because the standards set up by governments bore no relation to any articulated theory of education, they had no recognizable educational goals. The men who were appointed as inspectors rarely had any formal training. Beyond loyalty to the colonial state, and the vague notion of a work ethic, the standards put forward by governments had no positive agenda except for inculcating European notions of hygiene.

Not surprisingly, the strategy had little impact on mission education. Many missions, unwilling to change their curricula, rejected the proffered funds. Those missions that agreed to become "assisted" altered their programs only to the extent required to satisfy the expectations of government inspectors.

While colonial administrators were frustrated in their efforts to shape the direction of mass education, they felt they were much more successful in establishing elite school programs. Themselves the products of elite schools, administrators thought they knew what they were doing in setting up similar institutions in Africa. These elite schools were replicas of the elite schools that existed in the metropole. The assumption was that curricula that produced patriotism at home would at least produce loyalty in colonial collaborators. And because African graduates displayed enough of what Europeans read as loyalty, governments continued to fund these schools over the colonial era.

Western Education Between the Two World Wars

World War I intervened before governments could react to the failure of their initial strategies at mass education. The end of the war, however, prompted quick action. It was at this moment that colonial governments mounted their most determined offensives to shape Western education in Africa to their perceived needs. As a circular issued by the French Minister of the Colonies proclaimed in 1920, "The moment has arrived for a new effort, both strong and methodical, in promoting the development of education in our colonial domain."[1] Significantly, all such ef-

1. I.L. Kandel (ed.), *Educational Yearbook of the International Institute of Teachers College, Columbia University* (New York: Bureau of Publications, Teachers College, Columbia University, 1931), 272.

forts involved social engineering, that is, curricular programs aimed at producing specific types of Africans who would be comfortable with "subject" status.

In the decade following the war colonial governments throughout Africa moved beyond seeking partnerships with suppliers of religious education to mandating the goals that would have to be maintained just to operate. These new regulations applied mostly to Christian mission schools, and Muslim schools, especially in traditionally Muslim areas were left alone.

Prior to World War I governments had no real idea of what they wanted mass education schools to do. After the war, however, there was a broad consensus that they wanted schools not only to provide some language skills, but they also wanted schools to help train workers. Two basic approaches were followed to reach this goal. In the colonies of Catholic states, the French system of "adaptation" was widely copied. In British colonies, an effort was made to build upon the American program of industrial education.

By the start of World War I the colonial governments had come to understand that mission schools were producing Christian converts, not loyal subjects. The ambition of the new, stricter controls, colonial administrations placed on mission schools beginning in the 1920s was to force missions to produce Africans who would be more loyal to the state.

Three examples will help give a sense of the range of government initiatives. In the confederation of colonies that made up French West Africa the government proclaimed a law in 1922 that required all mission schools to observe the same curricula as the government schools. The following year, in a move clearly aimed at the control of Anglo-American missionaries, the government enacted another law that required all mission teachers to hold degrees from French institutions and to be capable of teaching in either French, Latin or the local vernacular. A few years later the government prohibited any mission from preaching or establishing a school without official permission.

In Nigeria, in 1926, the government enacted an educational code granting it the right to unilaterally shut down schools that did not meet its standards. The announced targets of the code were "bush schools," small classes in Western intellectual skills that were outside of mission supervision and were taught by Africans best described as educational entrepreneurs. Because there was little distinction between a mission school run by a mission-sponsored African catechist, and a bush school run by a nominally Christian, African educational entrepreneur, the law essentially aimed to force missions to police their own recruits.

Finally, in Sierra Leone, in 1929, the government promulgated a new education ordinance that essentially permitted it to nationalize mission schools. As part of what was called the "Amalgamation Scheme," the ordinance permitted the government to step in to consolidate competing but sometimes redundant mission schools. Further, the ordinance granted the government the right to standardize teachers' salaries and to take upon itself the task of collecting school fees. Lastly the ordinance permitted the government to force missions to build new schools, with the government having the power to shut down schools it declared unsafe. It could then offer to cover half the cost of construction and all of the cost of equipment and materials for new schools built as replacements.

Even with the new controls, officials remained skeptical about the ability and the willingness of missions to produce the desired African subjects. This was particularly the assessment of evangelical Protestant missions. Drawing upon the An-

abaptist tradition of separation of church and state, these missions were both sus-
picious of government and wedded to the idea that the primary objective of their
educational endeavors was to teach Africans how to read the Bible.

Colonial officials were skeptical about the ability of mission schools to turn
out the desired products, yet in only one instance did a colonial government suc-
cessfully develop its own school system. Despite the separation of Church and state
in France in 1905, French officials in French West Africa remained adamantly anti-
clerical. Their greatest objective was to make sure the Catholic church did not
achieve the level of influence in the colonies that it had in France itself, and they
saw a state school system as the greatest bulwark against this development. As of
1931, French West Africa boasted 345 state schools with 41,000 students, com-
pared to only 6,000 students in 62 mission schools. As mentioned above, however,
French West Africa was the exception. Mission schools made up between one-third
and one-half of the total in all other French colonial possessions.

The British were eager to emulate the French achievement in their colonies,
but two factors held them back. First was the cost of building and maintaining
school systems. Second, because missions had been present in most territories
conquered by the British before the advent of colonialism, and because in London
the mission lobby was so strong, colonial governments could never overcome the
mission protests against their educational schemes. The government proposal to
use Koranic schools as the basis for a mass education system in Northern Nigeria,
advanced in 1929, should be read as an effort to find an alternative to mission
schools as a platform upon which to build a school system. Yet mission com-
plaints to the Colonial Office kept the government from ever coming up with a
strategy to even present the idea to Muslim educators. In Zimbabwe (Southern
Rhodesia), in 1920, the government tried to start a state school system with two
training schools built on the idea of industrial education. But by 1925 protests by
both Africans and missionaries had forced the government to back down.

What happened in the British colonies was repeated in the colonies of other
states. Colonial governments may have wanted to build their own school systems,
but the lack of money, combined with the colonial presence of entrenched mission-
ary interests, led them instead to attempt to co-opt mission schools for their own
purposes. Co-optation involved more than just placing controls on school curric-
ula and regulations. Co-optation involved taking over educational systems then
franchising them back to missions. As described above, that is what happened in
Sierra Leone, but it was more typical in the colonies of Catholic states. In the Bel-
gian Congo, for example, the government also nationalized the mission school sys-
tem. While in Sierra Leone all mission schools were nationalized, in the Belgian
Congo Catholic schools were nationalized to the detriment of Protestant schools
and Protestant missions. Starting in 1924, Catholic missions were recognized as
"national" missions. As such they qualified for state subsidies that were off limits
to Protestant or "foreign" missions. To further marginalize Protestant mission
schools, degrees and certificates from Catholic programs were required as qualifi-
cations for state jobs. And after 1940, Catholic missions were formally granted
similar advantages in the Portuguese colonies of Angola and Mozambique.

Regarding the substance of school curricula, two theoretical issues preoccupied
colonial education experts, and they both related to the distinctions between mass
education and elite education. The first of these issues was about language. Should
the African masses learn to speak the same language of their colonizers? The British

solution of sponsoring the development of regional vernaculars was not adopted by any other colonizer since it was seen as too expensive and, besides, it ran contrary to the colonizers' ideas of civilization. Instead, the French model of "adaptation" was usually copied. In this model, while lip service was given to education in local vernaculars, it was understood that such education was only for those students perceived as lacking the mental abilities to be of some use to Europeans. As one Belgian official badly put it, "only those natives who are intending to live in direct contact with whites, as their assistants, should learn a European language."[2] Following the path pioneered by the French, most colonial governments developed a one to two year course of study that focused on spoken as opposed to written language skills in the language of the colonizer. Beyond learning a few words and phrases in a European language, young Africans were lectured on hygiene, basic arithmetic and the need to be loyal to the state. These "preparatory" or "initiation" schools were situated in the villages and taught by Africans who had been through normal school. After completing the course of study, most students were sent back out into the fields. Young men who were perceived as being intelligent were sent to larger regional schools where they completed the primary school curriculum.

The second issue that concerned colonial education experts was job training. African elites were trained to be political collaborators. How were the masses of Africans to be trained? The preferred answer was as economic collaborators. Here also the French model seems to have held the greatest sway. Two-tiered primary school systems were put in place. Rural primary schools concentrated on vocational training, while urban primary schools trained young men for clerical and technical service. Again the determining factor for selecting students for different types of schooling appears to have been perceived mental ability. Students identified as being brighter were sent on for clerical training.

It was not that the British contemplated ruling their African colonies through regional vernaculars, rather, thanks to the missions, by the advent of British colonialism, a significant group of Africans already existed who could speak English and who sought power and influence within colonial administrations based upon that ability. Behind the development of regional vernaculars was a concern to empower elites whose authority had nothing to do with the Christian missions. As for mass education, in keeping with the aims of indirect rule, the goal of British colonial governments was to direct African loyalties to the chosen elites and then through the latter to themselves. On the language issue, this prompted the subsidization of textbooks in a host of different vernaculars. Ironically, since the government could not pay to develop dictionaries and then to develop or translate texts into the various languages, beyond Hausa and Kiswahili, most of the translation work was farmed out to missionaries. This was also the case with most instruction on the primary and sub-primary level, with missionaries and African teacher-catechists doing the bulk of the teaching. Because missions were running the schools, there was no standardization in British colonies as there was (or at least attempted) in the colonies of other states. While in many regions Protestant missions banded together and worked out a school system that took students from "infants' class" on through to a secondary degree, this was not a given, and there was always a rival system set up by the Catholic missions.

2. *Educational Yearbook*, 38.

As with other colonial governments, the British hoped that schools for the African masses would generate a work force capable of supplying the needs of colonial economies. The British also expected that assisted schools would serve as a form of counter-programming against the literary/intellectual training traditionally offered at mission schools. Out of this hope the British turned toward industrial education.

Industrial education was the term used to describe the mixture of vocational training combined with social and moral self-improvement made famous at Tuskegee Institute by Booker T. Washington. Under the direction of Thomas Jesse Jones, the American-based Phelps-Stokes Fund became a tireless promoter of industrial education for all subjected peoples. As Jones presented it, industrial education directed the gaze of subject peoples away from political concerns and toward social development. In Britain the Protestant Evangelical political lobby listened most intently to what Jones was saying. In particular, J.H. Oldham, head of the International Missionary Council, heard in Jones' presentation an educational program that addressed most of the criticisms government officials leveled at mission education. Wanting to head off the government push to go around the missions as suppliers of education, Oldham used his considerable talents as a lobbyist to persuade leaders at the British Colonial Office to consider adopting industrial education as the basis for mass education in British colonies. Oldham was helped in his efforts by Jones. The Phelps-Stokes Fund sponsored tours of Africa in 1921 and 1924 by a committee of African, American and British experts on industrial education.

Oldham's work was crowned in 1924 with the creation at the British Colonial Office of an "Advisory Committee on Native Education in British Tropical Africa" (later renamed the Advisory Committee on Education in the Colonies). The original mandate of the Advisory Committee, which would shape educational policy in colonial Africa until the 1960s, was to identify ways to implement industrial education ideas in Africa.

The initiative taken by the colonial government in Zimbabwe in 1920 suggests that industrial education was already a gleam in the eyes of colonial educators before the Phelps-Stokes Commission arrived on the scene. It is not clear, however, if what was being implemented in Zimbabwe was industrial education as understood by Jones and Oldham, or an older missionary idea of vocational education, appropriated and updated by the colonial state. The attraction of vocational education for missionaries had always been that it turned Africans away from intellectual pursuits, which supposedly made them pretentious, and toward manual skill acquisition, which supposedly kept them humble. Jones and Oldham saw industrial education as an improvement on vocational education because it not only emphasized manual labor training, but it also admitted the possibility of African economic development giving rise to African political aspirations. It did this by postulating that the political energies Africans developed as a consequence of their training could be channeled away from challenging colonial authority and toward local community concerns. Jones and Oldham sold industrial education to the British government with the promise that it would inhibit in Africa the emergence of the types of nationalist movements that had resulted from Western education in India. That attribute of industrial education was perhaps never completely grasped by local administrators and other Europeans (settlers) in Africa, who continued to respond most positively to the vocational training aspect of industrial education which could teach Africans, "the discipline of work."

Oldham's successful promotion of industrial education in London should not be read as an indication of broader missionary support for industrial education in Africa. Oldham exercised no authority over missions. Individual missions certainly responded to the government funds offered to construct schools following this approach, but whether what was actually taught was industrial education is another matter. Beyond teaching agricultural techniques or some rudimentary artisan skills, the missionaries had very little idea of what they should be doing. And government education inspectors never developed sufficient expertise to provide participating missions much guidance. Perhaps more important, many missions continued to be antagonistic toward any change to the focus on religious instruction in their schools. Education was a means toward an end for them, one strategy among several for proselytizing among Africans. They had no desire to make the commitment in resources and personnel needed to make industrial education work.

Perhaps over time the British government might have come up with the right incentives to spark such desire. But it did not, primarily due to the Stock Market Crash of 1929. The early 1930s were a time when all colonial governments scrambled for revenues. When educational funding were severely cut, policies remained the same, but the ability of governments to implement those policies declined. Industrial education for the masses was stillborn due to lack of funds. This is not to suggest that with all the money in the world industrial education would have worked but that, with greater inducements, perhaps missions would have been more persuaded to try it.

The real opposition to industrial education, and the cause of its failure to take hold in Africa, came from Africans themselves. While there were protests against industrial education, as in Zimbabwe, in British colonial Africa, and elsewhere in Africa, Africans followed a far more effective strategy of resistance to the social engineering programs colonial governments attempted through mass education. The strategy is easiest to discern in the school systems in the colonies of Catholic European states, where policies of adaptation meant that even secondary education was aimed at producing narrowly trained artisans and clerks.

The Angolan Anedeto Gaspar, in narrating the story of his own education, explained how even after graduation from primary school he had wanted to go on to vocational school, but he was forced by his father and uncle to enroll instead in a minor seminary, the first step toward becoming as a priest. The rationale of the two men for the decision is what is important here. They had no expectation that Anedeto would become a priest. Rather, they recognized seminary education as the "best available" secondary education. It was for that reason that they themselves had undergone similar training in their day.[3]

Anedeto Gaspar's story suggests that Africans were consciously using religious education for secular purposes. By enrolling in mission schools, Africans were getting around the limitations governments placed on learning. Evidence to support this conclusion is provided by statistics for seminary education in the Belgian Congo. As these numbers show, over the period 1938–1959, the number of students in minor seminary grew from just under 1000 in 1938 to more than 2600 in 1959. Yet the number of African priests who emerged out of these semi-

3. Anedeto Gaspar, "Assimilation and Discrimination in Catholic Education in Angola and the Congo" in Edward Berman (ed.), *African Reactions to Missionary Education* (New York: Teacher College Press, 1975), 59–74.

naries grew from 37 in 1938, to only 369 in 1959.[4] Clearly the overwhelming majority of young men who attended minor seminary did not become priests. No doubt many of these young men realized along the way that they could not live up to the rigors of the priestly life and withdrew. But in light of Anedeto Gaspar's comments it also makes sense to see in these numbers an African exploitation of religious education for other purposes. Further, given that it would have been impossible for this sort of exploitation to escape missionary notice, it also makes sense to assume their tacit approval. In other words, while Belgian Catholic missions worked with the government to maintain the program of mass education desired by the government, they simultaneously allowed seminaries to be used by Africans so they could acquire the type of education mission schools offered before government intervention. Africans and missionaries colluded in making available to Africans exactly the sort of education colonial governments wanted to keep off limits.

Among the many ironies in the story of Western education in colonial Africa, perhaps the greatest may be that, in trying to create alternatives to mission schools, colonial governments may have been most successful at pushing more Africans into mission compounds. This is because it was only at these sites that Africans felt they could get a real Western education. In colonial Ghana (Gold Coast) an interesting phenomenon is observable. In 1925, there were 234 government and assisted schools, and 155 non-assisted (primarily Protestant mission) schools. By 1938, the number of government and assisted schools had grown to 439. By that same date the number of non-assisted schools had grown to 477.[5] It was exactly during this period of time that the British government made its most determined effort to apply the principles of industrial education in the schools in its African colonies. The data suggest that part of the African reaction was to flock toward schools outside of the government's control.

To sum up, between the two world wars colonial governments sought to produce, through the agency of schools, politically docile yet manually proficient, African subjects. They failed. No tradition of acquiescence to colonial rule was ever established in colonial Africa. Credit for this achievement goes to Africans for never allowing themselves to be programmed into a subject status. But credit also has to be shared with Christian missions who, for their own reasons, declined to alter the thrust of Christian education. Christian education had been producing leaders in Europe for centuries. It never stopped producing them in colonial Africa.

Western Education During the Closing Years of the Colonial Era

By the end of World War II, it was obvious to most colonial governments that nationalism was alive and spreading across the African continent. This awareness

4. Marvin D. Markowitz, *Cross and Sword: The Political Role of Christian Missions in the Belgian Congo, 1908–1960* (Stanford: Hoover Institute Press, 1973), 115.

5. F.H. Hilliard, *A Short History of Education in British West Africa* (London: Thomas Nelson and Sons, Ltd, 1957), 93.

prompted colonial governments to reverse the political objectives they hoped to accomplish through colonial schools. Instead of seeking to produce colonial subjects, now they wanted mass education to turn out imperial citizens. From the latter years of World War II, through the independence era, colonial governments did not give up on the idea that schools could be used as instruments of social engineering. But they also sought to identify new types of African collaborators and then to figure out ways to produce these new types of collaborators by using schools.

Again, three examples can provide a sense of the range of government initiatives. In French West Africa, the measure of true French citizenship was considered to be access to positions of power and authority in the French governmental bureaucracy. Since access to such positions was based upon performance on competitive examinations, in France "Outre Mer" (Overseas) students would be trained to sit for the same examinations for the same positions. Beginning in 1946 then, the official policy of "adaptation" regarding mass education was discontinued, only to be replaced by a new policy of "assimilation." In practice this meant that the state school system that existed in French West Africa was dismantled and replaced by a system that fed students at the secondary and university level into state schools in France itself.

In Britain the document that signaled the government's concession of defeat on the question of the application of industrial education to colonial educational needs was the memorandum on "Mass Education in African Society," issued by the Advisory Committee on Education in the Colonies in 1944. Among other things, the memorandum declared that one goal of colonial school systems must be "universal education within a measurable time."[6] The document reconfirmed, however, the government's commitment to directing African political energies toward an exclusive focus on local affairs, what the government still called "community development." What was now different was that instead of waiting for the primary schools to produce students whose political horizons as adults would be limited to a concern with local events, the government hoped to intervene and speed up the process through programs to increase adult literacy. As implemented in Nigeria, the programs involved the appointment of special "Adult Education" officers, who initiated what were called "Adult Literacy campaigns." By 1951, it was claimed that the classes managed by these officers had more than 65,000 students on the rolls.[7] Worth noting is that these students were being taught to read not in English, but in the various vernaculars the government had mandated be taught in primary schools in previous generations.

By 1946, the number of non-assisted schools listed by the colonial government in Ghana had grown from the 477, noted in 1938, to 2, 018.[8] Following a strategy similar to the one it had followed earlier in Sierra Leone, the colonial government created a new category of government assistance, then unilaterally applied it to these schools. Eight hundred of the 2000 non-assisted schools were identified as being worthy of classification as "designated" schools. The government then stepped in and developed them according to its own plans.

6. Hilliard, 173.
7. Hilliard, 153.
8. Hilliard, 101.

These initiatives all illustrate what can be labeled as "progressive" steps taken by colonial governments hoping to use education to corral African nationalism and direct the latter toward imperial purposes. On the southern third of the continent, where European mining concerns and settler communities held sway, local government policy was reactionary, and aimed to use education to help maintain Africans in a servile status. In Zimbabwe, although Africans clamored for Western education, the government refused to supply the requisite funds for schools. The Prime Minister there insisted that schools were a demand only of "misguided and so-called African intellectuals," who were motivated by "completely unattainable objectives such as self-government."[9] In the two Portuguese colonies of Angola and Mozambique, policies of "adaptation" continued to be followed in the few schools for the African population right up to the collapse of the colonial regime in the 1970s. In the Belgian Congo, the emergence of a liberal anti-clerical regime in Belgium in the 1950s translated into a joint effort by the colonial government and the mining interests to hold back initiatives launched by the missions to provide advanced training for the colony's Westernized African elite. Still African demands for higher education led to the establishment of Lovanium University in 1954.

Lovanium University was attached to, and considered an extension of, the University of Louvain in Belgium. In seeking this type of institutional arrangement for an African university, the Catholic missionaries who established Lovanium were following a British lead. Since 1876, Fourah Bay College in Sierra Leone had had an institutional affiliation with Durham University in Britain. In the years immediately following World War II, the British colonial government had used the Fourah Bay/Durham model to establish universities in three of its African colonies: the University College of Ibadan (Nigeria), affiliated with the University of London (1948); the University College of the Gold Coast, affiliated with Cambridge University(1948); the University College of Makerere (Uganda), affiliated with the University of London (1949). Protests by leaders in Sierra Leone about Fourah Bay College being passed over, despite it long history as a post-secondary institution, led the colonial government to grant that institution university status in 1959.

Conclusion

The establishment of universities in Africa has to be appreciated as a step by colonial governments to keep African colonies in the fold. Post-secondary education, both in Africa and abroad, were precious commodities with which governments hoped to cement alliances with Westernized elites. In following such ploys, governments were trying to get to the African's heart by way of his mind. But these appeals were too little too late. Colonial governments could not shake their legacy of trying to keep knowledge from the Africans. Western education remains something Africans took from their colonizers, not something they were given. Overall, then, from the perspective of colonial governments, western education in

9. Dickson A. Mungazi, *Colonial Policy and Conflict in Zimbabwe: A Study of Cultures in Collision* (New York: Crane Russak, 1991), 52.

Figure 8-3. Education Systems in Colonial Africa

Africa during the colonial era can be characterized as a tool for colonial domination they never quite learned to use.

Review Questions

1. How did religion help shape government educational policy in Africa?
2. What is collaboration and how did government hope to use schools to help promote collaboration?
3. Many scholars have argued that Western education in Africa is too oriented toward literary/intellectual study, and that there is not enough technical/vocational training occurring in African schools. Has this been the case? How would the experiences Africans had with colonial school systems predispose them toward literary/intellectual study?
4. Should mass education have been in the vernacular in colonial Africa? Or should it have been in the language of the colonizer?

Additional Reading

Anderson, John. *The Struggle for the School: The Interaction of Missionary, Colonial Government and Nationalist Enterprise in the Development of Formal Education in Kenya.* London: Longman Group Ltd., 1970.

Berman, Edward (ed.). *African Reactions to Missionary Education.* New York: Teacher College Press, 1975.

Kandel, I.L. (ed.). *Educational Yearbook of the International Institute of Teachers College, Columbia University.* New York: Bureau of Publications, Teachers College, Columbia University, 1931.

Hilliard, F.H. *A Short History of Education in British West Africa.* London: Thomas Nelson and Sons, Ltd, 1957.

Markowitz, Marvin D. *Cross and Sword: The Political Role of Christian Missions in the Belgian Congo, 1908–1960.* Stanford: Hoover Institute Press, 1973.

Mumford, W. Bryant and Major G. St.J. Orde-Brown. *Africans Learn to Be French.* New York: Negro Universities Press, 1970.

Chapter 9

Christianity in Colonial Africa

Joel E. Tishken

This chapter examines the role of Christianity in colonial Africa from the perspective of the converter and the converted. It views European missionaries as other than simply "agents of imperialism" by bringing a more nuanced and accurate perspective to their wide-ranging motivations and actions. As such, attention is given to their various methods of conversion and the nature of religious change. A particular focus is placed on the role of indigenous agency, arguing that it was this agency that was largely responsible for the spread of Christianity in Africa. The chapter closes with an investigation of Initiated Churches. A number of case studies will be utilized throughout the chapter.

* * *

Christian Missions in Africa
Before 1885

Christianity was known to many parts of Africa before the nineteenth century. The Coptic Churches of Egypt and Ethiopia were ancient organizations with many parishioners. Enclaves of Christians could be found in pockets along the coastline, most of them European but with sizeable populations of African Christians as well. The enclaves were in areas of white settlement such as North and South Africa and in the Portuguese colonies. Christian communities developed among Creoles in Sierra Leone and Liberia as well. However, with these notable exceptions, Christianity was not a dominant religion of the continent. But this was not due to a lack of effort from European missionaries.

As circumnavigation of Africa became more frequent in the late fifteenth century, and coastal enclaves were established, Catholic priests traveled to many parts of coastal Africa. These priests were typically Portuguese or Italian and their designations were varied: Cape Verdes, São Tomé, Senegambia, Gold Coast, Niger Delta, the mouth of the Congo River and the Swahili islands. Their greatest success occurred among the BaKongo people where an African Catholic Church has continued to the present. But the BaKongo were the rarity for mission accomplishments before the late nineteenth century. While some Christian communities developed in the sixteenth and seventeenth centuries, they were not able to sur-

vive the shortage of priests, attacks from Muslim or traditionalist neighbors, or turmoil within their own borders. The exception, Catholicism, did survive in some regions as a "folk" religion.

In the Itsekiri kingdom of Warri in the Niger Delta, Christianity was introduced in the 1570s by Augustinian monks from São Tomé. They converted the heir to the throne, who took the Christian name of Sebastian and became an ardent supporter of Catholicism until his death. But the climate of the Delta was unappealing for Europeans, and the Church in Warri always suffered from a shortage of priests. For a time, Sebastian instructed his people in Christian doctrine and eventually a small Itsekiri clergy developed. Debate exists as to whether Catholicism in Warri was strictly a court religion or whether it was adhered to by the entire populace. Visitors to Warri made both claims. However, it seems the lack of clergy prevented the Church from making deep roots in the populace since the king and court seemed to be the only followers by the eighteenth century. This lack of clergy, coupled with the lack of support from the throne, seemingly signaled to be the end for the Church in Warri. An English visitor of the late eighteenth century witnessed religious paraphernalia and iconography in a decayed state.[1] Warri's experience was fairly typical for these early mission attempts. Often the royal conversions were superficial and/or politically motivated. And ethnocentrism among Europeans often led them to believe that the most inadequate white clergy was superior to the possibility of training African ones. This lack of manpower and the concentration upon royalty produced only weak roots for Christianity. It could not survive long when royal support disappeared of the clergy left.

But this was to change with the evangelical revival of the late eighteenth and early nineteenth centuries that was experienced throughout the Christian world. Bolstered by new notions of evangelical commitment, the allotment of greater financial support, and often by humanitarian impulses to destroy the slave trade, a number of mission societies were formed in Europe and the United States. The Society for the Propagation of the Gospel (SPG) was formed in 1701 to provide clergy to British colonies. Influenced by the Oxford Movement of the 1830s, it became transformed into a mission society. The SPG was largely active in the Cape and Natal, of South Africa. The London Missionary Society (LMS) was formed in 1795 and sent missionaries to Madagascar and southern Africa. Founded in 1799, the Church Missionary Society (CMS) was active in Buganda and Sierra Leone, and from there followed Saros into southern Nigeria. The American Board of Commissioners for Foreign Missions (ABCFM), established in the United States in 1810 and dominated by Congregationalists, was active in various parts of Africa from the Sotho and Zulu to the Gabon estuary and Liberia. The Dutch Reformed Church also joined in missionary work, while focused on southern Africa, it had a mission as far away as the Tiv in Nigeria. But the creation of mission organizations was not limited to Protestantism. The Congregation of the Holy Ghost, or Spiritans, reorganized in 1848 and headquartered in Paris, sent missionaries to Senegal and Gabon and were active throughout West and Equatorial Africa. Missions throughout West Africa were created by the Society of African Missions (SMA) after its founding in 1856. Catholic missions were very

1. Elizabeth Isichei, *A History of Christianity in Africa: From Antiquity to the Present* (Lawrenceville: Africa World Press, 1995), 61–2.

active after 1878 when the Society of Missionaries of Africa, most commonly known as the White Fathers, gained four vicariates from Propaganda Fide, thus giving the White Fathers control from the lower Congo to the Great Lakes region.

Cooperation between mission organizations was rare, but not unknown. The LMS was designed to be ecumenical. The Basel Mission, formed in 1815, at first supplied missionaries for the CMS, although it later developed its own mission field in the Gold Coast in 1828. Faith missions, such as the Sudan Interior Mission (SIM), Africa Inland Mission (AIM) and the Gospel Missionary Union, while strictly fundamentalist, were interdenominational. And there is the celebrated instance of Bishop Samuel Crowther who gave the Holy Ghost Fathers a plot of CMS land in Onitsha. But the mission bodies remained divided by nationality and denomination. More typical was Lutheranism which was split between German, Norwegian, Swedish, Finnish, and American missions and Methodism which was divided until 1932 between Wesleyan and Primitive missions. Competition for converts was intense. The introduction of a rival mission into the mission field of another generated as much concern as the erection of an African indigenous religious shrine.[2] Animosity between Catholics and Protestants was high; each often regarded the other as little better than heathen.

Commonly, a degree of dissonance existed between mission headquarters in Europe or the United States and the missionaries on the ground in Africa. This was especially so among hierarchical denominations where missionaries were often hindered by their own chain of command and conflicted on issues of culture. Missionaries often defended African cultural practices while being encouraged by their mission body to destroy them. John Colenso, Anglican Bishop of Natal, defended polygamists and lauded aspects of Nguni culture. More importantly, he opposed the idea that all non-Christians were condemned to hell, a notion that got him labeled as a heretic. Mission records are replete with pleas for more manpower and resources, but mission bodies always had to be concerned with the administration of numerous mission stations and would often frustrate the demands of individual missionaries.

The Episcopal Church in Liberia:
A Case Study of Early Mission History and African-American Involvement in Missionizing

Christianity did not develop a presence among the peoples of Liberia until the nineteenth century, nor was Episcopalianism the first Christian sect to enter Liberia. As one might expect, the Baptist and Methodist churches were the first strong churches in the region because most settlers were practitioners of those churches in the United States. Lott Carey, a former Virginian slave and Baptist minister, founded the Providence Baptist Church in Monrovia in 1822. And the same year, the Methodist Church arrived. The Swiss attempted a Basel mission in May of 1828 but, by July 1831, decided to turn their missionary efforts else-

2. R.F. Wylie, "Some Contradictions in Missionizing," *Africa*(1976), 199.

where. John Pinney began the first Presbyterian church in 1833. Thus, by the time of the arrival of Episcopalians in 1836, a small Christian presence had already been established in a number of Liberian colonies by a number of mission bodies.

Like other US churches of the nineteenth century, the Episcopal Church was not immune to the intense missionary impulses of the age. Following several years of revival and domestic missionizing, the Episcopal Church formed, in 1820, the Protestant Episcopal Missionary Society in the United States for Foreign and Domestic Missions. This would later become the Domestic and Foreign Missionary Society, or DFMS. Liberia was targeted for missionizing because the colony was under U.S. influence and no Anglican presence had yet been established in the region. Liberia was the only mission to Africa that the Episcopal Church ever undertook. It is difficult to date the exact entry of Episcopalianism in Liberia. The original people designated as missionaries in 1830 had their qualifications called into question, despite their ordination and education at the African Mission School, which was part of Washington College (now Trinity College) in Hartford, Connecticut.[3] Gustavus V. Caesar, Edward Jones and William Johnson were not permitted to travel with DFMS funding. One might question whether it was their qualifications or merely their African-American status that led to the doubting of their abilities. Despite the denial of the DFMS, the group resolved to go to Africa anyway, and all of them acted as unofficial missionaries in Liberia or Sierra Leone until their deaths.

It was not uncommon in this period for African-Americans from throughout the Diaspora, but especially the United States and the British Caribbean, to serve as missionaries to Africa, when, it was found that white missionaries often could not handle the disease climate and died quickly. Liberia, Sierra Leone and South Africa were the most common destinations for Afro-American missionaries. Even when they did not receive institutional support, such as with Caesar, Jones and Johnson, their commitment to Africa and African peoples was so great that they managed to find their own means of getting to and supporting themselves in Africa. They often saw themselves as combating the global degradation of African peoples and regenerating Africa through Christianity, in addition to the traditional missionary impulse of saving "heathens." Alexander Crummel, the famous African-American intellectual, wished for the creation of what he called the "African Nationality." He envisioned Liberia expanding across Africa and uniting free blacks from the Americas with Africans to establish a single theocratic government imbued with Christian principles. Liberia would become more than just a missionary field but a demonstration to the world of black self-government and racial pride.[4] Henry McNeal Turner, Bishop of the African Methodist Episcopal Church of the US, spoke often of the need for pan-African involvement in missionizing, and thereby strengthening, Africa. He said of his organization's activities in South Africa, "Why, if we had a Negro nation in Africa…made and car-

3. D. Elwood Dunn, *A History of the Episcopal Church in Liberia, 1821–1980* (Metuchen, NJ, and London: Scarecrow Press and the American Theological Library Association, 1992), 37–8.

4. J.R. Oldfield, "The Protestant Episcopal Church, Black Nationalists and Expansion of the West African Missionary Field, 1851–1871," *Church History* 57 (March 1988), 34. Also see the Declaration of Independence contained within, *The Independent Republic of Liberia, Its Constitution and Declaration of Independence: Address of the Colonists to the Free People of Color in the United States* (Philadelphia: Geddes, 1848).

ried by our own race, the condition of the Black man would be elevated all over the world."[5] So, while African-Americans were not the majority of the initial missionaries, the case of Caesar, Jones and Johnson was not unique. African-Americans were an important force in early missionizing and played a critical role in the evolution of pan-Africanism.

The first official Episcopal missionary to Liberia was James M. Thomson, an Afro-American from Guyana. He married Elizabeth Mars Johnson, widow of William Johnson. In July of 1835, both James and Elizabeth were recognized as teachers under the direction of the Episcopal Mission Board. Both were awarded annual salaries from the mission board; $500 for James and only $200 for Elizabeth. W. A. B. Johnson, a Church Missionary Society worker in Sierra Leone, helped provide the DFMS with advice on a mission site. Construction was begun on the initial Episcopal mission church in Cape Palmas on March 1, 1836. Unlike the Baptist and Methodist churches that catered nearly exclusively to the Americo-Liberians (African-American settlers), the Episcopal Church made greater efforts to convert indigenous Africans. Because of this, a small group of Western-educated, Christian Grebo, emerged in the 1840s and 50s.

By December 1836, only nine months after its foundation, the mission board had already deemed it necessary that the mission be headed by a white man, the Rev. Thomas S. Savage, M.D. Within the next year, James Thomson was dismissed by the board for moral turpitude based "...on the facts laid before them by Dr. Savage."[6] Thomson was charged with seducing settler and African girls, but the case was dismissed by the local governor, John B. Russwurm, because of a lack of evidence. Despite dismissal of the charges against James Thomson, the DFMS saw fit to take his post from him all the same. Thomson died in Cape Palmas in 1838, while Elizabeth continued to work for the mission until her death in 1864. As was too often the case in mission organizations, qualifications and performance took a backseat to notions of race for both African-Americans and converted Africans. Two white missionaries followed on the heels of Savage in July of 1837, John Payne and Launcelot Byrd Minor.

The mission enjoyed a fair amount of success among the Grebo. Some of the early noteworthy converts included Ku Sia (Clement F. Jones), Mu Su (John Minor), and Bede-Wah (Gregory T. Bedell) the first Grebo ordained as deacons and priests, To Kla (Samuel W. Seton), ordained to the priesthood in 1868, and catechists Thomas Sidi Gabla Brownell and N. S. Harris.[7] By the mid 1850s, Grebo Christians began to call for a greater role for themselves within the Episcopal Church. As was too often the case in African mission history, however, the worst white missionary was perceived as better than the best black one. Their protests for greater advancement and the appointment of a black bishop went unheeded. Two unsuccessful breakoff churches were attempted in 1863 and 1876. A

5. "Bishop Turner's Views. He Will Visit Dutch and British South Africa," *Imvo Extra (Itole le'Mvo)* (April 20, 1898), as cited in J. Mutero Chirenje, *Ethiopianism and Afro-Americans in Southern Africa, 1883–1916* (Baton Rouge: Louisiana State University Press, 1987), 60–61.

6. While the exact circumstances remain unclear, Thomson was accused, but never convicted of, seducing some African and settler girls. Details in the DFMS archival documents remain equally ambiguous.

7. Dunn, 77.

black bishop, Samuel Ferguson was appointed from 1884–1916, only to be again replaced by a white bishop. This process was not unlike that experienced elsewhere. In the Nigerian Anglican Church, Bishop Samuel Crowther made many attempts to Africanize the Anglican church including its liturgy and clergy. He translated the Bible into Yoruba and promoted the use of indigenous languages in churches. He served as Bishop of West Africa from 1864–1891. However, from the mid-1880s onward more European missionaries were brought into the mission, pushing Crowther and his indigenous staff aside. With the death of Crowther in 1891, a European bishop was appointed to succeed him.

In summary, the early history of nineteenth century missions in Africa were not separate from the cultures which spawned them. That is, conceptions of race permeated mission bodies and non-white missionaries, whether from Africa or the Diaspora, were not treated equal to their white colleagues. The highest positions of administration were reserved for whites, and blacks were trained, ordained as clergy, and promoted within the mission hierarchy at a much slower rate than whites. Nonetheless, a small group of educated, Westernized Christian converts developed and challenged this system whenever possible. Many would later decide to form their own churches.

Missionaries: Sincere Evangelists or Part-time Colonizers?

One of the biggest debates regarding Christianity in Africa revolves around the relationship of missionaries to the colonial state. Most historians of Africa have argued that missionaries were compliant with the imposition and maintenance of the colonial state. This argument was born among nationalist scholars in the 1960s and has continued until today. It says that missions were part and parcel of the penetration of the West into non-Western cultures. Missionaries and colonial rulers shared the same worldview and were thus natural allies in the destruction of the African worldview and the overlordship of African societies. This argument further says that missionaries provided geographic and cultural information, weakened indigenous states, undermined indigenous culture, and enforced colonial law.

There is little question that one can find evidence to support all these activities by missionaries. In fact, one of the architects of colonial rule, Otto van Bismarck, recognized the importance of missionaries in paving the way for his troops when he said the missionary and the trader must precede the soldiers. And many of the most famous (or perhaps infamous) missionaries were quite cognizant of their role in the colonial machine and were very happy to contribute. David Livingstone wrote in his memoirs, "This account is written in the earnest hope that it may contribute to that information which will cause the great and fertile continent of Africa to be no longer kept wantonly sealed, but made available as the scene of European enterprise..."[8] Not only did Livingstone hope that his daily

8. David and Charles Livingstone, *Narrative of an Expedition to the Zambesi and its Tributaries* (New York: Harper and Bros. Pub., 1866), 2.

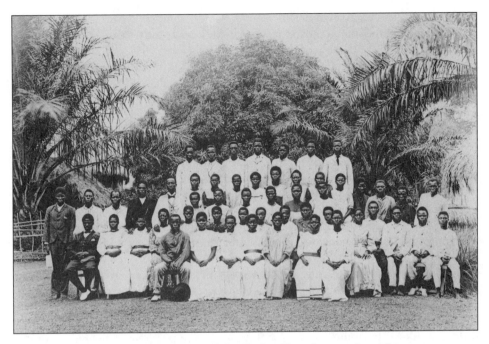

Figure 9-1. Members of the Ikoko Church posed outdoors

activity in Africa might be a tool of imperialism but that his very memoir might also become such a tool.

Some missionaries assisted colonialism through Westernization. Christianity came to represent the supernatural source of the white man's power and assisted in delegitimizing indigenous sources of supernatural power such as kingship, chieftainship, and priesthood. It provided access to education, employment and status in the white man's world. Indigenous cultural values were undermined through the promotion of Western cultural mores such as monogamy, secularism, abstinence from alcohol (depending on the denomination), and differing notions of evil. Many of the values promoted by missionaries were cultural in character, but were imbued with religious significance to the missionaries. The support for monogamy was seen as encouraging proper, sin-free living, and dictated by God. But as many Africans pointed out, monogamy was a cultural product and was not prescribed by Christian doctrine. Moreover, there was evidence of polygamy in the Bible. But taken in their totality, the promotion of Western values and culture, supplemented by evidence of the strength of Christianity's supernatural power and missionary's healing power, certainly played a role in undermining indigenous institutions. The weakening of these institutions may have indirectly aided colonial conquest by hampering resistance. Nonetheless, missionaries were working for their own goals of evangelization and what they thought was the good of their converts and "heathen" Africans. Few were deliberately promoting the spread of Western ideas for the good of colonial conquerors.

Some missionaries, in fact, were mindful of the influence of Western culture and tried to promote the value of African cultures. The Swiss missionary Henri Junod said, "among Bantu tribes there is a rich folklore...which illustrates the

voice of conscience in a wonderful way."[9] Placide Tempels wrote that Europeans did not understand the philosophy of Africans and until they did Christianity would be culturally dissonant for African Christians. He was an advocate of African cultural practices and said that enforcing cultural norms like monoga- mous marriage was to misunderstand how Africans defined the essence of life. The Africa Inland Mission in East Africa and the Sudan Interior Mission had a mission plan that involved mobile, rapid evangelization. They moved into com- munities, preached, formed a community of believers, and soon moved to the next community, trusting that those moved by the Word of God would maintain the community. They did not teach Western traditions or preach against African ones, but merely attempted to make a few rapid conversions. So it is not accurate to call all missionaries cultural imperialists, let alone political imperialists.

Some recent scholarship has begun to reflect a more nuanced understanding of missionaries and colonialism. This approach says that while many missionaries did welcome and aid the imposition of colonial rule, many others were used unknow- ingly and/or unwillingly, and yet still others protested it and even tried to frustrate the imposition of colonial rule. Very few became a missionary with the conscious intention of furthering imperialism.[10] Many missionaries were apathetic to the en- tire imperial enterprise. In the words of Church Missionary Society worker Ludwig Krapf, "Whether Europeans take possession of Eastern Africa, or not, I care very little, if at all."[11] It would seem difficult indeed to mistake this level of apathy for imperial agency. Krapf would very likely prefer to be remembered as a pioneering CMS missionary and not be labeled as an imperial agent when, to his knowledge, he did nothing to assist the conquest of Eastern Africa.

Other missionaries felt that their interests were not with the state or the mis- sion body but with one another. Most missionaries felt a high enough degree of autonomy that a German missionary in southern Tanganyika said, "In my con- ception, we missionaries stand to the Committee neither as mercenaries to their employers nor as Germans soldiers to their commander-in-chief...Rather, we stand...as individual shareholders in a corporation to one another."[12] In fact, the colonial state was often a threat to the autonomy that missionaries enjoyed and the colonial state's interference was something they resented.

Critical protests came from those missionaries serving in territories that were not ruled by their own national group. Missionaries did not band together in a pan-white conspiracy and welcome in colonial powers with open arms. It is easy to imagine that a German Lutheran in the Congo would have protested being ruled by Belgian Catholics or an Italian priest might attempt to stand in the way of British colonial- ism. To say that all white missionaries embraced any colonial power, no matter the nation, is to assign a level of national identification that simply did not exist. To be sure, racial allegiances were common and most missionaries were very aware of race.

9. *World Missionary Conference, 1910: Report of Commission IV*, 13.

10. Elizabeth Isichei, *A History of Christianity in Africa: From Antiquity to the Present* (Lawrenceville: Africa World Press, 1995), 92.

11. Johann Ludwig Krapf, *Travels, Researches, and Missionary Labours, During an Eighteen Years' Residence in Eastern Africa. Together with Journeys to Jagga, Usambara, Ukambani, Shoa, Abessinia and Khartum, and a Coasting Voyage from Mombaz to Cape Delgado* (Boston: Ticknor and Fields, 1860), 512–13.

12. Carl Nauhaus, as cited in M. Wright, *German Missionaries in Tanganyika, 1891–1941* (Oxford, 1971), 98.

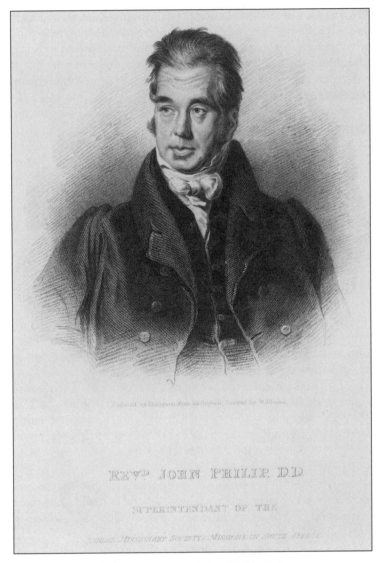

Figure 9-2. Rev. John Philip, D.D.

But that does not mean that national identities or denominationalism were forgotten, and these divisions among Europeans and Americans frustrated colonial ambitions.

Missionaries were often the only white voices that protested against abuses of the colonial system. J. H. Oldham, secretary for the pan-Protestant organization, International Missionary Council, along with the Anglican bishops of Uganda and Mombasa, and Dr. Arthur, leader of the Church of Scotland Mission, denounced official instructions in 1919 that were designed to force Africans to work for white settlers in Kenya.[13] White missionaries were also active in supporting African rights in other white settler societies such as South Africa, Zimbabwe and

13. Richard Grey, "Christianity" in A.D. Roberts (ed.), *The Cambridge History of Africa, Volume 7, from 1905 to 1940* (Cambridge: Cambridge University Press, 1986), 182–3.

Malawi. Missionaries of various national backgrounds and from a variety of de-
nominations were at the forefront of the international condemnation of King
Leopold of Belgium and abuses in the Congo. And they provided a critical voice
in having the colony turned over from royal hands to Belgian rule. Many mission-
aries, like Africans throughout the continent and people from throughout the
African Diaspora, denounced the Italian invasion of Ethiopia in 1935. In short,
missionaries were involved in a great deal of activity protesting the colonial state
and defending the rights of Africans. To call all missionaries willful colonizers is
simply untrue.

The case of the Primitive Methodists, who worked among the Valley Tonga of
Zambia, further illustrates this point. They had objectives that were not in align-
ment with those of Britain, despite being from the English-speaking and Protes-
tant world. The goals of the Primitive Methodists were much more far-reaching
than mere commercial relations and colonial rule. They wished to revolutionize
African societies into Christian nations that could join the worldwide Christian
church. They saw their role not as administrators or imperialists but as re-
deemers. The Secretary of the General Missionary Committee, A.T. Guttery,
wrote in 1912,

> The missionary motive is redemptive. Redemption is more than conver-
> sion; it begins with it, but it goes beyond it. Conversion is individual, re-
> demption is social. Now we go to other nations, not to bring them under
> our flag or possess their markets or add to our sectarian census, but to re-
> deem them, to make them strong, free and independent. Their nationality
> is a sacred thing, and we would redeem it, so that it may stand in that
> racial brotherhood that is the will of Christ, and the truest splendour of
> the morrows. We would make holy men loyal to their own racial type
> and social ties rather than the captives of a creed.[14]

While the Primitive Methodists may have possessed a religious arrogance, one can
not deny that their goals were far from those of the colonial state. They did not
see colonization, or even Westernization, as a necessary part of conversion. It is
likely that they saw the British rule of Zambia as diverting resources and the at-
tention of Africans away from what should be the real priority: religious redemp-
tion and the generation of an African-style Christian community.

In sum, it is a gross oversimplification to claim that all missionaries were de-
liberate and eager colonizers. While there were certainly some that happily aided
colonial conquest, just as many protested against colonialism and its abuses. Still
others were apathetic about colonialism and content to let the colonial state be,
so long as it did not interfere with the mission's goals. The attitude and actions of
missionaries were much more complex than a strictly nationalist argument can
possibly reveal.

14. PMMS Annual Report 1911–12, lxxxii, as cited in Luig Ulrich, *Conversion as a So-
cial Process: A History of Missionary Christianity among the Valley Tonga, Zambia* (London:
Transaction Pub., 1997), 65.

Methods of Conversion

Missionaries employed a number of methods and tactics to spread Christianity. Despite denominational and personal differences among missionaries, and cultural differences among Africans, missionaries and mission bodies employed relatively similar strategies at similar points in time. As the number of converts gained by each strategy was typically not high, missionaries were constantly coming up with new strategies in the hope of converting large numbers of the populace. While mass conversions were not uncommon, they were often the result of indigenous agency rather than the efforts of white missionaries.

The first strategy typically attempted by mission societies was the itinerant preacher approach. That is, a single missionary would travel through a region preaching where and when he could. The Norwegian Missionary Society presence in southern Africa began with H.P.S. Schreuder in 1845. He approached King Mpande for entry into Zululand and was declined. For the next five years Schreuder traveled between the fringes of Zululand and Natal attempting to find Zulu interested in hearing what he had to say. The Zulu, however, were usually more interested in what Schreuder might have for them or what he might be able to provide in the way of cures. Most missionaries, as Schreuder likely did, found traveling about to be discouraging and exhausting. Few converts were gained by this strategy, and there were rarely enough Christians in one place to maintain a community. Most missions attempted to set up their stations as quickly as possible.

This is what Schreuder began to do among the Zulu around 1850. He was granted a site for a mission station, permission to preach freely and the occasional use of the king's kraal for a Sunday service after he cured King Mpande's rheumatism in 1850. The king was said to be so impressed by Schreuder's healing skill that he wished to have him nearby. The king benefited by having a European who could act as intermediary between the British to the south in Natal and the Boers to the north. While King Mpande did not interfere much with Schreuder's activities, he was not supportive of Christianity either. Conversion was incompatible with Zulu citizenship in his eyes and converts lost their land rights, family rights and political privileges. By 1880, there were only 300 Zulu Christians at nine mission stations.[15]

The station strategy proved more successful for the Methodists in Ghana. Thomas Birch Freeman, an Afro-European (his father was a freed slave) and Wesleyan Methodist missionary, traveled throughout the Gold Coast setting up mission stations and building churches wherever possible. Freeman had been preceded by Joseph Dunwell, who died after just six months in Africa, and by G.O. Wrigley and P. Harrop and their wives, all four of whom died within ten months. So it was certainly no accident that the mission organization looked for someone whose biology could better handle the disease climate of tropical Africa.

Despite the short time in the Gold Coast of the pioneering missionaries, a few converts were gained and a handful of churches constructed. Freeman arrived in January 1838 and began by repairing the church at Cape Coast Castle. From there he constructed a station at Kumasi among the Asante and even managed to

15. Jarle Simensen, "Religious Change as Transaction: The Norwegian Mission to Zululand South Africa 1850–1906," *Journal of Religion in Africa* 16, 2 (1986): 84–6.

gain two royal converts, Quanta Missah and Ansah, who left for educations in England. He also traveled to Anamabu, Winnebah and Accra. Freeman made a case that a large staff was needed and, in 1840, Mr. and Mrs. Hesk, Mr. and Mrs. Watson, Mr. and Mrs. Shipman, Mr. Thackray, and Mr. Walden joined him. Within five months Thackray, Walden and Mrs. Hesk had died. In 1841, Quanta Missah and Ansah returned from England. Their continued dedication to Christianity aided the missionaries' efforts. As more stations were built, more missionaries continued to arrive including William Allen at Domanasi and Thomas Rowland and Robert Brooking at Kumasi. By the 1840s, small communities of Christians existed in a number of places and the training of indigenous clergy had begun.[16]

The station strategy met with a fair amount of success in some places. Most often Africans were attracted to the stations not out of a conversion experience but because of opportunities for paid work, security from warfare, hopes of being healed, or the promise of land. The people initially attracted to the stations were most often the dislocated, be they refugees, criminals, or outcasts. After their arrival many of these Africans found a place for themselves in Christianity that they found quite meaningful. Some others may have attended Sunday service simply because it was an expected part of living at the station. Some Zulu called it *sonda*, to do Sunday work. Missionaries like Schreuder and Freeman used the stations to preach to sizeable populations, and for some missionaries the stations served as an opportunity to Westernize their converts.

The stations often occupied ambiguous positions in their contemporary landscape. Schreuder's stations in Zululand occupied a space somewhere between the Zulu and the British, both spatially as well as culturally. The spread of Western culture and Christianity gave many converts a complex identity, somewhere between European and African, that they molded to suit their own individual needs and desires. Mission workers themselves also changed and developed a more multifaceted identity. Schreuder, in acting as the king's trusted mediator, became something of a Zulu diplomat and citizen. While a white European, he demonstrated a genuine identification with the Zulu kingdom and made attempts to help preserve the kingdom's independence. Identity and behavior had no clear-cut formula for both the converters and the converted in colonial Africa.

The most successful tactic initiated by mission societies were schools. Even before his arrival in Liberia, Episcopal missionary James Thomson said in 1834:

> Let there be a large native house built as a boarding school for the native children, some distance from any native town, and a decent dwelling house for the teacher or teachers… The children will then flock in multitudes, and stay at school night and day, by which means they will soon forget their native habits, and imbibe ours.[17]

Here children could be socialized and acculturated in a Western and Christian environment. Conversion in this case was more than a religious experience, it was a total cultural adoption. So critical did missionaries find schools that they were

16. G.G. Findley and W.W. Holdsworth, *The History of the Wesleyan Methodist Missionary Society, Vol IV* (London: Epworth Press, 1922), 151–57.

17. Proceedings of the DFMS, Report to the Board of Directors, May 13, 1834–Aug. 20, 1835, 42.

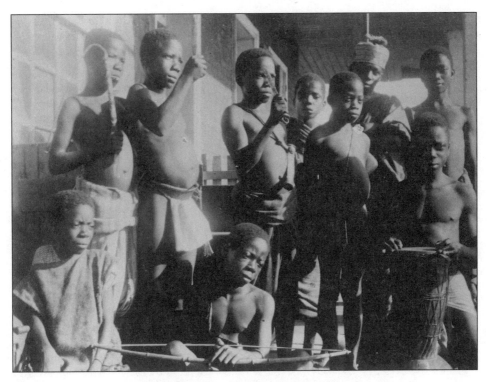

**Figure 9-3. Some Kroo boys in
Miss Sharp's mission, Monrovia, Liberia**

often willing to pay parents cash to permit their children to attend. All laborers and servants of the mission were forced to have their children attend or risk their jobs. Some were even threatened with eviction from their station land if they refused their children's mission education. Other parents, however, were eager to send their children as it was becoming obvious that education was the key to success in the white man's world. Generally, Christians who were educated in mission schools were Christians for their lifetime. Alienated from their own culture and religious traditions, for many it was the only life they knew. Christians from the mission schools were often the nationalist and independence leaders of the twentieth century.

However, the most converts to Christianity were, by far, gained by African initiatives. Such initiatives might be as simple as a young adult returning to their hometown after receiving an education at a mission school to something as complex as the foundation of a theological college. But everywhere, and in every way imaginable, African Christians took it upon themselves to convert their fellow Africans to their newfound faith. In Madagascar, Malagasy Christians did such an extensive job at converting their countrymen that by 1913 visitors commented that "probably in no country in the world are the Christian Churches better attended."[18] In Buganda, Dallington Scopion Maftaa aided Stanley in preparing a Swahili translation of the Bible, written in Arabic script. Maftaa acted as the first

18. Grey, "Christianity," 140.

apostle to the Ganda and helped trigger one of the most rapid conversions in African history, including some of the royal family. When some Christians were threatened with death for their faith in 1886, thirty-one faced gruesome deaths with incredible heroism rather than renounce their faith. In Liberia, largely under the direction of Bishop Ferguson, the Episcopal Church rearranged its educational system so that all of its primary and secondary schools fed into Cuttington College, founded in 1889. Rev. Martin Keda Valentine, a Grebo-Liberian, was appointed as head. An almost all-Liberian faculty was appointed and the school went on to train generations of missionaries, clergy, and even heads of state. The actions of many African Christians have gone virtually unremembered. Patrick Kwesha was a Shona Catholic who worked as a gardener in a convent in Johannesburg. He never married because he said his family was the whole Church. He taught catechism to fellow migrants and joined the Third Order of St. Francis. He longed for the foundation of an order of African Franciscans and for the erection of a Marian shrine in his homeland. His piousness and teaching would likely have been forgotten if it were not for a detailed study of his homeland in Makoni district.[19]

Whether it was the grand actions of Bishop Ferguson establishing a theological college or the humbler acts of Kwesha teaching catechism year after year, Christianity was largely spread by the actions of African Christians. Were it not for their actions, Christianity would likely have remained a religion of the marginalized. White missionaries often lacked the language skills, cultural literacy, and legitimacy necessary to convince individuals to forsake their own religion and adopt another, that was most often a synthesis of Christianity and an indigenous religion.[20] African Christians, on the other hand, did have the characteristics the white missionaries lacked; and they were willing to work toward what they saw as the salvation of their ethnic groups, and sometimes the salvation of all Africans.

Religious Change

A number of fundamental differences existed between Christianity and African indigenous religions. In the encounter between the two types, some fundamental alterations in the worldview and philosophy of Africans took place for many individuals and societies, especially among those who had not been exposed to Islam. One of the most important changes occurred in African notions of evil. For most Africans it was very difficult to accept the idea that human beings were born with original sin and needed redemption for it. For Africans, religion sanctified and celebrated the gift of this life, it did not rescue it in the next life. They certainly accepted that human beings were capable of sin and evil acts, but they attributed such acts to choice and supernatural forces, not a curse upon humans. Endorsing the notion of original sin was a considerable realignment of the African worldview and gave religion a more "other-worldly" perspective.

19. T.O. Ranger, "Poverty and Prophetism: Religious Movements in the Makoni District, 1929–1940" (paper read at SOAS African history seminar, October 1981), 16–19, as cited in Isichei, 244.

20. Isichei, *History of Christianity*, 132.

Africans also had difficulty accepting the idea that absolute evil had a super-natural, as opposed to a social source. Ultimate evil to the African mind came in the form of witches and witchcraft, not from a near infinitely evil god (Satan). Missionaries (except some priests of a folk Catholicism background) preached against beliefs in witchcraft, despite discussion in the Bible of demons and evil spirits. The African belief in witchcraft placed the causality of misfortune on other human beings where the source of evil could be identified, and purified or eradicated. A belief in Satan means that one can do nothing to alter the source of evil but to take refuge in goodness. The persistence of anti-witchcraft movements and charms, purification rites, and even witch trials, to the present, suggests that Christianity has not revised African notions of witchcraft and ultimate evil that considerably.

Another very important change concerned the transition from a polytheist to monotheist pantheon of gods. While great debate exists about the degree to which African notions of creator gods approximate Christian notions of God, there is no denying the fact that African indigenous religions were polytheistic. As such, they were fundamentally different from Christianity with its one God. Conversion to Christianity meant that an individual accepted a considerably altered supernatural universe; one inhabited by just one God, even if beliefs in evil spirits continued. What often happened, such as among the Yoruba, was a continuation of indigenous gods and goddesses alongside Christianity. For many Yoruba, the Holy Spirit and Shango could be valid intermediaries to handle prayers to God or perhaps equally potent sources of redress to God. For other groups, the polytheistic pantheon became overlaid with that of the Catholic sainthood or helped to explain the abundance of spirits or supernatural beings. Monotheism spread far and was adopted by many, but polytheism did not disappear.

Christianity, and Westernization, also introduced the notion of secularism that was modestly revolutionary to African life. African cultures had been underpinned by the fundamental basis that there was a unity of religion and life. Religion was not separated from politics or society, and leaders were not separated into different spheres. Missionaries, however, taught that life could be divided into spiritual and secular spheres. Most African institutions which developed and grew from the colonial milieu mirrored this division. Such a division remains in Africa, where political and economic leaders are distinct from today's religious ones. This means that today's political leaders are not buttressed by supernatural power, as they were in the past.

Christianity also partially modified African notions of the afterlife. In African indigenous religions, death meant joining the ancestors and living a life in the land of the dead similar to that in the land of the living. Excluded from this passage were the spirits of witches that would remain on earth and cause misfortune and malevolent acts. But even for those who made it to the land of the dead, life was not eternal. Once one was no longer remembered and revered by those in the land of the living, one tended to fade into oblivion, perhaps becoming a feature of the landscape or perhaps being reborn into the land of the living. Missionaries taught that life after death was eternal. But more than that, there was not a single land of the dead. They taught that one could go to an eternal paradise or a place of eternal damnation. Thus, Christian doctrine lengthened African notions of the afterlife, but also added a moral element that said one could be subject to eternal damnation after death. Africans had always possessed a moral barometer, but it had always dictated one's place in society, not the afterlife.

Figure 9-4. Christian ministers and church leaders

The encounter between Christianity and African indigenous religions found a number of metaphysical commonalities as well. Spirit possession in African indigenous religions was replaced by possession from the Holy Spirit among some African converts. Many Christian denominations frown upon claims to possession by the Holy Spirit, but it is a considerable part of the theology of many denominations. Some African converts gained the idea of possession by the Holy Spirit from Pentecostal missionaries while others gained it from their own reading of the Bible and the description of Pentecost. The heavy reliance on water in Christian ritual also found an easy compliment in African religions. The use of water for baptism was very similar to the purification rites of African religions and both rituals placed an emphasis on rebirth. Catholicism's use of holy water, again for purification purposes, was much like anti-witchcraft medicines or charms possessed by African religions. In some areas the respect given to the queen mother was used as an analogy to explain the powers of Mary. Rosaries and Marian medals were accepted as protective charms or medicines. Miraculous cures and spiritual healing were among the greatest attractions of both Catholicism and Protestantism for many Africans. African indigenous religions were often very concerned with healing and wellness, and this was an easily understandable and likable part of Christianity.

Initiated Churches

Variously known as separatist, independent, initiated, Zionist, and Ethiopian, many new churches were founded by Africans throughout the colonial period and into the present era. A great deal of debate has revolved around these churches.

Some scholars, most of them missionaries and theologians, have argued that these institutions should be seen as post-Christian and unorthodox because they do not contain a proper Christology and because they deviate from the standards of traditional Christianity. This perspective does not allow for an ample allowance for the accommodation of culture with religion. All people adapt religion to suit their cultural needs in a way that makes religion meaningful for them. Nor does it recognize that European Christianity contains many non-Christian elements. Further, what is heterodox today can be orthodox tomorrow. After all, even Lutheranism was once considered a sinful evil path. Other scholars claim that these movements were merely revivals and revitalizations of indigenous traditions and that Christianity was merely a veneer that could be easily removed. This perspective is largely nationalistic and sees ethnicity as the motivating force of human action. It does not treat religion seriously and sees churches as using religion as a tool for other motivations such as ethnic revival, resistance, or gaining land.

More recently, some scholars have begun to see the phenomena of Initiated Churches as part of a much wider process involving the intersection of religion and culture. It is not the case that the only religious choices for Africans were Christianity or Indigenous Religions (or Islam), and few Africans saw spirituality as being that neatly compartmentalized. "In reality, every individual made his or her own synthesis."[21] A Congolese Catholic and a member of Eglise Kimbanguiste could have held virtually identical views of theology and might not have been so very different despite belonging to different churches. Other scholars have drawn a parallel between the profusion of denominations within Western Protestant Christianity and the generation of Initiated Churches. They see the two processes as similar and deriving from comparable motivations like Biblical analysis and disputes concerning leadership. It would seem better to study Initiated Churches for what they do contain and profess, not for what they appear to lack from an outsider's perspective. In this manner, Initiated Churches could decide whether or not they wish to be considered Christian.

The sentiments that led to the formation of Initiated Churches were pervasive but did not always lead to the formation of separate organizations. Too often scholars have seen the followers of Initiated Churches and Mission Churches as being worlds apart when in fact many of these parishioners felt the same about issues of race, leadership, culture, and theology. Some chose to join Initiated Churches while others chose to remain where they were and try to affect change from there. The fact that the initial converts of almost all Initiated Churches were parishioners of mission churches, and not adherents of indigenous religions, suggests that they already shared a great deal in common. Jamaa illustrates how Africans within mission churches found ways to Africanize Christianity and yet still remain within a mission church.

Jamaa was born in the 1950s in southeastern Congo, and grew especially in mining centers. It was based in large part on the teachings of Placide Tempels, who said that Europeans and Africans did not understand the philosophy of the other and therefore had no common ground. Christianity was not being introduced with the philosophy of Africans in mind and it was therefore creating a dissonance for African Christians. Tempels further said enforcing cultural norms

21. Isichei, *History of Christianity*, 132.

like monogamous marriage was to misunderstand how Africans defined the essence of life. Churches should redefine their doctrine so that the eternal message of the church was presented using African symbols, language, and parables. A number of Congolese were attracted to his teaching and sought rectification of African culture with Christianity. These early adherents said they rediscovered in Jamaa the principles that had been with God for eternity: mutual understanding and marriage, mutual aid, and love. Fulfilling these principles made one close to God. It further taught that Mary was God's metaphorical wife in mutual understanding, and Satan was a great sorcerer who destroyed unity. Jamaa organizations used Swahili, recognized dreams as sources of valid religious insight, and employed initiation rites; all African cultural practices. The doctrine of Jamaa differed little from that of many Initiated Churches. Yet members of Jamaa remained faithful Catholics and saw Jamaa as a Catholic organization for adults.[22] They were eventually asked to leave the church for their "unorthodox" doctrines, but forming a separate church was not their intention. So, the lines between forms of Christianity in Africa can not be drawn too solidly as they often overlapped.

Whatever the scholarly debates involving Initiated Churches, they did share a number of commonalities. For instance, some churches differed only slightly in ritual and theology from the churches they split from. However, changes that did occur were often very significant ones to the congregations involved. Some churches split because of doctrinal differences. Isaiah Shembe, for instance, differed with the Methodist and African Baptist Churches. His interpretation of the Bible, most notably, suggested that the Sabbath was on Saturday, shoes should be removed during service, pork consumption was forbidden, and the use of medicines was prohibited. Quite common was the accommodation of some African cultural traditions, most notably the allowance of polygamy. In fact, polygamy was the primary impetus to the formation of the United African Methodist Church in Lagos in 1917. Ten men had been accused in a Methodist Church of having more than one wife. When they and fifty-five others admitted their "guilt," they formed a new church. Other Initiated Churches incorporated such practices as initiation rites, purification ceremonies, and the legitimacy of visions and dreams. Introduction of these practices made Christianity culturally and symbolically meaningful to the parishioners in a way it could not be in a mission church. Another commonality of Initiated Churches was that they were almost exclusively formed along ethnic lines; the Nomiya Luo Mission was founded for Luo, the first Aladura churches were formed for Yoruba, and the amaNazaretha was organized as a Zulu church. However, many Initiated Churches have spread far beyond a particular ethnic group and have become multi-ethnic and international. The Eglise Kimbanguiste, for instance, has spread throughout equatorial Africa from its origin in the lower Congo and the Harrist Church can be found throughout western West Africa.

Africans founded separate churches for a variety of motivations. Early in the history of Initiated Churches, racism was a significant motivator of schism. While welcomed as converts, many Africans found that they were not so welcome when

22. Johannes Fabian, *Jamaa: A Charismatic Movement in Katanga* (Evanston: Northwestern University Press, 1971).

it came to leadership positions. Qualified Africans would very rarely be given a position over white missionaries. This situation was especially acute in the Catholic and Anglican Churches where African bishops were a rarity until the 1960s. Not surprisingly, South Africa lead the way in Initiated Churches founded to escape white control.

The Tembu National Church was founded by Nehemiah Tile in 1884. Originally a Methodist, Tile was accused of being an agitator who was taking part in political matters and causing trouble for the magistrates. He responded by moving his faith outside the control of whites and taking a sizable portion of the congregation with him. In 1898, Pambani Mzimba, the first African ordained at Lovedale, founded an independent African Presbyterian Church and had two-thirds of the congregation follow him. South Africans were far from alone in the creation of churches due to race, however. Garrick Sokari Braide, born in a Kalabari town in the northern Niger Delta, was baptized in 1910 into the Niger Delta (Anglican) Pastorate. He experienced a vision in 1912 and gradually came to place greater faith in his healing abilities. Congregants flocked to his services for healing and Braide originally had the blessing of the Anglican Church. He later lost this blessing due to jealousy of others and accusations of heresy. His fame grew and he became known as Elijah II. He and his followers broke from the Anglican Church in 1916. Braide roused the hostility of the Anglican Church and that of the colonial administration and, because it was wartime, he was arrested and died in jail in 1918. Braide's followers formed separate churches such as the Christ Army Church but Braide never had the chance to serve as the institutional head of any church.

Racism and leadership were not the only motivations for schism. Many Africans found the content of Christianity, as presented to them by missionaries, to be an incorrect version imbued with too many trappings of Western culture. When the Bible was translated into indigenous languages, African Christians would interpret the Scriptures for themselves. As regards polygamy, many Africans pointed to its extensive appearance in the Bible. Many leaders said monogamy was a creation of Paul and had nothing to do with the Gospel. Miracles and healing, as discussed in the Bible, received renewed emphasis in many Initiated Churches. Divination, prophecy and dreams, which were such a vital part of African indigenous religions, obtained a prominent place in the foundation and maintenance of many Initiated Churches. They could be justified with scriptural evidence, as with the late Rev. S.B.J. Oshoffa and the Celestial Church of Christ. Other groups, just as did some Christian denominations, contested the method of baptism or communion. The Nomiya Luo Mission, founded by John Owalo in 1910, adopted circumcision as a condition of salvation. The ritual was not based on precolonial precedent as the Luo did not practice circumcision, but it was based on its appearance in the Bible. Biblical analysis by Africans covered great many issues and was used to justify the creation of countless churches. In short, the African's reading of the Bible was no less critical than that of other Christians and was the source of renewed denominationalism, as it had been since Luther. In fact, the creation of Initiated Churches was part of a global charismatic wave experienced throughout the Christian world during the early twentieth century. While uniquely African, Initiated Churches were not bizarre or anomalous in Christian history.

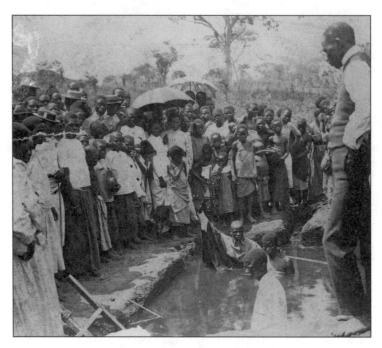

Figure 9-5. Baptism by John Chilembwe

Nazareth Baptist Church

The Nazareth Baptist Church was one such early Initiated Church. The founder of the Nazareth Baptist Church (NBC), Isaiah Shembe, was born near Harrismith, near the Drakensburg Mountains, in South Africa. It is said that his birth was foretold by prophecy when his mother heard a voice in the forest tell her, "Child of Hadebe, abjure fornication and drinking, for you will bear a child of Me... Your son will be my servant."[23] Isaiah was a healthy child but one day he became ill and died. A *sangoma* (indigenous priest) was called who said that he wasn't truly dead but was destined to become a great instrument. As his grave was being dug, a large ox died, and Isaiah revived. Shembe prayed as a child, which was something he said he learned to do instinctively. Between the ages of 12 and 15, he regularly heard voices telling him to give up sins and fornication, even though he did not exactly understand what he was being prohibited from doing. He did not hear the voice for many years, but then as a young adult the voice told him to leave his four wives. Finding the idea of his wives remarrying to be unbearable, he asked God to take them instead. Shortly thereafter a number of Isaiah's children died and the voice told him it was because of his prayer, but the children were taken because they were pure and not unclean like his wives. After the death of his children and being struck by lightning, Shembe finally heeded the demands of the voice. He left his wives and began wandering and preaching.

23. Robert Papini, *Rise Up and Dance and Praise God* (Durban: Local History Museum, 1992), 24.

Though unbaptized, Shembe began preaching in the Methodist Church and quickly gained a reputation as a great healer. He took Bible classes, and though not yet literate, he was able to memorize the entire Bible. His own interpretation of the Bible led him to disagree with ministers of the Baptist Church. Shembe promoted a literal interpretation of the Bible and insisted on removing shoes during worship, leaving hair uncut, avoiding pork, and many other proscriptive behaviors of the Old Testament. His main disagreement with the ministers of mission churches was on the proper Sabbath day. Shembe argued that the Sabbath was Saturday, not Sunday, and that mission churches were not honoring God correctly.

His separation with the church took place in 1903. From 1903–1908, Shembe worked as a migrant laborer near Durban. He continued to preach, heal, and attract followers who he always encouraged to attend the local Christian church, whatever denomination that might be. In 1910, he brought a group of 40–50 followers to the American Board mission, but they were refused because of their traditional clothes. Shembe then took it upon himself to care for these worshippers, a time that is generally accepted as the founding date of the Nazareth Baptist Church. Shembe continued to hear the divine voice until his death in 1935 and believed he had received divine anointment when the voice told him, "Go to the mount of Nhlangakazi; there I will ordain you as my true and full Prophet."[24] Henceforth, Shembe took his divine appointment very seriously and saw himself as fulfilling God's will.

Shembe and the NBC at first encountered resistance from whites, who felt he was using religion as an excuse for anti-government activity, as well as from missions, that felt he was stealing parishioners from them. But Shembe strongly opposed all anti-government activity and said that opposing whites, who had brought the word of God, was to fight against God. Shembe was unsympathetic to accusations that he was "sheep-stealing" from missions. He stated that he was also a Christian leader and people had a right to worship with whom they pleased. Shembe used to say, I am of all colors, meaning that people of all races were welcome in his church.

A great deal of debate has concerned the NBC and whether it is a Christian church or a revival of Zulu religion. Some have argued that Shembe was an ethnic nationalist and rejuvenated Zulu indigenous religion in new clothing. These scholars point to the continuation of Zulu dance (*ingoma*), worship conducted in isiZulu, use of traditional garb in church uniforms, continued reverence of ancestors, gender division of worship, and the almost exclusively Zulu membership, as evidence that Shembe revived Zulu culture and formed a venue for Zulu people to immerse themselves in Zulu culture. And it is indeed true that the NBC continued many practices from the Zulu past. However, it also altered many traditions and renounced others. For instance, polygamy, while tolerated if one entered the church with more than one wife, was not permitted of members. Circumcision, a practice outlawed by Shaka, was reintroduced on the basis of Old Testament mandate. The NBC forbade the consumption of pigs and other unclean animals. In Zulu society, *ingoma* was flashy and exhibitory; it promoted individual embellishment and was done to entertain and impress. But Nazareth Baptist dance, on the other hand, was pious and meditative, and promoted tight discipline and timing. Worshippers were

24. Papini, *Rise Up*, 25.

warned before the Sunday dances that showing off was a sin as they were dancing for God, not for attention. Thus, to claim that Shembe merely revived Zulu religion is to miss the fact that he did not adopt the ritual practices of Zulu culture *en masse*, but selected and adopted them to suit the needs of his church.

Other scholars have argued that these very same Zulu practices prevent the NBC from being a truly Christian church. They were disturbed by the high degree of reverence shown to Shembe and felt he interfered with a true Christology. And indeed Shembe was seen as an eternal and powerful entity that has served as God's prophet several times, most recently to act as liberator for the Zulu as Moses did for the Jews. The prophecies of Shembe, in addition to his parables and hymns, have served as Church doctrine. The spirit of Shembe was said to live on in the head of the church, who was always male and always from the Shembe line. However, no Shembe worshipper confused Shembe with God or Christ, and Shembe has not replaced Christ in importance. In the words of Johannes Galilee Shembe, Isaiah's son and the second leader of the NBC, Isaiah considered himself to be the *inceku*, the messenger or servant of God, but "Shembe is neither God nor Christ."[25] The NBC considers itself to be a Christian Church in the true sense of the word. Seeing as that they believe in a Trinitarian God and hold the Bible to be the literal word of God, it seems we should take them at their word rather than impose notions of Western orthodoxy upon them. In short, what Shembe did was to create a new religion; one that combined elements from both Zulu indigenous religion and from Christianity. The NBC is not a regurgitation of Zulu religion, although it contains elements from it; nor is it a poor imitation of Western Christianity, although it contains elements from it as well. It is a vital, cogent religion that is spiritually meaningful to its members.

Harrist Church

Another Initiated Church is the Harrist Church, which is perhaps the best known in African history. William Wade Harris, a Grebo of Liberia, had been raised in a Methodist minister's home and worked as a teacher for the Episcopal Church. While in a Liberian prison for having raised a British flag, he had a vision of the Archangel Gabriel who told him that God was coming to anoint him, and he felt the Spirit descend on him. When he was released from prison, probably early in 1912, he discarded his European clothing and adopted a long white robe. He carried a Bible, cross, gourd rattle, and bowl for baptism. From time to time he would destroy the cross and take another so people did not worship it. Harris proclaimed himself to be the last of God's prophets. He began preaching in Liberia but did not meet with much success and later crossed into Cote d'Ivorie. He denounced the old gods and encouraged communities to destroy their "idols" and other material relics of their indigenous religions. But while condemning the old gods, he did not dismiss the supernatural world of Africans or their religious anxieties such as witchcraft, evil spirits, and healing.

25. Hans Jurgen Becken, "The Nazareth Baptist Church of Shembe" in *Our Approach to the Independent Church Movement in South Africa* (Mapulo: Missiological Institute, Lutheran Theological College, 1965), 109.

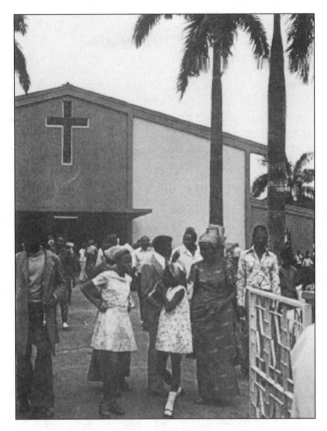

Figure 9-6. A modern church

Harris offered immediate baptism, healed people, and cast out evil spirits by beating converts on the head with his Bible. He tolerated but did not encourage polygamy.

It is thought that Harris baptized 100,000–120,000 in just one year. After several decades in the region, the Catholic Church had been successful in gaining several hundred converts. In an incredibly short time, the devotees of Harris far eclipsed the number of Catholics. But he told his converts to seek the teachers with Bibles. Catholic missions, the only ones in Cote d'Ivorie at the time, were overwhelmed with interested parishioners. Others founded their own churches based on the principles of Harris, which were eventually consolidated into a single organization. And still others joined the Protestant churches when Protestants arrived in Cote d'Ivorie in 1924 as Protestant reliance on the Bible was seen as fulfilling the instructions of Harris. Harris himself was expelled from Cote d'Ivorie in 1914 as his influence (but not his message) worried French officials. In just two short years he had done more to spread Christianity than dozens of European missionaries before him. He never enjoyed anywhere near the same sort of success back in Liberia and lived a fairly quiet life until 1929. Harris' greatest effect was on people in the lagoon area, but his message traveled far inland also, and even into western Ghana. His message inspired the creation of other Initiated Churches including the Church of the Twelve Apostles founded by Grace Thannie, and the Deima Church founded by Marie Lalou.

Conclusion

The conversion of Africans to Christianity has been one of the largest and most significant religious and cultural changes of the modern world. European missionaries have generally been considered mere pawns of the colonial state. It has been demonstrated that this was not necessarily so as most missionaries were religiously sincere, and often viewed imperialism with apathy or even disdain. African peoples of the Diaspora played an important role in missionizing. Mission organizations attempted a variety of conversion tactics, but their success was limited. By far the most successful conversion tactics were those employed by Africans themselves. Indigenous agency was responsible for the largest spread of Christianity, not the colonial state or European missionaries. In whatever manner Christianity may have spread, and wherever it went, Africans adopted it in such a way as to make it religiously and culturally meaningful to them. For some people that meant making some minor changes in liturgy or ritual, while for others, it meant succession and the formation of Initiated Churches. Whether in Mission Churches or Initiated Churches, by the close of the colonial era, it was clear that Christianity was a dominant religion of Africa and Africans were a considerable part of the global Christian community.

Review Questions

1. With the significant exceptions of the Coptic and Ethiopian Orthodox Churches, why was Christianity relatively unimportant in Africa before the nineteenth century?
2. What was the role of African Americans in Christian missions?
3. Were missionaries sincere evangelists or part-time colonizers? Provide evidence for your choice.
4. What were the methods of conversion? What was the most successful and why?
5. What religious changes were brought to the worldview of Africans by conversion to Christianity?
6. What were the reasons for the formation of Initiated Churches?
7. What was the theology of the Nazareth Baptist Church?
8. What reasons can you identify for the success of Christianity during the colonial era?
9. How does African Christianity differ from Christianity elsewhere in the world?

Additional Reading

Dunn, D. Elwood. *A History of the Episcopal Church in Liberia, 1821–1980.* Metuchen, NJ: London: Scarecrow Press, 1992.

Grey, Richard. "Christianity" in A.D. Roberts (ed.),*The Cambridge History of Africa, Volume 7, from 1905 to 1940*, 140–90. Cambridge: Cambridge University Press, 1986.

Hastings, Adrian. *The Church in Africa, 1450–1950*. Oxford: Clarendon Press, 1996.

Hexham, Irving (ed.). Londa Shembe and Hans Jurgen-Becken (trans.), *The Scriptures of the amaNazaretha of Ekuphakameni: Selected Writings of the Zulu Prophets Isaiah and Londa Shembe*. Calgary: University of Calgary Press, 1994.

Hinfelaar, Hugo F. *Bemba-Speaking Women of Zambia in a Century of Religious Change (1892–1992)*. Leiden, NY: E.J. Brill, 1994.

Isichei, Elizabeth. *A History of Christianity in Africa: From Antiquity to the Present*. Lawrenceville, NJ: Africa World Press, 1995.

Sanneh, Lamin. *West African Christianity: The Religious Impact* (1983). Maryknoll, NY: Orbis Books, 1990.

Chapter 10

Islam and Colonialism in Africa

Jonathan T. Reynolds

This chapter focuses on the interaction between African Muslims and European colonizers during the period from 1885 to 1939. Beginning with a survey of the demographics of African Islam at the time of the "Scramble for Africa," the chapter examines how different groups of Muslims and Europeans in Africa created different images of the "other." Further, the chapter examines how these various images led to reactions and policies which helped shape the nature of the colonial experience in different regions and times. The chapter closes with an examination of the impact of colonialism on the growth of Islam in Africa.

* * *

The colonial conquest of Africa was not simply a meeting of the "African" and "European" worlds. Neither Europeans nor Africans necessarily saw themselves in such broad terms during the late nineteenth century. National, ethnic, and religious identities played an important role in colonialism in both how it was spread and how it was resisted. This chapter focuses on how the presence of Islam in Africa influenced the nature and development of colonialism in the period between 1885 and 1939. The colonization of Africa can be seen not only as another stage in European and African interaction, or as another stage of colonial and imperial expansion, but also as another stage in the long-running and ongoing meeting between the West and Islam. The study of colonialism and Islam in Africa will thus help the reader to understand all of these wider topics. Several questions specific to Africa are examined in the course of this chapter: How did African Muslims and European colonizers see one another at the beginning of the "Scramble for Africa?" What was the nature of Islamic resistance to colonialism? How did colonial administrations seek to deal with the Muslim populations within their borders? How did Muslim populations accommodate themselves to or continue to resist colonial rule? Finally, what might account for the rapid growth of African Islam during the early colonial era?

Background: The Demographics of African Islam

At the time of the colonial "Scramble," Islam had long been established in many parts of Africa. During the latter part of the seventh century, Islamic

armies swept across North Africa, easily displacing the Byzantine Empire's, often unpopular, rule in the region. Over the next thousand years, the Berber and Arab inhabitants of the region slowly converted to Islam, often from Christianity. Over the same period, scholars and traders (following the busy caravan links across the Sahara) helped spread Islam into the savannas of West Africa and up the Nile into the Sudan. The conversion of the ruling and commercial classes of such West African empires as Mali and Songhai fostered trade to the north that helped these states grow rich and powerful. During the eighteenth and nineteenth centuries, West African Islamic reformers such as Usman dan Fodio and Al-Hajj Umar Tall launched jihads that led to the cre- ation of new Islamic states and the expansion of Islam in the region. In East Africa, the Indian Ocean trade brought Arab and Persian Muslims to important coastal towns as early as the seventh century. Intermarriage with the local population helped create a unique cultural group known as the Swahili, a group who drew upon African, Arab, and Islamic cultural traditions and who prospered in their role as mediators in the long-distance trade networks that tied East Africa to other regions of the Indian Ocean. Close contact between the population of the Horn of Africa and the Arabian Peninsula allowed for the spread of Islam from the ninth century onwards into the regions now known as Somalia and Eritrea. During the seventeenth and eighteenth centuries, the Dutch settlers at Table Bay on the Cape of Good Hope imported Muslim Slaves from Malaysia, Indonesia, and Bengal, creating the first Muslim communities in southern Africa.

In all of the above regions, the spread of Islam did more than simply foster religious change. Islam often introduced literacy in the form of Arabic and *ajami* (the use of the Arabic alphabet to write local languages), a wider sense of history, and an identity that stretched far beyond ethnicity or even the local or regional government. African Muslims were part of a wider Islamic civilization, and saw themselves as such. In most parts of Islamic Africa, Sufi brotherhoods (*turuq*, sing. *tariqa*), groups which stress the ability to achieve mystical union with God in this world, not only helped spread Islam, but also linked members into communities that fostered religious as well as economic and political unity under the guidance of a spiritual leader known as a *shaykh*.

Thus, at the advent of colonial conquest in the 1880s, significant areas of Africa were predominantly Muslim or included substantial Islamic minorities. In West Africa, powerful Islamic states such as the Sokoto Caliphate (founded by Usman dan Fodio), the Tukulor Empire (founded by Al-Hajj Umar Tall), and the Mandinka Empire (founded by Samori) controlled substantial geographical areas and populations numbering in the millions. Further, Sufi brotherhoods such as the Qadiriyya, Tijaniyya, and Sanusiyya had large numbers of adherents who shared common bonds through their *tariqa*. Also influential were the Mahdists, who had formed a large state centered at the confluence of the Blue and White Niles in the early 1880s. Along the East Coast of Africa, the sultan of Zanzibar oversaw a loose coalition of island and coastal trading centers stretching from modern Somalia south to Kilwa, off the coast of modern Tanzania, each with small but wealthy populations of Swahili and Arab Muslims. Thus, to conquer Africa, European powers also had to conquer a number of Islamic states.

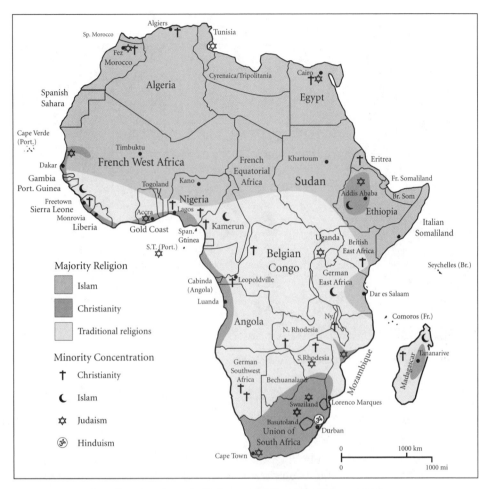

Figure 10-1. Religions in Colonial Africa, 1914

Islamic and European Perspectives of the "Other"

Given the long history of distrust and hostility between Christian Europe and the Islamic world (typified by the Crusades, the reconquest of Spain, and the long period of conflict between European powers and the Ottoman Empire) it is not surprising that African Muslims and the potential European colonizers of Africa looked upon one another with disfavor during the late 1800s. Muslims in sub-Saharan Africa were aware of the French conquest of Algeria and the French and British efforts to dominate Egypt during the nineteenth century. For hundreds of years, Muslims in such regions as the Senegambia had tolerated European traders as long as they focused on trade and remained in coastal enclaves such as St. Louis at the mouth of the Senegal River. For the Muslims of West Africa, Europeans were a tolerated minority who carried out their business only through the sufferance of local leaders. When it became apparent in the late 1800s and early 1900s that European states would use force to expand their influence beyond the

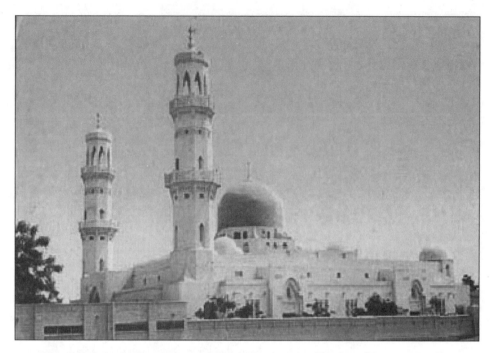

Figure 10-2. An imposing modern mosque in the city of Kano, Nigeria

coast, it should not be surprising that most African Muslims (in addition to non-Muslim Africans) responded in kind. Witness two letters, both written by Islamic leaders threatened by European invasion. Al-Hajj Umar Tall wrote to the Muslim Community of St. Louis (Senegal) in 1854 as follows:

> Now we will take action by the power of God. We will not waver until we receive a plea of peace and submission from your tyrant [French Governor Faidherbe], for our Master said: "Wage war on those who do not believe in God nor in the last judgement, who do not conform to the prohibitions of God and his Prophet and who, having received revelation, do not follow true religion, until they pay tribute, for they are in the minority position."[1]

Sultan ʿAbd al-Rahman of the Sokoto Caliphate wrote to Governor Lugard in 1902 (in response to a letter from Frederick Lugard demanding surrender):

> From us to you. I do not consent that any one from you should ever dwell with us. I will never agree with you. I will have nothing ever to do with you. Between you and us there are no dealings except those between Musulmans and Unbelievers, War, as God almighty has enjoined on us. There is no power or strength save in God on high. This with salutations.[2]

There can be little reason for surprise that the Islamic states of West Africa responded to colonial conquest with force of arms. These states had themselves been

1. Quoted by Christopher Harrison, *France and Islam in West Africa, 1860–1960* (Cambridge: Cambridge University Press, 1988), 10.
2. Quoted by R.A. Adeleye, *Power and Diplomacy in Northern Nigeria, 1804–1906: The Sokoto Caliphate and Its Enemies* (Ibadan: Humanities Press, 1971), 343.

established through conquest during the early part of the nineteenth century. Some, such as Umar Tall and Samori's empires, were still expanding at the time of European conquest. Further, this expansion had resulted in a considerable increase in the degree of religious fervor in the region. Islamic scholarship and devotion had experienced considerable expansion and revival. Thus, the meeting of European and African Islamic states was a meeting of expanding empires. Further, the competing empires shared a similar goal, to expand their respective civilizations to peoples they considered to be "uncivilized." The Muslim leaders of West Africa had little intention of allowing Europeans to threaten their expansion of the *dar-al-Islam* (the abode of peace). Even the Swahili states, which could draw upon only a small population and which were much more concerned with trade than with expanding the influence of Islam, sought to resist European conquest.

The European invaders of Africa also had a religious and historical framework through which to view African Muslims. Europeans had been aware of the presence of Islam in sub-Saharan Africa since the pilgrimage of Mansa Musa in 1324. In the nineteenth century, Europeans were conscious of the decline of the Ottoman Empire and of the costly European victories over Islamic regions in North Africa. For example, in the early 1800s, the Sufi *shaykh* 'Abd al-Qadir led such a spirited resistance in Algeria that it took the French over forty years to pacify the region, and even then only through use of scorched-earth tactics and at the cost of tens of thousands of French and Algerian lives.

Many Europeans, particularly missionaries, viewed the conflict with African Muslims as an extension of this wider competition for converts between Christian Europe and the world of Islam. Indeed, the missionary descriptions (such as those of David Livingstone) of Muslim participation in the slave trade in Africa were powerful tools used by European governments to justify the colonial conquest of Africa. This is ironic if one considers that European participation in the Atlantic slave trade had lasted hundreds of years and had gradually drawn to a close only in the nineteenth century. Nonetheless, the presence and expansion of African Islam could be used as one more reason to invade Africa for the good of the Africans. Even colonizers who were not particularly religious were aware that Islamic states stood as a barrier to rapid colonization. For the French, who were particularly concerned with spreading French culture to Africa, the strength and resiliency of Islamic culture was a particular barrier to their colonial goal of *assimilation*. Similarly, the strong strain of anticlericalism that made the French Republic hostile even to Christian religious leaders in the late nineteenth century also made the French colonial authorities suspicious of Islamic authorities. Other colonial powers, particularly the British and the Germans, were to become more positively inclined to Islam once their conquests were complete. As we shall see, the motives of different colonial powers and their attitude toward Islam greatly influenced the forms and functions of their colonial administrations.

Varieties of Islamic Resistance to Colonialism

As did other parts of Africa, Islamic regions of the continent fought to resist the imposition of European colonialism. Islamic states drew upon clear systems of hierarchy and political centralization, which helped them to mobilize their popu-

lations and organize strategies with which to wage long-term campaigns against European forces. Some kept large standing armies even in times of peace. The wealth of some states allowed them to purchase modern weapons that helped off-set the technological advantage of the European invaders. This section examines the tactics and relative success of four different Islamic states that fought against colonial rule. These are the Mahdists in the Sudan, Sayyid Mohammad 'Abd Allah Hassan in the Horn of Africa, Samori in the West African savanna and for-est region south of the Niger River, and the Sokoto Caliphate in the region of modern northern Nigeria, Niger, and northwestern Cameroon.

One of the most significant clashes between Europeans and African Muslims actually straddled the era of the Scramble. In 1881, Muslims in the northern Sudan were displeased with the rule of the Anglo-Egyptian condominium (as the British government of Egypt was euphemistically called). Rates of taxation were high, the British threatened to end the slave trade in the region, and the Egyptian officials in the employ of the British were often Christians. Even those who were Muslim were seen as corrupt and lax in their devotion. When a man named Muhammad Ahmed declared himself to be the Mahdi, the savior who, in popular Islamic belief, is expected to herald an era of religious purity and peace that will precede the final judgment, Muslims in the region flocked to his call for a "Jihad of the Sword." Having both pragmatic and religious reasons to throw off the en-croachment of the European "infidels" and their Egyptian and Turkish adminis-trators, the newly created army was able to defeat the better-equipped troops sent against them by the Anglo-Egyptian government. The greatest success of the Mahdists was the siege of Khartoum in 1885. Located at the confluence of the Blue and White Niles, Khartoum was the southern headquarters of the Anglo-Egyptian government, and was garrisoned by troops led by "Chinese" Gordon, a British general who had earned his nickname and heroic reputation as a result of his successful leadership of British forces in China. After cutting Khartoum off from supplies and reinforcement, the Mahdists starved the British and Egyptian garrison into submission, eventually breaking into the city despite the defenders' superior armament. The defeat and death of Gordon and the British troops in Khartoum was a major blow to British prestige and confidence and a substantial victory for African resistance to colonialism.

Despite the death of Muhammad Ahmad shortly after the victory at Khar-toum, the Mahdist state expanded and prospered for over a decade, largely due to the effective administration of Ahmad's son, Abdullahi. In 1898, a large British-Egyptian force under the leadership of Lord Kitchener was sent to seize Khartoum and avenge Gordon's death. Armed with the recently invented Maxim gun and new, more mobile, artillery, and supplied by a rail line to the north, Kitchener's army was able to defeat a much larger Mahdist force with minimal loss of life, while inflicting over 20,000 casualties on the Mahdists. The Mahdist state was destroyed. As we shall see, however, Mahdism was to remain a central factor in shaping the nature of colonial rule in Islamic Africa.

Another significant episode of Islamic resistance to colonialism was the conflict between Sayyid Muhammad 'Abd Allah Hassan and the British and Italian invaders of the Horn of Africa, in the northern region of modern Somalia. Dubbed the "Mad Mullah" by the British, Sayyid Muhammad was deeply influenced by Wahabi thought during a pilgrimage to Mecca in the mid-1890s. Wahabi Islam, which orig-inated in the Arabian peninsula during the eighteenth century, called for a very con-

servative approach to Islam, one that rejected Western political thought and stressed the completeness of the *Qur'an* as a source for all human needs. Sayyid Muhammad began calling for a "Jihad of the Sword" against the British and Italians in 1897. In 1899 he and his followers took up arms against the British and then the Italians. Taking advantage of their knowledge of local geography and their mobility, Sayyid's forces were able to harass both the British and the Italians for half a decade. A treaty called the Illig Convention granted Sayyid and his followers local autonomy under Italian protection in 1905, though the peace was short-lived. Abandoning the idea of rooting Sayyid out of his rural strongholds, the British shifted to a defensive strategy. For over a decade, Sayyid and his followers launched periodic attacks on European bases from the safety of their fortress at Taleh. After World War I, the British launched a major offensive against Sayyid, this time supported by aircraft. Unable to effectively counter such new technology, Sayyid and his followers retreated deep into the Ogaden desert, where Sayyid died in 1920. Though eventually defeated, Sayyid had blocked colonial encroachment into the area for over two decades, and had helped spread Wahabi thought in the Horn of Africa.

It may well be argued that in West Africa, the most successful resistance to colonial encroachment was that of the Mandinka Empire under the leadership of Samori Toure. Though he came from a family of non-Muslim traders, Samori became a convert to Islam in the 1860s or 1870s. First organizing a private army to protect his family's trade interests, Samori expanded his power in the 1870s into the Bure goldfields and the Niger River valley. He expanded southward and incorporated large numbers of non-Muslims into his empire. To promote pride and identity among his followers, Samori encouraged comparisons of the new empire to that of ancient Mali. Like the *mansas* (kings) of ancient Mali, Samori was forced to manage a populace that was split along religious lines between Muslims and pagans. In 1888, Samori attempted to convert the entire population of the empire to Islam. Popular discontent and revolts forced him to reconsider, but such a move shows Samori's support for Islam. There can be little doubt that he helped spread Islam in the region. The Mandinka Empire's links to the south (particularly Sierra Leone) helped Samori gain access to modern firearms with which to arm some of his army of 30,000. This, combined with his use of local ironsmiths to produce copies of modern weapons and cartridges, allowed Samori to wage an effective campaign against the French from 1881 to 1899. Samori and his core of followers did not surrender until the French starved them into submission in the highlands of Liberia in 1898. Samori was exiled to Gabon, where he died in 1900.

At the time of the Scramble, the Sokoto Caliphate was probably the largest African state. With a population of over 10 million, and centered on the fertile savanna region of modern northern Nigeria, the Sokoto Caliphate had been established via the Jihad of Usman dan Fodio, a local leader of the Qadiriyya Sufi Brotherhood, from 1804 to 1812. The Jihads had been waged largely by the Fulani to overthrow what they saw as the corrupt Islam of the region's Hausa rulers, the *Habe*. In the late 1800s, the Sokoto Caliphate was comprised of a loose confederation of Emirates, each headed by an Emir who owed ultimate fealty to the Sultan of Sokoto, himself a descendant of Usman dan Fodio. Beginning in 1885, the British tasked the Royal Niger Company, a private corporation, with the job of invading and defeating the region that would become modern Nigeria. The military success of the Royal Niger Company was slow, though, and by the end of the century they had only reached the southern fringes of the Sokoto Caliphate.

Fearful that the French would reach the caliphate first, the British sent General F.D. Lugard to command a new army, the West African Frontier Force, to defeat the Sokoto Caliphate. Able to attack the loosely organized emirates one at a time, Lugard succeeded in reaching the capital city of Sokoto by 1903. Defeated in battle by the superior arms of the WAFF, the sultan of Sokoto, Attihiru, announced a *hijra*, a retreat from the political rule of the non-believer. Comparing his actions to the flight of Muhammad and his followers from Mecca to Medina in 622, Attihiru called upon the region's faithful to accompany him in a retreat to Mecca. Thousands answered his call. The British, however, were unwilling to let Attihiru escape, and pursued him and his followers several hundred miles. At the battle of Burmi, the sultan and many of his followers were killed in a final stand against the British machine guns and artillery.

Not all the Muslims of Sokoto opted to follow Attihiru on his flight to Mecca. Attihiru's Waziri (Chief Advisor), Bukhari, opted to remain in Sokoto and accept the rule of the British. In so doing, he was invoking what Muslims call *Takiya*, that when faced with the threat of death for their beliefs, Muslims have the right to "speak with the tongue and not the heart." Thus, the Waziri and those who stayed behind planned to accept British rule only as a means of preserving their lives and religion. They were to be most successful in this undertaking.

Islam and the Colonial State

By the early 1900's, European colonial powers had conquered most of the African continent, though some areas, such as the vast interior reaches of Mauritania, would take decades more to be subdued. With the era of military expansion largely at an end, colonial powers were faced with the new challenge of how to create effective and lasting colonial administrations. For most colonial powers, a key question was how to deal with the large populations of Islamic Africans within the new colonial boundaries. How each colonial power dealt with their new Islamic subjects provides us with a valuable insight into the differences between colonial administrations, and also the underlying social, political, economic and historical assumptions and motivations that influenced the nature of colonial rule.

Some colonial powers had very few Muslims living within their new African colonies. Portuguese Angola was almost completely free of Muslims, and Guinea-Bissau and Mozambique had very small populations of Islamic traders. The Congo Free State similarly had a population that was predominantly composed of non-Muslims. Nonetheless, the willingness of the Belgian King Leopold to name the notorious Islamic slave trader Tipu Tip as "Governor of the Eastern Region" of the Free State shows just to what degree the Belgian government was influenced by the desire for economic gain rather than by any moralizing about stopping slavery in Africa.

More significant were the Islamic populations to be found in the regions under the control of the Germans, British, and French. The colony of German East Africa (Tanganyika) included a small but politically and economically influential population of Swahili and Arab Muslims concentrated in the coastal re-

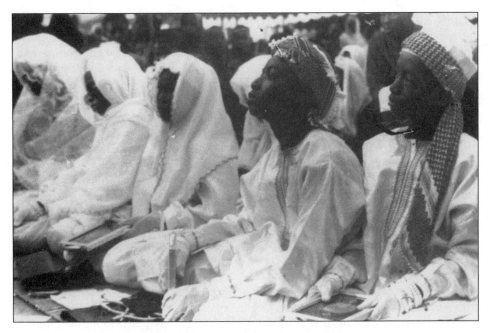

Figure 10-3. Muslims at worship

gion. Germany's West African colonies of Togo and Cameroon also included large populations of Muslims. Kenya, like German East Africa, included Swahili and Arab populations along the coast. British Somaliland was predominantly Muslim and, as we have seen, under Sayyid Muhammad's leadership, resisted British rule until 1920. South Africa had small numbers of Muslims in the Cape region. Elsewhere, the Sudan, Egypt, Gambia and Nigeria were predominantly Muslim. Both Ghana and Sierra Leone held substantial minorities of Muslims. For the French, almost all of French West Africa was either predominantly Muslim or had large Muslim minorities. French Equatorial Africa, however, included only a few scattered Muslim communities.

Initially, the Germans were not well disposed toward the religion of Islam. Harsh rule by German charter companies in East Africa helped spawn a significant Swahili/Arab revolt in the late 1880s. The revolt was later joined by non-Muslim groups who lived farther inland. In the end, the German government was forced to intervene in order to put down the rebellion. For this reason, in the early years of German colonial rule in Africa, there was considerable distrust of the Muslim population as a potential source of disaffection and armed revolt. The colonial administration in German East Africa even went so far as to subsidize pig production, in the hope that if the population developed a taste for pork, then they would be less inclined to convert to Islam, since the Islamic religion considers pork to be unclean and unfit for human consumption.[3] By the end of the first decade of the new century, however, the Germans had changed their attitude toward Islam. Improved relations and mutual defense treaties with the Ottoman

3. August H. Nimtz Jr., *Islam and Politics in East Africa: The Sufi Order in Tanzania* (Minneapolis: University of Minnesota Press, 1980), 13.

Empire led the Germans to believe that Muslims could perhaps be viewed as allies rather than potential enemies. In German East Africa, the founding of special schools to train Muslims as civil servants and clerks suggests that the colonial administration planned to work more closely with the region's Islamic populations, particularly the educated classes. The German defeat at the end of World War I, and the loss of their African colonies, would signal an end to this growing relationship between German colonialism and African Islam.

Like the Germans, the French began the Scramble for Africa with a considerable distrust of Muslims. In no small part, this was a result of conflicts with African Muslims earlier in the nineteenth century. French forces had been driven from Egypt by an Ottoman army under the command of Mohammad Ali in 1801. Also, following the French invasion of Algeria in the 1830s, Islamic forces, initially under the leadership of Abd al Qadir, continued to control the mountainous and desert regions of the interior for over forty years before the French could consider the Muslim Algerians to be "pacified." Indeed, the long and brutal conflict to subdue Algeria was a central factor in shaping French attitudes toward Islam. In particular, Sufi brotherhoods, which had provided much of the structure for resistance in the region, were considered by the French to be a source of potential resistance to French colonial rule. The long-running conflict between French colonizers and Algerian Muslims, however, led to the colonial government's sponsorship of considerable research into Islam in Africa. More than any other colonial power, the French would be influenced by an academic perspective on Islam and would produce a considerable body of research that would influence not only their own colonial administrators but also the British.

The era of the Scramble for Africa did little to improve French relations with African Islam. In West Africa, Emir Umar Tall proved a considerable impediment to the initial expansion of the French inland from the coast of Senegambia. The fact that Umar was a leader of the Tijaniyya helped undermine the brotherhood's member's reputation as "good Muslims," a reputation that had been fostered by a reasonably cooperative relationship between the French and the Tijaniyya in Algeria. We have already discussed the French conflict with Samori. Thus, staunch Islamic resistance to colonialism served to reinforce the French perspective that Muslims made difficult colonial subjects.

The nature of French colonialism and administration also did little to foster positive relations between the new colonial rulers and African Muslims. Under Louis Faidherbe, the conqueror and governor of French West Africa, the French were guided by a goal of *assimilation*. According to the *mission civilitrice*, colonized Africans (Muslim or otherwise) were to learn to speak French and adopt French styles of dress, culinary habits, philosophical perspectives, and so on. The more "French" someone acted, the more civilized he or she was considered to have become. Further, the more an individual assimilated, the more rights he or she would acquire. Ideally, to act as a French person was to become an equal member of an expanding France. Indeed, a few thousand Africans did receive full rights as French citizens. In reality, however, it was very difficult for Africans to achieve such a status. Also, many Africans did not see the acceptance of French culture as desirable. This was particularly true of African Muslims. Islam is itself seen as a holistic culture, and many elements of French culture were seen by Muslims as non-Islamic. In particular, the effort to expand literacy in French and to make it the only recognized language of governance and education ran counter to

the Islamic belief that Arabic was the language of God. Similarly, the French administration's insistence on the supremacy of French law ran counter to Islamic demands for maintenance of the *Shari'a*, the Islamic code of law based upon the Qur'an and the actions of the Prophet Muhammad.

French law and language were part and parcel of the administrative system of direct rule. Rather than utilizing local leaders and forms of governance, the French hoped to institute a system of rule in which French colonial officers were in charge of all levels and aspects of administration. Such a system left little room for the continued authority of local rulers. It is hardly surprising, then, that local Muslim leaders were antagonistic toward the expansion of a French colonial state that would not accept any alternative systems of administration or leadership.

Another important influence on French administration was the strong anticlerical bias that permeated almost all levels of French government. This bias was rooted in internal French conflicts between secular leaders and the Catholic Church, and many French administrators considered religious leaders to be parasites who lived only to mislead the uneducated and gullible masses. Muslim leaders, especially the leaders of the Sufi brotherhoods, were seen as no exception. Interestingly, the state's hostility toward Christian leaders did not prevent the French from allowing missionaries to operate in Africa. In part this was because spreading Christianity was an important means by which the colonial conquest of Africa had been justified to the French populace. Further, church-funded mission schools could provide "civilizing" education to African populations at little cost to colonial governments. Not surprisingly, African Muslims were all the more disinclined to accept Western-style education when it came only at the hands of Christian missionaries. Indeed, the relative willingness of non-Muslim Africans to accept missionary education was to become a factor in the creation of a cultural rift between Muslim and non-Muslim Africans in the colonial era. Further, the willingness of non-Muslims in some regions to convert to Christianity and gain access to both Western education and colonial jobs helped reduce the previous economic and political dominance of Muslim populations, often leading to resentment and conflict between the groups.

Despite the realities of French colonialism discussed above, the French did not seek to immediately destroy Islam in Africa. Even if many French administrators would have preferred such an outcome, it was far beyond French power. Overt hostility toward Islamic practices (such as daily prayers or the fast of Ramadan) or toward Muslims themselves would certainly have resulted in widespread revolt. Rather, the French colonizers hoped to slowly draw African Muslims away from their religion to a more secular and materialistic perspective on the world. Earthly pleasures and reason, rather than force, would slowly defeat Islam. Further, despite the ideal of direct rule, the French colonial administration was short on both manpower and local knowledge. This meant that however disinclined toward Islamic leaders the French might have been initially, they soon learned that such leaders, if provided with certain incentives, could be very useful to the colonial enterprise. For example, the French in Senegal originally viewed Ahmadu Bamba, the quiet and scholarly leader of the Mouride Brotherhood, with fear and suspicion. Despite Bamba's peaceful nature, he was repeatedly arrested and exiled from the region, though he never used his considerable religious influence to call for anticolonial activities. By the end of World War I, however, the French had come to see the

Mourides as a powerful force for expanding the economic production of the region, particularly through the brotherhood's support for the cultivation of groundnuts (peanuts). Despite their religious and cultural differences, the French and the Mourides found common ground in fostering economic growth in the region.

Indeed, during the postwar period, the French began to shift away from their policy of *assimilation* toward one of *association*. Thus, if African Islam could help support the most important aspects of French colonial rule, maintaining the peace and fostering the production of agricultural products, then it was at least to be tolerated. As we shall see, the French would still fear the specter of widespread Islamic rebellion, but the era of overt fear of Islam was largely at an end by the end of World War I. In no small part, this change in relations not only reflected a less antagonistic posture on the part of the French, but also reflected the fact that in the postwar era a new generation of Islamic leaders were coming to power in French West Africa. These individuals, such as Seydou Nourou Tall (the grandson of Umar Tall), who served in the French Army in World War I, and Shaykh Ibrahim Niasse of the Tijaniyya, tended to be more vocal in their support for the French and more willing to take a "let bygones be bygones" attitude toward the French conquest of the region.

Perhaps more than any other colonial power, the British appeared to be positively inclined toward Islam. Despite their brutal conflicts with Islamic states such as the Mahdist state, the Sokoto Caliphate, and the state of Sayyid Muhammad, the British seemed eager to "mend fences" with African Muslims once the period of conquest was complete. In a speech delivered to the leaders of the Sokoto Caliphate (who had not fled with Attihiru), General Lugard declared that the new British government would respect the religion of Islam. In particular, he stressed that the *shari'a* would be left intact (except in capital cases and in matters of sedition) and that there would be no interference with prayer or with mosques. Lugard's *laissez-faire* policy in religious matters would soon become a model for most of British Africa. As we shall see, these claims to religious noninterference were sometimes violated by British colonial governments. Nonetheless, the fact that they were accepted policy meant that the British had to attempt at least to appear impartial in religious matters.

What accounts for the British "benevolence" toward Islam? In no small part, this approach was necessitated by the British system of indirect rule, which sought to use local administrative structures and legal systems as the basic building blocks of British colonial rule. Because most African political systems, and Islamic political systems in particular, are legitimized by religious authority, the British could not make the system of indirect rule work in an atmosphere that was hostile to local religious beliefs. To attack local religion was to undermine the very systems of authority upon which indirect rule was to be built. Such a reality created a difficult situation for the British, because the introduction of Christianity to a region tended to disrupt local authority structures. As such, the British colonial government often found themselves restricting the access of Christian missionaries to Islamic and pagan regions, an activity that would surprise those who associate colonialism with the spread of Christianity in Africa.[4] In particular, areas of majority Islamic

4. See, for example, Andrew Barnes, "Evangelization Where It Is Not Wanted: Colonial Administrators and Missionaries in Northern Nigeria during the First Third of the Twentieth Century," *Journal of Religion in Africa* 25, 4 (1995): 412–441.

populations were protected from Christian missions, in no small part because Islamic leaders reminded the British of their promise not to interfere with Islam.

British claims to noninterference with local religion and culture and the preservation of local systems of administration also helped to legitimize their imposition of colonial rule. Newly subjected Muslim populations tended to find the burden of British colonial rule relatively light, at least as compared to that of the French, Belgians, or Portuguese. Witness the different names given to French and British rule in the former Sokoto Caliphate. In the area of the caliphate controlled by the British, the local Hausa population called the colonial rule *Mulkin Sauki*, or easy government. In the northern region controlled by the French (modern Niger), it was called *Mulikin Zafi*, or painful government.[5]

It would be a mistake, however, to think that the British colonial government's attitude toward Islam was one of real benevolence. The British attitude was in part a pragmatic approach that sought to make colonial rule cheap and to reduce the likelihood of revolt. Interestingly, the British tolerance of Islam was a reflection of the low esteem in which many British colonial rulers, particularly Lugard, held both the religion of Islam and Africans. Witness the following quote from Lugard's famous work, *The Dual Mandate in Tropical Africa* (1922):

> [Islam] is a religion incapable of the highest development, but its limitations clearly suit the limitations of the people. It has undeniably had a civilizing effect, abolishing the gross forms of pagan superstition and barbarous practices, and adding to the dignity, self-respect and self-control of its adherents. Its general effect has been to encourage abstinence from intoxicants, a higher standard of life and decency, a better social organization and tribal cohesion, with a well-defined code of justice.[6]

Thus, in the opinion of Lugard and many other British colonial officers, Islam suited Africans precisely because it was a less sophisticated religion than Christianity, which was seen as too complex for Africans to grasp. Reflecting the overt racism and social Darwinism of the times, British colonial policy saw Islam as the best religion to which Africans could aspire. Ironically, the tendency of the British to see Africans as genetically rather than culturally inferior (unlike the French), resulted in a policy which was less hostile to African culture, and generally benevolent toward African Islam in particular.

The British perspective on Islam, however, was not so simplistic as to assume that all Muslims made good colonial subjects. The British soon developed characterizations of different Islamic groups as "good" or as "bad" Muslims. In Nigeria in particular, the British considered members of the Qadiriyya Sufi Brotherhood to be good Muslims, those who could be counted on to support colonial rule and to resist calls for revolt. Thus, the Qadiriyya, which was closely allied with the region's ruling class, was given a free hand and access to state largesse. Conversely, members of the Tijaniyya Brotherhood and exponents of Mahdism were seen as threatening, since the British thought that they had dangerous "populist" characteristics and that they could turn fanatical and violent at any time.

5. William Miles, *Hausaland Divided: Colonialism and Independence in Nigeria and Niger* (Cornell, NY: Cornell University Press, 1994).

6. F.D. Lugard, *The Dual Mandate in British Tropical Africa* (London: William Blackwood and Sons, 1922), 78.

Despite their claims of noninterference in religious matters, the British were quick to use various means to limit the influence of members of these groups, means ranging from harassment to incarceration and exile. The British even went so far as to take steps to routinize and streamline the *hajj* to Mecca to help insure that generally benevolent Muslims did not come into contact with Mahdist thought while crossing the Sudan. It is very likely that British intrusion into the inter-Islamic politics of the region served to exacerbate divisions and conflicts within the Muslim population.

Islam and Anticolonial Revolts

Despite the general trend toward improved relations between African Muslims and colonial rulers during the colonial era, occasional Islamic revolts were a feature of the period. These revolts are evidence that despite the efforts of colonial powers to either displace or appease African Muslims, some members of the Muslim population continued to resent the imposition of European hegemony. Perhaps even more important than the fact that these revolts occurred, however, is the powerful impact of the continuing fear of such revolts on colonial governments, and the impact these fears had on colonial policy and perspectives toward Islam. An examination of these revolts tells us a great deal about how Muslims and Europeans continued to interact as the colonial era developed and the power of the colonial state grew.

Islamic revolts, large and small, were a common occurrence in colonial Africa. Perhaps the largest was that of Satiru, in northern Nigeria in 1906. The revolt was instigated by a Muslim refugee from Niger, Malam Shuaibu, and a local man named Malam Isa (whose father had died in prison after being jailed by the British in 1904). Beginning in the town of Satiru, the two called on the local population to overthrow the rule of the British and those Muslims who had cooperated with them. The popular response was huge, and the West African Frontier Force was dispatched to put down the growing rebellion. Ambushed in a small valley where the advantage of their rifles and machine guns was minimal, the colonial troops were wiped out. Amazingly, this left the colonial government of northern Nigeria with almost no military forces with which to defend themselves. It was a critical moment for British rule in Africa, since support by the ruling class for the rebels would have necessitated reconquest of the whole of northern Nigeria. Yet, it was the forces of the Sokoto Caliphate that helped isolate the rebels until British reinforcements could be transported from southern Nigeria. By 1906, it is clear that the ruling class of the region had decided that cooperation with the British was a safer path than resistance.

The Satiru revolt had important repercussions throughout the region. It helped convince the British that the Qadiriyya ruling class of the caliphate could be trusted, and that "popular" Islam and Mahdism were dangerous threats to colonial rule. Further, the revolt and the narrowly avoided disaster instilled fears of future Islamic rebellions. The French executed the emir of Zinder shortly afterwards on suspicion that he had Mahdist sympathies. The Satiru revolt, combined with other rebellions such as those at Dagana and Mossi (1908), Goumba (1911), and Darfur (1921–1922) convinced all the colonial powers of the importance of

establishing security networks and undertaking careful research in order to better understand (and control) the Islamic populations within their colonies.

Of particular concern was the call of the Ottoman Empire for all Muslims in the colonial world to rise up in support of the Ottoman-German alliance in World War I. The British and French colonial administrations took the threat of a widespread revolt very seriously. Indeed, the combined threat of Ottoman revival, German colonial expansion, and Islamic upheaval represented a sort of "sum of all fears" for the British and French at the time. Both took active steps to limit the possible introduction of Ottoman sympathizers or propaganda during the war. Further, in self-defense, the British and French launched their own propaganda campaigns to convince African Muslim populations of their benevolence toward Islam. The British issued statements that the Ottomans had been duped into siding with the "secular enemy of Islam" (the Germans). Further, both the British and French stressed their goodwill toward Islam. Indeed, the British went so far in one publication as to refer to themselves as "the world's greatest Muhammadan Power" and King George as "the leader of the faithful" (a title reserved for the caliph, the successor to Muhammad). In general, the fears of the British and French appear to have been unfounded, but their response to the Ottoman call for revolt is indicative of the general level of their fear of religious-inspired upheavals. Notably, French and British gains in the Middle East after the war, at the expense of the Ottoman Empire, expanded these colonial power's interest in and influence over Islam.

The Expansion of Islam, 1889–1935

However unlikely it may seem, the period that followed the imposition of colonial rule saw a rapid increase in the number of African Muslims and also the expansion of the geographical area where Muslims were found. Islam expanded in different regions for different reasons. In all areas, Islam benefited from the increased freedom of mobility brought about by the relative peace and the improvements in transportation fostered by the imposition of colonialism. Railroads, in particular, provided a means for Islam to spread with relative ease. Enhanced trade links between the African coast and interior encouraged the spread of Islam toward the coast (in West Africa) and into the interior (in East Africa). Also, improved international linkages encouraged the introduction of new Islamic populations into Africa. The British introduced large numbers of Indian Muslims into southern and eastern Africa. Also, the Ahmadiyya Sufi Brotherhood, which originated in India, undertook considerable missionary efforts in Africa, particularly in African coastal cities, efforts facilitated by colonial linkages between British India and British Africa. Each of these avenues of expansion was a continuation of the ancient tendency of Islam to follow and grow along trade routes. The expansion of Swahili culture and Islam into the interior of East Africa during the period is a case in point.

Other factors also helped encourage the spread of Islam. In French Africa, conversion to Islam often served as a means of resistance to the French policy of *assimilation*. Because Islam was not seen as foreign to Africa, and because Islamic states had so forcefully resisted colonial rule, conversion could be seen as a contin-

Figure 10-4. Muslims gathering for prayer

ued form of rejection of colonial oppression and a growing expression of African identity. Conversely, under the British, conversion to Islam could be a means by which an individual or group could gain access to state support and power, if one joined the Qadiriyya. If one joined the Tijaniyya or the Mahdists, Islam could serve the same purpose of resistance as it did under the French. Everywhere in Africa, the economic, social, and political advantages of belonging to a Sufi brotherhood were powerful incentives in and of their own right during the colonial period, and were powerful forces which helped to expand the realm of African Islam.

Conclusions

Clearly, the era from 1885 to 1939 was a time of considerable change for African Islam. The Scramble for Africa came at a time when African Islam was already expanding considerably as an important cultural, economic, and political force on the continent. The clash between European and Islamic states in Africa was long and bloody. Though it was militarily defeated, and it suffered the attempts of colonial powers to control it, African Islam survived, both by accommodating itself to colonial rule and by continuing a legacy of resistance. Indeed, it may be considered that African Islam "stooped to conquer" European colonialism. By taking advantage both of its status as an "alternative" civilization and of the expanded networks of trade and communication offered by colonial states, African Islam used colonialism to embark upon an era of rapid growth in the continent and to improve linkages with the wider Islamic world.

Review Questions

1. What was the nature of African Islam at the time of the colonial conquest? Where was Islam most common in Africa? How had it gotten there? What were the key economic, political, and cultural components of Islam in Africa, and how did these vary from region to region?
2. How did African Muslims and European colonizers view one another at the beginning of the colonial conquest? What were the historical and contemporary elements each used to define the other? Were there similarities in how each defined the "other"?
3. What were the different varieties of Islamic resistance to colonialism in Africa, both during and after the initial "conquest"? What factors led to the varying degrees of "success" of the efforts of those who resisted?
4. Once the colonial conquest of Islamic Africa was complete, how did different colonial regimes seek to deal with the reality of Islamic identity among many of their new African subjects? What might account for the different approaches of the various colonial powers?
5. Why did the imposition of European colonial rule not lead to the demise of Islam in Africa? What factors allowed African Islam actually to expand during the early colonial era? What does this tell us about the reality of colonialism in Africa?

Additional Reading

Harrison, Christopher. *France and Islam in West Africa, 1860–1960*. Cambridge: Cambridge University Press, 1988.

Hiskett, Mervyn. *The Course of Islam in Africa*. Edinburgh: Edinburgh University Press, 1994.

Levtzion, Nehemia, and Randall L. Pouwels (eds.). *The History of Islam in Africa*. Columbus: Ohio University Center for International Studies, 2000.

Robinson, David. *Paths of Accommodation: Muslim Societies and French Colonial Authorities in Senegal and Mauritania, 1880–1920*. Columbus: Ohio University Press, 2000.

Sanneh, Lamin. *The Crown and the Turban: Muslims and West African Pluralism*. Boulder, CO: Westview Press, 1997.

Chapter 11

Urban Culture and Society

Steven J. Salm

This chapter looks at urban culture and society during the early and mid-colonial periods. Many new cities arose and grew rapidly during this era. Most of them were centered around the economic and administrative needs of the colonial powers. Social stratification, changing technology, and a growing population demanded new forms of social organization, resulting in the development of unique genres of popular culture. Every day life reflected continuity with the past, but increasing availability of outside cultural stimuli meant a much quicker movement towards new cultural inventions, a process that served as an adaptive mechanism for urban residents. This chapter addresses social and cultural creativity in urban music, dance, theater, cinema, literature, and sports.

* * *

African societies underwent rapid social and cultural change during the colonial era, a period of culture clash resulting from the impact of complex political, economic, and social forces. The greatest degree of change was seen in the growing colonial administrative and economic centers, and in the expanding mining areas in southern Africa, where Africans of all classes created new methods of social and cultural adaptation. Cities and labor camps acted as transfer points for many different cultural influences and became forums for the development of new ideas and traditions.

This chapter presents a few of the major innovations in African popular culture during the colonial era. They illustrate one way in which Africans responded to colonial rule and how they employed adaptive mechanisms to cope with new regulations and environments. The colonial condition acted as a stimulus for the creation of new forms of popular culture, but its development also remained beyond the reaches of colonial control. The "popular" in popular culture must be seen as connected to the identity and inter-relations of "the people." The production and consumption of popular culture is thus inherently linked to the people, granting it an agency that allowed it to exist both within and outside of colonial attempts to control time and space. A study of music, dance, and theater provides "an important means of understanding the experience, attitudes, and reactions of the mass of otherwise inarticulate people, those who vitally affect the course of urban development but who do not read or write about it."[1] A study of cultural change gives us insight to types and motives of migrations, social organization,

1. David Coplan, *In Township Tonight!: South Africa's Black City Music and Theatre* (New York: Longman, 1985), 2.

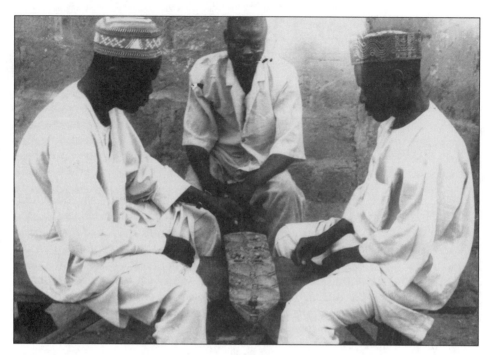

Figure 11-1. African leisure — men playing the popular Ayo game

and adaptation in the face of colonial subjugation because there is no better voice of the community than culture.

Within the realm of these new forms of popular culture there was a strong continuity with the past, but there was also a progressive look toward the future; it was both a reflection of the colonial condition and a symbol of resistance to it. New creations did not replace old, but blended with them to produce hybrid styles of music, dance and drama that better fit the conditions of the new environment. While the literature abounds with stories of the destruction of African social traditions and customs during their brief encounter with European colonizing forces, it is important to note the products of the resistance to those forces by Africans. The types of popular culture discussed here reveal tensions between the colonizer and the colonized, the older and younger generations, and the elite and masses of society. Since the main events and personalities of the colonial era are discussed in other chapters, this essay will focus on the processes and products of those forces as they relate to: (I) Urbanization, social organization, and the educated elite; (II) technological changes; and (III) the products of creative invention and adaptation in popular culture, covering areas of music, dance, theater, cinema, literature, and sports. Although it is difficult to present any in-depth portraits of these popular culture forms, the discussion should offer avenues to explore further interests.

Urbanization, Social Organization, and the Educated Elite

Urban centers like Cairo, Kilwa, Timbuktu, Djenne, Bamako and Ouagadougou existed throughout Africa long before the advent of formal colonial rule, but during the colonial era new centers grew quickly in places like Nairobi, Accra, Lagos, Dakar, and Johannesburg. They developed as important centers of colonial administration and trade, as harbors for migrant laborers needed for the developing mining industry, and as a result of enhanced transportation and communication systems. The social organization of these urban centers was centered on the economic and administrative forces of the colonial power.

Within these new cities there was basic segregation in both housing and social life. Whether it was those areas with a small white contingent or those with large settler populations there were separate African and European areas. These areas also corresponded to some of the worst and best conditions respectively in the city. The areas were characterized by drastic differences in material facilities like water, electricity, sewage, roads, and housing. By the time of World War I, for example, an African population of almost 10,000 in East London, South Africa had only eleven standing water pipes, creating the breeding grounds for multiple diseases to run rampant. Europeans, on the other hand, preoccupied with the potential of illnesses like malaria and motivated by racist ideas of Africans, sought to develop exclusive white areas within or on the outskirts of these cities. This physical and social separation enhanced the image of superiority of the European colonizer class, but it also allowed for the maintenance of certain African cultural norms while encouraging the development of others. Despite the perceived power of the colonial establishment, they were not able to impose Western cultural beliefs upon the mass of the population.

New city residents created adaptive mechanisms to replace those left behind in the rural areas. Voluntary associations based on employment, education, and shared cultural interests developed. Although these new associations were formed in urban settings, they did not break sharply with their rural ties. Urban societies should not be seen as distinct cultural entities, separate and opposed to rural life, but as part of a dynamic process of adaptation to new circumstances and conditions. In even the most extreme circumstances, urban immigrants continued to be influenced by their original cultures. This was often done through participation in formal or informal associations that helped to build and reinforce values and norms of behavior suitable to city life while providing networks of supporting relations. A central feature of many associations was the cultural aspect of entertainment and leisure. Faced with a variety of conditions unique to the urban environment, groups of people gathered together to search out new leisure activities, providing the impetus for urban cultural transformation within an interactive setting.

The educated African elite also looked to associate with people in similar conditions. Many of these people had been trained in mission schools, and they saw their education as a means for gaining employment in the colonial administrations. They tended to identify more with Western ways and to disengage from what the colonizers saw as the less civilized African culture.

Established in the late nineteenth century, elite African clubs, ranging from hobby associations to philanthropic associations and literary societies, were

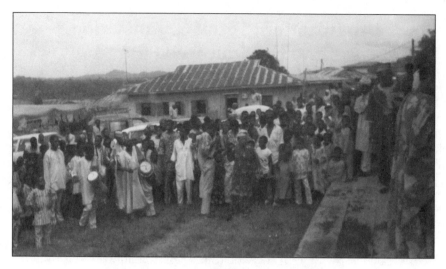

Figure 11-2. A ceremony in progress

formed. The members often wore European style clothing, tried to imitate West-
ern ways of living, and organized concerts and social dances based on European
models. Among the sources of inspiration for the African elite were the European
clubs found in most colonial urban and commercial centers. Here they could find
a European model of dress, ballroom dancing, theater production, and music. In
turn, the ruling class promoted this culture as evidence of progress and enlighten-
ment, as evidenced by such cultural "enhancements" as classical music and Eng-
lish literature. The development of the African elite increased the level of cultural
exchange and opened doors for certain cultural stimuli to enter and be adapted
into a wider cross-section of African life. The tension between the African edu-
cated elite and the rest of the population provided a catalyst for the development
of new forms of dance, music, and drama.

Technological Changes

New technological innovations also impacted the type of adaptive mecha-
nisms created. A major development affecting the creation of hybrid African
music styles was the gramophone. Wind-up gramophones first became available
at the turn of the century, but their presence was confined to Europeans and the
educated African elite and, because of their musical preferences, the records came
mainly from Europe and the United States.[2] From early in the twentieth century,
gramophone recordings were available with ragtime, jazz, cowboy ballads, and
vaudeville songs. Still, the mass of the population could not afford the expensive
gramophones and the additional cost of the records. Moreover, many areas were

2. Although the first field recordings done anywhere in sub-Saharan Africa were done
by Carl Meinhof in Tanganyika in 1902, there was little interest from researchers and no
popular demand for African music recordings at this time.

not electrified and the cost of a generator was certainly prohibitive. By the 19? however, a growing middle-class of merchants, property owners, and cold civil servants acquired gramophones. Along with bicycles, sewing machines, ana watches, gramophones were a symbol of prestige within the colonial system and helped identify a class of people who could afford such items.

The record industry quickly recognized the potential market for recording and sales. Representatives of the British-owned Gramophone Company and His Master's Voice, as well as the French-owned Pathé, began to seek outlets throughout Africa. By 1914, 100,000 records were being sold each year in South Africa alone, and by the latter part of the 1920s, the studios began recording indigenous music. The first recording of an East African musician was of Siti binti Saad from Zanzibar who recorded at His Master's Voice studio in Bombay in 1928. She soon became the most popular singer on the Swahili speaking coast and her records were sold as far away as the Belgian Congo, the Comoros, Somalia, and southern Arabia. Of course, exploitation went along with this. Royalties were seldom paid, and instead small single-session fees were given to the musicians with no hope for reaping any additional benefits.

Radio offered another way to spread popular music. While it was capable of reaching a wider audience more quickly than any other means, it did not make substantial inroads into African life until the late 1940s. Because radio receivers were expensive and dependent on electricity, many Africans who could afford to buy them were dissuaded from doing so. Also, except for a few afternoon programs in some of the vernacular languages, the colonial controlled programming catered mainly to a European audience.

Categories of Change — Music

The early musical recording industry focused on a search for the "exotic." These researchers saw "traditional" music as something trapped in the past, static and unchanging. It appealed to the colonial ideas of the "savage" African and justified the civilizing mission. Traditional music was, of course, not static. It was constantly undergoing change resulting from new stimuli created on the local level and flowing in from other African countries and the rest of the world. There are numerous examples of musical styles that developed during the colonial period as a result of changing social organization and increased culture contact. Highlife music of West Africa, *beni* of East Africa, and *marabi* of South African are three styles that will be addressed below.

Highlife Music of West Africa

The origins of highlife music are in the southwest of what was the colony of the Gold Coast, now the country of Ghana, a region with a long history of contact with Europeans. In the mid-fifteenth century, the Portuguese came to the coast of West Africa and established the first of many coastal forts at Elmina in 1482. The English, Dutch, French, and Danes followed the Portuguese lead over the next few centuries. The trader and missionary occupants of these European enclaves introduced military brass instruments, guitars, harmonicas and accor-

dions into the musical cultures of the coast. Missionaries set lyrics in local languages to the melodies of popular church songs and provided training and sometimes even instruments to some of their pupils. They promoted the playing of Western instruments and often prohibited the playing of African ones, pronouncing them to be heathen. By the end of the nineteenth century, church choirs and military bands were familiar features of many coastal towns of West Africa, but the imported forms were not taken without adaptation.

Increased contact with other Africans from the sub-region, especially the Liberian Kru people, famous both as seamen and guitarists, also influenced the development of highlife music. In the early part of the twentieth century, new musical styles emerged all over the West African coast, incorporating local and western elements. The *ashiko* music of Sierra Leone, the *dagomba* guitar songs of the Liberian Kru, and the *maringa* of Freetown were just a few. *Ashiko*, for example, emerged in Freetown, Sierra Leone in the first decade of the twentieth century and quickly became popular in the Gold Coast and Nigeria. It utilized a small, hand-held frame drum, a carpenter's musical saw and a tapped bottle. The music was accompanied by a ballroom type of dance, resembling the fox-trot or quickstep. This music form, which already consisted of various influences, combined with those on the Gold Coast to give birth to highlife music.

By 1920, the style known as highlife developed. Highlife is a musical hybrid resulting from various culture contacts and adaptations. It represented an active and creative response to the presence of European soldiers, missionaries, colonialists, and the influence of other African cultures. It represented African influences from outside of the Gold Coast and influences from different regions of the country. Highlife integrated elements of European and African music into a new, original form. It retained ties to traditional music culture and it incorporated new instruments and ideas from imported cultures, but it adapted both musical cultures to meet the needs of a changing social and cultural environment. Highlife spread quickly throughout southern Ghana, and by the beginning of the 1930s, three different styles had developed within its repertoire: brass bands, dance orchestras, and palmwine guitar bands.

Brass band highlife sprang directly out of the tradition of the regimental bands of European and European-trained African soldiers. The musicians began by playing Western style marches while incorporating local percussion instruments. This soon developed into a form of highlife known as *adaha*. Its influence spread inland. By the 1930s new styles of brass band music were popular not only throughout the towns of the Gold Coast, but as far away as Nigeria. One of these early interior forms of brass band highlife, *konkoma*, was created by "school drop-outs" and "ruffian boys" influenced by the brass bands that spread *adaha* music throughout the southern areas of the Gold Coast. *Konkoma* was associated with military style marching, but it also used many more local instruments than were typically found within the brass band tradition. For this reason, it is sometimes referred to as a "poorman's" version of brass music.[3]

The growing Christian and educated African elite patronized the second form of highlife music, dance band highlife. African musicians, already skilled on various Western instruments, began playing western popular dances like the "waltz"

3. John Collins, *Highlife Time*, 2nd ed. (Accra: Anansesem Publications, 1996), 101–103.

and the "quickstep" for social affairs of both British officials and the ⸤ elite. The first dance orchestra in the Gold Coast was the Excelsior Orchest⸣ tablished in 1914. Large dance bands played in fancy ballrooms filled people in formal dress who paid a prohibitively high rate for admission. It not uncommon for people unable to afford the entrance fee to gather around outer walls of the ballrooms and watch the events inside with a degree of both fascination and disapproval. These onlookers, unable to enter these exclusive events, first designated "highlife" as music for the elite. By the 1920s, some of these orchestras began to integrate a few local melodies into their musical repertoire, while keeping with the standard Western, four-part harmony. This resulted in the development of dance band highlife, a style that became very popular in the 1950s.

The third type of highlife, palmwine, grew out of the interaction between the music of the Fanti, the people indigenous to the southwestern part of Ghana, and the sailors that frequently passed through the region. This music style, commonly found in local drinking bars, was more readily accessible for all classes. Different from the large dance orchestras, palmwine highlife bands utilized "sailors instruments," those easily transported onboard a ship. The singing groups of Fanti fishermen, for example, utilized instruments like the hand piano, various drums, and the traditional Akan lute, known as the *seprewa*. West Indian, African American, and particularly Liberia Kru sailors, influenced local youth to take up new rhythms and instruments. The most important of these was the guitar. Young musicians already versed in the playing style of the *seprewa* picked up easily the two-finger style of the Kru guitar, known as *dagomba*. The prototype of highlife rhythm, "Yaa Amponsah," recorded by Kwame "Sam" Asare, grew out of this union. Typical palmwine highlife also incorporated rhythmic variations from calypso, a legacy of the influence of West Indian sailors. This type of highlife, more than the other two, became identified with urban working class needs. Its themes reflected those needs, which often included adverse comments on the wrongdoing of elites.

One can see that three different types of a single musical style grew out of different needs and adaptations, and each catered to a different audience. Significantly, highlife forms did not stop evolving when they achieved these three categories, but they continued, as they do today, to influence the creation of new genres. The popular Gold Coast guitar bands of the 1940s came out of the tradition of the early palmwine groups. The highlife dance bands of the 1950s grew out of the musical climate in Accra during World War II and drew on the styles of the earlier dance bands. Highlife recombined with indigenous forms to provide recreational music for young people's associations, and at the start of the new century, "hiplife," with its roots in highlife rhythms, is one of the most popular musical forms in Ghana.

Beni Music and Dance of East and Central Africa

In eastern and central Africa, *beni* dance societies spread throughout the region during the colonial era. This pervasive performance culture first emerged in the 1890s in Mombassa, Kenya, and had begun to deteriorate by the end of World War II. In the urban centers, its vibrant nature appealed to new communities of wage earners and youth, becoming a form of cultural expression and social organization. Its rise and fall provides a good example of social and cultural change during the period under review.

On the outside, the motifs and displays utilized by *beni* societies resembled European military customs. The participants organized dance competitions that looked like copies of European military drills. During the competitions they dressed in European-type uniforms, marched in different formations, and included exhibitions of military proficiency. They were characterized by the appearance of two competing groups facing each other and staging a "battle" of skill before the judges. Success was measured by the number of dancers and the level of enthusiasm displayed. Each association had a hierarchical structure with ranks and honorary titles. They were often led by a "king," a "prime minister," or a "field marshal." In Mombassa, where a large number of dock workers lived and worked, they had a hierarchy that consisted of "admiral," "vice-admiral," and "captain." Just as a *beni* organization reflected the European military order, the instruments used resembled, in part, those of military bands. Besides the bass drum, they included various wind instruments. The missing brass instruments were replaced with gourd trumpets and calabashes which, blown like kazoos, produced a polyphonic sound pattern. Although the external images and structure of *beni* revealed a fascination with colonial systems, there was also another side that incorporated African elements.

Beni societies were not as overtly focused on imported symbols as their outward displays might indicate. They had a fundamental concern for Africans in the urban setting. Rather than consciously imitating white society as a superior cultural force, they acted indirectly as a resistance to it. "They were, above all," remarks Terrence Ranger, "concerned with the survival, success, and reputation of their members, acting as welfare societies, as sources of prestige, as suppliers of skills."[4] *Beni* societies offered opportunities for recreation, creative expression, energy, leadership, and a way of coping with the pressures involved in the transformation to urban life. In the colonial situation, these societies offered an opportunity for Africans working within European enterprises and the colonial military to define their own domain in life outside of those areas of European control. *Beni* organizations were multi-ethnic, serving many social welfare functions otherwise assigned to one's ethnic group. They were based on and promoted relationships that emerged out of shared common experiences, such as employment or military service.

The two World Wars had a profound effect on the development of *beni*. World War I reinforced the military character of the cultural displays and hastened their spread inland into rural Tanganyika, the Rhodesias, the eastern Congo, Nyasaland, and Nairobi. *Beni* caught on quickly in Nairobi and, by the end of the war, one of the Africa quarters in Nairobi where *beni* was prolific was named "Mombassa Village."

Already weakened by the grim economic conditions of the 1930s that lessened the lavish performances of the earlier years, World War II was the instigator of *beni*'s demise. In Central Africa, it was being replaced by the similar dance styles of *kalela* and *mganda*, and in Tanganyika it was yielding to a new style modeled on ballroom dancing, *dansi*. In Nairobi, the influx of soldiers and increased rural-urban immigration of single men spurred the formation of new musical styles. The rapid decline of *beni* was further guaranteed by less favorable attitudes of the youth to the older, "colonial music." It was soon relegated to

4. T.O. Ranger, *Dance and Society in Eastern Africa, 1890–1970* (London: Heinemann, 1975), 75.

"gatherings of older people who like to recall the nostalgia of the Beni era and of their youth," but it also paved the way for the introduction of the new, more dynamic musical styles of "dry guitar" and *benga* that followed.[5]

Marabi Music of South Africa

In southern Africa, the growth of new popular culture forms was directly linked to the changing economic system designed to exploit African labor for the benefit of white mining interests. The discovery of gold and diamonds in South Africa had a great impact on the development of new social and cultural systems. Workers flocked to the gold fields of the Witwatersrand in South Africa, especially after the end of the Anglo-Boer War in 1902. The massive growth of the mining towns in the 1920s and 1930s gave birth to new, diverse communities and a need for the development of coping mechanisms able to serve them. *Shebeens*, illegal drinking bars catering to the new residents, provided a release from the deplorable living and working conditions. When the customers of the *shebeens* demanded "urban" entertainment more pertinent to their environment, *marabi* music arose.

Early forms of urban popular culture in the urban mining areas showed a preference by the middle and upper classes for American or European styles, rather than the local or African rhythms and images which they saw as too "primitive" and "heathen." Mission schools introduced brass band and choral music, but another important foreign influence came from American ragtime. Traveling vaudeville acts and the proliferation of gramophones helped to popularize the genre. In 1907, a local choir performing at a Christmas concert, included songs such as "My Old Kentucky Home" in their repertoire, while the gramophone played "An Evening with Minstrels" and "I'se Gwine Back to Dixie" during the band breaks.[6]

But there was also a desire to compose new choral pieces in a more "modern" African composition style. One of these individuals was Reuben T. Caluza, a teacher at an all-African training college in Natal. He served as director of the choir of Ohlange and formed a group of students that performed spirituals and ragtime, as well as Zulu traditional songs. His interests in choir merged with his goals as a composer, allowing him to integrate choir songs with South African dance. Not only did he successfully combine traditional African music and dance with the most popular Western influences of the era, but he performed with various instruments, including penny whistles, strings, and brass, for all types of audiences and in all types of settings.

His popularity grew, particularly in urban environments, partly due to the topics of his lyrics, which often dealt with possible solutions to contemporary African problems. They included *"Ingoduso,"* which spoke of the problems of drunkenness and crime, the dangers of Johannesburg and the importance of family; "Influenza," which addressed the "Great Flu" epidemic of 1918, and *"iLand Act,"* decrying the injustice of the Land Act of 1913.

5. George Mkangi quoted in Ranger, *Dance and Society*, 153.
6. Coplan, *In Township Tonight*, 71.

iLand Act[7]

We are children of Africa
We cry for our land
Zulu, Xhosa, Sotho
Zulu, Xhosa, Sotho unite
We are mad over the Land Act
A terrible law that allows sojourners
To deny us our land
Crying that we the people
Should pay to get our land back
We cry for the children of our fathers
Who roam around the world without a home
Even in the land or their forefathers

The Land Act and the Urban Areas Act affected all South African blacks, regardless of economic standing, and thus such lyrics appealed to them. Though sharing some of the atrocities of the new legislation, the middle class did not want to have its social life intertwined with that of the urban proletariat. As the popularity of music like Caluza's increased with lower-class Africans, the middle class and the elite began to turn away from it, opening the door to further adaptation. In the 1920s and early 1930s, the many social venues of black South Africans—churches, schools, clubs, drinking houses, parties, and dance halls—were producing new forms of popular culture, drawing on the rapidly changing political, economic, and social conditions.

Between 1921 and 1936 the permanent African population of Johannesburg rose almost 100 percent leading to the introduction of the Urban Areas Act of 1923. This law ensured the growth of slum yards and the denial of basic rights, but it also led to the development of a new urban working class culture of people sharing a common goal to reassert their identity in the face of this harsh environment. Dance competitions and theatrical displays incorporating music, dance, acrobatics and verbal expression were held for the laborers. Some of these early performances, drawing on the influence of American vaudeville, incorporated images of Europeans, such as a top hat and a tail coat, but they were worn in an off-the-cuff manner that satirized, not praised, European behavior.

The slum yards were the center of this culture. The nature of migrant labor, the lack of disposable income, and gross overcrowding demanded new forms of expression. With limited organized opportunities for recreation and little space to establish any, a leisure culture centered around the *shebeens* developed. People gathered to share experiences and relax from the exhausting conditions surrounding every day life. The women who ran the *shebeens* began to hire musicians in the 1920s to attract customers and increase their profits. Some of the first musicians, known as *abaqhafi*, had no preference for African, European or American cultures or social values. They often dressed like and practiced the manners of the singing and guitar playing cowboys of the American 'Wild West' films popular at many African cinemas in the 1920s. They played African, Afro-Western, and Afrikaans folk music.[8] Others strived to create music more relevant to peoples' every day lives in the city.

7. Coplan, *In Township Tonight*, 73.
8. Coplan, *In Township Tonight*, 93.

Some of the earliest *marabi* musicians were immigrants from the Cape who brought with them musical traditions of Cape Town and Kimberley. Influenced by Cape Afrikaans and African American music, they played banjos, guitars, and tambourines at the *shebeens* and other slum yard parties.[9] Performers had to please a variety of people from many different backgrounds who were now sharing a common environment, and thus they had to incorporate a number of different styles into their music. One of the styles they brought with them was the *tickey drai* style, an African-Afrikaans dance music first played on guitar. Some of the performers learned to play Afrikaans music while doing domestic work for Afrikaner families and merged this knowledge with their many other musical experiences.

Many of these performers became professional musicians and served an integral role in the entertainment life of the slum yards. One musician, Tebetjane, started playing guitar and kazoo with groups of roaming performers. By 1930, he was one of the most popular among the *shebeen* crowds. David Coplan notes that his 1932 composition, '*uTebetjana ufana ne'mfene*' (Tebetjana resembles a baboon), made him so famous that "his name became synonymous with the *marabi* genre."[10] Incorporating elements from different styles throughout South Africa, musicians created *marabi*, a style that rose directly out of the Johannesburg slum yards and the *shebeen* culture.

As the music developed, *shebeen* owners used musical competitions, dancers, and beautiful women to enhance their business. The pedal organ was incorporated into *marabi* music and dance to the extent that at its peak it was first and foremost associated with that instrument. Women dancing solo for male audiences became new features of *shebeen* culture and slum yard nightlife. Accompanied by a pedal organ playing *marabi*, the dancers portrayed images very sexual in nature, which often brought the crowd into a frenzy.

Marabi songs usually had well known titles, but the lyrics were not always recognizable. They tended to change from one setting to the next as performers created and recreated them. Like Caluza's music, the lyrics of *marabi* took on topics of social commentary and appealed to the audience:

> There comes the big van
> All over the country
> They call in the pick-up
> There, there is the big van
> "Where's your pass?"
> "Where's your tax?"[11]

Marabi music was not limited to its birthplace, *shebeen* culture. It became popular in the *stokfels*, self-help, mutual assistance, credit organizations brought from the Cape to Johannesburg. After the initial business was finished the meeting often turned to music and dance. Sometimes *marabi* owners formed *stokfels* among themselves. *Marabi* music and dance became pervasive in Johannesburg culture. It was seen in wedding ceremonies and other festivals of a social nature

9. Coplan, *In Township Tonight*, 95.
10. Coplan, *In Township Tonight*, 97.
11. Hugh Tracey, *Lalela Zulu* (Roodepoort, South Africa, 194), 55. Quoted in Coplan, *In Township Tonight*, 107.

and quickly became not only a music and dance style, but an important cultural adaptive mechanism. Its development exacerbated the divisions between lower and middle class Africans. It was a reflection of the new urban environment, but it also acted as an agent on that environment by bringing a diverse group of people together in entertainment associations and providing them with a coping mechanism to deal with the increasing chaos of every day life.

Theater and Cinema

Music and dance are not the only forms of popular culture that can provide us with a new way to view the colonial era. Like music and dance, drama formed an integral element within festivals, funeral celebrations, social singing, dancing, and storytelling activities. Colonialism increased cultural exchange, formal education, and rapid urbanization, leading to the development of new forms of drama and theater. Popular theater drew inspiration from the tendency for traditional African drama to express contemporary problems and sensibility, but as a product of urbanization and international cultural exchange, its development reflected both African and foreign influences. American vaudeville, for example, was an important influence on African theater traditions, especially in West and South Africa. Under the influence of Orpheus M. McAdoo, a group of African American performers, the Virginia Jubilee Singers, performed in South Africa from 1890 to 1898. Their departure coincided with the beginning of the Boer War, but their influence lived on. In Johannesburg, black middle class choirs, dance orchestras and variety artists performed at social functions. At the *shebeens*, workers held their own musical parties modeled on those of missionary "tea meetings," while other workers formed clubs for musical parties. As in South Africa, popular theater in West Africa was a feature of colonialism and of the influence of American vaudeville acts, but it existed outside of the colonial sphere and served as a mechanism for social commentary.

The West African "Concert Party"

"Concert Party" was the name used in Ghana for theater groups that traveled the country entertaining people. The performance style, still found today in parts of Nigeria, Togo and Ghana, emerged out of various factors, including colonial and mission education, visiting American artists and films, and developing music and dance styles. One concert party artist, Teacher Yalley, a headmaster at a Sekondi elementary school in the Western port city of the Gold Coast colony, began his career at his school's Empire Day celebrations in 1918. Mission schools frequently performed "cantatas," or morality plays, that gave aspiring actors valuable experience at an early age. Perhaps the most important influences on the development of the concert party tradition were the new films that began to arrive around the time of the First World War, particularly those that showed Charlie Chaplin and the comedian, Al Jolson. Vaudeville was also important in West Africa, as was music hall, brought by visiting artists, particularly African Americans and Caribbeans.

In the style of an American black-and-white minstrel, Teacher Yalley joked, sang and danced, donned fancy dress, wig, mustache and make-up. The shows lasted for three hours. They began with brass bands that marched around town and campaigned for customers. Following this, Yalley would perform his comedy sketches inside while a drummer and harmonium player performed a variety of popular ballroom dance themes: rag-times, fox-trots, quicksteps, and waltzes. Because the shows were in English and the tickets were expensive, the audience consisted mainly of the educated African elite, professional men of social standing.

Only a young boy at the time of Teacher Yalley's performances, Ishmael "Bob" Johnson created a group, "The Versatile Eight," which first performed shows at Sekondi Methodist School after the Empire Day parade around town. By the late 1930s, Bob Johnson had changed the conception of the concert party in many ways and redirected its appeal to a wider audience. His group created the three central characters of all subsequent parties: the Joker, the Gentleman, and the Lady Impersonator. Johnson, in playing the Joker, melded the imported blackface minstrel with the Ananse Spider figure central to Akan folklore, an important step in Africanizing the concert party performance.

Bob Johnson

Born around 1904 in the coastal town of Saltpond, Ghana, "Bob" Ishmael Johnson moved to Sekondi at a young age. While a young man in elementary school in the 1920s, he studied schoolteacher Yalley's sketches which were supported by ragtime and ballroom music from a trap drum and harmonium, a type of organ operated by a player's feet in which a pair of bellows blow air into reeds to make sound. Johnson also learned from a visiting African American vaudeville team, Glass and Grant, who toured widely in Ghana from 1924–26, performing for elite audiences. The act of Glass and Grant featured joking, tap-dancing and the singing of ragtime, with Glass playing the "minstrel" and Grant the female impersonator. Johnson viewed silent films, including Chaplin's and the first "talkie," *The Jazz Singer*. Ironically, the white Al Jolson's disguise as a "black minstrel" became a favorite mask for Johnson, who got his nickname, "Bob," from African American sailors who frequented the port in Sekondi.

In the 1920s, he formed a group, the Versatile Eight, with two schoolmates, C.B. Hutton and J.B. Ansah. Performing in a mixture of Fante and English, they played at school holidays, and on weekends they sometimes traveled as far as Axim, 47 miles to the west of Sekondi. Their act, with its lower rates of admission, clearly appealed to a much wider audience than did Yalley's. In 1930, after finishing elementary education, Johnson opted to turn professional and formed a new concert trio, "The Two Bobs," with his previous colleagues. Johnson and Ansah played the "Bobs," and Hutton played the female impersonator, who by 1932 was being billed as the "Carolina Girl." In 1935, Johnson left "The Two Bobs," to form "The Axim Trio," which toured Nigéria with a dance band from Cape Coast, Ghana. For the next twenty years his groups toured extensively throughout West Africa. Their success is evidenced by the proliferation of concert party groups in the 1940s and 1950s throughout the region, and by the fact that,

to this day, the name "Bob" and the group name "Trio" have been adopted by virtually all subsequent comedians and concert party groups.

Unlike the earlier shows of Teacher Yalley and various traveling groups, Bob Johnson, who was now a professional, began to stage his plays in the rural areas and for the urban poor. His group, "The Two Bobs and their Carolina Girl," publicized their shows with a masked bell-ringer wearing a sandwich board, a method much cheaper than hiring a full brass band. The show consisted of one half hour of "Comedies" in three segments: (1) an "Opening Chorus" in which the three actors danced a quickstep and sang; (2) an "In," where one of the Bobs sang rag-times; and (3) a "Duet," in which the two Bobs performed jokes. Music was integral to concert party performances and in these early times it was supplied by the group's own drummer with help from a few members of a local band. The "Scene," the main part of the performance followed the "Comedies," still performed in English at this time, but sometimes translated into Akan for the non-English speaking audiences, the main part usually lasted for one hour. Bob Johnson's new version of the concert party proved to be the more durable. By the 1940s, the high-class concert parties had disappeared, but those based on his model proliferated and could be found all over the Gold Coast as well as Nigeria.

Cinema, Literature, and Sports

Of course, there are many other forms of popular culture that provide insights into the changing colonial situation. Cinema, literature, and sports are just three of these; but in each case, their influence was limited until the later years of the colonial period. This was an era associated with increases in education and literacy, technology, improved facilities, and, of course, the freedom to express oneself without fear of recrimination.

As we have already seen, early films were an important influence on the formation of West African concert parties, but their impact was limited. In North African countries, cinema was introduced as early as 1896 in the back rooms of cafes in Cairo and Alexandria. In Algeria and Tunis it came just a few years later. The first cinemas in West Africa were founded in Dakar in 1900 and in Lagos three years later. However, the application of cinema as a method of urban adaptation is less pronounced because Europeans dominated the emergent film distribution channels and controlled the types of films shown to the public up to the end of the colonial period. The British created the Bantu Educational Cinema Experiment in 1935. Theoretically, they did this to educate adult Africans about new conditions, to reinforce classroom teaching, to conserve what they deemed the best features of African traditions, and to provide recreation and entertainment. In reality, the films were given little financial support and clearly had a more colonizing intent. Some of them attempted to teach Africans to adopt European ways, to accept the levies of taxes, or to prompt them to move towards cash crop, export agriculture.

The film industry in Africa expanded in 1939 with the establishment of the British Colonial Film Unit, which sought African support and participation in World War II, through the use of propaganda films. The French never formed a colonial film unit, but the Laval Decree of 1934 gave them control over what was

released in their territories. The Decree, like the French colonial system itself, had no real economic, political, or cultural policy that encompassed the majority of its subjects. Instead, it was limited to assimilating a few Africans at the top. No doubt, a study of films made by Africans would say much about the colonial era, but most of these films were made much later, after African countries became independent.

Like cinema, written work, even in the vernacular, did not have far-reaching effects until the last days of the colonial era. The available literature mainly consisted of translations of Christian scriptures into local languages. Some Western books, like *The Adventures of Robinson Crusoe*, were translated into local languages such as Kongo (1928) and Yoruba (1933), and Shakespeare's *The Comedy of Errors* (1930) and *Julius Caesar* (1937) were translated into Tswana. But there were original works written by Africans as well: Thomas Mofolo's *Chaka: An Historical Romance* (1925), Samuel Johnson's *The History of the Yorubas* (1921), Casely Hayford's *Ethiopia Unbound* (1911) and Sol Plaatje's *Mhudi* (1930). The moral corruptness of the new cities became a familiar theme. E.S. Guma's *U-Nomalizo* (1918), written in Xhosa and translated into Swahili and English, and O.S. Diop's *Karim* (1935) expressed the pitfalls of the urban experience in contrast to the beauty of the rural tradition. Despite the number of available work, their impact was limited to those who were literate, leaving most people unable to access their messages.

Certain sports were introduced to Africans by colonial powers. Football (American soccer) quickly became the most popular sport for young men and boys. In Cameroon, football was introduced by the early French colonizers. Because there were not enough Europeans to form a league of non-African football clubs, they first enrolled migrants from other African countries who came to Cameroon as colonial personnel, but who had some exposure to European norms and practices. By the 1920s, however, Africans in the larger towns were increasingly shunned from playing on the same field with non-Africans since there were now enough of the latter to form a league. Africans soon began to form their own clubs, but lack of equipment, facilities, and colonial attempts to control their leisure time made it difficult to develop the proper base necessary for the sport to take off until much later. Increasing cultural transfers during the colonial era also resulted in the introduction of other sports such as cricket, boxing, field hockey, and polo. None of these matched the popularity of football at the end of colonial rule, but they did, especially in the case of boxing, help to give young men an outlet for social organization in the cities.

Conclusion

This study of cultural change has focused largely on urban areas and mining centers, but it is not intended to dismiss similar processes of social, economic, political, and cultural change within other areas. Whether it was missionaries, tax collectors, emigrants or immigrants, everyone felt the impact of the colonial era. Newspapers, books, radio, and film reached the most outlying areas of Africa, albeit to varying degrees because of resources and literacy. The continuous movement of people between urban and rural areas also created strong links between the two. Many of the urban popular culture forms were carried into rural areas,

where they were again changed to suit local conditions, such as with *konkoma* brass bands. So too, urban cultures did not develop without continuous influence from rural societies.

Change during the colonial era encompassed various fields of African society and culture, including, the relationship between young and old. Young men, and to a lesser extent young women, gained more power, wealth and mobility. Living in the urban areas, they were often separated from their parents and other family members. They developed new mechanisms of coping unique to that environment. Some became more educated and spoke the language of the colonizer; some traveled widely and migrated to other urban centers or labor camps and immersed themselves into the wage earner economy. Some fought as soldiers in European wars. In many ways, performers and participants in new popular culture forms professed a need to adapt to their surroundings, but they also resisted the imposition of colonial force. They did not allow the colonial powers simply to impose Western cultural norms upon them, and they did not dismiss their past in search of a different future. Indeed, they combined all of the cultural stimuli around them, taking what was useful and discarding what was not, to create new, dynamic forms of popular culture.

Review Questions

1. How can the study of popular culture forms help us to understand the social and economic conditions of the colonial era better?
2. What factors influenced the development of popular culture during the colonial era? Choose one type and elaborate.
3. How do hybrid music, dance and theater forms represent the environment from which they arose and how do they also act as a resistance to that environment?
4. Discuss the impacts on popular culture of the ruling class, the elite and middle-class Africans, and the masses of the population? How did they differ?
5. How did Bob Cole contribute to the development of the concert party tradition in the Gold Coast?

Additional Reading

Barber, Karin, John Collins, and Alain Ricard. *West African Popular Theatre*. Bloomington: University of Indiana Press, 1997.

Collins, John. *West African Pop Roots*. Philadelphia: Temple University Press, 1992.

Coplan, David. *In Township Tonight!: South Africa's Black City Music and Theatre*. New York: Longman, 1985.

Diawara, Manthia. *African Cinema: Politics & Culture*. Bloomington: Indiana University Press, 1992.

Martin, Phyllis. *Leisure and Society in Colonial Brazzaville*. Cambridge: Cambridge University Press, 1995.

Ranger, T.O. *Dance and Society in Eastern Africa, 1890–1970*. London: Heinemann, 1975.

Suggested Recordings

E.T. Mensah & the Tempos, *All for You*, Retroafric, ASIN: B00000JLE4.
West African Highlife Band, *Salute to Highlife Pioneers*, ASIN: B00004TJDR.
Various Artists, *African Elegant: The Kru-Krio Calypso Connection*, Original Music, ASIN: B000000NT2.
Various Artists, *Before Benga 1: Kenya Dry*, Original Music; ASIN: B000000NT8.
Various Artists, *Shebeen Queen*, ASIN: B00000AZ40.
Various Artists, *Township Jazz 'N' Jive*, Music Club; ASIN: B000003QG5.

Chapter 12

Gender in African History

Kirk Arden Hoppe

Gender history is the study of how people have understood their identities and actions as being feminine and masculine. Since gender is a fundamental component of human identity, all history is informed by gender. This chapter takes a thematic approach to African gender history examining changing gender issues in African families, education and religion, rural and migrant labor, urbanization, and sexuality during this period of colonial conquest and occupation. While changes brought new vulnerabilities and opportunities to both African women and men depending on gender, social status and generation, the establishment of colonial power tended to reinforce the authority of African men to the disadvantage of African women.

* * *

What Is Gender History?

Gender is fundamental to the way humans organize social reality and lend meaning to their experiences. People construe their identities and actions as being feminine or masculine. Gender history examines how categories of masculinity and femininity relate to and inform one another. It also analyzes how these identity categories interact with other axes of social and political power, such as ethnic affiliation, economic status, and age in various places and times. Historians of gender reason that gender is culturally constructed, as opposed to being biologically determined, because ideas about who qualifies as a woman or a man (and how they should act) have changed over time and varied widely between human societies. The fundamental notion of gender history, then, is that gender is not the acting out of biological differences between people who are innately female or male. Instead, gender is a set of cultural meanings that imagine persons and practices as male, female, or otherwise gendered.

There are important differences between gender history, women's history, and other fields of history that might not refer explicitly to gender. Women's history is not necessarily gender history. Women's history focuses on women as agents of historical change. Women's historians argue that history is not exclusively about men and that men's actions, experiences and attitudes are not the only actions, experiences and attitudes that matter. They argue that masculine assumptions about history have been so overwhelming that even when a historian doesn't mention men specifically, but writes generally, for example, about Xhosa interactions with

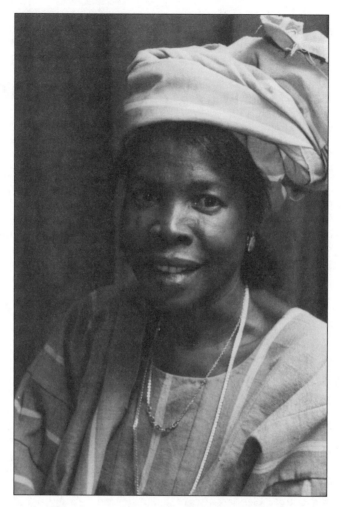

Figure 12-1. An African woman, wearing hand-woven attire, with a headtie

the Boers in South Africa, or about Bugandan trade on Lake Victoria, the as-
sumed actors are men. By examining such assumptions, historians can better un-
derstand the meaning of the past for both women and men. Women's historians
analyze women's lives and culture at all social levels, not as missing supplements
to the histories of men, but as integral ways of thinking about history.

Gender history, on the other hand, might be solely about women or solely
about men. Whether a gender historian's subject is female or male, the historian's
focus is on how individuals or groups articulate gendered identity, or how ideas
about gender shape events and inform experience. For example, gender historians
might be interested in certain occupations such as military service or child-care,
which are associated with one gender rather than with another. However, because
the meanings of female-ness and male-ness are not only fundamental to the orga-
nization of human experience, but also interrelated, gender historians view gender
analyses of historical phenomenon as crucial to any analysis of social reality, and
as applicable to all aspects of human experience. Any of the topics addressed in
this book, such as World War I, Western mission education, or early African na-

tionalism—whether or not they specifically mention men and women—can be read as gender history if the reader is concerned with what the historical evidence reveals about gendered experiences or gender relations.

When social analysts attempt to evaluate the impact of European colonialism on gender relations in Africa, they often adopt one of two opposing positions, both of which pose certain problems. Let's call one position X and the other Y. Both these positions draw on the racist idea linking Africans with primitiveness and Westerners with progress and civilization. These contrasts between Africa and the West have been used to justify colonialism, as well as to criticize it. The X gender analysis justified colonialism by demonizing precolonial Africa as a harshly patriarchal place where African women were exploited by African men. This argument presented European colonial rule as liberating African women by providing them with broader rights and economic opportunities. From this perspective, colonialism could be imagined as beneficial to Africans in as much as it helped liberate African women from African men.

The Y position, on the other hand, involves the romantization of precolonial African gender relations. In contrast to demonizing African men, beginning in the colonial period, some people presented precolonial Africa as less patriarchal than the West, as more gender egalitarian, and a place where women had more agency, freedom, and influence. This argument blamed Western colonialism for undermining women's power in Africa. A variant of Y viewed precolonial Africa as patriarchal but in a stable and uncontested way. This view saw African men and women as accepting pure and unadulterated roles of manliness and womanliness, which were then corrupted and debased by the West. This argument blamed colonialism for immorality and gender conflict in Africa. Both positions are essentialist and start from political positions rather than from evidence.

Since a gender analysis can be applied to any topic and all kinds of history, this chapter will touch on issues raised in other parts of the textbook. This chapter takes a thematic approach to African gender history from 1885 through 1939. I begin with a history of colonial conquest and warfare, including World War I. I then examine changing gender issues in certain aspects of Africans' lives: the family, education and religion, rural and migrant labor, urbanization, and sexuality. Finally, I look at how the colonial state intervened in African lives according to gender, and how African resistance to colonial change was gendered.

I emphasize throughout this chapter that Africans have not constructed gender the same way Europeans and European settlers have, even if sometimes African and European gendered experiences resembled each other greatly. Complicating the matter is history. Understandings of gender and gender roles, of what it means to be a woman and what it means to be a man in different cultures, as well as of the meaning of relationships between women and men, are always changing over time in Africa as well as in the West. With the great size of the African continent, and the cultural diversity within Africa, generalizations about gender, just like generalizations about all aspects of African history, do not apply. I have chosen specific examples to emphasize key points, but certainly this chapter is not a comprehensive survey of all gender experiences in Africa. For every example of gender history in Africa presented in this chapter, numerous other examples might diverge from or even contradict the interpretation I present here.

Issues of gender, status, and race cannot be separated. African and European women and men are not monolithic groups. Complex power relations existed

among African women, among African men, and between Africans and Europeans depending on age, status, occupation, religion, and gender. European colonialism brought a bundle of new opportunities and new oppressions that impacted these categories of power relations in different ways. Ideas and experiences of gender in Africa involved a melding of constantly changing African cultural forces and constantly changing meanings of European colonialism. Throughout precolonial and colonial Africa, gender relations in Africa were never stable and were always contested both between and within gendered groups.

Colonial Conquest and Warfare

For much of Africa, the late nineteenth and early twentieth centuries involved political, economic and environmental disruptions tied to European military conquest. In Africa, as in Europe, military conflict was a male activity that prioritized masculine values and gave paramount social and economic authority to men. The elite female regiments of the kingdom of Dahomey (Benin), massacred by a French colonial army in 1894, were unique in African military history. In Ethiopia, Zimbabwe, Rwanda, and Kenya, powerful women led military resistance movements, but African men were the primary combatants.[1] Both African men and women were killed and suffered, but they experienced colonial conquest and warfare in gender specific ways. While African men fought against colonial forces or were conscripted into colonial armies, women were subjected to the economic and social disruptions caused by war.

Women lost male children, husbands, and productive resources to war efforts. Warfare created widowed women without children who often found themselves in precarious economic and social positions. Colonial armies confiscated food stores, destroyed homes and fields, and took women and children captive. Some women followed armies to provide food and supplies, but for the most part women stayed away from armies and war zones when they could. In times of colonial invasion, when they were fleeing war zones or caught by famines (when food production was disrupted), families distributed their limited resources according to gendered hierarchies. At such times, women and female children usually received less food and other resources than men. The malnutrition and spread of disease resulting from colonial conquest disrupted female fertility rates, further undermining women's economic and social security. The gendered dangers of war for women are reflected in Buchi Emecheta's novel, *The Joys of Motherhood*, set in colonial Nigeria. In this novel, an Igbo woman reminds her husband, who is contemplating joining the British colonial army, that it is a curse among the Igbo people for women to sleep with soldiers, "who kill, rape and disgrace women and children, all in the name of the white man's money."[2]

Because colonial armies were usually comprised of African troops, colonial wars in Africa involved male outmigration. The gendered meaning of male outmigration in the colonial period will be discussed in detail later in this chapter. Mili-

1. Iris Berger and E. Frances White (eds.), *Women in Sub-Saharan Africa* (Bloomington: Indiana University Press, 1999), 35.

2. Buchi Emecheta, *The Joys of Motherhood* (New York: George Braziller, 1979), 88.

tary culture, in both forces of resistance and colonial armies, reinforced aspects of masculinity and male power. Colonial military service gave some African men new routes to power, and new ways to enforce power. African soldiers had gender specific access to wages, new markers of identity such as European military uniforms, knowledge of and access to Western technologies, travel experience, experience with a distinctly racialized male hierarchy, and advantages in post-war colonial employment. Military service and warfare reinforced African and Western systems of patriarchal control, and the values of masculine violence.

In responding to colonial conquest, African men joined together or joined with colonial powers. The Bali-Nyonga-German alliance in the Cameroon, or the Ganda-British alliance in Uganda allied African groups with colonial powers against other African groups. During the Maji Maji rebellion in East Africa from 1905–1907, various ethnic groups united against German colonial rule. But such political alliances usually empowered male political and military elites at the expense of female power, as they were relationships between European and African men.

African experiences in World War I and World War II fit into this rubric of analysis. The African men who served in the World Wars used powerful and masculine Western technologies, they fought beside and against whites, and witnessed the brutality and devastation of white men against other white men and women. African soldiers' war experiences broke down some components of colonial racial ideology, and of African ethnic difference. African veterans had a shared male experience of war and a shared understanding of Europeans. They were an active militant group in demanding political and economic rights for African men, in labor strikes, political demonstrations, and armed resistance. But they also manned the colonial state as police, medics, and local officials.

Gender and African Families

The Western idea of the nuclear family is a recent phenomenon and historically unusual in world history. African ideas of family varied greatly, but usually involved inclusion of three of four generations of parents and children, as well as aunts, uncles and cousins. They relied on each other for economic and social security. Both matrilineal and patrilineal societies were patriarchal. In matrilineal societies, uncles on the mother's side of the family had more formal influence over children's lives than women in the family. Corporate control of land and other resources has been more common in African history than individual private property. Social position and standard of living involved both real kin connections, by blood and marriage, and fictive kin relations through gender specific religious orders, professional organizations, or female and male age grade groups. Broadbased kinship connections (both real and fictive) were central to issues of identity, status, security, access to land to build a home or raise crops and animals, and marriage. Power in African families, as in many African communities, was diffused and negotiated through a variety of groups.

Discussion of the African family can be located in specific colonial contexts: in rural areas, in cities, or mines and plantations. In all these contexts, men primarily dominated, holding most key positions in the new colonial structures such

as wage labor, cash-crop production, private ownership of land, colonial government salaries and positions, access to new technologies, and access to Western education leading to better-paid employment. This can be explained partly by pre-colonial advantages of African men in controlling access to land and marriage. But it also involved the male-dominated colonial state, which gave priorities to African men.

In general, colonial rule at the level of the family, the community, and the state, established itself through an alliance with African men, and through the creation and reinforcement of patriarchal power. Colonial officials and magistrates consulted African men about local customs. Colonial states educated and appointed African men as local judges, chiefs, native authorities, police, medical assistants, and tax collectors and hired them to work in mines, colonial homes and on plantations. Local men used this relationship to colonial power to reshape gender relations to their own advantage, often at the expense of younger men and all women. The patriarchy of colonial culture lent political, legal and economic support to patriarchal components of African societies.

The history of the relationship between migrant labor, Christianity and mission schooling, and marriage is a good example of the complex contours of gendered power in African families. African marriages were often formalized through the payment of brideswealth. This involved a payment of goods or services by the groom's family to the bride's family. In patrilocal societies, when a bride went to live with the groom and his family, the bride's family would lose a contributing member of the household economy. Brideswealth compensated for this loss. Some European observers criticized the practice for selling brides without the bride's consent. While many young women had little say in their marriages, just as often the desires of young men and women were part of a family's decision making process, along with strategic political and economic issues. Marriages involved family alliances and were family decisions, but families also considered personal happiness to be important for the longevity of the family alliance. In many African societies, marriage was more fluid than in the West at the turn of the twentieth century, in that it was often less focused on the individual couple, and less connected to a religious moral imperative. A woman could initiate divorce by leaving the husband's home and returning to her family, or moving in with another man. If the separation became permanent, the woman's family was supposed to return the brideswealth payment and the family alliance would be damaged. Brideswealth and the mutual interest of the family alliances, therefore, provided incentives for brides' families to consider compatibility and to pressure wives to stay in marriages. Islamic husbands could easily divorce their wives, but it was difficult for Islamic women to initiate divorces. In most cases, the woman had to give up access to her children. This created a great problem for women, because economic and social status for women, as well as social security, was often connected to fertility. Unless they held special political and religious positions, women without children were socially marginal. They had no children to work or to care for them as they grew old, and they could not produce social capital for the community or for family alliances.

Men could not marry until they were in a position to pay brideswealth. This made younger men dependent on the patronage of senior men in their families to provide brideswealth. Senior men controlled family marriages. With colonial migrant labor beginning in this period, younger men began to challenge this control with independent access to wages. Migrant male laborers independently accumu-

lated brideswealth, giving them more freedom to decide when and whom to marry. Previously, African women usually married before the age of twenty to men at least ten years older. In migrant labor areas, initially the average age of men getting married fell, while the marriage age for women did not change. In response to this challenge from junior men, and in response to the colonial cash economy, senior men inflated the price of brideswealth. Senior men also sought to limit the actual form of brideswealth to local prestige items such as cattle while migrant laborers sought to introduce cash and purchased commodities as brideswealth. Senior men often controlled the price and sale of cattle, so while migrant laborers might have cash, they still couldn't marry without senior male approval. Migrant male labor wages were extremely low and by the 1930s, inflated brideswealth costs made formal marriages more expensive for men than before migrant labor.

Colonialism also impacted the prevalence of polygamy. In many African societies, a man could have more than one wife. Women's agricultural labor was crucial to a man's standard of living. Polygamy and numerous children were important for family productivity, prosperity, status, and social security. Colonialists argued that polygamy was immoral, and claimed it was an indication of excessive male power over women, where one man controlled numerous wives, and where a widow was compelled to marry her dead husband's brother. Co-wives might compete for a husband's resources and attention; but African women have pointed out that a polygamous household provided a community of women to share in agricultural labor, domestic labor, childcare, and husbandcare. Co-wives had time, when other wives were managing the household, to engage in trade, crafts, and other activities. Furthermore, in patrilineal societies, the assimilation of widows into husbands' brothers' families provided social security for these women. Christianity strongly opposed polygamy, and polygamy declined among Christian converts. Christianity offered some gendered opportunities to both women and men. Not only could women articulate their interests in church congregations, but they could play important roles in the success and spread of missions and independent African church movements like Watchtower and African Ethiopian churches. Christian women preached, and church communities gave them opportunities to form supportive social and economic networks where they could learn about and gain access to new colonial crops and technologies. Mission schools offered Western education for women and their children, which was increasingly vital for economic success and political agency. Christian men were supposed to be faithful and provide economic support for their wives and children.

Both Islam and Christianity gave women protection and legal rights in some respects, but they undermined women's freedoms and powers in other ways. Christianity, Islam and colonialism reinforced one another to exclude women from the public sphere. They emphasized domesticity for women, and Christianity made divorce more difficult for women to initiate. Mission schooling and church authority was dominated by men, and Christianity attacked non-Christian female religious organizations. Christian monogamous marriages did not necessarily benefit women more than they reinforced patriarchal power over property, children, and personal behavior.

Africans negotiated new religious ideas, like all other colonial changes, in gendered ways. Many African Christians did not practice Christian marriage, or combined Christianity with polygamy and brideswealth payments. John Iliffe argues

that polygamy probably increased among the new African male elite who had the necessary resources. But for most men, increasing economic segregation, land scarcity, inflated brideswealth prices, and taxation made second marriages prohibitively expensive. The proportion of polygynous marriages in Africa declined.[3]

Woman-woman marriages served as a strategy women used to seek status and power independently through the structure of the family. It also shows how differently some Africans understood the relationship between marriage, gender, paternity and biology. In a woman-woman marriage, a woman paid brideswealth to acquire legal marriage rights to another woman. The female husband became a husband socially and economically, with claims to any children born by her wife. This institution existed among at least thirty sub-Saharan African groups, including the Zulu, Yoruba, Igbo, Kikuyu, Luo, Pedi and Sotho. Often female husbands were wealthy and politically important women who hadn't married because of their political positions, or were widowed or childless. In some cases, marrying a man and having biological children undermined a woman's position as a chief or religious leader. Or, with the Nandi and Zulu, female husbands were the eldest daughters of a man who had no sons. These eldest daughters then took on the role of sons, inheriting cattle, and marrying women to have sons to continue the patriliny. Among the Venda, a woman might have been married to a man and also to a woman. Among the Nandi of Kenya, the community expected female husbands not to have sex with men because if they got pregnant, the issue of inheritance and the issue of their roles as a men would be thrown into confusion. By paying brideswealth for a wife, female husbands took on the legal and social position of men in the context of the family.

A wife provided a female husband with domestic labor, including cooking and caring for the household. These were not necessarily sexual relationships. Communities did not consider female husbands to be lesbians, nor were they stigmatized as inappropriately masculine. The wife was usually free and encouraged to have sex with men either of her own choosing, or of the female husband's choosing, in order to get pregnant. The wife's children belonged legally to the female husband and her lineage, and inheritance of the female husband's goods was the same as for men. In terms of gender as opposed to biology, the female husband was a male in the context of the family and community. A female husband might or might not take on broader male roles in initiation societies, dress and labor activities.[4]

I will use one of the groups who practiced woman-woman marriages, the Luo of Western Kenya, as a case study to illustrate changing power relations in African families. Jean Hay's history of the impact of the colonial economy on Luo families in Western Kenya focuses on changing gender power relations.[5] At the turn of the century, the Luo practiced a mixed economy with a gendered division of labor between male pastoral labor and female agricultural labor. Women also

3. John Iliffe, *The Africans* (New York: Cambridge University press, 1995), 237.

4. Joseph Carrier and Stephen Murray, "Woman-Woman Marriage In Africa," in Stephen O. Murray and Will Roscoe (eds.), *Boy-wives and Female Husbands* (New York: St. Martin's Press), 1998.

5. Margaret Jean Hay, "Luo Women and Economic Change During the Colonial Period," in Nancy J. Hafkin and Edna G. Bay (eds.), *Women in Africa: Studies in Social and Economic Change* (Stanford: Stanford University Press), 1976.

did all domestic labor. The Luo were partilineal and partilocal. A wife was responsible for providing for her children, and for her own social security. Luo women were innovative and successful farmers. They traded surplus foodstuffs at local markets, and in this way could accumulate livestock. A wife inherited from her sons, not her husband, and received help in her work from her children, and her son's wives. As an older woman, she would live with a married son and his family.

The British conquered the area militarily in 1899, imposing male chiefs and hut taxes. Major changes did not occur, however, until after 1910 when European missionaries began operating in the area, and the colonial state began to promote male labor migration by increasing taxation, limiting access to land, and demanding labor recruits from local chiefs. Initially, forced and voluntary migrant labor was seasonal, involving unmarried men from 15 to 20 years of age, and so did not greatly impact female labor. In fact, Christian men often helped women more with agricultural labor, and mission culture exposed women to new colonial cash crops and technologies.

Famines in the 1920s and 1930s, the growing importance of a cash economy, and the global depression in the 1920s transformed this early period of opportunity. By the 1930s, men up to the age of 50 were migrating for longer periods of time, abandoning women to increasing rural poverty and isolation. Left increasingly on their own, adult women took on greater responsibilities. But the colonial state in labor reserve areas reinforced and empowered senior men as leaders and household heads, and devalued women's labor and spheres of influence. Access to cash, Western education, and colonial jobs were valued more than agricultural productivity. Replacing women-dominated local barter markets were regional commercial centers, dominated by colonial agents who bought from African men. Outside wages and cash profits were key to family prosperity and stability, and men dominated the colonial economy and access to colonial education. Women adjusted by growing food crops with higher yields that were less labor intensive but that were also less healthy. In addition to growing crops such as cassava and white maize, they produced marketable crafts and cash crops. Throughout Africa's rural areas by 1939, poverty, the long-term absence of men, the devaluing of agricultural productivity, combined with Western education for men, resulted in women working harder with few opportunities and less social status and power.

Migrant Labor and Urbanization

African migrant labor connected to colonial mining, plantation production and urban employment transformed gender both in areas of outmigration and in new employment areas. All three labor sectors became densely populated and economically commercialized. Migration was both gendered and generational. Initially, vast numbers of young men were either recruited, sent by their seniors to earn tax money, or attracted by wages. In terms of labor demand, colonial employers prioritized men, but also in terms of labor supply, men had more freedom to migrate. Women were less able to escape domestic and agricultural labor demands at home. From gold and copper mining in Southern Africa, to sisal plantations in German East Africa, to domestic service in private homes, colonialists

employed men. Gold mining began in the Witwatersrand in South Africa in the 1880s. By 1910 the mines employed 200,000 African male workers, and by 1940, 300,000. A huge gender gap emerged in these areas.

The length of time African men spent away from rural areas increased, and the average age of migrant laborers rose, as wages became more important to acquire a desired standard of living. Many urban men sought to recreate aspects of the family life and social life they had left behind; they wanted relationships with women and home lives. Colonial employers struggled with whether to allow only male workers to migrate to work sites, or to allow families to accompany male workers. In the South African gold mines and on sisal plantations in East Africa, men migrated predominantly alone. In the Zambian mines, as they developed in the 1920s, employers encouraged married workers to bring families, and invested in family housing.

From the perspective of colonial employers, there were advantages and disadvantages to both approaches. On the one hand, employers were concerned about the stability and experience of the work force. Male workers with families at hand were more likely to remain and be committed to their employment. Wives provided workers with domestic labor, comfort, and emotional support, as well as responsibilities that theoretically translated into increased job productivity. On the other hand, employers wanted worker stability but not solidarity or any sense of entitlement. Single men with families far away did not consider employment areas as home, and returned to rural areas after their contracts expired. If they were sick, injured, or causing trouble, employers could send them away. Migrant laborers remained legal and emotional strangers in European-owned areas. Men with families at work sites not only came to think of these sites as their home, but they became urbanized and made claims on the land and for a place in society. In terms of housing, schools, clinics, and wages, it was more expensive for employers to support men with families. Single men were paid less. Accompanying women often pushed men politically to demand better wages and working conditions. The female dependents of male mine workers were a powerful force in early mine strikes.

In colonial urban centers such as Lagos and Nairobi, African men supplied domestic labor in colonialists' homes. African men served colonialists as launders, cooks, housecleaners, and even children's nurses. On the streets, men were tailors and food vendors. Through World War II, African men performed what in rural areas they would consider female labor. In some respects, colonial labor relationships were emasculating for African men. Colonialists referred to African adult male workers as boys. They called African men houseboys, or mine-boys, and even African mine workers with authority were still referred to as boss-boys. African men responded to these feminizing structures of power by resistance and by redefining their masculinity. African men emphasized that their higher wage earnings reinforced their patriarchal authority over the family (non-wage earning women, children and elders), and gave them new independence from women.

Women migrated to urban areas for gendered reasons. They might be following a husband or lover, escaping an unhappy marriage or fleeing an unbearable agricultural labor regime. By the 1930s, female migration increased when expanding urban centers generated more economic niches for women including domestic labor for African male wage earners and for colonialists. Because African men had access to higher paid employment, employers could pay female domestics less than male domestics. But there were always more men than women in urban areas, and this generated some advantages for women.

For both men and women, colonial labor sites offered new opportunities and new vulnerabilities. On the one hand, there were fewer family and community social, sexual and economic controls, better access to Western education, to money, and to colonial commodities and cultural forms. But on the other hand individual migrants arrived as strangers without family and community support to rely on for hospitality, shelter, emergency aid, or comradery. And men no longer had the advantages of rural women's domestic labor. For urban families, non-urban responsibilities needed to be translated into urban contexts. Were wages joint or separate? Who was responsible for or controlled family spending on clothes, food, rent, school fees, and medical costs? What responsibilities did urban families have to rural relatives, or urban men to rural wives and children? These issues were contested between men and women. To a great extent, men paid rent but did not give women enough to support their domestic responsibilities. This made women vulnerable, and pushed them into the cash economy. But women also had a great deal of independent control over the money they earned.

Africans developed new structures to meet these opportunities and vulnerabilities. Men participated in gender specific church groups, sports clubs, music societies, and gangs, as well as labor and political associations. Some of these male groups were ethnically inclusive. Particularly labor and political associations were often based more on class. In the Zambian copperbelt, men from a broad cross-section of ethnic groups, who were working and living in proximity for the first time, acted collectively out of shared experiences and grievances in a massive labor strike in 1935. New urban groups were early unionist and proto-nationalist threats to colonial power. Colonial states sought to mitigate male worker unity by keeping language groups legally distinct, and separated in housing and work experiences. Colonialists organized mine compounds and urban occupations according to ethnicity. They promoted ethnic distinction by hiring African men according to ethnic reputation. In Lagos, colonialists hired Igbo men as domestic servants, while hiring Hausa men as police and soldiers. In the Zambian copper mines, because the Mpondo had a reputation for physical strength, they became drillers and timber-lashers, while Xhosa men were often boss-boys and guards.[6] For African men, urban life emphasized ethnic identity and differentiation in contexts that did not exist in rural areas. Ethnic affiliation was important in finding housing, employment, and friends, and in affirming masculine identity in unfamiliar situations. Ethnic factional fights in mining areas were important assertions and confirmations of masculine ethnic identities. In multi-ethnic urban areas, ethnic conflict increased in times of economic hardship and insecurity.

As with men, women organized around religion, class, occupation, and ethnicity. Economic aid and social community were important components of women's groups. Often women's groups required small regular membership fees whose monthly or annual total was loaned in rotation to members to help them start small businesses. Urban women often dominated neighborhood retail marketing of cloth, as well as fresh and prepared food. Women's market organizations were powerful political forces. Women's groups helped generate not only economic security for women, but distinct women's culture. Margaret Strobel relates that

6. T. Dunbar Moodie with Vivienne Ndatshe, *Going for Gold: Men, Mines, and Migration* (Berkeley: University of California Press, 1994), 184–190.

women in Mombasa, Kenya, participated in single-sex Lelemama dance societies for reasons of status, mutual aid and entertainment. Lelemama flourished from 1920 through World War II. These women's groups would dance at weddings and other celebrations, have parties, and compete with one another. The societies awarded members status according to the material contributions they made to their group. While there was a degree of ethnic and regional specificity to the membership of different groups, any member, regardless of ethnic or status background, could increase her status if she contributed economic resources.[7]

While men dominated colonial employment through the 1930s, women actively provided informal economies to men such as food, alcohol, sex, and social services. The gender gap in urban areas provided an economic opportunity for women to market themselves. Colonial authorities and native authorities condemned these activities as the rise of prostitution. And some Africans viewed all town women as having lower social standing because they lived in supposedly sexually libertine places. But what connotes prostitution? While women's paid sexual services to men certainly involved issues of sexual exploitation and sexual violence, both by customers and male pimps, the range of sexual-economic relationships that emerged in urban areas extended beyond Western definitions of sex work.

African women often provided male workers with a bundle of domestic services including cooking, housekeeping, companionship, sex, and entertainment. Some women were involved in a series of relationships with male laborers. The man provided the woman with part of his wages, and they lived together as if married. Once he left, or if the woman was dissatisfied with the amount of the man's support, or with his behavior, she would find a new partner. A male worker might give several gifts to a woman in return for occasional sex and domestic labor. Sex work was also done at a fixed price for a specific amount of time, but even this took different forms. In Nairobi, a *malaya* was an independent woman who had a room or house where she acted out domestic life, including sex, with a number of men for money. Many of these women were very financially successful and went on to own businesses and real estate in Nairobi.[8]

Women also provided alcohol and entertainment for single men. In South Africa, beer-brewing women became famous as "*shebeen* queens," operating legal and illegal bars where men drank, danced, socialized, and initiated relationships with women. Colonial authorities considered these women a great threat to law, order and morality, partly because they were so economically successful and occupied a central position in South African urban culture. As small urban retailers, *malaya* and *shebeen* queens had a degree of independence from men, giving them opportunities to accumulate and control their own wealth and status.

Sexuality

The ideologies and realities of sexual desire and practice are important components of how Africans interacted with each other and how they structured gen-

7. Margaret Strobel, "From *Lelemama* to Lobbying: Women's Associations in Mombasa, Kenya," in *Women in Africa*, 191.

8. Luise White, *The Comforts of Home* (Chicago, University of Chicago Press, 1990).

dered identities. Just as a premise of gender history is that meanings of femininity
and masculinity are culturally constructed, so too are the meaning of sexuality
and how people responded to each other sexually. In other words, what people
considered alluring in terms of body shapes, attire and flirting is culturally deter-
mined and changes according to time and place.[9] Because this is a personal and
intimate history, it is difficult to link changes in behavior to specific economic or
political change, or to say what sexuality and changes in sexuality meant to
African men and women. Also because sexuality was and is a morally and emo-
tionally sensitive topic in Africa and the West, we must avoid making assump-
tions.

The African past was not one of "natural" heterosexuality corrupted by colo-
nization. The heterosexual monogamy promoted by Christian churches and sup-
ported by colonial states was a Western cultural ideal as opposed to African (or
Western) practice. But neither was the African past one of sexual permissiveness
and freedom oppressed by Western Christian values. African women and men
practiced a constantly changing range of heterosexual, homosexual, bisexual and
transvestite behaviors and understood these behaviors in different ways. Migrant
labor, urbanization, and economic and environmental changes in the early colo-
nial period influenced the diverse experiences and meanings of sexuality in Africa.

The great diversity of African history is reflected in the diversity of African re-
lationships to sexuality. In many African societies in the late-nineteenth century,
legal heterosexual marriage and biological paternity were important because of is-
sues of inheritance and children's affiliation to kin groups. In some patralineal
groups, a widow automatically became the wife of her dead husband's oldest
brother, and her children became his children. Marriage created corporate affilia-
tions and responsibilities, including sexual relations, beyond the bride and groom.
And biological paternity was not always important, as with woman-woman mar-
riages.

The importance of paternity did not mean that premarital and extramarital
female sex was always taboo. For many groups, premarital female virginity was
important to the amount of brideswealth and social status of a marriage, and
women were physically examined before marriages were agreed on. But groups
were more and less sexually permissive about premarital women's sexuality. The
Akan in Ghana didn't stigmatize female premarital sex. The Ijo of Nigeria didn't
punish pregnant women out of wedlock.[10] In some groups, such as the San, extra-
marital affairs for both women and men were common but kept discreet. Cer-
tainly the predominance of cultural patriarchy in Africa meant a double standard
existed where men were more free to engage in extramarital and premarital sex
than women, and sexual conquests were often markers of masculine pride and
feminine shame.

As with heterosexuality, African societies had more and less tolerant and fluid
attitudes about bisexuality, homosexuality, and transvestitism. Heterosexuality
was the norm, but there is no evidence that intolerance and homophobia were the
general standard. The Asante of West Africa did not stigmatize male homosexual-
ity or transvestitism.[11] In centralized states, such as the Zande in Southern Sudan

9. Deborah Pellow, "Sexuality in Africa," *Trends in Africa* 4, 4 (1990): 71.
10. Pellow, "Sexuality in Africa," 73–77.
11. Murray and Roscoe, *Boy-wives and Female Husbands*, 105–106.

and Ganda in Uganda, male political aristocracy often had institutionally-condoned sexual relationships with young male pages. In both centralized and less centralized societies, male soldiers and hunters took on younger men as apprentices, and these relationships sometimes involved sex. For the boys, the job training and sexual relationships were avenues to status, wealth and knowledge.[12]

During periods of same-sex segregation of both men and women, such as during initiations or during gender-specific labor, sexual relationships occurred, were tolerated, and sometimes valued. Among the Fon of Benin and the Fia of the Cameroon, social tolerance of homosexual behavior was age specific and considered an adolescent phase. People expected boys, especially during periods when they were socially segregated from girls, to engage in homosexual behavior. Once they were considered old enough to have sex with women, however, they were expected to stop having sex with one another.[13]

Urban areas, migrant labor and military service created communities where new forms of gender and sexual negotiations occurred. During periods of gender-segregated labor and training, men formed homosexual relationships that mimicked the sexual and domestic roles of marriage. In the mines of Southern Africa, mine marriages between male workers were common and semi-formalized. Relationships were between experienced laborers and younger men. While there certainly was sexual coercion and violence at wage labor locations, the institution of mine marriages was relatively voluntary, involving formal propositions and gift giving. The relationships were supposed to be exclusive. There were material and emotional advantages for both parties in mitigating the harsh conditions of life at the mines and mine townships. Young men took on feminine roles in the relationships, preparing food, washing and cleaning, as well as providing companionship and sex. The sex, as with much heterosexual premarital sex, was usually not penetrative, but between the thighs of the younger feminized partner. In return, as social females, younger men received money, gifts, protection, shelter and professional guidance from their partners. There was a strict gendered hierarchy to these relationships and what was expressed sexually, socially and materially. The partners played out gendered roles privately and publicly, the senior men articulating jealousy, for example, and the younger partners sometimes dressing and dancing as women.[14]

Homophobic missionaries and colonial officials condemned these relationships, as they condemned the rise of urban female prostitution, as evidence of immoral African primitiveness, or of the corrupting influence of colonialism on Africans. But in home communities supplying mine labor, and at mine compounds, the men in these relationships were not stigmatized as homosexuals, nor were gendered homosexual identities considered fixed. Both senior and younger partners might have wives and children or female lovers at home, so sexual behavior and gender roles would change at the end of a labor contract. Or a younger partner might decide he had enough work experience, money, and the inclination to become a dominant partner, and end his relationship as a male wife to form a relationship with a male wife on his own.[15]

12. Murray and Roscoe, *Boy-wives and Female Husbands*, 27, 38.
13. Murray and Roscoe, *Boy-wives and Female Husbands*, 105, 142.
14. Moodie with Ndatshe, *Going for Gold*, 119–158.
15. Moodie with Ndatshe, *Going for Gold*, 127–128.

Gender and State Intervention

Initially in the late-nineteenth century, colonial rule was relatively weak and fluid. In the decades leading up to World War II, colonial institutions solidified and formalized their power. Colonial officials presented themselves as protecting African women from exploitation by African men, and as helping African women overcome their own weaknesses. In some instances African women did turn to missionaries and colonial magistrates for protection from physical abuse, and for support in initiating divorce. But for the most part colonial law was an alliance between African men interested in accessing and protecting economic and political power, and in controlling women's agricultural and domestic labor, and a colonial state intent on consolidating power in the hands of men. Colonialism excluded African women from most political and economic power. In the formulation of customary law and indirect rule, colonial states ignored institutions of women's power. Colonialists collaborated with both senior African men to elaborate and enforce codes of customary law, and with the new male African middle class to transform economies and cultures. Colonial officials removed women from leadership positions, and weakened the power women had in terms of inheritance and relationships to children in matrilineal groups. Male elite took advantage of their positions in native authorities by emphasizing patriarchal controls over female labor.

Colonial states legislated gender power and gendered behaviors. For example, colonial rule abolished slavery in Africa but colonial officials feared the loss of productive labor, and discouraged female slaves from leaving their owners. Often they decided female slaves were wives who belonged to their husband-owners.[16] In 1904, the French Land Law recognized only individually registered private property. Since all property belonged to male household heads, men owned property. Law codes in South Africa in 1927 made all women legal minors.[17] Under British indirect rule, control of tribal lands was through the all-male institutions of native authorities. In West Africa, the British transferred control of markets from councils of market women to male town councils.[18] As colonial law undermined women's access to land and economic activity, women became more dependent on their relationships with men, and felt increasingly pressured by men to do greater amounts of labor.

Pass laws usually did not apply to women. However, as African male elite became more concerned about the loss of rural female labor, and colonial officials became concerned about the economic and sexual independence of women in urban areas, the state passed regulations attempting to control female migration and behavior. In Kampala, anti-prostitution acts of 1914 and anti-adultery and fornication acts of 1918, which regarded all single or unofficially married women in the city as prostitutes, were attempts to limit female migration. In South Africa, acts of 1930 and 1937, first limited female urban migration to women who had husbands or fathers already in the city, then to women who had received formal approval from native authorities in their home areas.[19]

16. Berger and White, *Women in Sub-Saharan Africa*, 97–98.
17. Berger and White, *Women in Sub-Saharan Africa*, 37.
18. Berger and White, *Women in Sub-Saharan Africa*, 100.
19. Catherine Coquery-Vidrovitch, *African Women: A Modern History* (Boulder: Westview Press, 1997), 75–76.

Christianity and Western education were powerful ideological tools for creating gender identities and for giving behaviors gendered meanings. Mission and state schools educated men as ministers, clerks, medical assistants, and police. Women's education stressed domesticity so African women might be good wives and mothers. In the 1930s, there were limited opportunities for higher education for women to become midwives, nurses, and teachers at girls' schools. In girls' boarding schools, student time was spent on practical domestic work and religious education. Academic programs for women gave less attention to literacy and mathematics. Schools educated women to sew, cook and wash, and to keep clean and tidy homes for their children and husbands.[20] In 1936 in Nigeria, girls' high school exams consisted of two written tests in domestic science, one practical test in domestic science, an English test that was the same as the boys' test, and a math test that was simpler than the boys' test.[21]

Education was not only gender specific in terms of realms of knowledge and skill levels, but also in terms of dress and deportment. Schools taught African women and men to look and act properly as women and men according to Western gender models. Missions ran most schools, and religious education emphasized female domesticity, piety, and modesty, as for men it emphasized the role of moral and economic family leadership. For both men and women, colonial education emphasized the value of work, and respect for authority. African women and men sometimes subverted religious education, and drew on biblical authority to resist colonialism. But the overlapping ideologies of mission and school prioritized male power in the public sphere, and female responsibilities in domestic life.

The colonial state intervened in the intimate order of the African family according to Western understandings of gender to transform gendered behaviors. In Uganda at the turn of the century, the British colonial state was concerned about the spread of disease, including what it thought was syphilis, and high infant and adult mortality rates. Colonialists imagined African women as the source of the problem, both in terms of their lack of sexual control leading to the spread of syphilis, and their poor mothering skills leading to high infant mortality rates. Missionaries and colonial officials collaborated to promote a social purity campaign and maternity programs for African women. Maternity Training Schools graduated trained African midwives who were to serve as examples to give other African women medical, moral and religious guidance in how to be proper mothers and wives.[22]

Gender and Colonial Resistance

Africans from all strata of society resisted their loss of freedom and power in various combinations: as individuals; as members of groups sharing gender, gen-

20. Nakanyike B. Musisi, "Colonial and Missionary Education: Women and Domesticity in Uganda, 1900–1945," in Karen T. Hansen (ed.), *African Encounters with Domesticity* (New Brunswick: Rutgers University Press, 1992), 186.

21. LaRay Denzer, "Domestic Science Training in Colonial Yorubaland, Nigeria," in *African Encounters with Domesticity*, 126.

22. Carol Summers, "Intimate Colonialisms: The Imperial Production of Reproduction in Uganda, 1907–1925," *SIGNS* 16, 4 (1991): 787–807.

eration, religion, occupation, or ethnicity; and *en masse*. Acts of resistance took overt and covert forms of disobedience including strikes, boycotts, out-migration (desertion), violence, sabotage, legal actions, public demonstrations and petitions. Gender influenced how people resisted, and gave particular meanings to acts of resistance. Histories of day-to-day individual resistance emerge from African biographies and autobiographies. Daily acts of resistance to the oppressions of an abusive husband or a colonial employer are not necessarily less important to the history of resistance in Africa, yet often go unexamined inasmuch as they are perceived as personal rather than public acts.

While group resistance reveals gendered social tensions and brought about gendered social change, colonialism also created new opportunities for gendered resistance between Africans. Colonial employment and urban migrations were means through which young African men resisted senior male power. In this period of transition when precolonial rural authority was undermined by colonial systems of indirect and direct rule, African women resisted virginity examinations, arranged marriages, and rules of abstinence during breastfeeding.[23] Young women migrated to urban areas to escape rural labor regimes. Missions and colonial courts provided places where African women could seek protection and redress from African men.

Organized African resistance to colonial power was often gender-based, with occupational and generational components. Although women and men might support one another in anti-colonial resistance, there was often tension between women and men in terms of agendas and power sharing. As African women and men became impacted by colonialism with labor and access to resources and power becoming increasingly gender segregated, women and men resisted various aspects of colonialism in different ways. Since resistance involved accumulating power, and successful resistance meant winning power, African men often resisted women's equal participation.

For example, men of the new African middle class in South Africa founded the African National Congress in 1912 as a men's organization. Urban-based African middle class women started the Native and Coloured Women's association in the Orange Free State that same year to protest pass laws for women. From 1913 to 1920, these women wrote petitions to the government, organized women's marches on government centers, refused to pay fines, and had themselves purposefully arrested. The ANC supported the women's actions tacitly, but did not join with them in their actions. In 1920, the government did away with pass laws for women. In response to this victory for the women's organization, the ANC created a non-voting women's section, the Bantu Women's league.[24] One analysis of this action by the men's group was that the male ANC wanted to align itself with a successful and powerful women's group. Another argument could be made that the ANC sought to co-opt and control women's actions and political power.

Organized African women's resistance, like men's, had a class and urban/rural split. In Kenya, female coffee pickers organized work stoppages demanding higher wages and protection from physical and sexual abuse. In South Africa, rural Christian women organized school and business boycotts protesting taxes and land registration.[25] In contrast, the history of the Bantu Women's League re-

23. Berger and White, *Women in Sub-Saharan Africa*, 40.
24. Coquery-Vidrovitch, *African Women*, 190.
25. Berger and White, *Women in Sub-Saharan Africa*, 42.

flects the interests and actions of Western-educated Christian women, often teach-
ers and nurses or relatives of important men. Their agendas usually represented a
liberal focus on female suffrage, political representation, and education. Their
methods were also liberal: petitions, peaceful marches, and letters to newspapers
and politicians. Western educated women's groups were active in urban centers:
Lome, Freetown, Lagos, and Nairobi. By the 30's, some dynamic African women
leaders gained entry into male political realms, but it was a struggle. Constance
Cummings-Jones served on the Freetown City Council from 1933 through 1942,
and Ray Alexander was elected to serve as an official in the Communist Party in
South Africa in 1938.[26]

Precolonial gender-specific organizations adjusted to new colonial contexts.
Urban women's resistance focused on colonial attacks on the commercial power
of market women, prostitutes and other female informal sector producers. A well-
known example of African women's collective resistance is the Women's War
against colonial taxation in Southern Nigeria. Market women had a long history
of economic power and organization at market centers in West Africa. In part this
was because the Igbo practiced patrilineal patrilocal marriage where wives arrived
as strangers in their husband's communities. Women met together and organized
in response to their relative powerlessness and isolation as outsiders.

Communities recognized wives as being less directly involved in local kinship
conflicts, and more active as arbiters. Women were the agricultural producers of
the primary staple, Taro root, and by World War I, they also controlled palm oil,
as well as cassava production and marketing. Women played large roles in local
food and handicraft markets. Travel between markets created a network of
women who knew each other personally and exchanged information. Precolonial
Igbo women organized collectively to protect their interests as producers, busi-
nesswomen and family members by "making war" on wrongdoers. Groups of
women would dress in costumes of short loincloths carrying sticks, and arrive at
an offending man's compound to dance, yell insults, and occasionally destroy the
house and rough the man up.[27]

Beginning in 1925, in Southern Nigeria, market women's groups began resist-
ing an array of market taxes, licenses and fees, and colonial policies undermining
their economic and social power. Colonial policies and mission ideologies were
pressuring African women to withdraw from public activities, stay at home, and
submit to a patriarchal alliance between the colonial state and some African men.
Indirect British rule focused previously diffuse power in the hands of men. Male
heads of households were responsible for paying, and therefore gathering, family,
head and hut taxes. African Male warrant chiefs had the mandate to collect taxes
and enforce colonial law. In late 1929, after a physical confrontation between an
Igbo woman and an African male agent for a warrant chief, the story of the fight
spread. Women's groups quickly mobilized, and thousands of women, dressed in
the costume for "making war," marched to the warrant chief's headquarters. In
the next month, women rallied to do away with warrant chiefs and native admin-
istration. Women sacked ten native courts, blocked roads, released prisoners from

26. Coquery-Vidrovitch, *African Women*, 168 and 191.
27. Jean Hay and Sharon Stricter (eds.), *African Women South of the Sahara* (New
York: Longman, 1984), 70–71.

colonial jails, attacked elite men, burned houses and government buildings, and destroyed European stores and trading centers.

Gender strategies informed this protest. Market women's travel and communication networks, as well as the abilities of women teachers to write letters, petitions, and read newspapers, served as mechanisms for spreading and sharing information during the rebellion. The colonial state excluded women from colonial employment, so women were less divided between those who had government jobs and those who did not. Some African men supported the market women, for example male urban professionals who shared the women's concerns about taxation and the power of warrant chiefs. Because the immediate focus of the protest was against the abuses of African native authority, the market woman appealed to the paternity of the colonial state to protect African women from African male leaders. One petition by the women called for more whites on courts as "our black men are too wicked."[28] Women's groups quickly realized that the colonial state was reticent to use violence against the women, because killing women ran counter to Western codes of male behavior. Initially, the colonial state gave in to some of the women's demands. Colonial officials tried and imprisoned the offending warrant chief, and promised that no new market taxes would be levied.

The war was over in January 1930. The women did not injure anyone seriously. In the end, the colonial state did use soldiers and police to restore order, and over 50 women were killed when troops fired on crowds. Most colonial officials in the area believed men were behind the women's actions, and that demands for female participation on courts and in native authorities was absurd. In the 1933 reforms stemming from the rebellion, colonial regulations divided the power of the warrant chiefs among groups of appointed African judges, and created a greater number of native authority councils. These were all African men drawn increasingly from the small group of the new Western educated, wealthy African colonial elite.

Conclusion

Colonial rule established itself through an alliance with African men, and through an economic and political creation and reinforcement of colonial patriarchal power. In rural and urban contexts, colonialism changed African experiences and understandings of femininity and masculinity, and gender relations. Although African women took advantage of some new economic and social opportunities, in general, colonial systems gave advantages to African men. They were given and took control of new cash crops, land ownership, new colonial technologies, access to Western education, and positions of political power in native authorities and state employment. But the history of gendered African experiences in the early colonial period involves more than the establishment of colonial patriarchy. There were conflicts and alliances between people according to occupation, generation, religion, and ethnicity, as well as among and between African men and women. Changes brought new vulnerabilities and new opportunities to women's and men's

28. Coquery-Vidrovitch, *African Women*, 164.

relationships with the state and with each other. African wives and husbands were always negotiating with one another for power in the context of the family, as were elders and youths, and people with differing amounts of wealth and property. In one strategic decision, all the women in a family might decide to cooperate with the men to resist colonialism. In another, the women might ally themselves collectively against patriarchal power. Or young women might decide their interests were best served by allying generationally with young men, for example on issues of schooling or marriage, in opposition to the wishes of elders. Colonialism in Africa involved multi-directional compromise and negotiation among and between Africans and colonizers. These processes were always gendered.

Review Questions

1. What is gender history?
2. How did urbanization and colonial employment areas such as mines and plantations in Africa impact African ideas about gender and gender relations?
3. How did male migrant labor impact rural women's power and status?
4. How did colonialism often create and reinforce African patriarchies?
5. How are issues of gender and generation interlinked in early colonial African History?

Additional Reading

Coquery-Vidrovitch, Catherine. *African Women: A Modern History*. Boulder: Westview, 1997.

Hansen, Karen (ed.). *African Encounters with Domesticity*. New Brunswick: Rutgers University Press, 1992.

Hay, Margaret Jean and Stichter, Sharon (eds.). *African Women South of the Sahara*. New York: Longman, 1984.

Moodie, T. Dunbar with Vivienne Ndatshe. *Going for Gold: Men, Mines, and Migration*. Berkeley: University of California Press, 1994.

Murray, Stephen O. and Roscoe, Will (eds.). *Boy-wives and Female Husbands*. New York: St. Martin's Press, 1998.

Chapter 13

Population, Health, and Urbanization

Patrick U. Mbajekwe

Significant social transformations occurred in Africa between 1885 and 1939, resulting from the difficult negotiations between Africans and Europeans in the new colonial world. This chapter continues to discuss these social transformations by chronicling and analyzing the changing patterns of population dynamics, health and disease, and urbanization. The chapter is divided into two sections: the first section discusses population and health, while the second section focuses on urbanization.

* * *

Population, Health and Disease

Scholars of Africa have long noticed the sharp decline in the African population during the early years of colonial conquest and rule between the 1880s and 1920s. In explanation, some people have cited the so-called prevalent "inter-tribal" warfare among African states and ravaging epidemics of the era, especially sleeping sickness. But these factors never satisfactorily explained the serious demographic crises experienced in most regions of Africa, especially in Central and East Africa, during the first four decades of colonial invasion. The so-called "inter-tribal" warfare and tropical diseases had existed in Africa long before the 1880s, but except for the era of the slave trade, Africa had never experienced such a decimation of its population as occurred between the 1880s and 1920s. To understand what happened during this era, we must look at the changing health and disease patterns, and the African population dynamics in the context of the changing political, economic, social, and environmental landscape of the continent. The ravages accompanying the imposition of European colonial rule destabilized the African health and therapeutic balance, and created a demographic disaster for most of Africa. In this section, I will analyze how the European wars of conquest, ecological destabilization, the introduction of Africans into the western capitalist exploitation, the new labor demands, and urbanization, affected the health and population dynamics of Africans.

The European wars of conquests and the brutal suppression of African resistance inflicted heavy casualties on the African population. "Punitive expeditions," as they were called, by the European conquerors, not only led to deaths of hun-

239

dreds of thousands of Africans, but also to flights and destabilization of African settlements. Agricultural cycles were also upset, leading to further devastating consequences. Between 1880 and World War I, the major European colonial powers of France, Britain, Italy, Germany, and Portugal embarked on brutal wars all across the continent to acquire African territories. Despite spirited and heroic resistance by Africans, in the end the Europeans triumphed with their superior firearms. But the wars of conquests and resistance, followed by suppression of resistance, decimated the African population during this era. Other chapters cover this story more fully, but a few examples will suffice here. The vicious Italian military campaigns in Libya killed an estimated one-third of Libyan peoples.[1] In the bid to break the Cyrenaica resistance, Italian commanders evacuated all the rural population of Cyrenaica to the desert of Sirt where they were kept in wire-fenced concentration camps. Conditions in these camps were so horrible that more than 100,000 people, mostly women and children, died of starvation and diseases. In the al-Barayka prison camp alone, out of 80,000 persons, 30,000 died between 1930 and 1932, according the Italian's own records.[2] During the sadistic German suppression of the Herero of South-West Africa in 1904, between 75% and 80% of an estimated Herero population of 60,000–80,000 were slaughtered; 14,000 were put in prison camps, and the survivors fled their homeland.[3] In Tanzania, the Germans adopted a "scorched earth" policy in dealing with the 1905–6 Maji Maji rebellion and killed over one-third of the region's population. Hundreds of thousands of Africans were killed in the French conquest of Samori Toure in West Africa, in the British suppression of the Mahdi revolution in the Sudan, in the Ndebele war in Southern Rhodesia (now Zimbabwe), and in the Belgian suppression of the Batetela rebellion in the Congo Free State. Between the 1880s and the 1930s, all over North, West, Central, East and Southern Africa, Africans were slaughtered in droves as the Europeans tried to impose imperial rule over them. Many who were not killed directly by the colonial wars, died of starvation and diseases that were caused and exacerbated by the turmoil.

Many more were displaced from their homelands. Mass migration served as a widespread protest against the harshness of colonial conquest. Unable to persist in armed revolt, many Africans fled their homes in a seemingly futile effort to elude the measures they found so oppressive and humiliating. Between 1882 and 1889, the Fulani population of Saint-Louis in French West Africa migrated *en masse* towards Ahmadu Ahidjo's empire. Of the 30,000 Fulani living in the Saint-Louis suburbs in 1882, only 10,000 remained in 1889. In 1916 and 1917 alone, more than 12,000 people left the Ivory Coast for the Gold Coast. Large numbers also left Senegal for the Gambia, Upper Volta for the Gold Coast, and Dahomey for Nigeria during the period.[4] These mass migrations destabilized the socio-economic conditions of those societies with devastating demographic consequences.

1. John Davis, *Libyan Politics: Tribe and Revolution* (Berkeley: University of California Press, 1987), 2.

2. A. Laroui, "African Initiatives and Resistance in North Africa and the Sahara," in Adu Boahen (ed.), *General History of Africa, Vol. VII: African Under Colonial Domination, 1880–1935* (London: Heinemann, 1985), 100.

3. D. Chanaiwa, "African Initiatives and Resistance in Southern Africa," in Boahen (ed.), *General History of Africa*, 219.

4. A.I. Asiwaju, "Migration as Revolt: The Example of the Ivory Coast and the Upper Volta before 1945," *Journal of African History* 17, 4 (1976): 577–594.

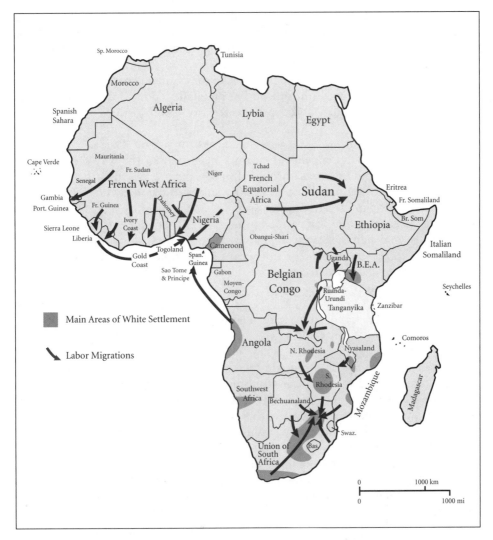

Figure 13-1. Migration and Settlement

As the Europeans gained political control of Africa, they began to incorporate Africans into their capitalistic exploitation. After all, that was the primary goal of colonial rule. Incorporation in the early stages involved brutal efforts to restructure the political economy by redirecting production, and by extracting labor from African peoples. The predatory policies of the early colonial state undermined the health of Africans with high demographic consequences. The worst incorporation efforts took place in the Central African region where much of the French Equatorial Africa, the Congo Free State and the German Cameroon were given to private concessionary companies with rights to all the natural resources and monopolies on trade. The primary objective was profit. With some of the most callous European riff-raffs serving as agents, these concessionaires ran their colonies with unprecedented brutality. They imposed taxes payable by forced collection of ivory, rubber, and wax. Punishment for not collecting enough was not imprisonment, but beating, flogging, mutilation, rape, burning of villages, and

death. Families of men who refused to collect, or who did not meet their quotas were seized as hostages. The companies' policies disorganized families, social life, and local production of food. People fled to the forests to avoid further punishment, where they lived for many years. Diseases and famine followed them as they were forced to abandon their farms. And many died. There were also many health problems including ill health during pregnancy, poor post-partum health, and a cycle of low fecundity and depressed fertility, lower birth rate, and high infant mortality.[5]

Colonial labor policies had a very significant impact on African demographics. Colonizers in the late nineteenth century believed that the way their colonies could be made profitable was through forced labor, a practice that was very prevalent in all the colonies during the early stages of colonial rule. The colonial state required African men to provide specified and constantly increasing number of labor days each month for various projects as porterage, construction of railways, roads, and administrative buildings. When critics unfavorably compared forced labor to slavery, which the Europeans had claimed they were out to abolish, the colonial rulers resorted to more subtle coercive strategies to continue the flow of cheap African labor to their mines and firms. Africans were also conscripted into the colonial armies and police forces. As a result, there was a heavy movement of African labor all over the continent.

These labor movements during the early colonial period had an immense impact on African demographics. They undermined the health conditions of Africans in several ways, and brought high levels of disease and mortality. Laborers were often moved far distances from their homes, where lacking immunity to new diseases, many came down with sickness and died. Many laborers were weakened by hunger, partly because they were offered diets very different from what they were used to, and partly because their exploitative employers purposely underfed them. Many who lacked necessary food, clothing, and shelter, died of respiratory diseases like tuberculosis and pneumonia, which they contracted at the work places. Conditions at the work camps encouraged the spread of venereal diseases and diarrhea. We may never know the number of deaths associated with these new labor demands on Africans, but available evidence indicates the rate was very high. A British Consul at São Tomé and Principe in 1915, estimated a death rate of 100 per 1000 among the indentured workers there, and a similar rate has been calculated for forced labor on the railway from Brazzaville to the sea in 1922.[6] In 1889, de Brazza estimated the mortality rate of porters in Central Africa at 150 per 1000. Azevedo's research among the Sara of Moyen-Chari (in present day Chad) suggests that in a five-day trip, the mortality rate was 50 per 1000.[7] Dennis Cordell estimates a death rate of 100 per 1000 among the porters that worked on the *route de Tchad*. This is equivalent to about 10% of the adult

5. Dennis Cordell, J. Gregory, and V. Piché, "The Demographic Reproduction of Health and Disease: Colonial Central Africa Republic and Contemporary Burkina Fasso," in Steven Feierman and John Janzen (eds.), *The Social Basis of Health and Healing in Africa* (Berkeley: University of California Press, 1992), 53.

6. J.C. Caldwell, "The Social Repercussions of Colonial Rule: Demographic Aspects," in Boahen (ed.), *General History of Africa*, 475.

7. Mario J. Azevedo, "Sara Demographic Instability as a Consequence of French Colonial Policy on Chad, 1890–1940" (Ph.D. diss., Duke University, 1976), 21.

male population.[8] Surely, as the Mossi would say, "White man's work eats people."[9] The devastating impacts of forced labor extended to the rural homes of the laborers, where the prolonged absence of men led to diminished agricultural production and malnutrition, and led to spread of disease and mortality. Furthermore, when these migrant laborers became sick, their European employers would often repatriate them back to their villages rather than provide them with medical care. As a result, some of the laborers with infectious diseases such as tuberculosis, smallpox, and venereal disease, returned to their villages only to infect their otherwise healthy relatives.

Although the expansion of a cash crop economy benefited some Africans, most of rural Africa was impoverished by this type of production, which increased malnutrition and hunger during the early colonial era. The worst of these cash crops was cotton. Driven by the nineteenth century romantic imagery of Africa as a bountiful tropical region with immense potential for the production of such tropical products as cotton, and the excessive demands of the metropolitan mills, the early colonial regimes embarked on a very aggressive campaign for cotton cultivation throughout Africa. Coercion, intimidation, and other mechanisms of social control, designed to force Africans to cultivate cotton, were used widely. In the Belgian Congo, for example, failure to produce cotton earned a "treatment" of fifteen days in jail, fines, and whipping. The forced cultivation of cotton wrecked havoc on the health environment of rural African peasants. Because cotton was so demanding, it restructured the social rhythm of the growers' lives, their short- and long-term strategies for production and consumption, and their relationship with the natural order. Forced cotton cultivation exhausted soil nutrients, devastated the ecology, and exacerbated the threat of food shortage. By compelling the peasants to sell their cotton at the market conditions over which they had no control, colonial authorities made sure the peasants' incomes remained low. Such depressed prices meant that many cotton growers could not earn enough from cotton to purchase food, nor could they grow their own food because they had to grow cotton. The result was impoverishment. Cotton-induced famine was widespread in Tanganyika, Kenya, the Congo, Nyasaland, and Mozambique.[10] In rural colonial Africa, cotton was indeed "the mother of poverty."[11]

Another early colonial activity that had immense impact on African demographics was military recruitment. Right from the inception of colonial rule, Africans were recruited into the colonial military, both as combatants and as auxiliaries, especially as carriers. This had demographic implications. The removal of large numbers of physically able-bodied young men for periods of three years or more from their villages and communities affected family life, including the age of marriage and birth rate. It also involved considerable population movements, as

8. Dennis D. Cordell, "Extracting People from Pre-capitalist Production: French Equatorial Africa from the 1890s to the 1930s," in Dennis Cordell and Joel Gregory (eds.), *African Population and Capitalism: Historical Perspectives* (Boulder: Westview Press, 1987), 142.

9. Caldwell, 475.

10. Allen Isaacman and Richard Roberts, "Introduction," in Isaacman and Roberts (eds.), *Cotton, Colonialism, and Social History in Sub-Saharan Africa* (Portsmouth: Heinemann, 1995), 35.

11. Allen Isaacman, *Cotton is the Mother of Poverty: Peasants, Work, and Rural Struggle in Colonial Mozambique* (Portsmouth: Heinemann, 1996).

the various military campaigns took recruits long distances away from their homes. By far, the greatest African mobilization in the colonial army before 1939 happened during World War I. In that war, more than one million African soldiers were involved in campaigns in Africa and in Europe. Even more men, as well as women and children, were recruited, and often conscripted, as carriers to support armies. Michael Crowder estimated that over 150,000 African soldiers and carriers lost their lives during the war, either in combat or through disease and exhaustion.[12] Many more were wounded and disabled. On the whole, the social consequences of World War I on Africa varied considerably depending on each region's level of involvement, in terms of recruitment or military actions. For eastern Africa, the destruction and devastation was immense. As T.O Ranger puts it: "The scale of the forces involved, the massiveness of the fire-power, the extent of devastation and disease, the number of African lives lost—all these dwarfed the original campaigns of colonial conquest, and even the suppression of the Maji Maji rising."[13] Apart from those directly claimed by the war, many Africans suffered indirect consequences. Not only was labor cut short from subsistence farming, but the massive troop movements contributed to widespread of disease and epidemic, the worst of which was the influenza pandemic of 1918–19.

The reorganization of space, redistribution of population, greater mobility, and intensified inter-communication that followed the turmoil of early colonial experience created new disease environments that ravaged the African population. One of the greatest consequences of these activities was famine, which wrecked havoc in much of tropical Africa during the first three decades of colonial rule. We have seen how the predatory colonial system undermined the African food production system and eroded the survival strategies of Africans through the disruptions of military conquests, demands of labor conscription, and forced cash crop cultivation. Not only did these demands undermine agricultural production but they also broke down the famine relief mechanisms developed for several generations by many societies. Thus, when the rains faltered between 1880s and 1920s, the ensuing drought inaugurated a series of devastating famines all across sub-Saharan Africa. Starting in East Africa in 1880, the drought produced its first major crises in Ethiopia and Sudan in the famine of 1888–92 where, combined with locusts, violence and disease, about one-third of Ethiopian and Sudanese population was decimated. In 1913–14, the West African savanna experienced the worst famine in over a century, when an exceptional drought struck in the midst of new tax systems, cash crop demands, and labor migration. The entire Hausaland was devastated. Human mortality was immense. In Kano Province alone, the death toll was estimated at 30,000–50,000, while that of Bornu Province was put at 84,000. Thousands fled their homes in search of food. In some districts, entire communities were abandoned. Thousands died in the course of fleeing starvation, perhaps as many as 80,000 from the impact in the French colonies. In Hadeija and Katagum, 40% of the total population apparently migrated.[14] One colonial officer described the pathetic sight thus:

12. M. Crowder, "The First World War and its Consequences," in Boahen (ed.), *General History of Africa*, 283.

13. T.O. Ranger, *Dance and Society in Eastern Africa* (London: Heinemann, 1975), 45.

14. Michael Watts, *Silent Violence: Food, Famine and Peasantry in Northern Nigeria* (Berkeley: University of California Press, 1983), 291.

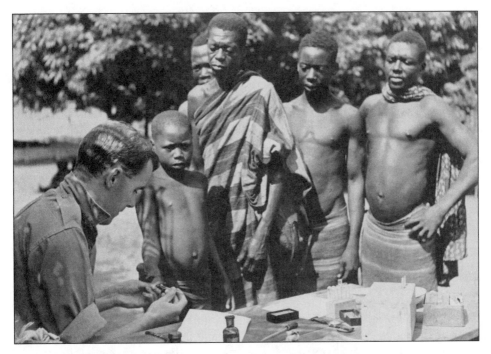

Figure 13-2. European medical and personnel at work

> The gaunt ghost of famine stalked abroad through Kano and every other part...They died like flies on every road. One came across them in the town markets emaciated to skeletons, begging feebly for sustenance, or collapsed into unconsciousness.[15]

Those that survived the famines were heavily weakened by hunger and malnutrition, which greatly reduced their immunity.

Weakened populations often presented fertile grounds for the ravages of diseases and epidemics. In early colonial Africa, epidemics, especially sleeping sickness, smallpox, tuberculosis, and Spanish influenza wrecked havoc on the African population. Sleeping sickness was caused by microorganisms called trypanosomes that attacked the central nervous system, leading from fever to coma and death. It was transmitted by tsetse flies and infected cattle. Because the disease was not new in tropical Africa, long before the colonial invasion, Africans had developed effective public health strategies and practical knowledge on how to control it. For example, the Ngoni of southern Africa had a complex system for controlling contact between tsetse flies and people or cattle. They had multiple zones, some cleared land, land with brush where people could hunt out wildlife (the reservoir of infection), and wildlife preserves where people and cattle did not go. In this way they controlled trypanosomiasis infection. In the early colonial period, however, violent changes in the human ecology associated with colonial conquests, and European ignorance of biological hazards in Africa, made sleeping sickness an epidemic of horrendous magnitude all over sub-Saharan Africa. Africans had

15. Mr. Hastings, the Kano Resident, quoted in Watts, 288.

always known that the way to prevent the disease was to stay away from tsetse flies but colonial demands forced people to move into settings they had hitherto avoided.[16] Increased mobility exposed more people to infection. Tens of thousands of Africans died from sleeping sickness when they had to be moved to work in the railroads or roads that passed through infested forests, or were compelled to clear infested forests for cash crop cultivation. From the 1890s, the diseases took on epidemic proportions throughout Africa south of the Sahara. During the next thirty years, it killed up to 90% of the population in the worst affected localities of Equatorial Africa.[17] Around Lake Victoria in eastern Africa, a 1905 outbreak killed over 200,000 people. Hundreds of thousands died of sleeping sickness epidemics in the Belgian Congo, in Northern Rhodesia, in the British and French territories in the savanna. The ignorance of the early colonial administrators compounded the problem when they tried to control the disease by moving people away from the encroaching bush, leading to still further spread of tsetse flies and sleeping sickness.

Smallpox was another major epidemic during the early colonial period. Again, compounded by famine and increased mobility into unfamiliar environments, the disease reached epidemic proportions in several regions. There were heavy outbreaks in Kenya in from 1898–1900, 1909–10, and 1916–17. The 1898–1900 epidemic (combined with the famine and rinderpest plague of the year) wiped out entire populations in many Kikuyu and Kiamba villages of Kenya, and claimed the lives of at least 10% of all the country's inhabitants. The actual number of deaths is difficult to determine since many people fled their homes, but the famine and epidemic were so severe that as late as 1903, the Kiambu area appeared to be largely uninhabited.[18] Half the population of the new French post of Brazzaville was wiped out in 1889 by a smallpox epidemic in the French Congo. Four years later Loango was decimated by the epidemic.[19] All through Africa the disease remained a regular killer of children.

Another disease that reached epidemic proportions in early colonial Africa was tuberculosis. At the beginning of the nineteenth century, tuberculosis was a rare disease in sub-Saharan Africa, but by 1920, it had reached epidemic level. A classic social disease, the incidence of tuberculosis is always directly connected to changing social and economic conditions. Randall Packard has analyzed how the growth of industrial and urban centers in Africa in the late nineteenth and early twentieth centuries was accompanied by sharp rises in tuberculosis mortality in Africa, similar to what happened in Europe and America in the eighteenth and nineteenth centuries during the early era of industrial revolution.[20] With the end of the colonial conquest, commercial and industrial capital began to expand into

16. Philip Curtin et al., *African History: From the Earliest Times to Independence* (London: Longman, 1995), 491–2.

17. John Iliffe, *Africans: The History of a Continent* (Cambridge: Cambridge University Press, 1995), 210.

18. Marc H. Dawson, "Smallpox in Kenya, 1880–1920," *Social Science and Medicine* 13B (1979): 246.

19. Rita Headrick, *Colonialism, Health and Illness in French Equatorial Africa, 1885–1935* (Atlanta: African Studies Association, 1994), 33.

20. Randall M. Packard, *White Plague, Black Labor: Tuberculosis and the Political Economy of Health and Disease in South Africa* (Berkeley: University of California Press, 1989).

Africa. Gold mines were opened in South Africa, Rhodesia and the Gold Coast, copper mines in the Congo and Northern Rhodesia, and tin and coal mines in Nigeria. Africans were drawn into these mining centers. At the same time, the expansions in cash crop production and the growth of port cities like Accra, Lagos, Dakar, and Mombasa, geared towards the exports of African mineral and agricultural wealth, drew thousands of Africans into an expanding urban environment. These were favorable conditions for the rapid spread of tuberculosis. Conditions in these towns, particularly for Africans, nurtured tuberculosis epidemics. Overcrowded housing, low wages, inadequate diet, poor sanitary and health conditions, and stressful conditions in the mines, all led to tuberculosis epidemics. Tuberculosis mortality rates of blacks in South Africa were as high as 15 per 1,000 per year in many places before World War I. The migrant labor system compounded the problem by causing urban-based tuberculosis epidemics to spread at very rapid rates into rural areas, with alarming morbidity and mortality. By the late 1920s, over 90 percent of the adult population of some parts of Ciskei and Transkei had been infected with tuberculosis. This spread reflected not only the high turnover of African labor, but also the practice of forced repatriation of sick workers to their villages by their employers instead of providing them with medical help. The spread was also a reflection of the impoverishment of the rural population, faced with a declining access to their means of production and hindered by low industrial wages. This impoverishment undermined the ability of rural Africans to resist diseases such as tuberculosis that were transmitted by returning migrants.[21]

By far the greatest single short-term demographic catastrophe that befell Africa during the early colonial period was the Spanish Influenza pandemic of 1918–19. Imported into Africa from Europe in August of 1918, the epidemic killed at least 1.5 million Africans in less than a year. By the time it was over, between 2 and 5 percent of the African population in almost every colony was wiped out by the epidemic. "Nothing else," wrote K. David Patterson, "not slaving, colonial conquest, smallpox, cerebrospinal meningitis, the rinderpest panzootics of the 1880s and 1890s, nor the great trypanosomiasis outbreaks in East and Equatorial Africa after 1900 killed so many Africans in so short a time."[22] The explosion started from Freetown, Sierra Leone, introduced by a ship that came from England in August of 1918. From there it spread like wild fire all across the continent, spreading through seaports, by roads, railways, and rivers to interior towns, and thence slowly percolated through the countryside. Traders, migrant workers, World War I troop movements, and other travelers spread the virus. Population concentrations in the new urban centers were especially vulnerable. The loss was horrendous.

There were many other diseases that took their tolls on the African population between 1885 and 1920. These included malaria, cholera, yellow fever, cerebrospinal meningitis, and venereal diseases. Many of these diseases spread along the new transport routes, and infested large population concentrations.

21. Packard, 11.

22. K. David Patterson, "The Demographic Impact of the 1918–19 Influenza Pandemic in Sub-Saharan Africa: A Preliminary Assessment," in J. Gregory (ed.), *African Historical Demography, Vol. II, Proceedings of a Seminar Held in the Centre of African Studies, University of Edinburgh, 24–25th April, 1981* (Edinburgh: University of Edinburgh, 1981), 404.

As a result of ignorance, parsimony, and racism, colonial medicine did not do much to help Africans during the first three decades of colonial rule. Until the 1930s, because Western medical authorities were largely ignorant about tropical diseases, they could not intervene effectively in most of the African health crises. And the few areas where they did attempt to intervene, they created more problems than solutions. Worst of all, they could not understand that most of the African health crises were actually created by the social and economic turmoils that were produced by the political conquest of Africa. There was a running competition, as well as a yawning gap, between African and European understandings of the causes of health and illness, and especially the relationship between humans and the environment. The African therapeutic system was undermined, yet there was no immediate alternative provided by the new conquerors. Although the application of germ theory to tropical medicine began in 1881, and the first tropical medical schools were established in 1897 in London and Liverpool, it was not until the 1920s that the development of drugs and vaccines to combat tropical diseases really began.

The Western ignorance about tropical diseases was compounded by the parsimony of the colonial state, which was not prepared to invest any money into the African health care system. The *raison d'être* of the European colonial system in Africa was profit, which the Europeans tried to achieve with as little investment as possible. Certainly, African health was not a priority, an ironic fact given that making a profit from Africa depended heavily on African labor. This irony was the result of yet another factor: racism.

Racism was so heavily mixed up with early colonial medicine that some scholars have viewed the doctors as allies of colonial capitalism. This is because the meager medical services available for Africa during this era were concentrated on saving Europeans, not Africans. Medical theories served as excuses to establish and enforce urban racial segregation, and to override African property rights. Instead of providing improved social, economic, and health conditions for African workers, exclusionary social control measures were applied in South Africa and elsewhere in the name of disease control, to push Africans away from the boundaries of white society.

1930s and After

By the 1930s, the worst of the population decline and health disaster for Africans had ended. In the late 1920s, the African population began to stabilize, epidemics and famine came under control, death rates began to reduce, and but for a brief setback during World War II, the African population began to rise again steadily. Once again, we shall turn to changes in the political, social, and economic factors to understand this demographic change.

First and foremost, the wars of colonial conquest were pretty much over by 1930. Although anti-colonial agitation continued, relative stability had been established by direct colonial rule all over Africa. Brutal suppression of anti-colonial revolts had ended, with Africans having been subdued for the most part. European imperial flags were now flying full mast all over the continent.

With the era of conquest and "pacification" over, the naked exploitation of African laborers became less necessary. The basic infrastructure of the colonial system, the road and rail networks, had been completed, and what remained was the "consolidation of capitalist relations and the institutionalization of the colonial experience."[23] As a result, not only did deaths due to direct physical violence declined, but migration as a means of escaping colonial oppression, also declined with the colonial state exercising tighter border controls. Understandably, the African population became more settled.

At the same time, Africans were developing adaptation and survival strategies. By the 1930s, realizing the limitations of their resistance to colonial conquest, the Africans began working out ways to maneuver and survive the system's brutalities. Workers in the mines and cities would send part of their earnings home to hire labor for their farms, buy high yielding seeds, or acquire more cattle. More Africans were also beginning to take advantage of Western education and move into new professions. Agitation for better wages, working and living conditions began to emerge as working-class consciousness developed among African workers. All these factors helped to improve the lives and health environment of many Africans.

By the 1930s the colonial health care system had gradually been extended to Africans, starting with African troops, government workers, and mission personnel. This greatly helped control and reduce the mortality rates of various diseases, including infant mortality. Both preventive and curative medicines were employed, and epidemics were checked with great success. Some diseases like smallpox were effectively contained with mass vaccination. Using mass screening and treatments with effective new drugs, mobile teams were able to bring sleeping sickness under control during the 1930s. Public hygiene, urban sanitation, and the provision of pipe-borne water supplies dramatically reduced urban waterborne diseases. Although the development of road and rail networks had initially contributed to the fast spread of disease in Africa, by the 1930s, the same system helped bring relief faster to rural populations during times of famine and epidemic crises. Furthermore, many Africans who survived the previous epidemics had developed immunities.

Although most epidemics were contained, much less success was recorded against endemic diseases. Malaria continued to ravage Africa. Moreover, the social differentiation created by colonialism impacted the availability of Western medicine. Medical services and public health campaigns were concentrated in the urban centers to the neglect of rural populations. And even then, mostly these services were available only to the few privileged Africans—the chiefs, the new elite, wage earners, and entrepreneurs. Further still, most of this access was skewed in favor of men. In Nigeria, for example, two-thirds of all hospital admissions in the 1930s were males. Most of the population, particularly women and children, continued to wallow in poverty and poor health.

23. Cordell, Gregory and Piché, 58.

Cities and Urbanization in Early Colonial Africa, 1885–1939

One of the significant social and demographic developments in Africa during the early colonial period was the rapid expansion of urbanization and urban life. Larger numbers of Africans began to leave the countryside to move into urban centers. The impoverishment of the rural economy, which was the byproduct of the incorporation of Africa into the colonial capital economy, forced many Africans to begin to move to urban centers. Cities and urbanization were certainly not new in African history, but by 1880, only about one in 300,000 Africans lived in centers with population of over 100,000, compared with perhaps, one in fifty in Asia.[24] By 1939, that had changed tremendously. Urban populations had doubled or trebled in almost all of Africa, with significant implications for the lives of Africans, and their relationship to colonialism.

One of the most enduring, yet inaccurate stereotypes about Africa was that Africans never lived in urban centers or that urbanization never existed in Africa before the European colonial rulers arrived. Yet, urbanization had been an important feature in Africa's history for thousands of years in the precolonial past. From the Nile valley in the north, through the trade routes of the Sahara, the Atlantic and Indian Ocean coastal states, the forest regions of West Africa, to the edges of the Kalahari, precolonial Africans built great cities, of diverse sizes, structures, and architecture.[25] Towns and cities flourished in precolonial Africa where they served as centers of trade, economic activities, and wealth accumulation; as foci of political power and authority; as military garrisons and symbols of physical domination; as centers of ritual power, ceremonies and displays; and as places of refuge, shelter, and collective security in times of trouble.[26]

In the North and Northeastern Africa, cities like Cairo, Carthage, Alexandria, Fez, Meroe and Aksum (Axum) flourished in Egypt, the black kingdom of Kush, and in the ancient kingdom of Ethiopia. In the western Sudan, Kumbi-Saleh, Timbuktu, Gao, Jenne, and Kano were great centers of trade, administration, and learning during the era of Trans-Saharan trade. Further down in the forest regions of West Africa, there were Benin City, Kumasi, Katunga (Old Oyo), Ife, Ilorin, Ibadan, and other Yoruba towns. Whydah (Ouidah), Old Calabar and Lagos were great trading cities in the Atlantic trade. In West-Central and Southern Africa, Mbanza Kongo and the Great Zimbabwe were perhaps, the best known cities. In eastern Africa, particularly on the Indian Ocean coast, towns like Kilwa, Mombasa, and Zanzibar flourished in international commerce before European colonial rule started.

24. Caldwell, 484.

25. See Basil Davidson, *The Lost Cities of Africa* (Boston: Little Brown and Co., 1970); Richard Hull, *African Cities and Towns Before European Conquest* (New York: W.W. Norton, 1976); Graham Connah, *African Civilizations: Precolonial Cities and States in Tropical Africa* (Cambridge: Cambridge University Press, 1987).

26. David Anderson and Richard Rathbone, "Urban Africa: Histories in the Making" in David Anderson and Richard Rathbone (eds.), *Africa's Urban Past* (Oxford and Portsmouth: James Currey and Heinemann, 2000), 1.

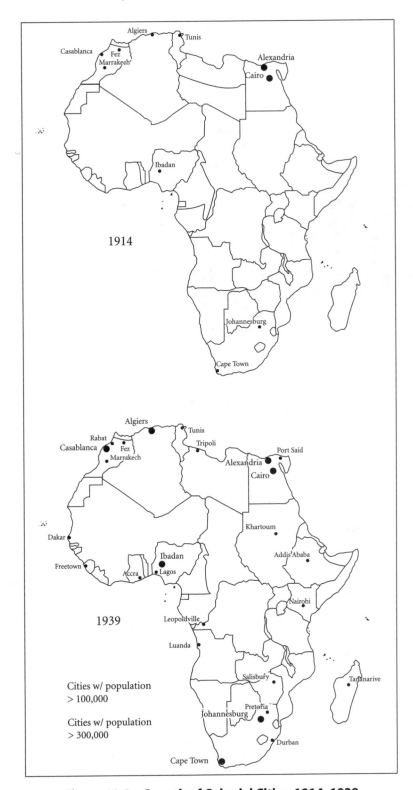

Figure 13-3. Growth of Colonial Cities, 1914–1939

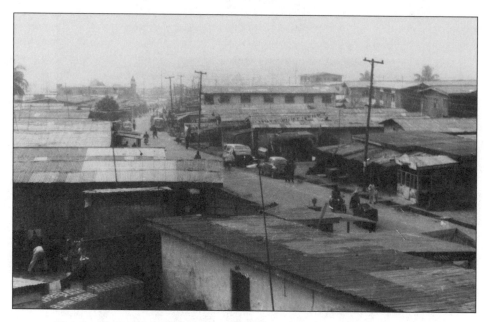

Figure 13-4. Part of the city of Ibadan, the largest in West Africa. Urbanization became a common feature in Colonial Africa.

If European colonialism did not create urbanization in Africa, however, it gave a new concept and dimension to urbanization in the continent. Towns grew very rapidly during the colonial period. Hundreds of thousands of Africans migrated to urban centers. The expansion of European commercial interests into the interior, the building of railways and ports, the establishment of administrative and military bases, the mining revolution in southern Africa and other parts of Africa, as well as the impoverishment of most rural areas, all set in motion forces that would dramatically change the face and pace of urbanization in Africa. Between 1885 and 1939, many historic precolonial towns adapted to the new changes and expanded even larger; while many new towns emerged, some of which were built from the scratch. By 1935, old cities like Cairo, Alexandria and Algiers trebled their populations to over one million, about 600,000, and 250,000, respectively. Ibadan grew from about 150,000 in the 1880s to over 400,000 in the 1930s. Lagos and Kano doubled their populations during the same period.[27]

At the same time, new urban centers were emerging as seaports, mining centers, railway routes, and administrative centers established by the new imperial rulers. Africans began pouring into these growth spots in search of jobs and economic sustenance, the population of these towns doubled on average every twenty years.

Many towns grew rapidly because the Europeans chose those places for their colonial administrative headquarters. Although Accra in Ghana was established in the seventeenth century in response to Atlantic commerce, the town grew very slowly until the 1870s. At that time, the administrators of the Gold Coast colony

27. Caldwell, 485.

decided to transfer the capital from Cape Coast to Accra. The new site, Accra, was healthier than Cape Coast, and was considered more convenient for subduing the "disorderly and uncivilized" people to the east.[28]

But even more important to the colonial development of towns for political control, was their development as a means of economic exploitation. Many new towns sprang up, and old ones expanded rapidly, as a result of constructions of ports and railways all over Africa. Although Lagos had begun to emerge as an important center of international commerce, its fortunes expanded greatly in the late-nineteenth and early-twentieth centuries when its modern harbors and ports brought new commerce to the colonial capital of Nigeria. Port Harcourt was built from the scratch in early twentieth century to serve as the main port for eastern Nigeria. Both the seaports of Lagos and Port Harcourt were linked by extensive railway connections with the inland towns of Aba, Umuahia, Enugu, Jos, Kafanchan, Kano, and Kaduna, to ensure an effective extraction and export of Nigeria's agricultural and mineral wealth to Europe. The same pattern was followed in Senegal, where the port at Dakar (also the administrative capital of French West Africa) was linked by rail to Bamako in Mali. In the Gold Coast, railway construction began in 1898, linking the coastal town of Sekondi with interior mines. As a result, this small Asante fishing village was transformed into a bustling cosmopolitan town.[29] A port was also developed at nearby Takoradi to handle the export of the country's cocoa. The railroad ended at Kumasi, which greatly increased this precolonial town's potential as an administrative and commercial center. Nairobi in Kenya started almost from the scratch as a railway station on the Mombasa-Lake Victoria line, and quickly developed into an important administrative and commercial center. Given the crucial importance of the railway in the economic exploitation of East Africa, it is easy to see why Nairobi grew very rapidly from 1899 when the Railway Administration established its headquarters there. In 1905, the colonial government moved the capital of the East African Protectorate (as Kenya was then called) from Mombasa to Nairobi. Algiers also grew rapidly from the 1880s, both as an administrative center for the French government of Algeria and as a major Mediterranean port.

Mining capital was another important factor in the urbanization of early colonial Africa. In West Africa, the developments of coal, tin, and gold mines led to the expansion of Enugu and Jos (both in Nigeria), and Obuasi (in the Gold Coast). In Central Africa, copper mining led to the establishments of Elisabethville (Lubumbashi) in the Belgian Congo, and the Copperbelt towns of Northern Rhodesia (Zambia). The discovery of diamonds and gold led to the emergence of the great mining-industrial cities of Kimberley and Johannesburg in South Africa.

Between 1885 and 1939, these emerging urban centers grew rapidly as Africans and foreigners poured into them in search of jobs and opportunities. And such growth would become even more explosive after World War II. Nairobi that started from scratch had reached 48,000 in 1931. In 1898, more than 100,000 people had flooded into Johannesburg after only a decade of its existence; by 1920s, the city had a sprawling population of over a quarter of a million. While most Francophone African towns never exceeded 5,000 in population

28. Margaret Peil, *African Urban Society* (Chichester: John Wiley & Sons, 1984), 19.

29. Emmanuel Akyeampong, *Drink, Power, and Cultural Change: A Social History of Alcohol in Ghana, c. 1800 to Recent Times* (Portsmouth: Heinemann, 1996), 59.

in 1900, by 1938, Dakar had become the largest city in French sub-Saharan Africa with a population of about 100,000.[30] By 1940, Leopoldville (Kinshasa) had reached up to 40,000.[31]

Colonial Rule and Urban Planning

As Europeans settled down to rule in Africa, they became concerned with town planning. The major objectives of their town planning policies and programs, however, were domination, power and control. As Africans were beginning to move into the urban centers in large numbers and coming into direct contact with the rulers, the Europeans thought it imperative to make clear who was in charge. Thus, policies and plans about urban layout, urban land, housing, and urban services were designed to keep Africans not only under control and surveillance but also segregated from Europeans. Europeans used urban space both to protect their interests, and as an instrument of social and psychological distancing.

The Europeans often couched their racist segregationist policies in the metaphors of disease and public health — the "sanitation syndrome." As Maynard Swanson puts it: " ...equating black urban settlement, labour, and hiring conditions with threat to public health and security became fixed in the official mind, buttressed a desire to achieve positive social controls, and confirmed or rationalized white race prejudice with a popular imagery of medical menace."[32] Using the pretext of protecting Europeans from the so-called "diseased" Africans, and from contracting tropical diseases, the colonial officers instituted urban racial segregation, dividing the towns into "European city or Reservation" and "African Quarters." The Europeans carved out for themselves the choicest parts of town, often on a hilltop. They appropriated African lands and built for themselves spacious houses with surrounding gardens, while providing for themselves the best of amenities.

In his urban master plan policy for colonial Nigeria, Governor Frederick Lugard decreed in 1917 that all towns in Nigeria (except Lagos) should consist of "a European Reservation" and a "non-European Reservation," separated by a non-residential area of 440 yards. No African, "except *bona fide* domestic servants of Europeans may reside in the European Reservation, and no European may reside in the Non-European Reservation."[33] He went further to rationalize his urban racial segregation policy:

> The first object of the non-residential area is to segregate Europeans, so that they shall not be exposed to the attacks of mosquitoes which have become infected with the germs of malaria or yellow fever, by preying on Natives, especially on Native children, whose blood so often contains

30. Raymond Betts, "Dakar: Ville Impériale (1857–1960)," in Robert Ross and Gerald Telkamp (eds.), *Colonial Cities: Essays in Urbanization in a Colonial Context* (Dordrecht: Martinus Nijhoff Publishers, 1985), 197.

31. Patrick Manning, *Francophone Sub-Saharan Africa, 1880–1985* (Cambridge: Cambridge University Press, 1988), 39.

32. Maynard Swanson, "The Sanitation Syndrome: Bubonic Plague and Urban Native Policy in the Cape Colony, 1900–1909," *Journal of African History* 18, 3 (1977): 410.

33. Lord Lugard, *Political Memoranda*, 3rd edition (London: Frank Cass, 1970), 416.

those germs...Finally, it removes the inconvenience felt by Europeans, whose rest is disturbed by drumming and other noises dear to the Native.[34]

Lugard's segregation plans would mark the high tide of urban planning in British West Africa.

Africans were pushed to squalid parts of the towns with inadequate facilities, poor housing, and little or no planning. As the population of Africans increased, the "African Quarters" often turned into slums with all the health hazards. When confronted by frequent epidemics, made worse by squalid conditions, the colonial governments, instead of improving urban facilities preferred to burn down the "quarters" and push Africans even further away from them. The key issue is that Europeans never wanted Africans in the towns, except for their labor, and they did not want to see Africans live comfortably in the towns. The few Africans that were allowed in the cities should be under effective social control. The "undesirables"—which for the most part included women, the unemployed, or those not directly employed in the "formal" sector—were not wanted in the towns.

The most glaring urban racial segregation started in South Africa, where the interests of the mining capital, combined with racist political ideology, introduced public health and town-planning legislation that was intended to regulate African urbanization and enforce segregation. The 1900–04 bubonic plague and the 1918 influenza pandemic provided a so-called rationale not only to burn down the African sections of urban centers but also to expel huge numbers of Africans from city precincts while introducing them to stricter social order control measures.

The French and Belgian colonies were no different. Following an outbreak of the bubonic plague in Dakar in 1914, the French government burnt the Africans' homes and, using military troops pushed the African population to a new settlement on the outskirts of town called the Medina—"a specially designated isolation area northwest of the city."[35] The *de facto* racial segregation was further defined and enhanced by medical, sanitation, housing, and planning regulations, that effectively divided Dakar into two towns—one for Europeans and the other for Africans. In Leopoldville (Kinshasa), the Belgians separated the European residential section of the town by a *cordon sanitaire* (sanitary cordon) of uninhabited ground, consisting of a golf course, botanical gardens, and a zoo. No Congolese was allowed to live in the white quarter, except for few domestic servants. From 9.00 p.m. until 6.00 a.m., Africans were not allowed in the European section of the town, except with a special pass, and no European was permitted to visit the African section either. The only exceptions to this after work segregation rule were a few African elite that enjoyed quasi-Belgian status, called the *immatriculês*. But even they could not live in the European quarters until 1956.[36]

Although the Europeans wanted to control both the immigration and social behaviors of Africans in the cities, the reality of colonial developments did not allow them to have their way. For one thing, the contradictions inherent in colonial capitalism, which impoverished the rural economies at the same time as the colonial officers increasingly demanded tax, ensured an unabated flow of Africans

34. Lugard, 420.
35. Bretts, 198.
36. J.S. LaFontaine, *City Politics: A Study of Leopoldville, 1962–63* (Cambridge: Cambridge University Press, 1970), 19–20.

to the urban centers. Furthermore, a new African elite was beginning to emerge, some of whom challenged the European racial segregation plans.

Urban Social Relationships

Social life in colonial urban Africa was a world Africans made. In their struggles to make sense out of the European colonial structure, to survive under the harsh economic exploitation, to maneuver the strict bureaucratic legalities, Africans created unique urban cultures. Both the indigenous and foreign were ingeniously appropriated in this new cultural creation. For Africans, city life in colonial urban Africa was creative and fun. City life was also a struggle for survival. It was a struggle to survive against the forces of industrial capitalist exploitation. It was a struggle to survive the imposition of colonial social control. It was a struggle for the Africans to maintain their sanity in this era of fast social changes. It was struggle for the young men to extricate themselves from the traditional control of elder men. And it was a struggle for the women to redefine their position in the patriarchal African societies. The era was therefore a period of conflicts—economic, generational, and gender.

Out of these struggles and conflicts emerged enormous creativity by Africans that defined their new urban social world. New survival strategies were developed; new economic opportunities (especially in the "informal sector") were exploited; women re-negotiated gender relationships. New urban cultures that were truly unique to Africa's urbanization emerged.

Surviving in the new towns was tough for Africans, and even tougher for newly arrived immigrants. Because the cities then, and even now, offered little or no social security or safety net, the Africans developed voluntary associations, the most common of which were organized around villages, kinships, or ethnic origins. These organizations met on a regular basis, and provided a variety of social and economic services to their members both in the cities, as well as in their home communities. They offered accommodation for newly arrived immigrants to the city, and used their networks to help them obtain jobs. They provided information to their members on where good jobs were available, and on which employers to avoid. They provided loans to their members, and always helped indigent members. They offered support to members' businesses, and provided scholarships to members of their communities. They settled disputes among their members, and sometimes provided legal defense funds for members who were on trial in the colonial courts. They also provided funeral support when members died in the city. In numerous ways, these voluntary organizations helped cushion the harsh vagaries of the colonial capitalist exploitation, and indeed helped many Africans to maintain their psychological balance in the cities.

One of the striking features of the new urban centers was the large number of young men living in the towns. Up to two-thirds of African population of most cities was comprised of people under the age of thirty.[37] The city attracted the young, especially those without wives and children, for it was easier for them to

37. Michael Crowder, *West Africa Under Colonial Rule* (London: Hutchinson, 1968), 341.

leave home to seek their fortunes. Also the labor recruiters in the mines of southern Africa and elsewhere preferred young energetic men. As the rural economy became impoverished, struggles for access to resources became more competitive and drawn along generational lines. Elders and chiefs tightened their controls in the rural areas. At the same time Western education, wage labor, and international commerce, most of which were located in the urban centers, offered expanding opportunities for giving ordinary people access to wealth. The young men, therefore, had to leave for the cities where they hoped not only to get their freedom from oppression of the elders, but also to strike it rich. Many young commoners hoped to take advantage of the new economic opportunities in the cities to became "big men," and go back to their villages and take chiefship titles. Ultimately, few succeeded and many were disappointed. Urban reality in colonial Africa was harsh.

Young men were not the only ones interested in going to the cities for economic opportunity and social freedom. Women, particularly young women, were also interested in accumulation and autonomy, especially from the patriarchal control of old men in the villages. Although the colonial state did not want African women in the towns, many women of course, did move. While gender was relatively balanced in the older precolonial towns, there was a heavy gender imbalance in most of the new towns. Some towns had ratios of men to women as high as five to one, especially in the mining migrant labor towns. Generally, wage labor, either in the mines, railway, seaports, or the colonial civil service, had no room for women. But once in the towns, women found other opportunities. The expansion of commerce and the cash economy during the colonial era helped some urban women acquire wealth through trade. Sekondi-Takoradi, for example, was an active site of female accumulation in the colonial Gold Coast.[38] Just as there were "big men" during this era, there were also "big women," who succeeded in the expanding urban economies. In Onitsha, there were such great wealthy women entrepreneurs as Omu Okwei, Okwunne Bachi, Iyaji Enwezor, and numerous others who controlled the exchange between the European trading companies and Africans.[39] These women acquired property on their own, especially in parts of the town where property rights and law were becoming fluid and changing because of colonial intrusion. Some bought cars—a new symbol of wealth. They also acquired followership—old symbol of wealth—including retinues of servants and hangers-on to whom they doled out largesse and generosity just as the "big men" used to do. Simply put, those women were challenging the patriarchy.

Most urban women did not become this wealthy, but many were able to find ways to earn income on their own, independent of male providers. As sellers of cooked food, retailers of alcoholic beverages, providers of recreation and domestic comforts, and sellers of sex, urban women contributed to the social reproduction of urban wage labor, while accumulating some wealth for themselves.

38. Emmanuel Akyeampong, " 'Wo pe tam won pe ba' ('You like cloth but you don't want children') Urbanization, Individualism and Gender Relations in Colonial Ghana, c. 1900–39," in David Anderson and Richard Rathbone (eds.), Africa's Urban Past (Portsmouth: Heinemann, 2000), 225.

39. Patrick Mbajekwe, "Trade and Development in Onitsha, 1857–1960," (MA Thesis, University of Lagos, 1991), 61–62; Felicia Ekejiuba, "Omu Okwei: The Merchant Queen of Ossomari, A Biographical Sketch," Journal of Historical Society of Nigeria 3, 4 (1967): 633–646.

In these struggles for accumulation and survival, women began to challenge the patriarchy and assert their rights to control of their sexuality. Some of them even exploited their sexuality for the acquisition of wealth. Traditional Africa subsumed female sexuality within the context of marriage, which was controlled and negotiated on men's terms. But in the emerging urban centers, where urbanization was beginning to dilute the male elders' control, women could contract their own marriages (or concubinage), using their sexuality to negotiate for their interest. From the 1880s, court records in the colonial Gold Coast revealed an increasing tendency in the coastal towns for women to contract marriages without the support of their male kin. In Lagos, educated elite women were insisting on ordinance marriage, that is marriage according to English common law.[40] In the Zambian Copperbelt, women were flooding the colonial courts to divorce unsatisfactory and abusive husbands in recognition of their new jural rights.[41] What was being contested was "the very definition of sexuality and the obligations of marriage."[42] Some women sought to reshape gender relations.

But the emerging assertiveness of women did not please African men or the colonial authorities. African men, both in the towns and the villages, viewed with alarm this new female challenge. The colonial authorities perceived women's newfound freedom as a threat to the authority of the chiefs, and consequently a threat to the colonial system that depended on the chiefs. Both the African men and the colonial authorities couched the women's assertiveness and quest for accumulation in the metaphors of "moral crises" and prostitution, saying that they must be checked. That women could have autonomy over their sexuality was bad enough, but that they could accumulate wealth with that autonomy was intolerable. By the 1930s, the colonial authorities, chiefs, and even educated African elite men began to look for ways to reassert their patriarchal power. They redefined or invented customs through the codification of customary laws that were designed to expand the powers of the chiefs, and brought "frivolous" women under control "through the regulation of newly amended "traditional" marriage, divorce, child custody, and inheritance laws."[43] Simultaneously, Western missionary education was actively emphasizing and indoctrinating women on their roles of "wifehood" and "motherhood." By the start of World War II, the gates of patriarchy had been "firmly shut, and women were again subordinated to men."[44]

Emergence of New Urban Popular Culture

As the urban centers were taking shape during this early colonial period, new forms of urban culture and city life were also emerging. African cities created new forms of social life and brought new interpretations and meaning to the concepts

40. Kristin Mann, *Marrying Well: Marriage, Status and Social Change Among the Educated Elite in Colonial Lagos* (Cambridge: Cambridge University Press, 1985), Chapter 4.

41. Jane Parpart, "Sexuality and Power on the Zambian Copperbelt: 1926–1964," in Sharon Stichter and Jane Parpart (eds.), *Patriarchy and Class: African Women in the Home and the Workforce* (Boulder: Westview Press, 1988), 117–119.

42. Akyeampong, *Drink, Power and Social Change,* 48.

43. Parpart, "Sexuality and Power," 119.

44. Akyeampong, *Drink, Power and Social Change,* 48.

Figure 13-5. Modern urban scene

of leisure, sports, and performance culture. In their attempts to make sense out of their new colonial exploitation, Africans developed new urban popular cultures that became not only excellent symbols of African creativity and syncretism, but also instruments of struggle against the colonial rulers for control of the cities. It was a struggle to create a congenial environment for survival.

For many young urban migrants, social drinking became a new way of life. Bars, clubs and drinking circles emerged as central institutions of urban life. Alcohol, especially in the mining and industrial cities, provided an escape from the harshness of industrial labor and social alienation of colonial towns.[45] For many of the migrants who were unprepared for the alienating nature of industrial labor, drinking circles provided a replacement, albeit a false one, for the family and kinship networks left behind in the countryside. In the mining compounds of the Witwatersrand, the state and capital concerns unashamedly encouraged African workers to consume cheap liquor. This not only provided handsome returns to the state and the entrepreneurs that supplied the liquor, but was supposed to help provide "a more stabilized—if not more sober—black labour force since the many migrant workers who spent their wages in liquor saved less of their earnings... and thus tended to labour underground for periods that were significantly longer than would otherwise have been the case."[46]

In the townships, new European-oriented sports like football (soccer), boxing, athletics, and tennis were beginning to emerge during this early colonial pe-

45. Akyeampong, *Drink, Power and Social Change*, Chapter 3.
46. Charles van Onselen, *Studies in the Social and Economic History of the Witwatersrand 1886–1914: Vol. 1 New Babylon* (London: Longman, 1982), 6.

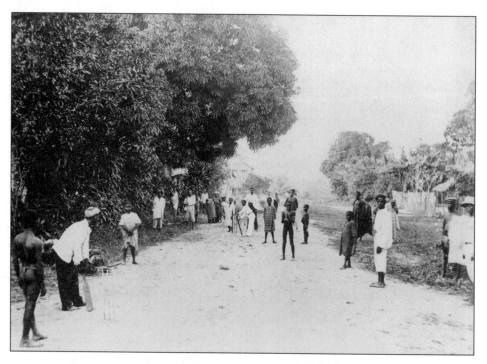

Figure 13-6. New sport in Africa: Cricket game in the street

riod. European mission schools as a means of channeling the bustling energy of
young African boys and girls to "disciplined" and "civilizing" forms of leisure in-
troduced most of these games. But soon Africans appropriated these sports, and
developed them into instruments of identity, group solidarity, and socialization. In
Brazzaville, as in most colonial towns, football (soccer) "was a child of the
streets, popularized by players in neighborhood games."[47] The boys played on the
dirt roads barefooted, and often with rag balls. Later they began to organize soc-
cer teams on their own, or with the support of the schools, missionaries, their em-
ployers, or the municipal governments. In 1929, they formed the Native Sports
Federation to coordinate activities and arrange matches. By 1931, there were
eleven independent teams in Brazzaville, each with hundreds of supporters.

But it was in the area of performance culture—music, dance, and theater—
that the vitality and creativity of African urban popular culture was best exhibited.
In African societies where music and dance had always been integral aspects of life,
these performance cultures were extended to express the process and experience of
urbanization. Before World War II, the old and the new were blended together all
over urban Africa by ingenious urban dwellers, who produced unique and vibrant
music and dance forms. In Lagos, for example, *Juju* music was beginning to
emerge as a named popular genre in the 1930s. The originators of this musical
genre fused elements of urban palm wine guitar music, Africanized Christian
hymnody, and Yoruba verbal and musical traditions to construct a distinctive, eco-

<hr>

47. Phyllis Martin, *Leisure and Society in Colonial Brazzaville* (Cambridge: Cambridge
University Press, 1995), 103.

nomically viable urban syncretic musical style.[48] Most of the early *juju* musicians in Lagos were immigrant African working class, who performed at naming, wedding, funeral, and house-warming ceremonies, as well as at hotels, bars, and club houses. Their performances sometimes provided them with secondary income as they tried to survive in an economically precarious urban environment. And their patronage was as diverse as the urban environment itself, ranging from the Western-educated elite to the heterogeneous illiterate and semi-literate urban working class immigrants. *Juju* has since grown to be one of Africa's greatest contributions to the world of music, with such internationally acclaimed superstars as King Sunny Ade and Chief Commander Ebenezer Obey. Throughout the continent, elements of creativity and syncretism, survival and protest, resonated with the emergence of new urban popular cultures, as could be seen in the development of the "Highlife" music in the Gold Coast, the Beni *Ngoma* dance societies of eastern Africa,[49] or the myriad of new performance styles of urban Black South Africa.[50]

Cities and Early Nationalist Agitation

The towns also provided centers for early African participation in modern politics as well as nationalist agitation. They were centers for articulating demands by the educated African elite of the various colonies. The towns brought together Africans from diverse ethnic groups, and although many still retained the sentiments of their ethnic interests, they also began to transcend and challenge those sentiments. As they did so, a new crop of emerging educated elite began to articulate their demands from the colonial governments. Having obtained Western education, only the towns could provide them with employment that matched their skills. Naturally, they also began to agitate for greater participation in political affairs.

In French West Africa, African participation in French elections had been allowed since 1848 only in the Senegal's four communes—Dakar, Rufisque, Gorée, and Saint Louis. But it was not until 1914 that an African, Blaise Diagne, an educated customs official, was elected as a representative to the French parliament. Diagne organized one of Africa's earliest modern political parties, the Republican Socialists. Along with other colleagues like Galandou Diouf and opposition leaders like Lamine Guèye, these educated Africans made what then were considered radical political demands. They wanted more political participation, equal pay for equal work (Europeans were paid higher wages than Africans even if they held the same position), better educational opportunities, and equality with Europeans. Also in the British colonial towns of Lagos, Accra, Cape Coast, and Freetown, the educated African elite were also forming political movements and demanding to have elected representatives in the colonial governments, while criticizing and attacking colonial authorities. They established newspapers in

48. Christopher Waterman, *Juju: A Social History and Ethnography of an African Popular Music* (Chicago: University of Chicago Press, 1990).

49. Terence Ranger, *Dance and Society in Eastern Africa, 1890–1970: The Beni Ngoma* (Berkeley: University of California Press, 1975).

50. David Coplan, *In Township Tonight! South Africa's Black City Music and Theatre* (Johannesburg: Ravan Press, 1985).

these towns for articulating their opposition to colonial forces. In 1920, these educated elite formed the National Congress of British West Africa to demand social, political, and economic changes in West Africa. They urged the British to lay the basis for a future self-government, to introduce franchise, and provide for higher education, and to recruit Africans into the senior civil service.

These early anti-colonial movements were always criticized as being too elitist and accommodationist. But when the more radical nationalist movements arose in the 1930s and after, they almost always began in the towns and were led for the most part by the urban educated elite. The Nigerian Youth Movement was formed in Lagos in 1934, the Gold Coast Youth Conference was convened by J.B. Danquah in 1938, as well as the West African Youth League in Freetown by I.T.A. Wallace-Johnson. Nnamdi Azikiwe established his highly influential *West African Pilot* in Lagos in 1937, after editing the *African Morning Post* in Accra for three years.

Conclusion

By 1939, when European colonial rule in Africa was reaching its middle age, the African population growth was increasing. Epidemics had been greatly controlled, death rates reduced, and access to modern medicine improved. At the same time, Africans were increasingly moving to the urban centers, despite efforts by colonial rulers to check them. From the end of the World War II onwards, both population and urbanization rates in Africa had been growing exponentially.

Review Questions

1. Account for the state of African population and health in the early years of colonial rule, 1880–1920.
2. Why and how did European colonial rule transform the nature of urbanization in early colonial Africa?

Additional Reading

Steven Feierman and John Janzen (eds.). *The Social Basis of Health and Healing in Africa.* Berkeley: University of California Press, 1992.

Dennis Cordell and Joel Gregory (eds.). *African Population and Capitalism: Historical Perspectives.* Boulder: Westview Press, 1987.

Joel Gregory (ed.). *African Historical Demography Vol. 2: Proceedings of a Seminar Held in the Centre of African Studies, University of Edinburgh, 24th and 25th April 1981.* Edinburgh: University of Edinburgh Press, 1981.

Catherine Coquery-Vidrovitch. "The Process of Urbanization in Africa (From the Origins to the Beginning of Independence)," *African Studies Review* 34, 1 (1991): 1–98.

David Anderson and Richard Rathbone (eds.). *Africa's Urban Past.* Portsmouth: Heinemann, 2000.

Chapter 14

African Intellectual Life During the Colonial Era

Andrew E. Barnes

This chapter considers three developments in African intellectual life during the colonial era. First, the migration of African intellectuals away from Christian ways of thinking toward secular scientific modes of thought. Second, the emergence in Paris of the Negritude movement, which, as promoted by Léopold Senghor, celebrated the African mind as instinctively poetic. Third, the emergence of African Prometheans, that is, Africans who sought in some way to steal the "fire" of some aspect of European civilization and then introduce this fire to other Africans.

* * *

This chapter sketches some of the developments that characterized African intellectual life during the era when the African continent was occupied by European colonizers. Many ideas unrelated to colonial occupation first emerged in Africa during this era. Given the theme of the volume, however, it makes sense to concentrate on those developments that best convey African reactions to the ideas of the colonizers. Three developments are highlighted. The first is the African migration toward secular and away from religious modes of intellectual explanation. The second is the Negritude movement, presented here as an African response to European ideas of the connections between civilization and race. The third involves several examples of "African Prometheans," that is, African individuals who introduced European ideas in Africa in the face of European opposition.

All three developments reveal the same pattern of response by African intellectuals to the stimulus of colonization. In all three, African intellectuals aggressively laid claim to European ideas and attempted to apply these concepts in order to further what they saw as the African cause. Far from withering in the face of European assertions that Africans as a race were mental midgets or that African peoples had nothing to contribute to world civilization, African intellectuals sought recognition as thinkers and as bearers of culture in ways that both frustrated and angered European racists. More important, instead of rejecting all European knowledge as tainted with racism, African intellectuals systematically explored Western thought in search of ideas that might aid them in their struggles. As noted in the chapter on Western education during the colonial era, European colonizers did their best to inhibit African access to Western intellectual thought. But the colonizers failed, and by the end of the colonial era African intellectuals were turning around the ideas with which Europeans had justified colonization and using those same ideas to garner worldwide support for African liberation.

The Secularization of African Thought

At the start of the twentieth century Africa had a maturing, if not mature, westernized African intelligentsia. This intelligentsia was self-consciously Christian. A primary concern of the colonizers was to suppress the influence of this intelligentsia, both among Africans and among European sympathizers. While the colonizers never quite achieved their goal, they did succeed in discrediting Christian African thinkers as representatives of African consciousness. Christianity was recognized by Europeans, and the rest of the world's peoples, as a European religion, with the result that the same audiences dismissed African Christians as indulging in collective self-denial about who they were and what they and other Africans were about. The marginalization of African Christian intellectuals created an opportunity for Africans trained in secular-scientific intellectual traditions to seize the spotlight. The case against European domination being made by this second group of intellectuals was not very different from the one being made by the first. But European sympathizers listened to the latter argument, and invested it with authority as more authentically African. African intellectuals who wanted public recognition progressively came to seek it through the agency of secular modes of expression.

The late-nineteenth-century African Christian intelligentsia was small and very localized, existing almost exclusively in the western and southern regions of the continent. Its members wrote mostly in French and English. It would be wrong to say that this intelligentsia narrowly associated Christianity with Europeans and European culture. One of the signs of its maturing was in fact the effort by some of its leaders to establish churches that offered Africans a Christianity in which they could see themselves. But this intelligentsia did associate civilization with notions drawn from nineteenth-century European Christian liberalism.

Liberalism emphasizes individualism and celebrates the idea of a society built upon laws that apply equally and fairly to everyone. Christian liberalism supported such views, mostly by granting theological justification to the idea that obstacles in the path of individual achievement were not just counterproductive but contrary to God's will. In nineteenth-century Africa, Christian liberalism was identified further with the development of an African bourgeoisie in the image of the existing Western European bourgeoisie. Such a bourgeoisie would be composed of well-educated merchants and professional people, who respected and rewarded proper behavior and intellectual achievement.

At the moment when Africans were embracing them, these ideas were being rejected in Europe itself. By the end of the nineteenth century, liberalism was being attacked in Europe as promoting the interest of the individual over the interests of the community. Even more damaging, Christian liberalism was seen as the ideology of financial and industrial elites, who were primarily concerned with profit and rarely concerned with the groups they exploited to make that profit. Positioned as ideological alternatives to liberalism were imperialism and scientific racism on one side, and trade unionism and communism on the other. Theorists for all these alternatives were antipathetic toward Christianity among Europeans as well as among Africans.

Colonial governments feared the political threat posed by educated Africans. European racists dismissed Africans as lacking the intellectual ability to say things worthy of attention. Both of these factors help explain why during the early

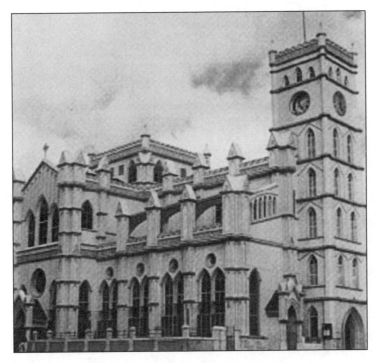

Figure 14-1. A cathedral in Lagos

decades of the colonial era Europeans turned a deaf ear toward the statements of African intellectuals. Equally significant as a factor, however, was the fact that most African intellectuals were Christians, and the dominant European intelligentsia was antagonistic toward Christianity.

As far back as twelfth-century Europe, when groups of Christian laymen known as Waldensians had insisted on preaching on street corners, intellectual authorities, in those days the clerical elite in Rome, had postulated that there were two levels of preaching, by which they meant intellectual expression. On the lower level there was testifying, that is, giving evidence of moral and spiritual truths through narratives of one's own experiences or those of others. On the higher level there was dogmatizing, that is, theorizing and commenting upon moral and spiritual truths. Recognizing the spiritual sincerity of those preaching laymen, Roman authorities granted them the right to preach as long as they restricted themselves to testifying, leaving the dogmatizing to the clergy itself.

Since the twelfth century, testifying has retained a niche in Western intellectual life as the space where those with cultural authority permit those without cultural authority to have a say. As a literary form, testifying continued to evolve, achieving under Protestant Christianity its purest form in the literary genre of autobiography. More generally, beyond its continued vitality in Christian evangelism, testifying can still be seen as the principle underlying a plethora of Western cultural forms from the "expert witness" in legal trials to the self-confessions in daytime American television talk shows.

In the history of African intellectual life, testifying is important because it was the one way Europeans allowed Africans to express themselves to European audiences. Beginning in the nineteenth century, most missionary organizations sold

monthly magazines to European and American subscribers to help raise funds. When Africans authored the stories in these magazines, they attached testimonials about the meaning of Christianity to them and to their people. Books and other extended pieces of writing by Africans followed the same pattern. They were published as varieties of autobiographical testimonials, even if their subject matter varied.

Secular cultural authorities followed the same practice. Africans were introduced into the texts written by secular Europeans as witnesses to the truths these Europeans had discerned. This process is seen most powerfully in the discipline of anthropology, where African "informants" were used extensively to confirm the findings of researchers. But political officials also made use of "native" testimony. The notion that all the Africans were doing was testifying allowed Europeans to simultaneously claim African ideas and dismiss the intellectual import of those ideas. For example, few individuals in Africa or Europe could claim the scholarly and intellectual attainments of the nineteenth-century West African thinker Edward W. Blyden. Blyden's work was characterized by its use of texts and of textual analysis. Blyden is best remembered for his case against Christianity and for Islam as the best religion with which to "civilize" the African. Yet when Frederick, Lord Lugard, made use of Blyden's arguments in his *Dual Mandate in Tropical Africa*, he introduced Blyden only as a distinguished "native" writer, and gave him credit only for his ability to validate Lugard's own observations on the value of Islam for the African.[1]

Lugard's use of Blyden provides a clue to one of the primary uses to which government officials put the words of Africans, that is, in arguing the case against Christianity. Concerned to blunt the lobbying efforts of missions in European capitals, officials turned to Africans for evidence of the destructive impact of Christian evangelization on African communities. Condemnation of missionary initiatives by colonial officials in turn invited condemnation of government initiatives by missionaries using Africans for evidence. Thus, over the course of the colonial era, Africans found that opportunities to testify for Christianity were progressively replaced by opportunities to testify against some aspect of the European presence in Africa.

The true measure of the degree to which the growth of secularism in Europe changed the nature of African intellectual thought would not become obvious until the 1950s, the last decade of the colonial era. By then, at least two generations of Africans had been through (secular) government schools in Africa, and those identified as intellectually gifted had completed post-secondary education in Europe or the United States. During the same decade, the first novels by African authors were being published in European languages to almost universal acclaim. From that time onward it has been as writers of fiction that African intellectuals have gained their greatest recognition.

But there is evidence of the growing impact of secularism from earlier decades of the colonial era. Take, for purposes of illustration, two texts authored by African intellectuals, written at different times and in different places, but with the same goal in mind. Sol Plaatje's *Native Life in South Africa* (1916) was written to protest the Native Land Act passed in 1913 in the Union of South Africa.

1. Frederick Lugard, *The Dual Mandate in British Tropical Africa* (London: W. Blackwood Press, 1922; reprint, London: Frank Cass Publishers, 1965), 78, note 3.

This act prohibited the African ownership of land in Union territory. Plaatje, a journalist, linguist, and poet best known for his compilations of Bantu proverbs, wrote *Native Life in South Africa* in an effort to sway political opinion in Britain and among British South Africans against the act. There is very little about native life in the book, except for depictions of African farmers being evicted from the land. Rather, the book narrates the history of the legislative process through which the act was enacted and the subsequent social costs for both black and white South Africans. Most striking in the book are the intellectual ploys used by Plaatje to manipulate his audience. Plaatje stoutly affirmed the connection between property ownership and social progress that was an axiom of Christian liberalism. His indictment of the land act was that it took away from Africans the opportunity to work hard and get ahead through the ownership of property. So his book is full of stories of African farmers who, just as their industry was beginning to bear fruit, had their future wiped out by the Native Land Act. Clearly, the people he was trying to reach were bourgeois Christians in Britain for whom private property was inviolable And he was trying to communicate that if it could happen in the colonies, it could happen in the metropole. Plaatje was aware, however, that racism and imperialism inhibited most Britons from seeing themselves in the same plight as exploited African peasant farmers. So a second theme he emphasized was the role of the Native Land Act as a destroyer of African yeomanry loyal to the Union Jack. Celebrating the vision of the British empire builders of the nineteenth century, Plaatje ponders, "What would those Empire builders say if they came back here and found that the hills and valleys of their old Cape Colony have ceased to be a home to many of their million brawny blacks, whose muscles helped the conqueror to secure his present hold on the country?"[2]

Plaatje's book can be compared to Jomo Kenyatta's *Facing Mount Kenya*, written a generation later in 1938. Like Plaatje, Kenyatta was writing against settler appropriation of African land, in his case, the appropriation of Gikuyu (Kikuyu) tribal lands in the Kenyan highlands. Unlike Plaatje, Kenyatta made his case using arguments from anthropology. Like Plaatje, Kenyatta began his career as a journalist, before moving on to become an activist in the Gikuyu's struggle to regain their lands. He traveled to London, where he spent many years as a lobbyist for the Gikuyu cause. While in London he studied anthropology and was one of the first Africans to receive a degree in that discipline. *Facing Mount Kenya* was a reworking of his master's thesis. One of the tenets of anthropology as it was then taught was that every race or group of people evolves as a culture at its own rate and out of its own social institutions. Building upon this idea, Kenyatta argued in *Facing Mount Kenya* that the European appropriation of Gikuyu land, because it compromised Gikuyu social institutions, and particularly the family structure, inhibited the evolution of the Gikuyu as a group. Scientific racism insisted that Western civilization was a European affair, and that Africans had to evolve their own culture, derived from their own racial past. Turning this argument around, Kenyatta made the case that European actions were interrupting the very process for which Europeans were looking.

2. Sol Plaatje, *Native Life in South African Before and Since the European War and Boer Rebellion* (London: King and Sons Press, 1916; reprint, New York: Negro Universities Press, 1969), 162.

Neither the argument of Plaatje nor that of Kenyatta produced the desired outcome. But that is not the point. What is important is the intellectual stance the arguments permitted their authors to take. Plaatje could not grasp that Christians did not control the British Empire. Thus there is a plaintive cry of disbelief and betrayal running through *Native Life in South Africa*. As Plaatje commented at one point, he could not accept that a "government of professed Bible readers...in defiance of all Scriptural precept," could pass and enforce a law such as the Native Land Act.[3]

In contrast, Kenyatta knew that he had (social) science on his side. Thus he expressed a confident certainty in *Facing Mount Kenya* that the Gikuyu occupied a moral high ground and would some day be vindicated. After narrating the subterfuges by which Europeans gained control of Gikuyu land, Kenyatta related a story supposedly told among the Gikuyu. One day during a driving rainstorm a man, representing the Gikuyu, gave shelter in his hut to an elephant, representing a European. No sooner had the elephant entered the hut than he claimed it for his own. The man and the elephant began to argue. Along came a lion, who as king of the jungle, represented the British Crown. In good British fashion, after hearing the nature of the argument, the lion decreed that there should be a commission of enquiry into the dispute. The elephant, one of the chief ministers of the king, was given the task of staffing the commission. Not surprisingly, he staffed it with other animals of the forest, in other words, other Europeans and not surprisingly as well, the commission ruled in favor of the elephant. Disappointed and disillusioned, the man moved out and built himself another hut. But the same process was repeated. Another animal laid claim to his hut and another commission of enquiry ruled in the animal's favor. This continued until all the animals lived in huts built by the man. Finally the man used all of his skill and ability to build the biggest and best hut that he could. All of the animals saw it and came running to claim it. While they were inside the hut arguing, the man set fire to it and burned them all to death. The man, Kenyatta informs us, "lived happily ever after."[4]

Negritude

In the 1930s French-speaking African and Afro-Caribbean students living in Paris initiated an intellectual movement to identify and proclaim the nature of African consciousness. The search they began for the essence of "Negritude" or blackness was the starting point for many later movements to define black consciousness, including the recent Afrocentric movement in the United States. From the start, however, the notions of Negritude were controversial, especially as propounded by their first great African advocate, the poet and politician Léopold Sédar Senghor. Senghor angered many black intellectuals by suggesting that in contrast to the rigorous masculine rationalism of the European way of thinking,

3. Plaatje, *Native Life in South Africa*, 76.
4. Jomo Kenyatta, *Facing Mount Kenya: The Tribal Life of the Gikuyu* (London: Secker and Warburg, 1938; reprint, New York: Vintage Books, 1965), 47–51.

the African way was emotional, feminine, and intuitive. As he once
tion is Negro, while reason is Hellenic."[5]

Senghor and the rest of the first generation of thinkers about N
to be seen, however, in the context of the intellectual dialectic tl
tween Africans and Europeans during the colonial era. This dialectic, .
trolled by Europeans, granted no space for an autonomous African intellectual
existence. That first generation carved out a space for just such an existence. The
qualities they ascribed to blackness may have angered other groups of black intel-
lectuals, but the overall image of black consciousness they advanced has had re-
markable vitality among peoples of African descent.

What follows is not so much a history of the movement, as a brief sketch
aimed at situating it within the broader confines of the exchange of ideas between
Africans and Europeans and conveying some of the movement's cultural import.
Aimé Césaire and Léon Damas figured as prominently in the origins of the negri-
tude movement as did Senghor. Their ideas will not be discussed here primarily
because they were Afro-Caribbeans, while the concern here is to identify African
reactions to European cultural hegemony. Césaire and Damas, like Senghor, were
poets, and while the poetry of all three continues to be read, it is rarely given
pride of place in any anthology of poetry by peoples of African descent. Given
that most of this poetry was written and published in Paris, it might even be ar-
gued that what the poets of Negritude had to say is best appreciated in the con-
text of French intellectual history. It bears repeating, however, that it is not so
much what they said but the space their writings created for later generations that
makes them important in the study of African intellectual life.

From the beginnings of systematic contact between European explorers and
African peoples in the fifteenth century, European intellectuals insisted that the
superior civilization of the Europeans validated their exploitation of Africans.
The original arguments for cultural superiority were all based on the European's
possession of Christianity. Because Africans were heathen, these arguments went,
Europeans were doing Africans a favor by enslaving them, because only through
slavery would Africans develop the discipline needed to convert to Christianity
and thus be saved. By the end of the eighteenth century, African writers such as
Olaudah Equiano were mounting effective challenges to such arguments, mostly
by questioning the depths of the European's own Christian faith.

The arguments Europeans used to rationalize the colonial conquest of Africa at
the end of the nineteenth century were based on a different notion of civilization,
one which celebrated European technological and scientific achievements. These
achievements proved to Europeans that their mental abilities were far superior to
those of all other peoples on earth, and that their civilization was beyond anything
that non-European peoples could grasp. Following the notions of social Darwin-
ism, which sought to explain human social behavior according to the laws of na-
ture, most specifically Charles Darwin's notion of the "survival of the fittest," con-
quest of African lands was justified as a natural act by a superior biological species.

An important attribute of late-nineteenth-century European imperialist ideol-
ogy, now rarely discussed, was that it promised a solution to class conflict within

5. Jacques Louis Hymans, *Léopold Sédar Senghor: An Intellectual Biography* (Edin-
burgh: Edinburgh University Press, 1971), 66.

European societies. Industrialization and capitalistic growth had created societies of haves and have-nots, with the have-nots incessantly demanding inclusion. Colonies were presented to the European public as places where the have-nots could go and seek inclusion. The reason why there was so much social conflict in Europe, the argument went, was that the competition among members of Europe's "master races" necessarily generated winners and losers. The losers in these contests, however, were still far superior to even the most outstanding members of "subject races." It made sense, then, to conquer the lands inhabited by subject races to provide "living space" where losers from Europe could lay claim to their perquisites as members of master races.

Among other things, the idea that any European was better than every African helped guarantee that intellectually gifted Africans would be alienated from colonial-era liberal ideologies. Liberalism as advanced by European thinkers during the first half of the twentieth century left the door open to the possibility that intelligent non-Europeans might contribute to Western civilization's furtherance. Racist arguments such as the one just outlined closed this door. And because the motivation behind the closure was the creation of more opportunities for the poorer classes of Europeans to get ahead, the door remained shut for most of the colonial era. Because liberal ideals were honored only in the breach, many Africans who were trained to believe in liberalism, such as the students in Paris, came to distrust it. Observing the thinly veiled policies of racial preference maintained by ostensibly liberal colonial governments, just as earlier generations of African intellectuals had grown skeptical about the sincerity of European Christianity, colonial era generations grew skeptical about the sincerity of European liberalism.

Nowhere was this skepticism a more important factor than in the African reaction to the European celebration of European scientific achievement. Europeans proclaimed science as a great moral breakthrough for all the earth's peoples. Science was a new truth that rendered all proceeding truths meaningless. Because of the European use of science to reinforce racism and oppression, however, Africans remained skeptical about science's moral validity.

Throughout the nineteenth century, a prime concern of European science was to demonstrate the mental superiority of Europeans. Early theories all started from the premise that the physical size of the brain was the clearest indicator of intelligence. So tests were devised to demonstrate that Europeans had larger or heavier brains. Later theories postulated instead that intelligence was a measure of cognitive capacity, that is, the ability to process data. These theories spawned the intelligence tests and other standardized tests that are still a feature of Western education. These tests were initially applied to the task of justifying the status quo in European societies. They were used to demonstrate not only that the have-nots were mentally inferior to the haves, but that the have-nots were prone to crime, violence, and sexual license. Only after justifying social inequality among Europeans were the tests used to demonstrate the mental superiority of Europeans over the other peoples of the globe. In other words, again we see that a desire to validate divisions among Europeans resulted in an emphasis on the difference between Europeans and Africans to the detriment of Africans. In Africa the tests were used to illustrate the general intellectual inferiority of all Africans, and to justify the exploitation of Africans for manual labor. Some Africans, and Senghor was prominent among them, were so obviously intelligent that even Europeans

could not deny their intellect. At least in the French colonies these individuals were recruited to work for the state and sent to France to study. But for these African intellectuals it was impossible to ignore either the brutalization of other Africans based upon their supposed lack of mental ability, or the obvious lack of intelligence of many Europeans in privileged positions.

Europeans claimed superiority in all mental and physical skills. Reflecting a sense of pride in their technological and scientific achievements, however, Europeans identified tool use as the greatest of all human abilities, and the mathematical skills required to make and use tools as the highest of mental skills. What made Europeans collectively the smartest race on earth, European writers explained, were the Europeans' mathematical abilities. The various tests of mental abilities devised by Europeans demonstrated this. And the histories of Western civilization were rewritten to tell the story of how Europeans discovered this ability and put it to use to make themselves masters of the globe.

Intellectuals of African descent in the United States never conceded primacy in tool use to Europeans. They insisted that the ability to invent and use tools was inherited by Europeans from Africans. Tool use, or technology, had been developed in ancient Egypt, where the first principles of mathematics were also first discovered. From there it had spread to ancient Greece, and then from there to Rome, the Arab Muslim world, and finally Germanic Europe. Europeans had tried to hide the connections first by denying the transfer of culture from Egypt to Greece, and second by picturing the ancient Egyptians as Europeans, not as Africans.

African intellectuals who concerned themselves with the question of European intellectual pretensions during the colonial decades, however, approached it from a very different perspective. Africans were interested not so much in challenging the consciousness Europeans claimed for themselves as in developing an alternative African consciousness. Alienated from Western civilization, they sought to identify an African way of thinking that they could claim as distinct from and even opposite to European patterns of thought. Yet while African intellectuals did not challenge the European self-image, they did use it as the point of departure for their own investigations into self. Thus, they sought to affirm as African all the qualities they believed the Europeans lacked.

Negritude as presented by Senghor was never as much a celebration of African achievement as it was a proclamation of the superiority of the African way of perceiving the world. In a sense Senghor was guilty of putting the African perspective on a pedestal, because his greatest concern was to demonstrate that it would be impossible for a true African to create something as hypocritical and spiritually bankrupt as early-twentieth-century Western civilization. The fact that he could make this point only in the context of telling Europeans they were exactly the people they wanted to see themselves as being does not take away from power of the point. It simply reveals the intellectual constraints out of which Senghor and the other poets were trying to break. Senghor was no intellectual freedom fighter; that title might more appropriately be granted to Césaire. But his many years of study and interaction with the best and the brightest of the French intelligentsia taught him the value of establishing an intellectual high ground and then arguing from it. Negritude was an intellectual high ground, the very first high ground intellectuals of African descent had forced European intellectuals to concede.

Reflecting later on his experiences in the 1930s, Senghor observed that

we were at that time in the depths of despair. The horizon was closed. There was no reform in the offing, and the colonizers were legitimizing our political and economic dependence by the tabula rasa [blank page] theory. They deemed that we had invented nothing, created nothing, written, sculpted, painted and sung nothing. Dancers, perhaps! . . . to institute a worthwhile revolution, our revolution, we had first to get rid of our borrowed clothing — the clothing of assimilation — and to assert our essential being, namely our negritude.[6]

For Senghor, that "essential being" emerged out of emotion: "Negro values opposed those of Europe; they opposed discursive, logical, instrumental reason. Negritude was intuitive reason, a loving reason, not the reason of the eye."[7]

For Senghor, emotion was the foundation of the intellectual high ground he sought. It was the quality that, as possessed by the African, guaranteed the African would not make the mistakes made by the European. What Senghor did not explain was that he could give the idea of emotion moral and spiritual value and then use it as a high point from which to look down at things European precisely because of the intellectual disrepute in which both discerning Africans and discerning Europeans held the European cultural ideal of mathematical cognition. By the 1930s, in other words, it had become clear to all but the most myopic enthusiasts that there were limits to what tools could do, and that there were areas of human consciousness inaccessible to mathematical reasoning. "Logic by itself," Senghor argued, "is incapable of comprehending reality."[8] To understand the real world, he continued, what was required was "a superior reason," a "vital elan," an "intuition of faith."[9] That superior reason was, of course, emotion. And since the "Negro" or African mind possessed this quality in the instinctive manner in which the "Hellene" or European mind possessed the quality of logic, Africans as a race had a better grasp of reality than Europeans did.

It may be that what truly alienated other black intellectuals from Negritude was that the poets who founded the movement never bothered to grant practitioners of any other intellectual discipline a space at the table. Negritude was first and foremost a poet's creed. What Senghor had in mind when he used the word emotion was not unregulated sentiment, but the rhythmic cadence of a poem being performed. "Rhythm," he observed, "which is born of emotion, in turn engenders emotion."[10] To this can be added the thought that, "Monotony of tone, which distinguishes poetry from prose, is the seal of negritude, the incantation enabling one to reach the truth of essentials, the Power of the Cosmos."[11]

Today Senghor's words seem remarkably prescient. The hip-hop revolution of the last two decades of the twentieth century has meant that at the start of the

6. Lilyan Kesteloot, *Black Writers in French: A Literary History of Negritude*, trans. by Ellen Conroy Kennedy (Philadelphia: Temple University Press 1974), 102.
7. Hymans, *Leopold Sedar Senghor*, 107.
8. Hymans, *Leopold Sedar Senghor*, 99.
9. Hymans, *Leopold Sedar Senghor*, 99.
10. Kesteloot, *Black Writers in French*, 103.
11. Kesteloot, *Black Writers in French*, 103.

twenty-first century, for people of African descent, it is indeed the rhythmic incantations of the poet that solemnize an event as authentically African. The hip-hop revolution suggests both the original pertinence and the continued relevancy of Senghor's ideas. What Senghor and the poets of Negritude had to say may have frustrated black intellectuals looking for rigorous arguments with which to do battle with white racism. But clearly they tapped a vein that ran deep in the collective self-image of African peoples vis-à-vis European peoples. At the start of the twenty-first century it remains important for African intellectuals, both in Africa and in the diaspora, to affirm the humanistic, artistic character of the African mind. These intellectuals point, first, to the black dominance of world musical culture, and second, to the black dominance of world athletic culture to support the case that the African is an emotive performer, not the cold hard thinking machine the European has discovered him/her self to be. These images may just be racial myths, soon to be discarded as new forms of collective identity emerge. But across the latter years of the twentieth century, they continued to provide black intellectuals with a moral and spiritual high ground from which to do battle with white racism.

The concern of this chapter, however, has been with the import of those ideas during the colonial era. Here, it is worth repeating that their greatest importance was that they gave Western-trained intellectuals of African descent a black "issue" to argue about. In all the centuries of cultural interaction between Africans and Europeans, there had never before been such an occasion where Europeans necessarily had to sit on the sidelines and observe while Africans performed, using cultural idioms Europeans considered their own. There had never before been a circumstance in which the African could presume the cultural authority to show the European where he/she had missed the point. The concept of Negritude, for all its weaknesses, provided the first entry of an autonomous African voice into Western consciousness. In that sense it was the most significant African intellectual achievement of the colonial era.

African Prometheans

Liberalism retained its advocates among Africans, however. Just as there were Africans who looked upon European culture and society with disdain, there were also Africans who looked upon European technology and material prosperity with wonder. Among the latter there were those who asked themselves the question, "How can we produce those things here in Africa?" then went in search of the one key idea or reform that was the secret to European success. The focus of the final section of the chapter is on these Africans and their efforts to introduce European ideas among Africans and then apply those ideas to the task of resisting colonial domination.

The last decade of the nineteenth century and the first three decades of the twentieth were the moment when European colonizers held their greatest sway over African peoples. Looked at from the African perspective, this was the moment of maximum confusion and disorientation. As suggested in the above discussion of the plight of Christian intellectuals, Africans were confronted with a situation where the old strategies for dealing with Europeans no longer worked.

In part because European life and society had changed, and Africans as yet had no insight into the nature of those changes.

In the decades under discussion, there was a further complication. For insight into the nature of European society African intellectuals had previously turned to critiques of European societies written by Europeans themselves. Fearful of Africans gaining any intellectualized understanding of colonial domination, during the early decades of the colonial era Europeans made a determined effort to halt both African exposure to contemporary European intellectual debate and dissemination of European ideas among Africans. The story of the introduction of European ideas by Africans in Africa during the colonial era, then, can be characterized as one of Africans lighting fires quickly extinguished by colonial authorities. Whether once lit the fires would have continued to burn is a moot question. It is impossible to determine whether or not the ideas had any real intellectual value for Africans, and whether or not the ideas might have provided the basis for some form of political mobilization among Africans. What the historical evidence makes clear is that there was a broad consensus among Europeans that the diffusion of any and all ideas currently being discussed among Europeans should be outlawed in Africa. One of the chief rationales for colonial governments developing written versions of African vernacular langauges, and then requiring all school texts be translated into these languages, was in fact a concern to limit the African acquisition of literacy in European languages and in that way control the spread of European ideas among Africans.

Of interest here are the African intellectuals who challenged this embargo. The European obsession with African rebellion meant that colonial authorities stepped in with force whenever a leader began to attract a following. Thus there were few political or social movements during this period, only leaders with dreams. These leaders and their dreams were important, however. They threatened the cultural arrogance out of which Europeans insisted that Africans could not mount effective challenges to colonial domination.

In Greek mythology there is the story of Prometheus, who, determined to help humankind, steals the gift of fire from the gods and passes it on to humans. The individuals in question can be portrayed as African Prometheans. They consciously grabbed and then promoted European ideas they thought contained the secret to European success. In Greek mythology, Prometheus' gift set humankind on the path to civilization. For the Africans who followed in his footsteps, however, whatever the nature of the benefits of European civilization they tried to introduce, European intervention usually compromised or negated the African reception of these benefits.

The stories of the African Prometheans did not have happy endings, at least in the short term. In the long term, however, they can be credited with having added something crucial to the African understanding of Europeans and their ways. Historians have never sufficiently appreciated the degree to which Europeans have jealously guarded the right to introduce European culture in Africa. If nothing else, African Prometheans forced Europeans, jealous of their roles as truth bearers, to be a bit more forthcoming in the knowledge they had to share. But for Africans perhaps the greatest legacy of the Prometheans has been the tradition of challenge to European intellectual hegemony that the Prometheans provided.

The early decades of the colonial era were a great age for the African Prometheans. The general confusion and disorientation provided an opportunity

for individuals to step forward with their ideas of the secrets of the Europeans and of how these secrets could help Africans fight back. Some of these individuals left Africa to tour and study in Europe or America. Some instead gained their insights through observing and conversing with European expatriates in Africa. All of them dreamed of illuminating the way forward for African peoples.

What follows is a series of brief biographies, highlighting the ideas and careers of three of the Africans who tried to introduce European ideas in Africa during the colonial era. The three individuals chosen, Herbert Macaulay, Simon Kimbangu, and Clements Kadalie, were chosen to provide some sense of the range of ideas intellectuals thought might help in the battle against European domination and the range of reactions these intellectuals and their ideas triggered, both among Africans and Europeans.

Herbert Macaulay

The Nigerian Herbert Macaulay sought to open African eyes to the power of the law. Macaulay, the scion of an illustrious West African family (he was the grandson of Bishop Crowther), was trained as an engineer, yet he made his mark as editor of his own newspaper and writer of political pamphlets. Macaulay trained in England, where he spent three years. Presumably it was during this period that he realized that the best way to do battle with the colonizers was to insist that they strictly adhere to their own laws. Macaulay's strategy against colonial rule was very similar to the strategy followed by the National Association for the Advancement of Colored People (NAACP) in the United States against segregation. In both instances the idea was to insist that the letter of the law be observed. For the NAACP the goal was to make "separate but equal" schools so prohibitively expensive to maintain, that segregation would have to fall. For Macaulay, the goal was to force the British colonial government to respect the legal rights Africans possessed as inhabitants of the British Empire. The government was not obeying its own laws, he argued, with the result that colonial officials were exercising their powers arbitrarily and to the detriment of Africans. If the laws were obeyed, then the actions of government officials could be regulated, and the civil rights of Africans protected.

Macaulay's most famous battle with the British Crown was over the question of the treatment by local colonial officials of the eleko, the traditional ruler of the city of Lagos. In 1861 the eleko had signed a treaty with the British Crown ceding the territory of the city to the British government. The eleko was supposed to receive a pension in return. Over the years, colonial governors had arbitrarily reduced the pension paid to the holder of the office of the eleko in order to pay other costs. Macaulay's case was that the government had no right to do that. A contract was a contract and the government was not free to change its commitments as it saw fit. As Macaulay argued, leaving aside the fact that the eleko did not have the authority to enter into such a contract in the first place and that this authority actually belonged to the "White Cap chiefs" who served as his advisors, the bottom line was that the holder of the office was being impoverished by the government's parsimoniousness. Macaulay first raised the eleko question in 1913. It took twenty years for the government to acknowledge the merit of his case and grant to the office of the eleko the funds and recognition it deserved.

Macaulay realized that to insist that British law be enforced in Africa was to insist that Africans be treated as equal to Britons before the law. The ultimate import of his lobbying efforts would have been the recognition of Africans as citizens of the British Empire on the same level as Britons themselves. The colonial government did not want this. Macaulay was harassed by the government. On a surveying trip outside his native Lagos in 1923, he was arrested on the suspicion that he was engaged in political activities and sent back to Lagos. In 1929, he was tried and convicted for criminal libel and sent to jail for six months. Macaulay died in 1946, just before the British government began its campaign to convince Africans that they could be treated fairly and equally within the British empire. As with the case of the eleko, then, the government eventually came to see the merit of Macaulay's argument. What is important here is that Macaulay based his arguments upon the idea of legal rights and bequeathed a legacy to later generations: an appreciation of the legal rights Africans possessed even while they were subjected to colonial domination.

Simon Kimbangu

Simon Kimbangu sought to introduce Africans to the power of the Protestant ethic. Kimbangu was a Christian religious leader and prophet who lived and preached in the Belgian Congo. Kimbangu's ministry was remarkably short. In April 1921 he began to preach and to perform miracles in his home area. By September of the same year he had been arrested and jailed by the colonial authorities. In October 1921 he was condemned to 120 lashes with the whip, then execution for "sedition and hostility toward whites."[12] In November the death sentence was commuted to life imprisonment. At that time he said goodbye to his family and was transported to prison in Elizabethville (Lumbumbashi) where he spent the last thirty years of his life, most of it in solitary confinement. He died in October 1951.

At first glance Kimbangu would not appear to be an African Promethean. He was only one of many African Christian leaders striving to develop an African church independent of European missionaries. But Kimbangu's special insight was to take his church in a very different direction from most other African independent churches. Most of the latter sought to reconcile Christianity with indigenous traditions and customs. Thus, many of them incorporated indigenous rites and rituals into their devotions. Many of them also permitted polygamy. Kimbangu, to the contrary, demanded that his followers leave behind the rites and rituals of their former lives, renounce polygamy, and concentrate their energies on living a pure life.

Most of the contact Kimbangu had with European missionaries before he began his ministry had been with British Baptists, who traced their origins back to early-seventeenth-century English Puritanism. Perhaps this connection provides the explanation for Kimbangu's essentially Puritan message. Puritanism had taken its thrust from the idea that it was the task of all true Christians to purge the world of its many pollutions. Kimbangu certainly followed this idea. Along with

12. Marie-Louise Martin, *Kimbangu: An African Prophet and His Church*, trans. by D.M. Moore (Grand Rapids, MI: William Eerdsmans Publishing Co., 1976), 62.

polygamy he condemned dancing. And as the historian of his movement reports, after he had preached, along the road he had followed, "discarded fetishes were found everywhere."[13]

Over the course of the twentieth century, seventeenth-century Puritan Protestantism was argued to be the source of almost every major social and political development in modern Western European history. Early in the century, for example, the German sociologist Max Weber wrote a highly influential treatise entitled *The Protestant Ethic and the Spirit of Capitalism* in which he argued that Puritanism was the source of the economic rise of Europe. Later in the century, the American political scientist Michael Walzer wrote a treatise entitled *The Revolution of the Saints*, in which he argued that Puritanism helped forge the model for modern political revolutions. What is clear is that looking back, modern Europeans saw in the discipline and internal drive of the Puritans a force powerful enough to change the world.

Belgian colonial officials must have seen something of the same thing in Kimbangu's movement. There is no other explanation for the Belgian overreaction. Kimbangu was not preaching sedition. Nor was he preaching hatred of whites. What he was preaching was a powerful, protean form of Protestantism that if it had been allowed to spread, would have created a disciplined, focused force for change among Africans.

Clements Kadalie

Clements Kadalie demonstrated for Africans what could be accomplished through mass political mobilization. A belief shared among many Africans living in the Republic of South Africa during the early decades of the colonial era was that the Africans who had gone furthest in beating Europeans at their own games lived in the New World, specifically the United States. Some local Africans nursed dreams of waves of African Americans parachuting down from the sky to liberate them from European settlers. More broadly, local peoples entertained hopes that African Americans would send money and guides to show them how to defeat the European. In the years after World War I, these hopes had come to center on Marcus Garvey and his United Negro Improvement Agency. Garvey's phrase, "Africa for the Africans" resonated in a land where Europeans had laid claim to the land. Starting in 1919, a young clerk from Nyasaland (Malawi) Clements Kadalie, tapped into these hopes to create what was by far the most successful grass roots political organization of the colonial era.

From its establishment until 1929, the Industrial and Commercial Workers Union (ICU) in South Africa was a labor union in name only. Many of its members were migrant workers, men who worked in the European economy only because their ability to farm the land had been taken away. Others, however, were clerks and white collar workers, while others still were teachers and intellectuals. Kadalie expressed a dream of creating "one big union"[14] that would fight for the

13. Martin, *Kimbangu*, 48.
14. George M. Fredrickson, *Black Liberation: A Comparative History of Black Ideologies in the United States and South Africa* (New York: Oxford University Press, 1995), 168.

rights of all African workers. Behind that dream he had an even greater one of becoming the "African Marcus Garvey."[15] It was this second dream that attracted African followers.

Kadalie's greatest achievement was to show the way to use European-style tactics of mass mobilization to create a political movement in Africa. The ICU launched its own newspapers, held rallies, sponsored church socials. Equally significantly, it intervened as often as it could against acts of economic and racial exploitation, organizing squatters to fight eviction, and labor tenants to fight their landlords. Lastly, it promoted efforts at self-help among its members, sponsoring consumer and producer cooperatives. Kadalie had spent much time listening to European union organizers before he established the ICU. Presumably he learned his tactics from them. In any case, the results were outstanding. Between 1926 and 1929, the ICU spread across rural South Africa, garnering a membership between 150,000 and 250,000.

The real Marcus Garvey had succeeded in creating a similar mass movement in the United States, but had then been jailed on what many felt to be trumped up charges of mail fraud. Kadalie had no role model to follow. Thus, having put together a powerful movement, he had no idea about where he should lead it. Among the intellectuals in the movement there were many Marxists who wanted to take the ICU into the Communist camp. By the same token, the Garveyites among Kadalie's followers wanted the ICU to push for the realization of the goal of Africa for Africans. Kadalie opted instead to try to transform the movement into a real trade union. With this in mind, in 1929 he invited in a labor union expert from Great Britain. Soon Kadalie was fighting with the labor union expert and eventually he repudiated his own movement and created a new one which he named the Independent ICU (IICU).

The effort to turn the ICU into a labor union failed, and after 1929 it quickly fell apart. Through the IICU, Kadalie continued for a while as a labor union boss, but only on a local scale in the town of East London. South Africa was not to know another grass roots movement of a similar magnitude until the United Democratic Front of the 1980's.

The three individuals whose efforts have been described looked upon European culture and civilization as a source to be drawn upon. Yet they looked at this culture and civilization not so much as European but modern. The ideas they promoted did not belong to Europeans, but like European science and technology, had merely been first discovered by Europeans. The ideas were out there for any and every people to grab and use. What is important is that thousands of other Africans, the people who read Macaulay's paper, and the people who joined Kimbangu's and Kadalie's movements agreed with them. There was never a time during the colonial era, even when European domination was at its height, when a significant number of Africans did not believe that Europeans could be beaten at their own game. African Prometheans built upon and reinforced this belief. Their various causes, whatever their worth in terms of later historical developments, kept Africans engaged in the intellectual evaluation of European thought and practice, significantly not from the perspective of the search for things to condemn, but from the perspective of the search for things to appropriate. Eventually

15. Fredrickson, *Black Liberation*, 169.

Africans would figure out that the fire that animated modern Europe was nationalism. Those later generations of Prometheans carried their discovery back along pathways forged by pioneers during the colonial era.

Review Questions

1. How did social class come together with religion to shape the pre-colonial Westernized African intelligentsia?
2. Is nationalism a secular ideology? If so, does the African embrace of nationalism reflect the development of African intellectuals away from Christianity and toward secularism?
3. What are some of the reasons why non-literary intellectuals have found Negritude an unattractive philosophical stance?
4. What did Senghor mean when he talked about "rhythm?"
5. Were African Prometheans antipathetic toward Western Civilization? Why or why not?

Additional Reading

July, Robert W. *The Origins of Modern African Thought: Its Development in West Africa during the Nineteenth and Twentieth Centuries*. New York: Praeger, 1967.

Mwase, George Simeon (ed.). *Strike a Blow and Die: The Classic Story of the Chilembwe Rising*. Introduction by Robert I. Rotberg. London: Heinemann, 1975.

Fredrickson, George M. *Black Liberation: A Comparative History of Black Ideologies in the United States and South Africa*. New York: Oxford University Press, 1995.

Chapter 15

African Nationalism, 1914–1939

Funso Afolayan

This chapter examines the development of nationalism in the early colonial period. It focuses particular attention on the growth of a national consciousness and on protest and resistance to colonial rule, especially during the time between the two world wars. After an exploration of the phenomenon of proto-nationalism, the chapter examines the social, economic and political basis of the grievances of the elite, the impact of World War I, the ideologies of negritude, and pan-Africanism on Islamism and Christianity and on the generation of nationalist sentiment. The chapter concludes with an elucidation of the different forms and expressions of nationalist sentiments and protests, ranging from constitutionalism, media publications, and political party formation to more militant manifestations such as trade unionism, workers' strikes, tax evasion, protest migration, public rallies, and religious revolts.

* * *

As shown in Chapters 1 and 2, the European conquest of Africa was neither easy, nor a foregone conclusion. The Africans did not willingly or meekly submit to European domination. All over the continents, efforts were made to resist and thwart the new white invaders. In Ethiopia, Emperor Menelik II issued a proclamation on September 17 1895, rallying his people to defend the cultural integrity and political independence of this ancient African kingdom. "Enemies," he declared, "have now come upon us to ruin our country and to change our religion.... With the help of God I will not deliver my country to them... Today, you who are strong give me of your strength, and you who are weak, help me by prayer."[1] Though Menelik succeeded in routing the Italian invaders and in maintaining the independence of his country, other African rulers and states were not so lucky. Military and strategic weaknesses in the face of European concerted assault and superior firepower spelled the doom of African independence. Nevertheless, while submitting to colonial rule, Africans did not leave the new imperial rulers under the illusion that they had become permanently reconciled to alien domination. Hence, periodic revolts and protests against many aspects of imperial domination punctuated colonial rule in different parts of the continent. For decades after independence, from Algeria to Namibia, and from Bussa (Nigeria)

1. Quoted in H.G. Marcus, *The Life and Times of Menelik II: Ethiopia 1844–1913* (Oxford: Clarendon Press, 1975), 160.

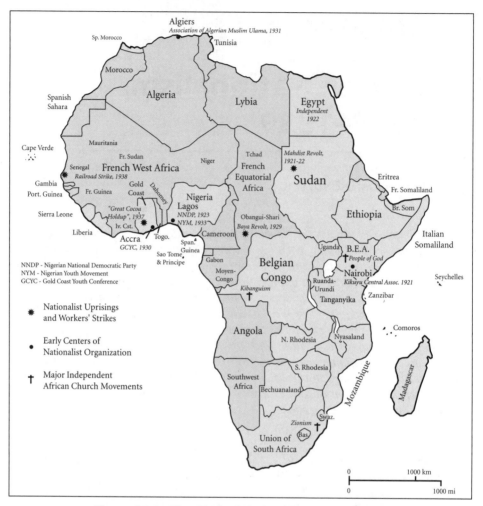

Figure 15-1. The Birth of Nationalism, 1918–1939

to Nyala (Sudan), the colonial masters were kept busy fighting to establish and consolidate their rule. It is against this background that the anticolonial movements of the years before 1939 can be fully understood and assessed.

Proto-Nationalism

A defining feature of the nationalist movement during the inter-war years was that it could hardly, in the strict sense of the term, be described as nationalism. Nor could its leaders be defined as nationalists, without some qualifications. With few exceptions, such as the case of Egypt, they did not ask for independence. Instead they demanded for a larger voice in the governance of their land. They did not seriously question the colonial project, nor demand an end to colonialism. They sought accommodation within the colonial order, rather than a recovery of their sovereignty. They were reformists, not revolutionaries. Their quest was for a

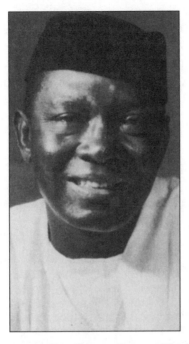

Figure 15-2. Dr. Nnamdi Azikiwe, pioneer Nigerian nationalist

better deal for themselves as elites and for their peoples in the colonial enterprise. They organized to redress the injustices and abuses occasioned or permitted by colonial rule. Limited in their demands, gradualist in their approach, and moderate in their rhetoric, they aimed at participation in the colonial system, not replacement of it. However, in sustaining the tradition of resistance to alien domination and the defense of African interests, they foreshadowed and became the precursors of the modern, post-World War II nationalists. Hence the term proto-nationalists is used to describe them. Indeed some of the leading elite members, like Edward William Blyden in Sierra Leone or Henry Carr in Nigeria, were supporters of European imperialism, though not always for the reasons that inspired the European conquests. African emancipation, rather than European glory, was their goal. Having benefited from Western education and in some cases converted to Christianity, they saw imperialism as temporary and looked forward to the time when out of Africa would emerge extensive, modernized, and powerful nations like the United States and Canada.[2]

Another key feature of nationalism during the inter-war years was its elitist nature. It was dominated and led by the small western-educated elite. As such, it was limited in its geographical spread and operation to the coastal cities such as Lagos, Calabar, Accra, Freetown, and the Four Communes of Senegal, where the educated elite predominated. Similarly, and for much of our period, the proto-nationalists did not primarily nor exclusively identify themselves with particular nations or ethnic groups. Instead they were cosmopolitan, international and inter-re-

2. For a fascinating study of a group of these early intellectuals, see Philip Serge Zachernuk, *Colonial Subjects: An African Intelligentsia and Atlantic Ideas* (Charlottesville: University Press of Virginia, 2000).

gional in operation and orientation. They saw themselves first as British West Africans or French Africans before describing themselves (if at all) as British Nigerian or French Senegalese. In this sense, they were Pan-Africanists more than they were nationalists. They dreamt of a future united British West Africa or French Western or Equatorial Africa, not of an independent or autonomous Nigeria or Mauritania. They warmly and enthusiastically aspired and subscribed to full *assimilation* into the colonial culture. Many of them took pride in bearing English names, marrying French women, and donning European attire.

Origins and Roots of Protests

Many factors account for the development of nationalism in the early colonial period. A major cause of protest was the nature and practice of colonialism. Imperial conquest resulted in the removal of autonomy and independence from Africans, who could no longer freely decide and control their destiny. Sovereignty moved from African rulers and states to the colonial officers and the metropolitan governments and states in Europe that they represented. Imperial interests assumed priority over indigenous African interests. Since the two sets of interests were not always in agreement, the contradictions between them generated much tension and many conflicts during the colonial period. Imperial conquests and consolidation created problems in their wake. Accidents of conquest, political exigencies, and administrative convenience determined the boundaries of the newly acquired colonies.

In most cases, preexisting political, cultural, and linguistic frontiers were simply ignored. In Nigeria the kingdom of Borgu was split into two, with one half in British Nigeria, and the other in French Dahomey. A similar fate befell the western Yoruba, who were separated from their kith and kin and merged with Dahomey.[3] In northern Nigeria, part of the Sokoto Caliphate went to French Niger, while the closely related Kanuri-Kanembu peoples were split between British Nigeria and French Chad. On the Nigerian-Cameroonian border, the Emirate of Adamawa's capital, Yola, was included in Nigeria, but the emirate lost the bulk of its territory to German Cameroon, prompting the exasperated emir of Adamawa to exclaim: "They have left me the latrines of my kingdom...they have left us the head but they have cut off the body."[4] On the Slave Coast, the Ewe, in spite of their strong protests and representations, found themselves divided between French Togo and the British Gold Coast. This violation of preexisting indigenous ethno-cultural frontiers reached the peak of its absurdity on the Western Guinea coast, where several ethnic groups, such as the Susu, Koranko, Yalunka, Kpelle, and Loma, were divided almost evenly between French Guinea, independent Liberia, and British Sierra Leone. Agitation for boundary adjustments and protest migrations across "unacceptable" boundaries remained a problem for the colonial administration throughout the colonial period.

3. I.A. Asiwaju, *Western Yorubaland under European Rule, 1889–1945: A Comparative Analysis of French and British Colonialism* (London: Longman, 1976).

4. Quoted in J.B. Webster and Adu Boahen (with M. Tidy), *The Growth of African Civilization: The Revolutionary Years, West Africa since 1800* (Harlow, England: Longman, 1980), 175.

The almost complete loss of sovereignty associated with alien domination was another source of disenchantment. In spite of the enlightened pretensions of the British system of indirect rule and the French policy of *assimilation*, colonialism in Africa was authoritarian. Provinces and divisions, *canton* and *cercle*, were set up without much consultation with the local people. The positions of traditional rulers ceased to be either sacred or revered. Even the British, who sanctimoniously insisted that political officers must uphold the prestige of the local rulers,[5] did not hesitate, again and again, to remove, and sometimes sentence to internal exile, rulers found wanting in their commitment to the imperial enterprise. The French, who had fewer scruples and less respect for "tradition," went as far as to humiliate local rulers, making some of them cut grass in public, and in many cases (as in Dahomey) the French abolished the institution of monarchy entirely. A case in point is that of the kingdom of Nikki in French Borgu. Reduced in power and deprived of the control of many of his former dependencies, the king of Nikki remained resentful of French rule. In 1902, the king was arrested and imprisoned without trial by the French authority. He felt so humiliated that he committed suicide. In 1911, the governor-general of French West Africa summoned the next king, ordering the king to meet him at the provincial headquarters of Parakou, a town that the king of Nikki was traditionally forbidden to visit. The death of the king shortly after this visit is associated in local tradition with the enforced breaking of this taboo. It is not surprising that six years later, in 1916, the new king of Nikki, Chabi Prouka, gave his support to a major rebellion in Borgu directed at removing many of the political and administrative injustices of European colonialism.[6] Colonial highhandedness and arbitrariness created many occasions for protests and violent uprisings during the colonial period.[7]

The Elite: Grievances and Protests

The educated elite had other complaints against the colonial system. They were especially critical of, if not openly hostile to the policy of indirect rule, which they felt was designed to exclude them from any meaningful participation in the administration of the colonies. One of the cardinal principles of indirect rule was the use of "native authorities" or indigenous rulers, meaning kings, emirs, obas, nkosis and other chiefs in the administration of their people. In many places, this resulted in the strengthening of the power of the rulers. Now solely responsible to the colonial officers, the paramount chief was no longer answerable to his people. Councils of chiefs and other indigenous institutions lost their power of "destoolment," which they had exercised as watchdogs of communal interests in precolonial times. In French West Africa, the traditional electoral process was subverted, as the French administrator was free to appoint as chief anyone he considered

5. On the principles behind the British policy of indirect rule, see F.D. Lugard, *Political Memoranda* (London: Frank Cass, 1970) and *The Dual Mandate in British Tropical Africa* (London: Frank Cass, 1965).

6. Michael Crowder, *Revolt in Bussa: A Study of British "Native" Administration in Borgu 1902–1934* (London: Faber, 1974).

7. For other examples of these revolts, see J.A. Atanda, "The Iseyin-Okeiho Rising of 1916: An Example of Socio-Political Conflict in Colonial Nigeria," *Journal of Historical Society of Nigeria* 4, 4 (1969): 487–514.

competent, often because of that candidate's literacy in the French language and perceived loyalty to France. The imposition, as chiefs, of candidates who had no traditional right to rule, resulted in the election of straw chiefs. These were chiefs elected in secret through the traditional methods to perform the ritual functions considered necessary for the spiritual wellbeing of the community.[8]

In places like Yorubaland and among the Asante, the new political centralization ran counter to the decentralized check and balance system of precolonial times. Indirect rule had degenerated into a policy of supporting authoritarian rule. The western-educated elite did not mince words when they railed against indirect rule for distorting and perverting indigenous customs through its transformation of local rulers into bastions of oriental despotism.[9] Criticizing the unprecedented and ever-increasing powers given to the chiefs, the *Gold Coast Leader* wrote in 1927: "The time is coming when a chief once installed will sit firmly on the neck of the people, like the old man of the sea, and rule them in his own way without any means of getting rid of him."[10] In most places, the colonial masters confirmed preexisting chiefs in their positions. In others, as among the Igbo of southeastern Nigeria and the Maasai of Tanganyika, where such chiefs did not exist, the colonial officials proceeded to "discover" or more accurately create them. The alien nature and the mounting atrocities of the so-called "warrant chiefs" provoked a major uprising, the Aba Women's War, in 1929.[11]

Equally distressing to the educated elite was the divide and rule strategy of the colonial administration, which constantly pitched the educated elite against the traditional elite. Though the educated elite were not opposed to the institutions of chiefs as such, they resented the chiefs' acquiescence in their subordinate roles as willing tools for the enforcement of unpopular colonial measures like forced labor recruitment and taxation. In places like Sierra Leone, the Creoles, who had no chiefs and had dominated the politics and trade of the hinterland in the nineteenth century, became bitter when they suddenly found themselves sidelined by the British policy of protecting the hinterland groups from the Creoles' influence and control. Even more galling, especially in British colonies, was the near total exclusion of the educated elite from the colonial administration. In spite of their education or more likely because of it, they were given no formal recognition and were deliberately ignored in the government of their country.

Consequently, the educated elite seized every opportunity and used every means to demand the Africanization of the colonial civil service. Referring to the

8. See Robert Delavignette, *Freedom and Authority in French West Africa* (London: Published for the International African Institute by the Oxford University Press, 1950) and Geoffrey Gorer, *Africa Dances* (London: 1935) for examples of this type of resistance to colonial rule. On the changing status of traditional rulers in colonial West Africa, see Michael Crowder and Obaro Ikime (eds.), *West African Chiefs: Their Changing Status under Colonial Rule and Independence* (New York: Africana Publishing Corporation, 1970).

9. Rattray, *Asanti Law and Constitution* (Oxford: Oxford University Press, 1956), 400; Obafemi Awolowo, *Path to Nigerian Freedom* (London: Faber & Faber, 1966), 57.

10. Quoted in David Kimble, *A Political History of Ghana. The Rise of Gold Coast Nationalism* (Oxford: Clarendon Press, 1963), 494.

11. A.E. Afigbo, *The Warrant Chiefs. Indirect Rule in Southeastern Nigeria* (London: Longman, 1972). See also Judith Van Allen, "'Sitting on a Man': Colonialism and the Lost Political Institutions of Igbo Women," in R.R. Grinker and C.B. Steiner (eds.), *Perspectives on Africa: A Reader in Culture, History and Representation* (Cambridge: Blackwell Publishers, 1997), 536–549.

much-flaunted imperial slogans of "Dual Mandate" and "Colonial Pact," they could not fathom why they were routinely turned down for jobs, even when there were vacancies they were more than qualified to fill. Africans who managed to sneak through the needle's eye into the civil service were often relegated to inferior positions compared with Europeans who had similar or sometimes inferior qualifications and experience, and who, as a rule, held all executive and other important positions. Writing on this phenomenon in 1925, the *African Messenger* growled: "The young European assistant is placed in each Department in turn, until he is familiar with all sides of his business, while the African lives and dies a book-keeper, store-keeper or Customs clerk."[12] In Sierra Leone and the Gold Coast, where the educated elite had successfully proved their mettle in commerce and administration in the nineteenth century, the *Gold Coast Independent* reminded a reluctant and hostile colonial administration in 1919 that "every office from that of the Governorship downwards has been held by a black or coloured man.... No amount of disparaging their descendants can obliterate the fact."[13]

The British, on the other hand, were contemptuous of the Western-educated elite, whom they considered pretentious and presumptuous. Dismissing them as "Black Englishmen," "extravagant European caricatures," and "apes in trousers," the British insisted they were neither competent to lead their people, nor mandated to speak for them. For the colonial administration, the true leaders or representatives of the people were the chiefs, not the members of the educated elite, "with their preposterous, tall chimney-pot hats, their gaudy Manchester prints, or suits of heavy black coats and trousers and double-breasted waistcoats."[14] Indirect rule, the British argued, had no need for such men. The educated elite, for their part, were convinced that the dogmatic use of illiterate and conservative chiefs, apart from being an anachronism in an age of modernization, was a subterfuge by the British, designed to enable the colonial masters to rule Africa indefinitely. Related to this grudge was the pervasiveness of racism in the colonial system. Everywhere the educated elite turned, they met the color bar. They were discriminated against in access to public facilities and to transportation systems, such as the railroads, and in social treatment. They could be dumped into jail without trial. The depressing atmosphere of colonial racism is well captured by a contemporary African elite member from South Africa, Peter Abraham. Just before embarking on a journey of no return from his white-minority dominated country he noted: "All my life had been dominated by a sign, often invisible but no less real for that, which said: RESERVED FOR EUROPEANS ONLY.... All that was finest and best in life was 'Reserved for Europeans only.' The world, today, belonged to the 'Europeans.'"[15]

In the midst of the uncertainties of the colonial era, the elite were certain of one thing: no future awaited them in the colonial civil service. Consequently, the handful of elite members who managed to travel abroad for higher education took to professions, like journalism, law, medicine, and engineering, that they could practice on their own. With their livelihood independent of the colonial sys-

12. Quoted in *West Africa*, April 25, 1925.

13. Quoted in Kimble, *Ghana*, 106.

14. Sir Harry Johnson in *The Times*, March 6, 1922, quoted in Michael Crowder, *West Africa Under Colonial Rule* (London: Hutchinson, 1968), 359.

15. Peter Abraham, *Tell Freedom* (London: Faber and Faber, 1954), 310.

tem, they had few inhibitions and indeed many reasons to be critical and unsparing in their literary assault on the colonial order. A notable example was Nnamdi Azikiwe. After obtaining a bachelor's and two master's degrees from major American institutions, he returned home to Nigeria in 1934. The colonial administration, always and rightly suspicious of the pernicious nature of the ideas of the educated elite, refused to offer him any job. Azikiwe moved to the Gold Coast, where he edited a leading nationalist newspaper, the *African Morning Post*, from 1935 to 1937. Having been constantly harassed by the colonial authorities in the Gold Coast, he returned to Nigeria in 1937 to establish another newspaper, the *West African Pilot*, which became a major mouthpiece of the nationalist cause for many years.

Recognizing the centrality of formal education in the successful Africanization of the colonial civil service and in the eventual liberation of Africa from alien rule, members of the educated elite were very resentful of the limited nature of educational opportunities available under colonialism. This neglect of education they blamed on the insidious plan of the colonial masters to keep Africans illiterate and thus unfit for self-government. They remained suspicious of the colonial educational system, which they believed was consciously devised, not to produce intellectuals and thinkers who could challenge the colonial order, but to make available low-level manpower that would service the technical and clerical needs of the colonial system. They decried colonial education as second-class education, with second-class certificates, meant to produce second-class citizens and perpetuate African underdevelopment and subservience to Europe. In Lagos in 1929, when the government attempted to replace the Oxford and Cambridge School Certificates with a Nigerian School Certificate, mass demonstrations were organized that foiled the government's plan. Similarly, in 1934, the Lagos Youth Movement was organized to protest against a government plan to give "inferior" diplomas to students graduating from the new Yaba College of Technology, instead of reputable degrees certified by a British university, such as were given by Fourah Bay College in Sierra Leone. The establishment of a West African university remained a top priority in all the petitions submitted by the educated African elite to the colonial masters during the inter-war years.

The Colonial Economy and Nationalism

The economic change brought about by colonialism also generated many grievances that provided fuel for the nationalist flame. The immediate impact of the colonial takeover was land alienation. In the regions of Africa that Europeans found most suitable to white settlement, the best and most fertile lands were forcibly appropriated and given to white settlers and farmers. In Kenya, the British seized the best lands from the Kikuyu cultivators. In Algeria, French settlers took the best coastal land in this otherwise desert country and reduced the indigenous population to servile status as laborers on white farms and markets. In Nigeria, Herbert Macaulay, a British-trained surveyor, who would later receive the honor of being regarded as the founder of Nigerian nationalism, first came to the limelight when he took on the colonial administration in a land dispute involving one of the paramount chiefs of Lagos, Chief Oluwa. Chief Oluwa had demanded compensation for the forcible appropriation of his lineage land by the Lagos government. When the government insisted on its right to the land by right

of conquest, Macaulay took the case to the Privy Council in London. The Privy Council ruled in favor of Chief Oluwa and ordered the Lagos Government to pay him compensation of 22,600 pounds. Macaulay received a hero's welcome on his return to Lagos from London, where he had "slain the imperial colossus."[16]

In South Africa, the first major nationalist movement, the Native African National Congress (later the ANC) was organized in 1912 to campaign against the promulgation of the proposed Land Act of 1912. The efforts failed. The act successfully appropriated and reserved 87 percent of South African land for the exclusive use of its white population, which constituted roughly 13 percent of the population. Uprooted and dispossessed, millions of Africans found themselves landless and destitute in their own country. Compelled to pay taxes, they had no choice but to become tenant farmers on white farms, domestic servants in white homes and laborers in white-owned mines. African family life and communal life began to break down as migration to the cities where workers lived in shanty towns or were herded together in hostels, became the order of the day. Compulsion characterized the colonial system. Forced taxation, forced relocation to homelands or "bantustans," forced labor, and forced cultivation were imposed in different forms and to varying degrees by all the colonial powers.[17]

The economy was also foreign dominated. European oligopolies such as the UAC, CFAO, John Holt, Patterson and Zochonis, and others controlled the economy, and dictated the price of imported and exported goods. With ready access to government credits and tax concessions, these companies, along with their associates such as the Syrians and Lebanese in West Africa and the Indians in East Africa, controlled both the retail and the produce trade, gradually but progressively edging out Africans.[18] While European companies and merchants reaped huge profits, African workers remained impoverished, poorly paid, suffering appalling conditions of work, and subject to a reactionary and inhuman labor policy, which was indifferent to workers' welfare and made liberal use of the whip and body mutilation. In the Congo, mass terror, random killings, and hostage taking were all used to ensure compliance. Workers who failed to produce enough rubber had their hands or legs cut off as warnings to others of the horrifying consequences of frustrating the imperial mission of economic exploitation.[19] Thus it was not only the educated elite which had an axe to grind with the colonial masters. Other groups in the society like the rural dwellers who were forcibly relocated, the labor migrants who found their family life disrupted and were forced to live all year round in squalid and congested hostels, the factory workers who became victims of labor discrimination, the indigenous merchants who found them-

16. On Macaulay and the Lagos land crisis, see Patrick Cole, *Modern and Traditional Elites in the Politics of Lagos* (London: Cambridge University Press, 1975), 89–119.

17. See Asiwaju, "Control through Coercion: A study of the *Indigénat* Regime in French West African Administration, 1887–1946," *Bulletin de l'Institut Fondamental d'Afrique Noir* (Dakar) B, 61, 1 (1979): 35–71.

18. On the Lebanese in West Africa, see Toyin Falola, "Lebanese Traders in Southwestern Nigeria," *African Affairs* 89 (October 1990): 523–553; "The Lebanese in West Africa" in J.F. Ade Ajayi and J.D.Y. Peel (eds.), *Empires and Peoples in African History: Essays in Memory of Michael Crowder* (London: Longman, 1992), 121–141.

19. For a riveting account of the savagery and horror of this dark side of European imperialism in Africa, see Adam Hochschild, *King Leopold's Ghost. A Story of Greed, Terror and Heroism in Colonial Africa* (New York: Houghton Mifflin Company, 1998).

selves outsold and pushed out of their previous middleman trade position, had ample reasons for disenchantment. These groups would later supply the national-ist leaders with the support needed to organize mass movements for change in the colonial order.

External Dimensions and Interconnections

World War I and African Nationalism

Political developments in Africa between the two world wars were affected by developments in other parts of the world. The first of these was World War I. Un-able to recruit Africans in sufficient number to fight on behalf of France without provoking major revolts, the French took the extraordinary step of appointing Blaise Diagne, the African deputy for Senegal, as the "High Commissioner for the Republic for the Recruitment of Troops." Diagne succeeded beyond all expecta-tions in securing for France all the troops it needed. He was criticized for sending his fellow Africans to the slaughter to die as cannon fodder for the French. Rebut-ting this criticism, Diagne argued that there were two reasons why Africans should support the French. The first was a sense of appreciation "of what France, hitherto, had brought to these peoples...The second was that thus they were gaining the ransom for their liberty in the future."[20] In the end, some 200,000 able-bodied men went from French West Africa to fight in support of France. In the course of the war, the embattled European nations of Britain and France spoke of self-determination as the basis of the postwar settlement. President Woodrow Wilson of the United States joined Vladimir Lenin and Joseph Stalin of Russia and other statesmen in blaming imperialism for the war. He enunciated a fourteen-point peace program, at the core of which was self-determination for all colonized people. Thus there were high hopes in Africa that the war would usher in a new era of freedom for all oppressed or colonized peoples of the world. In Africa, there were calls in the press and in public speeches for African delegates to be sent to the peace conference in Paris. Africans, of course, felt disappointed and betrayed when the imperial powers began to qualify their promise of self-determi-nation by explaining that the groups they had in mind were the ethnic minorities of the Austro-Hungarian and Ottoman Empires and not the peoples of Africa and Asia. For African nationalists and African veterans who had risked their lives to rescue Europe from its self-annihilating war, this was European perfidiousness at its worst.

In Egypt, Sad Zaghlul, a lawyer who had resigned in protest from his ministe-rial position in the colonial government, led a delegation to the British high com-missioner, informing him of his group's intention to send a delegation to the peace conference in Paris. The high commissioner, Sir Reginald Wingate, however, re-jected their claims and refused to grant them permission to travel to Paris, arguing that their three-man delegation had no mandate to speak for the Egyptian people,

20. Quoted in Crowder, *West Africa*, 265.

who had not expressed any desire for independence. Shocked and dismayed, Zaghlul spoke calmly but confidently to the high commissioner in words that have echoed down the years:

> Do we have to ask a nation whether it wants independence? Ours is the oldest of civilizations. Our ancestors have handed down to us indisputable social virtues. Our civic sense is there for everyone to see. One can see it in our respect for the rule of law, our even temper and identity of outlook. To ask a nation like this whether it is agreed on independence is an affront to it.[21]

The "Wafd," meaning "delegation," became the most important political party in Egypt throughout the inter-war years, and Zaghlul became the most dominant nationalist. The deportation of Zaghlul and other leaders to Malta only exacerbated the tension. The nationalist virus spread to the *fellahin* (common people), who abandoned their farms, to the women, who abandoned their harems, and to the students, who abandoned their classrooms, to take to the streets in demonstrations against the colonial administration. Violence broke out as a wave of terror and riots swept through Cairo, other delta towns and Upper Egypt. Unable to contain the riots, the British hurriedly imported special troops to suppress the rebellions. The Milner Commission, set up to investigate the crisis, recommended negotiation and compromise. Zaghlul was released from Malta and summoned to London. Negotiations, however, broke down as the nationalists refused to accept autonomy on British terms. More disturbances followed in 1921. A year later, Egypt became self-governing. About the same time, the Irish, after a bloody war, wrested their independence from British rule in 1921. Similarly, after years of agitation, the Statute of Westminster granted both Canada and white-ruled South Africa virtual independence in 1931. In India, Mahatma Gandhi with his strategy of nonviolence was moving towards a showdown with the British Raj and eventual independence for his country. The African elite followed these events in other parts of the world with keen interest, asking anyone who cared to listen: "If it could happen in Egypt and Canada, why not here and now?"

Pan-Africanism

Meanwhile, developments in the black world of the Americas were beginning to make their impact felt in Africa. Africans on both sides of the Atlantic and in Europe were becoming more conscious of one another, especially as the wave of events began to inextricably connect their fates and destinies. Common African ancestry and similar experience of European slavery and colonialism combined to create a bond of kinship that would transcend national or continental frontiers. Blacks in the New World began to connect the struggle against segregation and for civil rights in the Americas with the quest for self-determination in Africa. They began to conclude that no black man anywhere could gain respectability or rest content as long as another black man was being oppressed somewhere.

21. Quoted in E.A. Ayandele, et al., *The Growth of African Civilization: The Making of Modern Africa, Volume 2: The Late Nineteenth Century to the Present Day* (London: Longman, 1971), 55.

Equality in America was part of the struggle for freedom in Africa as well as the struggle for dignity for black men everywhere. To achieve these ends, peoples of African descent all over the world should strive to overcome the limitations engendered by centuries of European slavery and colonialism. Thereafter, they should work to transcend the artificial barriers of time and space to carry out a united and concerted assault on the enemies of their emancipation in Africa, Europe, and the Americas.

Four leading individuals dominated the Pan-Africanist movement in Africa during this period. The first of these was Booker T. Washington, an African American educator based in Atlanta, Georgia. He believed that educational self-help through the acquisition of agricultural and manual skills was the key to black emancipation, in a society that would always be dominated by racial segregation and white domination.[22] Washington's ideas gained a positive hearing among the ranks of the conservative Western-educated elite in Africa. Henry Carr, the leading African civil servant in the Lagos Colony, was an admirer. In the Gold Coast, Washington's ideas were adapted to the African conditions by James Kodwo K. Aggrey (1875–1927). Born of Fante parents, Aggrey received his early education in Cape Coast. Between 1898 and 1924, he lived in the United States, where he acquired three degrees and became a teacher and a clergyman. Twice he served on the Phelps Stokes Commissions (1920, 1923) on education in Africa. He was instrumental in the establishment of Achimota College in Ghana and in ensuring that technical training would be the main feature of the new school. His philosophy of harmonious relations between Africans and Europeans and of black-white partnership made him popular among Europeans but provoked sharp criticisms from Africans. His critics insisted that the inequality in power relations precluded any possibility of a partnership between blacks and whites, just as there could be no partnership between a master and his slave or between a horse and his rider.[23]

In Africa as well as in the Americas, a number of elite members led by William E. B. DuBois regarded Washington's ideas of self-help as a dangerous compromise and a capitulation to racism and white supremacy. DuBois argued that black Americans should refuse to accept segregation as a given. Instead, led by their intellectuals, they should agitate and compel white Americans to grant them economic freedom as well as social and political equality. DuBois' main contribution to the nationalist movement in Africa was his successful organizing of a series of five Pan-Africanist congresses, beginning at the Paris Peace Conference of 1919 and ending with the Manchester Congress of 1945. These periodic congresses brought Africans in Europe and the Americas together to discuss issues of black interest and to draw the attention of the world to the plights of the black race all over the world.

Nevertheless, the "golden globe" award for radical nationalistic influence during these years should go neither to Washington nor to DuBois, but to a Jamaican-born black, Marcus Garvey. In 1914, he established his Universal Negro Improvement Association (UNIA). By 1923, the association claimed 6 million

22. On Washington, see Booker T. Washington, *Up from Slavery: An Autobiography* (Garden City, New York, 1932); Louis R. Harlan, *Booker T. Washington: The Making of a Black Leader, 1856–1901* (New York: Oxford University Press, 1972); and *Booker T. Washington: The Wizard of Tuskegee, 1901–1915* (New York: Oxford University Press, 1983).

23. On Aggrey, see E. Smith, *Aggrey of Africa: A Study in Black and White* (London: SCM, 1929).

members, making it the biggest mass protest movement in American history. Garvey was a captivating speaker, and his ideology of racial purity, his slogans of "Africa for the Africans," and "Ethiopia Awake" and his stirring calls to arms stirred more hearts and inspired more followers in Africa than anyone before or since. He spoke of raising an unstoppable black army of 400 million men. Speaking in New York in August 1920 at Carnegie Hall, he sent a sharp warning to the European peacemakers then meeting in Paris to take their hands off Africa or else face the consequences:

> The Negroes of the World say we are striking homewards towards Africa to make her a big republic... We are coming 400,000,000 strong and we mean to take every square inch of the 12,000,000 square miles of African territory belonging to us by right divine... we are out to get what has belonged to us politically, socially, economically and in every way. And what 15,000,000 of us cannot do, we will call 400,000,000 to help us get.[24]

It is not surprising that the colonial powers did not take his threat lightly. Garveyism was regarded as a pernicious evil during the colonial period. The mission churches cooperated with the colonial administration to deny the UNIA the use of their church or school halls for rallies. Garvey's journal, *Negro World*, became anathema in colonial Nigeria. Postal workers were given firm instructions to seize and burn all copies before they could be delivered. In French Africa, to be caught with a copy of this "dangerous" periodical could mean spending the rest of one's life in prison.

Negritude

Unlike the British colonies, few people went to school in French West Africa, and still fewer acquired university education. The French educational system, like the British, was strictly organized to produce an elite of auxiliaries, not intellectuals who would threaten the imperial order. The French wanted subordinate partners, not rivals or critics. The few who managed to obtain university degrees were easily and enthusiastically absorbed into the French civil service. Unlike the British, the French were neither hostile to their educated African elite nor suspicious of them. The policy of *assimilation* was meant to transform educated Africans into bona fide black Frenchmen. The few Africans who successfully passed the test of *assimilation* became French citizens and were accorded all the rights and privileges of Frenchmen. They were free from forced labor and could not be arrested and jailed without due process of law. They could vote and be voted for in elections into the French Chamber of Deputies. Some of them, like Blaise Diagne and Leopold Senghor, became cabinet ministers in the government of France. All this was inconceivable in British Africa.

The French, of course, believed that they were doing these emergent African elite members an invaluable favor by assimilating them, giving them the benefit of French civilization, and rescuing them from cultural depravity and backwardness.

24. Quoted in Edmund David Cronon, *Black Moses: The Story of Marcus Garvey and the Universal Negro Improvement Association* (Madison: University of Wisconsin Press, 1962), 66.

For a while, the nascent African elite bought into this French logic of *mission civilisatrice*, and missed no opportunity to profusely express their gratitude to the French for civilizing them. During the Paris Peace Conference, Blaise Diagne, the leading French African, rejected Marcus Garvey's call to Europeans to take their hands off Africa. He informed Garvey: "We French natives wish to remain French, since France has given us every liberty."[25] Later, at the Second Pan-African Congress held in Paris in 1921, Diagne told the delegates: "I am a French-man first and a Negro afterwards."[26] However, the elite soon discovered that *assimilation* as practiced by the French was a zero-sum game. Becoming French signified ceasing to be African, except in the color of one's skin. Acceptance as a human in French society did not translate into the acceptance of African culture, which was branded inferior. The assimilated man was taught to disregard his past, despise his culture, and deny that Africa ever contributed anything worth-while to civilization. It was this negative attitude to other cultures that made French African elite members like Frantz Fanon describe the French as being racists of a peculiarly insidious type, because they believed in the superiority of French culture and way of life over all others, while espousing, in the same breath, the revolutionary slogan of equality and fraternity of all mankind.

To become French, an African would have to both hate and completely abandon his culture. *Assimilation* was an invitation to self-hate and cultural suicide. Gradually, in the cosmopolitan and artistically boisterous Paris of the 1930s and among French West Indians and African students, voices began to be raised against the ethnocentric dimension of the French assimilative agenda. This was the beginning of Negritude, a literary and ideological movement to reclaim, assert, and affirm the validity, authenticity, and respectability of African culture. Negritude was a revolt against the successful assimilative strategy of French colonialism with its arrogant and reductive racist ideology of the superiority of European culture. It rejected every attempt to give exclusive and universal priority to Western values and paradigms. It argued that the black man must come to terms with the reality of his history, his culture, and most especially his blackness without any shame or apology. "I am black and proud," became Negritude's popular slogan. Aimé Cesairé, from Martinique in the West Indies, was the founder and leading ideologue of the movement. His sense of alienation from his roots suddenly dawned on him when on a train ride he found himself gloating at his "superior" elite status and despising his nonliterate and nonassimilated blacks. Léopold Sédar Senghor, later president of Senegal, was the leading African contributor. In poems, drama, novels, art, and dance, these and other scholars rejected the French policy of *assimilation*, which divided Africans and deprived them of their cultural sensibility and historical destiny as black peoples.[27] While English-speaking Africans like the Nigerian Nobel laurel, Wole Soyinka, could afford to question the usefulness of Negritude by declaring, that "a tiger does not proclaim its

25. R.L. Buell, *The Native Problem in Africa*, Vol. 2 (New York: Macmillan, 1928), 81.

26. Rayford W. Logan, "The Historical Aspects of Pan-Africanism, 1900–45," in *Pan-Africanism Reconsidered* (Berkeley: University of California Press, 1962), 44.

27. On Negritude and Pan-Africanism, see Adekunle Ajala, *Pan-Africanism: Evolution, Progress and Prospects* (New York: St Martin's Press, 1974); George Padmore, *Pan-Africanism or Communism?* (Garden City, NY: Anchor Books, 1972); and Vincent Bakpetu Thompson, *Africa and Unity: The Evolution of Pan-Africanism* (London: Longman, 1969).

tigritude," French Africans who had had to endure decades of anti-African accul-
turation could not but feel alienated from their African roots. Hence their need
for a reaffirmation of the authenticity and integrity of African culture and for
reincorporation into it. The works of English-speaking writers like Christopher
Okigbo of Nigeria, Ngugi Wa Thiong'o of Kenya, and FEK. Parkes of Ghana re-
veal that this crisis of identity and the feelings of cultural alienation and nostalgia
were not uniquely Francophone.[28]

Forms and Strategies of Protests

Constitutionalism

To achieve their objectives, the nationalists adopted various means and meth-
ods. The aims and the strategies of the nationalists also varied with the differing
colonial ideologies under which they operated. For the elite in French Africa, the
goal was the attainment of full citizenship. Extending full citizenship to the ma-
jority of the African population would eventually bring an end to colonialism,
hence the aim was the extension to all territories and groups the full rights and re-
sponsibilities of citizenship. For the British African elite, the desire was for re-
forms and increased participation in the administration of the country. For much
of the inter-war period, the elite adopted constitutionalism as the most viable
means of achieving their ends. This was due to the fact that constitutionalism was
the most appropriate means of effecting change in contemporary Western Euro-
pean society, and the method most likely to receive a favorable response from the
colonial authorities and to elicit some sympathy from liberal political groups in
Europe. In French West Africa, the Four Communes of Senegal had elected repre-
sentatives to the French Chamber of Deputies since 1848. All the elected members
were Europeans until 1914, when Blaise Diagne, from Senegal, became the first
African to sit in the French parliament. Two years later, he successfully pressured
the French Chamber to pass the Loi Diagne, which extended French citizenship to
the people of the Four Communes. During World War I, he was instrumental in
recruiting hundreds of thousands of Africans to fight for the defense of France.
During the Great Depression of 1931, he successfully negotiated a special higher
price from the French government for groundnut producers in French West
Africa. Diagne's attempt, as an assimilated African, to walk the fine line between
absolute loyalty to France and protection of African interests led him into many
troubles. His fellow Africans criticized him as a stooge and a sell-out, while in the
black worlds of Europe and the Americas he was a symbol of African ability and
equality.

Largely in response to the elite's relentless agitation for the franchise, new
constitutions were introduced in the British colonies in the 1920s. The constitu-
tional provision for elected representatives was neutralized by the power granted
the governor to nominate the overwhelming majority of the Legislative Council
members. The Legislative Council, which was set up in Nigeria in 1922, could

28. Christopher Okigbo, *Collected Poems* (London: Heinemann, 1986); Okigbo, *Heav-
ensgate* (Ibadan, Nigeria: Mbari Publications, 1962).

criticize the government and pass resolutions, but it had no power to enforce its decisions. The Nigerian colonial governor, Hugh Clifford, contemptuously described it as a "dreary and apathetic" body, "a debating society in which nobody would enter into debate."[29] In Nigeria, the leading opposition figure was Herbert Macaulay, grandson of Bishop Ajayi Crowther and a civil engineer by training. After studying with the aid of a government scholarship in England, he worked briefly as a surveyor in the Lagos Colony civil service, before resigning in 1898 to devote his time to politics. Intelligent and articulate, with his tireless energy, unusual talents, and charismatic personality, he dominated Nigerian politics from 1908 to 1938, when a new breed of younger and more radical nationalists began to appear on the scene.[30]

Interterritorial Movements and Political Parties

The provision for elected representatives led to the formation of political organizations, especially in British Africa. In Nigeria, the first to be established was the Nigerian National Democratic Party (NNDP). Founded by Macaulay in 1923, it won all the elective seats in the elections of 1923, 1928, and 1933. Though its activities were generally confined to Lagos, its impact was felt in other parts of the country. Macaulay's caustic criticisms of the colonial administration, his championship of countless anti-state causes, and his many law suits against the government made him an inveterate enemy of the Lagos governor, who refused to attend any function to which Macaulay was invited. However, the situation soon changed; as colonial patronage increased, the firebrand rebels of the 1920s became the self-satisfied conservatives of the 1930s, who were regularly courted and feted at Government House. The public soon became disenchanted with the NNDP and its leaders. In the election of 1933, only 700 of the 3,000 eligible voters went to the poll, and in 1938, the NNDP lost all its seats to the newly formed Nigerian Youth Movement.

In the Gold Coast, politics was dominated by two major organizations. The first was the Aborigines' Rights' Protection Society (ARPS), formed in 1897 by a group of chiefs and elite members, to protest against the introduction of a bill that would have declared all unoccupied land the property of the state. Its deputation to England succeeded in persuading the colonial government to drop the bill. However, by 1914, the ARPS, led by Chief Nana Ofori Atta, had become a conservative group, parleying with the colonial administration, which did not shy away from playing the chiefs of the ARPS against the elite. With the neutralization of the ARPS, the initiative in the nationalist struggle passed to the National Congress of British West Africa (NCBWA). Organized in 1919 under the leadership of J.E. Casely Hayford of Ghana, it held its first meeting in Accra in 1920. With representatives from all four British West African colonies, it demanded the introduction of the franchise and equal opportunities in the civil service and in higher education. It also requested a West African university and the separation of the judiciary from the colonial administration. Its attempt to send a deputation to

29. Quoted in Joan Wheare, *The Nigerian Legislative Council* (London: Faber and Faber, 1950), 30. See also Tekena Tamuno, *Nigeria and Elective Representation, 1923–1947* (London: Heinemann, 1966).

30. On Macaulay, see Cole, *Modern and Traditional Elites*, 89–119.

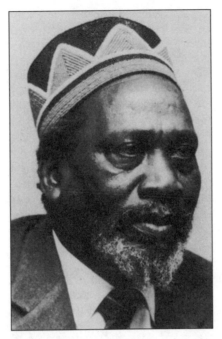

Figure 15-3. Jomo Kenyatta, first leader of independent Kenya

London to press home its demand, met with a hostile reception from the British administrators in West Africa.[31] Hugh Clifford, the governor-general in Nigeria, after ridiculing the claims of the Congress, dismissed the Congress leaders as

> a self-selected and self-appointed congregation of educated African gentlemen who collectively style themselves "West African National Conference,"...whose eyes are fixed, not upon African native history or tradition or policy, nor upon their own tribal obligations and the duties to their Natural Rulers which immemorial custom should impose upon them, but upon political theories evolved by Europeans to fit a wholly different environment, for the government of peoples who have arrived at a wholly different stage of civilization.[32]

Nevertheless, the introduction of a limited franchise (1923), the establishment of Achimota College in Ghana (1927), and the inauguration of a West African Court of Appeal during this period showed that the efforts of the Congress were not in vain.[33]

In South Africa, the African Peoples' Organization was formed in 1903. The attempt of its leader, Dr. Abdurahaman, a prominent Colored politician, to pro-

31. For details of official hostile reactions in West Africa to the claims of the Congress leaders to represent their peoples, see J.S. Coleman, *Nigeria: Background to Nationalism* (Berkeley: University of California Press, 1958).

32. Hugh Clifford, Address to the Nigerian Council, December 29, 1920, quoted in Coleman, *Nigeria*, 193.

33. For more information on the NCBWA, see Coleman, *Nigeria*, 187–196; and Kimble, *Ghana*, 399–453.

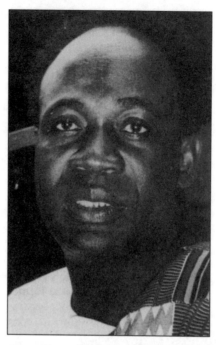

Figure 15-4. Kwame Nkrumah, first leader of independent Ghana

mote interracial alliances among non-Europeans proved abortive. In 1894, the Natal Indian Congress had been established under a young lawyer, Mahatma Gandhi, to fight against white oppression of Indians in South Africa. However, the group that would turn out to be the most resilient and the most influential would be the South African Native National Congress, organized in 1912. It adopted a nonviolent, nonracial, and constitutional approach, which reached its peak with the anti-pass movement of 1919–1920. In 1921, the SANNC metamorphosed into the African National Congress. During the inter-war period, the ANC achieved very little; its peaceful methods were met regularly with police brutality, arrests and detentions. In Kenya, Harry Thuku organized the Young Kikuyu Association (YKA) in 1921 to defend the interests of the Kikuyu in the face of relentless settler encroachment on their land. Writing in the *East African Chronicle*, Thuku sharply criticized the policies of the government in relation to land, labor, and taxes. Alarmed by the popularity of his ideas, the colonial administration arrested and incarcerated Thuku. While he was in prison, his followers transformed the YKA into the Kikuyu Central Association (KCA) in 1925. In addition to demanding Thuku's release, the KCA demanded that Africans should be permitted to grow coffee and that laws should be published in the Gikuyu language. Largely in response to these efforts, the government set up the local native councils in 1925. Earlier in 1923, the government in a white paper directed that the interests of the Africans must be considered paramount over and against those of the settlers.

Like the NCBWA, many of the movements were interregional and international. Such groups included the West African Student Union founded by Ladipo Solanke in London in 1925 and the West African Youth League founded by Isaac Wallace Johnson in 1938. Other groups that contributed to the development of

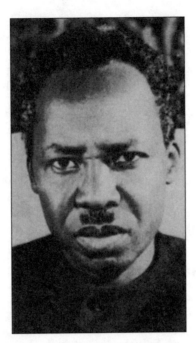

Figure 15-5. Julius Nyerere, first leader of independent Tanzania

nationalism during these years included the League for the Rights of Man and of Citizenship in Gabon, and the Liga Africana with bases in Portuguese Angola and Mozambique. In Dahomey (later Benin), Tovalou Quenum organized La Ligue Universelle pour la Défense de la Race Nègre in 1925. All these organizations as well as youth, ethnic, old boy's and other associations became catalysts for the expression of anticolonial politics, the demand for civil liberties, and the protection of human rights.

The Press and Nationalism

The educated elite were aided in their efforts by their access to and use of the independent press. Many of the members of the elite either trained as journalists or became journalists by necessity. They established a string of newspapers all over the continent. Though many of the papers did not last for long, and made little profit for their owners, a few lasted long enough to become major voices of opposition and protest during the colonial period. Notable among these were the *Sierra Leone Weekly* (established in 1884), the *Lagos Weekly Record* (1890), and the *Gold Coast Independent* (1895). In French West Africa, where the readership was small and censorship strict, no African owned a newspaper until *Le Guide du Dahomey* was established in 1920 and *L'Eclaireur de la Côte d'Ivoire* in 1935. Missionary newspapers like the Anglican-CMS *African Messengers* and the *Methodist Times* also, in spite of their imperial associations, attempted to defend African interests. The *Methodist Times*, for instance, championed the ARPS campaign against the 1894 land bill, describing the bill as "civilized robbery and British brigandism," before its dissenting voice was muted by instructions from its London headquarters that it should keep out of local politics. From outside Africa, in addi-

tion to the *Negro World*, came other periodicals, such as *Race Nègre*, *African Times*, and *Orient Review*, spreading communist and pan-African ideas all over the continent. *Al-Liwa* (Arabic), published in Egypt, and *Akede Eko* (Yoruba), published in Nigeria from 1932, were among the many newspapers in locally used languages meant to extend the reach of nationalist ideas to as many people as possible.[34] Most of these newspapers had a life of their own. Though they were usually very popular among the few but literate elite who could read them, they did not last for too long. Their appearances were eclectic and were rarely profitable. Nevertheless, the press was a vital organ for the dissemination of nationalist feelings and ideas during the inter-war years. The newspapers kept the colonial masters on their toes, exposing corruption and oppression, defending African values and dignity, and keeping Africans informed about developments in other regions of the world. For these roles the journalists and sponsors were constantly kept under surveillance, continuously harassed, and routinely tossed into jail.

Religious Expressions of Protest

Opposition to colonial rule also found expression in the establishment of independent and separatist churches. Emancipatory in character, these churches represented African reactions and adaptations to colonialism. Many of these churches were the results of disenchantment with the practice of Christianity in the established missionary churches that originated in colonial societies. Though the missionary posed as the friend of the African, for whom he had done much, most especially in providing him with Western education and improved health care facilities, the missionary was seldom free from the racial prejudice of his non-clerical white kinsmen. Similarly, while the missionary preached of the equality of all men in God's eyes, he showed little enthusiasm either to welcome African believers into leadership positions or to fraternize with them socially. The importance of the new Churches lay less in what they did than in what they stood for or symbolized. In the face of European repression, constant denigration of the black race and discrimination against it, they represented African initiatives, self-improvement, and political rights. By demonstrating African leadership in the church, they demonstrated Africans' ability and readiness to assume leadership in the state as well.

Examples of such liberationist groups can be seen all over the continent, most especially in sub-Saharan Africa, the area most affected by Christianity. In Nyasaland (later Malawi), John Chilembwe established his Providence Industrial Mission. In 1915, he led an armed revolt against the British colonial practices of taxation and military recruitment.[35] In Nyasaland and Southern Rhodesia, the Watchtower Movement developed with strong political overtones. Its millenarian predictions of the imminent collapse of colonialism and the end of the world attracted many followers, especially among the impoverished peasants and uprooted migrant workers of southern Africa. The colonial administration's banish-

34. On the press in colonial Nigeria, see Fred Omu, *Press and Politics in Nigeria, 1880–1957* (London: Longman, 1978).

35. G. Shepperson and T. Price, *Independent Africa: John Chilembwe and the Origins, Setting and Significance of the Nyasaland Native Uprising of 1915* (Edinburgh: Edinburgh University Press, 1958).

ment of its leader, Elliot Kenan Kamwana, from 1909 to 1937, neither weakened the movement nor limited its continuing spread in the region.

In the Belgian Congo, Simon Kimbangu established his "Church of Jesus Christ as revealed to Simon Kimbangu" in 1921. He was initially ignored, but when his numerous followers refused to pay taxes, withheld their labor, and denounced forced labor, the Belgian authorities intervened. Kimbangu was arrested and kept in prison until his death in 1951. Widely regarded as a martyr for his faith and for African freedom, Kimbangu gained more fame and followers after his death than when he was alive.[36] In Uganda, Ruben Sparta Mukasa, an ex-serviceman who had served in the King's African Rifles, a British colonial regiment, established the Christian Army for the Salvation of Africa and the African Orthodox Church, both dedicated to the total redemption of all of Africa at whatever personal cost to the faithful.

In Nigeria, the economic and political misery of the Niger Delta gave impetus to the emergence of a proselytizing movement in 1915. This was led by Garrick Sokari Braid, whose wide reputation as a prophet resulted in the conversion of thousands who thronged to hear him. When Braid preached against gin, the mainstay of European trade, the gin ceased to sell, adding European traders to the growing ranks of Braid's enemies. Another enemy was the Delta Pastorate, which viewed his spectacular success with envy. Finally the British colonial administration could see nothing but subversion in the movement. Though there was no credible case against him, Braid was tried four times by the colonial administration between 1915 and 1918, spending much of his time in jail, where he died in suspicious circumstances in 1918. A similar fate befell the Harris Movement, begun in 1914, in the Ivory Coast by the Liberian Grebo Christian preacher, William Wade Harris. The shattering impact of European conquest and twenty-seven years of killings and deportation by the French had left the forest peoples of the Ivory Coast exhausted, humiliated, and leaderless. Broken in power and in spirit, many had lost faith in the indigenous religions and the gods associated with them. The appearance of Harris with his message of self-determination was a welcome sign of hope. Within a year, Harris had converted 120,000 people, before the alarmed French colonial authorities moved against him, deporting him to Liberia in 1916. In southern and eastern Africa, Reformist-Zionist and Ethiopian churches emerged, emphasizing, to varying degrees, the Holy Spirit, healing, prophecy, and speaking in tongues. While many of the indigenous churches attempted a synthesis of African and Western values, others were committed to preserving and accommodating traditional beliefs and customs such as polygamy and circumcision.

The use of religion as an expression of anticolonial sentiments was not limited to Christianity. Islam also developed as a counter-ideology to European imperialism. Most distressing for the colonial administration was the periodic and often intractable manifestations of messianism or Mahdism. Most especially in the early colonial period, the threat of Mahdism hung like a sword of Damocles over the colonial states, causing anxiety and uncertainties for the colonial masters. Notable among movements that haunted the colonial authorities in North and West Africa

36. On Kimbangu, see G. Balandier, "Messianism and Nationalism in Black Africa," in P. Van den Berghe (ed.), *Africa: Social Problems of Change and Conflict* (San Francisco: Chandler, 1965).

were the Madhists in Sudan and Somalia, the Mourides in French West Africa, the Sanusiyya in Italian-ruled Libya, the Salafiya in Egypt, and the Hamaliyya and Tijaniyya in the Maghreb and much of West Africa. The activities of these groups and their leaders were closely monitored. Incipient revolts were promptly nipped in the bud, their leaders being either killed or left to languish and die in jail. For instance, in Senegal, even though the Mourides would later become faithful allies of the French in the production of groundnuts, their leader, Ahmadu Bamba, spent the greater part of his adult life in French jail, where he eventually died. In the Sudan, from 1899 to 1955, hardly a year passed without at least one Mahdist uprising to afflict the British administration. The most serious revolt occurred at Nyala in 1921. It was led by Faki Abdullah al-Sihayni. With a force of about 5,000 warriors, al-Sihayni declared a jihad against the "infidel" British colonial rulers and for the restoration of the "glorious" Mahdiyya rule in the Sudan. Though al-Sihayni was captured and hanged within a few days of the beginning of the revolt, it took a British punitive expedition and several months of mopping-up operations, which involved mass arrests of suspects, burning of houses, seizing of cattle, and confiscation of properties before the revolt was finally suppressed.

Similarly, in the southern Sudan revolt followed revolt, showing the unsettled nature of this region. Two of these revolts stand out. The first occurred among the Dinka. Years of abuses, most especially the extortion of cattle and women, by the ma'mur or colonial administrator, provoked a violent revolt among the Aliab Dinka in 1919. On October 30, 1919, a Dinka force of 3,000 warriors took on the colonial state, attacking and destroying rest houses and police stations, and killing all policemen and others unlucky enough to cross their paths. Though the revolt was eventually suppressed a year later, the campaign proved to be costly and unsettling for the administration. The second major revolt was among the Nuer who, in spite of years of periodic British punitive military expeditions, refused to acquiesce in their loss of independence. They would neither disband their armies nor lay down their arms. Their resistance came to a head in December 1927. Acting under the orders of their powerful and influential prophet, Garluark, a Nuer force of 7,000 warriors attacked and killed the district commissioner and eighteen of his officials. This and other revolts were suppressed with considerable brutality and violence resulting in numerous deaths and large-scale destruction. Nevertheless, the British were compelled to pursue a more conciliatory policy toward the heterogeneous groups of the southern Sudan for the remaining years of the colonial period.

In the Maghreb, as in much of North Africa, a mixture of liberal and Islamist ideas inspired resistance to colonialism. In the French and Spanish controlled Maghreb, opposition to colonialism was symbolized in the life and career of Muhammad ben 'Abd a-Khattabi ('Abd al-Karim). Born the son of a *kadi*, a Muslim judge, and educated at the Islamic University of Karawiyyin at Fez, Abd al-Karim brought his considerable energy, military talent, political dexterity, and resourcefulness to provide much-needed inspiration and leadership for the fledgling nationalist movement in the Moroccan Rif. With considerable diplomatic skill and political acumen, he forged a union of the various factious clans of Morocco, nudging them successfully to eschew anti-Islamic practices and return to true Islam. To consolidate his position, he campaigned among the masses, secured their support as well as the alliance of the elite and of trade unions. By 1921, he was ready to take on the colonial overlords. The first clash occurred in July 1921

at the battle of Abwar, in the course of which he inflicted on Spain its most disastrous defeat in colonial Africa. Three years later, in November 1924, Spain suffered another defeat at the hand of Abd al-Karim at the battle of Shafshawin and was forced to hurriedly evacuate her soldiers to avoid a major catastrophe. Though the Spaniards, using overwhelming and exaggerated force, eventually reasserted their control in 1926, the forces of unity and nationalism set in motion by Abd al-Karim would continue to grow and afflict the Spanish rulers for the rest of the colonial period.[37]

Workers and Peasants:
Strikes, Riots, Revolts and Migrations

Trade Unions, and Rural and Urban Protests

The establishment of trade unions was another important means for the articulation of nationalist feelings during the colonial period, especially in the areas of labor and economic policies. These unions included the Railway Workers Union of Sierra Leone and the Nigerian Mechanics Union, both established in 1919. That same year, Clements Kadalie, a Malawian migrant worker in South Africa, organized the first South African trade union, the Industrial and Commercial Workers Union (ICU). By 1928, it had 200,000 members, making it the largest nonwhite organization in South Africa. In French Africa, unions were illegal; in British Africa they were tolerated, though in the words of the governor of Sierra Leone, a workers' strike for any reason would be regarded as a rebellion against the government, to be ruthlessly suppressed. Consequently, the unions were not significant in the organization of strikes until after World War II. Nevertheless, terrible working conditions especially in the mines, extremely low wages that could not keep workers from starvation, and forced labor ensured that workers would have reasons to risk their lives and jobs in illegal strikes and revolts. Workers on the railways went on strike in Sierra Leone in 1919 and 1926 and in Senegal in 1925.[38] A year earlier, workers in the Asante goldfields downed their tools in protest against the introduction of time clocks. In 1925, the Enugu coal miners went on strike. Most of these strikes achieved very little. The government took a hard line, calling in troops to suppress the strikes, shooting some to death, sacking all the workers involved, and in some cases blacklisting their families and relatives, preventing them from ever being eligible for government employment.

Protests against colonialism were not limited to the workers. In Lagos, market women, led by their powerful and influential Madam Alimotu Pelewura, organized successfully to protect their interests and confront the colonial adminis-

37. On Abd al-Karim, see J. Berque, "Politics and Nationalism in the Maghrib and the Sahara, 1919–35," in A. Boahen (ed.), *UNESCO General History of Africa, Volume VII: Africa Under Colonial Domination, 1880–1935* (Berkeley: University of California Press, 1985), 609–612.

38. On the Senegal railway strike, see the novel by Sembene Ousmane, *God's Bits of Wood* (London: Heinemann, 1970). See also J. Suret-Canale, "Strike Movements as Part of the Anti-Colonial Struggle in French West Africa," *Tarikh* 5, 3 (19): 44–56.

tration over policies they believed were inimical to their traditional position and power in Yoruba society. By 1900, Pelewura had established herself as a successful fish trader in Lagos. Though she never went to school, and spoke only in the Yoruba language, her resourcefulness, courage, oratory, and leadership qualities soon catapulted her into the center of Lagos and colonial politics. As the undisputed and highly respected leader of the market women, she soon secured a position in the king's important Ilu (city) Committee, where she served as the spokesperson for the representatives of the sixteen most important markets of Lagos. For close to fifty years, Pelewura mobilized the women of Lagos, identifying them with all the nationalist causes of the day, working hand in hand with the educated and traditional elites to fight the injustices of colonialism. She was a popular speaker at political rallies, where she always prefaced her speech with the statement: "I am she who is called Pelewura." Addressing crowds mostly made up of men, she would challenge them to get their women involved in the great issues of the day. "We wonder," she would ask, "why your womenfolk did not show up here today. Tell me of that thing which men can undertake alone without the help of the womenfolk?"[39]

In 1932, when the women heard that the colonial administration was planning to tax the women of Lagos, Pelewura mobilized a handful of women who marched to Government House, where they met the commissioner of the colony and expressed their opposition to the taxation of women in any form. After advising the commissioner that, "Europeans should not interfere with native custom and impose taxation on women," the women warned that "any person who tried to tax them would be pinched to death by their fingernails."[40] The women kept up their pressure until the government relented and promised never to tax them. The attempt of the government, during the economic exigencies of World War II, to renege on this promise generated violent reactions from the women, who insisted that the government must live up to its promises. Similarly, in the mid-1930s, the women compelled the government to drop its plan to relocate the Ereko Market, even though several of the women, including Pelewura, had to spend some time in jail before this could be achieved. The colonial administration was at a loss as to how to deal with these women. The administration was unable to fathom how a woman like Pelewura could command so much respect and exercise so much power (in a seemingly patriarchal society) that she could almost single-handedly order the closure of all the markets of Lagos and bring the economy of the city to a halt. The British attempts to whittle away Pelewura's power and relegate the women to the sidelines, through the use of divide and rule tactics, constant harassment, and imprisonment, failed.

In other parts of West Africa, the peasants who were affected by colonial economic policies also had sufficient reasons to organize against the colonial order. The fall in prices associated with the Great Depression of the 1930s meant eco-

39. Quoted in Cheryl Johnson, "Madam Alimotu Pelewura and the Lagos Market Women," in *Tarikh* 7, 1 (1981): 1–10, my main source for the Pelewura story. For a fuller study of Pelewura and other prominent Yoruba women during this period, see Cheryl Johnson, "Nigerian Women and British Colonialism: The Yoruba Example with Selected Biographies" (Northwestern University at Evanston, Ph.D. dissertation, 1978) and Nina Mba, *Nigerian Women Mobilized* (Berkeley: Institute of International Studies, 1982).

40. Quoted in Johnson, "Madam Alimotu," 5.

nomic hardship for the peasant farmers. In Senegambia, discontentment among the poorer peasants was galvanized into a rebellion by the fiery preaching of a Mouridiyya marabout, Haidara. In a letter to his followers in February 1931, he called on them to rise against the Europeans and against the Bai Inga, the local paramount chief, and other notables, who had allied with the infidels, grown too rich, compromised the faith, and failed to help their poorer Muslim brothers. "God," he wrote,

> sends his messengers without guns or sword staff or daggers. But he gives them something which is more than a gun or sword but I have the name of God with me, you should look at what is in the air, so you should not fear the European be he French or English as the four corners of the earth are guarded by the Prophet Mohammed. Bai Inga and the Government have all fallen. I have also cursed everybody who is under the Government. I am also telling you not to pay your House Tax to any Paramount Chief[41]

The showdown with the colonial administration finally came on February 16, 1934. The battle ended with the death of Haidara and the defeat of his followers, though not until they had had the satisfaction of killing the commander of the British force.

Protest Migrations

Protest against colonial rule at the grassroots level was also expressed through interregional or trans-territorial migrations. These migrations were often provoked by the desire to explore and exploit economic opportunities in other places. European taxation was a major stimulant to migration. Taxes were demanded in European currencies. To obtain the cash, young men had to travel to such places as the mines of southern Africa and the cocoa plantations of West Africa, where their labor was in demand. Others abandoned their villages and fled to the cities to free themselves from the strangulating restrictions of traditional societies. Most of these migrations were involuntary responses to the exactions of colonial rule. In places where armed confrontation was considered either impracticable or too risky due to the colonial master's dominance in the possession of the instruments of coercion, cross-boundary migration became an effective form of unarmed protest against colonialism. In most cases, such migrations were inspired by certain compelling aspects of imperial rule, such as burdensome taxation, forced labor, land dispossession, forced cultivation of crops, compulsory military recruitment, forced relocation, and requisitioning of property. Other causal factors included government's flagrant disregard of established customs, plus official arbitrariness in the appointment of chiefs and the delineation of provincial boundaries. Others also took to their heels in the face of what they considered to be intolerable police repression, arbitrary arrests, and imprison-

41. Quoted in B.M. Jusu, "The Haidara Rebellion of 1931," *Sierra Leone Studies*, New Series, no. 3 (December 1954): 150. See also Martin Kilson, *Political Change in a West African State: A Study of the Modernization Process in Sierra Leone* (New York, Atheneum, 1969), 113–117.

ment without trial due to the application of the *indigénat* and the native penal codes.[42]

Protest migration was a widespread phenomenon in French Africa, an area which furnishes us with the best examples of this manifestation. Communities located close to interstate boundaries, especially Anglo-French frontiers, were usually the ones most likely to employ migration as a means for expressing political discontent. Protests against forced recruitment into the army and other distasteful policies of the administration compelled thousands of Mande-speaking peoples to migrate from French Guinea into British-ruled Sierra Leone. Similar resentments drove many Yoruba, Gun, and Bariba to cross from French Dahomey into British Nigeria. In the Ivory Coast, the "walk-out" from French territory to the British Gold Coast, assumed alarming proportions involving dozens of ethnic groups, such as the Kulango, Mossi, Dagari, Dioula, Baoule, Agni, Kusasi, Abron, and Sanwi, to name just a few. Unable to stem the tide of this exodus, which became a flood during World War I, Joost Van Vollenhoven, the governor-general of French West Africa (1917–1918), in a rare but candid admission, acknowledged the seriousness of the crisis. Accepting French official culpability in triggering much of West African protest migrations during the inter-war years he wrote:

> On the other side of this frontier [i.e., the British Gold Coast side] there is almost complete liberty; life is hardly affected by the fact of British intervention. On this side [i.e., the French Ivory coast side] on the other hand, the authority of chiefs is ill understood or annihilated by the frequent interference of the French authority. Our administration is rendered vexatious; it interferes in every little detail of daily life; complicated regulations become obstacles in the way of the very people they are supposed to protect; we demand taxes, we demand forced labor, we demand soldiers. Where is the surprise, then, that our subjects abandon us to go to the other side of the boundary in search of a tranquility or peace, which we could not guarantee them.[43]

African Farmers: Discontent and Resistance

The most successful demonstration of rural discontent in colonial West Africa was the Gold Coast Cocoa Hold-up of 1937. The hold-up was a revolt against the attempts of the huge European monopolies, *grands comptoirs* (great combines), led by the United African Company (UAC), to fix the prices paid to the cocoa farmers. As early as 1914, 1916, and 1921, farmers in Ghana had held up their cocoa to demand higher prices. These efforts yielded precious few results since they were haphazard and not well organized. Consequently John Ayew of Mampong in Ghana and J. K. Coker of Lagos in Nigeria pioneered the efforts to organize farmers' unions in their countries. From about 1924, Winifred (later Musa)

42. On resistance to the French policy of the *indigénat*, see I. Asiwaju, "Control Through Coercion: A Study of the *Indigénat* Regime in French West African Administration, 1887–1946," *BIFA* (Dakar), B, XLI, 1 (1979): 35–71.

43. Cited in A.I. Asiwaju, "Migrations as an Expression of Revolt: The Example of French West Africa up to 1945," in *Tarikh* 5, 3 (1977): 31–43. See also Crowder, *West Africa*, 336–340.

Tete-Ansa, a Ghanaian businessman, who had studied banking and commerce in Britain, took over the leadership. First, he set up his own bank to provide credit for the farmers and break the European monopoly of the financial market. Thereafter, he established the West African American Corporation, with a black American directorate, to buy cocoa and sell it directly to the United States, the world's largest market for the produce, thus bypassing the European companies and middlemen and paying the farmers higher prices for their produce. Tete-Ansa's West African Cooperative Producers brought together several farmers' unions to give them a strong and united voice in deciding to whom and for how much they would sell their cocoa. The first test came in 1937, when fourteen European firms led by the UAC fixed a cocoa price which the farmers felt was too low for their produce. In the Gold Coast, the world's leading exporter of cocoa, farmers led by their unions simply refused to sell their cocoa. They also boycotted all the shops owned by the European companies involved. With the leadership of Tete-Ansa, and the support of the West African press and of traditional chiefs led by Nana Ofori Atta, nearly 100 percent of the farmers joined the hold-up. After seven months of great personal suffering for the farmers and dwindling revenue for the colonial government, a government commission vindicated the farmers and compelled the companies to break their price-fixing agreement. The farmers had won their most spectacular battle against at least one of the economic injustices of imperialism.[44]

The hold-up showed that peasants could no longer be regarded as passive onlookers whose welfare could safely be ignored by the colonial state, and that when pushed to the extreme, they were capable of organizing to protect their interests. This lesson would be repeated again and again in a series of revolts and agitations against unjust taxes and other indignities of the colonial system. In British Africa, such revolts often brought amelioration; in French Africa, they were met more often with mindless repression.

In 1923, when the price paid for palm oil, Dahomey's main export commodity, fell, the French governor, Fourn, ordered a 500 percent increase in taxes. Led by Louis Hunkarin, son of a local blacksmith, who had studied and lived in Paris, a campaign of passive resistance was launched. Apart from refusing to pay the taxes, the resisters also boycotted European firms and instigated a general strike involving the port workers of Cotonou. Alarmed by the rapid spread of the resistance, Fourn hastily rushed in troops from Togo and the Ivory Coast. Thereafter, he declared a three-month state of emergency, during which he used troops to forcibly collect the taxes, destroy recalcitrant villages, and relocate others for more effective control. All the leaders of the rebellion, including members of royal clans, were arrested, disarmed, and exiled to Mauritania, where they all died in detention, except for Hunkarin. With such ironclad control, it is not surprising that the French colonial empire appeared so peaceful. Since open revolt was either impossible or too costly, the people turned to the subtler medium of the vernacular, to compose songs and chants to give vent to their nationalist feelings. These excerpts from a widely circulated song of the *griots* and troubadours of Futa Jalon show how reconciled the people truly were to the continuation of French imperialism:

44. On the cocoa holdup, see Crowder, *West Africa*, 476–77.

Destroy the European throughout all Futa; cast him out of Futa,
O Thou our help.... They put down the men of worth and exalt the
worthless.
And if even our chiefs tremble before them, what of the poor peasants?[45]

In other parts of Africa, it was the same story. A new repertoire of songs and
iconography, couched in local cultural images and symbols, became the medium
for the expression of anticolonial sentiments, especially in places where overt op-
position was impossible. Among the Makua and Makonde of Mozambique, styl-
ized sculptures were carved to satirize European officials, caricature their features
and question their humanity. Among the Chope of Southern Mozambique, hostil-
ity to increased taxation, forced labor (*chibalo*), forced cotton cultivation, and
sexual and other abuses led to the composition of songs such as the one below:

We are still angry; it's always the same story
The oldest daughter must pay the tax
Natanele tells the white man to leave him alone
Natanale tells the white man to let me be
You, the elders must discuss our affairs
For the man the whites appointed is the son of nobody
The Chope have lost the right to their own land
Let me tell you about it.[46]

Such calls would become more strident with the approach of the World War
II, a war that would explode the myth of European racial superiority, leave the
colonial powers prostrated and exhausted, and, through the German-perpetrated
Jewish holocaust, give racism a bad name. More significantly, this war would also
draw Africans into its vortex and eventually transform the nature and pace of na-
tionalism and decolonization on the continent.

Review Questions

1. What were the main features of the nationalist movement in Africa before
 1939?
2. With reference to specific examples assess the nature and the effectiveness of
 the strategies of protest and nationalism in Africa before World War II.
3. "We French natives wish to remain French, since France has given us every
 liberty." (Blaise Diagne) In the light of this statement, account for the inspi-
 ration and expressions of the ideology of negritude in Africa during the colo-
 nial period.

45. Webster and Boahen (with M. Tidy), *The Growth of African Civilization: The Rev-
olutionary Years*, 251.
46. Quoted in E. Mondlane, *The Struggle for Mozambique* (Harmondsworth, England:
Penguin, 1969), 103. For more information on early rural resistance in Mozambique, see the
fascinating study by A. Isaacman and B. Isaacman, *The Tradition of Resistance in Mozam-
bique: The Zambezi Valley, 1850–1921* (London: Heinemann, 1976). For much of Central
and southern Africa, see A.B. Davidson, A. Isaacman, and R. Pelissier, "Politics and Nation-
alism in Central and Southern Africa, 1919–1935," in Boahen, *Africa under Colonial Domi-
nation*, 673–711.

4. "In spite of its widespread popularity and considerable activism, the National Congress of British West Africa was unable either to live up to its many promises or achieve its many objectives." Discuss.
5. In what sense, and to what extent, can World War I be regarded as a turning point in Africans' perception of, and resistance to, European colonialism?
6. "Masks of Anarchy." How accurate is this description of the major revivalist and millenerian religious movements in Africa before 1939?
7. Assess the historical significance of four of the following in the development of nationalism in Africa during the early colonial period:

 1. Zad Zaghlul 2. Blaise Diagne 3. J. Casely Hayford
 4. Abd al-Karim 5. Marcus Garvey 6. Ahmadu Bamba
 7. Alimotu Pelewura

Additional Reading

Beinart, William, and Colin Bundy. *Hidden Struggles in Rural South Africa: Politics and Popular Movements in the Transkei and Eastern Cape, 1890–1930.* Berkeley: University of California Press, 1987

Berque, Jacques. *French North Africa: The Maghrib Between Two World Wars.* London: Faber, 1967.

Coleman, James. *Nigeria: Background to Nationalism.* Berkeley: University of California Press, 1963.

Davidson, A.B. *South Africa, the Birth of a Protest.* Moscow: African Institute, 1972.

Langley, J.A. *Pan-Africanism and Nationalism in West Africa, 1900–1945: A Study in Ideology and Social Classes.* Oxford: Clarendon Press, 1973.

Kohn, Hans. *African Nationalism in the Twentieth Century.* Princeton: Van Nostrand, 1965.

Rotberg, Robert, and Ali Mazrui, eds. *Protest and Power in Black Africa.* New York: Oxford University Press, 1970.

Rotberg, Robert. *The Rise of Nationalism in Central Africa.* Cambridge, MA: Harvard University Press, 1966.

PART C

REGIONAL HISTORIES

Chapter 16

Southern Africa

Funso Afolayan

This chapter examines sociopolitical developments in southern Africa from the late nineteenth century to 1939. Notable among the states that will be covered in the chapter are South Africa, Botswana, Swaziland, Lesotho, Angola, Mozambique, Namibia, and the Indian Ocean states of Madagascar, Comoros, Seychelles, and Mauritius. The chapter explores such issues as the expansion and consolidation of white colonization; African dispossession; the discovery of minerals, most especially diamonds and gold and its consequences; industrialization and capital formation; the making of an African peasantry; the intersection of race, class, and gender; and the development of protest movements and nationalism.

* * *

The Mineral Revolution and the Consolidation of African Dispossession

Diamond and Gold Discoveries

The year was 1867. Two small children, Erasmus and Louisa, were playing on their neighbor's farm, by the south bank of the Orange River, close to Hopetown in South Africa. Stumbling on a shinny little pebble, they picked it up, hoping to increase their collections of toys. The little bauble, however, impressed their farmer-father, Schalk van Niekerk, who thought it might be more than an ordinary stone. Van Niekerk gave the pebble to John O'Reilly, who took it to Hopetown to see whether anyone could identify the shiny object. He had no luck as most of the local shopkeepers dismissed the stone as worthless. Undeterred, O'Reilly took the stone to Colesberg, where a diamond test on a pane of glass proved positive. The stone was sent to Grahamstown, where a local jeweler confirmed that it was a diamond. The following year, a distinguished British geologist was asked to investigate reports of diamond finds in this region of Southern Africa. He replied that such an investigation was unnecessary, because "The geological character of that part of the country renders it impossible...that any (diamonds) could have been discovered."[1] He was wrong. By the end of the decade,

1. Quoted in *The Reader's Digest Illustrated History of South Africa: The Real Story* (Pleasantville, NY: The Reader's Digest Association, Inc., 1989), 166.

as more diamond finds were made, it became clear that this flat and arid region of southern Africa most probably contained the largest concentration of diamond deposits anywhere in the world. In addition, tests revealed that the diamonds were of the highest quality (21, 25 carats). A few years later, in 1886, history repeated itself with the discovery of gold in the region that became known as the Witwatersrand. It was soon realized that this region also contained the largest deposit of gold anywhere in the world. These discoveries of precious metals, acting in concert with other forces, would dramatically transform the history of southern Africa in many ways and for many years to come.

First, the news of these finds created considerable excitement, not only in South Africa, but also in Europe, the Americas and other parts of the world. The most immediate impact was a flurry of immigration, as settlers, colonists, and other adventurers and fortune seekers flocked to South Africa. Most of the new migrants came from Europe and the Americas, with Britain and the United States supplying the bulk of the fortune seekers. Those from the United States and Australia brought along with them valuable experience, gained working the gold mines of California and Australia. By 1870, there were close to 10,000 diggers in the Orange-Vaal River valley, working round the clock to extract whatever diamonds luck would bring their way. New discoveries, in the area that later became known as Kimberley, resulted in another flurry of immigration, increasing the number of white diggers to 20,000 and black diggers to 30,000 by 1872. Second, the fallout of this huge and rapid concentration of fortune hunters led to the rise of new cities in this previously sparsely populated area of southern Africa. The first to develop was Kimberley. It began in 1867 as a land of ropes and pulleys, as thousands of individuals and cooperatives feverishly and confusedly drew lines and demarcated their claims to exclusive mining rights over portions of the landscape. Within a few years Kimberley had become the second largest city in southern Africa, surpassed only by Cape Town. By 1911, the Witwatersrand, the land of gold, had a population of nearly 500,000; nearly half of these lived in the new city of Johannesburg, making it at that date the most populous city in southern Africa.[2]

Development of Mining Capitalism

Third, after the surface outcrop of diamond and gold bearing rocks had been mined, a more intensive application of capital and technology was needed to reach and unearth the rich and extensive deposits buried deep within the earth's crust and beyond the reach of manual diggers. The chaos and cut-throat competition associated with the multiplicity of small-holdings soon gave way to concentrations, as a few enterprising or better endowed individuals bought off the small claim holders and amalgamated numerous smaller claims to form larger holdings. Small claim holders and private prospectors who worked the alluvial field surface

2. On the discovery of minerals and the major consequences, see Robert Turrell, *Capital and Labour on the Kimberley Diamond Fields* (Cambridge: Cambridge University Press, 1987); William M. Worger, *South Africa's City of Diamonds* (New Haven, CT: Yale University Press, 1987); Frederick Johnstone, *Class, Race and Gold: A Study of Class Relations and Racial Discrimination in South Africa* (London: Routledge & Kegan Paul, 1976); and *Reader's Digest Illustrated History*, 163–215.

with picks and shovels were systematically supplanted, set aside, or (the lucky ones) hired as deep-level miners by the new super corporations. In the Witwatersrand, management of the mines passed to a handful of highly capitalized companies with the resources to provide the expensive technology necessary for the deep-level mining, the rock haulage, and the surface-level crushing and processing required to turn the deposits into gold. The fierce and destructive competition between the leading companies provided a favorable environment for further consolidation into fewer and larger oligopolies.

This process of concentration and mechanization began in Kimberley. It was led by a handful of young and enterprising immigrants from Europe who grew immensely rich through diamond prospecting and speculative marketing. Three of these men were notable. The first was Barney Barnato. Born in 1852 into a British-Jewish rabbinical family, he arrived in Kimberley in 1873, with "a little cash and forty boxes of cheap cigars." Setting himself up as a dealer in diamonds, and through fair and foul means, he systematically bought up the claims of private prospectors and the shares of other companies to make himself the richest diamond dealer and share holder in southern Africa. In 1888, he achieved complete control of the diamond mining in Kimberley, when his Kimberley Central Company bought out the shares of the only remaining competitor, the French Company. Another notable individual was Alfred Beit of Hamburg who was sent to South Africa by a German firm to buy diamonds. When he arrived in 1875 at the age of twenty-two, he was struck by the chaos and confusion associated with the cutthroat competition of the numerous small claim holders and thousands of tiny plot owners in the mines. Though shy and unobtrusive, he became the brain behind the amalgamation of plots and the introduction of advanced technology for deep-level mining by well-capitalized joint-stock companies.[3]

Cecil Rhodes, De Beers, and Mining Monopoly

The last of the trio and certainly the most influential was Cecil Rhodes. Son of an English country parson, Rhodes had suffered early in life from repeated bouts of bad health. While Rhodes was still a student at Oxford University, his doctor recommended that a change of climate might do his declining health some good. In 1869 at the age of sixteen, still uncertain of his future and heeding the advice of his doctor, Rhodes took off for South Africa to spend his vacation with his brother, Andrew, who had joined the "rush" to Kimberley, the new El Dorado, to seek his fortune. With his health remarkably restored in the African climate, and unable to resist the lure of diamonds and the prospect of sudden wealth, Cecil Rhodes joined in the fray, staking his fortune and future in the minefields of Kimberley. For the next twelve years, Rhodes would alternate between Kimberley and Oxford, dealing or prospecting in diamonds in one and accumulating course credit hours in the other. By the time he graduated in 1881, at the age of twenty-eight, he was a multimillionaire. By this time, the diamond mining industry was plagued with many practical and technical problems such as collapsed roadways, rockfalls, flooding, and flunctuating prices. The solution to all these, Rhodes rec-

3. On the South African mining magnates, see Geoffrey Wheatcroft, *The Randlords: The Exploits and Exploitations of South Africa's Mining Magnates* (New York: Atheneum 1986).

ognized, was amalgamation. After personally buying off several small claim hold-
ers, Rhodes teamed up with another entrepreneur, C. D. Rudd, to form the De
Beers Mining Company in 1880.

The successful consolidation of De Beers was a catalyst to other dealers and
stake holders, who began to combine their capital in joint-stock companies. By
the middle of 1881, some seventy-one joint-stock companies had emerged. How-
ever, the wild speculation and feverish buying became counterproductive, result-
ing in the collapse of the diamond market in 1881. Many of the new companies
went under. Only a few survived. Among these were De Beers, Kimberley Cen-
tral, and the French Company. To avoid a repeat of the events of 1881, Rhodes
attempted to persuade his competitors to agree to a voluntary reduction in out-
put. When the attempt failed, Rhodes decided to deploy his already enormous
wealth and the financial backing of the Rothschild banking family of London to
buy out the competition. Rhodes' ruthlessness, manipulation, cajoling, and re-
morseless pressure soon paid off. By 1888, only one other major company, Bar-
nato's Kimberley Central, was still in existence and beyond the reach of the claws
of De Beers; but this did not last for long. In 1889, after much financial and po-
litical pressure, Barnato accepted a cheque for £5,338,650 from Rhodes, allow-
ing De Beers to finally swallow up Kimberley Central, its last competitor, in the
race to dominate the diamond industry and indeed the political affairs of South
Africa.[4]

With monopoly control, stability and security were brought to the diamond in-
dustry. The monopoly also allowed market control through the regulation of pro-
duction and output to ensure a profitable and stable price for the precious gems.
For Rhodes this was the beginning of his rise to become the most influential politi-
cian of his age and country. Charismatic, visionary, manipulative, and ruthless,
Rhodes was blatantly imperialistic and racist in his dreams and visions. Believing,
as he wrote in his "Confession of Faith," in 1877, that the English people "are the
finest race in the world," he argued "that the more of the world we [the English]
inhabit the better it is for the human race."[5] Consequently, Rhodes dedicated his
life and willed his enormous wealth to "one object, the furtherance of the British
Empire and the bringing of the whole uncivilized world under British rule for the
recovery of the United States for the making of the Anglo-Saxon race but one Em-
pire."[6] He firmly believed that the loss of the United States was a great mistake,
which must be reversed, and that it was a great pity that Britain did not yet have
enough resources to annex the stars and the planets and make them part of the
British Empire, on which the sun must never be allowed to set. Certainly the
wealthiest and the most dominant statesman of his day, Rhodes went on to live a
colorful, eventful, and controversial life in South Africa. As early as 1881, he be-
came a member of the Cape Assembly. His political influence rose rapidly with the
dramatic growth of his personal wealth. By 1890, he was the Prime Minister of the
Cape. In 1895, he planned the bungled Jameson raid, intended to overthrow the

4. On the life and career of Cecil Rhodes, see John Flint, *Cecil Rhodes* (Boston: Little &
Brown, 1974); and Robert Rotberg, *The Founder: Cecil Rhodes and the Pursuits of Power*
(New York: Oxford University Press, 1988).

5. For details and further analysis of Cecil Rhodes' will and last testament, see Basil
Williams, *Cecil Rhodes* (New York: Greenwood Press, 1968), 50–57, 321–324.

6. Williams, *Cecil Rhodes*, 321–324.

Transvaal government and integrate the Republic into the Cape.[7] The scandal of the failure of this daring adventure combined with other factors to force Rhodes' resignation as prime minister in 1896. He remained active in Cape and Rhodesian affairs until his death in 1902 at the relatively young age of forty-nine.

Social and Economic Effects of the Mineral Revolution

To meet the need of the mines, subsidiary industries developed. Coal mines, dynamite factories, hotels, textile industries, and other enterprises sprang up all over Kimberley and the Witwatersrand. To solve the problem of transport, Afrikaner transport riders provided valuable services for the ever-expanding population of the mining regions. Wagons, usually drawn by sixteen oxen, became the means for moving grain, skins, and wool from the agricultural hinterland to the ports. They were, however, slow and inefficient, especially when large quantities had to be moved quickly and over long distances. The solution to these problems would be provided by the extension of the railway from the coast to Kimberley and the Witwatersrand. A beginning was made in 1873, when the Cape government purchased the privately owned Cape Town-Wellington railway line. For a while construction was stalled by the opposition of Afrikaners in the Transvaal and the Orange Free State, who perceived the construction of a railroad through their territories as a threat to their independence. The Afrikaner republics remained resentful of the Cape Colony's successful absorption of the diamond and gold bearing regions. However, with the active support of notable Cape parliamentarians, such as John X. Merriman and Saul Solomon, the railroad project gathered steam and by the end of the century, several arteries radiated from Johannesburg and Pretoria to different parts of southern Africa. Kimberley was connected to the Cape in 1885. The lines from the Cape reached the gold belt in 1892. The port of Delagoa Bay in Portuguese-ruled Mozambique was reached by rail in 1894, providing the independent-minded Transvaalers direct access to the sea, free of British control. Durban in Natal was linked to the rail network in 1895.

The consequences of the advent of the railways were far-reaching. In Kimberley, in the year that the railway arrived, the prices of almost everything fell drastically. With the cost of transportation drastically reduced, coal, which had sold for £24 a ton, fell to under £7 a ton. Grain-producing white farmers of the high veld

7. Starting from 1835, groups of Voortrekkers migrated from the Cape into the interior of Southern Africa, in protest against British domination and interference with their ways of life at the Cape. After a series of wars with and land appropriation from the preexisting African groups, the Boers organized themselves into several competing and tenuously independent "republics." Eventually, all these would coalesce into three major republics. The first to be set up was the republic of Natalia (later Natal), established in 1839 on land newly conquered from the Zulu. However, Natal's independence would be short-lived. Concerned over the security of the strategic Indian ocean port city of Durban and worried that the region might fall into the hands of rival European powers, the British annexed Natal in 1843, though not before a short and sharp military engagement with Boer commandos. Thereafter, the defeated and disgruntled Voortrekkers moved north to join other Boers who ended up establishing the South African Republic also known as Transvaal in 1852, in the region north of the Vaal River and on land seized from the Rolong, Kgatla and Tswana. Finally two years later, in 1854, the Orange Free State emerged as an independent republic, amalgamating the various Boer settlements between the Vaal and the Orange Rivers and on land heavily peopled by the Sotho, who outnumbered whites 12 to 1.

demanded and received special concessional rates from the railway companies, thus increasing their profit margins, while reducing the cost of food for the inhabitants of the mining centers. By the end of the 1930s the truck had replaced the ox-wagon as the subsidiary means of reaching the railheads from regions not linked to the railroads. Nevertheless, the wagon would remain a powerful symbol of Afrikaner nationalism, as the single most important instrument of the highly mythologized Boer Great Trek of the 1830s. Impressive improvements were also recorded in road, bridge, and harbor construction. Kimberley was connected by telegraph to Cape Town in 1876. This was followed a few years later by the telephone, which was introduced to South Africa in 1882. On the other hand, African farmers and settlements in the rural areas received no consideration in the railroad plans and were often bypassed and thus further marginalized by the new highways of commerce and productivity.

Migrant Labor and African Societies in Industrial Southern Africa

European Imperial Expansion

The discovery and production of diamonds and gold had major consequences for African rural life as well as for African societies all over the southern African subcontinent. First, it accelerated the process of the conquest of African communities and the appropriation of their land. All the parties involved, from the British rulers at the Cape to the Afrikaners of the Transvaal and the OFS, from adventurers such as Cecil Rhodes to Griqua leaders such as Nicolaas Waterboer, were keen to establish possession of the rich mineral regions. After much political squabbling, the British succeeded in supplanting and setting aside the claims of the Afrikaner republics. Thereafter a systematic assault was launched on the African societies within or bordering the mineral reefs of southern Africa. From different directions, white farmers, British or Boer, traders and businesspeople, missionaries and speculators combined their energies and resources to subject African peoples and societies to economic, political, and social domination. Believing themselves to belong to a superior Christian race and civilization, they felt morally justified in appropriating African land, exploiting African minerals, harnessing African labor, and reducing Africans to a state of servitude in the name of a civilizing mission.

As in the rest of the African continent, Europeans assisted one another in the conquest of Africa. Europeans, either as individuals or as groups, who had benefited from African patronage and support, had no scruple in betraying their former benefactors in the name of the imperial cause. In 1879, Paul Kruger, formerly a friend of the Zulu, provided the British with useful logistic advice on how to best conquer the Zulu. Similarly, the British adventurer and polygynist, John Dunn, who had grown fabulously wealthy as a result of his client relationship with the Zulu King Cetshwayo, and in the course of which he had obtained and married forty-six Zulu wives, swiftly defected to the side of the British invaders at the first sign of the crumbling of Zulu power. The process of conquest varied from

group to group but in virtually all cases, alien economic penetration and African internal cleavages prepared the way.

Most decisive, of course, was the superiority of European military technology. This ensured that even in cases where Africans were able for a while to hold the white invaders at bay, the seemingly inexhaustible and lethal weapons of the Europeans ensured their ultimate victory. A case in point was the Zulu kingdom. After surviving the untimely death of its founder, Shaka, in 1828, the Zulu kingdom recovered and even expanded under its later rulers. However, from the mid-nineteenth century onward, internal factionalism and civil wars, coupled with Afrikaner economic infiltration and predatory attacks, began to weaken the kingdom, giving a British force of 7,000 men the confidence to invade the kingdom in 1879. However, the British were in for the shock of their lives. On the night of January 21, 1879, a British force of 1,600 men found itself surprised and surrounded by a determined Zulu army, which mowed the British down and virtually eliminated them. It was the worst British disaster since the end of the Crimean War (1854–1856) and the most costly in colonial Africa. Two years later, the British struck back, defeated the Zulu army, abolished its monarchy, and exiled its ruler to Cape Town. As for the Zulu kingdom, it was broken into thirteen separate, weak units to be administered by chiefs whose loyalty and subservience to British rule were unquestionable. Like the Zulu, one after the other, the African states of the Swazi, Tswana, Sotho, Venda, Pondo, Mfengu, Xhosa, and other Nguni groups were compelled to submit to British or Afrikaner domination, and sometimes to both. By the end of the century, the whole of southern Africa had been assaulted, sanitized, and incorporated into states under white domination. A new era of major transformation had begun in the history of this volatile and resource-rich region of Africa.[8]

Mining and Migrant Labor

The problem of labor for the mines was solved through migrant labor. This became the chief source of labor supply to the mines with significant consequences for the mineral industries, urban culture, and rural life of southern Africa. Long before the discovery of diamonds in the 1860s, Africans had migrated to the settler-dominated region of southern Africa in search of work as farmhands on the settlers' farms and as domestic servants in his settlers' households. Others had moved to the rising new cities of Cape Town and Durban to peddle their labor and services. For instance, decades before Kimberley was founded, Pedi workers from the Eastern Transvaal had walked between 600 and 1,000 miles regularly to Port Elizabeth and the Cape in search of work. Natural cataclysms such as the devastating Xhosa cattle killing of 1854–1857 had produced spurts of migration that reduced cattleless and destitute Africans to a com-

8. For the rapid expansion of white settlements and the consolidation of African dispossession in Southern Africa, see Leonard Thompson, "The Subjection of the African Chiefdoms," in Monica Wilson and Thompson (eds.), *The Oxford History of South Africa*, Vol. 2 (Oxford: Clarendon Press, 1971), 245. See also J. Guy, *The Destruction of the Zulu Kingdom* (London: Longman, 1979); and William Beinart, Peter Delius, and Stanley Trapido (eds.), *Putting a Plough to the Ground: Accumulation and Dispossession in Rural South Africa, 1850–1930* (Johannesburg: Ravan Press, 1986).

pulsory state of servitude to the white settlers. The rinderpest epidemic of 1896–1897, which killed 80 percent of the cattle on the east coast, had the same effect. With the discovery of minerals, and as the mining operations went deeper and deeper into the earth's crust, new technology as well as vast supplies of labor became essential for successful extraction. Rural-urban migrations that had been in trickles now became a torrent and a flood as hundreds of thousands of workers were needed to work the mines. Rural urban migration, of course, was not unique to South Africa. Beginning with the industrial revolution in Great Britain in the mid-eighteenth century, the demographic shift from rural to urban areas became one of the pillars on which the new European capitalist order and industrial dominance were constructed. In South Africa, in its extent, longevity, operations, and impact, the migrant labor system assumed its own peculiarities. For the next hundred years and more, migrant labor was the major source of labor for the mines. Its profitability led to its extension to other industrial and economic enterprises in South Africa.[9]

The migrant laborers came from all over southern Africa and beyond. With the relentless expansion of white settlements, and as more and more African groups became dispossessed of their fertile farming or grazing land, the surge to the mining centers intensified. To meet the ever-increasing and seemingly insatiable demand for labor, recruiting agents and touts went out from the mines to the far corners of southern Africa to entice the African peasants with exaggerated tales of the fabulous salaries, the splendor, and the promise of working in the lands of gold and diamonds. Thousands who were taken in by the story and other needy individuals found their way to the mines. This was a journey that was often filled with hazards, usually from thieves and swindlers who regularly relieved the migrants of their meager personal belongings, from extortionate touts and fake doctors who extracted shillings for bogus inoculations, and from renegade white policemen who extracted illegal tolls from the hapless migrants. In Kimberley, during the 1870s, close to 50,000 African workers arrived every year to work in the mines. It became a major challenge to control the laborers and ensure that they would remain at their work. Usually the laborers were contracted to work for the same employers for a period ranging from three to nine months. Those who worked longer, like the Zulu and the Pedi, were considered better workers than the Sotho, whose closeness to the mines facilitated a quicker turnover of workers.

Initially, African workers lived side by side with their white employers, but as their number grew, open compounds were constructed to house them. To check the frightening possibility of white, black, and Colored workers coming together in an alliance against the mining magnates and management and to squelch the flourishing practice of diamond theft and illicit diamond buying, a policy of strict segregation between the races, most especially with regard to housing, was adopted. Thereafter Africans were housed in barrack-like closed compounds or hostels. From these compounds, everyday the laborers came forth and were es-

9. On the phenomenon of migrant labor, see N. Levy, *The Foundations of the South African Cheap Labour System* (London: Routledge & Kegan Paul, 1982); A. Jeeves, *Migrant Labour in South Africa's Mining Economy, 1890–1920* (Kingston, Ontario: McGill-Queen's University Press,1985); and Turrell, "Diamonds and Migrant Labour in South Africa," *History Today* 36 (1986).

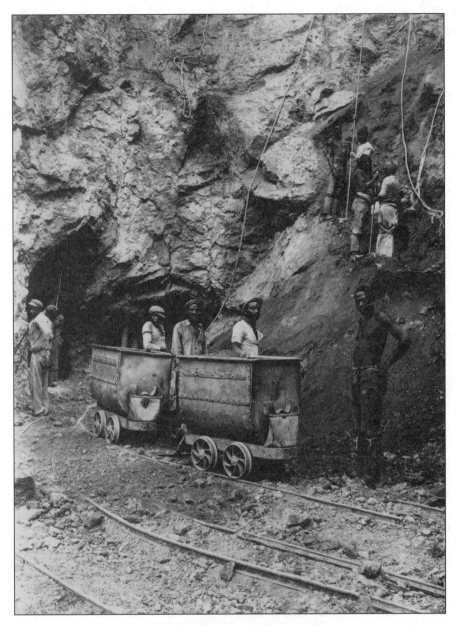

Figure 16-1. Mining in South Africa

corted like convicts by armed guards to the mines and back. On arrival at the mines, the laborer was issued a pass, which he carried with him at all times. To be caught outside one's assigned compound without the authenticated signature of one's master, which was rarely given except at the expiration of one's contract, was to risk arrest as a vagrant and pass breaker. For the length of their contracts, African workers were not permitted to leave the compounds except when marching to the mines to work. Hemmed in by high corrugated-iron walls, the workers were legally excluded from having any contact with the outside world or receiving

visitors. They could not bring their wives or families to the mines, since the hostels could not accommodate them, while the pass system prevented visits from family members.

The conditions of the African workers were, to say the least, deplorable. Forced to live in overcrowded all-male hostels, they were compelled to carry passes at all times. Subjected to inhuman and dehumanizing regulations, they could neither own land, nor mine on their own, nor trade in diamonds. They could be stripped completely naked in public in any place and at any time and searched for diamonds at the whim or suspicion of any white overseer or security agent. Those found with diamonds or found to be violating the pass laws received punishments ranging from fifty lashes to terms of imprisonment. Laws were passed to make it a crime for a laborer to desert one master for another on the basis of better treatment or payment. White workers, on the other hand, were not subjected to these indignities. With virtually all the skilled jobs reserved exclusively for them, they were a better-paid free-working class. Unlike blacks, they could organize themselves into unions and strike for better conditions, though the management, ever weary of their claims and pretensions, did not hesitate on several occasions to brutally repress their protests and strikes. Whites were also permitted to bring their families to live with them in the mines and they cooperated with management to ensure a racially structured labor and reward system that privileged whites over blacks and Coloreds.

Labor Migration and Its Impact on African Societies

From the Pedi in the north to the Xhosa in the south, from the Tswana in the west to the Pondo in the east, labor migration had major consequences for African societies. Certain dynamics within African societies rendered them especially vulnerable to the lure of the European-dominated mines and urban centers of southern Africa. Many factors combined to create an environment favorable to large-scale migrations to the cities in African societies. For some, like the Pedi, the desire was to obtain cash for guns to defend their land and fledgling independent polities from more truculent neighbors like the Zulu. For the African groups of southern Mozambique who provided the bulk of the labor supply to the Witwatersrand, the need to acquire enough material resources, most especially in cattle, to cope with the rising costs of bridewealth, was a powerful impetus. From Mozambique to Lesotho, inflation of bridewealth, largely in response to the ability of young men to pay and marry early, became a common feature. Labor recruiters and local traders also made advance payments of wages to the families of potential migrants, to ensure their migration as well as to cement an exchange relationship between the various parties involved. Bridewealth inflation and advance payments ensured that the migrants would return after their contracts to share their earnings with their people, while giving the traditional elders a stake in maintaining the migrant labor system.

For the African societies involved, rural-urban migration had far-reaching consequences. For the young men, migration was an opportunity to set out on their own. For other, migration provided a means of escape from the strangulating hold of traditions and control by the elders. The division of labor in African societies, in which women had control of the domestic sphere, ensured that

mainly men would migrate. When men stayed in the mines for months or even years, family life would be disrupted, while the women would be left alone to bear the heavy burden of child care, household management, and food production.[10]

Afrikaner Nationalism, White Politics and the Struggle for South Africa

Land, Gold, and Afrikaner Nationalism

For the white rulers of southern Africa, the struggle for control of the newly discovered riches and the surrounding areas would create considerable tension between the British and the Boers, as well as between the white workers and the mine owners. Many forces coalesced to lead to the Anglo-Boer or South African War of 1899. At the heart of the conflict was gold. Who would control the fabulous, newly discovered wealth? The Afrikaner, in whose land much of the gold-producing region lay, felt it belonged to them by the right of primacy of settlement and conquest. The British, on their part, wanted the mines. They thereafter sought to bring the Afrikaners under control. In 1871, Griqualand West was annexed. In 1873, it became a Crown Colony. Seven years later, it came under the jurisdiction of the Cape. Ignoring strong Boer protest, the British annexed the Transvaal Republic in 1877. Three years later, in 1880, the Afrikaner Bond was formed at the Cape, by S.J. du Troit, a minister of the Dutch Reformed Church, as a political party to promote Afrikaner interests. A year later, in protest against British tax measures, the Transvaal Afrikaners declared their independence of British rule, leading to war with the British. The disastrous British defeat at Isandhlwana at the hands of the Zulu in 1878 reassured the Boers that the British were not invincible. The Boers, fighting on familiar ground and for survival, did surprisingly well, inflicting on the British a major defeat at Majuba in 1881.

The British, having underestimated the ability and doggedness of the Boer soldiers, were compelled to grant them autonomy, while Britain retained control of foreign affairs. But the problems of the Boers were not over. The discovery of gold in the Transvaal opened the region to a flood of black as well as white migrations.

10. On the impact of labor migrations on Southern African societies, see William F. Lye and Colin Murray, *Transformations on the Highveld: The Tswana and Southern Sotho* (Totowa, NJ: Barnes & Noble Books, 1980); Murray, *Families Divided: The Impact of Migrant Labour in Lesotho* (Cambridge: Cambridge University Press, 1981); and Elizabeth Eldredge, *A South African Kingdom: The Pursuit of Security in Nineteenth-Century Lesotho* (Cambridge; New York: Cambridge University Press, 1993). Labor migration to Johannesburg from Zululand is one of the key themes of the acclaimed South African classic, *Cry the Beloved Country*, first published by Scribner in 1947. In this book, the author courageously confronted the "problem of the decay of tribal culture, the poverty of the [African] reserves, and the flight of the people to already overcrowded urban centers." Early in the book, we see a mother lamenting the loss of her only son to this "terrible" city of gold: "'He is in Johannesburg,' she said wearily. 'When people go [to] Johannesburg, they do not come back.'" See Alan Paton, *Cry the Beloved Country* (New York: Scribner, 1987), 23, 38.

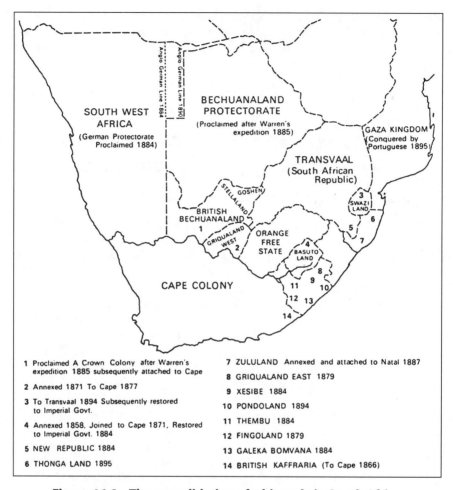

Figure 16-2. The consolidation of white rule in South Africa

The white migrants were known as Uitlanders. They came in thousands from all over Europe, America, and Australia, bringing their skills, experience, and racist ideology with them. Resolved and aggressive, by 1892 they had purchased nearly a third of all the land in the Transvaal. For the Boers, the Uitlanders with their British loyalty posed a definite and intolerable threat to Boers' way of life as well as to their hegemony and independence in the region. Consequently the Boers took steps to put the Uitlanders in their place by denying them citizenship rights until they had completed ten years' residency. The Uitlanders were forbidden to speak English on public occasions, and were denied all civil rights including trial by jury, until they became citizens.[11]

11. For the bloody history of the struggle over the control of land in South Africa, see Peter Delius, *The Land Belongs to Us: The Pedi Polity, the Boers and the British in the Nineteenth-Century Transvaal* (Berkeley: University of California Press, 1983); P. Bonner, *Kings, Commoners and Concessionaries* (Cambridge: Cambridge University Press, 1983); and Thompson, "Great Britain and the Afrikaner Republics," in *The Oxford History of South Africa*.

For much of the nineteenth century, the Boers (farmers) had fought cease-lessly with the indigenous African groups, whose land and cattle they forcefully and often violently appropriated.[12] In addition to all these troubles, the Boers had to continuously contend with the British relentless attempts to re-assert a form of control over them, most especially since their much celebrated Great Trek escape from the Cape in 1834. As far as the Afrikaners were concerned, they desired nothing from the British except to be left alone. But this was not to be. The dis-covery of extensive deposits of diamonds and gold in lands close to or partially controlled or claimed by Afrikaners would further accentuate the tension between the two competing groups of White rulers of South Africa. For the Afrikaners, the combination of all these pressures and hostilities, most especially from the British, created a feeling of being a people under duress, persecuted and repressed, a cul-ture and a civilization under threat. Their acute sense of injustice began to be doc-umented and given expression in books such as *A Century of Wrong*, by Jan C. Smuts. Afrikaner nationalism became the Boers' ideological and political response to what they perceived as British perfidiousness and unbridled and unjustified in-tervention in their affairs and livelihood. This nationalism became the weapon through which to ensure and assert the unity of the "volk" and mobilize them to hold on to their own while firmly resisting British attempts to supplant them and deprive them of the wealth and resources of the land of their birth for which they had risked their lives, dared the elements, and shed their blood in the Great Trek and later.

Under the able and inspiring leadership of Stephanus J. du Toit and Jan Hen-drick Hofmeyr, an Afrikaner social and literary culture was "manufactured" and propagated with major consequences for politics and race relations in southern Africa. Afrikaans, originally a Creole language formed and spoken by the slaves, the Colored people, and the domestic servants of the Boers, was adopted as the new language of the "volk." In the hands of the volk it was refined, infused with Dutch words, purged of its vulgar elements, reduced to writing, professionalized, and made respectable through a dictionary which was written for it. In newspa-pers and journals such as *Die Afrikaanse Patriot*, and in cultural associations such as the Fellowship of True Afrikaners and the Afrikaner Bond (formed in 1879), the new sense of cultural identity and mission was reinforced and affirmed. His-tory became serviceable in the hands of tireless Afrikaner patriots. Du Toit, whose book in Afrikaans titled *The History of Our Country in the Language of Our People*, unabashedly glorified Afrikaner history and Afrikaner folk heroes, em-phasizing again and again that the Afrikaners (not the British) were a distinct and chosen race, ordained and sanctioned by God to dominate southern Africa, rule its people, enjoy its wealth, and bring civilization to its "uncivilized" inhabitants. Though crude, distorted, and tendentious, the book remained a best seller in all the Afrikaner republics for many years.[13]

12. On the realities and myths of the Great Trek, see Eric A. Walker, *The Great Trek* (London: A. & C. Black, 1960).

13. On the development of Afrikaner nationalism, see F.A. van Jaarsveld, *The Awaken-ing of Afrikaner Nationalism, 1868–1881* (Cape Town: Human & Rousseau, 1961); and Leonard Thompson, *The Political Mythology of Apartheid* (New Haven, CT: Yale University Press, 1985). On the politics of race and "tribes," see L. Vail (ed.), *The Creation of Tribalism in Southern Africa* (Berkeley: University of California Press, 1989).

The South African War, 1899–1902

Finally, in 1899, British imperialism and Afrikaner nationalism came to a head. The crisis had been brewing for some time, with the British attempt to seize control of the mines and of the Boers' republics in addition to the British demand that the Afrikaners grant full civil and political rights to the Uitlanders, who were mostly British and rabidly anti-Afrikaner. For the Afrikaners of the Transvaal, granting full citizenship rights to the now more populous Uitlanders would inevitably tilt the balance of power against the Afrikaners and to the advantage of the new migrants and their British mentors and allies. Paul Kruger, the President of the Transvaal refused to make any major concession to the British demands on behalf of the Uitlanders. To force matters, Britain ordered troops to be moved to the border of the rebellious republics. Kruger demanded that the troops be immediately withdrawn. As far as Britain was concerned, the line had been crossed. The greatest imperial and industrial power in the world would not be bullied by one of the tiniest states, though in this case one producing much of the world's supply of gold.

On October 11, 1899, war broke out between the "proud and brave" Boer republic of Transvaal, in alliance with the Orange Free State, and the British Empire. Britain expected a quick victory, but it was soon disappointed. Though Britain eventually won the war, the Afrikaners put up a good fight and the war dragged on remorselessly and with lethal consequences for three years. Unable to match the superior military armament of the British fighters, the Boers resorted to guerrilla warfare. In exasperation, the British generals adopted a scorched-earth policy, which devastated the Boers' countryside and towns, and herded the inhabitants into concentration camps, where 28,000 Boer civilians, mostly women and children, died in squalid and disease-ridden conditions. The British lost 21,000 soldiers compared to the Boers, who lost only a third of this number in combat. Overall, however, a tenth of the Boer republics' population died in this war. The Peace of Vereeniging, May 31,1902, which terminated the war, was generous to the Afrikaners, who had lost the war. Though the Transvaal and the Orange Free State became British colonies, self-government was promised to both in the near future. In addition, the British offered financial and other support to reconstruct the battered lands and rehabilitate their surviving inhabitants. Finally, both Dutch and English would have the same status as official languages in the colonies.[14]

The Union of South Africa and the Triumph of the Afrikaners

With the achievement of peace, the new British governor, Alfred Milner, took steps to effect the political and economic integration of the different colonies. A year after the war, a customs union, which federated all the colonies and abolished all internal tariffs and other barriers, was established. To promote better communication between the regions, all the railway systems were brought under a single controlling authority in 1905. A broadly similar political system was in-

14. On the Boer-British War, see Thomas Pakenham, *The Boer War* (New York: Random House, 1994); Peter Warwick (ed.), *The South African War* (Harlow, England: Longman, 1980) and *The Black People and the South African War, 1899–1902* (Cambridge: Cambridge University Press, 1983).

troduced to all the regions and in 1907, both the Transvaal and the Orange Free State were placed on the same political level as the Cape and Natal. In 1908, a National Convention of delegates from all the four regions drew up and proposed a constitution that would grant independence to the Union of South Africa within two years. Of its many provisions, three stood out. First, it established the Union Parliament, made up of a House of Assembly and a Senate, as the supreme authority over the four colonies or "provinces." Second, it established three political capitals, with the legislative at Cape Town, the executive at Pretoria, and the judiciary at Bloemfontein. Finally, in deference to the feelings of the Afrikaners, nonwhites would not be granted the franchise, except in the Cape and Natal, but even there, they could have representation only in the provincial assemblies and not in the Union Parliament. In spite of some reservations with regard to the treatment of non-whites, Britain ratified the proposed constitution and granted independence to the Union of South Africa in 1910.

Following the 1910 Act of Union, three major challenges confronted the new country. The first was to deal with the rivalry and struggle for supremacy between the Dutch-speaking and the English-speaking whites. The second was to deal with the persistent problem of poor whites. The third was to control and contain the resistant impulses of the disenfranchised and repressed African and other nonwhite populations of South Africa. These three problems would remain at the heart of South African politics and affairs for much of the twentieth century. With regard to the first, after independence, power shifted to the hands of Afrikaner generals who had distinguished themselves in the British-Boer War. General Louis Botha became the first prime minister under the new constitution. Botha would dominate South African politics until his death in 1919, when the former guerrilla leader, General Jan Smuts, took over the prime ministership. Smuts, like Botha, pursued a policy of cooperation and partnership between Afrikaners and English-speaking South Africans. During World War I, both Botha and Smuts enthusiastically supported Britain and sent thousands of South Africans to fight for the Allied cause. In recognition of South Africa's contribution to the war effort, at the peace conference, which was attended by both Botha and Smuts, German South West Africa was given to South Africa as a League of Nations mandated territory. Nevertheless, the embers of hostility between the Boers and the British continued to be fanned by Afrikaner exclusivists, who refused to accept that a policy of cooperation was in the best interest of the Afrikaner people. One of these politicians was Barry Hertzog, a former general and an ambitious lawyer, who along with others formed the Nationalist Party in 1914. Another was the Cape politician, D. K. Malan, who formed the "Purified" Nationalist Party in 1933. The politics of these two and their followers would gradually set the stage for the triumph of Afrikaner racialist ideology and the formal institutionalization of the policy of apartheid in South Africa in 1948.[15]

The growing popularity and increased electoral successes of the extreme nationalist parties were closely tied to the plight of the white poor. The discovery of minerals brought thousands of white migrants to the new urban centers of South Africa. The bubble, however, soon burst for many of them, especially follow-

15. On white politics and the reemergence of Afrikaner dominance in South Africa before and after the Union Act of 1910, see T.R.H. Davenport and Christopher Saunders, *South Africa: A Modern History* (Basingstoke, England: Macmillan, 2000); and Merle Lipton, *Capitalism and Apartheid* (Totowa, NJ: Rowman & Allanheld 1985).

ing the consolidation of the mining concerns into huge and powerful monopolies and the mechanization of the mining process. Government's attempt to encourage the movement of poor whites from the urban to the rural areas, through a back-to-the-land policy, could not reverse the trend toward the continuing impoverishment of these whites. With no land, the poor whites found themselves shortchanged by a capitalist system fueled by the need to maximize profit. They were especially resentful that they had to constantly compete with nonwhites for whatever low-skilled jobs were available. With little education and precious marketable skills, and unwilling to take menial jobs, the poor whites became a thorny problem and an embarrassment to the administration.[16]

What the law of supply and demand could not be trusted to do, the government took steps to bring about. In 1911, it passed the Mines and Work Acts, which reserved all skilled and most semi-skilled jobs exclusively for whites, in the Transvaal and the Orange Free State, the two provinces most affected by competition from African workers. Two years later, the Native Land and Labor Act proscribed the recruitment of nonwhites from beyond the Limpopo River to the north. In 1922, the Apprenticeship Act prescribed the seventh grade as the minimum educational qualification for would-be apprentices, thus effectively cutting off most Africans from such positions. Four years later, the Mines and Works Act was ammended to ban Africans and Indians from skilled mining work. Earlier in 1925, the Wages Act had taken away whatever rights non-Europeans had either to strike or to demand higher rate of pay than that approved by the government. Thus, while the position of white workers improved over the years, that of black workers deteriorated. Little thought was given by the white authorities to the fate of the African workers who became increasingly marginalized and weakened.

Dealing with the challenges posed by the presence of Africans in large numbers in the urban and mining centers would prove to be more problematic for the governing authorities. From 1911 onwards, a series of acts would provide the building blocks of racial segregation in South Africa. The most far-reaching of these acts was the Native Land Act of 1913. Among other things, this act was meant to provide a consistent land policy throughout the country as well as effect the territorial segregation of Europeans from Africans. In its crude simplicity, the Land Act reserved one-eighth of South African land for the African majority and reserved the remaining seven-eighths for the exclusive use of the white minority. Millions of Africans lost their land and residency rights overnight as they found themselves confined to reserves scattered all over the country. Landlessness, overcrowding, overgrazing, overcultivation and poor harvests soon rendered the African reserves uninhabitable. In consequence large-scale African migration from the impoverished reserves to the urban centers and white-owned lands became the norm. Forbidden by law from buying or leasing land from Europeans, Africans became laborers working for white farmers on white lands. Other laws would follow to curtail Africans' freedom of movement and to whittle away whatever little rights they had left as residents of South Africa. The 1920 Native

16. For new perspectives on the problems and politics of "poor whites" in South Africa, see R. Morrell (ed.), *White but Poor* (Pretoria: University of South Africa Press, 1992).

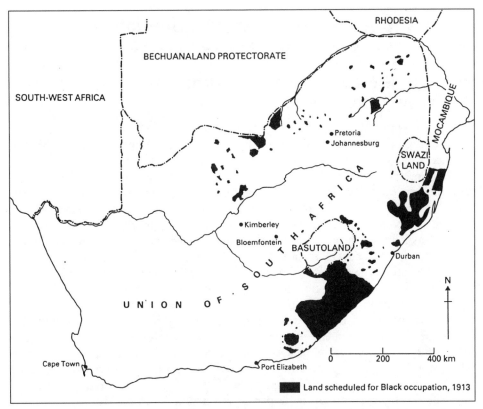

Figure 16-3. The South African 'Natives' Land Act, 1913

Affairs Act established tribally based, government appointed district councils for the African reserves. The 1923 Native (Urban Areas) Act attempted to control and restrict African movement into and within the towns. Africans who had legitimate reasons to move out of their designated living areas were required to carry passes with them all the time. To deal with the scandal of poor white men marrying black women, a practice that had become epidemic by the 1940s, the Prohibition of Mixed Marriage Act was passed in 1949. A year later, the Immorality Act of 1950 prohibited any form of extramarital sexual relations across the racial divides.[17]

17. For the foundations of South African segregationist society, see John Cell, *The Highest Stage of White Supremacy: The Origins of Segregation in South Africa and the American South* (Cambridge: Cambridge University Press, 1982); and Herbert Adam and Hermann Giliomee, *Ethnic Power Mobilized: Can South Africa Change?* (New Haven, CT: Yale University Press, 1979).

Beyond South Africa: Colonialism and Political Development

Portuguese Rule in Southern Africa: Angola and Mozambique

For the states of southern Africa, the period 1885 to 1939 was one of colonial conquests, consolidation, and rule. In Angola and Mozambique, thanks to the assistance of the British at the 1884–85 Berlin West African Conference, Portugal reasserted its tenuous imperial claims. After a prolonged and costly period of military pacification, which lasted till 1921, Portugal was able to effectively assert its rulership over Angola. As for Mozambique, the huge colony was farmed or "rented" out to concessionary interests, who were free to rule and tax their "farms" as it suited them, as long as they continued to pay the required tax to the Portuguese colonial covers. As it was for the Swahili city states of East Africa in the sixteenth century, the period of Portuguese domination would turn out to be a season of political repression, economic exploitation, and administrative inefficiency. Portuguese economic backwardness, resulting from Portuguese failure to industrialize while the rest of Europe was doing so in the eighteenth and nineteenth centuries, meant that its imperialism would be a poor man's version. With its largely illiterate population and its lack of capital, Portugal found itself in a situation where it had to resort to desperate and repressive measures to control its colonies.

Two objectives inspired Portuguese policies in Africa. The first, meant to relieve the Portuguese state of its desperate poverty, was directed to using the land and labor of the colonies to enrich Portugal and benefit the small Portuguese ruling and trading elite. Achieving this end meant the adoption of at least three strategies of economic domination and exploitation. The first was the use of African forced labor. The second was compelling African farmers to grow only the export crops desired by Portuguese trading companies, most often to the neglect of food crops and other more profitable commodities. The third was the deliberate attempt to increase the number of permanent Portuguese settlers. The prohibition by the United States' government of the entry of illiterate immigrants in 1917 made the colonies the only guaranteed port of destination for many of the displaced and ambitious people of Portugal. The fourth strategy was to give Portuguese trading companies complete control of all import and export trade, as well as special privileges in domestic business.

The second objective was ensuring unchallenged Portuguese economic and political control of the colonies. Achieving this goal meant, first, keeping out of the colonies all European trading competitors and, second, stifling every attempt made by the local people to demand, organize for, or secure any form of autonomy and independence from Portuguese imperial rule. A succession of competent, authoritarian, and repressive governors, the most notable of whom was Norton de Matos, ensured the achievement of these objectives by 1921. Having lost their political independence, Africans found themselves subjected to the most severe and repressive form of economic domination. With the passing of the law known as *indignato* in 1914, Africans lost all civil and political rights as well as other rights enjoyed by white settlers and others of Portuguese ancestry. Some concessions were granted to the *mesticos* (the fruit of sexual liaisons between Portuguese

men and African women) that gave them second-class citizenship status. Similar rights were accorded to a handful of Africans who had turned away from their African heritage and assimilated Portuguese culture (*assimilados*). Nevertheless, the *mesticos* and the *assimilados* between them constituted less than 1 percent of the entire population of the Portuguese colonies in Africa. For the remaining 99 percent of Africans, defined as "natives," the harsh reality of Portuguese imperialism was as corrosive as it was inescapable, canceling out whatever incidental benefits might have resulted from Portuguese domination.[18]

German Rule in South West Africa, 1883–1915

In South West Africa or Namibia, the late nineteenth and early twentieth centuries were also periods of white colonization and settlement and of African dispossession. The main actors here were the indigenous Nama and Herero pastoralists, who fought on and off with each other, for much of the nineteenth century, over control of the grazing fields of the central Namibian plateau. By the 1830s, Afrikaner trekkers began to infiltrate into Namibia. They allied with one local group to fight another, raiding their farmsteads and seizing their cattle. One of the trekkers was Jonker Afrikaner, who led a group of mercenaries to fight for the Hama against the Herero, in the course of which he captured thousands of Herero cattle, and attracted large numbers of Nama, Bergdama, and Herero clients. With these resources, he set up a chiefdom with its capital at Windhoek. By the mid-nineteenth century, British traders and German missionaries were already active in the region. Determined to achieve their related objectives of commercial profit and religious conversion, and resentful of the Hereros' repeated and successful attempts to keep the alien intruders at bay, these European agents put pressures on their home governments to intervene and "pacify" the Herero and other indigenous groups that were allegedly in dire need of civilization and redemption.

Perennially embroiled in the turbulent politics of the Boer republics, the British were unable to intervene. The initiative thus fell to the Germans, who in 1884 declared a "protectorate" over the whole of South West Africa. Transforming this protectorate into reality would take another twenty years of relentless warfare and, for the indigenous peoples, a mortal struggle for survival. Three factors combined to ensure an eventual German victory. One was their possession of better ammunition, though this was not always decisive, since the Nama led by Hendrik Witbooi and the Herero led by Maharero were equally well armed. However, unlike the indigenous groups who soon became subjected to various arms embargoes, the Germans were always assured of a continuous flow of ammunition from Europe. The second factor was the lack of unity among the indigenous groups, which made them vulnerable to the divide and rule politics of their German invaders. In virtually all the wars, the Germans used the Nama against the Herero. The third factor was the Germans' strategy of warfare and their adoption, especially in relation to the Herero people, of the policy of total extermination of the enemy.

18. On Portuguese rule in Africa, see Basil Davidson (ed.), "Portugal in Africa," *Tarikh* 6, 4, (1980). See also Doug Wheeler and R. Pelissier, *Angola* (New York: Praeger, 1971); and A. Isaacman and B. Isaacman, *The Tradition of Resistance in Mozambique:Tthe Zambesi Valley, 1850–1921* (London: Heinemann, 1976).

Having lost virtually all their arable land to white settlers and mineral speculators and having had most of their cattle confiscated by European creditors, the Herero became destitute and desperate. In 1904, while the German governor, Leutwein, was busy suppressing a revolt in the south of the country, the Herero rose in rebellion. Within six months, after killing over a hundred German colonists, they had gained control of much of their former territory. Shocked by the success of the Herero and exasperated by the repeated failure to compel them to reconcile themselves to their loss of independence, the new governor, General von Trotha, issued his infamous extermination proclamation on October 2, 1904:

> The Herero are no longer German subjects. They have murdered and plundered...The Herero nation must leave the country. If it will not do so I shall compel it by force...Inside German territory every Herero tribesman, armed or unarmed, with or without cattle, will be shot. No women and children will be allowed in the territory: they will be driven back to their people or fired on. These are the last words to the Herero nation from me, the great General of the mighty German Emperor.[19]

In essence, the Herero were to be destroyed as a nation and exterminated as a people. This chilling proclamation marked their death sentence as a group. Within days of the issuing of the proclamation, its implementation soon assumed genocidal dimensions. The swift implementation gave the already harried and battered Herero no time to contemplate a response or even begin to plan their escape. General Trotha's soldiers followed his orders to the letter. Showing no mercy, they launched a massive manhunt for the Herero throughout the length and breadth of South West Africa. In the open and dreary terrain of the Kalahari Desert and the undulating Namibian plateau, there would be no place safe enough to hide a Herero from the wrath of the Germans. No one would be spared. Neither discriminating between soldiers and civilians nor sparing women and children, the German soldiers coldly and methodically put everyone with Herero features or blood to the slaughter. In the end, this German colonial policy of extermination was extraordinarily successful. Apart from about 2,000 Herero who managed to escape by crossing the Namibian frontier before the messengers of death caught up with them, out of a pre-proclamation population of 80,000 Herero only 16,000 starving and destitute Herero were left a year later. The German imperial aim had been effectively, though chillingly, achieved: the Herero ceased to exist as a distinct cultural group in southern Africa. What was left of their land and cattle passed to their German conquerors.

The Nama, who had assisted the German invaders in their initial wars with the Herero, soon found themselves the next object of German expansionist ambition and fury. In 1905, the Nama also rose in rebellion. However, neither the inspiring leadership of Witboor nor their gallant resistance through guerrilla warfare could save them from the fate that had befallen the Herero. By 1908 the German rulers had successfully broken Nama resistance. Pursuing the same policy as they did with the Herero, they herded thousands of Nama into concentration camps, from which only a handful came out alive. Like the remnants of the

19. H. Bley, *South West Africa under German Rule, 1894–1914* (London: Heinemann, 1971), 163–164.

Herero, the few Nama who survived were reduced to a state of pitiful servitude to the German overlords and settlers.[20]

However, for the German rulers, the near extinction of these highly dynamic and versatile "nations" was a pyrrhic victory. In exterminating these two dominant groups in Namibia, they had also inadvertently wiped out their colony's chief sources of labor. Consequently, they took steps to extend their imperial control over the Ovambo to the north. They were, however, careful not to seize the land and cattle of the Ovambo, in order to avoid revolts and maintain a steady supply of labor. This also ensured that the Ovambo would emerge as and remain the most dominant group in Namibia in place of the Nama and Herero, who had previously been dominant. German rule was among the most brutal in colonial Africa. Workers, including pregnant women, were regularly flogged and sometimes beaten to death, often with impunity. The defeat of Germany at the end of the World War I led to the seizure of its colonies by the League of Nations. The mandate to rule Namibia was given to the Union of South Africa, whose General, Botha, had conquered the territory. Namibia would remain under South African control and would be governed by South African laws for the better part of the twentieth century, until it gained its independence in 1989.

British Rule in the High Commission Territories: Botswana, Lesotho and Swaziland

In Botswana (also Bechuanaland), the British had established effective control by 1899. Following their practice of indirect rule in India, they made use of pre-existing indigenous rulers in the administration of the territory. They recognized and confirmed a number of Tswana chiefdoms, whose chiefs were given the responsibility of collecting the hut tax. The practice of allowing the chiefs to keep 10 percent of whatever was collected acted as an incentive to faithful and at times forceful collection by the chiefs. The attempt of the British to check, transform, and reduce the powers of the chiefs and the resistance of the latter to such diminution of authority ensured that chieftaincy politics would dominate the politics of Botswana for much of the colonial period. When, in 1920, the British established a Native Advisory Council, they were opposed by the khama of the Ngwato, the most dominant chief in the territory. The khama saw the council as a direct threat to chiefly prerogatives, and he refused to nominate members to the council.

The death, in 1923, of Khama III of the Ngwato, and of his son and successor, Sekgoma, two years later, threw the Ngwato state into a state of crisis. Sekgoma's successor was his four-year-old son, Seretse. Several of his uncles jostled for appointment as regent. In the end, the twenty-one-year-old Tshekedi, a student at Fort Hare College in South African assumed the regency. Rejecting the attempts of the British to manipulate and control him, Tshekedi soon established himself firmly on the throne. In 1926, he confiscated the property and burned the houses of his rivals in the royal family, who had tried to assassinate him, before banishing them permanently from Serowe. In 1933, in accordance with custom-

20. On German rule and the tragedies of the Nama and Herero peoples, see Bley, *South West Africa*; and P. Katjavivi, *Namibia: A History of Resistance* (London: James Currey, 1987).

ary laws, he tried and flogged a white resident of Serowe, who had physically as-saulted a Ngwato woman.[21] For the British, such humiliation of a white man, whatever his offense, must not be allowed to stand if the racial order which was the basis of colonial society were not to be compromised. Within days, 200 British naval troops were dispatched from Cape Town to teach this upstart native ruler a lesson in British imperialism. Tshekedi was publicly tried and deposed, but this action generated such widespread and united Tswana opposition that the British were compelled to reinstate Tshekedi. Further attempts made by the resi-dent commissioner, Rey, during the 1930s, to curtail the power of the chiefs, espe-cially through the abolition of the village *kgotla*,[22] also came to nothing in the face of united and unabated Tswana opposition. The appointment in 1937 of Arden-Clarke, a less dictatorial personality, as the resident commissioner, marked a new era of cooperation and peaceful coexistence between the British and the Tswana chiefs. At the outbreak of World War II, in spite of years of prolonged drought, crop failures, and cattle deaths, the Tswana demonstrated their loyalty to the British by recruiting and sending 10,000 Tswana to fight on the side of the British in North Africa and in southern Europe.[23]

In Lesotho and Swaziland, two states under the shadow of South Africa, British rule followed a similar pattern as in Botswana, though with varying degrees of differences. After repeatedly rebuffing the attempts made by South Africa to ab-sorb the two land-locked territorial enclaves, the British set out to establish control over the two high commission territories. Politically the British adopted the policy of indirect rule, which in theory meant control through the indigenous rulers. In practice, this resulted in minimal interference in internal affairs and in the buttress-ing of the powers of the chiefs for as long as they ensured peace, and faithfully col-lected the hut and other taxes imposed by the British. In Lesotho, between 1891 and 1939, three rulers, Lerotholi, Letsie II, and Griffith, ruled as paramount chiefs. The establishment of a National Council, presided over by the resident commis-sioner, further strengthened the power of the paramount chief, who had the pre-rogative of nominating ninety-four of its one hundred members. Similarly, in Swaziland, effective control was exercised through the agency of the Swazi royal family. In the more centralized Swazi chiefdom, the paramount chiefs became even more powerful than hitherto. With the basis of their authority being loyalty to the British they became more autocratic and less answerable to their people. The be-lated British attempts to curtail their powers met with only limited success.

Beyond the issue of politics, the challenge of land access and ownership was of more pressing concern to the two territories. In Lesotho, only one-sixth of the land was arable. The rest was mountainous and barren and thus unsuitable either for farming or for pastoralism. With no land to satisfy the needs of its expanding population, labor migration, especially to the mines of South Africa, became the

21. On this episode, see the fascinating study by Michael Crowder, *The Flogging of Phinehas McIntosh: A Tale of Colonial Folly and Injustice: Bechuanaland, 1933* (New Haven, CT: Yale University Press, 1988).

22. The *Kgotla* was a kind of community assembly where major decisions were taken and chiefs made answerable to their people.

23. On British rule in Botswana, see T. Tlou and A. Campbell, *History of Botswana* (Gaborone, Botswana: Macmillan, 1984); and Kevin Shillington, *History of Southern Africa* (Harlow, England: Longman, 1987), 167–171.

only viable alternative to the ever-present rural poverty, starvation, and banditry. By 1900, about 30,000 migrant workers were moving into or returning from South Africa every year. By the end of our period (1939), nearly half of Lesotho's adult males were employed as migrant workers in South Africa. It is also not surprising that during the World War II, with little of profit to do at home, 20,000 Basotho volunteered and fought on the side of the British in the war with Germany in Africa and Europe.

In Swaziland, the situation was even more problematic. During the Scramble for Africa, European concession seekers and fortune hunters had taken over two-thirds of the land of Swaziland. In 1907, determined to preserve the beautiful and fertile land of Swaziland for exclusive white settlement, the British issued a proclamation recognizing the concessions as being held by absolute freehold ownership. The strong Swazi protest and delegation to London demanding the return of the land was coldly and curtly rebuffed by an unsympathetic British government. Traditionally agriculturally self-sufficient and unused to migrant labor, the Swazi resolved not to allow themselves to be reduced to the same level of crippling poverty as the people of Lesotho. In 1912, the Swazi Queen Regent, Labotsibeni, set up a national fund into which all Swazi young men working in South Africa were expected to contribute. With this fund, the Swazi began to buy back part of "their" land from the government as well as from white settlers. By 1945, they had increased their share of the national land from 33 percent to 45 percent, thus making land available for more of their people. These bold initiatives notwithstanding, by the 1930s about 30,000 Swazi were working in the mines and farms of South Africa.[24]

The French in Madagascar, 1880–1939

In Madagascar, after two wars (1883–1885, 1894–1895), the French succeeded in establishing their control over this great island off the east coast of Africa. However, resistance to French rule continued throughout the early colonial period. The first major opposition came from the traditional ruling elite, led by Queen Ranavalona III (1883–1897) and her husband and prime minister, Rainilaiarivony, which refused to reconcile itself to the loss of sovereignty to the French. The abolition of the Imerina dynasty in 1897, while weakening Merina opposition, did not mark the end of elite resistance. When Toera, the king of the large and well-organized Menabe kingdom, attempted to surrender in 1897, the French commander, Major Gerald, rejected his overtures, ordering instead the "massacre of all the Sakalava who could not escape, including King Toera."[25] Resistance continued in other chiefdoms, and it was not until 1904 that the French could claim effective pacification of the island.

24. On Lesotho and Swaziland, see J. Halpern, *South Africa's Hostages: Basutoland, Bechuanaland and Swaziland* (Harmondsworth, England: Penguin, 1965); and Shillington, *Southern Africa*, 171–177.

25. Quoted in M. Esoavelomandroso, "Madagascar, 1880s–1930s: African Initiatives and Reaction to Colonial Conquest and Domination," in Adu Boahen (ed.), *UNESCO General History of Africa Vol. VII: Africa under Colonial Domination, 1880–1935* (Berkeley: University of California Press, 1985), 238. This work is the major source for much of the section on Madagascar.

General Gallieni, the new French governor, took various measures to consolidate French control. First he adopted the policy of divide and rule by appointing as "native governors" former rulers and their sons. Second he adopted the Merina *fokonolona*, a kind of village consultative and legislative assembly, introducing it to the entire island. Third, he reintroduced the Merina royal *fanompoana* or forced labor, under which every able-bodied Malagasy male between the ages of sixteen and sixty was obligated to provide fifty days of unpaid labor a year. For the Malagasy, *fanompoana* was nothing but "slavery in disguise," and the practice was widely and deeply resented. Fourth, Gallieni allowed large numbers of white settlers and Asian immigrant workers into the island, and these competed for land and jobs with the indigenous people. Finally, a decree promulgated in 1925 forcibly declared as state property "all vacant and ownerless land not developed, enclosed or granted by way of a concession as of the date of the promulgation of the decree."[26]

The changes brought by French colonialism had far-reaching consequences for the Malagasy people. Colonial rule resulted in the break-up of many clans, the termination of dynasties, the undermining of traditional institutions and ruling oligarchies, and the subversion of indigenous values and practices. Even members of the Western-educated elite were disappointed by their systematic exclusion from positions of responsibility in the colonial system. Protests and reactions were not long in coming. The first insurrection broke out in November 1904, in the region of Farafangana. Led by disenchanted chiefs of the Bara clans, it gained the support of dissident militiamen and locally recruited infantrymen who deserted their posts to join the rebellion. The second major anticolonial outburst began in 1915, in the southwest regions of Ampanihy and Tsihombe, where the combination of violent but infrequent rainfall, food shortages, and cattle tax had reduced the people to a situation of desperate poverty. In what is known as the Sadiavahe movement, armed peasant insurgents organized themselves into small mobile bands, attacking travelers, destroying settlements, stealing cattle, and vandalizing telegraph wires and other government installations, before they were finally brought under control after two years.

Less overt opposition took the form of tax evasion, withdrawal of children from mission and colonial schools, flight from "forced labor" recruitment, and abandonment of government established villages. Others channeled their resentment into secret societies, such as the Vy Vato Sahelika, meaning "strong and hard like stone and iron," organized in 1913 by seven students from Malagasy's only medical school. Sahelika's open hostility to French imperialism and its widespread support among clerks, office workers, school teachers, and others brought upon it the ire of the colonial administration, which took harsh measures to repress it. The repression of clandestine political activities led to the adoption, during the 1920s and '30s, of strategies of open protest and militant resistance through the use of press campaigns, trade union formation, strikes, political party formation, protest marches, and demonstrations.

26. L. Rabearimanana, quoted in Esoavelomandroso, "Madagascar, 1880s–1930s," 242.

Protest and Nationalism in South Africa, 1910–1939

Mission Education and the Ethiopian Church Movement

African resistance to colonial domination and its attendant land dispossession, economic deprivations, and loss of political and civil rights developed early and took different forms in South Africa. The first spark in the nationalist movement was lit by the early products of missionary evangelism and education. Having abandoned their traditional beliefs, the new converts eagerly adopted European beliefs and values. However, their expectation that this wholesale assimilation into European culture would ensure them equality with whites in church and state affairs, in accordance with Christian teachings and principles, were not met.

Disappointed by the failure of whites to live up to the principles of the brotherhood and equality of all believers irrespective of race or class, restive African clergymen began to form their own independent African churches. One of the earliest of these was the independent Ethiopian Church, established in 1892 by black clergymen led by Mangena Mokone, a fiery preacher from Natal. The black ministers had been excluded from the Governing Board of the Wesleyan Mission of South Africa. Though white missionaries and the colonial administration remained hostile to these churches, the principle of African initiative and autonomy that they represented made them popular among Africans. By the end of World War II, there were about 1,000 independent African churches in different parts of southern Africa.[27]

Gandhi and the Natal Indian National Congress

The next major expression of protest occurred among the Indians of South Africa. Thousands of Indians had arrived in South Africa to work as indentured servants in the nineteenth century. At the expiration of their contracts many of them chose to remain in South Africa, where they rapidly established themselves as shopkeepers, and as skilled and unskilled mine workers. By the 1890s, they numbered 80,000 in Natal alone. Indians' successful forays into merchandising were deeply resented by the British settlers and traders who hitherto had dominated the retail and wholesale trade of South Africa. The Boers, who resented Indians' entry into skilled employment in the mines, successfully put pressure on the British to ban them entirely from the Orange Free State. In the Transvaal, where they had already established themselves as successful traders, measures were taken to register and control Indian traders. In Natal, where the bulk of Indians lived, steps were taken to undermine or remove whatever few political or voting rights Indians had. Treated as second-class citizens, they were required to carry passes and remove their hats and move off the sidewalks at the approach of a white man, or run the risk of being kicked into the gutter or even detained. To

27. On independent African churches, see B. Sundkler, *Bantu Prophets in South Africa* (London: Published for the International African Institute by the Oxford University Press, 1961); and Peter Walshe, *Prophetic Christianity and the Liberation Movement in South Africa* (Pietermaritzburg: Cluster Publications, 1995).

force Indians back into the labor force or back to India and out of the retail trade, a £3 tax was imposed on all ex-indentured servants.

It was in this atmosphere that the Durban Indian traders in 1893 invited a young London-trained Indian lawyer, Mohandas K. Gandhi, to come to South Africa to defend them in a major legal case against the government. In 1894, he helped establish the Natal Indian National Congress. Aware of the enormous power of the South African state and the military weakness of the opposition, Gandhi seized the higher moral ground by adopting the policy of nonviolent resistance (*Satyagraha*) in his challenge to the colonial state. The struggle lasted for several years, and was expressed through the public burning of passes, press campaigns, strikes, and massive demonstrations. Gandhi and his supporters suffered the indignities of racial discrimination, police brutality, and imprisonment. The glare of world attention became focused on South Africa, forcing the British and the Union governments to buckle, abolishing the Indian Pass Law and the hated indentured tax as well as recognizing non-Christian Indian marriages.[28]

Black Elites, Newspapers, and Early Political Formations

Among the African population of South Africa, anticolonial sentiments found expression in a number of regional newspapers, whose establishment became the leading feature of nationalistic activities during the late nineteenth and the early twentieth centuries. One of the earliest of these newspapers was *Imvo Zabantsundu* ("Native Opinion"), founded in 1884 by John Jabavu, a lay preacher and journalist from the eastern Cape. Another was *Izwi la Bantu* ("The Voice of the People"), established by A.K. Soga in 1897, and published in Xhosa and English. In 1906, John Dube, an American-trained clergyman, founded the Zulu-English *Ilanga lase Natal* ("The Sun of Natal"). Limited in circulation and readership, and moderate in tone, these and other African papers nevertheless became instruments for the expression of African opinions. They commented freely on government policies, criticized injustices, and appealed to the few mission-educated African voters of the Cape as well as to white liberals who they felt were sympathetic to African interests. For these elites as for other nonwhites in South Africa, the 1910 Act of Union was a major disappointment and betrayal. They were especially irked by the failure to extend the nonracial franchise of the Cape to other provinces and by the complete banning of blacks from the national parliament.

Recognizing the futility of depending on their white liberal "friends" for support, scores of educated Africans from all over South Africa gathered in Bloemfontein in January 1912. Setting aside their regional differences, they resolved to organize politically to fight for African interests, by establishing the South African Native National Congress (SANNC). John Dube, clergyman, newspaper editor, and principal of his own Ohlange Industrial and Technical Training Institute, became the first president. Solomon Plaatje, newspaper editor and leading African spokesman, became the secretary general. Another of the leaders was Rev. Walter Rubusana, author of *A History of South Africa from the Native Standpoint*.

28. On Gandhi and organized Indian resistance in Natal, see the critical study by Maureen Swan, *Gandhi: The South African Experience* (Johannesburg: Ravan Press, 1985).

Within one year of its formation, the Congress faced its first major test, when the government passed the Native Land Act of 1913. The act confiscated virtually all the land of South Africa for exclusive white ownership and use, reserving only about 7–13 percent for the occupation and use of the black majority population. Despite vigorous protests, petitions, and the sending of a delegation to England, the Congress failed to stop the passing of the act and was unable to persuade the British government to intervene to stop this massive and unprecedented land appropriation and dispossession. Sol Plaatje's *Native Life in South Africa*, published while he was a member of the SANNC delegation to London, remained a classic of South African literature and a scathing documentation of the suffering and injustice caused by the Land Act.[29]

The SANNC became the African National Congress in 1923.[30] However, its failure to record many positive gains in its campaign against the Land Act weakened its influence, while paving the way for the emergence of other resistance movements. The most notable of these was the Industrial and Commercial Workers Union (ICU). Founded in Cape Town in 1916 by Clements Kadalie, a mission-educated migrant worker and clerk from Malawi, the ICU organized a major Cape dock workers' strikes in 1919, which brought it widespread publicity and increased membership. Another was the Communist Party, organized during these years and committed to the revolutionary overthrow of the South African capitalist social order. Communist Party membership cut across the racial divides and several of its members were active in the various strikes (of whites, Indians and blacks) as well as in the ICU.

Chieftaincy Politics, Rural Protests, and Popular Struggles before 1939

Beyond elite politics, rural discontent found expression in what a leading historian of modern South Africa has described as the "age-old peasant strategies of delay, demands for consultation, refusal to listen, silent boycott, and attempts to restrict the state's knowledge" of local affairs.[31] The imposition of new taxes, the manipulation of chieftaincy and succession rules, and the undermining of indigenous institutions and values often resulted in resistance, ranging from protest petitions to violent rural riots. Among the Zulu and other Africans of Natal, the memory of Shaka's military greatness made the Zulu royal family the symbol of resistance to the humiliation and powerlessness brought about by alien domination. Solomon Ka Dinuzulu, the Zulu king, who had tasted the bitter fruit of imperialism by being exiled to St. Helena, provided an alternative focus of resistance as he became associated with the revival of national

29. On the development of early African protest and nationalism, see A. Odendall, *Vukani Bantu: The Beginnings of Black Protest Politics in South Africa to 1912* (Totowa, NJ: Barnes & Noble, 1984); and Peter Walshe, *The Rise of African Nationalism in South Africa* (Berkeley: University of California Press, 1971).

30. On the history of the ANC, see F. Meli, *South Africa Belongs to Us: A History of the ANC* (Harare, Zimbabwe: Zimbabwe Publishing House, 1988).

31. William Beinart, *Twentieth-Century South Africa* (Oxford: Oxford University Press, 1994), 93. This work is a concise and perceptive introduction to the history of modern South Africa.

feeling and desire among the Zulu "to remain one people under English rule."[32]

Rural discontent in Natal reached a head in the Bambatha rebellion of 1906, led by a deposed Zulu chief and by tenant farmers embroiled in complicated legal and rental disputes with their white landlords. The savagery of its suppression by the British colonial administration, which refused to accept the rebels' surrender but instead took to wholesale slaughter of all participants, leaving 24 whites and 4,000 Africans dead, left no one in doubt who was in charge in this part of colonial Africa.[33] A similar rural protest in the eastern Cape assumed a millenarian dimension. Led by Enoch Mgijima, a Mfengu Methodist preacher, the Church of Israelites seized land and refused to pay taxes. A showdown became inevitable. It finally came in 1921 at Bulhoek, when the police ordered the 3,000 white-robed and unarmed Israelites to disperse. When the community refused and pleaded to be left alone to continue their prayer and apocalyptic contemplation, the police opened fire. By the time the dust settled, about 200 Israelites were dead.[34] A year later, in the Herschel district, bordering on Lesotho and the Orange Free State, local women, inspired by the ICU and infuriated by the government's repressive measures, boycotted European trading stores. In 1925, when the local magistrates attempted to register their land, the women withdrew their children from the mission schools, in protest against the teachers' sympathy with the government. Many joined the emerging African independent churches, whose backbone was their women members. Though more men than women migrated to the cities, the few women who migrated took their rural skills with them. The scarcity of women (white or black) in the cities gave the few women the opportunity to quickly establish themselves on the periphery of the urban economy. They became adept at the brewing and selling of home-made maize and sorghum beer, the providing of domestic services for whites, and the selling of sexual services to both whites and blacks in the male-dominated mines and cities of southern Africa. Many of these women were in the forefront of the organized resistance movement associated with the burning of passes during the 1930s and '40s in South Africa.[35]

The limited nature of the achievements of African protest and resistance movements before World War II should not lead us to underestimate the significance of their efforts or the very difficult circumstances under which they operated. The African elite of southern Africa in the early part of the twentieth century faced many obstacles in their struggle against the injustices of imperialism.

32. Shula Marks, "Natal, the Zulu Royal Family and the Ideology of Segregation," *Journal of Southern African Studies* 4, 2 (1978), 98.

33. Shula Marks, *Reluctant Rebellion* (Oxford: Clarendon Press, 1970).

34. On the Israelites, see Robert Edgar, *Because They Chose the Plan of God* (Johannesburg: Ravan Press, 1988); *Prophets with Honour: A Documentary History of Lekhotla la Bafo* (Johannesburg: Ravan Press, 1988).

35. On the active roles of women in the resistance struggle in South Africa, see Cherryl Walker, *Women and Resistance in South Africa* (New York: Monthly Review Press, 1991); and Cherryl Walker (ed.), *Women and Gender in Southern Africa* (Cape Town: D. Philip, 1990). On rural protests, see the collections of essays in D. Crummey (ed.), *Banditry, Rebellion and Social Protest in Africa* (Portsmouth, NH: Heinemann, 1986); William Beinart and Colin Bundy, *Hidden Struggles in Rural South Africa: Politics and Popular Movements in the Transkei and Eastern Cape, 1890–1930* (London: James Currey, 1987).

Politically, they were severely limited by the highly restricted nature of the electorate, since all Africans, except for a few at the Cape, were completely disenfranchised. The African elite, by virtue of their westernization and Christianization, continuously experienced cultural alienation and confusion over values and over what objectives they should pursue in their struggle against the colonial order. As in other parts of Africa, the leadership of the nascent nationalist movement remained elitist in orientation, objectives, and followership. The masses of the people were neither actively courted nor directly engaged in the nationalist struggle. Divisions and rivalries within the ranks of the educated elite, as well as between the elite and the indigenous chiefs, did not help matters. Instead, it played into the hands of the colonial state, rendering both groups susceptible to state manipulation and control by cooptation. Finally, the state's monopoly of the instruments of coercion, its constant and insidious use of force and intimidation, and the ever-present threat of dreadful punishment and brutal repression demonstrated beyond reasonable doubt the unequal power equation and the limits and dire consequences of armed resistance. This situation would remain largely unchanged until well after World War II.

Review Questions

1. With reference to specific examples, examine the connections between the mineral revolution and African dispossession in southern Africa between 1867 and 1899.
2. With particular reference to the South African War (1899–1902), how accurate is the statement that "Britain won the war, but the Afrikaners won the peace"?
3. Account for the main features and the major achievements of the early African nationalism in South Africa before 1923.
4. Account for the inspirations for and the major consequences of the emergence of Afrikaner nationalism in South Africa between 1877 and 1939.
5. Assess the significance of four of the following in the history of southern Africa before 1939:
 1. Cecil Rhodes 2. Bambata Rebellion 3. Tshekedi Khama
 4. General von Trotha 5. *Assimilados* 6. Mohandas Gandhi
6. With specific reference to the Merina of Madagascar and the Herero of Namibia, compare and contrast the major consequences of French and German imperialisms in southern Africa before World War II.
7. Using a comparative approach, and with particular reference to the "High Commission Territories," to what extent can colonialism be regarded as the principal agency of socio-political transformations in southern Africa before 1939?

Additional Reading

Beinart, Willaim. *Twentieth-Century South Africa*. Oxford: Oxford University Press, 1994.

Davidson, A.B., Alan Isaacman, and R. Pelissier "Politics and Nationalism in Central and Southern Africa, 1919–1935," in Adu Boahen (ed.), *UNESCO General History of Africa. Vol. VII: Africa under Colonial Domination, 1880–1935*. Berkeley: University of California Press, 1985.

Davis, N.E. *A History of Southern Africa*. Harlow, England: Longman, 1981.

Drechsler, Horst. *Let Us Die Fighting": The Struggle of the Herero and Nama Against German Imperialism (1884–1915)*. Translated by Bernd Zollner. London: Zed Press, 1980.

Moleah, Tokollo A. *South Africa: Colonialism, Apartheid and African Dispossession*. Wilmington, DE: Disa Press, 1993.

Shillington, Kevin. *History of Southern Africa*. Harlow, England: Longman, 1987.

Thompson, Leonard. *A History of South Africa*. New Haven, CT: Yale University Press, 1995.

Chapter 17

Central Africa

Femi J. Kolapo

Up until the 1880s, Central African societies were witnessing significant political and economic transformations. The societies were being linked more effectively to the external commerce in slaves and ivory. There was a rise of new political centralizing states, many of which were based on the expanding commerce. Some of the volatile sociopolitical conditions resulting from this development facilitated the eventual colonization of Central Africa. The colonial exploitation of Central Africa was by private commercial concerns. Their primary profit-making goal overrode all other worthwhile considerations that might benefit the peoples of Central Africa. The region was thus turned into a huge pool of coerced labor to service rubber export, settler agriculture and mineral extraction. Many Africans were turned into migrant laborers to service these sectors. Africans did not accept these impositions and changes without protest, as they began at this time to challenge their exploitation and mistreatment.

In this Chapter, I discuss the colonial experience of the Central African peoples between 1885 and 1939. The geographical area under examination includes part of present-day Cameroon, the Central African Republic, Gabon, Zaire, the Republic of Congo, Angola, Zambia, Rwanda, and Burundi. This region came under the colonial domination of several European countries. Germany occupied Kamerun (Cameroon), Rwanda and Burundi; Portugal occupied Angola and Gabon; Belgium occupied the Congo Free State (later Belgian Congo); Spain occupied Equatorial Guinea; and Britain occupied Zambia. France federated its territorial holdings of Gabon, Moyen-Congo, Ubangi-Shari and Chad into French Equatorial Africa (AEF) in 1910. Following the World War I, France took over eastern Cameroon (formerly Kamerun) from Germany as a mandated territory, while Rwanda and Burundi were severed from Tanganyika and were attached to the Belgian Congo.

* * *

The sociopolitical picture of the region on the eve of colonial conquest was diverse. This was a region consisting of peoples with different languages, cultures, and social and political organizations. Some of these people, in the area that became the Congo Free State, included the baCongo, the Tyo, the Bobangi, and the Ngala. The Lunda were divided between Congo, Angola, and Zambia. The Kikongo also straddled Angola and Congo, while the Congolese/Sudanese border divided the Azande. Notable sociopolitical groups in Angola included the Imbangala, the Ovimbundu, the Chokwe, the Ovambo, and others. To the north of Zambia were the Bemba, the Bisa, the Lamba, the Mambwe, and the Nyamwanga peo-

ples; in the south were the Tonga, the Ila, the Lozi and the Nguni. The Chewa (Cewa), the Yao, the Bisa, the Ngonde and the Tumbuka populated Malawi. Arab and Swahili settlers had also become important in northeastern Congo and some Nyamwezi or Yeke from western Tanzania had traversed the region to settle in Katanga.

These peoples and their societies by 1885 had developed different levels of economic, military, diplomatic, and demographic ties among themselves and with the outside world. One of the most important connections between these societies and the Euro-American world was the presence of a Portuguese colonial enclave in Angola radiating out from Luanda on the West Atlantic coast. From this pre-1885 European colony, Afro-Portuguese traders (*pombeiros*) and their African colleagues carried imported articles into the region in exchange principally for slaves and ivory. Similarly, the Nyamwezi and Swahili/Arab traders had linked up these areas with the external trade in slaves, ivory, guns, cloves, clothes, and other goods through the Indian Ocean coastal towns of Zanzibar and Kilwa, in the course of the nineteenth century.

The issues examined in this chapter include the general pattern of sociopolitical and economic arrangements in Central Africa on the eve of colonial conquest. The chapter also examines how the region came under direct colonial control and, especially, the agencies by which the African states eventually lost their sovereignty. I will also briefly discuss the societies' reaction to European military-political incursion. Following military invasions, or the signing of treaties that subordinated the states of the region to European political control, colonial administrations were established to carry out political, economic, and social policies. The policies that were implemented between 1885 and 1939 affected the region in different ways and produced various types of reactions. Hence, a final issue that this study examines is the nature of Central Africa's colonial economy and the peoples' reactions or adaptations to it.

Central African Societies on the Eve of Colonization

What was Central Africa like by 1885? What were the general socioeconomic and political conditions that the colonizing Europeans met? By 1885, Central Africa was home to different types of political organizations ranging from chiefdoms comprising related but largely independent villages to principalities and kingdoms.[1] The less centralized and hierarchized political forms were most common in the entire region. Oscillation over the centuries between less and more centralized forms of political organization was a major historical pattern in this region, and it was closely connected with the balance between demographic patterns and ecological capacity, among other factors.[2]

1. Jan Vansina, "The People of the Forest," in D. Birmingham and P. Martin (eds.), *History of Central Africa*, Vol. 1 (London: Longman, 1983), 93.

2. J.L. Vellut, "The Congo Basin and Angola," in J.F. Ade Ajayi (ed.), *UNESCO General History of Africa. Vol. 6: Africa in the Nineteenth Century until the 1880s* (Paris: UNESCO, 1989), 315; see also Vansina, "People of the Forest," 83–100.

Some of the kingdoms in the area that became the Congo Free State include those of the Kuba in the center, the Luba in Katanga, the Mangbetu in the forest to the north of the Kisangani River and the Azande to the north in the savanna. In the southern savanna area shared by Zaire, Zambia, and Angola, the Songye and the Lunda established their kingdoms. Kazambe's kingdom was the most famous and most highly centralized Lunda kingdom in the nineteenth century. To the south and east in the area that became Northern Rhodesia (Zambia) and Nyasaland (Malawi), some of the important sociopolitical groups included the Bemba, the Bisa, the Tonga, the Mambwe, the Yao and others. The Maravi groups from which Malawi derived its name were organized into chiefdoms. The Tumbuka to the north, like the Tonga and the Yao to the southeast, had lived in non-centralized communities. Some of them by the late nineteenth century had reorganized their clans into a loose but effective federation under a single ruler and were able to repulse a Ngoni attack.[3]

In the decades preceding the colonial conquest, the peoples and states of this region experienced some dramatic sociopolitical and economic changes. Long-distance trade was able to penetrate into the remotest part of the region, thereby linking it more effectively with the outside world. A number of important states and societies in the region underwent violent military-political changes that involved radical reorganization of state structures and political power. The changes were related to developments associated with the volume, value and character of the nineteenth century commerce that linked the region to the Atlantic and Indian Ocean coasts and the outside world. The principal agents for these external connections were the Arabs, the Swahili, the Nyamwezi, for the eastward commerce, and the Angolan Portuguese, the Brazilians, the Pombeiro, and the Chokwe/Ovimbundu and Imbangala network for the westward trade.

However, as J. Vellut warned, external commerce was not the only major theme of nineteenth century Central African history. There were also important internal historical developments. Among the latter were advances in stockbreeding, increased success in the use of poor soil for expansion of production, and an overall increase in the commercial production of gathered export products like ivory, wax, copal, coffee, copper, and so on. There was also the development of production sectors that employed slave labor in the major centers associated with external commerce. Another significant internal development was related to population movements induced by socioeconomic, especially commercial, and other factors. However, as Vellut again noted, up to the period of colonization, most people of Central Africa lived in peace, and the violent military-political activities of earlier years had given way to conditions of prosperity and affluence. Moreover, production rather than trade remained the major economic activity in this region.[4]

3. L. Vail and L. White, "Tribalism in the Political History of Malawi," in L. Vail (ed.), *The Creation of Tribalism in Southern Africa* (London: James Curey, 1989), 156–157.

4. Vellut, "The Congo Basin and Angola," 298–303; see also A. Isaacman and J. Vansina, "African Initiatives and Resistance in Central Africa, 1880–1914," in A. Adu Boahen (ed.), *UNESCO General History of Africa. VII: Africa under Colonial Domination 1880–1935* (Paris: UNESCO, 1985), 169–171.

External Commerce and Internal
Developments to 1885

In the northeast part of the area that became the Congo Free State, King Leopold's agents met the kingdom of the Azande in the savanna, as well as what remained of the Mangbetu kingdom. To their immediate south as far as Katanga and across the present-day border with Zambia, Zanzibari or Afro-Arab trade caravan leaders with their armed followers had established political control over local chiefdoms and kingdoms. By 1885, the most successful of the trade caravan leaders, Tippu Tip, had federated several of these trading settlements between and around the Luapula and Lomani Rivers under his paramountcy in Manyema. Further to the south, in Katanga, another principality had been established by mid-century under another trade caravan leader, Msiri, with his armed Nyamwezi trader/warrior followers. Thus, in the whole of the Luba and Lunda area of the northeast, new political forms were superseding the old. These were essentially trading states that were mobilized to hunt elephants, raid for slaves, and collect tribute in ivory, copper, iron, and salt. They were able to buy arms and ammunition with their trading profits and with these they imposed military and political authority, as well as economic influence, over communities that had previously owed allegiance to the Kazembe.[5]

The east and southeastern parts of Central Africa, which became Zambia and Malawi, were also affected by powerful socioeconomic changes, in this case, deriving from the Mfecane. The Mfecane was a military-political and demographic expansion of conquest and refugee groups from present-day South Africa. The most important of the latter to invade Central Africa were the Ngoni, who established their centralized states among the Cewa. Another was the Kololo, who settled among the Lozi on the Zambezi. The Yao (originally from Mozambique) moved into southern Malawi and imposed their domination on the local people, using firearms bought with the profits from their trade with the east coast. They displaced the Maganja and became the rulers of the land.[6] Also from the west, traders from Angola like the Ovimbundu and the Mambari (Afro-Portuguese) pushed their search for ivory, copper and slaves into the lands of the Lozi, Kaonde, and other western Zambian peoples, in exchange for cloth and guns. The Chokwe had also acquired guns and began to expand east and northeast, hunting elephants and trading in ivory and wax, as well as raiding in the western Lunda areas of present-day Zambia. They were recruited as mercenary soldiers in local disputes. They eventually transformed themselves into rulers of considerable areas that they had conquered from their hosts. They essentially put an end to the famed kingdom of Mwata Yamvo.[7] A new political and economic

5. T.Q. Reefe, *The Rainbow and the Kings. A History of the Luba Empire to 1891* (Berkeley: University of California Press, 1981), 160–182; Jan Vansina, *Paths in the Rainforests. Toward a History of Political Tradition in Equatorial Africa* (Wisconsin: University of Wisconsin Press, 1990), 240; R. Oliver and A. Atmore, *Africa Since 1800* (Cambridge: Cambridge University Press, 1994), 69–73.

6. Andrew Roberts, "The Nineteenth Century in Zambia," in T.O. Ranger (ed.), *Aspects of Central African History* (Evanston: Northwestern University Press, 1970), 80–83.

7. Vellut, "The Congo Basin," 316–318; Oliver and Atmore, *Africa since 1800*, 68–9; J.C. Miller, "The Paradoxes of Impoverishment in the Atlantic Zone" in Birmingham and Martin (ed.), *History of Central Africa*, Vol.1, 155–158.

landscape was being created in the region. Powerful new military and political leaders whose followers were well equipped with guns arose in some areas. These built their power and influence on commerce, slave raiding, ivory trading, and war. Political fluidity in parts of the region was one reason some beleaguered communities sought alliances with European Christian missions or welcomed European invaders.[8]

Colonization Process

By 1885, European explorers had mapped out the major rivers of Central Africa, as well as the land routes. Their reports concerning the produce available, the nature of slavery and the slave trade and the prospects for commerce and Christian work were of the utmost significance in preparing the ground for the eventual colonial takeover of the region. In general, direct colonization of the region involved a first stage of treaty making by prospective European colonizers for commercial and, ultimately, political ends. European agents sought and made treaties with African rulers for preferential, and in some cases, monopolistic, trading privileges. With the onset of the European Scramble for African territory and the convening in 1884 of the Berlin Conference, the treaties became the legal tool that demonstrated and confirmed the prospective colonizers' territorial and political claims to the exclusion of the claims of their rivals. The presence of Christian missions from the colonizing countries in coveted territories further aided such claims to title. Such missions demonstrated effective occupation by the tangible presence of citizens of the colonizing country. Moreover, the missions, in their ideological role of promoting "Christianity, Commerce and Civilization," actively implored their countries to intervene in local situations that the missions considered inimical to the progress of their work. Thus they were forerunners, and occasionally loud advocates of direct imposition of formal colonial rule by their countries.[9] It should be noted, however, that the Portuguese colony of Angola predated the late nineteenth century European expansion. Portuguese military expansion away from its coastal enclaves had occurred as early as the 1830s, but this expansion was renewed from the late 1870s onward.[10]

Soon after 1884, the process and mechanism of colonial invasion progressed quickly from the stage of diplomatic/economic/religious alliances with African peoples and their rulers to the stage of political exclusion of European rivals from the area of influence, and, finally, to the stage of military occupation. The ultimate outcome of the process in Central Africa, as in other regions of Africa, was the imposition of colonial rule, the establishment of colonial administration, and the ultimate formulation and execution of colonial policies by each colonizing power.

8. J. MacCracken, "The Nineteenth Century in Malawi," in Ranger, *Aspects*, 101–110.

9. R.I. Rotberg, "Introduction" in R.I. Rotberg (ed.), *Africa and Its Explorers. Motives, Methods, and Impact* (Cambridge: Harvard University Press, 1970), 1–2.

10. D.L. Wheeler and R. Pelissier, *Angola* (New York: Praeger Publishers, 1971), 51–62.

Means and Method of Colonial Occupation

The formal British colonial presence in Central Africa dates to the 1889 declaration of a protectorate over the Shire highland of Malawi. The basis of the British colonial claim to Malawi was the significant presence of Scottish Christian missionary establishments in the territory. David Livingstone's ground-breaking expedition to Central Africa in the 1860s was a pioneering expedition and encouraged others to go to Malawi. A British consular presence followed shortly afterward to protect the missionaries and keep European rivals out of the area. The Scottish missionaries, as well as the African Lakes Company that soon began operation here, were instrumental in obtaining treaties from African chiefs. The treaties provided the legal basis for the declaration of protectorates over the peoples. By 1891, the whole of what is now Malawi passed onto Britain as its colony of Nyasaland.[11]

The British South Africa Company (BSAC) was the original colonizing power that staked out the territory that constituted Zambia, Britain's second colony in the region. The company's officials represented themselves as British government agents, and Lawenika, the Lozi king, who wanted to head off the expansive Afrikaner republics of South Africa, granted a concession to the BSAC in 1890. On the strength of the treaty, a protectorate was declared over the Lozi people and over those whom the BSAC claimed had been Lozi subjects. The company established two outposts, one in the northeast and the other northwest, from which military occupation was effected and the territory put under direct colonial administration by 1900.[12]

H.M. Stanley, the principal agent of King Leopold of Belgium, negotiated with several Congolese African chiefs the treaties that were used to confirm Leopold's claim of imperial suzerainty over the Zaire basin. In the late 1870s, Leopold held the region as his sphere of commercial interest just as George Goldie did on the lower Niger with his Royal Niger Company. In 1882, when the Frenchman, P.S. de Brazza, concluded his treaty with the Bateke chief, Makoko, by which France laid claim to the lower Congo basin, Leopold's activities changed gear. Leopold had his agent renegotiate earlier commercial treaties to include clauses giving him "suzerainty" over the African chiefs. At the 1884 Berlin Conference, King Leopold advertised his venture as a commercial and philanthropic effort to unite several Congolese polities into an association of "free states." They would be engaged in legitimate commerce with all the European countries, and would thus be introduced to European civilization and development through a benevolent political association. Soon after the conference, and aided by the jealousy among the principal European colonizers, Leopold's sole claim to the colony was recognized, and the Congo "Free states" concept quickly gave way in 1884–1885 to the highly exploitative colony of the Congo Free State.[13]

11. B. Fetter, *Colonial Rule and Regional Imbalance in Central Africa* (Colorado: Westview Press, 1983), 35.

12. Roberts, "The Nineteenth Century in Zambia," 156–159; Fetter, *Colonial Rule,* 85.

13. H.S. Wilson, *The Imperial Experience in sub-Saharan Africa Since 1870* (Minneapolis: University of Minnesota Press, 1977), 74–80.

In the European Scramble for African territories, Portugal was able to retain its coastal enclave of Angola and to expand inland from Luanda, Benguela, and Mossamedes on the Atlantic coast. Immigrant Portuguese, Brazilian, Afrikaner and *bastaards* (half-caste descendants of the Khoi and the Dutch settlers of South Africa) were encouraged to colonize the hinterland and thereby to preserve the colony in the hands of Portugal. Independent estates of settlers and Afro-Portuguese were taken over and brought under tighter colonial control by Portuguese governors. Military occupation of the hinterland was launched.[14]

Colonial Policies and African Engagement

An important characteristic of the colonial experience in much of Central Africa was the partition of most of the region into territories that were held and managed as private commercial enterprises. This was due to the unwillingness of major colonial powers to bear the huge financial costs that the establishment of direct metropolitan colonial administration would have entailed. The region was considered to have a limited prospect of immediate returns due to several factors. It was considered less strategic or valuable than West or southern Africa, having a much smaller population, fewer known economic resources, and fewer prior non-slave socioeconomic structural linkages with the outside world. In an era of public scrutiny, the metropolitan governments had to be careful to minimize public expenditure and to provide justifiable reasons for spending metropolitan tax money. The colonies must not only pay their way, but they must generate incomes for the metropolitan governments and peoples.[15] Huge land concessions were, therefore, granted to mining concerns and railway construction companies complete with administrative and, in some cases, police powers over local residents on the land. These companies were to develop transportation and communication facilities in their territories, and thus relieve the colonial administration of the cost of such projects.

Thus, in Central Africa, private company rule became the major means by which the people were ushered into colonialism. In West Africa by contrast, company rule preceded and gave way to formal imposition of protectorateship and direct colonial rule. The reverse was the case in much of Central Africa. Although Nyasaland was kept under direct British protectorateship due to missionary pressure, by 1895 the territory actually came under the military and financial control of the British South Africa Company. Thus, the Congo, which in 1885 had become the private colonial possession of King Leopold of Belgium, was soon portioned out to concessionaire companies for them to exploit and administer. King Leopold, finding himself incapable of bearing alone the financial burden of effective occupation, civil administration, and the development of communication and transportation, soon divided the Congo Free State among several concessionaire

14. W. Rodney, "European Activity and African Reaction in Angola" in T.O. Ranger, *Aspects*, 63–64.

15. P.M. Martin, "The Violence of Empire" in Birmingham and Martin (ed.), *History of Central Africa* Vol.2, (London: Longman, 1983), 13; Oliver and Atmore, *Africa Since 1800*, 131, 136; Wilson, *Imperial Experience*, 81.

companies. All uncultivated land was declared to belong to the state and a Crown Domain was carved out in 1896 for the special benefit of King Leopold. Northern Rhodesia came under the chartered rule of the British South Africa Company of Cecil Rhodes. Angola had only one major land-holding company, the Companhia de Cazengo, and only Malawi escaped having any portion of its territory leased to big concessionaire companies.

A second most important characteristic of the colonial experience in Central Africa is related to the first. The colonial economy of the region up to 1939 was organized around very coercive mobilization of African labor for the extraction of natural forest and mineral resources. This was due to the fact that the administration of most of the region fell directly or indirectly into the hands of private companies more so than in other colonies. Hence, capital investment, especially in the domestic productive sectors, was virtually nil.

Colonial Economic Policies

An important unifying trend in Central Africa's history between 1885 and 1939 was the character of the economy of its colonies. These economies were initially based essentially on mere collection of export produce and minerals. Hence, there was minimal capitalization and mechanization of forest, agricultural, and mineral production, and output and profit was largely dependent on maximizing the use and exploitation of African labor. With much of the region in the hands of private concessionaire companies that were out to profit in administrative control, only limited investment in capital and equipment was introduced into the extractive sector of the colonies' economies. Moyen Congo and Gabon started with the establishment of an administrative post under the direct control of an agent of the French government, Savorgnan de Brazza. However, within a decade the entire region was leased to private companies to administer and exploit. Indeed, up to 80 percent of AEF was allocated to concessionaire companies that would exercise "a monopoly of 'exploitation.'" Some of these companies included Société du Haut-Ogooue, (Gabon), the Compagnie Propriétaire du Kouilou Niara, and the Compagnie Française du Haut et du Bas Congo.[16] The colonial government allocated labor to these companies and assisted them with policing or law enforcement activities, and in turn they paid tax to the state and were required to invest in infrastructure in the areas of their operation.[17] Commenting on the nature of economic production by concessionaire companies in Central Africa, Austen and Headrick noted, however, that, in general, "investment by all concessionaires was very low. . . . For those concessionaires who actually took up their territories, the principal goal was not long-term investment but the realization of quick profits from ivory, palm-oil, palm kernels and rubber."[18]

16. C. Coquery-Vidrovitch, "The Colonial Economy of the Former French, Belgian and Portuguese Zones, 1914–35" in Boahen, UNESCO *General History of Africa. VII*, 375.

17. R.A. Austen and R. Headrick, "Equatorial Africa Under Colonial Rule" in Birmingham and Martin (eds.), *History of Central Africa* Vol. 2, 46–47.

18. Austen and Headrick, "Equatorial Africa," 47.

Central Africans and Colonial Agricultural Export Production

Colonial economic policy involved the mobilization and deployment of the African populations living within each concession area to work in the forest or on the plantations by force and for virtually no payment. The labor tax was a major instrument in the region for state and company exploitation of African labor. The policy of stiff taxation, together with land alienation when necessary, was employed to squeeze out and coerce underpaid labor from the generally scattered and small population of the region. Both policy strands were often backed by arrests, torture, and forced marches of the male adult population into the forests and the destruction of entire villages, especially in AEF and the Congo Free State. The French colonial administration in AEF imposed heavy taxes on the people and by 1920, both men and women were forced to pay.[19] The burdensome and ruinous nature of the taxation system was reflected in the fact that cotton, rubber, and other export crops constituted important means of tax payment.[20] In Angola, the labor of slaves was available to settler planters in the form of contract labor. The 1870 legal abolition of slavery did no more than "recontract" slaves to their masters, though some regulations to improve their lot were promulgated with varying success rates.[21] However, as C. Coquery-Vidrovitch observed, the burden of taxation was very heavy on the Africans of Angola, because "it...corresponded officially to three months' labor, the tax being payable in labour."[22] Indeed, with the exception of the Congo Free State, there was more labor coercion in Angola than in any other Central African colony.[23] As in the Congo and the early AEF, company/government officials in Northern Rhodesia and Malawi recruited labor for planters up to 1904, and they "pursued a vigorous policy of tax collection involving the burning of homes of those in default, thereby driving them off into wage employment."[24]

Thus, throughout most of the region, up to about the 1920s, the collection of wild rubber and palm products and the cutting of timber in the rainforest, were the most important export production activities outside of mining. Thereafter, some efforts at settler plantation agriculture for export were also embarked upon. Central Africans were forced to leave their homes and their farms to collect produce for concessionaire companies or compelled to supply farm labor for the cultivation of coffee, cocoa, and tobacco on plantations owned by small settler groups in west Cameroon in Katanga, up to the 1920s, and in the Shire highland

19. Ibid., 62.
20. Ibid., 63.
21. Wheeler and Pellissier, *Angola*, 63; W.G. Clarence-Smith, "Capital Accumulation and Class Formation in Angola" in Birmingham and Martin (eds.), *History of Central Africa*, Vol. 2, 172.
22. C. Coquery-Vidrovitch, "The Colonial Economy," 367.
23. A.B. Davidson, A. Isaacman and R. Pelissier, "Politics and Nationalism in Central and Southern Africa" in *UNESCO General History of Africa*. VII, 697.
24. L. Vail, "The State and Creation of Colonial Malawi's Agricultural Economy," in Robert I. Rotberg (ed.), *Imperialism, Colonialism, and Hunger: East and Central Africa* (Toronto: Lexington Books, 1983), 44–55; L. Vail, "The Political Economy of East-Central Africa" in Birmingham and Martin (eds.), *History of Central Africa* Vol. 2, 225.

in Malawi. The Portuguese in Angola also resorted to "indentured" "corrective" or "contract," that is, forced rather than wage labor to meet the needs of the greater number of their agricultural and construction projects. The Companhia de Cazengo was the major land holding company in Angola where rubber and coffee constituted the most important export crops, with rubber making up over three-quarters of the total export volume by 1910. Meanwhile, Angolan traders were also exporting slaves illegally to Sao Thome sugar plantations.[25]

Leopold's Congo had the dubious honor of initiating the colonial concession-aire system in the region, which was eventually copied by the French in AEF. The German colonial government of Cameroon was not left out, as it granted similar concessions to produce-gathering companies during the 1890s. The Anglo-Bel-gian India Rubber and Exploration Company (Abir) in the southern basin of the middle-Zaire and Société Anversoise du Commerce au Congo (Anversoise) in the northern basin were the principal concessionaire companies of the Congo Free State. The chartered companies received their land grants in exchange for tax pay-ments to the king. It was the attraction of the huge profit that Anversoise and Abir made that lured Leopold, in 1896, to carve out a Crown Domain in the basin of the Lukenia river from what remained of *domaine privée*, land that was not allotted to companies but held in trust for the state. This "royal estate" was managed by state officials and its revenue financed the royal family and royal construction works in Belgium.

The concessionaire companies and the "Crown" had exclusive rights to the territories that were allotted to them. They had full rights to the products of the forest and to the labor needed to explore it, and were the only agencies authorized to purchase products from Africans. The local peoples had rights only to areas they had under cultivation, and even there, the profitable crop, rubber, belonged to the state, on the ground that Africans had not exploited it before colonization.[26] Concessionaire company agents, assisted by either government or company militia, enforced rubber collection so rigorously that wild rubber vines were killed off. The agents were motivated to drive Africans out into the bush to collect rubber since the agents were remunerated according to the yield they obtained for the compa-nies.[27] This continued until the scandals caused by the atrocious treatment of the local people forced the Belgian state to take over the Congo from King Leopold in 1908. Some of the worst atrocities perpetrated against Africans of this region were reported for the Congo Free State. The following statement by an ex-agent of An-versoise Company summarized the company agents' mode of operation:

At first the blacks generally promised what they are asked for—100 kilos monthly for every persons—but they hardly ever keep their word. Then it is necessary to use coercion. The refractory village is attacked, a certain number of hostages are seized, and only released upon the payment of so many baskets of rubber for every hostage. Sometimes the outbreak ex-

25. Clarence-Smith, "Capital Accumulation," 165, 167–8.

26. S.H. Nelson, *Colonialism in the Congo Basin 1880–1940* (Athens, OH: Ohio University Center for International Studies, 1994), 89.

27. Nelson, *Colonialism in the Congo*, 85–89; B. Jewsiewicki, "Rural Society and the Belgian Colonial Economy" in Birmingham and Martin (eds.), *History of Central Africa* Vol. 2, 98; Austen and Headrick, "Equatorial Africa," 53–54.

tends to the neighbouring villages, and then the entire region is in revolt, and the troops of the State placed at the disposal of the Company have to put it down. In this manner, a condition of war exists almost continuously in one portion or another of the Mongalla district.[28]

Arrests, burning down of villages, flogging, and hostage-taking to enforce the supply of ever-increasing quotas of rubber were the hallmark of this economy throughout the forest area of Central Africa, Angola included. After Belgium took over control of the Congo from Leopold, the worst excesses of the concessionaire companies stopped, but the era of economic exploitation by concessionaire companies did not.

Until World War I, therefore, extraction of rubber through coerced African labor constituted a major agricultural export policy of the colonies. Together with ivory, rubber accounted for over 90 percent of annual export value of Congo up to 1900.[29] By 1905 up until 1927, in AEF, rubber accounted for 53 percent of export value, after which it was replaced by timber (58.7 %). Similarly, in Cameroon, by 1905, rubber accounted for 43 percent of export value, replaced by palm produce (48.7%) by 1927. Most of AEF's timber export was from Gabon.[30] The recruitment of labor for cutting and hauling logs by companies and individuals holding concessions to particular forest areas was also state assisted, though much less so than for rubber,.[31] Given the huge extent of the territories, the labor cost of building and maintaining roads was great, and when added to the labor need of the export agricultural sector, it severely affected the people of these colonies.[32]

In German Cameroon a settler plantation sector developed initially for the large-scale production of cocoa, and then oil palms, rubber, and bananas. In Angola, the Portuguese encouraged immigration to strengthen their hold on their large territory. British-held Malawi also had a fairly important settler plantation sector in the south in Shire highland where close to a million hectares of fertile land had been alienated for European farmers. Some expropriated Africans were forced into supplying labor to settler coffee planters and others became tenants and squatters who paid labor rents. Elsewhere in Malawi, the rural economy was neither invested in nor developed.[33] Malawi, in contrast to the other colonies, had no concession-holding company.

Until 1924 when Northern Rhodesia came under direct metropolitan colonial control, the British South Africa Company (BSAC) was the ruling power. The company expanded from South Africa to Southern and Northern Rhodesia in the hope of discovering another Rand. The mercenary character of the concessionaire company was manifest in its early economic policies. Thus, it awarded a concession to the North Charterland Company for a sizable portion of Zambian Ngoniland, a concession lasting throughout our period of study. The BSAC, moreover,

28. E.D. Morel, *King Leopold's Rule in Africa* (Westport, CT: Negro Universities Press, reprint 1970), 131.

29. Jewsiewicki, "Rural Society," 99. See also Nelson *Colonialism in the Congo Basin*, 8. In 1890 the Congo produced 135 tons of rubber valued at half a million francs, in 1901, over 1300 tons at over 43 million francs, and in 1904, 5500 tons at 48 million francs.

30. Austen and Headrick, "Equatorial Africa," 48–51.

31. Ibid., 57–58.

32. Ibid., 32.

33. J. McCraken, "African Politics in Twentieth-Century Malawi," in Ranger, *Aspects*, 191–192.

settled a number of Europeans in limited areas in Ngoni country close to Lake Tanganyika, where they grew coffee, though a few of them cultivated tobacco. Others settled along the railway in Tonga country where their farms supplied the Katanga copper mines with maize and beef.[34]

However, neither the extraction of forest produce nor settler plantation agriculture was the major preoccupation of the BSAC. The company failed to locate any major viable mine until the late 1920s when the large-scale mining of its Katanga copper became feasible. It rather encouraged the migration of Northern Rhodesian males as laborers to Southern Rhodesia, South Africa, and the Congolese Katanga mines. Hence, the primary economic effect of colonial policy during the period was the transformation of Northern Rhodesia's able-bodied male population into a pool of unskilled migrant labor. Here too, the principal means by which the Africans were forced into the mines as laborers was the imposition of taxation and tribute labor. The expropriation of much Ngoni land and the deterioration of the overcrowded land that was left for them was an additional reason for the people to seek for wage labor away from home. By the close of our period, Zambian unskilled migrant laborers who worked in the Copper mines numbered over 20,000; those who worked in the goldfields and sisal plantations in Tanganyika to the east numbered more than 15,000; and those who went periodically to Southern Rhodesia numbered about 34,000.[35]

Central Africans and the Colonial Mining Sector

Mineral exploration in Central Africa produced generally the same land and labor effects as produce export. The same went for railroad companies. Together, the mining and railroad companies were the sectors that alienated land and commandeered cheap African labor. Leopold gave a concession of 1,500 hectares for a kilometer of railroad to be constructed from Matadi to Leopoldville by its concessionaire Compagnie du Congo pour le Commerce et l'Industrie. The construction of other rail lines to bypass unnavigable portions of the great river routes were similarly awarded to risk-capital investor companies. Thus, the Compagnie du Katanga that undertook to construct the railway line from Kasai to Katanga was granted a third of all unoccupied land and mineral rights in its area of operation.[36]

The Congo had the biggest mining sector in colonial Central Africa. Mineral exploration began in the late 1880s. Société Général, the Belgian financial holding company, with its subsidiary, Union Minière du Haut-Katanga, held substantial concessions in the extractive industry in the Congo, as well as in Angola. Other companies included Forminière (formed in 1906) which shared with the state half

34. A. Roberts, "The Political History of Twentieth-Century Zambia" in Ranger, *Aspects*, 157.

35. Ibid., 156–162.

36. A.P. Merriam, *Congo. Background of Conflict* (Evanston, IL: Northwestern University Press, 1961), 13; Coquery-Vidrovitch, "Colonial Economy," 378–79; Roland and Atmore, *Africa since 1800*, 131. A good summary description of road and railway construction in the AEF is given in Austin and Headrick, "Equatorial Africa," 56–58.

of the total interests in diamond mining concessions, and Geomines (formed in 1910) which mined tin in its estates. Copper, the most important mineral in the colonial Congo, was found in Katanga region and diamonds were mined in Kasai. From early dredging of alluvial gold on the Shari, Kibali, and Ituri Rivers, mechanization began to be applied to mining operations by 1920. Tin mining expanded considerably in the mid-1930s and by 1939, the mining products of these companies included cobalt, uranium, tantalum, columbium, tungsten, copper, and diamonds.

The mining industry in the Congo attracted immigrants from Northern Rhodesia and other colonies.[37] Provision for the industry was ensured by new means rather than by labor taxes and conscription. By the 1920s, especially in Kasai, a policy of settling migrant Luba along railway lines was embarked upon. Here the Luba farmed and sold their produce to mine laborers. In the northeast, South African and Belgian settler agriculture provisioned the mines. Food was also imported from Northern Rhodesia.[38] By the beginning of the World War II, close to a million Central African men, women, and children were engaged as laborers in the mines, in railroad construction, and on the farms in the Congo Free State alone.[39] Most of the mine labor was unskilled, contracted for limited periods, and came from the Congo, and Northern Rhodesia.

Mortality among the earliest recruits to the Congo mines was very high. Disease, bad working conditions and deficient nutrition wreaked havoc on mining compound populations, as they had done earlier among villagers conscripted to tap rubber. Housing conditions did not improve beyond the bachelor style imported from South Africa until the 1930s when a drive to develop townships around the mines began. Eventually, migratory patterns became so well entrenched that conscription of labor to satisfy some mining areas was dispensed with.[40] Northern Rhodesia's copperbelt mines came into production only in the mid 1920s. By 1930, they were achieving full production capacities. By 1930, 32,000 African laborers were employed in the mines, and by 1938, copper and other minerals accounted for 97 percent of the colony's export volume. Wages, of course, were low, housing conditions were poor, and tax rates were high.[41] Colonial production by 1939 had become highly capitalistic, as had labor relations.

African Reactions in Central Africa

Allen Isaacman and Jan Vansina developed a typology of early African resistance movements. These ranged from attempts to preserve precolonial independence to movements defending social and economic structures that were fast

37. Jean-Luc Vellut, "Mining in the Belgian Congo," in Birmingham and Martin (eds.), *History of Central Africa* Vol. 2, 129–143; R.W. Hull, *Modern Africa: Change and Continuity* (Englewood Cliffs, NJ: Prentice-Hall, 1980), 123; Martin, "The Violence of Empire," 5.

38. Vellut, "Mining," 148–149.

39. Ibid., 143.

40. Ibid., 147, 150, 155.

41. Vail, "East-Central Africa," 245; Robin Palmer, "Land Alienation and Agricultural Conflict in Colonial Zambia" in Rotberg, *Imperialism, Colonialism, and Hunger*, 99.

being eroded in the face of colonial policies, and to rebellions that sought to eject the colonizers and terminate the system they had installed.[42] This typology also applies to Central Africa. Many people there forcefully resisted military occupation, including the Yeke in the Congo, the Yao of Malawi, the Chokwe, Ovimbundu, and Bihe of Angola and the Cewa of Mwase Kasungu in Malawi. Others, like the Bemba of Zambia, the Yeke successors of Msiri in Katanga, or the Arab/Swahili rulers of the northeast Congo engaged in diplomacy or alliances with invading European powers so as to be able to negotiate or preserve some form of independence. However, with the colonizing authorities bent on total control, these societies all eventually resorted to military resistance. Resistance to occupation in the north and south of Angola lasted well into the twentieth century, among the Ovimbundu until 1903, and among the Chokwe until 1914.[43] This was followed by a series of popular uprisings, primary resistance, some of which persisted until the 1940s.[44] In Northern Rhodesia, a section of the Bemba resisted invasion until 1898–1899. It took a large BSAC force in 1899 to defeat the Lunda of Kazembe and to occupy their capital; the Kazembe did not give himself up until the following year. In Malawi between 1889 and 1904, some Yao and most Ngoni groups took up arms against colonial incursions.[45]

Many peasants and traders resisted colonial control of production and exchange. For some, it was this rather than military invasion of their polities that brought them face to face with colonial imperialism. Their eventual armed revolt thus represented efforts, at the same time, to protect their ways of life, preserve their land, cattle, labor, women, and young men, and to fight against foreign political domination. Such were the Yaka, the Budja and Bowa and some of the Mongo in the Congo Free State who resisted until 1906.[46] Indeed, rubber-induced revolts and military operations to put them down, called the "rubber wars" by Jan Vansina, lasted in the Congo rubber region from about 1893 to 1910. They lasted in the border area between Cameroon and the Moyen Congo and Gabon from 1902 to about 1920.[47] In 1929, the Baya on the Cameroon-Ubangi border rebelled. Resistance against economic demands was the reason military officials rather than civil commissioners remained an important feature of colonial administrations in the AEF up to the end of our period, and up to the outbreak of the First World War in German Cameroon.[48] For some groups in this region, especially the newly formed elite and laborer groups, localized resistance began much later. In 1935 following increased taxes, revolts organized by the working class to demand higher wages, lower taxes and better working conditions broke on the Zambian copperbelt.[49]

42. Isaacman and Vansina, "African Initiatives," 171.

43. Wheeler and Pellissier, *Angola*, 71–73.

44. Rodney, "African Reaction in Angola," 63–64.

45. Roberts, "The Nineteenth Century in Zambia," 90–94; MacCracken, "The Nineteenth Century in Malawi," 107–110.

46. Fetter, *Colonial Rule*, 137–138; Isaacman and Vansina, "African Initiatives," 172, 176.

47. Vansina, *Paths in the Rainforests*, 242–244.

48. Austen and Headrick, "Equatorial Africa," 40; Nelson, *Colonialism in the Congo Basin*, 100–112.

49. Austen and Headrick, "Equatorial Africa," 81; Fetter, *Colonial Rule*, 89–91, 101; Davidson, Isaacman, and Pellissier, "Politics and Nationalism," 685.

The development of colony-wide nationalist movement with a well articulated goal of rooting out colonialism started late in Central Africa compared to other regions of Africa because of the late development of a modern elite. Nonetheless, anti-colonial religious movements did occur in the early 1920's in Cameroon, and in the 1930's in the Belgian Congo and Nyasaland. These were the Lar and Matsous movements in Cameroon, and the Kitawala and Kimbanguist movements in the Congo. They propagated anti-white and anticolonial messages. The Kimbanguist movement, despite its repression by the colonial government revived several times and continued into the 1960s. Offshoots of the Kitawala and Kimbaguist movements sprang up and spread into Angola. In the Belgian Congo, they "exhorted the people not to work for Europeans, not to grow the export crops imposed by the colonial administration, not to pay taxes and levies, not to send their children to missionary schools, and generally to disobey the Belgians."[50] The Kitawala movement denounced colonial authority and affirmed the legitimacy of its own religious leaders only. The movement became entrenched in the southern Katanga mining area from where returning migrant miners spread its message across the Congo and into Zambia.[51] Other expressions of cultural resistance, like dance and antisorcery movements, also flourished.[52] The rebellion led by Rev. John Chilembwe in Nyasaland was an early anticolonial millenarian movement that initially voiced specific grievances against the colonial administration and aspects of Nyasaland's World War I policies. In late 1914, the movement gathered steam very quickly, its leadership became more radical, and it quickly graduated to denouncing colonialism. Soon the movement developed into an armed rising against the colonial administration. However, as in Zambia, the elite were yet unable to articulate an anticolonial position that was popular enough to attract a colony-wide mass following.[53]

Protest activities against specific colonial policies by local or "native" or "welfare" associations (in the Congo, *associations des ressortissants*) like the North Nyasa Native Association, the West Nyasa Native Association, and the Mombera Native Association were the norm. The people also used Christianity to create ideologies and institutions, like independent churches and development associations, within which self-development could proceed outside the colonial framework. The people sought to promote and control their socioeconomic opportunities through these agencies.[54] These were precursors of nationalism that developed late in this region. They were the earliest experiences of protest and the background against which popular protest politics were organized. However, movements for political reform organized to cover entire colonies and to embrace more than district-level interests really developed only after the World War II, starting first in the British colonies.[55]

50. Davidson, Isaacman, and R. Pelissier, "Politics and Nationalism," 691–692.

51. Ibid., 692–693.

52. Jewsiewicki, "Rural Society," 120–121.

53. Austen and Headrick, "Equatorial Africa," 81–82; J. MacCracken, "African Politics in Twentieth-Century Malawi" in Ranger, *Aspects*, 190–198; Fetter, *Colonial Rule*, 44.

54. Davidson, Isaacman and Pelissier, "Politics and Nationalism," 683; MacCracken, "Twentieth-century Malawi" in Ranger, *Aspects*, 200.

55. MacCracken, "Twentieth-Century Malawi," 201.

It is important, however, to note that there was a wide range of local engage-
ment with different aspects of colonial rule in Central Africa, as there was in
other regions of the continent. Peasants, local traders, chiefs, new elite members,
women, and migrant laborers tried to respond positively to every opportunity of-
fered by production or commercial or, indeed, administrative processes. Peasants,
for example, often seized any independent and profitable opportunities to gather
or produce export goods. However, colonial policies such as monopoly trading,
land alienation, enforced cash crop production, and labor and taxation policies
largely frustrated and destroyed such initiatives. Among the Mongo of the middle
Congo basin, for instance, rubber collection at first was enthusiastically wel-
comed as an opportunity to earn cash. But total state and company control over
production, produce-marketing, especially as effected by the quota system, ar-
rests, physical violence, and other abuses, quickly removed any profit the activity
could have brought the people. Also, during the World War I when the demand
for copal became very high, many were able to collect more than the state's tax re-
quirements. They earned incomes with which to acquire consumer articles and in-
crease their living standards. Copal collection did not conflict with local domestic
and agricultural work schedules. The Mongo response to high demand for this
product was to step up supply.[56]

In Nyasaland, by late 1900, local farmers, including tenants on white estates,
produced cotton in the lower Shire valley much more efficiently than did the
white settlers. Yet, settler-organized buying cartel deprived Africans of more than
90 percent of the profit realized on the export market for their crop.[57] When an
increase in demand and a rise in price between 1923 and 1926 temporarily shat-
tered the white settler tobacco marketing monopoly, African tenant farmers on
settler farms of Nyasaland immediately responded with a greatly increased local
independent cultivation of dark-leaf tobacco. Unfortunately, with the onset of de-
pression, this was quickly stifled by government regulations. New growers were
discouraged; seed distribution was drastically reduced; and regulations went as
far as allowing uprooting of cotton plants, all in the name of shoring up falling
prices and reduced settler and state incomes.[58] Successful African responses to the
high demand and prices for maize and beef from the newly operating Northern
Rhodesian copper mines suffered the same fate. Worse, during the World War II,
settler planters were able to pressurize the colonial government to move Africans
into reserves. This and other control policies, most of which favored the white
farmers, eventually had the effect of clearing land for settlers and destroying the
vibrant competition of African independent production.[59] In Cameroon, the for-
mer slave traders and colonially appointed chiefs were able to join in the early
production of cocoa, until they were suppressed by state policies. It was not until
World War II that peasant production became significant in the colonial econ-
omy.[60] High taxes also had dampening effects on the local agricultural export ini-
tiatives of Central African farmers. All over Central Africa, especially from 1914
to the 1920s, colonial governments increased tax rates. As noted by Coquery-

56. Nelson, *Colonialism in the Congo Basin*, 121–122.
57. Vail, "Colonial Malawi's Agricultural Economy," 47–48.
58. Ibid., 61–64.
59. Palmer, "Land Alienation," 99–100; Vail, "East-Central Africa," 244.
60. Austen and Headrick, "Equatorial Africa," 77.

Vidrovitch, "the average amount of the direct tax collected in 1915 per inhabitant was...F. frs 1.55 in AEF, and B. frs 1.35 in the Belgian Congo."[61] The colonial governments introduced price fixing policies for export crops, as well as the hated *cultures obligatoires* or compulsory cultivation of state designated crops in the Congo, and also in the savanna region of AEF during the World War I. Under the latter policy, farmers in some areas were mandated to produce fixed amounts of cotton, rice, and other foodstuffs at predetermined below-market rates. This was aimed at provisioning workers in the mines, in railroad construction, and elsewhere. Noncompliance was met with imprisonment and floggings, complementary judicial policies that further weakened independent local African productive efforts.[62]

In areas affected by serious labor outmigration, the quality of rural life deteriorated. Only a few groups, such as the Tonga who were able to engage in local export production, were able to record improved rural economic situations. Most other rural areas, having lost their men to foreign mines and other workplaces, largely depended on remittances from migrants for survival.[63] Others suffered the removal of their male population to work on road construction. Widespread forced relocation of villages along the roads in the 1930s in the Congo also produced devastating effects on rural life. In the villages, only the women, the aged, the infirm and the children were left behind. Self-sufficiency in food production all but disappeared and diets became deficient. Divorce increased, especially as men stayed away for long periods, or stayed away permanently in the towns or the mines. Such stagnation and unraveling of rural life was reported for Malawi, and for the Mongo and other forest peoples of the Congo.[64]

Traditional social organizations were disrupted as precolonial social arrangements—orders of privilege, patriarchy, or headmanship—were ignored or violated to suit the maximization of rubber collection or other state labor needs. Diseases and epidemics became rife and a clear demographic crisis, particularly in the sparsely populated forest area of AEF and the Congo, ensued.[65] All these conditions were worsened by the depression of World War I when prices of imported goods rose and taxes increased but wages of workers and earnings of peasants stagnated.[66] This ultimately forced colonial governments from the 1920s onward to develop some workable health services to better manage what was euphemistically referred to as the "fragility" of the native population, that is, the high mortality rate that resulted from the abuse of African labor.[67]

As colonial administrative and economic structures were established in the region, considerable changes in social relations followed in most areas. These we can only briefly mention in this chapter. In northern Cameroon and AEF where

61. Coquery-Vidrovitch, "Colonial Economy," 367–68.

62. Nelson, *Colonialism in the Congo Basin*, 124–125; Fetter, *Colonial Rule*, 200–202; Austen and Headrick, "Equatorial Africa," 59–60.

63. A. Roberts, "The Political History of Twentieth-Century Zambia" in T.O. Ranger, *Aspects*, 164.

64. Vellut, "Mining," 14714–8; Vail, "Colonial Malawi's Agricultural Economy," 57–58; Nelson, *Colonialism in the Congo Basin*, 167–177; Hull, *Modern Africa*, 110.

65. Coquery-Vidrovitch, "Colonial Economy," 372–374.

66. Ibid., 366–367.

67. Martin, "The Violence of Empire," 17; Jewsiewicki, "Rural Society," 106; Austen and Headrick, "Equatorial Africa," 34–35, 63–70.

precolonial bureaucratic structures had existed, they were generally retained. Outside of this area, a new social group emerged as the "political auxiliaries" of colonial administration. This group included "chiefs" that were appointed over newly created administrative units or, in many cases, appointed to replace legitimate chiefs who had been removed. They collected tax, recruited labor, organized the remittance of commodity taxes, and generally serviced the law and order needs of the colonial administration.[68] The African members of the colonial military/police forces, for example, the Congolese *Force Publique*, AEF's *tirailleurs*, Angola's *capitas* as well as the clerks, teachers, pastors, and catechists were members of a new emerging modern elite. They were particularly important in the restricted protest activities early during the colonial period in the region. Some of these individuals capitalized on their positions within the colonial structure to improve their economic positions. Where some of them, like the *capitas* and company agents, had allied with the concessionaire companies and labor-recruiting agents to the detriment of local populations, they were attacked and in some cases killed by resisting peasants.[69]

Conclusion

By 1939, many changes had taken place in Central Africa. Railroads had been built. Settler agricultural sectors in some of the colonies had huge acreage under cultivation and the export volume of agricultural produce kept increasing. The mining industry, especially in the Congo and later in Northern Rhodesia also boomed, attracting a large labor force and plenty of foreign capital. New urban administrative and commercial centers were established to which Central Africans were attracted. A new class of wage earners was created all over the region and the social basis of a capitalistic or modern economy was laid. From the point of view of colonial enterprise these constituted modernizing and profitable developments. The concessionaire companies, the colonial governments, private foreign investors, and financial institutions reaped considerable profit and the European governments were happy with the opportunity of "civilizing" "dark" Africa. Some Africans who were able to position themselves in the colonial administration (the chiefs, the *capitas*, the auxiliaries, some dexterous middlemen, some members of the educated elite, and others) also earned cash incomes and could acquire imported European goods. However, the crucial enabling factor in all of these developments was the labor of the Africans of the region. The social system, the land, rural and local work patterns, domestic agriculture, and precolonial settlement pattern were all brought under colonial state/company control, manipulation, exploitation, and transformation.

In comparison with West Africa, for instance, the European sector in Central Africa was more developed, especially in the Congo and Zambia. Both mining and settler agricultural production were on capitalist basis, hence, this region by 1939 had experienced more capitalist penetration of its economy than other regions of Africa, excepting southern Africa. The region had also developed a sub-

68. Austen and Headrick, "Equatorial Africa," 78.
69. Morel, *King Leopold's Rule*, 128.

stantial pan-regional mix of migrant laborers who by the end of World War I were gradually being transformed into a stable urban working class. The obverse side of this development was that capitalist production by Africans themselves was thwarted by state policies that favored the development of the foreign-dominated capitalist mining and settler-dominated agricultural export sectors. Moreover, except for the Rwanda/Burundi area, parts of the Congo, and Malawi, peasant production was adversely affected by state policies meant to create labor pools for settler and mine production. The Africans of Central Africa thus suffered poverty, rural backwardness, and hardship, as their living standards stagnated or dropped with falling earnings and rising inflation.

Review Questions

1. What were the sociopolitical arrangements in Central Africa on the eve of European colonization?
2. To what extent and by what means were the societies of Central Africa linked to external commerce by the late nineteenth century?
3. Discuss the colonial partition process in Central Africa.
4. What were the basic features of the colonial economy of Central Africa?
5. How would you assess the African experience of colonialism in Central Africa?

Additional Reading

D. Birmingham and P. Martin (ed.). *History of Central Africa*, Vol.1 (London: Longman, 1983).

A.B. Davidson, A. Isaacman and R. Pelissier, "Politics and Nationalism in Central and Southern Africa" in A. Adu Boahen (ed.), *UNESCO General History of Africa VII. Africa Under Colonial Domination 1880–1935* (Paris: UNESCO, 1985: 673–711).

C. Coquery-Vidrovitch, "The Colonial Economy of the Former French, Belgian and Portuguese Zones, 1914–35," in A. Adu Boahen (ed.), *UNESCO General History of Africa. VII. Africa under Colonial Domination 1880–1935* (Paris: UNESCO, 1985: 351–381).

B. Fetter, *Colonial Rule and Regional Imbalance in Central Africa*, (Boulder, CO: Westview Press, 1983).

S.H. Nelson, *Colonialism in the Congo Basin 1880–1940* (Athens: Ohio University Center for International Studies, 1994).

Chapter 18

East Africa

Erik Gilbert

In the period from 1885 to 1939, Britain and Germany wrested control of the East African coast from the Arab state of Zanzibar. They then proceeded to carve out new colonial territories in the interior. Just as the final wars of resistance against the new colonial powers were coming to a close, World War I broke out and war again raged across East Africa as the colonial powers turned their guns on each other. In the aftermath of the war, Africans found new ways of accommodating and resisting the colonial state by creating clubs and associations. These were initially dance societies, but later were more overtly political.

* * *

The colonial experience in East Africa is, to the popular mind, the essence of colonial Africa. Words like "Nairobi," "safari," and "Mau Mau" usually cause some flicker of recognition in even the most uninformed mind. When most Americans think of "Africa" it is colonial Kenya that comes to mind: animals (always animals first, then people), steely-eyed Englishmen downing gin and tonics before shooting one of the animals, and then telling the latest joke about the pitfalls of relying on American Express.

Not surprisingly, most of these images are inaccurate and misleading. The settlers' world in the Kenya highlands was hardly representative of the colonial experience in most of East Africa, much less the rest of the continent. The emphasis on animals is also misleading in that it suggests that East Africa's most salient characteristic is wilderness, when nothing could be farther from the truth. East Africa was home to ancient urban civilizations on the coast and elaborate states in the interior, as well as home to some animals. But perhaps the single thing that makes East Africa's early colonial experience different from the colonial experiences of other areas was that there was already a colonial state present when the European powers began to divide the area up. The Arab state of Zanzibar had created an empire on the coast in the early part of the nineteenth century and it was Zanzibar that had to be forced to give up its claims before the Europeans could begin to stake theirs.

The famous expeditions of Burton and Speke, Livingstone, Grant, and Cameron all went into the interior with the permission and support (sometimes coerced) of the Zanzibari state. Zanzibar's economic influence spread far into the interior shaping the outcome of the colonial transformation in many ways. As a result, East Africa's colonial experience was substantially different from that of the West African colonies of Senegal or Nigeria. Just as every unhappy marriage is

unhappy in its own way, so too the colonial encounters between Africans and Europeans were different (though mostly unhappy) all over the continent.

This chapter deals with four colonies—Kenya, Uganda, Zanzibar, and Tanganyika (known first as German East Africa, then as Tanganyika, and now as Tanzania). *Please see Map 2: Colonial Africa for the location of these colonies.* In each place the colonial encounter was different. This was partly because of the differences in the styles of the colonizers, but mostly because of the differences in places they tried to colonize. In Zanzibar, the British encountered a recently arrived Arab ruling class. Seeing in the Arabs a distant reflection of themselves, they chose to rule through the Arabs and in part for the benefit of the Arabs. In Kenya a cool, fertile highland region in the center of the country made it highly attractive to European settlers. These settlers poured into central Kenya, giving Kenya an economy and politics unlike those of any of the other East African colonies. Uganda, the only landlocked East African colony, and Tanganyika, with its sparsely populated center and tiny settler population, were also distinctive. At the same time we can also say that commonalities exist between these places and that in some respects their colonial experiences are bound together by a common precolonial history.

The common experiences include the caravan routes that stretched from Zanzibar's coastal possessions all the way to Uganda and beyond. All parts of East Africa had some experience of the slave trade in the nineteenth century. As the colonial encounter began, all experienced wars of conquest and wars of resistance. And these coincided with periods of famine, cattle dying off, and other hardships that both facilitated the extension of colonial power into the interior and made the early years of the colonial period especially bitter. No sooner had the dust settled from this harsh era of colonial "pacification" than World War I broke out. Kenyans and Tanganyikans found themselves dragged into a war—a brutal total war at that—that was not of their own making and in which they were largely uninterested. Thousands of people were conscripted into the service of both the Germans and the British as fighting raged across East Africa. In the aftermath of the war, cities grew up, often where none had been before. To be sure, East Africa had cities long before the colonial period, but these were new cities that grew, full of new opportunities, new dangers, new forms of self-expression, and new ways of striking back against the colonial state. In these cities lived a huge variety of people. Dockworkers, sailors, railwaymen, Africans working for the colonial state, Europeans, prostitutes, and Indians all crowded into the fast-growing cities. The last group here—Indians, or Asians as they are called in East Africa—warrant special attention. Asians, and to a lesser extent Arabs, played a critical role in the colonial experience in East Africa. In addition to controlling most of the commerce of the region, Asians also came to dominate the professional classes and the colonial service. The result was a racial hierarchy whose complexities and tensions were exceeded only in South Africa.

Variation Within the Region

Zanzibar

In 1870 Zanzibar was the key to East Africa. The Omani Sultans of Zanzibar ruled not just Zanzibar and its sister island of Pemba, but also the coast from

Lamu in northern Kenya to the port of Lindi in the south. The major ports of the coast—Mombassa, Tanga, Bagamoyo, and Kilwa—were ruled from Zanzibar. Zanzibar was also the commercial center of the coast. Merchants from India, Arabia, France, Germany, Britain, and the United States were all represented there.

These merchants came to tap into the flow of ivory, gum copal (a tree resin used to make varnish), hides, and dyestuffs that were brought to the coast by the caravans that moved between the great East African lakes and the coast. The islands themselves produced cloves and coconuts in great quantities, and Zanzibar would soon be the world's leading producer of cloves. Zanzibar's tax system insured that the coastal ports served as feeders for Zanzibar town, making it the commercial center and home base for the foreign merchants. Zanzibar was also at the center of the East African slave trade. Slaves were an important export from Zanzibar until the 1860s, by which time the British had pressured the Zanzibari sultans into restricting the export trade. The clove industry still demanded large numbers of slaves and these could legally be transported between the sultan's possessions on the coast and the islands until 1872.

While Zanzibar's sovereignty stopped a few miles from the coast, its commercial reach and economic influence stretched well into the interior. Swahili subjects of the Sultan could be found living along the major trade routes and the shores of the lakes. Tabora, in central Tanzania, had a significant Swahili community with strong ties to Zanzibar. On the lakes, dhows (sailing ships built in the Swahili style) transported slaves and ivory that belonged to Swahili caravan leaders. Beyond the lakes, a few Zanzibari merchants had turned themselves into warlords and were busily carving out private empires supported up by the profits they earned by selling ivory and slaves. The saying, "when the flute plays in Zanzibar, they dance on the lakes," was partly true. Zanzibari sultans did not rule the lakes or any other part of the interior, but Zanzibar's economic and cultural influence could certainly be felt there.

And what was the nature of that cultural influence? It is typically described as "Swahili" which literally means coastal. (SHL is the Arabic root meaning coast. The Sahel region of West Africa takes its name from the same root, but there the coast in question is the "coast" of the desert.) In the literature, "Swahili" is used to describe clothing, cuisine, architecture, and people. While most coastal Africans would agree on the nature of Swahili food, dress and houses, the question of who can be described as a Swahili person is much more slippery. In some contexts "Swahili" means a slave or free person of slave origin. In others it might be used to describe all coastal people. Because of the association of the word with slave status, many coastal East Africans reject it when applied to themselves and instead describe themselves as "Arab" (there are also distinctions within this category) or "Shirazi"(Persian). The complexity of ethnic identity is not my real interest here, so while recognizing the many distinctions within their society I will refer to the people of the coast collectively as Swahili.

Swahili culture in the nineteenth century was the cosmopolitan product of the interaction between East Africans and the larger world of the Indian Ocean. The Swahili were Muslims, they dressed in clothing that was characteristic of western Indian Ocean Muslims, they spoke a language that, in its fundamentals, belonged to the Bantu family of languages but was peppered with vocabulary drawn from their contacts with the commercial world of the Indian Ocean. They built their towns partly in stone and were first and foremost and urban people. They had

also absorbed immigrants from the various regions of the western Indian Ocean. From the Persian Gulf came Omani Arabs, from South Arabia came Hadhrami merchants and Muslim holy men, from India came merchants. Each of these groups was still distinct from the main population in the nineteenth century, but since most were Muslims, most adopted the Swahili language, and most lived in the cities, they were a part of the patchwork quilt of Swahili culture.

As these Swahili merchants, slave traders, ivory buyers, and aspiring empire builders spread through the hinterland, they brought their language, their religion, and their style of architecture with them. The most important result of this was the use of Swahili as a regional trade language. Swahili received a further shot in the arm when the Germans chose to use it as the language of administration when they took over Tanganyika. Now Swahili is spoken in eight East and Central African countries and its widespread use is the result of Zanzibar's commercial colonialism.

By 1885 Zanzibar was being eyed hungrily by the Germans. They were already in the process of staking a claim to the sultan's territories on the coast and it looked as if it would be only a matter of time before they attempted to seize the islands too. Since 1884 Dr. Karl Peters of the Society for German Colonization had been traveling through the hinterland west of the sultan's coastal territories, signing treaties with local notables who relinquished all control over their land to the German East Africa Company. These treaties were of dubious legality, but in February 1885 German Chancellor Bismarck extended imperial protection to the company and its possessions.

By 1887 the German East Africa Company was ensconced in Dar es Salaam (the future capital) and was demanding the right to take over customs collections on the coast. Within a year, armed resistance to the Germans arose. It was in the chaos of this revolt that Zanzibar lost control of the Tanganyikan portions of the coast. The resisters were not fighting for the interests of the Zanzibari state. They fought for their own purposes and had they succeeded in driving out the Germans, it is unlikely they would have handed the coast back to the sultans.

The northern part of the coast, in modern-day Kenya, was also stripped from the Zanzibaris at this time. In this case though it was the British who took over. Under the leadership of William McKinnon, a shipping magnate, the Imperial British East Africa Company took over the Kenya coast. Unlike the Germans, the British company still recognized the sultan's theoretical sovereignty over the coast, but as a practical matter they took most of the administration into their own hands. Zanzibar in 1889 was a shadow of its former self. Stripped of its coastal possessions its role as the central clearinghouse of the region's sea trade was threatened.

In 1890, with the Germans gaining the upper hand on the coast and showing ever keener interest in Zanzibar, the sultan decided to go with the more familiar, if not the lesser, of two evils and accepted a British protectorate over Zanzibar. The British took control over Zanzibar's foreign affairs and over its finances. Soon, however their control extended to the port, where a British port officer was appointed, to the police, and by World War I to every aspect of government.

When the British and Germans usurped Zanzibari control of the coast and then of the islands of Pemba and Zanzibar proper, they set in motion two major processes. First, they made Zanzibar a backwater. In 1860, save for Bombay, Zanzibar was the busiest port in the western Indian Ocean. Aden and Karachi

both lagged behind Zanzibar. No East African port came even close. Zanzibar was a colonial power with territories on the coast, and a commercial reach that stretched inland as far as the lakes. By 1920, Zanzibar had lost most of its trade with the coast. As the Germans and the British set up their own ports in Dar es Salaam and Mombasa, Zanzibar's port became a conduit for the one cash crop Zanzibar produced—cloves. And other than clove growing, not too much of regional or international significance happened in what was now a much smaller Zanzibar.

The second major effect of Zanzibar's decline was to open the gates for the colonization of the coast. Once Zanzibar's claims to the points of entry to the interior had been dispensed with, the race was on for effective control of the interior. The result was that the big mainland colonies of Kenya, Tanganyika, and Uganda quickly surpassed Zanzibar in importance. A sad and undeserved fate for a once great island.

German East Africa

The German East Africa Company, which had wrested away the southern part of Zanzibar's coastal territories, soon set about extending its control to the interior. It frequently met fierce resistance as it did so. Indeed, resistance was fierce from the start, even during the first efforts to establish control on the coast. When the Germans first arrived on the coast they entered a situation far more complex and strife riven than they imagined. The coastal strip was more than the terminus of the caravan routes that linked the interior to the sea, it was also home to a plantation economy. Big planters—the Sultan of Zanzibar included—grew coconuts and grain on the coast. The plantations used large numbers of slaves, many of whom were relatively recent arrivals from the interior and understandably disgruntled. Even the free population had its contending factions. Old coastal families resented the wealth and political pull of the new Omani families (many of which were either related to or allied with the sultans of Zanzibar) that had settled on the coast. The spark that set off this powder keg came in 1888.

When the Germans showed up in 1888 to take possession of the customs houses that the Zanzibari sultan had reluctantly ordered to be turned over to them, they did it in so high-handed a manner that they undermined the existing authorities without fully replacing them. The result was an uprising that nearly drove the Germans from the coast and brought the full weight of the German Imperial Government to bear behind the company. In Bagamoyo, one of the main ports on the coast, Emil von Zelewski publicly insulted the sultan's representative and desecrated a mosque by entering it in his boots and with his hunting dogs. A few days later the coastal population rose. German stations on the coast had to be abandoned and two Germans were killed at Kilwa. The Germans managed to hang on to Bagamoyo and Dar es Salaam. As the severity of the crisis became apparent on the home front, Chancellor Bismarck reluctantly gave £100,000 to support the cause. A small army with German Officers and NCOs and a rank and file consisting of Sudanese mercenaries was dispatched to the coast.

At first the Germans believed that their real enemies here were the sultan's agents and hence the sultan himself. But it soon became clear, even to the Germans, the leadership of the uprising came from the old coastal families rather than the Omani elite. The Germans had unwittingly triggered a power struggle on

the coast. One of the two main leaders of the uprising, Abushiri, seems to have sought to create a state on the coast free from both Zanzibari and German control. Jonathon Glassman has taken the argument a step further arguing that events were soon taken entirely out of the hands of the elite and that it was the slaves and other excluded members of coastal society who ultimately directed these events.[1]

A German naval blockade of the coast (sold to the German public as an effort to clamp down on the slave trade) and the modern weapons employed by the newly deployed army eventually settled the issue on the coast. Abushiri was captured and hanged. Bwana Heri, the other leader of the uprising, was run to ground but "rehabilitated." The old social order was reestablished and the authority that slaveholders exercised over their human property restored, the naval blockade notwithstanding. But the war for the coast in many respects set the pattern for future conflict during the process of pacifying Tanganyika. The Germans were a destabilizing force, sometimes intentionally, sometimes not. Their presence and machinations frequently triggered upheavals that included but were not limited to resistance to the expansion of German power.

The Hehe war fits this pattern. The Hehe fought the Germans in the 1890s when the Germans started to interfere with Hehe expansionism. The Maji Maji war of 1905–1907 brought together people from a variety of ethnic groups to fight the Germans. Throughout southern Tanganyika, religious leaders distributed medicines that were believed to make their users invulnerable to bullets. Maji Maji has usually been seen as a remarkable effort by people from a huge variety of backgrounds to unite against a common colonial enemy. And it was. But a recent article by Jaime Monson suggests that Maji Maji was also a part of a struggle over resources in southern Tanganyika in which the Germans were only one of many contenders.[2]

By the late 1890s the Germans had sufficient control to begin to collect taxes. In 1898 they ordered that chiefs collect a tax of 4/per hut. This caused unrest but was enforced in order to bring Africans into the cash economy and to formalize their subservience to the government. The Germans ruled through preexisting political structures, retaining Zanzibari administrative structures and terminology and spreading some of these institutions and the use of the Swahili language into the interior.

The British in Kenya and Uganda

In addition to taking Zanzibar as a protectorate, the British took two colonies on the East African mainland: Kenya and Uganda. The two were very different places from a colonizer's perspective. Kenya's coast was similar to Tanganyika's, which is to say, Swahili in culture and politically part of Zanzibar. But the interior was quite different. Caravan routes passed through Kenya's interior, but they were more recently established and less intensively used than those in Tanganyika. The peoples who lived in the interior were less involved with trade than their counterparts further south and lived in stateless societies. By contrast the Kingdom of Buganda, a large centralized state, dominated Uganda.

1. Jonathon Glassman, *Feasts and Riot* (London: James Currey, 1995).
2. Jaime Monson, "Relocating Maji Maji," *Journal of African History* 39 (1998): 95–120.

Both Uganda and Kenya were initially under the control of the Imperial British East Africa Company. The company dispatched Captain F.D. Lugard to the Kingdom of Buganda in 1890. He reached an agreement with Kabaka Mwanga, the king of Buganda, which placed his kingdom under the company's protection. As was the case with the Germans in Tanganyika, the British arrived in Buganda at a time of great internal upheaval, in this instance conflict between Christian and Muslim factions in Buganda. By 1894, the company was in financial trouble and the British government stepped in to declare a protectorate over Uganda. The Kabaka was allowed to continue to rule through his senior chiefs provided he remained loyal to the British. This approach to administering a colony came to be called "indirect rule" and although the British took a variety of approaches to governing their colonies, indirect rule is considered a typically British approach to governance. Lugard would later be transferred to Nigeria, and he used this model of colonial administration there.

Despite a climate that would have probably attracted European settlers and rich volcanic soil in the south, the British administrators of Uganda decided early on to focus their development efforts on turning Africans into cash croppers, rather than encouraging Europeans to create plantations. The end result was the creation of a relatively prosperous society, dominated by small-scale cotton production.

Kenya was a very different story. Here the Imperial British East Africa Company found not a single centralized state to treat with, but many decentralized societies. Some of these saw the British as providing an opportunity, others chose to avoid them. In the 1890s the company set up a few fortified trading posts in the interior. Some of these were attacked, but more often resistance took the form of refusing to sell trade goods or even food to the posts. Kenyans were also unwilling to engage in wage labor. When the Uganda Railway was built (1895 to 1903) the British initially tried to employ Kamba (one of the larger ethnic groups of central Kenya) laborers, but these were so reluctant that eventually the British resorted to importing labor from India. Likewise, once the railroad was complete and the fertile highland areas were open to development, the British again chose to rely on outsiders. The result was the creation of a large settler community in the highlands of Kenya. The settlers created a plantation economy by alienating land that belonged to the Kamba and Kikuyu and then using draconian methods to coerce them into working the land that was once theirs. While colonial Uganda was dominated by the Ganda, whose kingdom was allowed to survive partly intact, Kenya came to be dominated by its settlers. They saw to it that the colonial administration required Africans to use cash, but restricted their ability to grow cash crops. To get cash Africans had to work for the planters, and working for the planters meant working under harsh conditions and being subject to labor laws that were written with the white employers' interests in mind.

World War I and East Africa

World War I exacted a huge price from Africa. All over the continent, colonial administrations increased the pressure on African farmers to produce food and strategic materials like rubber and sisal. Some Africans were conscripted and oth-

ers volunteered to fight for European armies in Europe. Those who survived were more often humiliated than thanked. East Africans did not go to the war; it came to them. And the results were devastating.

When the war began in 1914, the civilian administrators of German East Africa hoped to stay neutral. They lacked the resources to defend the colony and concluded that fighting their British, Belgian, and Portuguese neighbors would be fruitless. German military officers felt differently. They concluded that it was their duty to force the Allies to devote as many resources to East Africa as possible, in order to take resources away from the European theater. What effect this might have on East Africans was not their concern.

The man who led the German forces in East Africa was Colonel Paul von Lettow-Vorbeck, and he accomplished his goal. He fought a brilliant guerilla campaign that tied down more than 200,000 Allied troops. But the cost to Africans was tremendous. African soldiers, who constituted about half of the Allied armies and a majority of the German forces, did much of the dying. But the number of combatants killed pales in comparison with the number of noncombatant deaths. By one estimate as many as 100,000 porters employed by the British may have died. In addition, both sides lived off food they took from African farmers. The result was large-scale famine.

The East Africa Campaign

The opening move in East Africa came from the British. They shelled the port of Dar es Salaam in an attempt to prevent it being used by German warships that might prey on ships bound for British India. This emboldened Lettow-Vorbeck, who had been at odds with civilian officials over their attempts to stay out of the war, to seize Taveta, a town in southern Kenya. Then in November 1914, units from the Indian Army (Indian soldiers with British officers) landed at the port of Tanga hoping to gain a foothold and then drive south toward Dar es Salaam. The landing was a disaster. The Indians were forced to withdraw, leaving behind 359 of their number. Had things been left at that, the effect of World War I on East Africa would probably have been minimal. Instead both sides regrouped after this defeat, the Germans to recruit more African soldiers and the British to rethink their strategy.

The next time the British attacked not from the sea but overland from the neighboring colonies. The invading forces included white Britons and South Africans, Indians, and a new force called the King's African rifles. This force was made up of an officer corps of white settlers from Kenya and African enlisted men. Although they were a small force, at first numbering only about 6,000, by the end of the campaign their strength had increased to over 35,000 as Africans increasingly replaced Indian and British troops. This force was under the leadership of Jan Smuts, a South African who had fought against the British during the Boer War and would eventually play a crucial role in the formation of the League of Nations. Allied forces from the Belgian Congo, the vast majority of whom were African, augmented Smuts's British forces. As the second phase of the conflict began, over 70,000 Allied troops set off in pursuit of 15,000 Germans.

But these numbers tell only part of the story. In addition to the soldiers there was a host of carriers. The lack of roads and the difficulty of keeping traction animals alive in areas where tsetse flies were present meant that the majority of the

supplies that the hungry armies demanded had to be headloaded by porters. At the height of the war, the Germans employed some 45,000 carriers. The British recruited 400,000 carriers from Kenya and others in Tanganyika. The Belgians recruited 260,000. A German estimate puts the total number of carriers employed by the Allies at one million.[3] Both Dar es Salaam and Nairobi have districts called Kariakoo ("Carrier Corps," Swahilified), named after the places where the Carrier Corps was quartered.

Lettow-Vorbeck did exactly what a guerrilla fighter is supposed to do. He refused to fight a full-scale battle with the Allies. Instead he led them on a chase that ranged from central Tanganyika to Mozambique and finally into Northern Rhodesia (modern-day Zambia). He forced the Allies to follow him through appalling terrain and he let disease, hunger, and exhaustion do the work that his guns could not. The East Africa Campaign came to a halt only because the war in Europe did. Lettow-Vorbeck surrendered only after he learned of Germany's defeat, and even then he had trouble convincing his men to lay down their arms and become prisoners of war. When it was all over the Germans had lost 2,500 dead, the Allies close to 12,000. But that was just soldiers.

At least 45,000 members of the British Carrier Corps died. These were only rarely combat deaths. Far more common for both carriers and soldiers alike was death from disease. The carriers' official rations were poorer than those given to the soldiers and as a practical matter neither soldiers nor carriers usually got the rations to which they were officially entitled. Also as a practical matter, when food is in short supply, people with guns eat better than people without. Even as they did grueling work, the carriers had to make do with poor food and little of it. Many also moved into climates that were unfamiliar to them, exposing them to unfamiliar diseases. Most were conscripts and so were often kept under armed guard to help ensure their loyalty. Still, they deserted whenever they could. For them, Lettow-Vorbeck's decision to draw Allied troops away from the European theater was a terrible one.[4]

Famine

The misery created by the war was not limited to soldiers and carriers. The peoples who lived in the areas through which the armies traveled — and the armies covered a lot of ground — suffered greatly too. The political vacuum created by the war also triggered jockeying for power between rival African states and chiefdoms as the previous German yoke was often only slowly replaced by a British one.

The misery created by the war is best documented in Ugogo in central Tanganyika.[5] Ugogo has always been prone to food security problems. The region is dry to begin with and the occasional failure of the rains causes food shortages. But the failure of the rains by itself is rarely sufficient to cause a famine. It takes drought compounded by other sorts of upheavals to trigger a real famine. Famine struck Ugogo in the 1890s, as drought in combination with the upheavals associ-

3. John Iliffe, *A Modern History of Tanganyika* (Cambridge, Cambridge University Press, 1979), 249.

4. All the statistics about the war are taken from Iliffe, *Tanganyika*, 240–252.

5. Gregory Maddox, "Famine in Central Tanzania, 1917–20," *Journal of African History* 31 (1990): 181–197.

ated with the German conquest combined to limit both the customary agricultural food supply and people's ability to fall back on alternative sources of food.

The famine of 1918–1919 in Ugogo is known to the Wagogo as the *mtunya* (the scramble). It was triggered first by the Germans' efforts to collect food and labor, then by British efforts to do the same, and then by a failure of the rains. The Germans requisitioned grain by force. As the Allies took more and more territory, the Germans began to take cattle as well. Before they were driven from the region they had confiscated 26,000 cattle. Cattle represented stored capital and provided a buffer against famine since they could be eaten or traded for grain during a food shortage. The Germans also conscripted some 35,000 carriers and laborers from the region. Often they went through the motion of paying for the grain and cattle they took, but they did so with worthless military scrip. As the Germans became more predatory in their search for food, the Wagogo withdrew into the hills to hide themselves and their food stocks in caves. The Germans hunted them in the mountains and took what they could when they discovered the refugees' hiding places.

When the British arrived, the main change was "the language in which the demands were made."[6] The British continued to requisition food and labor although they did make a point of paying for it. As the war dragged on into 1918 the timing of the rains caused increasing pressure on food supplies. The 1918 rains were late and the timing of the 1919 rains was bad too. Famine resulted.

The price of cattle dropped precipitously as people desperate to buy grain flooded the market with cattle. People ate grain husks, searched the forests for food, and eventually resorted to banditry to try to survive. According to Maddox, the *mtunya* is remembered as a time when normal social rules and expectations were suspended. Normally honest people stole food to survive. Parents pawned children rather than watch them starve and in extreme cases abandoned them. When the situation finally returned to a semblance of normality in the early 1920s, 30,000 Wagogo had died. Maddox makes it clear that this was a man-made famine.[7] World War I, something East Africans had little stake in, cost them dearly. In Kenya there was recruiting for both the King's African rifles and the Carrier Corps. In Tanganyika there was recruiting by both the Germans and the Allies as well as requisitioning of food with all the misery that entailed. Even in Uganda there was pressure to increase cotton production to support the war effort.

As part of the peace treaty, Germany was stripped of all of its colonies. Rwanda and Burundi went to the Belgians. Tanganyika went to the British as a League of Nations trust territory. It was renamed the Tanganyika Territory and administered by the British until independence. Now all four major East African colonies were under British rule.

Urban East Africa, 1920–1939

By 1920, primary resistance (which is to say military resistance as opposed to other types of resistance) to colonialism was over. In many ways the period be-

6. Ibid., 184.
7. Ibid., 197.

tween the end of World War I and the beginning of World War II was the high tide of colonialism in East Africa. With African societies no longer able to contest the political dominance of the British, the British were free to begin the economic transformation of the colonies. New colonial cities grew as the loci of colonial political and economic power. Nairobi, Mombasa, Entebbe, and Dar es Salaam came into their own during this period as colonial cities. They sat astride the infrastructure system that was developed before the war. As farmers in the countryside made the transition from subsistence farming to cash cropping, the city dwellers profited as the cash crops moved on trains and trucks to the port cities. And as the cities increasingly offered wage work to clerks, railwaymen, stevedores, prostitutes, domestic servants, and soldiers, people flocked to the cities. Nairobi grew from a dusty provincial town into a great city. Established cities like Mombasa and Dar es Salaam increasingly lost their Swahili flavor and came to reflect the ethnic diversity of the region. This era is best viewed from the perspective of the cities and especially from the perspective of the associations East Africans joined in the cities.

Beni

In the years immediately following World War I the most popular social organizations in East African cities were dance societies. These societies grew out of a tradition of competitive dance in Swahili towns. Neighborhoods would hold competitions in which they tried to outdance each other, to wear better and more expensive costumes, and to serve more and better food than the opposition. After the war, as new people came into the cities, leaving behind the social support of kinship networks, they turned to dance societies as a source of social support, prestige, and entertainment.

The dominant form of competitive dance was called Beni ("band" Swahilified). Beni societies had names like Marini, Arinoti, Scotchi, and Kingi. The Marini ("marines") attracted former soldiers, especially those who had served the Germans and saw the war's end as a source of humiliation. The Arinoti, the derivation of which is not known, attracted mostly former members of the Carrier Corps and lacked the status of the Marini. The Scotchi ("Scotch") and the Kingi ("Kings") drew upon people of different backgrounds in different towns.

You have noticed by now that these are not names that have a "traditional" ring to them. Beni societies were up to date in every respect. Their members wore elaborate military uniforms, and marched to the music of military bands (hence the name Beni), and their leaders used titles like "Admiral," "King," and "General." The societies constructed elaborate floats, often models of warships, which they dragged through the streets during their processions. The Scotchi, of course, sported kilts and their bands included pipers.

A typical Beni procession would include a king and queen marching with their court at the head of the procession. They were followed by floats which were followed by uniformed marchers and a band, and at the rear came the women of the organization. The purpose of all this was to taunt the other Beni societies. Every innovation or new expense was matched by the other societies. When expensive pressurized gas lanterns were purchased to enable the Kingi of Lamu to hold their procession at night, their rivals the Kambaa quickly followed suit.

What was the point of all this? Was it slavish imitation of Europeans? T.O. Ranger, the author of a major work on Beni, says that Beni was an accommodation to power, in this instance to European power. But there was more to it than that. Beni met a particular set of social needs as the colonial societies took shape in East Africa. For defeated soldiers it let them recapture some of the glory of their service with the Germans. For Africans who had held administrative posts under the Germans and were stripped of their positions by the British, Beni offered status and an outlet for organizational talent. Ranger cites the case of Saleh bin Mkwawa, son of the Hehe chief Mkwawa, who had served the Germans as an akida in the Dodoma region. After the war he was put in a detention camp and after his release could do no better than a job as a "hut counter," a big step down for the son of a prominent chief and a former akida. He sought solace in the Marini. He became a leading light in the organization, apparently exercising the right to appoint officers in the organization throughout East Africa, on one occasion as far away as southern Somalia.[8]

For most Africans, Beni served other purposes. Although originally a Swahili cultural institution, Beni was appropriated by people from the interior. As large numbers of job seekers moved into Swahili cities like Mombasa, they found that they could turn Beni to their own advantage. It provided prestige, a sense of belonging, and a social welfare network. If one's kin were 500 miles away, one's Beni society might stand in for them. Beni gave new arrivals status and a sense of belonging in the city.

In the 1930s, as the depression bit hard in the colonies, Beni came under increasing criticism. Islamic scholars in Lamu and Mombasa began to criticize Beni as a waste of time and money that might better be spent on education and modernization. Some also disapproved of the use of Western-style dress in Beni. And then European residents of Nairobi and Mombassa began to complain of the noise. The Kenya government began to place restrictions on the size of Beni processions and the times at which they could march. In Tanganyika, ambitious men began to direct their energies in new directions. By the late 1930s Beni was in decline, partly because there were so many other types of organizations competing for members, but also because Beni was an accommodation to European power and East Africans were becoming less accommodating.

The Rise of Political Associations

A new African elite emerged in the 1930s, composed mostly of civil servants. The British hired many mission-educated Africans as clerks and minor officials. Many of these initially dabbled in Beni and other dance associations, but eventually founded new organizations that better met their needs. Beni came to be associated with an older and more culturally conservative tradition. The new administrative class found itself busy with other, more "modern," concerns. Ranger cites the case of Elias Kisenge, a clerk in the provincial commissioner's office in Arusha, Tanganyika. Kisenge was "the Secretary of the Tanganyika Territory Civil Service Association, Secretary of the Football Association, part-time librar-

8. T.O. Ranger, *Dance and Society in Eastern Africa* (Berkeley: University of California Press, 1975).

ian of the Gymkhana Club, English teacher to the servants of the Arusha Europeans...and Secretary of the Christian Youth Organization."[9]

Some of the new organizations were political pressure groups. The Tanganyika Civil Service Association (TCSA) represented the interests of African civil servants to the colonial government. While it did not play an overtly political role, as the voice of an emerging elite and the group that would lead the struggle for independence after World War II, the TCSA was a precursor of the more overtly political organizations that would follow. Other organizations would have a broader base and a more explicitly political role. During the 1920s all four East African colonies had set up Legislative Councils (Legcos). These allowed for some degree of self-government. Usually representatives were appointed by the colonial government and the seats on the councils were allotted by race. In Kenya, for instance, the council had eleven seats for Europeans and five for Asians. In Zanzibar, Europeans, Indians, and Arabs all had representatives on the council. Noticeably absent were Africans. In theory government officials who were ex-offico members of the Legco represented their interests. In practice Africans found their interests mostly ignored by the Legcos. Their answer was to create pressure groups to lobby on their behalf. In Tanganyika it was the African Association that represented African interests. Likewise, in Zanzibar, in addition to Arab and Indian Associations, an African Association was formed in the 1920s. In Kenya it was the Kikuyu ethnic group that first organized to represent its interests through formal channels. The Kikuyu, who formed the majority of the population in the areas farmed by settlers, provided most of the labor to settlers, and lived close to the capital city of Nairobi, in 1925 formed the Kikuyu Central Association (KCA), itself a product of an earlier organization. This ethnically oriented society represented only Kikuyu interests, but other more radical groups also emerged during the post-World War I period. One of these, the East African Association was far ahead of its time, both in its ability to attract support across ethnic lines and in the nature of its demands. The East African Association intentionally looked beyond the world of the Kikuyu to other African groups. It also attracted support from the Indian community, by then a prominent force in the colonial economy. Its leader, Harry Thuku, bypassed local colonial officials and contacted the Colonial Office in London, making the radical demand that educated Africans be given the vote. Harry Thuku proved more radical than his contemporaries and, more significantly, than the colonial state could bear and he was exiled to Kismayu in Somalia. Eventually the KCA took on some of Thuku's more radical positions. One of the prominent members of the KCA was Jomo Kenyatta, who joined in 1927. Kenyatta founded a new organization after World War I, the Kenya African National Union (KANU), which eventually led Kenya to independence and remains the nation's ruling party.

The leaders of these movements (Harry Thuku is a good example) were mostly mission educated. Their ability to meet colonial officials on more or less equal terms allowed them to mount increasingly effective resistance to colonial rule. In the end it was mission-educated men like Julius Nyerere in Tanganyika and Jomo Kenyatta in Kenya who led their nations to independence. In Zanzibar, the virtual absence of missions and the divisiveness of local ethnic politics diluted

9. Ranger, *Dance*, 93, quoting a paper by E.B. Emos.

the voice of anti-colonial protest. When the pot finally boiled over in Zanzibar in 1964, it did so extremely violently.

Review Questions

1. How did the presence of an Arab state in Zanzibar affect the development of colonialism in East Africa?
2. Why was Zanzibar so rapidly marginalized once it was stripped of its mainland possessions?
3. Why was the German conquest of Tanganyika so much more violent than the British conquest of Uganda and Kenya?
4. How did World War I transform East African resistance to colonialism?

Additional Reading

Glassman, Jonathon. *Feast and Riot*. London: James Currey, 1995.

Iliffe, John. *A Modern History of Tanganyika*. Cambridge: Cambridge University Press, 1979.

Tignor, Robert L. *The Colonial Transformation of Kenya*. Princeton, NJ: Princeton University Press, 1976.

Ranger, T.O. *Dance and Society in Eastern Africa*. Berkeley, University of California Press, 1975.

Chapter 19

West Africa

Julius O. Adekunle

This chapter considers the regional history of West Africa from 1885, when the Berlin Conference ended and the partition began. It traces the major historical developments from 1885 to 1960 when most West African states became independent. The Berlin Conference initiated an enormous change in West Africa's political structure and reduced its people to the status of subjects of the European powers. To acquire territories, the Europeans either signed treaties with African rulers or resorted to brutal wars of conquest. By 1900, the Europeans had penetrated the interior and had subjugated and controlled the whole of West Africa with the exception of Liberia. After World War II, Africans put pressure on the Europeans until they achieved independence.[1]

* * *

The Growth of Sierra Leone and Liberia

Sierra Leone and Liberia were products of the abolition of the slave trade. While the British founded Sierra Leone in 1787, the United States established Liberia in 1820. By the end of the nineteenth century, both Sierra Leone and Liberia had emerged as nation-states. Liberia was an independent, sovereign state, but Sierra Leone became a British protectorate in 1896. As Sierra Leone grew in population, it evolved a distinct culture. The Creoles (freed African slaves in Freetown) played a major role in spreading Western culture, Western education, and Christianity in West Africa. In addition to preaching and teaching, the missionaries in Sierra Leone supported the Anti-Slavery Squadron in order to redirect the minds of Africans from slavery to freedom. It was hoped that the rest of West Africa's peoples would be similarly directed toward Christianity and Western education. Eventually, the Europeans pursued the spread of Christianity, commerce, and colonization in West Africa.

1. This work was supported, in part, by a Grant-in-Aid-of-Creativity Award from Monmouth University, West Long Branch, New Jersey.

The Partition of West Africa

Great Britain and France played the central role in the partition. In the name of legitimate commerce, both the British and the French gradually extended their spheres of influence into the interior and systematically became involved in the political affairs of the indigenous peoples. By the 1880s, the French were attempting to penetrate into the Gambia and Sierra Leone, where the British had already established themselves. The advances made by the French in these areas alarmed the British. Emphasizing the importance of commercial relations with West Africans, Lord Salisbury, the British prime minister, declared that Great Britain "has adopted the policy of advance by commercial enterprise. She has not attempted to compete with the military operations of her neighbor [the French]."[2] The European powers signed treaties of protection with some West African rulers, coerced others into submission, and fought those who resisted them. Overall, conquest and partition was not easy in spite of the advantage Maxim guns gave to the Europeans. When the partition was over, the British colonies in West Africa included Sierra Leone, the Gambia, the Gold Coast (now Ghana), and Nigeria. The French controlled what was known as French West Africa, which included Mali, Niger, Chad, the Ivory Coast, and Dahomey (now the Republic of Benin).

The British in the Gold Coast

The Asante (Ashanti) had a long history of resistance against the Europeans, from 1823 to 1896. On several occasions, the British were defeated. However, through a combination of diplomacy and superior military power, they eventually overran the Asante. In 1868, the Fante in the southern Gold Coast formed a confederation to oppose economic domination by the European merchants, especially the Danes, Dutch, and British. The confederation fought a series of wars of survival against the Danes and Dutch, who eventually sold their possessions to the British in 1872. Now solely in control but not willing to pay land rent as the Danes and Dutch had, the British marched on the Fante states and made the Asante sign the Treaty of Fomena in 1874 in which the Asante renounced control over the southern states. Thereafter, the British declared the southern Gold Coast a Crown Colony and advanced into the interior, penetrating especially into the heartland of Asante territory. The British came to recognize the economic and military power of the Asante. The British realized that Asante power had to be broken in order for the British to gain control of the Asante lands.

The British knew that they were competing with the French and Germans who had been advancing into the interior. If these advancements were not checked, the British would lose control of the rich interior region. That situation prompted them to enforce the Lands Bill in 1894, which permitted European

2. Quoted in Robinson and Gallagher, *Africa and the Victorians: The Climax of Imperialism* (Garden City, NY: Anchor Books, 1968), 382–383.

companies to acquire forest and mineral concessions at very low prices. The British unsuccessfully tried to make Asantehene Agyeman Prempeh I accept a British protectorate. Diplomatically but firmly rejecting the British offer of protection, the asantehene wrote to the queen of England:

> The suggestion that Asante in its present state should come and enjoy the protection of Her Majesty the Queen and Empress of India I may say is a matter of very serious consideration, and which I am happy to say we have arrived at this conclusion, that my kingdom of Asante will never commit itself to any such policy. Asante must remain independent as of old, at the same time to remain friendly with all white men. I do not write this in a boastful spirit, but in the clear sense of its meaning.... the cause of Asante is progressing and there is no reason for any Asante man to feel alarm at the prospects or to believe for a single instant that our cause has been driven back by the events of the past hostilities.[3]

Prempeh's position worried the British. At his official installation in 1894, he indicated his willingness to cooperate with the British in order to insure a continuation of peace and prosperity. He emphasized bilateral trade with the British, but not protection.[4] Without much difficulty, the British gave their protection to those rulers who did not share the same view as Prempeh. When all efforts to persuade Prempeh failed, the British sent him an ultimatum in 1895 stating that the Treaty of Fomena (1874) should be respected and that Asante should accept British protection. The Asante tried to negotiate without fighting but the British, who were determined to subdue them, sent an expedition in 1896, which took control of Kumasi, the Asante capital. Prempeh and his supporters were deported to the Seychelles. The unseating of Prempeh by the British weakened the Asante Union and, now leaderless, each of its constituent states signed treaties accepting British protection. The Asante continued to resist British control in other ways. For instance, the Aborigines' Rights Protection Society was formed to protest against the Land Bills of 1894 and 1897.

In the Anglo-French agreement of August 10, 1898, the northern boundary of the Gold Coast was fixed. Sir Frederick Hodgson, the governor of the Gold Coast, antagonized the Asante by demanding the surrender of the sacred Golden Stool, the symbol of Asante unity. Determined to maintain their national integrity, the Asante people declared war on the British. They tried to attack the British fort in Kumasi but "the machine-guns on the bastions proved too effective for them."[5] In spite of this, the Asante continued to resist the British until they were finally defeated and Asante was annexed in 1902. That same year, the Gold Coast officially became a British colony.[6]

3. Quoted in J. K. Flynn, "Ghana-Asante (Ashanti)," in Michael Crowder (ed.), *West African Resistance: The Military Response to Colonial Occupation* (New York: Africana Publishing Corporation, 1971), 43–44.

4. See the letter he wrote to the governor of the Gold Coast in 1894, in A. Adu Boahen, *African Perspectives on Colonialism* (Baltimore: John Hopkins University Press, 1987), 24.

5. Flynn, "Ghana-Asante (Ashanti)," 47.

6. Daniel Miles McFarland, *Historical Dictionary of Ghana* (Metuchen, NJ: Scarecrow Press, 1985), xlii.

The British Conquest of Nigeria

Following the trading activities of the National African Company (NAC), founded by Sir George Taubman Goldie, the British declared a protectorate over the Oil Rivers in 1885. That was a huge stride toward British control of Nigeria. Company rule began in 1886 after the NAC received a British royal charter and a new name, Royal Niger Company (RNC). The Berlin Act of 1885, resulting from the Berlin Conference, stipulated that when a power acquired a new territory or assumed a protectorate over any part of Africa, it should notify other signatory powers. The act also forbade any European company either to monopolize trade or to mistreat the indigenous people. The RNC was, however, empowered by the British government to politically administer the Niger territories from its head-quarters at Asaba. As a result, the company assisted in the spread of British influence in Nigeria.

Company rule in the Oil Rivers was not easy for two reasons. First, the company interfered in the local politics and culture of the indigenous people, often picking its own favorite candidates as rulers. Second, there was competition in trade from Nigerian, German, and French merchants. For instance, a prominent ruler and merchant, Jaja of Opobo, was accused of monopolizing trade as well as exacting high customs duties. In 1887, an acting consul of the Niger Delta, H.H. Johnston, invited Jaja for talks on relaxing his monopoly of trade but Jaja refused, suspecting the intentions of the British. However, the British eventually lured Jaja on board the gunboat HMS *Goshawk* where he was confronted with an ultimatum. He would either allow free trade or face the bombardment of Opobo, or face deportation. Jaja chose the last option and was taken to Accra for trial. The result of the trial was foreordained; Jaja was found guilty. To prevent the continuance of his competition and to deter others, the British deported him to the West Indies. He died in 1891 on his return to Nigeria.[7] Another challenge to the British came from Nana of Itsekiri, who was accused of monopolizing trade and defying the authority of Ralph Moor, the British acting consul general. When invited to answer charges against him, Nana refused to cooperate, remembering what had happened to Jaja. However, after a long struggle, Nana gave himself up; the British found him guilty and deported him to the Gold Coast in 1894. In Brass (Nembe), disturbances erupted in protest against company rule, its monopoly of trade, and the imposition of obnoxious taxes. The Brassmen resorted to the use of violence in 1895, raiding Akassa, the port of the Royal Niger Company. The company felt threatened because trade had been interrupted. The British sent a punitive force that subdued the Brassmen and destroyed Nembe.[8]

The British occupation of southern Nigeria was not complete until the conquest of Benin in 1897. The Benin Kingdom, known in West African history for bronze casting, practiced slavery and human sacrifice. It also refused to trade with the Europeans, presumably to preclude alien control. Relations with the British improved in 1892, when Vice-Consul Gallwey visited Benin to sign a treaty with Oba Ovonramwen (or Ovenramwen). The agreement was expected to open up

7. Obaro Ikime, "Nigeria-Ebrohimi," in Crowder, *West African Resistance*, 216ff.
8. Michael Crowder, *The Story of Nigeria* (London: Faber and Faber, 1966), 188–209.

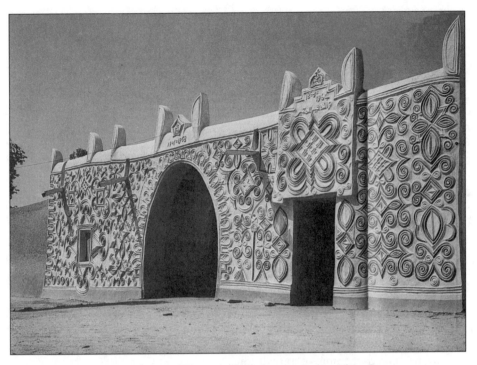

Figure 19-1. Palace wall and gate, Zaria, Nigeria

Benin for trade and place it under British protection. The improved Benin-British relations were short-lived, not because of conflicts over trade but because of tradition. In early 1897, J.R. Philips, the acting consul general, planned to visit Benin to reinforce British control. Unfortunately, he did not bother to wait for a reply to his demand for a meeting, before setting out. His visit coincided with the celebration of the Ague festival, during which time tradition did not permit the oba of Benin to receive foreigners. As a result, Philips and his entourage were entreated to postpone their visit.

Philips felt humiliated that he could not meet with the oba. Disregarding the people's tradition, he attempted to force his way into the kingdom. In the ensuing dispute between power and tradition, Philips and five members of his entourage were killed in order to prevent Benin's custom from being broken. Six weeks later, the British sent an expedition of 1,500 soldiers to Benin and the consequences were great: they destroyed Benin, brought its empire to an end, captured and deported Oba Ovonramwen to Calabar, and looted his palace. In addition, the British carried away about 2,500 valuable Benin bronzes to Europe.[9]

The British attacked Lagos, which was formerly under Benin control, in 1851 and established it as their center of administration. In 1861, the British annexed Lagos as a British crown colony and from there they were able to trade with the Yoruba people in the interior. However, the British trade with the interior was disrupted because of the civil war that engulfed Yorubaland and by 1885, the British realized that they had to intervene in the war in order to allow free flow of trade

9. Ibid., 202–203.

and for the colony of Lagos to survive. After Lagos was established as a self-administering colony in 1886, Moloney, the governor of Lagos, sent delegations to the various warring parties and a cease-fire was arranged.

The British encountered difficulties in penetrating Yorubaland. They fought with the Ijebu, Egba, and Oyo. The attention of the Yoruba kingdoms had been divided because of the widespread civil war in Yorubaland. Owing to their location, the Ijebu and Egba people had direct commercial contact with the Europeans and prevented others from engaging in trade at the coast. Ibadan, a powerful military town, rose to oppose the monopoly of trade, but taking advantage of that situation, the British appeared as mediators, with a hidden agenda, to take over Yorubaland. Where diplomacy did not succeed, they resorted to warfare. In the end, they subdued Ijebuland in 1892 and the following year British Governor Carter visited Abeokuta, the Egba capital. He also went to Oyo where the alaafin (the king) was forced to sign a treaty accepting British protection.

Sir William MacGregor was appointed as administrator of Lagos in 1885 and became Lt. Gov. of Lagos in 1895. His concept of colonial rule was articulated in a paper that he read on June 7, 1904, at the annual meeting of the African Society of London, in which he stated that

> The system of government carried out in Lagos takes native character, native customs, and native susceptibilities into account, and the native authorities are allowed, and required, to take such a large share in their own government that punitive expeditions, or plots against the Government, are unknown.... Under such a system a great chief is a very valuable possession; his authority is an instrument of the greatest public utility, which it is most desirable to retain in full force.[10]

MacGregor's jurisdiction was restricted to Lagos, but he believed that if Nigeria had to develop, it had to be done "by its own people, through its own people, and for its own people."[11] He was a popular governor because he used persuasion and personal influence to extend and consolidate British administrative control rather than using Maxim guns. This contrasted with the attitude of British administrators elsewhere in Nigeria, and in Sierra Leone and the Gold Coast, where governors adopted coercive means or punitive expeditions.[12]

In northern Nigeria, the Royal Niger Company signed treaties with traditional rulers in the Sokoto Caliphate such as the emir of Gwandu, but its policy of peaceful negotiation with the sultan of Sokoto failed. Hence, Frederick Lugard was brought in as an "expression of British willingness to overthrow the [Sokoto] caliphate by conquest."[13] The overthrow of the caliphate was necessary for the success of the British in northern Nigeria. Although not willing to meet heavy financial expenses, the British had weapons and were determined. The lack of unity between the caliphate and its constituent emirates also weakened resistance against the British. When the company encountered Nupe and Ilorin (the southernmost emirates of the caliphate)

10. Quoted in T.N. Tamuno, "Sir William MacGregor's Administration in Lagos, 1899–1904," in *Historia* 4 (1966–1967): 43–48.

11. Quoted in Tamuno, "Sir William MacGregor's Administration," 44.

12. Tamuno, "Sir William MacGregor's Administration," 44.

13. R.A. Adeleye, *Power and Diplomacy in Northern Nigeria, 1804–1906* (London: Longman, 1977), 213.

in 1897, it could not effectively control them because "it lacked the resources to impose a vigorous system of administration over the conquered provinces."[14] But by 1899, the caliphate had become a British protectorate, with the West African Frontier Force (WAFF), a small colonial army, stationed in several places. Presumably because of the administrative deficiencies of the Royal Niger Company, the British government revoked the company's charter on January 1, 1900. From 1903, when the Sokoto Caliphate was completely conquered, the British directly controlled the Protectorate of Northern Nigeria under Frederick Lugard.[15]

"The Race for Nikki"

The British were aware of the steady French advance into the interior of West Africa. Lugard strongly opposed the French advance, realizing that it would jeopardize British economic interests. In response to the French action, Lugard wrote: "it is due to the unceasing energy of French extension in West Africa—an extension which in England we have invariably stigmatized as 'aggression'—that... England has awakened to the necessity of some action."[16] In the 1890s, the French planned to annex Dahomey and Borgu in order to extend their authority to the Niger. For the French to carry out their plan and for the British to thwart it, both needed to sign treaties with the ruler of Nikki. Thus, Borgu became central ("a must possess") to both powers. As Lugard himself put it, "the possession... of Borgu became a matter of some importance to France, but of vital importance to the Royal Niger Company if they desired to maintain the sole control of the lower waterway by Great Britain."[17] The centrality of Borgu led to what was known as the "race for Nikki" in 1894. British Captain Lugard outpaced French Captain Decoeur in signing a treaty of protection with the king of Nikki, whom the Europeans erroneously referred to as the king of all Borgu.[18] That episode showed the desperate desire of both the British and French to acquire Borgu, in spite of its limited economic resources. Suspicious of each other, both powers established military camps in Borgu. The division of Borgu was decided in an Anglo-French agreement of 1898 when the French took control of Nikki while the British acquired Bussa.

French West Africa

In the 1880s, the French began to advance into the interior of West Africa from their base in Senegal. They occupied Porto Novo in 1882, reorganized their forts in

14. Robin Hallett, *Africa since 1875* (London: Heinemann, first published 1974, reprinted 1980), 291.

15. Ibid., 291.

16. F.D. Lugard, "England and France on the Niger: 'The Race for Nikki,'" *The Nineteenth Century* 37, 220 (June 1895): 889–903.

17. Ibid., 893.

18. Captain Lugard signed a treaty with the king of Nikki on November 10, 1894, while Captain Decoeur signed a different treaty on November 26, 1894. John E. Flint, *Sir George Goldie and the Making of Nigeria* (London: Oxford University Press, 1960), 225.

the Ivory Coast in 1886, and took over Conakry in 1887. In spite of strong resistance by Samori Toure, the French occupied Bissandugu, the capital of the Tukulor Empire, in 1891. Samori Toure himself was captured and exiled in 1898. When the French invaded Dahomey, King Gelele resisted, but after being defeated in 1893, King Behanzin accepted French protection. Dahomey eventually became a French colony in 1900. The French conquered Masina in 1893. The following year, they occupied Timbuktu on the Niger bend. Two years later, they took control of Say.[19] These victories made the French a dominant power in the large area of West Africa stretching from Senegal to Timbuktu. By 1896, this area had been conquered and placed under the administrative control of a governor-general with his headquarters in Dakar. Like the Royal Niger Company in Nigeria, French companies such as the Société Commerciale de l'Ouest Africaine (S.C.O.A) and the Compagnie Française de Afrique Occidentale dominated the economy of French West Africa.

European Interest in West Africa

West Africa was attractive to the Europeans because of its rich economic resources. The peoples of West Africa became suppliers of cocoa, palm produce, cotton, groundnuts, rubber, and mineral resources such as gold, tin, and lead. The importance of the Senegal, Gambia, and Niger Rivers cannot be overlooked in the overall economic scheme of the Europeans especially in regards to the British. British and French imperial interests in West Africa had deep roots in economic and political exploitation. The seizure of Lagos, the defeat of the Fante Confederation, the destruction of the Tukulor Empire, the "race for Nikki," the subjugation of Yorubaland, and the conquest of the Sokoto Caliphate testified to the imperial ambitions of the Europeans in West Africa. By 1900, the British and French had redrawn the map of West Africa by creating artificial and arbitrary boundaries and establishing effective colonial rule.

Early Stages of Colonialism

A fundamental objective of the European colonial administration was to achieve the financial self-sufficiency of the colonies. Neither the British nor the French wanted to spend money on the colonies, despite the huge economic advantages they derived from them. The Europeans also intended to maintain peace within their colonies. They grappled with the task of finalizing their boundaries, and setting in motion effective colonial administration. In the early stages of colonialism, the British and French focused on realizing these objectives.

Each of the colonial powers in West Africa adopted an administrative style that conformed to the political and economic objectives of their home governments. Aside from believing in the superiority of their culture, the French envi-

19. B. Olatunji Oloruntimehin, "The Western Sudan and the Coming of the French, 1800–1893," in J.F. Ade Ajayi and Michael Crowder (ed.), *History of West Africa*, Vol. 2, (New York: Columbia University Press, 1973), 379.

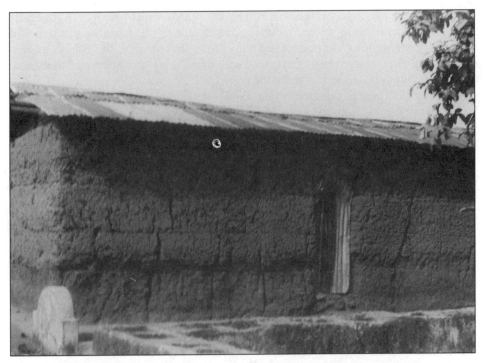

Figure 19-2. A mud house with corrugated iron sheet — the use of corrugated iron defined modernity in many rural areas

sioned the colonies becoming part of the "Grand Empire." As a result, the French adopted the *assimilation* policy, a form of direct rule that would systematically turn Africans into French citizens. Rather than preserving African culture, the purpose of *assimilation* was to transform African subjects into people who accepted French culture. The French believed that their self-imposed and racially biased "civilizing mission" would be effective and successful only if Africans were absorbed completely into French culture. That approach failed and the French changed to a policy of *association*. Under the *association* system, the French collaborated with the African elite and did not tamper with local customs and practices. Africans resented both the *assimilation* and *association* systems because they disrespected native traditions and institutions.

Unlike the French, the British adopted the indirect rule system, realizing the impracticability of changing Africans into British citizens, although they claimed that they carried the "white man's burden" to civilize Africans. Nevertheless, irrespective of the administrative approach the Europeans adopted, Africans remained Africans and resistant to colonialism.

Indirect Rule in British West Africa

British colonial policies in West Africa were initially guided by the Durham principle, which involved the stages of development that Canada went through

before gaining self-government. The British adopted a similar method in Australia and, in a modified form, in South Africa. The objective was to allow a measure of political participation by residents of the colony, based upon the British experience of the American War of Independence, when Americans claimed that there would be "no taxation without representation."

Frederick Lugard, the governor-general of Nigeria, formulated the concept of indirect rule as enunciated in his *Dual Mandate in British Tropical Africa* (1922). The concept behind indirect rule was to preserve African institutions and use African rulers as instruments to enforce British colonial policies. Traditional rulers were to maintain law and order and to collect taxes while native customs would remain undisturbed. The British introduced indirect rule first in northern Nigeria, where an aristocratic ruling class had been created in the wake of the Sokoto jihad, which had engulfed the whole of Hausaland during the first half of the nineteenth century. The Sokoto Caliphate had been organized in such a way that the caliph held and wielded strong political and religious powers. This structure suited Lugard's scheme, and to ensure success, he did not interfere with the caliphate peoples' religion and customs. While retaining considerable power, the British used traditional rulers in some aspects of their administration, with the objective of implanting the British system gradually but systematically. From a practical point of view, the system encountered few problems, especially in societies where the traditional form of government was based on kingship.

The political situation in Benin made it relatively easy for Lugard to implement the policies of indirect rule without strong resistance. Oba Ovonramwen had been in exile in Calabar since 1897, providing Lugard with the opportunity of introducing Native Administration under the new ruler, Ovonramwen's son.

Among the Yoruba, the indirect rule system encountered some difficulties. First, Lugard arbitrarily raised the status of some rulers. The concept of *ebi* (kinship affiliation) graded Yoruba rulers according to seniority, especially those who traced their descent directly from Oduduwa.[20] Problems arose when Lugard ignored this existing arrangement and elevated the status of some rulers. Having lost their political power and influence to the British, the rulers became even more dissatisfied because of the irregularities in the colonial administration. The favor enjoyed by the alaafin of Oyo provoked the jealousy of other rulers. Second, when the British placed Ibadan under the alaafin, riots broke out in opposition to the arrangement. Third, the imposition of taxation, and the use of forced labor caused disturbances among the Egba, Ijebu, and Oyo. All these problems made indirect rule less successful in Yorubaland than in the north.

Lugard committed a blunder in eastern Nigeria when, for the purposes of colonial administration, he imposed kingship on a segmentary society. He appointed "warrant chiefs" and imposed them on the Igbo and Ibibio. Not surprisingly, many of them were killed because their people considered them to be traitors and collaborators with the oppressive colonial rulers. Ironically, Lugard did not intend indirect rule to be a "rigid system devised by the Europeans to be forced in uniform

20. Aside from the alaafin of Oyo, other top-ranking rulers in Yorubaland include the oni of Ife, alake of Abeokuta, bale of Ibadan, owa of Ilesa, akarigbo of Sagamu, awujale of Ijebu-Ode, and orangun of Ila-Orangun.

structure over the immense varieties of African society."[21] But though he had adopted it in northern and southwestern Nigeria, Lugard could not find ways of making the system flexible enough to accommodate societies without traditional institutions of kingship. The imposition of the system on the Igbo and Ibibio, therefore, contradicted the very nature and purpose of indirect rule.

Similarly, the British introduced indirect rule into the Protectorates of Sierra Leone and the Gold Coast. In 1896, the British proclaimed a protectorate over Sierra Leone in spite of resistance by the Temne people. Many of the leaders in British colonies benefited from the Western education provided at Fourah Bay College, founded in 1827 and attended by the Creoles and other West African students at that time. It was the only institution of higher learning in West Africa. The Creoles emerged as leaders of nationalist movements, organizing public demonstrations and strikes to undermine colonial administration. As a result, they became a threat to colonial aspirations and administration. The British distrusted and discriminated against the Creoles, who because of their educational advantages also became unpopular among the Temne.

From the British standpoint, the indirect rule system was designed to protect traditional institutions and to train Africans in Western administrative methods. Also, the British expected the Native Administration to serve as the nucleus of an efficient modern system of local government.[22] But to Africans, the argument was unacceptable since no one had invited the British. They had acquired the colonies by military conquest without the consent of the people.

In addition, the policy of "divide and rule" had divided rather than united ethnic groups in West Africa. Deliberately dividing the people was not a sound way of laying a foundation for ethnic integration. The impact of this approach became evident in the postcolonial period when most West African countries experienced frequent ethnic conflicts. For instance, in Nigeria, the Hausa and Fulani in the north, the Yoruba in the west, and the Igbo in the east had not been fully integrated, as indicated by the many ethnic and religious conflicts since independence. Some of the blame can be placed on Lord Lugard, who amalgamated the Northern and Southern Protectorates in 1914 without any concrete arrangement for unified national development.

The French System of *Assimilation*

The French planned to create a "greater France" in Africa by adopting the policy of *assimilation*. They divided French West Africa into *cercles*, each with approximately the same size and population, and divided the people into *citoyens* (citizens) and *sujets* (subjects). Citizens enjoyed all the rights and privileges of the French, but subjects served longer in the army and they were compelled to do forced labor. Through the policy of *assimilation*, the French intended to integrate metropolitan

21. Lord Lugard, *The Dual Mandate in British Tropical Africa* (London: Archon Books, 1965), xlv.

22. W.E.F. Ward, "The Colonial Phase in British West Africa," in J.F. Ade Ajayi and Ian Espie (ed.), *A Thousand Years of West African History* (Ibadan: University of Ibadan Press, first published 1965, reprinted 1970), 393.

France and its overseas dependencies in a centralized administrative and judicial system with its headquarters in France. In addition, the French expected Africans to abandon their social, cultural, linguistic, and political identities and to adopt the French way of life. This approach to governance was accused of being rigid, absurd, and impracticable. Because of denunciations of the policy, the French adopted *association*, which allowed more African participation in the colonial administration.

West Africa in the Interwar Years

During World War I, the colonial powers recruited the peoples of West Africa to fight in battles they knew nothing about. Given the colonial policy of forced labor, recruitment conditions were coercive and arbitrary. The attitude of West African peoples toward colonialism changed dramatically after World War I, because of several factors. First, West African ex-servicemen joined the educated group in criticizing colonialism. They urged their people to fight for freedom based upon their experiences on the battlefield. They had seen that Europeans were as susceptible to bullets as Africans were. The veterans expected that they would be given responsible positions with increased involvement in colonial administration, but this did not happen. Instead, both the British and the French became more aggressive in their search for ways to revamp their economies, which had been battered by the war. The colonial powers became more insensitive to the needs of their subjects, thus bringing about widespread resentment.

Second, a small group of educated West Africans became disillusioned about the exclusive and discriminatory nature of the colonial administration. Many of them were qualified for administrative positions, which the colonial government denied them. They became disillusioned because the British and French gave no serious consideration to African participation in administration. Noticeable nationalist activities began in British West Africa after the signing of the peace treaty that concluded World War I. The nationalists felt betrayed and consequently formed organizations and movements to oppose colonial policies.

In 1918, J.E. Casely Hayford founded the National Congress of British West Africa to serve as a mouthpiece for the people demanding colonial reforms and equal job opportunities for blacks and whites. In its first meeting, held in Accra in 1920 and attended by representatives from four British colonies in West Africa, the Congress passed eighty-three resolutions dealing with various aspects of colonial administration.[23] It also sent a delegation to London to express the disappointment of the peoples of West Africa about the discriminatory nature of British government and to ask for reforms. In all the British colonies, nationalists tried to create political awareness and to garner support from the local people, especially in the urban centers.

23. The representatives included six from Nigeria, forty from the Gold Coast, three from Sierra Leone, and one from Gambia. They were unanimous in their demand for an increase in the number of Africans in the Legislative Council, reforms in education, commerce, and social services. Michael Crowder, *West Africa under Colonial Rule* (Evanston, IL: Northwestern University Press, 1968), 427–428.

As part of their "divide and rule" policy, the British created a cleavage between the traditional rulers and the educated elite. While the traditional rulers wanted to regain their former authority without antagonizing the Europeans, the educated elite believed that they should oppose colonial rule because they had been denied the positions and the status they deserved. Education gave them the confidence to demand colonial reforms and it also alerted them to the importance of self-determination. Not surprisingly, the British supported the traditional rulers, who did not constitute any political threat to the colonial government.

The activities of the nationalists created political awareness among the people and helped to win some concessions from the British government. For instance, the Clifford Constitution of Nigeria in 1922 introduced significant changes. Sierra Leone and the Gold Coast received constitutions in 1924 and 1925 respectively. In 1923, Herbert Macaulay, "the Father of Nigerian Nationalism," formed the Nigerian National Democratic Party (NNDP) and he became the president of the Nigerian Youth Movement in 1934. In 1938, Wallace Johnson of Sierra Leone founded the West African Youth League. The establishment of newspapers such as the *African Morning Post*, the *Lagos Weekly Record*, the *West African Pilot*, the *Gold Coast Leader*, and the *Sierra Leone Weekly News* provided the opportunity for nationalists across West Africa to challenge the British government. Many of the West African nationalists received great inspiration from Edward Wilmot Blyden, a West Indian educated in Liberia, who conceived the idea of a West African empire where Africans would rule their own people. He encouraged Africans to acquire Western education and use it to fight for their freedom.

Religious and economic groups organized pressure groups. For example, in 1914, William Wade Harris, a Liberian evangelist, launched protests against the French administration in the Ivory Coast. His movement spread fast but the French authorities wasted no time in crushing it, after which they deported Harris to Liberia where he eventually died.[24] Women organized the Aba riots of 1929 in eastern Nigeria as a reflection of their opposition to colonial economic policies, especially taxation during a period of economic depression. As a result, they destroyed all the emblems of colonialism that they could find. These examples show that protests against colonial rule extended beyond the educated elite.

Lively political activities did not take place in French West Africa as they did in the British colonies. The French officially prohibited politics except in the Four Communes of Senegal, and in other places, they imprisoned anticolonial activists without trial, as illustrated in the 1920s by the fate of Louis Hunankrin (Hunkanrin) and his followers in Dahomey (Republic of Benin).[25]

The most prominent nationalist in French West Africa after World War I was Blaise Diagne, the first West African to be elected to the French Chamber of Deputies in Paris by the Four Communes in 1914.[26] Although his election as deputy surprised the Europeans, it revitalized politics in Senegal. Diagne became so influential that in 1916 he got a law passed ("loi Diagne") which recognized

24. Adu Boahen, *Topics in West African History* (Harlow: Longman, second edition, 1993), 136.

25. Louis Hunkanrin was a former teacher who led the protest that led to the recalling of "a harsh and unpopular governor" to Paris. Boahen, *Topics in West African History*, 136.

26. These communes were Gorée, St. Louis, Dakar, and Rufisque.

the rights of Africans who had gained French citizenship in the Four Communes. Diagne assisted the French to recruit thousands of soldiers from different parts of French West Africa to fight in World War I with the promise of concessions in return. While the French granted some of these concessions, they did not grant others.[27] With the support of the ex-servicemen, Diagne formed the Republican-Socialist party to demand concessions and to defend the rights of West African peoples in the French parliament. Diagne even rose to the position of under-secretary of state for colonies, and in spite of his political struggles for his people, he became unpopular because of his pro-French activities and proclamations. With Diagne's death in 1934, Galandou Diouf became the leader of the Senegalese, but unfortunately, he was "much less articulate than Diagne."[28] Lamine Guèye, a radical nationalist, emerged as the next leader, garnering support through his Parti Socialiste Sénégalais. He was one of the foundation members of the Ligue contre l'impérialisme et l'oppression coloniale, and he established the Comité de la défense de la race nègre, a group that sought improvement for African French citizens.[29] Like Diagne, Guèye too became pro-French, championing colonial policy.

Despite the lack of lively political activities, nationalists and trade union leaders organized protests to express the dissatisfaction of the peoples of French West Africa against exploitative French political, economic, and social policies. For example, in the Ivory Coast and Upper Volta protests were organized against forced labor. In 1923 the French governor, Fourn, increased the headtax, which the people of Porto Novo opposed by rioting. Workers organized strikes, veterans formed associations, and the educated elite provided leadership for various groups of people. But by March 1923, the French had suppressed all anticolonial movements.

The worldwide economic depression during the interwar years strengthened nationalist efforts. During this period, prices of agricultural products fell, workers received very low wages, and child labor became more prevalent. Foreign companies dominated the West African economy and prices of imported manufactured goods rose. These were potential causes for political, economic, and social disturbances as they reflected the continuing economic suffering and exploitation of West African peoples by the Europeans.

Constitutional Developments: The Gold Coast

The British discriminated against the nationalists in the Gold Coast in the same way as they discriminated against the educated elite in the other colonies. At its inauguration in 1850, the Legislative Council of the Gold Coast consisted of four official and two unofficial members. The latter included one African; a second African member was added in 1861. But because of the forceful activities of the educated elite, the British increased the number of Africans and included more traditional rulers in the Legislative Council. By 1916, the Legislative Council consisted of eleven official and ten unofficial members. The Guggisberg Con-

27. Elizabeth Isichei, *History of West Africa since 1800* (London: Macmillan, 1977), 259.

28. Crowder, *West Africa under Colonial Rule*, 437.

29. Hallett, *Africa since 1875*, 348.

stitution of 1925 made provisions to increase the membership of the Legislative Council, which rose to fifteen official members and fourteen unofficial members, with nine Africans (who were mainly traditional rulers).[30] By 1946, official membership no longer existed. The end of World War II brought rapid and significant changes because the nationalists became more active and critical of the colonial administration.

The Burns Constitution of 1946 took another major stride toward self-government by introducing representative government. The constitution introduced an elected unofficial African majority in the Legislative Council, the first in West Africa. Nationalists such as Dr. J.B. Danquah, Dr. Kwame Nkrumah, George Grant, Nana Ofori Atta, and Aarku Korsah led the struggle for self-government. They formed the United Gold Coast Convention (UGCC) Party, with Danquah as its president and Nkrumah as its secretary. Riots broke out in 1948 due to political and economic unrest and the colonial government arrested and imprisoned Danquah, Nkrumah, and four other members of the UGCC.[31] However, ideological differences with members of the UGCC prompted Nkrumah in 1949 to form his own party, the Convention People's Party (CPP). Nkrumah used the *Accra Evening News*, which he had established in 1948, to disseminate his ideas to the masses and to call for "Self-Government Now."[32]

The British set up the Watson Commission to investigate the riots of 1948. The commission recommended political and economic changes. A general strike and boycott of foreign goods organized by the Trades Union Congress began in January 1950 before the Watson Commission published its report. The colonial government once again arrested and imprisoned Nkrumah. The riots and the commission's report gave rise to the Coussey Constitution of 1951, which made provision for elections. While Nkrumah remained in prison, the CPP won the elections in 1951 and in the wake of this victory, Nkrumah became the leader of government business. He remained in this position until the Gold Coast achieved independence in 1957 and was renamed Ghana.

Constitutional Developments: Nigeria

Constitutional developments in Nigeria followed a pattern similar to those in the Gold Coast, with an increased effort geared toward establishing representa-

30. Although nationalists in the Gold Coast regarded Guggisberg as a great man who promoted education and economic development, their relationship with him was not devoid of antagonism. In some cases, they bypassed him by sending petitions to London. Throughout his period as governor (1919–1927), "Guggisberg and the nationalists pulled against each other unnecessarily." Wraith, *Guggisberg*, 160–188.

31. One of the causes of the riot was the British government's policy of cutting down cocoa trees that were infested with diseases. In addition, there were high prices of goods. On February 28, 1948, police fired at ex-servicemen at Government House in Accra. That shot precipitated riots, which left in their wake twenty people dead and a significant loss of property. Five leaders of the UGCC and Dr. Nkrumah were arrested and imprisoned for causing the riots. Webster, J.B., A.A. Boahen, and H.O. Idowu, *The Revolutionary Years: West Africa since 1800* (London: Longman, 1971), 324–325.

32. McFarland, *Historical Dictionary of Ghana*, xlviii.

tive government. Established in 1862 for the Colony of Lagos, the Legislative Council consisted of the governor, officials of the government, four unofficial members (nominated by the governor), and two Africans. The Legislative Council had a small membership because it served only the Lagos Colony, but the governor exercised strong reserved powers. However, when Lugard amalgamated the Northern and Southern Protectorates in 1914, the Legislative Council, now known as the Nigerian Council, had thirty-six members. As in the Gold Coast, the Nigerian Council served only as an advisory body because the government could reject its recommendations. Africans expressed their dissatisfaction with the situation since they wanted more participation in the government.

Sir Hugh Clifford, who succeeded Lord Lugard as governor, made some political changes. He abolished the Nigerian Council and replaced it with a Legislative Council with an increased membership. Clifford took a significant step toward representative government for Nigeria when he inaugurated the Clifford Constitution of 1922, the first constitution in the whole of British West Africa. Nigerians elected four of the fifteen unofficial members (three to represent Lagos and one to represent Calabar). The Clifford Constitution did not promote the unity of Nigeria because the council legislated only for the Southern Provinces while the governor directly ruled the Northern Provinces. Lugard's attempt to protect the north resulted in differences in the pace of political development, which eventually slowed down the process of constitutional change in Nigeria as a whole.

Before the end of World War II, Nigerians had formed a number of political unions that became the precursors of the post war nationalist movements. Herbert Macaulay formed the Nigerian National Democratic Party (NNDP) in 1923 with Lagos as its stronghold. However, Macaulay established affiliated unions in Ibadan, Abeokuta, Ife, and Oyo. Some members of the NNDP included Ernest Ikoli, J.C. Vaughan, H.O. Davies, Samuel Akinsanya, and Dr. Nnamdi Azikiwe. The same group of people founded the Lagos Youth Movement (LYM) in 1934.

The Lagos Youth Movement changed its name to the Nigerian Youth Movement (NYM) and in 1941, a crisis occurred within NYM on the nomination of a candidate to fill a vacant seat on the Legislative Council. Ernest Ikoli (an Igbo) and S. Akinsanya (a Yoruba) were nominated. Although Dr. Azikiwe supported Akinsanya, some members believed that he did so in order to weaken the Movement. The crisis, based on ethnic affiliation, led to the resignation of Dr. Azikiwe and all the Igbo members from the NYM to form a new party. He established the National Council of Nigeria and the Cameroons (NCNC) with Herbert Macaulay as the president and himself as the secretary.[33] The NCNC drew the majority of its leaders and supporters from southern Nigeria. Azikiwe was an outspoken individual as well as a powerful writer. He established newspapers in which he wrote pungent anticolonial articles. Azikiwe supported the workers in the 1945 General Strike, which cut across ethnic boundaries. In November 1949, the miners at the Enugu Colliery protested against the refusal of the colonial government to grant them wage raise and improved welfare facilities. Fearing that the miners might riot and become violent, the government ordered the police to remove the explosives in the mine. While

33. Dr. Azikiwe succeeded Macaulay as the president of the NCNC and remained its president until 1960 when he became the governor-general of Nigeria. Later he became the first president of Nigeria.

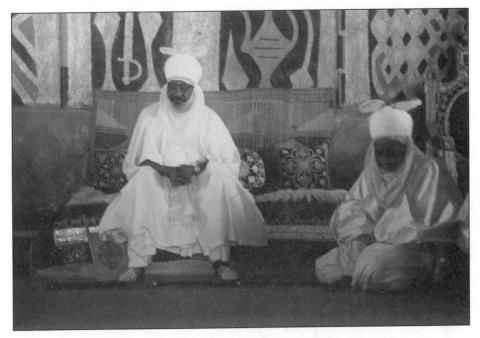

Figure 19-3. The King of Kano, northern Nigeria

carrying out the order, the miners attacked and the police opened fire. The police killed twenty and wounded twenty-nine of the miners. Although the governor, Sir John Macpherson, immediately appointed a Commission of enquiry, Azikiwe and the Zikist Movement wrote to condemn the shootings. The Zikist Movement, which expressed radical nationalist ideas, was an outgrowth of the NCNC.[34]

The pressure that the educated elite put on the colonial government for reforms culminated in the introduction of the Richards Constitution in 1946. Among other things, the constitution created regional councils in the east, north, and west. From the perspective of the nationalists, the constitution did not represent a progressive step toward unity because it further divided Nigeria into sectional groups. Instead of lasting for nine years as planned, the constitution came under review within two years and was replaced by the Macpherson Constitution.

In the north, the Northern People's Congress (NPC) was founded in 1949 as a cultural organization dominated by the Hausa-Fulani oligarchy. Its leaders included Alhaji Tafawa Balewa, and Malam Aminu Kano. In 1950, Aminu Kano broke away to form the Northern Elements Progressive Union (NEPU). In the west, the Action Group (AG), led by Obafemi Awolowo, developed from the Egbe Omo Oduduwa, a Yoruba cultural group, in 1951.[35]

Conflicts over ideologies and approaches to self-rule impacted on the unity of the nationalists. For instance, while Azikiwe and his NCNC proposed a unitary

34. Among the members of the Zikist Movement were Nwafor Orizu, Osita C. Agwuna, Nduka Eze, Raji Abdalla, and Kolawole Balogun. Because of its radical approach, the movement was banned in 1950. G.O. Olusanya, *The Second World War and Politics in Nigeria 1939–1953* (London: Evans Brothers Limited, 1973), 118–119.

35. One of the most authentic sources of information on nationalism and political parties in Nigeria is Sklar, *Nigerian Political Parties*.

form of government, Awolowo and the northern leaders embraced strong regional autonomy. The Robertson Constitution of 1954 established a loose federation of three regions. Under that constitution, the Western and Eastern Regions attained self-government in 1957 and the Northern Region in 1959. The British granted independence to Nigeria as a member of the Commonwealth in 1960.

Constitutional Developments: French West Africa

French colonial policies hindered progressive political activities. Most of the leaders, such as Diagne and Lamine Guèye, were ambitious to become assimilated as French citizens. Guèye's political goal was to ensure that the French extended citizenship to all Senegalese. He openly expressed his ideas in the *L'Afrique Occidentale Française* (French West Africa), a newspaper, which served as the mouthpiece of the SFIO. He also formed a group called the Bloc African to garner support for the extension of citizenship to all Africans in Senegal. In 1945 Guèye and Léopold Sédar Senghor, a schoolteacher, renowned poet, and originator of the philosophy of Negritude, were elected as deputies representing Senegal to the constituent assembly in Paris.[36] In spite of the struggles by Africans, the French regarded independence as "a nasty word banned in polite political society."[37] Even after the war, the French did not consider self-government for their colonies.

Nevertheless, it would be misleading to characterize Africans under French rule as politically inactive, especially during the period of decolonization. For example, Félix Houphouët-Boigny of the Ivory Coast led the interterritorial party known as the Rassemblement Démocratique Africain (RDA) in the Bamako Conference of 1946, demanding colonial reforms and the creation of a French Community. In composition and objective, the Bamako Conference resembled the National Congress of British West Africa whose first meeting was held in 1920. Sekou Toure represented the Progressive Party of French West Africa and he adopted a more radical approach than his colleagues by demanding complete decolonization by the French, just as Nkrumah asked for "self-government now." Following the demands of the nationalists in the Conference of 1946, the French government made significant reforms. Eight countries emerged from French West Africa,[38] the "Loi Lamine Guèye" granted citizenship to many people in French West Africa, the use of forced labor was abrogated, and trade unions were allowed to function.[39]

The formation of more political parties strengthened the nationalist struggles in French West Africa after World War II. Léopold Senghor broke away from Guèye and the French Socialist party (SFIO) in 1948 to form the Bloc Démocratique Sénégalais (BDS). Guèye was a *citoyen* while Senghor was a *sujet*, therefore

36. Janet G. Vaillant, *Black, French, and African: A Life of Léopold Sédar Senghor* (Cambridge, MA: Havard University Press, 1990), 199–203.

37. Hallett, *Africa since 1875*, 354.

38. These countries include Dahomey (Republic of Benin), the Ivory Coast (Côte d'Ivoire), Guinea, Senegal, Upper Volta (Burkina Faso), Sudan (Mali), Niger, and Mauritania.

39. Hallett, *Africa since 1875*, 370–372.

Senghor appealed to a class of people who opposed assimilation but upheld African culture. That position helped Senghor to defeat Guèye in the elections of 1951. Senghor has been described as "one of the most firmly established leaders in French West Africa."[40] In 1958 the French Socialist party merged with the BDS, under a new name, the Union Progressiste Sénégalaise (UPS).

The French introduced further reforms in 1956 when Guy Mollet, the dynamic leader of the French Socialist Party, became the French prime minister. He allowed French West Africa to move faster to self-government. For example, the *Loi Cadre* (Outline Law) reforms of 1956 introduced new constitutions for French West Africa and allowed a degree of internal self-government for the constituent colonies. The *Loi Cadre* set up territorial assemblies to be elected by direct universal suffrage. With this reform in place, elections to the new territorial assemblies were held in 1957 elections, which the RDA won in the Ivory Coast, Guinea, Upper Volta, and Soudan (Mali). In 1958, when General De Gaulle became the president of France, he allowed a referendum in which the French West African states, except Guinea, voted to remain within the French Community. Guinea, led by Sekou Toure, became independent in 1958 without preparation.[41]

Conclusion

Significant developments have taken place in West Africa since 1885 as shown in this chapter. The transformation from the precolonial period to the period of colonization was not a pleasant experience. In northern Nigeria, as elsewhere in West Africa, resistance against the British was very strong and "most emirs preferred to die rather than submit to British rule."[42] European conquest meant the loss of political and economic power as well as relegation of social status for the African rulers. West African rulers and their peoples were not oblivious to the importance of freedom. They wanted to remain free. But they gave away that freedom because only the Europeans clearly understood the terms of the treaties they wrote and signed with African rulers. Looking at the resistance movements of the last two decades of the nineteenth century, it is clear that many people in West Africa were determined not to relinquish their land and freedom to the European intruders. Although the Europeans eventually subdued them, due primarily to their lack of unity, technology, and organization, they struggled to maintain their independence. Conquest and administration was not easy for the Europeans.

The Colonial administrations did not share power and positions with Africans. The inclusion of traditional rulers in the colonial administration did not reflect a deliberate attempt to train Africans in the Western political system; it was simply a convenient administrative arrangement for the colonial powers. African rulers were not empowered to make laws or execute policies without taking orders from colonial officials. Strict, oppressive, exclusive, and exploitative policies

40. Ibid., 375.
41. Ibid., 372–373.
42. Obaro Ikime, "The Establishment of Indirect Rule in Northern Nigeria," *Tarikh* 3, 3 (1970): 1–15.

made colonial administrations unsuccessful. The transfer of power to Africans after World War II was difficult because some colonial powers did not want to decolonize. In French West Africa, only some Africans enjoyed privileges while the others suffered under the yoke of colonialism. Africans were detached from colonial governments. Other than paying taxes and being forced to provide labor, the generality of the people were not involved. Thus, most of the benefits accruing from colonialism went to the Europeans. The means to the colonialists' economic success was exploitation of Africans through the enforcement of cash cropping, compulsory or cheap labor, and taxation. Nationalist activities, strengthened by the denunciation of colonialism after World War II, made the transfer of power from the Europeans to Africans possible, culminating in independence. The struggle for political freedom, which began in 1885, ended in 1960 when most West African countries gained independence from the colonial powers.

Review Questions

1. Why were the Europeans interested in colonizing West Africa?
2. Describe the indirect rule of the British in West Africa.
3. Compare and contrast British and French colonial policies in West Africa.
4. Discuss the constitutional developments in French West Africa.
5. What role did the educated elite play in the constitutional developments in the Gold Coast and Nigeria?
6. Discuss the main political developments in West Africa during the interwar years.

Additional Reading

Ayittey, George B.N. *Africa in Chaos*. New York: St. Martin's Griffin, 1999.

Boahen, Adu. *Topics in West African History*. Second edition. Harlow: Longman, 1993.

Crowder, Michael. *The Story of Nigeria*. London: Faber and Faber, 1966.

Legum, Colin. *Africa since Independence*. Bloomington: Indiana University Press, 1999.

Tordoff, William. *Government and Politics in Africa*. Second edition. Bloomington: Indiana University Press, 1993.

Gordon, April A., and Donald L. Gordon (eds.). *Understanding Contemporary Africa*. Second edition. Boulder, CO: Lynne Rienner Publishers, 1996.

Isichei, Elizabeth. *History of West Africa since 1800*. London: Macmillan, 1977.

Khapoya, Vincent B. *The African Experience: An Introduction*. Second edition. Upper Saddle River, NJ: Prentice Hall, 1998.

Vaillant, Janet G. *Black, French, and African: A Life of Léopold Sédar Senghor*. Cambridge, MA: Havard University Press, 1990.

Webster, J.B., A.A. Boahen, and H.O. Idowu. *The Revolutionary Years: West Africa Since 1800*. London: Longman, 1971.

Chapter 20

Northeast Africa

Saheed A. Adejumobi

The history of northeast Africa between 1885 and 1939 is extremely pivotal to the narrative of the African continent's transition to the modern era. Geopolitical issues tied to the area provide a triadic perspective regarding the cultural, political, and economic activities of shifting global power configurations from the late nineteenth century into the twentieth century. The implications of Ethiopia's relationship with the rest of the world, especially with Europe, provide deep insight into modern Africa's diplomatic fortunes, particularly in the context of political and economic developments. A focus on northeast Africa also offers an avenue to study Africa's attempt at charting its own historical course while dealing with both the positive and negative aspects associated with premodern traditions. This chapter allows the reader to explore three main themes: (1) the organized attempts by Africans to revolutionize social and political initiatives in order to deal with modernization reforms; (2) the implications of global European imperialism as characterized by military and nationalist economic expansion; and, above all, (3) the forms of cultural and political resistance carried out by Africans. All of these are represented in the history of northeast Africa in the period between 1885 and 1939.

* * *

Geopolitical Issues in Northeast Africa

In historical context, the northeast region of Africa has experienced numerous shifts in power configurations arising from domestic and international forces. The international significance of the region is largely due to the Red Sea's strategic geopolitical importance. In Ethiopia, the death of a prominent historical figure, Emperor Tewodoros, in 1868 marked a turning point in the history of the country. With easy access to the sea and relative prosperity, for a long time the Ethiopian emperors were able to purchase enough weapons to outgun their imperial rivals in Africa and Europe. Successive Ethiopian emperors were anxious to unify the territory and sought religious and political uniformity across the multiethnic and religious terrain. Political and religious threats from the country's neighbor, Egypt, contributed to a heightened awareness of such domestic and regional issues.

397

Yohannes IV (1868–1889)

In the story of African empires and communities as they were influenced by European expansionism and the imperial division and occupation of the continent, Ethiopian emperors stood out in their ability to resist external forces. While Emperor Tewodoros had laid a far-sighted foundation for modernization, Yohannes IV, the second of Ethiopia's great nineteenth-century rulers, was an uncompromising patriot. He was different from previous rulers, as he did not try to establish a fully centralized monarchy. Yohannes, from his power-base in the province of Tigray, exploited his territory's proximity to the Red Sea coast, through which firearms had long been imported. For the rulers of Tigray, taxes on commerce augmented the revenues they garnered from transit trade. The province's location also had its disadvantages, a fact made more obvious during Yohannes' reign, which coincided with the beginning of the age of imperialism.

Late Nineteenth-Century Diplomatic Relations: European Explorations in "The Horn" and the Defeat of Early European Imperial Excursions

On the eve of the "Scramble for Africa," Africa's northeast region was dominated by a border dispute between Ethiopia and Egypt, mainly over the ports of Massawa and Zula, as well as other important settlements. The Egyptians, led by Khedive Ismail Pasha, imposed a rigid blockade to prevent the import of arms by the Ethiopian ruler. In an example of Ethiopian rulers' reliance on faith in the face of major obstacles, Yohannes, who claimed sovereignty as far as the Red Sea coast, retaliated by appealing to European Christendom, a plea which received little attention in Europe. The opening of the Suez Canal in November 1869 meant that overwhelming interest and sympathy shifted toward Egypt and away from far-off Ethiopia, which as a direct result lost Bogos, Karan, Aylat, Afar, and Danakil, in succession, to military and political adventurers. In 1875, Egypt successfully annexed the Gulf of Aden ports of Zayla and Berbera, and, advancing inland, seized the old mercantile town of Harar. The decision to attack Yohannes and occupy Adowa with European mercenary-led Egyptian troops was met, however, by overwhelming resistance and major victories for Yohannes and Ethiopia. Through a combination of moves, which included the forceful conversion of feudal rulers to Christianity and other more conciliatory and accomodationist gestures, Yohannes proved to be an even more successful unifier of Ethiopia's citizens than Tewodoros.

The Suez Canal, the British Occupation of Egypt, and Mahdism in Sudan

The reign of Yohannes witnessed other important international developments, although these were to Ethiopia's disadvantage. The opening of the Suez Canal made the Red Sea, for the first time since the era of the pharaohs, an annex of the Mediterranean. The changing world economy, especially the Western World's growing appetite for commodities, also influenced local politics in the re-

gion. In combination, these developments greatly increased Europe's level of interest in the Red Sea and Gulf of Aden area, particularly in the case of Italy.[1]

In Egypt, Ahmad Urabi led a military revolt in 1881, which threatened the status quo in that country. This event coincided with a rebellion in the Sudan, a large-scale revival of Islam, which was led by Muhammad Ahmad—the Mahdi, or "guided one" who claimed to be a descendant of the Prophet Muhammad. The economic and political implications of the Mahdi's pronouncement of a holy war, or jihad, were in direct conflict with British and French imperial ambitions in the whole region of the upper Nile. Fearing a similar revolution in Egypt, Britain intervened and began a "temporary" occupation of Egypt, which lasted well into the twentieth century. In addition, Britain complemented its presence in Egypt with an alliance with Emperor Yohannes. Two friendship treaties were signed between Rear Admiral Hewitt and "the King of Kings" at Aksum in 1884. In the ensuing political negotiations, Yohannes recovered for Ethiopia the northwestern region including the province of Bogos, which had been seized and governed by Egypt. The British also presented arms and ammunitions from Egyptian garrisons to Ethiopia. Although Egypt withdrew from Ethiopian territories in 1884, political instability continued as a result of the activities of the Mahdists.

Yohannes and Modernization

Unlike his predecessor Tewodoros, Yohannes was more a conservative than a modernizer. Moreover, his successive struggles against foreign invaders, whether Egyptian, Mahdist, or Italian, left him with little time for technological or other innovations. He nevertheless succeeded where Tewodoros had failed in sending envoys on important diplomatic missions abroad. The reign of Yohannes also witnessed several other important innovations. In the medical field, mercury preparations for the treatment of syphilis came into extensive use at this time, at least in principal Ethiopian towns. Furthermore, Yohannes was the first ruler of Ethiopia to have a foreign physician at his court, a Greek doctor named Nicholas Parisis. He was the first Ethiopian monarch to be inoculated with a modern-style smallpox vaccine, which was then beginning to replace the country's traditional type of inoculation. The victories over the Egyptians at Gundat and Gura during the reign of Yohannes resulted in the extensive distribution of breech-loading rifles, as well as modern artillery obtained from the British.[2]

Political Events on the Eve of "Scramble for Africa"

The collapse of Egyptian power in the Sudan, and therefore in the Horn of Africa, created a power vacuum, but it did not last long. Ethiopia, Great Britain, and Egypt signed the Treaty of Adowa on June 3, 1884. Fearful that the French might take over the area of the Red Sea, London courted Ethiopian support only to renege on its treaty obligations in the end, refusing to take Ethiopia seriously as a regional power. Relations between Italy and Ethiopian provinces dated back to

1. Richard Pankhurst, *The Ethiopians* (Oxford: Blackwell Publishers, 1998), 169.
2. Ibid., 176.

the 1870s. In 1883, a treaty of friendship was signed between Italians and Menelik, an agreement that was short-lived. Despite the friendship treaty, on February 3, 1885, only eight months after its conclusion, the Italians seized Massawa, a natural harbor. On February 5, 1885, Ethiopia turned to England to complain when the Italians landed at Mitsiwas and blocked arms shipments from coming into Ethiopia. This action was supported by the British government, however, which favored Italian expansion on the Red Sea coast as a way of curbing the potential involvement of France, Britain's principal rival in the European Scramble for Africa. Italian troops advanced inland as far as Sa'ati and Wi'a, both around 30 kilometers from the sea. Ras Alula, the governor of the northern marches of Ethiopia, provided resistance to the imperial mission, attacking the Italian garrison at Sa'ati on January 25, 1887. His troops were repulsed with heavy casualties. On October of the same year, Italy signed the Treaty of Friendship, an alliance promising Menelik, the ambitious ruler of the Ethiopian province of Shewa, arms and protection from Italian attack. Overwhelming prejudice eventually pushed London toward a European ally, Italy, which had nurtured imperial interests in the Horn of Africa since the early 1870s. Involving itself late in the process of imperialism, Italy gladly welcomed cooperation with England to fulfill its imperial ambitions.

Much farther to the south, as a result of the impact of 1883 Mahdists rebellion in Egypt, which was going through economic hardship over lack of access to the Red Sea, the British needed Ethiopian support against the Mahdists. London sent an expedition to Emperor Yohannes under Sir Gerald Portal. The emperor received this mission near Lake Ashangi but it served little useful purpose. Portal wanted Ethiopia to cede to Italy the area Italy wanted. Ras Alula, speaking on behalf of Ethiopia, stressed that the empire's natural frontier was the sea and Italian advances would be permitted only when he "could go as Governor to Rome." Alula added:

> How can you say that I shall hand over to them the country, which Jesus Christ gave to me? That command to me would be unjust on your part. If your wish were to make peace between us it should be when they are in their country and I in mine. But now on both sides the horses are bridled and the swords are drawn; my soldiers in numbers like the sand are ready with their spears. The Italians desire war, but the strength is in Jesus Christ. Let them do as they will, as long as I live I will not hide myself from them in a hole.[3]

In spite of European aggression in northeast Africa, rivalry between the royal houses and between the provinces of Ethiopia still continued. While Ras Alula and Yohannes were involved with battles against Islamic and European forces, Menelik of Shewa, who had signed a friendly agreement with the Italians and received a large consignment of rifles from them, remained an observer. Military expeditions by the Mahdists continued until 1889. On March 9 of that year, Yohannes was wounded by a sniper's bullet and died the next day. The unexpected death of the emperor was followed by the disintegration of the Ethiopian army and Menelik of Shewa proclaimed himself emperor.

 3. Quoted in Richard Greenfield, *Ethiopia: A New Political History* (New York: Frederick A. Praeger, 1965), 93–94.

Menelik II (1889–1913)

The reign of Menelik II as ruler of the Shewa province and later as emperor of Ethiopia coincided with the Berlin Conference of 1884–1885, the official beginning of Europe's foray into territorial imperialism in Africa. Menelik also exploited the political atmosphere to reoccupy provinces previously subject to Ethiopian suzerainty. Between 1872 and 1896, the territory Menelik ruled more than doubled in size. He sought to occupy as many areas as possible before they were seized by European powers in the Scramble. Menelik's II reign is also considered the starting point of modern history in Ethiopia. His location in Shewa placed him geographically in a more favorable position than his predecessors, Tewodoros and Yohannes. Like Tewodoros, Menelik was keenly interested in both unification and modernization. He engaged in rebuilding the empire with campaigns in the Galla region and, in addition, he laid territorial claims to the Sultanate of Harar. As a result of Menelik's activities, the regions of Wellega, Wellamo, Jimma, Kaffa and Gomma, witnessed large-scale political realignments as tributary or protected territories. Although he steadily imported firearms to further his plans of expansion, it was through diplomacy rather than personal military leadership that he fulfilled his purpose. As with his predecessors, the international correspondence of Emperor Menelik II revealed the concept of Ethiopian emperors cultivating their own images as protectors of a besieged bastion of Christendom. As the "King of Kings," Menelik also sought alliances domestically with the rulers of Tigre, Hamasien, Begemidir, and Gojjam and on the international front with the territorially aggressive Italians. The treaty of Wuchale, or Uccialli, signed with Italy in 1889, was supposed to protect Ethiopian sovereignty. It was destined, however, to be one of the most controversial agreements ever signed between the two countries. The Italians attempted to deceive Menelik by printing two versions, one of which, preferred in Europe, regarded Ethiopia as an Italian protectorate. When he learned of the Italian interpretation, Menelik denied it and paid back an earlier loan from Italy to avoid any financial obligations. By the end of 1889, the Italians entrenched themselves on the upper plateau of Ethiopian territory and on January 1, 1890, officially named their colony Eritrea, after the Latin term Erythraeum mare, that is, the Red Sea. They soon afterwards began expanding far beyond the boundaries agreed upon in the previous year. Menelik protested, but the Italian government refused to listen, engaging instead in political machinations with a number of local chiefs who agreed upon an oath of solidarity with Italy.

Menelik engaged the Italian threat by cultivating a united political front in the provinces. Resistance appeared in the form of feudal overlords influenced by self-interest on one hand and the Ethiopian Christian Church on the other. However, the Church, many local chiefs, and the peasantry finally rallied and became a positive influence for national solidarity. The reign of Menelik was marked by the notion that the central government rather than the Christian Church should become the symbol of national unity, a process which brought about some semblance of secularized central authority.

In light of political developments, especially the threat from Italy, Menelik embarked upon large-scale importation of arms from France. At the beginning of 1893, he officially broke off relations with Italy and notified other powers that

Ethiopia refused to be recognized as an Italian protectorate. He also alluded to a biblical prophecy which seemed appropriate to the empire's actions when he proudly declared that "Ethiopia has need of no one; she stretches out her hands to God."[4]

By the end of 1894, it was clear to the Italians that they could achieve their expansionist aims neither by negotiation with Menelik nor by the subversion of local chiefs. The Italian government concluded that its objectives could be achieved only by military action, in other words, by outright invasion. However, the Italians were routed in Amba Alage, and their other holdings were threatened. On February 25, 1896, Italian Prime Minister Francesco Crispi dispatched a historic telegram to his army commander declaring that Italy was "ready for any sacrifice to save the honor of the army and the prestige of the monarchy."[5] The Italian commander responded by ordering a surprise attack on Menelik's army. On March 1, 1896, one of the greatest battles in the history of Africa was fought at Adowa between Ethiopia and Italy. Menelik was able to harness the efforts of elite political strategists such as Ras Mangasha, Ras Wolie, Ras Makonnen, and Ras Abate and the military leadership of Ras Alula, Empress Taytu, Ras Abate, Fitwrary Habta Giorgis, Fitwrary Damtew, and Dejazmatch Balcha, as well as peasant soldiers and guides, to defeat Italy decisively. The Italians lost 261 officers and 2,918 men; about 2,000 *askaris*, or "native" soldiers, were killed; 954 Italians were listed as missing; and 471 Italians and 959 *askaris* were wounded. The invaders thus lost 44 percent of their fighting force. Three out of the five Italian field commanders were killed, a fourth wounded, and a fifth captured. Fleeing the field of battle, the defeated Italian army abandoned all its artillery, as well as 11,000 rifles and most of its transport. The Ethiopians also suffered greatly, losing between 5,000 and 6,000 men with 8,000 seriously wounded. Their victory was however, complete.

The Ethiopian victory at Adowa proved of vital significance in Europe, where the political Left had campaigned vigorously against Italian adventurism. Both the French and the British governments dispatched diplomatic missions to seek treaties of friendship with Menelik. Other missions arrived shortly afterwards from the Sudanese Mahdists, the sultan of the Ottoman Empire, and the czar of Russia. The outcome of the battle gave Ethiopia a unique position in Africa. The victory made Ethiopia, in the eyes of many Africans both then and later, a beacon of independence on a continent almost entirely enslaved by European colonialism. The image of tall, dark Menelik and his political achievements spawned a new symbolic significance for Ethiopia in the African Diaspora. This was especially important in light of the economic and racist principles which supported the slave trade and European imperialism. The Haitian Benito Sylvain visited Menelik's court to make him the honorary president of Sylvain's African-centered political organization. According to Sylvain, this was done "in order to secure his Majesty's adhesion to a program for the general amelioration of the Negro race."[6]

The late nineteenth century was marked by the expansion of European imperialism in Africa. Ethiopia was able to exploit the desires of Europe through diplomatic and commercial relations, which largely kept imperial influence at bay.

4. Quoted in Pankhurst, *The Ethiopians*, 189.
5. Quoted in ibid., 191.
6. Quoted in ibid., 109.

A combination of domestic and European foreign affairs advisers and diplomatic corps representatives enabled Ethiopia to engage in the international trade in arms and other valuable goods. Ethiopia's ability to retain its independence was attributable in part to the diplomatic skills of several emperors who were involved in the intrigues of feudal political leadership. In their desire for political power, many of the emperors were prepared to cede territorial control of selected areas to their European allies. Others, such as Menelik, tried to sustain Ethiopian independence and nationalism through cultural avenues, which entailed the promotion of inter-group marriage and alliances among various provinces and regions. In Europe, the connection between capitalist expansion and direct political interference began to increase during this time. This development had a major impact upon the historical direction of northeast Africa.

Modernization Projects

After the Battle of Adowa, Menelik's Ethiopia was at once accepted by the European powers as a very real political force. The last decades of Menelik's reign marked the beginning of Ethiopia's modernization, which had been delayed for reasons including almost a century of internal and external warfare. The unprecedented period of peace, which followed the Battle of Adowa, led to an increase in foreign contacts. The advent of increasing numbers of foreign craftsmen created an entirely new climate for economic and technological development. A new administrative headquarters, Addis Ababa, was established in 1886 and five years later became Ethiopia's new capital. The city became the site of many of the country's principal innovations, and, because of its large population, enabled a degree of specialization of labor scarcely known elsewhere in the land.[7] Modern bridges were erected in Addis Ababa, Awash, and Gojjam. This era also featured revolutionary developments in education. The first modern school, the Menelik II School, was founded in 1908. Having to contend with Church opposition to Western ideas, Menelik entrusted this school and three others in the provinces at Hara, Ankobar, and Dase to Egyptian Coptic teachers and priests. Other innovations included the construction of telephone and telegraph systems, water pipes, and modern hospitals, and the introduction of new vaccines. The threat posed by the Italians had led Menelik to reorganize the system of taxation in 1892 and issue the country's first national currency two years later. The currency was based on a silver dollar, of the same weight and value as the old Austrian Maria Theresa dollar which had circulated throughout Ethiopia, as well as much of the Middle East, since the mid-eighteenth century.

Also in 1894 came the inauguration of Ethiopia's first postage stamps, produced in Paris, and the approval for the construction of Ethiopia's first railroad, which was to link Addis Ababa with the French Somaliland port of Djibouti. Conservative elements wary of modernization schemes encouraged opposition from Empress Taytu and Ras Makonnen against the railroad schemes. Menelik wanted the railroad to provide a means for the transportation of low-price commodities such as coffee, skins, and wax, the main Ethiopian exports. Although the project encountered technical, financial, and political difficulties, the coming of

7. Ibid., 195.

the railway marked the country's greatest technological achievement of the period. Backed by French finance, the railroad project helped turn Addis Ababa into a major city. These developments together with the construction of modern roads and a new shipping line all led to substantial expansion of the import-export trade. In 1905, the Bank of Abyssinia was established and two years later the first government hotel was established. Hotels, restaurants, and tailoring establishments all sprang up as symbols of urbanization and modernization.

The host of foreign advisers, ambassadors, emissaries, and adventurers brought problems as well as opportunities. Menelik sought to modernize his realm and thus listened to the advice of foreigners. Each foreign adviser sought to promote the influence and advantage of his own government and there was competition in the presentation of impressive but not always economically sound military and commercial schemes. In spite of the laudable modernization schemes and projects, development was still too slow and limited to greatly change the pattern of traditional Ethiopian society.

Between 1897 and 1908, Menelik was able to obtain international recognition for Ethiopia's frontiers, although the country was never safe from imperial intrigues from neighboring Italian Somaliland and from British interests on the Upper Nile. Short of military victories, France, Britain, and Italy continued jostling for influence in the Horn of Africa and Eritrea. European financiers tried to impose new forms of control over Ethiopia by exploiting its modernization schemes. Menelik was angered by the terms of European financial involvement and accused the Europeans of seeking to compromise Ethiopia's independence by economic means. In reaction to increased efforts by the European powers to increase their spheres of influence in this region by invoking a 1906 treaty guaranteeing the protection of European citizens, Menelik pointed out: "We have received the arrangement made by the three powers. We thank them for their communication and their desire to keep and maintain the independence of our government. But let it be understood that this arrangement in no way limits what we consider our sovereign rights."[8]

Menelik won respect both at home and abroad. He had, with the exception of Eritrea, managed to preserve and extend the territories of ancient Ethiopia; he had restored order and held down dissident feudal lords; and he had laid the foundations for development. In 1908, Menelik was almost completely paralyzed by a stroke although he lingered on until 1913. His death was followed by political struggles. A settlement agreed to by the various feudal lords led to the emergence of a division of power mainly between the Empress Zawditu and the regent and heir to the throne, Ras Tafari, also known as Haile Selassie.

Ras Tafari (Haile Selassie, 1930–1975)

Tafari Makonnen, the son of the widely traveled Ras Makonnen, was born on July 23, 1892. His father was the younger son of Tenagne Worq, a daughter of the Shewan Negus Haile Malakot who claimed Solomonic antecedents. At his

8. Quoted in Greenfield, *Ethiopia: A New Political History*, 126–128.

baptism, Tafari Makonnen was given a Coptic Christian name-Haile Selassie. A member of the nobility, he was introduced to statesmanship at an early age, representing Menelik at the coronation of King Edward VII of Britain. He was assigned to Catholic priests for his education, learning French under the direction of European scholars. Unlike his rival for power, the Empress Zawditu, who had received only a minimum of modern education, Tafari was widely read and had more understanding of modernization and global politics. Although Zawditu as empress held sovereign power, Tafari, who was younger by twenty years, was a more able leader. He was a more able diplomat at home but even more so in foreign affairs as he spoke European languages, notably French. He established an imperial bodyguard, a modern force composed largely of Ethiopians who had served with the British in Kenya or the Italians in Libya.

Ethiopia in the League of Nations

At the end of World War I, Haile Selassie courted Western friendship by dispatching diplomatic missions to the victorious allies in Europe and to the United States, congratulating them on their military triumph. In 1923, he achieved a great diplomatic success when his country was accepted as a member of the League of Nations. He expected that membership would ensure his country a period of peace in which to develop free of any threat from the colonial ambitions of other powers. Britain and Italy revealed other ideas when in 1925 they signed and publicized an agreement that included recognition of each other's spheres of economic interest within the Ethiopian boundaries. Using his League membership, Haile Selassie, in a strong parallel with Emperor Menelik II, in 1926 succeeded in obtaining a statement that such an agreement in no way limited Ethiopian sovereignty. His dignified insistence that the League's "Treaty Series" publish his protest together with the offending agreement made the European powers' claim seem ridiculous.

In 1924, Haile Selassie had undertaken an extensive foreign tour, which took him to Palestine, Egypt, France, Belgium, Holland, Sweden, Italy, Britain, Switzerland, and Greece. His modern and innovative outlook created a lasting impression during his foreign trips, which laid the foundation for the myths that grew around his personality in subsequent years.[9] Haile Selassie outmaneuvered his rivals and conservative elements and eventually Empress Zawditu recognized his enhanced position. She agreed when he demanded the title of "Negus," and he officially assumed the customary title of "King of Kings" on October 6, 1928. In the following year, he concluded an arms agreement with Britain, France, and Italy, but in historical perspective the value of this agreement was limited.

The coronation of Haile Selassie took place on November 2, 1930. Representatives from Britain, Italy, France, Sweden, Holland, Belgium, Germany, Poland, Greece, Turkey, Egypt, the United States, and Japan attended the ceremony. The celebrations attracted considerable international media coverage, both of the monarch and of the country. The worldwide publicity accorded the coronation had great international ramifications. Ethiopia, through the popular media, became far better known than ever before, above all in Africa, where many regarded

9. Ibid., 156–157.

the country as an island of independence in a sea of colonialism. Many in far-off Jamaica, where Marcus Garvey's "Return to Africa Movement" was by then well established, saw the coronation as no less than the realization of the biblical prophecy that "Kings would come out of Africa." Jamaicans identified themselves with the monarch of an independent African state, while they rejected traditional European missionary-based Christianity and created a new religion of their own. In it, they accorded the emperor the status of divinity, as the Messiah of African redemption. This gave birth to the Ras Tafarian movement, a new faith and ultimately a cultural form.

Modernization Projects

Haile Selassie sought to move the provincial administration closer to his concept of a salaried civil service responsible to the central government. He took this step to undermine the practice of unpaid feudal lords living off the country, which had been the price paid to maintain some form of order and the collection and forwarding of tribute to the central coffers. His reform measures also included a ban on soldiers' requisitioning or looting supplies from the peasantry, and anyone who killed another person was punished regardless of political rank or economic classes. Several printing presses were established in the capital and considerable publishing was carried out. Amharic newspapers appeared weekly and exhibited some freedom of the press. Families of intellectuals such as the Habtewold received state patronage. In order to ensure the growth of a class of modern educated young men from whose numbers he could draw his supporters in the years ahead, Haile Selassie took considerable trouble to extend government schooling. He enlarged the Menelik II School for the sons of nobles and founded the Tafari Makonnen School in 1925. He also encouraged other leading Ethiopians to found and finance schools. The Educational Department was made into a ministry in 1930 and new schools were opened in the provinces. A school for women was opened in 1931 and several Ethiopian teachers and students were sent abroad. In 1936, there were in total some 200 foreign-educated Ethiopians, at home and abroad. In 1934, a school was established to help groom the sons of rulers of additional provinces incorporated within Ethiopian's spheres of influence.

The years 1930 to 1935 were a great period in the consolidation and development of the empire. In 1931, a new "people's" constitution aimed at reforming Ethiopia's political structure was enacted. Haile Selassie sought to break the power of the feudal lords through the development of the authority of the central government or bureaucracy. The emperor was to form a senate from among the nobility who had for a long time served his empire as ministers, judges, or high-ranking military officers. He established a parliament whose function was to discuss those matters placed before it by the emperor. His control of central power was visible in the fact that he was the one who convened and dissolved parliament, appointed ministers, and had full power to issue decrees when the chambers were not sitting. He also laid down the organization and regulations for all administrative departments. The constitution confirmed Emperor Haile Selassie's line as the only legitimate line, descended "without interruption from the dynasty of Menelik I, son of King Solomon of Jerusalem and of the Queen of Ethiopia known as the Queen of Sheba." The document went on to affirm that the emperor's person was sacred, his dignity inviolable, and his power indisputable. The

Emperor also initiated legislation aimed at progressively abolishing the traditional feudal dues paid by the farmers and peasants, usually in the form of food and produce levies, in favor of taxation. He helped gradually erode customs such as special payments out of state coffers to government officials on their attainment of familial or administrative goals.

Haile Selassie successfully built up Ethiopia's military power, introducing airplanes to the country for state and military uses and establishing an Ethiopian airforce in 1929. He sent promising soldiers to the French military academy at St. Cyr. From 1930 until 1935, a Belgian mission trained the imperial guardsmen, and in 1934 a small military college was opened at Holeta, otherwise known as Guenet. By 1935, with the assistance of foreign military experts such as those provided by Swedish commissions, of the 200,000 to 300,000 men who were mobilized, about 7,000 had received some form of modern military training.

Conservative groups in Ethiopia resisted what they considered as radical modern changes. One of these figures was Menelik II's former minister of war, the aged Fitwrary Habta Giorgis. Fitwrary, like other conservative elements in modernizing societies, was opposed to Haile Selassie's interest in external, mostly European, ideas and innovations. He led a formidable group of nobles whose vested interests in feudalism dictated their opposition to reform. Feudalism varied from province to province in Ethiopia but was predominant in the Galla region. In other regions the governors and their officials also often looked upon the provinces as conquered fiefs which they would hold only temporarily and from which they ought, therefore, to squeeze as much personal spoil as they could, as quickly as possible. There was also a major clash between old ministers and young director-generals of institutions stipulated for reforms. In the words of an observer,

> Older men of rank, who still wore baggy white jodhpurs with bandages round their heads and straggly beards round their chins disliked the civil service and the young directors and 'to keep them in their place they made these young men with moustaches and European clothes bow down to the ground in the presence of age' and if the young whipper-snappers still wore *shemmas*, they had to tie them across their chests out of respect for the old men's blood and rank. Meanwhile, the old men would sit heavily in their chairs exchanging words of primeval wisdom, supporting their policy by proverbs, and pretending not to notice the callow youth around them...[10]

Twentieth-Century Colonial Project

With the exception of a weakened Liberia, Ethiopia was the only major symbol of African independence, the only area remaining beyond the imperial grasp on the African continent in the twentieth century. Major European nations including England, Belgium, France, and Russia had for several centuries cast envious eyes upon the green Ethiopian highlands. Italy, a late participant in the

10. Quoted in ibid., 174–175.

Scramble for Africa, had secured Eritrea, which consisted of the natural coastal region and the peripheral foothills of the Ethiopian Highlands, with a capital at Asmara. Italy was unhappy with the 1919 post-World War I treaty, which had overlooked its desire for "a place in the sun." Ethiopian emperors and lords had for decades frustrated Italian ambitions, and the routing of Italian troops in 1896 at Adowa deflated the ego of the Italians who had been defeated by a supposedly less civilized state and people. In the early 1930s, the aggressive fascist regime of Benito Mussolini of Italy embarked upon a new period of expansion in northeast Africa. Italy was able to exploit the fact that Ethiopia's peripheral areas were not effectively controlled from Addis Ababa, the capital. Nomadic raids, migration, and social and economic relationships prevented this. The European powers had also limited the quantities of firearms entering Ethiopia, thus making it very difficult for the Ethiopian government to police the boundaries. Thus, Italy from its territorial base in Somaliland could embark on territorial expansion. The stage was thus set for a test of the world's conscience, as the value of Ethiopia's numerous treaties with European powers was put to test. The Ethiopian crisis assumed global proportions because it became a test of the value of Ethiopian diplomatic relationships with European powers and membership of the League of Nations.

Towards the end of 1934, a joint Anglo-Ethiopian Boundary Commission examining the limits of the grazing areas of the nomadic Somali peoples came across an Italian garrison of colonial troops at Wal-Wal and a recently erected military fort. The Italians prevented the commission from proceeding. In January 1935, Ethiopia lodged a formal complaint with the League of Nations. The British government made some attempts at mediation but obtained little support and no results. The United States took refuge in isolationism and the French, terrified of driving Italy into the arms of Germany and upsetting the balance of European power, favored territorial adjustments in favor of Italy at Ethiopia's expense. The general mood of the European populace favored Haile Selassie who at this stage became the symbol of the appeal of conscience versus the realpolitik of world leaders. Italy exploited Ethiopia's feudal structure and infiltrated consuls and commercial agents, medical personnel and missionaries. On October 3, 1935, without a formal declaration of war, Mussolini ordered an attack on Ethiopia from Eritrea and Somalia. On October 7, the League of Nations unanimously declared Italy an aggressor but failed to follow up with any meaningful action. Attention turned away from Africa in March 1936, when Hitler recognized the weakness of the League and moved into the Rhineland.

In May 1936, Emperor Haile Selassie fled, a few days before his capital was occupied and all hope that an independent Ethiopia could survive was abandoned in the outside world.[11] The Italians appropriated Ethiopia's gold reserves and production. Realizing that many Ethiopian leaders and peasants were ready to face death rather than succumb to Italian colonialism, the Italians engaged in capital development, building roads, bridges, hospitals, and schools. In spite of such benevolence, continual opposition led to drastic measures such as the use of poison gas and military attacks. In February 1937, after an Italian viceroy was attacked, the Italians unleashed a three-day reign of terror. In addition to 300 educated young Ethiopians, thousands of peasants lost their lives. The Ethiopian

11. Ibid., 195–196.

Christian Church also suffered from Italian activities. Punitive measures exposed the activities of patriotic monks who resisted the Italian presence. Many were summarily executed and many churches were burnt. Women patriots such as Woizero Balainesh, Woizero Ayalech, Woizero Lilelesh Beyan, Woizero Abedech Cherkose, and Woizero Kebedech were also persecuted. Although many Italian and European media outlets and publications underreported the Italian atrocities in northeast Africa, sympathetic coverage for the benefit of British and Ethiopian audiences came from people like Sylvia Pankhurst, editor of the *New Times* and the *Ethiopian News*, which also ran some Amharic editions for circulation in Italian-occupied Ethiopia. Besides providing a home for Ethiopian exiles, the British eventually withdrew their earlier recognition of the Italian occupation of Ethiopia and provided covert protective support for several Ethiopian leaders, including the exiled Haile Selassie. Fascist Italy eventually declared war on Britain and for the first time Ethiopia gained a prestigious albeit weakened ally.

Ethiopian patriot forces eventually entered Ethiopia through the British colonies of Kenya and Sudan. The British forces included colonial armies from Nigeria, Ghana, the Sudan, southern Africa, and the Indian subcontinent. Haile Selassie, who had been nurturing his warrior image and duties even while in exile, was able to broadcast and arrange for propaganda leaflets to be dropped into Ethiopia primarily from the Sudan. In addition, he sought and received limited British help to suppress domestic political intrigues. With the aid of pamphlets and newspapers, the sentence "Ethiopia stretches her hands towards God," which Emperor Menelik II had popularized on September 27, 1890, when he rejected Italian protection, became the new clarion call for patriotic support. On January 20, 1941, Haile Selassie left the Sudan for Ethiopia, and Ethiopian patriot troops under the command of British Commonwealth officers defeated the Italians. By the end of 1941, Ethiopian troops were victorious in their territorial battles against Italian forces, apart from a few isolated pockets of resistance from forces that exploited the chaotic atmosphere to pursue parochial agendas. Haile Selassie reentered Addis Ababa in May 1941 and signed an Anglo-Ethiopian agreement in January 1942.

Conclusion

At a period when colonial powers were scrambling to carve up the African continent, Ethiopia was regarded as an anachronism. The founding of a modern state by Menelik threatened the global development of a racialized international political and economic order defined by European political and economic prerogatives. Conflicts between Ethiopian provinces undermined the empire's goals, a factor which helped sealed its fate. Ethiopia never fully realized how much opposition was stacked against the country's interests especially with the evolving global political and economic relations. Armed with a religious and political legacy, institutions, and an intellectual history older than those of many Western nations, Ethiopia too often had to resort to the sacredness of international agreements and its Christian faith. The location of the empire, however, necessitated an appreciation for military and strategic decision-making processes. As a result, Ethiopia was able to defend its territory against European, mainly Italian, imperi-

alism. The events in northeast Africa between 1885 and 1939, particularly those which occurred in Ethiopia, merit recognition in the history of the building of a "New Africa."

Review Questions

1. Highlight the importance of Ethiopia in the history of Africa in the transition to the modern era.
2. Describe and analyze the historical achievements of Emperors Yohannes IV, Menelik II, and Haile Selassie.
3. What are the factors responsible for the successes and limitations of the Ethiopian Empire?

Additional Reading

George A. Lipsky. *Ethiopia: Its people, Its Society, Its Culture*. New Haven, CT: Hraf Press, 1962.
Harold G. Marcus. *A History of Ethiopia*. Berkeley: University of California Press, 1994.
David Mathew. *Ethiopia: The Study of a Polity, 1540–1935*. London: Eyre & Spottiswoode, 1947.

Chapter 21

North Africa

Edmund Abaka

The period of 1880 to 1939 saw the replacement of Ottoman hegemony by European hegemony in North Africa. Spanish, French, and Italian political, economic, and social policies during the period resulted in conflicts between the colonial administrations and the local people on the one hand, and sometimes between the colonists and the imperial government on the other. In North Africa, as in other parts of Africa, resistance to European colonial rule was fierce. Islamic brotherhoods played important roles in both initiating revolts and supplementing the activities of the secular leaders. The impact of colonial policies and the practice of looking down upon Muslim religion and culture, united disparate groups—religious leaders, workers, peasants, and educated elite—in the fight against colonial rule between 1880 and 1939.

* * *

North African responses to European invasion and colonial rule were not radically different from the broad patterns of resistance to colonial invasion and colonial rule in other parts of Africa.[1] Two major differences are, however, discernible. First, European colonial activity in North Africa antedated the high point of European expansion in Africa (the new imperialism of the 1880s). Spain established a foothold at Melilla (1494) and Ceuta (1580) on the Moroccan coast, and invaded Morocco itself in 1859–1860 to break the long-standing Moroccan blockade of the two Spanish enclaves. France under Charles X invaded Algeria in the 1830s. In Egypt, Napoleon defeated the Mamluks at the Battle of the Pyramids in 1798, and made himself "master" of Egypt.[2] Muhammed Ali, who seized the reins of power after the departure of the French in 1801, strove to prevent European control of the Egyptian economy. His successors were not, however, prudent, and by 1885, Egypt was heavily indebted to European countries.

1. For broad patterns of resistance, see, for example, Michael Crowder (ed.), *West African Resistance* (London: Hutchison, 1971). For theories on resistance and responses in general, see A. Adu Boahen (ed.), *UNESCO General History of Africa. VII. Africa under Colonial Domination 1880–1935* (Paris: UNESCO, 1985); Robert O. Collins (ed.), *Historical Problems of Imperial Africa* (Princeton: Marcus Weiner, 1994), especially Part II: Collaboration or Resistance to European Rule. See also A. Adu Boahen, *African Perspectives on Colonialism* (Baltimore: Johns Hopkins University Press, 1987).

2. All of these had been preceded by the activities of the Romans, Vandals, Greeks, Arabs, and Turks. The major difference lay in the numbers of migrants and the European political economy of the period. Western European populations in North Africa in the nineteenth and twentieth centuries dwarfed earlier immigrants, numbering about 2 million.

The European control of the economies of North African countries, and the problems it spawned, sparked revolts in Egypt, Morocco, Algeria, Tunisia, and Libya and eventually engulfed various parts of the region. European rule failed to stamp out the Islamic identity of Maghrebi society, and the exploitative behavior and racism of European settlers caused Muslims to transcend traditional divisions and fight for liberation.

North Africa thus represents an interesting case study of fierce and long-drawn-out African resistance to European invasion and colonization between 1885 and 1939. North Africans were involved in a series of revolts against European invasion and colonization. At one level, the state was the focal point of resistance, as in Morocco, but with the support of the Islamic brotherhoods. At another level, the Islamic or Sufi brotherhoods, first and foremost religious, but definitely political, constituted the fulcrum around which resistance was initiated, organized, and executed. This type of resistance occurred even when the state was too weak and impotent to resist European rule. The Islamic brotherhoods played a very important role in the struggle against external invasion, took the initiative when the state was incapacitated, and kept up the pressure of resistance. This was the case in Cyrenaica when the Sanusiyya brotherhood resisted Italian invasion. A third level of resistance involved the *djemaa*, an assembly representing one of the various levels of ethnic divisions, which took up the struggle after resistance at other levels had been subdued.

Geography also played a part in North Africa's long resistance to colonial rule. Morocco, Algeria, Tunisia, and Libya (the Maghrib), and the Sahara cover an area of over 3 million square miles. The rocky massif of Tibesti, Ahagar, Air and its oases, together with the Atlas Mountains and their outlying ranges, provided a rugged topography that enabled the Berbers of the Rif, Shleuhs, and Imazighen region to resist European subjugation until the early twentieth century.[3]

North Africa at the Time of the European Invasion

In 1875, large parts of North Africa were under the suzerainty of the Ottoman Empire. Turkish officials ruled Libya, and Tunisia, though ruled by its own beys, paid annual tribute to Turkey. Algeria was also under Ottoman suzerainty until France invaded it in 1830 and made it a French colony. Morocco's independent statehood dated back over 1,000 years. Moroccan rulers, however, had a very difficult time exerting control over the village republics of the Berber montagnards of the Atlas Mountains and the Rif. Several Saharan communities and ethnic groups—Bedouin Arabs, Tuareg, and Tebu—dominated different sectors of the great desert. Between 1880 and 1930, France, Spain, and Italy invaded the region and altered its history.[4]

3. Robin Hallett, *Africa since 1875* (Ann Arbor: University of Michigan Press, 1974), 193.

4. Hallett, *Africa since 1875*, 195.

Morocco

For over four centuries, Morocco resisted Spanish incursions and successfully prevented Moroccans from having any meaningful interaction with the Spanish enclaves of Melilla and Ceuta. However, Spain invaded Morocco in 1859–1860, imposed a heavy war indemnity, and secured an enlargement of the fortified port of Melilla. In addition, Morocco ceded to Spain a port on the Atlantic coast as a refuge for fishermen from the Canary Islands.[5]

Late nineteenth-century Europeans considered the Sharifian Empire of Morocco as one of the last bastions of "medieval" and "picturesque" Africa characterized by walled cities, court ceremonies, and prancing horsemen. Morocco, in the eyes of Europeans, was in a state of decay and could only be revived through a liberal transfusion of European reforms. But these European perceptions ignored the history of a state with dynastic traditions harking back to the eighth-century, traditions that had survived the peculiar geographical configuration of Morocco. In the words of one French historian, "Morocco has been for almost five hundred years the only Islamic country which was aware of itself as constituting a nation."[6] This was due to its homogeneous population and tradition of effective centralized administration under the Hussaynids. Over the centuries, the Moroccan sultans became adept at holding together the divergent demands and interests of the people of the *bilad al-makhzen* (the land controlled by the imperial government), and the people of the so-called *bilad as-siba* (the independent territories over which the sultan had only nominal influence). During the Scramble for Africa in the 1880s, Morocco faced intense pressure from Western Europe. Along its long and troubled border with Algeria, Ottoman hegemony had been replaced by French hegemony, and Ceuta and Melilla had long been Spanish enclaves. The intensified European activity eventually led to a revolution in 1908, spearheaded by the members of the imperial government and the political and religious elite of the country. The revolution led to the overthrow of Sultan Abd al-Aziz (1894–1908) who had ratified the French conquest of the province of Tuat and acceded to reforms imposed by European powers at the Algeçiras Conference of April 1906.[7]

Algeria

The French conquest of Algeria (1830–1860) made that country the base for further French expeditions eastward into Tunis and westward into Morocco. The French presence created a serious problem between Europeans (*colons*) and Muslims (*indigènes*). There were 300,000 Europeans in a population of 3 million in

5. A. Laroui, "African Initiatives and Resistance in North Africa and the Sahara," in A. Adu Boahen (ed.), *UNESCO General History of Africa. VII. Africa under Colonial Domination 1880–1935* (Paris: UNESCO, 1985), 90.

6. E. Levi-Provençal, quoted in R. Landau, *Moroccan Drama, 1900–1955* (London, 1956), 34. For similar cases in South Africa, see Mark Mathabene's *Kaffir Boy: The True Story of a Black Youth's Coming of age in Apartheid South Africa* (New York: Macmillan, 1986); Nelson Mandela's *No Easy Walk to Freedom* (Oxford: Heinemann, reprint 1989), especially Chapter 4, "Land Hunger." Current land problems in Zimbabwe also reflect the "land issue" in colonial African history.

7. Laroui, "African Initiatives and Resistance in North Africa and the Sahara," 87.

1870, and 752,000 in a population of 5.6 million in 1911. Between 1860 and 1870, a large part of French Algeria was ruled or administered by the army. The European settlers felt that the *régime du sabre* was distasteful, since it was restrictive and denied them rights they would enjoy in metropolitan France. They were disgusted by Napoleon III's statement that Algeria was "not a colony but an Arab Kingdom" (*un royaume arab*), and that both Algerians and Frenchmen were equal.[8] In 1870, the French government averted a settler rebellion in Algiers. A decree of October 4, 1870, gave the *colons* the right to send six deputies and three senators to the French parliament, thus ensuring a strong Algerian lobby. In the context of the instability of French politics during the Third Republic, the lobby asserted itself and secured the transfer of a large part of Algeria from military to civilian rule. Between 1870 and 1891, the area under civil authority was expanded from 6,000 to 60,000 square miles. "Native Affairs" under the military administration were handled by the Arab Bureau that was paternalistic at best towards the local people. The *colons*, faced with the harsh Algerian environment, saw the *indigènes* as "the evil genius of the land, apart and impenetrable, partly a menace and wholly a nuisance."[9] This warped perception conditioned their attitudes toward Algerians.

Using the revolts of the Algerian people (the 1871 revolt in Kabylia and revolts in the 1880s) as opportunity and justification, the French aggressively pursued a policy of *refoulement*, that is, pushing the local people off the land to make way for colonists.[10] Land was confiscated on a massive scale while the burden of taxation still fell on the local population; 70 percent of revenue from direct taxation came from the *indigènes* in the early twentieth century, even though only about 3 percent of the revenue was devoted to them. In addition, they were subjected to the harsh disciplinary code of the *indigénat*, which required all Muslims to carry passes and imposed prison sentences for many offenses including late payment of taxes and traveling without the authorities' permission. These measures shattered the structure of Algerian society, reducing the nobility from adjudicators and representatives of the clan to ineffectual debt-ridden opportunists, and the rest of the population to the level of pauperization as pastoralists were deprived of their pastures and peasants were forced into areas of poor fertility.[11]

Always a major bone of contention in colonial Africa, the alienation of land to settlers caused serious problems in North Africa. Muslims considered the land as sacred, and in Algeria, where the *colons* appropriated 2.7 million hectares of the most fertile lands, the situation was particularly bad. The appropriation meant that people were driven away from the coastal plains and the valleys into the highlands and steppes. Later, they were encouraged to work as laborers for the new *colon* owners. In Tunisia, the *colons* took most of the agricultural land, and in Morocco, about one-sixteenth of the cultivable land.[12]

8. Jamil M. Abun-Nasr, *A History of the Maghrib in The Islamic Period* (Cambridge: Cambridge University Press, 1987), 264–265; Hallett, *Africa since 1875*, 196.

9. Quoted in S.H. Roberts, *History of French Colonial Policy* (London, 1929), vol. I., 208, for which, see Hallett, *Africa since 1875*, 197.

10. Abun-Nasr, *History of the Maghrib*, 268.

11. Ibid., 269–270.

12. A.E. Afigbo, E.A. Ayandele, R.J. Gavin, J.D. Omer-Cooper, and R. Palmer, *The Making of Modern Africa. Vol. II. The Twentieth Century* (London: Longman, 1986), 140.

Libya

By 1875, Libya, one of the largest and poorest provinces of the Ottoman Empire, was ruled directly from Constantinople. It was divided in the 1880s into two main provinces, Tripoli (comprising most of Tripolitania and Fezzan), and Benghazi (covering Cyrenaica). Even though the local governors at Tripoli and Benghazi were directly subject to the control of the government at Constantinople, the difficulties facing the Turkish government militated against any effective control of this unimportant part of the Turkish Empire. Libya was only required to pay annual tribute, and governors, supported by a small force of about 8,000 Turkish troops, were left in peace as long as they made no demands on the government in Constantinople. Turkish officials, assisted by the Sanusiyya brotherhood (founded in the 1830s), made no attempt to establish any system of direct administration over the Bedouin Arabs. Rather, they developed harmonious relations with local chiefs, using incentives and the threat of force to induce them to collect the taxes required by the Turkish administration.[13]

In the 1850s, the founder of the Sanusiyya brotherhood, Sayyid Muhammed ibn Ali as-Sanusi, moved from the Hejaz to Jaghbub in southern Cyrenaica. Under Sayyid Muhammed's direction and inspiration, Jaghbub became one of the most vigorous intellectual centers in the Muslim world. The spread of the Sanusiyya and its *zawiyas* (lodges) had a profound political impact on Cyrenaica, which was organized into a multitude of independent political units that were always at war with each other. The holy men of the Sanusiyya became arbiters of political disputes and mediated between the Bedouins and the Turkish authorities. In the process, they came to acquire political influence and over time, took on the character of a "theocratic empire."[14] This influence enabled them to play an important role in Libyan politics during the struggle against colonial rule.

Tunisia

The ineffectiveness of the nineteenth-century beys of the Hussaynid dynasty meant that real power lay with a small group of Mamluk ministers of Greek or Circassian descent. Between 1837 and 1873, Mustapha Khaznadar, a Mamluk, held the highest ministerial office of state in the government of Sultan Muhammad as-Saduk (1859–1882).

From the 1860s onward, the Tunisian government embarked on an ambitious modernization program with high-interest loans from European financiers. During Mustapha's stewardship, a motley crew of French, British, and Italian adventurers initiated grandiose schemes for mining and railway construction, schemes which contributed little to the development of the state, but were skillfully designed to extract money from the coffers of the state. Faced with a deteriorating economy, the government of the regency was forced to hand over complete control of its finances to an international financial commission. Khayr al-Din, who succeeded Mustapha, was an able, public-spirited minister who initiated reforms.

13. Hallett, *Africa since 1875*, 233.
14. Ibid., 234.

He ensured that tax collectors could no longer swindle the treasury. He promoted agriculture and redeemed all the treasury bills that fell due.[15]

Tunisia and Foreign Powers

Italian interest in Tunisia antedated the period of colonial rule. The united Italy had settled people, invested capital, and propagated Italian culture in Tunis. France, already well established in Algeria, was also interested in Tunis. The sultan in Constantinople, having lost his suzerainty over Algeria due to the French conquest of 1830, sought to regain political control over Tunisia, and was aided by considerable pro-Ottoman feeling among the elite.[16]

Turkey, France, and Britain were all interested in Tunisia in the 1880s. Constantinople still regarded Tunisia as part of the Ottoman Empire. The French in neighboring Algeria were worried about the frontier and about newly unified Italy's interest in the large Italian population in the Tunisian regency. Britain, preoccupied with the strategic importance of Egypt to its commercial interests in Asia, was concerned about neighboring Tunisia and the designs of other European powers. British policy in Tunisia up to 1870 was designed to shore up Ottoman control in Tunisia and preserve the status quo against French threats. In French thinking, however, an independent Tunis could easily be brought into the French empire.

Afraid of the imminent collapse of the Ottoman Empire, Britain acquired Cyprus in 1878 and made it the focal point of British eastern Mediterranean policy. With Italy striving to be a colonial power, France feared that if Tunis fell to the Italians, France would be faced with hostile European powers on either side of the narrowest point of the Mediterranean. The British foreign secretary, Lord Salisbury, signaled that the British would remain neutral in the event that France took Tunis, but despite Bismarck's encouragement, the French ministers prevaricated, thinking that German support was a ruse to distract them from the issue of Alsace-Lorraine. Intense rivalry between the French and Italian consuls, Roustan and Maccio, and the intrigues of financial interests in Tunis finally propelled the French government to act.

Using the autonomous status of the Kroumir (a group of *montagnards* between the Tunisian and eastern Algerian frontier) as an excuse, a French expeditionary force invaded Tunis. On May 12, 1881, the bey signed the Treaty of Bardo. Under its terms, the finances and foreign relations of the regency of Tunis were placed under French control, and a French army of occupation was put in place to oversee local administration and to maintain law and order. Responding to the French invasion, the London *Daily Telegraph* opined that "The real object is to drill the unfortunate Regency into a happy hunting ground for French speculators."[17] The first phase of the invasion passed without problems but in July 1881, the people in the south rose in rebellion against French occupation, and were only subdued after months of fighting.[18]

15. Abun-Nasr, *History of the Maghrib*, 287.
16. Laroui, "African Initiatives and Resistance in North Africa and the Sahara," 92.
17. Quoted in J. Ganiage, *Les Origines du protectorat français en Tunisie (1861–1881)* (Tunis: Maison tunisienne de l'ed, 1968), 661, in Hallett, *Africa since 1875*, 201.
18. Hallett, *Africa since 1875*, 211–220.

With the Algerian experience fresh in their minds, and desirous not to create another Algeria by annexing and turning Tunisia into a colony for European settlement, the French placed a resident-general (Roustan) in Tunis. In 1883, when the term "protectorate" was applied to Tunisia, Paul Cambon (a departmental prefect who succeeded Roustan as resident-general in Tunis),[19] sought greater powers than those stipulated in the treaty of Bardo to transform the country. By the Convention of La Marsa (1883), the bey of Tunis supposedly "promised to proceed with the administrative, judicial and financial reforms that the French government will judge necessary."[20] Tunisian administrative positions were not abolished. Instead, French officials were placed by the side of every important Tunisian official as advisors. A new system of administration staffed mainly by Frenchmen, from the resident-general down to the civil controllers and their assistants in the provinces, was superimposed upon the old Tunisian administration. The task of implementing the new technical services, such as education and public works, fell on officials from France or Algeria, or French-settler families in Tunisia. In this way, the Protectorate of Tunis became what Paul Leroy-Beaulieu described as *une colonie d'exploitation*, in the sense that France provided the capital and personnel to exploit the natural resources for the transformation of the country.[21] By 1910, there were 130,000 Europeans in Tunisia, but in the first decades of the twentieth century, a small group of educated Tunisians started to talk about nationalism.

Religious Nationalism and the World Wars

Some of the fiercest responses to European invasion and occupation came from North Africa. Religion became the focal point of resistance. Muslims resented the rule of "unbelievers." The French compounded this resentment when they derided Islam as an inferior religion, fit only for retrogrades, and responsible in large part for what they considered to be the primitiveness and backwardness of Maghrebian society. The French even issued the Berber Dahir (decree) by which they indicated that the Berbers would no longer be governed by the *Shari'a* (Muslim law). Rather, they would be governed by a combination of traditional Berber customs and French criminal law. The French had wrongly assumed that the Berbers were not Muslims at heart, and that they only professed Islam because they had been forced to do so. But the French could not have been more wrong. The Berbers joined the Arabs in protesting against the *Dahir* (decree).[22] Crowds poured into the mosques to pray for deliverance from the "time of peril" and Moroccans made pilgrimages to the shrine of Moulay Idris, founder of the city of Fez, asking for protection against the French.[23]

19. Paul Cambon was a French civil servant who had made a name for himself and who became ambassador to London in the years before World War I.
20. Hallett, *Africa since 1875*, 202. See also Abun-Nasr, *History of the Maghrib*, 292.
21. Hallett, *Africa since 1875*, 203.
22. Afigbo et al., *Making of Modern Africa*, 141.
23. Ibid., 141.

Algeria

World War I created a very explosive situation in Algeria. On the one hand, North African products were in high demand and enabled the settlers to accumulate credit. On the other hand, North Africans had to fight for France. The first major source of outrage was conscription into the French army. This was introduced in the years before World War I and the mufti of Tilimsan called upon Algerian Muslims to undertake the *hijra* in order to avoid conscription. This call was seen as the ultimate rejection of French conscription. Between 1910 and 1912, about 4,000 Muslims migrated to Syria in protest against French conscription.[24]

Yet, about 173,000 Algerian Muslims served in the French army. About 87,000 saw action in the trenches, and of this number, 25,000 were to lose their lives in World War I. After the war, the French government wanted to reward them for their services but the settlers forced the French government to drop the idea. Thus, Algerian Muslims emerged after the war with awakened hopes that were not fulfilled.[25]

On another front, conservative Muslims objected strongly to the Muslim Code of 1916. Drafted by a 1905 commission of eleven Frenchmen and five Muslim jurists, the code made references to the *Qur'an, hadith*, and works of classical jurists, especially where the code differed from the provisions of Malikite law. But Muslims considered the French claim to the right to codify Islamic holy law as a major humiliation perpetrated by the colonial system.[26] In addition, an articulate minority of French-educated Muslims wanted assimilation into the French Algerian community, but on terms of equality with the French.

In 1931, Sheikh Abdel Hamid Ben Badis raised the banner of revolt in Algeria. He founded a cultural, religious, and political organization called the Society of the Reformist Ulema, and, in 1938, issued a proclamation which labeled any Algerian seeking French citizenship an apostate. The society put a great deal of emphasis on education for Muslims, something the French had neglected. The society emphasized Arabic, mathematics, history, and geography and used the schools as the training ground for instilling nationalism and passing nationalist ideas to the young generation who were taught that "my religion is Islam, my language is Arabic and my country is Algeria."[27]

Similarly, religion played an important part in nationalist activity in Tunisia between 1900 and 1935. The French resident-general and his provincial officials overruled the government of the bey of Tunis, and seized *waqf* (religious) lands and religious endowments, thus depriving the government of money needed for schools, hospitals, and mosques.[28] Since these institutions were very important to the Muslim community, the *ulema* (learned men) from the religious center of Zaytuna Mosque in 1906 issued a scathing criticism of the French concept of land ownership. While the *Dahir* controversy was raging in Morocco, the French administration in Tunis encouraged Christian missions to try to convert Muslims. In

24. Abun-Nasr, *History of the Maghrib*, 330.
25. Ibid., 328.
26. Ibid., 320.
27. Afigbo et al., *Making of Modern Africa*, 141.
28. Ibid., 141–142.

1931, a 2 million franc grant was given to the Eucharistic Conference in Tunis that was held to celebrate the fiftieth anniversary of the occupation of Tunis. In consonance with French policy, the Catholic bishop of Tunis described the conference as a crusade against Islam. In response to this, people demonstrated against the conference, and dockworkers resorted to strike action on the day the delegates were supposed to arrive. Cotton merchants and their employees joined in the strike and when the national press finally joined in the mass protest against France, the conference was abandoned.[29]

Political Nationalism and World War I (1885–1918)

Tunisia

The westernized elite first took up the nationalist struggle against the French first in the Protectorate of Tunisia. In 1908, the Young Tunisian Party was founded under the leadership of Ali Basah Hamba, a French-trained lawyer. The aims and aspirations of the party were much like those of the Young Turks of Turkey; the party wanted Tunis to remain part of a reformed Ottoman Empire. Due to the hostility of the French resident-general, Ali Basah Hamba was deported in 1911 after presenting demands for constitutional reforms. Hamba was succeeded as leader of the Young Tunisian party by Sheikh al-Aziz al-Taalbi. Even in exile in Constantinople, Hamba continued his anti-French activities until he died in 1918 while he was preparing to lead an expedition to liberate North Africa.

World War I had important ramifications for the Tunisian westernized elite, as it did for similar elites in other areas of Africa. Tunisians, like other peoples of the French colonial empire, were compelled to fight on the side of the French. The principle of self-determination, as enunciated by President Woodrow Wilson of the United States, was a very attractive proposition.[30] Al-Taalbi demanded the right to send a mission to Paris, but the request was denied. In 1920, the Young Tunisian Party converted itself into the Destour or Liberal Constitutional Party (*Hizb al-Destour al-Hurr*).

The first Tunisian graduates of the Western-style education system formed the basis of a nascent nationalist movement. They became the bedrock of a new elite that would agitate for the end of colonial rule.

Algeria

In 1911, not more than 80,000 Algerians could find employment in industry and commerce and in the first years of World War I, a few enterprising men from Kabyla started to migrate to France in search of work. Many Maghrebians, especially from Algeria, crossed the Mediterranean to France, to find work. France

29. Ibid., 142.
30. Ibid., 142.

also actively recruited thousands of workers from North Africa. In the interwar years, thousands of Maghrebians continued to migrate to France due to unemployment at home. In all about 40,000 left for France.

During this period, a small group of liberal reformers, the Young Algerians, initiated heated discussions on the colonial regime in Algeria, but they demanded *assimilation* first, although the majority of Algerians, *colons* and local people alike, detested *assimilation* (the word derives from the French verb *assimiler*, which means, "to cause to resemble"). For the European minority, *assimilation* would lead to diminution of its power, and the African majority was not prepared to renounce its culture for the culture of the masters.[31] The liberals were intelligent and articulate, but their French education and background prevented them from identifying themselves with, or speaking for, the majority of Algerians, and, therefore, until 1939, it was the Islamic revival, not the Young Algerians, which was the more important force in Algerian politics.

Morocco

Mulay Hassan, the Moroccan sultan from 1873 to1894, grasped the importance of a modernized infrastructure and the creation of an efficient standing army as a way to expand his territory and authority, enforce tribute payment, and assert his authority in Morocco.

To modernize his army, Mulay Hassan brought in foreign military instructors and arranged for young Moroccans to attend military academies in Western Europe. In addition, he bought military hardware from European and American firms. Mulay Hassan invited the Italians to set up a munitions firm at Fez, and the German firm, Krupp, to provide coastal artillery. To pay for these, Mulay Hassan had to squeeze taxes from his people and collected by very harsh means, tribute from the *bilad as-siba*. Mulay also had to contend with European interlopers who had established bases on the Mediterranean coast of North Africa to siphon off part of the profits from the trans-Saharan trade.[32]

In the short term, Mulay Hassan successfully squeezed as much money from the people as possible for his reforms, but in the long run, his harsh method of tribute collection created resentment. Added to this, the steady decline in Moroccan exports of wool and corn, due mainly to competition from Australia and North America, and the mounting imports for a large European population led to an unfavorable trade balance and currency flight militated against Mulay's reforms.[33] He also had to contend with an increasing European merchant class that settled in the ports, placed themselves under the protection of a European consul, and succeeded in evading taxes imposed by the administration.

Mulay Hassan's son Abd al-Aziz was a minor at his father's death in 1894, and the court chamberlain, Bu Ahmad, took over the reigns of government. Aziz, an intelligent but weak ruler who was dominated by European friends and hangers-on, spent heavily on European technology.[34] Aziz's collaboration with Europeans was captured on postcards in Tangier showing the sultan in European uni-

31. Hallett, *Africa since 1875*, 198; Abun-Nasr, *History of the Maghrib*, 331.
32. Hallett, *Africa since 1875*, 206–207.
33. Ibid., 206.
34. Ibid., 207.

form. The horror of the Islamic community was encapsulated in the words of the
ulema of Fez: "Our ancestors lived in peace and quiet at a time when Europeans
had no means of interfering in our affairs and when it was impossible for them to
corrupt us. What use have these foreigners been to us? What new sciences have
they taught us and what advantages have we gained from them?"[35] Led by an ad-
venturer (nicknamed Bu Hamara, "father of the she-ass" who claimed to be a
brother of the sultan), revolts broke out in Morocco. Hamara gained control of
most of northeastern Morocco and held out from 1902 to 1911.

The twists and turns of European politics and the intensification of the parti-
tion of Africa seriously affected the fortunes of Morocco. England had preserved
the security of the Straits of Gibraltar with a view to developing open markets for
its traders, and had therefore vigorously defended Moroccan independence, and
made Egypt the cornerstone of the British policy of securing its trading empire in
India and the Far East. After constant friction with France over Egypt, and the
Sudan, Britain asserted control over that region, especially after the Fashoda crisis
of 1898. In 1904, France and Britain signed a treaty that recognized British para-
mountcy in Egypt in return for British recognition of French influence in Morocco.

Prior to this, France and Spain had drawn up contingency plans for the parti-
tion of Morocco. It suited Britain if a harmless power like Spain occupied the
northeastern coast of Morocco, which was very close to Gibraltar.[36]

From 1870 to the outbreak of World War I, German interest in Morocco grad-
ually increased, and German trade likewise grew by modest amounts. The Anglo-
French Entente of 1904, viewed in the context of outstanding colonial questions,
was a step leading to Germany's diplomatic estrangement from Britain, and a
diplomatic isolation which was highlighted at the Algeçiras Conference.[37] To Ger-
many, the Anglo-French agreement was an attempt to exclude Germany from exer-
cising legitimate rights in Morocco and, therefore, an affront to national prestige.
What precipitated the first Moroccan crisis of 1905 was the celebrated visit of
Kaiser William II to the Moroccan port of Tangier on March 31, 1905. A tense
standoff between France and Germany followed, and in the Algeçiras Conference
of 1906, the preponderant role of France in Morocco was recognized.[38]

In 1907, a fresh local crisis broke out in Morocco when a number of Euro-
peans were killed and France used this as a pretext to occupy a number of Moroc-
can towns. In the aftermath of these events Sultan Abd al-Aziz was overthrown in
a revolt, and his brother Mulay Abd al-Hafiz seized power. In 1911, Hafiz was
besieged in the capital, Fez, by hostile tribesmen and appealed to the French for
help. While France sent in an expeditionary force, Germany dispatched a gunboat
to the southern Moroccan port of Agadir, thus precipitating a further crisis. The
crisis stirred up public opinion in France and Germany, and after months of hard
bargaining, France gave Germany territory in the Congo Basin in exchange for

35. Quoted in J.L. Miège, *Le Maroc et L'Europe (1830–1894)* (Paris, 1963), vol. 4,
136, n. 5, for which see Hallett, *Africa since 1875*, 207.

36. Hallett, *Africa since 1875*, 208.

37. S.L. Mayer, Anglo-German Rivalry at the Algeçiras Conference," in Prosser Gifford
and W.M. Roger Louis (ed.), *Britain and Germany in Africa. Imperial Rivalry and Colonial
Rule* (New Haven, CT: Yale University Press, 1967), 215–216.

38. W.O. Henderson, *The German Colonial Empire 1884–1919* (London: Frank Cass,
1993), 94–95; Mayer, *Anglo-German Rivalry at the Algeçiras Conference,"* 215–217; Hal-
lett, *Africa since 1875*, 208.

German recognition of a French protectorate over Morocco. Four months later, on March 12, 1912, Sultan Mulay Hafiz signed the Treaty of Fez, which placed Morocco under French protection. To the Muslim population, the Treaty of Fez was a cowardly act of sale of *dar al-Islam* (the domain of Islam) to unbelievers.

One of the clauses of the Treaty of Fez provided for the partition of Morocco into a French zone and a small Spanish zone. The attempt to assert administrative control over a people passionately devoted to Islam and fiercely independent, and over a Muslim state that had not been conquered by a Christian invader in its thousand-year history, proved to be a very formidable task. In spring 1912, Berbers from the mountains harassed the cities of the plain, and soldiers of the sultan's army stationed at Fez mutinied and murdered their European officers.[39] At the same time, al-Hiba, a religious leader from the Western Sahara in the south, proclaimed a jihad against the unbelievers (*infidels*), attracted the warriors of the desert and mountains, and marched on Marrakesh. The French and Spanish deployed more than 10,000 troops in Morocco but they were inadequate to cope with the problems of the period. By a stroke of good fortune, the first French resident-general, General Hubert Lyautey, who had served under Galliéni in Indochina and Madagascar (now the Malagasy Republic), proved to be an excellent administrator who developed an intense personal sense of mission in Morocco. His primary task was to gain control of the imperial government (*makhzen*), the fertile plains, and the populous cities, without resorting to force.[40] Using both diplomacy and divide and rule tactics, Lyautey won over the Berber *caids* (members of the prominent al-Glawi family) and other "lords of the Atlas" who were confirmed in their possession of their domains. Al-Hiba was defeated by a French force and forced to leave Marrakesh. With the "lords of the Atlas" posing no threat, Lyautey had succeeded by the summer of 1914 in bringing the populous cities under some sort of control. In 1917, he launched a campaign against the *bilad as-siba*. This met with fierce resistance, but in the end, Lyautey succeeded in imposing a system of military occupation on the region.[41]

Even though Lyautey had conquered Morocco in the name of the sultan, he forced Mulay Hafiz to abdicate in favor of his pliant brother Yusuf, and in the end, the French established a system of direct control similar to the system in Tunisia. While other French administrators looked down upon Moroccans, Lyautey realized that the French would have to reckon with the new generation of Western-educated Moroccans and he tried to win them over by appointing some of them as members of the administration, but he was not prepared to send any more to France for fear that they might be exposed to "subversive" influences. He attracted collaborators, a small group of feudal magnates, the great *caids* of the Atlas. As in other parts of North Africa, the French *colons* became an immensely powerful pressure group determined to maintain its gains by all necessary means. The administration was, therefore, saddled with layers of interest groups by the time Lyautey resigned in 1925.

In the Spanish section of Morocco, very little had been achieved by 1921 in the face of a Berber population determined to maintain its independence. The Spanish were faced with a revolt led by two brothers of the same name,

39. Hallett, *Africa since 1875*, 209.
40. Ibid., 210–211.
41. Ibid., 211.

Muhammed ibn Abd al-Karim. The elder Abd al-Karim worked as a Muslim judge, and later, as a newspaper editor. The younger Karim trained in Spain as a mining engineer. They aimed to unite the peoples of the Rif and to create a modern nation state.[42] The Rifians enjoyed an initial victory over a large Spanish force at Melilla, seized a large supply of arms and ammunition, and advanced into the western Rif where they won other victories over the Spanish army. If the Rifians had lived within well-defined borders, Abd al-Karim might have established his state. As it happened, the Rifian territory also cut across the ill-defined boundaries between the Spanish and French areas and some of the Rifians attacked French frontier posts in 1925. The French counterattacked vigorously under Marshal Pétain, and by autumn 1925, the French and Spanish combined had over half a million troops in northern Morocco, the largest European force to be employed in Africa.[43] In May 1926, the Rifians were defeated. Abd al-Karim and his brother surrendered and were exiled to Réunion. This defeat enabled the Spanish to effectively control their part of Morocco, and in 1931, the French, employing a squadron of bomber planes and massive concentrations of artillery, finally subdued the High Atlas and the Saharan borderlands. By 1935, the *bilad as-siba* had been effectively suppressed.

The Colonial Economy in North Africa

Agricultural Colonization

The transfer of land from the local population continued as in many parts of North Africa. Settlers came to own about 8 percent of the land under cultivation in Morocco. Morocco was seen as a potential granary and European farming was encouraged on the Atlantic plains. In Tunisia, Europeans owned 920,000 hectares by 1914, about half of them in the ancient grain-growing areas of the north. As much as 40 to 45 percent of the land in the rich plains south and west of Tunis was taken over. In Algeria, European landholding doubled between 1881 and 1921, driving the indigenous people on to marginal land. Nearly a third of the cultivated land came into the possession of Europeans. Most of the best land was managed in large units, and Muslim North Africans performed most of the agricultural labor.[44] Thus, by World War I, North Africa had become to all intents and purposes a region of European settlement.

The intense European agricultural activity in North Africa meant that Europeans largely monopolized export production and shifted from small-holder grain farming to plantation crops, focusing on wine in Algeria and fruit in Morocco. By the 1930s, over half of Algeria's exports consisted of wine; half of this came from 5 percent of the producers. European farming practices had a dramatic impact on the population. Mechanization in Algeria and other North African countries further drove Muslim sharecroppers from the land. In Tunisia and Morocco, unlike

42. Ibid., 213.
43. Ibid., 214.
44. Philip Curtin, Steven Feierman, Leonard Thompson, and Jan Vansina, *African History* (Boston: Little, Brown & Company, 1978), 486.

Algeria, however, some Muslims prospered under the new dispensation. There was a sizable group of prosperous Tunisian Muslim olive-growers in the Sahel, and in Morocco, wealthy landlords and Muslim farmers still operated in the Atlantic plains.[45]

After the establishment of the protectorate in Tunisia, colonization by capital displaced the *fellahin* (peasants). Large European capitalist firms such as the Compagnie des Batignolles, Société Marseillaise de Crédit, and Société Foncière de Tunisie obtained nearly 430,000 hectares of land. In addition, France promoted "official colonization" which transferred Tunisian-occupied lands to Frenchmen. A beylical decree of November 13, 1898, required pious foundations to make 2,000 hectares of land available to the state each year. The protectorate authorities offered substantial financial help to settler cooperatives and farming unions and loans to settlers. By 1931, settler estates in Tunisia, which covered about 7,000 hectares of the most fertile parts of the country had received improved water and sewage provision, public roads, and railroads, all at public expense.[46] Italian estates in Tunisia were occupied by Sicilian and Calabrian settlers who were vine-growers, market gardeners, and nurserymen in the Tunis-Bizerta area.

Agricultural colonization started late (1918) in Morocco, but benefited from the Algerian and Tunisian experiments. Between 1923 and 1930, the protectorate administration rapidly promoted European settlement. It sold state and communal land to settlers at very low prices, and made available installation and equipment loans and subsidies for land clearing, mechanization, planting, and so on. The only condition was that settlers should live on the land and develop it.

Agricultural colonization affected rural North African society in many ways. Whereas a small number of large-scale North African farmers took advantage of the agricultural techniques and capitalization of the settlers with varying degrees of success, many farmers became agricultural wage laborers on settler farms. This led to increased proletarianization and social inequality. The use of tractors and other agricultural machinery led to an insatiable demand by settlers and large-scale North African farmers for land. The expansion of mechanized farms only became possible when small and middling Muslim farmers were driven off the fertile land and pushed farther and farther into the mountains. Furthermore, the colonial authorities tried to turn the pastoral peoples of the Tunisian high steppes, for example, into sedentarized cereal-growing farmers so that their lands could be parceled out to the settlers. The cattle-grazing grounds of the indigenous people were gradually taken over. The result was sedentarization, impoverishment, and flight from the land.[47]

Agriculture (animal husbandry) and trade constituted the main props of the Libyan economy during the colonial period. During the Ottoman period (1880–1911), agriculture had remained traditional. Wheat, barley, dates, olive oil, and citrus fruit production all depended on the rainfall pattern. On the other hand, large numbers of livestock were raised on the plains of Cyrenaica and

 45. John Iliffe, *Africans. The History of a Continent* (New York: Cambridge University Press, 1995), 218.

 46. A. Kassab, "The Colonial Economy: North Africa. Part I: The Economy of Tunisia, Algeria and Morocco, 1919–35," in A. Adu Boahen (ed.), *UNESCO General History of Africa. VII. Africa under Colonial Domination 1880–1935* (Paris: UNESCO, 1985), 422.

 47. Ibid., 428.

Tripoli. By 1908, Cyrenaica exported about 58,000 head of cattle and 340,000 head of sheep annually. Transportation was mainly by camel and donkey caravan both within Libya and in other North African countries. But from the end of the nineteenth century the caravan trade started to decline due to the introduction of alternative forms of transportation. Tripoli and Benghazi did brisk business exporting cattle, sheep, wool, camel-hair, dates, barley, and wheat to Italy, England, Malta, Egypt, Tunisia, France, Austria, and Germany, in return for cotton and silk textiles, glass, firearms, rice, tea, sugar, and coffee.[48]

To encourage settlement, the government granted large Libyan estates to wealthy Italians for agriculture. By 1929, the government had leased 58,087 hectares of land to Italian farmers. The government also provided £62 million in subsidies, and £158 million in loans, but only about 2,031 families were settled, way below government expectations. But after the end of national resistance in 1932, the Italian government entrusted to semi-public institutions (ENTE per la Colonizzione delle Libia, Instituto Nazionalle della Providenza Social, and Azienda Tabacci Italiani) the plan to settle 300,000 Italians in Libya. These institutions cleared land, provided water supplies, erected farm buildings, and provided stock to settlers. In turn, the farmers were required to sell their produce to these institutions, which would credit their accounts.[49] By 1936, about 85,000 Italians had been settled at a cost of £800 million.

Mining

European settlement in North Africa also implied the exploitation of mineral resources for the benefit of European companies. In 1845, the first mines were opened in Tunisia, and phosphate deposits at Kafsa were discovered in 1885–1886 and exploited from 1889 onwards. In Morocco, a mining decree on prospecting and exploiting minerals was issued in 1914, and by January 1, 1939, there were 3,500 prospectors in the country. In 1923, coalfields were discovered at Djerada, and the Moroccan mining legislation was redrafted. The Bureau de Recherches de Participations Minières (Mining Research and Joint Stock Bureau) was set up to search for solid and liquid fuels. This accelerated the pace of mineral exploitation in the Djerada coal basin, and the Khenifra iron ore deposits, the Imini manganese mines, and the Awli lead mine on the Upper Muluja (one of the largest in North Africa) were systematically exploited. The manganese deposits at Abu Arafa in southeastern Morocco, cobalt at Abu Aziz, lead and zinc at Mibladen, tin at Wukmis, and molybdemum at Azzekur in the High Atlas were all mined. Mineral exports rose from 8,232 tons in 1921 to 1,179,000 tons in 1930.[50]

In Algeria and Tunisia, phosphates (at Kuwayf and Kafsa), iron ore (at Beni Saf, Wen Za, and Djarisa), lead, and zinc were exploited before World War I.

48. A.A. Abdussalam and F.S. Abusedra, "The Colonial Economy: North Africa. Part II: Libya, Egypt and the Sahara,'" in A. Adu Boahen (ed.), *UNESCO General History of Africa. VII. Africa Under Colonial Domination 1880–1935* (Paris: UNESCO, 1985), 440–441.

49. Ibid., 444–445.

50. A. Kassab, "The Colonial Economy: North Africa. Part I: The Economy of Tunisia, Algeria and Morocco, 1919–35," in A. Adu Boahen (ed.), *UNESCO General History of Africa. VII. Africa under Colonial Domination 1880–1935* (Paris: UNESCO, 1985), 429.

These minerals were exploited by French companies (and a few other European ones) such as the Société des Mines d'Aouli et Mibladen, which was controlled by the Société Penaroyya-Maroc and affiliated with a number of banks in France. A Belgian company (Compagnie Royale Asturienne des Mines) owned the zinc and lead mines at Tuwaysit, and the American Morgan company owned majority shares in the Zellidja mine. Similarly in Algeria, all the mines were in the hands of foreigners.[51]

The Fiscal System

While Algerian and French goods were reciprocally duty-free, French ships had the exclusive right to sail between the ports of the two countries. Algeria was consigned to the role of exporter of raw materials and agricultural produce in exchange for French manufactured goods. In Tunisia, the act of May 2, 1898, gave a preferential position to French manufactured goods such as metal goods, machinery, and textiles in Tunisian markets. Under French tariff laws, similar goods from other European countries were liable to duty. In effect, French goods competed with goods from other industrial countries, and sometimes eliminated them as competitors. This action made imported goods more expensive.[52]

In Morocco, the Algeçiras Conference of 1906 called for strict economic equality between signatory countries in the Moroccan market but goods entering Morocco were subject to a 10 percent ad valorem duty and a 2.5 percent duty for goods destined for public works. This system enabled foreign companies to flood Moroccan markets with goods and agricultural produce and became an impediment to Moroccan prosperity. Consequently, Morocco resorted to indirect protectionism to restrict the importation of specific foreign foodstuffs. A *dahir* (decree) of February 1921 subjected wheat and barley imports to the payment of license fees, and another, of June 1929, banned flour and wheat imports completely, although manufactured goods continued to pour into Morocco.[53] Thus, the imbalance in the type of goods bought and sold in North Africa resulted in continual trade and balance of payments deficits between World War I and World War II.

Italy embarked on colonization in the early twentieth century. Initially, it pursued "economic imperialism," establishing the Banco di Roma for financial business in Tripoli in 1907, and later, for the establishment of business ventures in industry, agriculture, transportation, sheep farming, shipping and land purchasing. It also started shipping services between Libya and its neighbors, and Italian survey teams began prospecting for minerals. These activities aroused suspicion about the Italian role in Libya and Turkish authorities frustrated the Banco di Roma's activities. Using this as a pretext, Italy invaded Libya in 1911 and systematically sought to make the new colony a source of raw materials for Italy.[54]

51. Ibid., 429.
52. Ibid., 430–431.
53. Ibid., 431.
54. A.A. Abdussalam and F.S. Abusedra. "The Colonial Economy: North Africa. Part II: Libya, Egypt and the Sahara," in A. Adu Boahen (ed.), *UNESCO General History of Africa. VII. Africa Under Colonial Domination 1880–1935* (Paris: UNESCO, 1985), 443–444.

No major industries were established by the Italians in North Africa except for a small tuna-processing plant in Tripoli, a tobacco factory in Tripoli in 1923, and two shoe factories (Tripoli in 1923 and Benghazi in 1929). Salt production increased from 14,000 tons in 1927 to 50,000 tons in 1937. Local handicrafts industries also continued to exist.[55]

The Italian government also made huge investments in infrastructural projects, but at the expense of the Libyan people. Already reduced in numbers by war with the Italians and brutalized by life in concentration camps, many Libyans had migrated to neighboring countries. Those who survived the prison camps were herded into semi-slave conditions to provide labor for the new infrastructural projects. The Italians aimed to push the local population to marginal land in the interior and resettle Italians in their place. Furthermore, they reduced the sheep and camel population (the backbone of the local economy, as food and transport). They killed or confiscated large numbers of livestock and drove the rest into the inhospitable areas near the prison camps to make way for settlers.[56] These policies weakened the local economy and impoverished the people to such an extent that when the Italians tried to revive the livestock industry after resistance ended in 1932, it took years for the herds to be restored to their previous levels.

The Great Economic Crisis, 1930–1935

Between 1930 and 1935, the North African economies were hit by a serious economic crisis emanating from the collapse of settler agriculture. In most North African countries, imports exceeded exports and caused balance of trade deficits. Tunisian imports, for example, amounted to 1,984 million francs in 1929, while exports yielded only 1,408 million. Budgetary discipline, exercised by the French, enabled them to balance receipts and expenditure but crisis expenditure exceeded receipts between 1919 and 1929. Furthermore, Algeria, Morocco, and Tunisia borrowed huge sums of money from France to purchase equipment. The attempt by France to recover the loans and service the public debt caused an economic crisis in North Africa. Starting in Morocco, the crisis gradually spread to Tunisia and Algeria. Prices collapsed and foreign loans became scarce.

The mining industry suffered because the industry relied on foreign rather than domestic markets. While selling prices continued a free fall, prime costs for phosphate, zinc, lead, and iron continued to rise. For example, the prime cost of a ton of Tunisian phosphate in 1932 was 65.77 francs, at the port of loading, but sold for only 53.77 francs. In the end, many North African mines were closed down.[57]

Wine, the industry that represented 66 percent of Algerian exports, declined in value from 168 francs a hectoliter to 108 francs in 1931 and 54 francs in 1934.

55. Ibid., 445.
56. Ibid., 446.
57. Ibid., 435–436.

Since the settler economy was undergirded by wine production in Algeria and Tunisia, this spelt disaster for the entire economy.[58] In Tunisia, the olive industry was badly hit by the crisis. Italy initially subsidized the olive-oil producers and in 1932 imposed prohibitive duties on foreign oils. In 1935, Italy stopped imports from France altogether, prompting French retaliation in connection with a League of Nations embargo (October 5, 1935) on Italy for its aggression against Ethiopia. The crisis affected Tunisian growers first, and the large estates of European export farmers later, drastically reducing the quantity of olive oil exported, from 409,800 quintals in 1930 to 200,000 in 1936.[59]

Since the North African economy at the time was mainly agrarian, the majority of the population was badly affected by the economic crisis, especially those involved in cereal (particularly wheat and barley), wool, and oil production. All producers, including settlers and *fellahin* (peasants) were badly affected when the price of wheat fell. The crisis also affected the craft industries. Their share of exports fell from 3 percent to 1.95 percent between 1920 and 1930.

The social effects of the crisis were devastating. Many North African farmers went bankrupt. Many mortgaged their possessions, and small and middling farmers turned to moneylenders in the towns and countryside in order to pay off their debts. One byproduct of this was that financiers, moneylenders, and rich landowners continued to increase their wealth. In Algeria, the catastrophic drop in cereal and sheep prices impoverished the peasants who often sold all or part of their land to pay off their debts. Wealthy property and land owners increased their holdings and this laid the foundation for the emergence of even larger settler and some large Muslim estates in North Africa after 1930.[60]

The farming crisis was worsened by natural calamities such as drought and famine in the agricultural regions of North Africa. Large numbers of the *fellahin* were ruined and faced starvation. Many flocked to towns to eke out an existence in shantytowns.

Response to the Crisis

The future of the European communities in North Africa was endangered by the crisis, and both colonial governments and France took steps to revive the wine industry by increasing the quotas of wine admitted duty-free into France. In addition, stocks of wheat were piled up, stockpiling grants were given, and a minimum price fixed for wheat. Farmers could obtain bank loans on government-guaranteed warehouse warrants and France adopted measures to regulate the cereals market in Morocco, Tunisia, and Algeria. A Consolidation Loan Fund was set up in Algeria in 1932, and a Tunisian Credit and Consolidation Fund in 1934 to help end foreclosures and the prosecution of insolvent farmers.[61]

The economic crisis and peasant distress led to nationalist unrest in North Africa. The French authorities established a Pool of Indigenous Provident Soci-

58. Ibid., 446.
59. Ibid., 434.
60. Ibid., 437.
61. Ibid., 438.

eties (Fonds Commun des Sociétés Indigènes de Prévoyance) in Algeria in 1933 to give loans and grants to Muslims. An Agricultural Loans Fund (Caisse des Prêts Agricoles) was set up to provide relief to the *fellahin* through consolidation loans. Similarly, a "social economy" department in the Directorate of Native Affairs in Algeria provided long-term loans for tree planting, fertilizers, and the purchase of ploughs. In Tunisia and Morocco, similar attempts were made to inject credit into the countryside and help with agricultural production. Unfortunately, the measures were inadequate to solve the problems of the *fellahin*. They were not backed by large-scale campaigns to ensure their success, and in the end, proved to be an exercise in futility.[62]

Politics and Nationalism in the Post-World War I Period

The post-World War I period saw an upsurge of resistance against colonialism in North Africa. The Berber resistance of precolonial times continued, albeit in a different form. The French penetration of the Middle Atlas region, while still carried out in the name of the Moroccan government met stiffer resistance. In response to French policies, resistance took the form of xenophobia and holy war. The south and southwestern regions of Morocco and the Taza corridor to the north remained unsubdued while to the east, the Sanusiyya Brotherhood consolidated its position in the oases.[63] In other parts of the Maghreb, there was a relative measure of peace and stability and the establishment of civilian (as opposed to war-time, military-dominated) governments masked the restlessness and passive resistance which, given the right conditions, could be transformed into political action.

Tunisia

The second half of the nineteenth century was characterized by a reformist upsurge. After World War I, a new nationalism and hope in Wilsonian principles replaced Ottoman nostalgia. Shaykh Abd al-Taalbi and his friends formed the constitutionalist Destour Party in February 1920 to restore Tunisia to its independent existence. Their pamphlet *La Tunisie martyre* (The Martyrdom of Tunisia) vigorously criticized colonial rule. Even though there had been local representation on the Consultative Committee in Tunis since 1907, most of the French majority and about half the local representatives (who were usually nominated), supported agitation for reforms in 1920. They demanded elective representation and the extension of their powers beyond fiscal responsibilities. In 1923, beylical decrees and resident-general's orders were used to set up *caïdal*, that is, regional and

62. Ibid., 439.

63. J. Berque, "Politics and Nationalism in the Maghrib and the Sahara, 1919–35," in A. Adu Boahen (ed.), *UNESCO General History of Africa. VII. Africa under Colonial Domination 1880–1935* (Paris: UNESCO, 1985), 603–604.

central representation by election at various levels. Shaykh al-Taalbi, who had been imprisoned, was released, but his party broke up into two factions.[64]

In spite of the large concentration of wage laborers in Tunisia, the slow pace of industrialization and the authoritarian nature of the society stifled mass action. The focus of agitation centered on the small elite. The workers of Bizerta responded to al-Haddad's analysis and criticism of the plight of Tunisian workers and women, and nine regional unions joined together in October 1924, supported by the French Communist Party. However, the Tunisian section of the Workers' International, which worried that the new group was nationalist as opposed to socialist, criticized them. The Destour dissociated itself from this association with the French Communist Party. Instead, it joined a coalition that also included the indigenous section of the French General Confederation of Labor. Sectarian and ideological considerations in these alliances led to conflicting influences and undermined the unity of these movements.[65]

The 1920s saw the emergence of a new generation and a call for change. In Paris, in 1924, an *émigré* from the Maghreb formed the Etoile nord-africaine (North African Star) a group with a revolutionary and anticolonialist agenda. The new generation called the authority of both colonialism and tradition into question. In both Algeria and Tunisia, the pace of events, which had picked up after World War I, slackened off a little, but not in Morocco.

Morocco

A Rifian revolt led by Muhammad ibn Abd al-Karim and his brother reached a climax in 1925–1926. Karim, son of a *qadi* (judge), had studied at the University of Karawiyyin at Fez. Karim possessed military skill and an openness of mind that enabled him to unite neighboring communities against the Spanish. The Rifians, led by Abd al-Karim, enjoyed an initial victory over a large Spanish force in July 1921. On January 18 (or February 1), 1923, the "Rifian Republican Nation" was proclaimed.[66] Abd al-Karim had established relations with the French Communist Party in Morocco, and in October 1925, the Communist Party called a strike in support of him. Some French workers in Morocco demonstrated in this strike against the colonial war in Morocco. From spring 1926 the French authorities resorted to the use of force to eliminate Karim, who surrendered on 26 May 1926.

The Berber Dahir (royal decree) of 16 May 1930, which incorporated Berber customary law into the French colonial judicial system, provided the ammunition for mass action by the middle class. The Berbers regarded the decree as an attack on Islam and an attempt to divide their country. It solidified an opposition that had been limited to small clandestine groups. Numerous incidents in 1930 (120 from June 20 to September 30) demonstrate the extent of mass discontent, which the authorities responded to with summonses, imprisonment, and beatings. The Muslim prayer of distress rang out in mosques and the clashes spilled into the streets. The country Lyautey had held together was in tatters. Culture lay at the center of this new struggle against colonialism.

64. Ibid., 606.
65. Ibid., 608.
66. Ibid., 610–611.

Algeria

The reforming impulse was felt all over North Africa. In Algeria, a settler-dominated regime called Délégations financières, existed from 1901 to the end of colonial rule. The settler administration refused to sanction the governor-general's estimates for social welfare and school meals in 1927, and signed its own death warrant. Articles written by Ferhat Abbas and other Algerian scholars between 1922 and 1926 demanded colonialism. In 1931, in *The Young Algerian*, Abbas castigated colonization as "power without thought, brain without soul," and described the troubles of the Algerians in claiming their right to be an Arab nation. A 1930 preface to the reprinted articles (the 1922 and 1926 articles) asserted that colonization was a military and economic venture to the French, but a "veritable revolution overthrowing a whole ancient world of beliefs and ideas and an immemorial way of life" to the Algerians.[67] Similarly, the *Book of Algeria* (Kitab al-Djazair), written in 1931 claimed the right of Algeria to be an Arab nation,[68] and Abd al-Hamid ben Badis, insisting on intellectual and moral reform, raised the question of identity, all the while taking care not to defy French sovereignty. Ben Badis addressed himself to the existing signs of social dispersion and moral deterioration claiming that his religion is Islam, his language, Arabic.[69] In this case, culture became the rallying cry and the focal point of the resistance against the colonizing authorities. Under the aegis of the *ulemas*, many centers of resistance sprang up.

Conclusion

A depressed economy and increasing inequality marred the economic situation in North Africa in the interwar years. Social change and collective identity became focal points of resistance for the North Africans. Economic deterioration also introduced another element into the struggle: workers and workers' unions. The colonial regime, with superior resources on its side, played down the political importance of the forces that were massing beneath a seemingly tranquil surface. People like Abd al-Karim, or even institutions like the French Communist Party, were often cited as troublemakers. In this climate of both religious and secular agitation against colonialism, a new group of leaders entered the scene and carried the struggle to its logical conclusion.

In Tunisia, Habib Bourguiba and his friends Bahri Kika Tahar Safar and Matari, rallied public opinion. The Tunisian bourgeoisie, that had provided many recruits for the Destour, continued to be very critical of the colonial administration. The men of the Sahel became more militant, and they politicized the country districts. Clashes between the residents and the colonial authorities became more and more violent, resulting in obnoxious decrees that legalized repression. Bourguiba and his friends were arrested and imprisoned.[70]

67. Ibid., 612–613.
68. Ibid., 612–613.
69. Ibid., 614.
70. Ibid., 619–20.

In Algeria, the administration tried to restrict the *ulema*'s influence. Seeing people flock to the *ulema* in large numbers, the authorities forbade them to preach in the mosques. The "Michel Circular" of February 16, 1933, and three supporting decrees, which enforced this ban, led to demonstrations by believers, trade unionists, and militants of the extreme Left. An anti-Jewish riot in Constantine in 1934 shocked politicians by its violence. In the elections of January 1935, the opposition led by Dr. Bendjellul carried the day.[71]

In Morocco, the interwar years led to bitterness and frustration and the settler community reacted to whatever small-scale restrictions there were. The period also saw the rise of a nationalist press in Morocco. The Moroccan Action Committee led by Allal al-Fasi put forward a "Reform Plan" on December 1, 1934. Nationalist stirrings were also felt in the Spanish zone as well.

Therefore, in Algeria, Morocco, and Tunisia, social change weakened old solidarities and created new ones. Throughout North Africa, the towns became focal points of mass action. The old traditional groupings gave way to new mass action in which culture became an integral part of the struggle against the colonial administration. An affirmation of identity took precedence over union and socialist activities, and eventually won the day.

Review Questions

1. Why was North African resistance to European colonial rule so fierce and long lasting?
2. What role did religion play in the nationalist wars in North Africa between 1885 and 1939?
3. How did the economic crisis of the 1930s affect North African society?
4. Trace the pattern of European colonial activity in Algeria and Tunisia to World War I.
5. What were the main features of the colonial economy in North Africa?

Additional Reading

Gershovich, Moshe. *French Military Rule in Morocco: Colonialism and Its Consequences*. Portland, OR: Frank Cass, 2000.

Goutor, Jacques R. *Algeria and France 1830–1963*. Muncie, IN: Ball State University Press, 1965.

Joffe, George. *North Africa: Nation, State and Religion*. London: Routledge, 1993.

Marsden, Arthur. *British Diplomacy and Tunis, 1875–1902: A Case Study in Mediterranean Policy*. New York: Africana Pub. Corp., 1972.

Julien, Charles André. *History of North Africa: Tunisia, Algeria, Morocco. From the Arab Conquest to 1830*. R. Lee Tourneau, ed. and rev. New York: Praeger, 1970.

71. Ibid., 620.

Index